EYEWITNESS COMPANIONS

ROBERT CUMMING

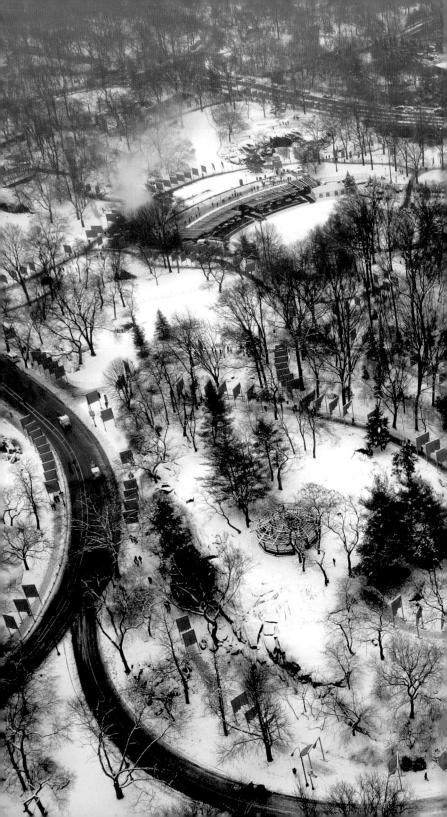

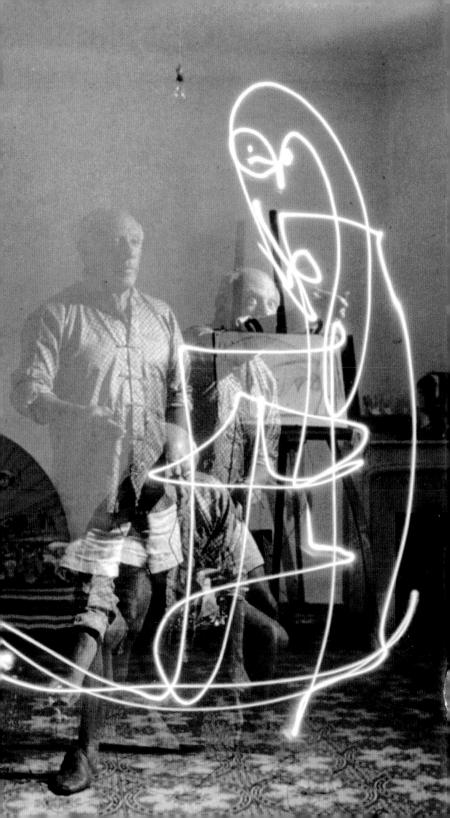

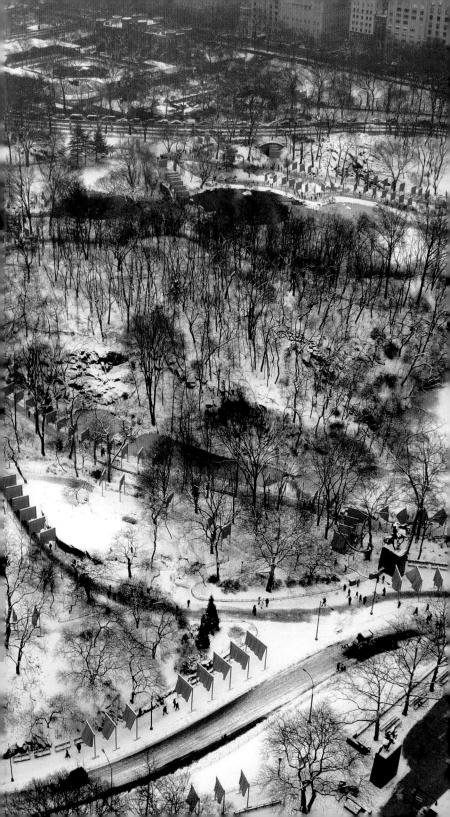

LONDON, NEW YORK, MUNICH, MELBOURNE, AND DELHI

Senior Art Editor Senior Editor Design assistance Editorial assistance Additional text contributions Picture Research

> DTP Production

Managing Editor Managing Art Editor Executive Managing Editor Editorial Director Art Director Publisher Juliette Norsworthy Ferdie McDonald Peter Laws David John, Rob Houston Thomas Cussans Sarah Smithies, Celia Dearing, Carlo Ortu John Goldsmid Rita Sinha

Debra Wolter Phil Ormerod Liz Wheeler Andrew Heritage Bryn Walls Jonathan Metcalf

at Studio Cactus

Design Editorial

Laura Watson, Dawn Terrey,
 Sharon Rudd, Peter Radcliffe
 Aaron Brown, Jennifer Close,
 Lorna Hankin, Clare Wallis

First published in 2005 by Dorling Kindersley Limited 80 Strand, London WC2R ORL Penguin Group

24681097531

Text © Robert Cumming 2005

All rights reserved, no part of this publication may be reproduced, stored in a retrieval system, or transmitted in any form or by any means, electronic, mechanical, photocopying, recording, or otherwise, without the prior written permission of the copyright owner.

A CIP catalogue record for this book is available from the British Library

ISBN 1 4053 1054 5

Colour reproduction GRB, Italy Printed and bound in China by L Rex

Discover more at

www.dk.com

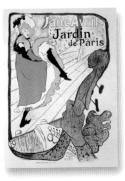

> WHAT IS ART? 16

MEDIA AND MATERIALS

THE HISTORY OF ART 44

CONTENTS

EARLY ART 3000 BCE-1300 CE **46**

GOTHIC AND EARLY RENAISSANCE c.1300–1500 72

HIGH RENAISSANCE AND MANNERISM c.1500–1700 128

THE BAROQUE ERA c.1600–1700 **162**

FROM ROCOCO TO NEO-CLASSICISM c.1700–1800 218

ROMANTIC AND ACADEMIC ART c.1800–1900 258 **MODERNISM** c.1900–1970 **340**

CONTEMPORARY ART 1970 – 448

> GLOSSARY 478

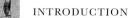

THIS BOOK HAS EVOLVED OVER MANY YEARS OF LOOKING AT WORKS OF ART, OFTEN ON MY OWN, BUT PREFERABLY IN THE COMPANY OF OTHERS. THE EYE IS THE SOVEREIGN OF THE SENSES, AND TO SHARE LOOKING IS ONE OF LIFE'S GREAT PLEASURES – IT INCREASES WITH AGE AND IS NOT CONFINED TO WORKS OF ART.

My first job in the art world was at the Tate Gallery, as a new member of a small team whose task was to stand in front of the works on display and explain them to the public. I soon learned that four questions were asked over and over again:

 What should I look for? What are the key features in a Picasso,
 a Rembrandt, a Raphael, a Turner?
 What is going on? What is the story? Who is Hercules? What is the Nativity? Who is that girl with a broken wheel? Who is the man abducting the woman who looks like a tree? Does that big red square mean anything? **3** What is its value? Am I looking at $\pounds 10? \pounds 10,000? \pounds 1$ million? $\pounds 10$ million? **4** Is it any good? And, in front of a pile of bricks or an unmade bed, am I being taken for a ride?

I also found that most of my audience seemed to enjoy getting involved in an informed discussion or exchange of

opinions about a particular work of art, or about specific issues (especially provocative or controversial ones) and about what *they* saw, thought, and felt.

In this book, I have tried to capture that sort of involvement and to address the four basic questions I have listed above. Also, I have been part of the art world long

enough to know that when those of us who work in it are "off duty", looking at art purely for pleasure, uninhibited by the need to maintain professional credibility, we often voice different – and sometimes much more interesting – opinions than we do when "on duty". The present-day art world is a huge industry of museums, teaching institutions, commercial operations, and official bodies, all with reputations

and postures to maintain. They are often desperate to convince us of the validity of their official messages.

I understand the pressures that impel all these official art institutions to maintain a party line, but in the face of all that vested selfinterest there is a need for

a no-nonsense alternative voice. In the main section of the book, *The History of Art* (pages 44–477), you will

Hidden treasures, the Hermitage, St. Petersburg This photograph taken in 1994 gives some idea of the vast quantities of works of art that are not on display, but are held in museum archives around the world.

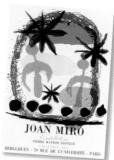

POSTER FOR MIRÓ EXHIBITION

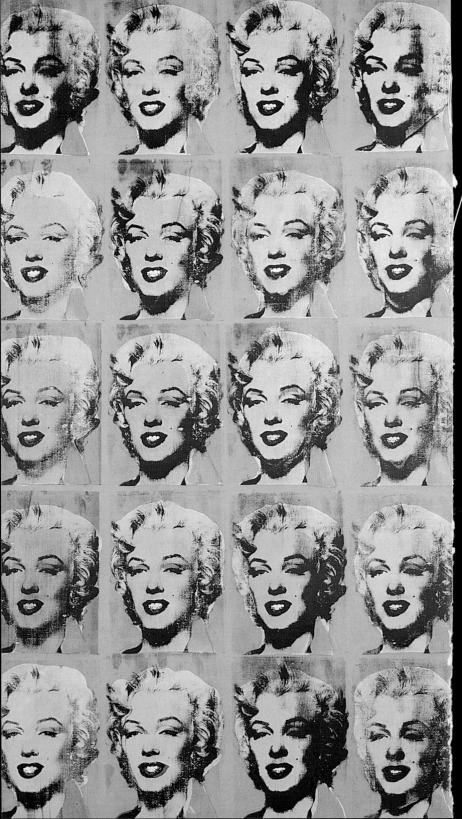

INTRODUCTION

find painters and sculptors, from the early Renaissance onwards, arranged as separate entries. In these I have indicated characteristics to serve as a guideline when looking at their works. My observations are entirely personal, but I have tried to pick out qualities that anyone with a pair of eyes can see, and have pleasure in searching for. Most of the entries were written, at least in note form, while looking at the works of art. In fact, nearly everything I have written in this book is what I would say if we were standing in front of a work of art. In such a situation it is, I think, better to say too little rather than too much, so as to allow those who are with me to make their own discoveries and connections.

I have included record prices paid for works by each artist because what people pay for works of art is fascinating, both in absolute terms and comparatively. Some works are worth every penny of the vast sums of money paid for them; some are ridiculously overpriced; and some wonderful works of art are almost given away because they are out of fashion or overlooked.

All prices are "hammer" prices, that is the value called out at auction when the item is "knocked down" to the bidder. The actual price paid by the successful bidder will be increased by the addition of a premium charged by the auction house (the amount varies between auction houses). Prices are given in US dollars, with no allowance for inflation. Where the sale was made in another currency, the price paid has been converted at the exchange rate at

Twenty Marilyns Andy Warhol, 1962, silk screen, Private Collection. Since the 1960s, prices for works of art have escalated and are now greater than at any other time in history. the time. You will see that a record price is not given for all artists. Works by many of the old masters rarely come onto the market because most now are in public collections. I would like to thank Duncan Hislop of Art Sales Index Ltd, 54 Station Road, Egham, Surrey, TW20 9LF, UK

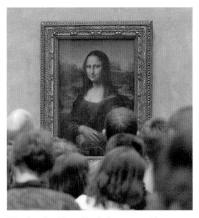

Viewing the Mona Lisa in her new setting To allow more people to see the world's most famous painting, the Louvre created a special gallery costing over \$6 million, which opened in April 2005.

(www.art-sales-index.com), for his generous help in providing the information on prices.

I hope this book will prove to be a friendly companion, an entertaining and practical aid for looking at art. If it fulfils its aims, it will provoke you, make you query your own opinions, cause you to stop, think, and, I hope, smile too. It should also encourage you to believe what you see, rather than what you are told and make you go back to a painting or sculpture and see aspects of it you had not perceived before. My first wish is to increase the pleasure you get when looking at a work of art.

> ROBERT CUMMING London, May 2005

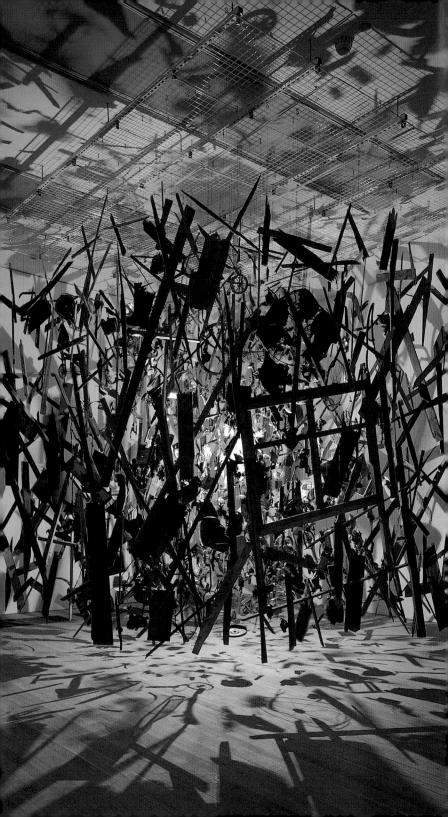

WHAT IS ART?

Very few artists fit the stereotype of suffering for their art, starving in an unheated garret, producing one unrecognized masterpiece after another, and finally achieving recognition on their deathbed. The image of the artist as a lonely, neglected genius is attractive but misleading. The reality is much more prosaic.

ost artists have been skilled in their trade, hard-working, professional, and aware of their business potential, often running busy, well-organized studios with assistants, not unlike a modern architectural practice. The artist whose talent goes unrecognized in his or her lifetime is rare. Much more common is the artist who attracts lavish praise and recognition in his or her lifetime only to sink into irrecoverable obscurity, a footnote in art history rather than a chapter.

THE ARTIST THROUGH HISTORY This is not to say that the role of the artist does not change. It is possible to pinpoint three turning points when the role of the artist and his and her

Cold Dark Matter: An Exploded View Cornelia Parker, 1991, mixed media, London: Tate Modern. Cornelia Parker is one of the current stars specializing in installations for museum settings. In the art history of the future, will she merit a chapter or just a footnote? relationship with the rest of society altered significantly. In Ancient, Classical, and Medieval times, artists were essentially skilled craftsmen working for an employer such as a monarch, the Church, or a corporate organization. Their activities were supported and regulated by a professional body or guild.

At the beginning of the 16th century, Leonardo da Vinci argued that the artist should be treated as the social and intellectual equal of aristocrats and scholars. The great artists of the High Renaissance shared this aspiration, and the majestic flowering of their art proves how successful they were in establishing this role. It suited both artist and patron and endured right up to the end of the 19th century. It allowed artists to play the fullest possible role in society, becoming the confidants of kings and popes, and sometimes even acting as diplomats and courtiers.

RADICAL CHANGE

The French Revolution of 1789 ushered in profound political and social changes. The privileged world of monarchy and aristocracy began to wane. With a new sense of individual liberty in the air, art attracted new personalities who previously would have ignored an artistic life. The Romantic spirit exploited this freedom to express individual emotions, and to create art about personal experiences. The Classical tradition, with its admiration for antiquity and disciplined professional training, continued to flourish alongside Romanticism, but it was in decline.

This spirit of independence led to a turning point in the second half of the 19th century, and to a new role for the artist. The change was most forcibly expounded by the radical French painter, Gustave Courbet, who argued that the true artist should be an outsider to the rest of society, free of all normal social conventions and at liberty to set his or her own rules. The idea was potent, particularly to the disaffected young, many of whom Francis I Receives the Last Breaths of Leonardo da Vinci Ingres, 1818, oil on canvas, Paris: Musée du Petit-Palais. Ingres, a painter firmly in the Classical tradition of the Benaissance, presents the image of the artist as intellectual giant, the equal of kings.

wished to establish a new art that would address issues at the heart of industrial society and the new awareness of human relationships and emotions that were revealed, for example, by Freudian analysis. It was a necessary condition for the development of Modern Art, and led to a rare chapter in the history of art in which the prime motivation

Andy Warhol and friends

In the 1960s Warhol commented on his era through images of products such as Coca-Cola and iconic figures such as Marilyn Monroe. In the 1970s his art increasingly featured images of himself and his followers. of the artist was not widespread recognition, professional advancement, riches, or social success, but a desire

to reform society and human relationships and literally to change the way we see the world.

THE ARTIST TODAY

The most recent turning point occurred in the 1960s and the most articulate advocate for another role for the artist was Andy Warhol, who found the image of the artist as penniless reformer outdated and unattractive. He wanted artists to share in the

material benefits of the post-war era and argued that they should have a role in society akin to that of Madison Avenue advertising executives or businessmen. If you look at the lifestyle and careers of most young artists born since the

1960s, you can see that they have, by and large, embraced Warhol's ideas with enthusiasm. The artist today is often a successful businessman or woman (in itself not that new a

> concept) selling to institutions or private clients such as large corporations or internet millionaires.

The most recent refinement is the artist's assumption of a managerial role - where the artist does not create a work of art in the traditional manner. but promotes an idea or concept, often in collaboration with others, and then manages it as a project or installation, delegating the physical

manufacture or assembly of components to select subcontractors.

PATRONS AND PATRONAGE

A patron is someone who provides the necessary financial assistance for an artist to create a work from scratch.

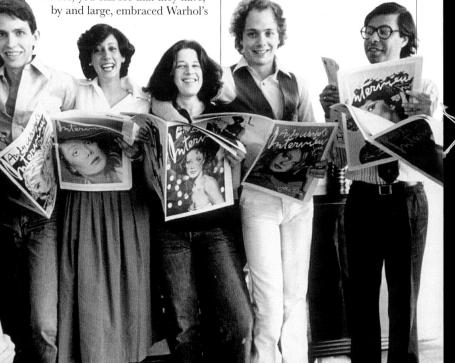

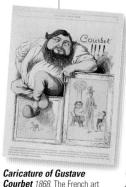

establishment hated Courbet

because of his radical political

and aesthetic doctrines.

In the early Renaissance, the patronage of one of the noble courts or the Church was the essential framework within which an artist was

obliged to operate, and the influence of a creative and imaginative patron was immense. Any selfrespecting monarch was now expected to be a patron of the arts, and this tradition continued even into the 20th century. Europe's rulers consciously used works of art to increase their prestige, credibility, and political power. The Church employed art in a similar way to spread the Christian message and to promote its influence. Without such patronage,

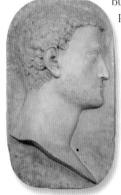

Cosimo I de' Medici Baccio Bandinelli, marble relief, Florence: Museo del Bargello. A reflection of Cosimo's self-image as a noble Roman in the mould of Caesar.

the great artists of the Renaissance and the 17th century, such as Michelangelo and Rubens, could never have created their masterpieces.

COLLECTORS AND DEALERS Collecting works of art without patronage is a different matter.

It presupposes collecting of the art of the past as well as that of living artists. If one had to nominate a godfather figure it could be Cosimo I de' Medici (1519–74). Cosimo used art to consolidate commercial and political power,

> but he also collected for pleasure. Collecting is thus an aspect of that concept of individual personality which lies at the heart of much Western art and thought. Cosimo was also influenced by his love of antiquity. Seeking to emulate the ambitions of Classical Greece and Rome he discovered how the Romans had been passionate collectors and bought and sold works of art at auction.

> > Private collectors, dealers, and auctioneers flourished in the new

mercantile Dutch Republic in the 17th century. Much of the framework of today's art market was established then, but the golden age for the dealer was the 19th century and the early 20th century. Many of today's famous firms were founded then, and many great works of art, intended for a particular setting in a church or palace, were torn from their original context, sold by dealers to private clients, and have eventually come

DEALERS

In the late 19th century, as the artist found greater freedom to express a private vision, rather than one shared by, or demanded by, a patron, modern art dealers became a necessary intermediary between the artist and collector. Indeed, without the courage of a few adventurous dealers, such as Paul Durand-Ruel, Ambroise Vollard, and Daniel-Henry Kahnweiler, the Impressionists and great masters of the Modern Movement would have found it impossible to survive economically, and would have lacked a valuable source of intellectual and moral encouragement.

to grace the National Galleries of the world. Other dealers effectively acted as patrons for young artists.

The art market used to be rather secretive. However, the rise of the international auction house since the 1960s and the buying and selling of works of art in full public view, has fuelled popular interest in recordbreaking prices. In relative and absolute terms, major works of art now command more money than ever before. This is partly because of their increasing scarcity in the market place, for once they enter a public collection, it is most improbable that they will come back on the market. And it is

also because rich people are prepared to go to almost any lengths to obtain the rarest of the rare.

FILLING SPACE

Very few works of art change the world or the way we see it. The reality is that most art does little more than fill a space. This is not a criticism, for

RECORD PRICES FOR ARTISTS' WORK

The figures given here are the prices paid at the time (in US dollars) with no account taken of subsequent inflation.

Garçon à la pipe Pablo Picasso	\$93m , 2004
Portrait of Dr Gachet Vincent Van Gogh	\$75m , 1990
Au Moulin de la Galette Pierre-Auguste Renoir	\$71m , 2002
Massacre of the Innocents Sir Peter Paul Rubens	\$68m , 2002
Rideau, cruchon et compotier Paul Cézanne	\$55m , 1999
Portrait of Cosimo I de' Medici Jacopo Pontormo	\$32m , 1989
Madonna of the Pinks Raphael	\$39.4m , 1999
Interchange Willem de Kooning Record auction price for a living	\$18.8m , 1989 artist's work

Fountain of Apollo Jean-Baptiste Tuby, 1670, gilded lead, Versailles. Louis XIV commissioned statuary glorifying himself as the "Sun King". Such patronage created an industry to supply art for his palaces.

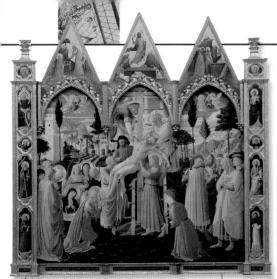

Santa Trinità Altarpiece Fra Angelico, c.1434, 176 x 185 cm (6914 x 7234 in), tempera and gold on panel, Florence: Museo di San Marco. Altarpieces of this high quality were rarities even in Renaissance Florence.

it is possible to fill a space very well, enhancing life with beauty and style. Moreover, the works of art of a period - their subject, size, style, appearance – are influenced by the spaces they are expected to fill. The characteristic public spaces of the Renaissance were churches, and quantities of altarpieces were required to fill them. The finest of these now reside, paradoxically, in the secular public spaces of galleries, revered as icons of art history. But a visitor to Italy, making a tour of churches, will soon suspect that such lifechanging icons are rare and that most Italian religious art does little more than fill spaces.

The monarchs of the 17th century quite literally created industries to produce works of art to fill their vast palaces. They required large sizes and complex mythological iconographies to proclaim their message of absolute temporal authority. By contrast, the newly established

Grand Gallery of the Louvre Hubert Robert, 1796, 112.5 x 143 cm (44 ¼ x 56 ¼ in), oil on canvas, Paris: Musée du Louvre. Robert was curator of the collection, which opened to the public in 1793. Dutch Republic had different spaces to fill. Wealthy merchants wanted to fill their town houses with images of their newfound political freedom and prosperity – small-scale meticulously crafted landscapes, portraits, domestic genre scenes, and still lives.

Eighteenth-century Britain created yet another new space, the country house. As well as filling them with old art brought

home from the Grand Tour, they filled them with the art of their own day which seemed to them most relevant and desirable, namely landscapes and portraits.

GALLERIES AND ACADEMIES The idea of a National

Gallery – a public space containing works of art that somehow define a nation's cultural identity was a legacy of the Napoleonic era. But these spaces held only historic art, never the work of living artists. In the 19th century the major spaces for the display of contemporary art were controlled by the Academies. These powerful institutions trained young artists and put on regular displays prepared by their members. Although their intentions were worthy, the Academies became obsessed with rules and internal politics and this is reflected in the increasingly ostentatious, but vacuous works of art created to fill their spaces.

One of the unique characteristics of the art of the early Modern Movement is that it was not created to fill public spaces. Detested by the Academies, ignored by private collectors, and with no museum willing to house them, many of the avant-garde works

of art produced by young artists, such as Picasso, never left the privacy of their studios. Their principal purpose was to change the way we see the world or to express a deep private personal sensibility. It was a rare and unusual interlude. Today, filling spaces has returned as a dominant influence in contemporary art.

The idea of a public place dedicated to a permanent display of work by living artists and of "Modern Art" in particular was pioneered by MOMA in New York in 1929. Not much imitated at first, in the last 50 years the idea has spread like wild fire. Museums dedicated to the display of Modern and Contemporary

GREAT ART GALLERIES

Listed below are some of the world's largest and most famous public collections of art.

Galleria degli Uffizi *Florence, Italy* **1591** The Medici art collection, viewable on request from 1591, bequeathed to the city of Florence in 1737

Musée du Louvre Paris, France 1793 Originally the gallery of the royal palace; opened to the public by the revolutionary government

Museo del Prado, Madrid, Spain 1819 The creation of King Ferdinand VII, encouraged by his wife, Maria Isabel de Braganza

National Gallery London, England 1824 Moved in 1838 from its initial home in banker John Julius Angerstein's house to a purpose-built gallery

Gemäldegalerie *Berlin, Germany* **1830** Originally the royal collection; finally reunited, after several name and location changes, in 1997

Hermitage Museum, St Petersburg, Russia 1917 Declared a state museum in 1917; began in 1764 as the private collection of Empress Catherine II

National Gallery of Art, Washington DC, US 1941 Purpose-built gallery designed by John Russell Pope

Museo del Prado, Madrid Spain's national gallery of fine art opened to the public in 1819, when Ferdinand VII transferred the royal collection to a fine Neo-Classical building in the centre of Madrid.

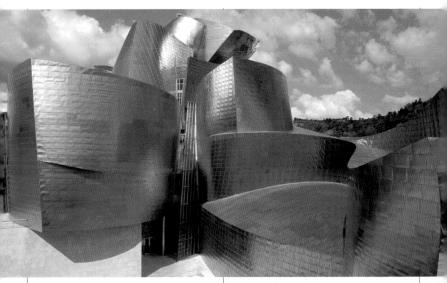

Art are now to be found in every city in the world. They have large spaces to fill, and an enormous industry has grown to supply them. Just as churches required works that were identifiably "religious" and "Christian", so these spaces require works that are "modern" and "contemporary", which is often interpreted as shocking and provocative. As the spaces become larger and more architecturally spectacular, so, in order not to be overwhelmed, do the works of art. All of which begs the questions:

Guggenheim Museum, Bilbao

Since it opened in 1997, the spectacular museum of Modern and contemporary art designed by Frank Gehry has been the city of Bilbao's main tourist attraction.

Which came first? The altarpiece or the church? The museum of contemporary art or the installation?

ART HISTORY

There are many ways of looking at and talking about art. When Queen Victoria and Prince Albert wanted to develop their appreciation of art, they

ART HISTORIANS, CRITICS, AND CONNOISSEURS

The natural habitat of the art historian is the library and archive, the museum and the lecture hall; that of the art critic is the media, the studio and art school, and the dinner table. The connoisseur is likely to be found in the auction room, the dealer's gallery, or in some long neglected attic. The connoisseur combines the best of the art historian and art critic with something extra – a discrimination and an instinctive eye for real quality plus a knowledge that comes from years of looking at works of art at first hand.

Critic and connoisseur Bernard Berenson An expert on Italian Renaissance art, whose opinions are often still valid, American Berenson (1865–1959) authenticated paintings for collectors and museums.

WHAT IS ART?

FAKES AND FORGERIES

There is a distinction between the two words, fake and forgery. A fake is a work of art made or altered so as to appear better, older, or other than what it is. A forgery is something made in fraudulent imitation of another thing. Throughout history people have produced what they claim to be lost paintings by Leonardo or Vermeer, for example, which they have created with great skill in their studios. Such works are not fakes but forgeries.

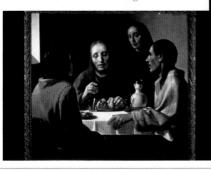

followed the fashion of their day and took drawing and painting lessons. Today they would sign up for an art history course. Art history as an academic subject effectively began in Germany at the end of the 19th century. It has brought discipline, rigour, and objectivity to a notoriously woolly topic. It has rescued many reputations and even proved the existence of forgotten artists.

But art history also has a downside. Works of art are not just historical documents. Art has the ability to engage with individuals and create experiences that can range from tears to ecstasy. At its worst, art history can reduce even the greatest works of art to a tedious list of facts. There is a danger that one can become so obsessed by "history" that everything "old" comes to be blindly revered like the bones of long dead saints.

ART CRITICISM

Good art criticism respects facts and history but is principally concerned with value judgements. It questions

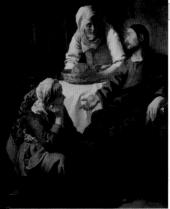

Christ in the House of Martha and Mary Jan Vermeer, c. 1654–56, 160 x 142 cm (63 x 56 in), oil on canvas, Edinburgh: National Gallery of Scotland (above).

The Dutch forger Han van Meegeren painted "Vermeers" that were authenticated by leading figures in the art world. He produced *The Disciples at Emmaus* (left) c.1936–38.

and probes an artist's purpose, intentions. and technical ability, asking whether the final outcome delivers what the artist has set out to do. Equally, in a historic display of art, such as an exhibition, the critic should examine the validity of the curator's interpretation. For contemporary art the critic ought to cut through the lavish rhetoric, which is often heaped on it by curators and dealers, to determine the true merit of what is being promoted.

Many reputations and much money ride on the current boom in contemporary art and there is a dangerous temptation, fuelled by the supremacy of art history, to treat every new manifestation and star name instantly as historically significant. This is disingenuous since, in any field of human endeavour, whether what happens today will have any significance in the longer term depends almost entirely on what happens tomorrow, and that is completely unpredictable and unknowable. WHAT IS ART?

THE MASTERPIECE

Is the idea of a "masterpiece" valid today? The term implies excellence and the desirability of the pushing of individual technical skill, ideas, and innovation to their limits. Ultimately it suggests the identification of those few works that have the ability to inspire emotion and communicate meaning long after their creation. Many works of art speak powerfully to the generation for which they were created, but very few have the power to continue to speak meaningfully to subsequent generations.

The origin of the term "masterpiece" dates back to when artists were considered to be craftsmen. It was the piece the artist presented to the guild to prove his ability and gain the coveted rank of "master". When the guild system became redundant and the role of the artist changed, the word lost this meaning and became attached to those outstanding works in which an artist is judged to display the full range

of his or her powers. Yet the word is overused. History is littered with the names of artists who have been hailed as the "Michelangelo of our times", but now barely merit a mention. Equally, the geniuses, such as van Gogh, who were neglected in their lifetime only for their masterpieces to be found after their death, are surprisingly few and far between. And there are those interesting second-rank artists who manage to produce just one or two outstanding works worthy of the description "masterpiece".

Taste and perception also change. Few would deny that for us, Botticelli's *Birth of Venus* is one of the early Renaissance masterpieces. Yet in his own lifetime, Boticelli's style was condemned as old-fashioned, and his name lapsed into obscurity until his works were rediscovered at the end of the 19th century.

HARMONY AND IDEAS

So what makes a masterpiece? Perhaps there are two things to look out for. First, a complete unity between subject, style, and technique. Raphael's paintings of the Madonna and Child are a good example. Raphael's harmonious, graceful style and flawless technique perfectly complement the qualities he seeks to portray in his divine subject. Second. and equally familiar to Raphael, is the belief that art should express an idea greater than art itself. Without such a belief, and a commitment to communicate

that idea to others, all art, however accomplished technically, is confined to

decoration and illustration. Technical skill can fill and decorate spaces, but only an idea connects at a deeper level with the needs of others and can change the way we see things. Artists live and work in a world peopled by patrons, collectors, dealers, art institutions, and fellow artists. To stand out from the crowd requires courage and individuality. Only those endowed with a depth of vision beyond the ordinary, and who use

David Michelangelo Buonarroti, 1501–04, height 410 cm (161 in), marble, Florence: Galleria dell'Accademia

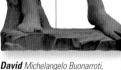

art, not as an end in itself or as a means of personal and commercial gratification, but as a means of trying to tell a greater human or spiritual

The Madonna of the Pinks Raphael, 1507–08, 30 x 23 cm (11¹/4 x 9 in), oil on canvas, London: National Gallery. An example of Raphael's skill and engagement with beauty and faith, this painting was unrecognized from 1855–1991, but recently sold for \$39 million. truth, are those who will succeed in creating masterpieces that can survive the judgement of the sternest critic of all – time.

For Raphael, beauty was an essential element in the search for ultimate truth – an inspired vision was more important than doctrine

The two figures together form a triangle filling most of the picture space. It suggests stability, permanence, dignity, and seriousness

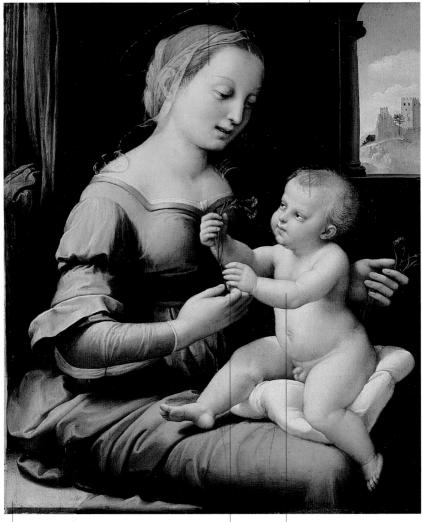

This tiny painting was to be an object of intense and private contemplation for a young widow who was entering a nunnery to take up a life of Christian devotion

Raphael's complete mastery

of the technique of oil painting with rich colours, subtle gradations, and fine detail such as fingernails, honours the spiritual profundity of his subject The playful activity and darting eyes of the Christ-child contrast with the stillness and lowered eyes of the Virgin; his naked maleness contrasts with her modesty and sweet femininity

MEDIA AND MATERIALS

Artists have always enjoyed appropriating, devising, and combining new media in pursuit of visual expression, from the rudimentary materials of charcoal, chalk, wood, and stone, to paint in the form of pigments and binders, through to the contemporary technology of digital editing.

The first artists collected and manipulated simple, basic materials to achieve a likeness or design. As tools and technologies developed, artists progressed from carving bone, wood, and stone to manipulating and firing clay. Sculptors later appropriated the technology of the forge and foundry to make bronzes. Painters, meanwhile, explored the environment for suitable pigments: chalk, charcoal, the dve of berries, crustaceans, and minerals extracted from the earth. For these materials (pigments) to be formed into paint, they needed to be mixed with a medium to bind them as a liquid. Effective media were resins, gums such as gum arabic, still used to bind watercolours today - and wax. A tempera paint made from egg was the

dominant medium in the Middle Ages until the 15th century, when oil painting came to the fore. Oils and watercolours dominated until the advent of acrylic in the 1940s.

Artists have often combined media, for example in the 20th-century practice of collage. Contemporary artists often juxtapose incongruous images and materials in installations and land art, as a means of challenging our conceptions of both the world around us and the aesthetics of art.

REPRODUCING ART

Printing allows multiple images to be generated, for example, by using woodcuts, engraved copper plates, and by plates etched with acids. The other major means of reproduction is photography. Most recently the advent of computer technology has allowed artists an unprecedented level of image manipulation and editing.

Oil paint was and continues to be widely used for many reasons: flexible, durable, easily manipulated, it offers rich colours, and can carry the personal style of the individual artist's hand.

Drawing

Drawing is the most immediate form of artistic expression. Before the Renaissance it was rarely valued as an art form in itself, but was seen as the preparatory design for a work in another medium. Cennini (c.1370–1440) gave it a certain status, calling it "the triumphal arch" to

painting, but the first artists who really exploited drawing as an independent expressive medium were Leonardo da Vinci and Michelangelo.

CHARCOAL

Charcoal is one of the oldest drawing media and remains popular with artists to this day. It is made from twigs of willow and created by a slow burning process which reduces the wood to carbon. It is available in varying

thicknesses, ranging from the very thick scene painters' charcoal to medium and thin sticks used for more detailed drawings. It is commonly used for drawing under painting as it is easily overpainted without discolouring the overlaid paint. Charcoal drawings can be edited very easily by means of a brush, putty rubber, or even soft doughy bread.

CHALKS AND PASTELS

ARTIST'S CHARCOAL

Study of a Man Shouting

Michelangelo, 16th century, charcoal on paper, Florence: Galleria degli Uffizi. Michelangelo drew in many differnt media: pen and ink, pen and wash, charcoal, and red and black chalks.

Blue Dancers Edgar Degas, c.1899, pastel on paper, 65 x 65 cm (25 ½ x 25 ½ in), Moscow: Pushkin Museum. Degas' practice was to develop the drawing in charcoal and then to apply layers of soft pastel to create a vibrant optical mixture of colour. Other well-known exponents of pastels include Mary Cassat, Odilon Redon, Picasso, and R.B. Kitaj.

SOFT PASTELS

White chalk was originally used to add highlights to other drawing media and was particularly effective on toned papers. Pigments such as iron oxide were added to chalk to make the red chalk characteristic of the drawings of Renaissance artists. Chalks are now produced in a full range of colours. Pastels, made of powdered pigments lightly bound in gum tragacanth, became popular with portrait artists in the 18th century. With soft pastels, the pigment is imparted to the paper by the slightest touch and can be

> blended in the manner of painting to create gradations of subtle, vibrant colour. Hard pastels, bound in a higher concentration of gum, are more suitable for drawing.

MODERN CHALKS

MEDIA AND MATERIALS

PEN AND INK

The pen evolved as an alternative to the brush as a means of controlled line drawing. The advantage of inks over dry drawing media was the precision and permanence of the line. Inks have been made from a diversity of sources, ranging from souty carbon-based materials (bistre) to dyes derived from berries, oak galls, insects, cuttlefish, and crustaceans. Water-soluble inks are more prone to fading than the more permanent waterproof inks such as Indian ink prepared with gum or shellac. The dip pen was the mainstay of graphic art for generations and evolved into the fountain pen, felt pen, and technical drawing pen.

REED PEN

FOUNTAIN PEN

31

DIP PEN WITH ASSORTED NIBS

MONET'S QUILL PEN

MECHANICAL GRAPHITE CLUTCH PENCIL STICKS PENCIL

MODERN Coloured Inks

The "lead" in pencils is actually graphite (a form of carbon). In the 16th and 17th centuries the only source of solid graphite was Borrowdale in the English Lake District. In the late 18th century the French devised a method of combining crumbly, amorphous graphite with clay. This mixture, encased in wood, is the pencil we are familiar with today. The use of graphite pencils thus became widespread in the age of Ingres, Turner, and Constable. Many artists today prefer to work with either a solid graphite stick or leads of variable width and density of tone, held in pencil holders. The term "pencil" is used for many graphic media, including compressed charcoal, chalks, and wax, that can be encased in wood like a pencil. Some use water-

soluble pigments which can be reworked with a wet brush.

Industrial buildings in a northern English town by an unknown artist, pencil on paper. Private collection.

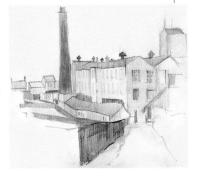

Painting

All paints require a binding medium that can hold pigments in suspension and permits successful application to prepared supports – walls, wood panels, vellum, paper, or stretched fabric (canvas). Early forms of paint consisted of pigment bound by a water-based glue called size, made from animal skins. Alternatives were gums and resins extracted from trees, the white and yolk of eggs, and beeswax. From the 15th to the 20th century the

of eggs, and beeswax. From the 15th to the 20th century the dominant medium was vegetable – usually linseed – oil.

ENCAUSTIC

Encaustic (wax) painting is a very durable medium which was one of the principal techniques of the ancient world, used by the Egyptians, Greeks, and Romans to paint images on panels and walls. The word "encaustic" comes from the Greek and means "burnt in". Artists would apply the paint using brushes and spatulas to create the image, and on completion they would run lit torches across the surface of the mural to reheat the wax, causing the wax and pigment to be absorbed permanently into the lime surface of the wall. Wax can also be added to oil paint to

aid the separation of clear areas of colour, a process used most notably by Van Gogh. This ancient medium was surprisingly revived in the latter half of the 20th century by Jasper Johns (pages 442–43), who used encaustic paint for a series of images of the American flag.

BEESWAX

Encaustic portrait from Egyptian tomb Some of the best ancient encaustic paintings to have survived are mummy-case portraits from the 2nd century cE.

EGG TEMPERA

Medieval painters of illuminated manuscripts used beaten egg white in a form of paint called clarum or glair. Painters on panel, on the other hand, used egg yolk mixed with pigment and a little water – egg tempera. This was the principal painting medium before the advent of oil paint. Although tempera is quick-drying, building up the colours of

a painting was a slow process. Panels were prepared with layers of gesso, a mixture of size and chalk to form a smooth surface. The paint was applied over a prepared drawing. Gradations of colour had to be built up slowly, by means a series of carefully juxtaposed applications of paint.

Entombment of Christ Russian icon, 15th century, 45 x 32 cm (18 x 13 in), tempera on panel. Tempera was used for most medieval Byzantine and Russian icons.

> EGG AND WATER EMULSION

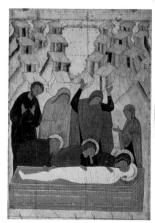

EGG YOLK

TEMPERA PIGMENTS

FRESCO

Fresco (the Italian word for "fresh") denotes the method of painting in which pigments, mixed solely with water, are painted directly onto a freshly laid lime-plaster ground. The liquid paint is absorbed into the plaster and as the plaster dries the pigments are bound within the fabric of the wall surface. Fresco was practised by the Minoans, the ancient Greeks, and the Romans long before its use by Michelangelo (page 136) and other painters during the Renaissance.

The Creation of Adam (detail) Michelangelo Buonarroti, 1508–12, fresco (pre-restoration), Rome: Sistine Chapel, Vatican Museums.

OILS

Vegetable oil – principally walnut, poppy and linseed – had been used as a medium for painting for some time before the Renaissance, but was more popular in northern Europe than in Italy. It was the skill of Flemish painters such as Jan van Eyck (page 110) at the beginning of the 15th century that convinced the Venetians and subsequently

other Italians and the rest Europe that oils were the best medium for easel painting, especially portraits. The advantages of oil paint are its strength and flexibility. The paint can be applied in many ways from thin glazes, diluted with turpentine, to thick impasto. It can be worked when wet for much longer than any other form of paint, allowing the artist to create subtle blending effects, or built up in layers according to the artist's favoured technique. The

> masters of the 16th and 17th centuries, from Titian (pages 143–145) to Velasquez (pages 187–190) , exploited the new medium to create astonishing new effects of colour and light.

The Arnolfini Portrait with detail, Jan van Eyck (see page 109). Van Eyck's mastery of oils produced remarkably fine detail and subtle gradations of colour in the dress and draperies where the sunlight from the window strikes them.

Oil painters employ a wide range of techniques. Here an artist exploits the texture of the canvas in a technique known as "scumbling".

FILBERT HOG

ROUND SYNTHETIC

SHORT FLAT HOG

ROUND HOG

Paint brushes are traditionally made from animal hair, stiff brushes from hog's bristles, finer ones from squirrel or sable hair. Both kinds are now produced using synthetic fibres.

VERMILION PIGMENT

WATERCOLOUR AND GOUACHE

Both watercolour and gouache paints are bound in gum arabic, the difference being that watercolour is transparent, while gouache, through the addition of white chalk, is opaque. Watercolour uses the brightness of the paper or other support to generate a distinctive luminescence. Light passes through overlaid transparent washes and is reflected back from the support – for example, white paper.

The opacity of gouache, also known as body colour, makes it ideal for overpainting and its

WATER AND Sponge

ROUND SABLE BRUSH

SYNTHETIC FAN BLENDER

FLAT SYNTHETIC BRUSH

FINE ROUND SABLE BRUSH

capacity for continuous tone makes it suitable for bold design and flat colour work. Watercolour as a specialist medium was raised to new heights in 18th- and 19th-century Britain, most notably in the works of J.M.W. Turner (pages 281–83). More recent exponents of watercolour include Emil Nolde (page 362) and Paul Klee (page 387), who exploited the medium's luminosity and ethereal properties.

Sunset over a Ruined Castle J.M.W. Turner, 1868, watercolour and gouache on paper, London: Tate Collection. Turner mixed gouache with a little yellow watercolour to highlight the clouds above the scene created by washes of colour laid over the toned ground of the paper.

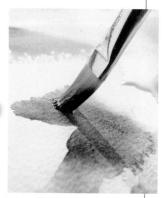

Watercolour can be applied in a series of overlaid washes or, as here, using a wet-into-wet technique in which the colours bleed and merge.

PAN COLOURS

MASKING FLUID

GUM ARABIC

ACRYLICS

Acrylics were developed in the 1940s and adopted by many modern artists for their fast drying and permanence. Pioneers included Mexican muralists Orozco (page 402) and Siqueros (page 402). The advantage of acrylics is that they are water-soluble when wet, but dry quickly to a durable surface. They can be used in transparent applications like watercolours or in thick, impasto applications like oil paints.

PALETTE WITH ACRYLICS

> PAINTING KNIFE

PALETTE KNIFE

Tree Harvey Daniels (contemporary artist), acrylic on paper, 92 × 49 cm (36 ¹/₄ × 19 ¹/₄ in), Private Collection. The inert properties of acrylics mean they are not susceptible to cracking or darkening in the

manner of oil paints.

ACRYLIC BRUSH STROKE

COLLAGE

Collage is an assembly of assorted materials – printed matter, pieces of fabric, even solid objects – stuck onto a support to form a composition. Early exponents were Picasso (pages 396–97) and Braque

(page 351), who in their Cubist works (page 350) frequently combined pieces of newspaper and other objects with paint. The German Artist Kurt Schwitters (page 368) did most to develop the use of collage, incorporating bus tickets and all manner of litter from the streets in his poetic compositions. Other notable exponents were the German artist

Max Ernst (page 369) and the American Joseph Cornell (page 406), who extended the idea of collage to three dimensional box constructions. What was at first something of a novelty was soon accepted as a respectable form of artistic expression.

Sleep for Yvonne Rainer Robert Rauschenberg, 1965, 213.3 x 152.4 cm (84 x 60 in), collage, Private Collection.

Minotaur Pablo Picasso, 1933, collage with paper, foil, and leaves, New York: Museum of Modern Art. One of Picasso's own drawings of the minotaur is incorporated into a collage of assorted debris.

Printmaking

The oldest form of printmaking is "relief printing", where the image is created by means of raised areas which receive the ink, as in a woodcut. In intaglio techniques, such as engraving and etching, the ink is held in lines inscribed or bitten into a plate. Other printing processes used by artists

include the planographic (flat-surface) techniques of lithography and silkscreen.

WOODCUTS

In Europe the great age of woodcuts was the late 15th century when printing spread across the continent from Germany. To make a woodcut, a v-shaped chisel is used to remove the negative areas of the design, the raised positive areas of the block are then inked over, a sheet of paper is laid onto the inked block and pressure applied by using either a screw- or lever-operated press.

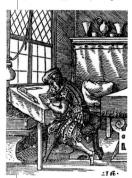

More sophisticated half-tones are generated by engraving finer lines in the manner of hatching. The greatest master of the art was Albrecht Dürer (pages 126–127). The Japanese artists of the 18th and 19th centuries perfected the art of multi-coloured prints, overprinting several woodblocks in succession with the final block applying a black line drawing.

The Engraver published by Hartman Schopper, 16th century, engraving, Private Collection.

Woodblock of a hussar on horseback c.1850 This simple design for the amusement of children shows the raised positive areas that receive the ink to make a print.

ENGRAVING

Engraving and etching are related intaglio techniques that produce a finer line than is possible in woodcuts. In the process of engraving a diamond-shaped tool called a burin is used to inscribe a precise line in either a tightgrained wood such as boxwood or a soft metal such as copper plate. Etching differs from engraving in that acid is used to "bite" a line. The copper plate is first coated in a thin layer of wax, called an etching ground, to resist the action of the

e s, involves dusting

ENGRAVED COPPER PLATE

point to draw the image and where the wax is displaced the acid bites a line. Areas of tone can be created using a process called aguatint. This

involves dusting resin powder onto the plate and heating it to make the resin adhere. When the plate is etched, the acid bites around each grain of resin and when inked produces a subtle uniform tone.

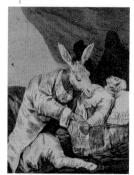

acid. The wax is inscribed using a

Of What III will he Die?

plate 40 of "Los Caprichos", Francisco José de Goya y Lucientes, 1799, etching, burnished aquatint, drypoint and burin, Private Collection. Goya combined a number of engraving techniques to produce his striking satirical prints.

LITHOGRAPHY

Lithography is a planographic (flat-surface) method of printing, which works on the principle of the mutual repulsion of oil and water. The process was invented in 1798 by Aloys Senefelder, a Bavarian playwright. A drawing design is applied to a prepared limestone or ground litho plate. The unique attribute of lithography is the directness with which either drawing or painterly technique can be applied using either a brush, pen, or crayon to apply a greasy ink. Lithography also facilitates the building of an image in multiples of overlaid coloured printing. The plate is kept damp with a dilution of gum arabic and a mild etch to assist both the resistance to the ink in

the undrawn areas and the take-up of the oil-based ink to the drawn areas of the lithograph.

A lithographic print is lifted from a litho stone. As in all printing processes where the image is lifted directly from the stone, block, plate, or screen the print is a mirror image of the original.

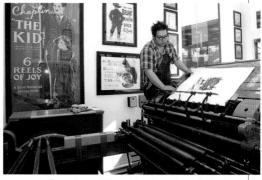

To produce a lithograph, a sheet of paper is placed over the plate and run through a litho press. This press is an antique dating back to the 1870s, which is being used to make top-quality prints of classic movie posters.

SCREEN PRINTS

Silkscreen printing or serigraphy was developed out of stencil printing, primarily used for commercial textile printing. In the 1930s, particularly in America, it became popular as a means of creating commercial prints in vivid opaque colour. As in the process of lithography, a design can be drawn or painted directly onto the screen in an oil-based medium and then the undrawn areas sealed using a glue or varnish. Oil-based ink is then squeegeed through the mesh of the silk screen onto paper. Stencils can be used to mask areas of the print. Alternative methods of transferring an image to silkscreen are the use of photo stencils. Andy Warhol (page 444) popularized the technique using a 1960s celebrities.

686 Good Morning City Friedensreich Hundertwasser, 1969–70, 85 x 55.5 cm (33 ½ x 21 ¾ in), silkscreen. Silkscreen works tend to feature clear shape and areas of flat colour.

Silkscreen printing on material

Ink is forced through the fine mesh of the silk screen with a squeegee. The masked areas form a stencil preventing ink from passing though the screen.

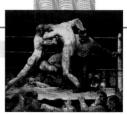

A Stag at Sharkey's lithograph by George Miller (1917) from a painting by George Wesley Bellows, Houston: Museum of Fine Arts. Miller was the USA's leading fine art lithographer.

Sculpture

The first and most ubiquitous form of artistic expression. The earliest sculptures appear to have been created by modifying found objects which suggested either animal or human forms. As tools and technologies developed, artists progressed from carving bone, wood, and stone to manipulating and firing clay, then to casting in bronze. While we are familiar with the bleached remnants of Greek and Roman sculpture, Classical statues were in fact rarely left uncoloured as artists applied pigments and precious stones to decorate or enhance the realism of their work.

BRONZE

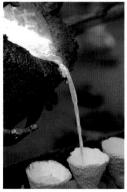

Pouring molten bronze The funnels are created by the lost wax process along with the mould.

Rodin in his studio Rodin (pages 318–319) had several hundred copies cast of his great works such as *The Kiss* and *The Thinker*. Sculpting in bronze is a complex process which was developed independently by many cultures – in South America, China, Ancient Egypt, and in West Africa. Bronze casting involves the modelling of a form in clay, plaster, or wax. The earliest bronzes were solid and small, created by means of a sand casting. In the lost-wax process two moulds are usually made. First a mould is made of the original sculpture – nowadays using latex and plaster. This is used to make the wax form. To this is attached a funnel shape and gates or ducts, also made of wax. The wax form is covered in heat-resistant plaster, hardens and the wax melts and runs out through the ducts. The plaster mould is now inverted and packed in sand and molten bronze is poured into the funnel. The mould is subsequently chiseled away and then the gates chiseled and chased from the surface of the bronze cast. When creating a large statue the mould of the original

model has to be cut into two or more pieces to make a wax shell, from which a hollow bronze can be cast.

The wax form of a solid statuette with two runners is created in a mould in the first stage of the lost wax process.

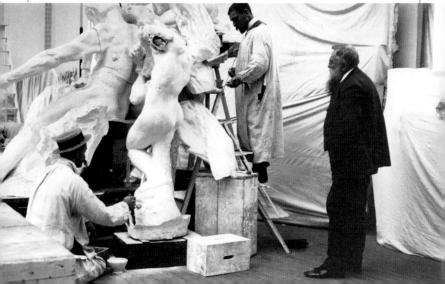

WOODCARVING

Carving in wood is common to all cultures worldwide. It flourished in medieval Europe, and the carvings of the Romanesque period are particularly expressive. In medieval and Baroque workshops the wood was frequently coated in plaster stucco and painted, a practice that goes back to Ancient Egypt. The carving of wood requires an awareness of the flow of the grain. This respect for the natural form of the wood was a notable feature of the work of the British sculptors Henry Moore (page 399) and Barbara Hepworth (page 400). The woodcarvings of Brancusi (page 356) are outstanding for their simplicity and elegance.

DOGLEG CHISEL

GOUGE

Woodcarving tools Today there are of

hundreds of differently shaped carving tools available, suitable for work on any scale.

Lamentation over the Dead Christ

(detail), woodcarving, German school, early 16th century, Venzone Cathedral, Italy. The work shows traces of the paint and gilding with which it was originally decorated.

MALLET

SCULPTING IN STONE

Prehistoric man first produced small-scale portable figures such as the Willendorf Venus (page 48) before progressing to freestanding figures. The Greeks adapted the stance of the striding figure from the Egyptians to create the stylized but expressive *kouros* (page 53). They subsequently developed the art of stone-carving to achieve astonishing degrees of naturalism. This was achieved through techniques of carving, pinning, drilling, and polishing. The most prestigious stone for sculpture since Greek times has been marble, which is very hard and difficult to carve. Alabaster, which can give a similar effect, is much softer. Limestone, granite, and sandstone are also popular media. In imitation of the Greeks and Romans, the Italian Renaissance

revived the practice of creating large, freestanding sculptures of idealized human forms. The great innovator of the High Renaissance period was Michelangelo (pages 136–137).

BLOCK OF GRANITE

SCULPTOR'S CHISELS

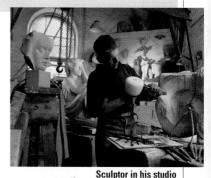

There are two methods of stone-carving: directly carving into the stone or using mechanical means such as calipers to scale up from a smaller model made of clay or plaster. According to Pliny, this process was in use in the 4th century scc.

HAMMER

40

Modern sculpture

The roots of modern sculpture lie in the early years of the 20th century, when European artists fell under the influence of "primitive" African art. They were also starting to realize the expressive power of abstraction. Two pioneers of new sculptural forms were Picasso (pages 396–97) and the Paris-based Romanian

Brancusi (page 356). In the course of the 20th century more and more materials were appropriated by sculptors, while "readymade" and "found" objects were incorporated in sculpture or exhibited as works of art themselves.

MODERN SCULPTURAL MEDIA

Modern sculpture has exploited almost every conceivable material, construction process, and method of assembling objects. While many sculptors still find their inspiration in human and natural forms, others, from the Russian

Constructivists onwards, have moved towards pure abstract geometry. One of the most influential figures in this field was American sculptor David Smith (page 410). Whereas Smith welded and polished his stainless steel structures himself, many modern sculptors simply make a design which is then realized by a team of assistants. Modern sculpture also delights in recreating everyday objects on an unexpected scale or using

Contemporary sculptors and their assistants routinely make use of modern industrial manufacturing processes such as arc welding.

unexpected materials. Artists such as Eva Hesse (page 460) and Claes Oldenburg (page 439) produced sculpture using soft materials, such as foam rubber and latex, as in Oldenburg's *Giant Hamburger*.

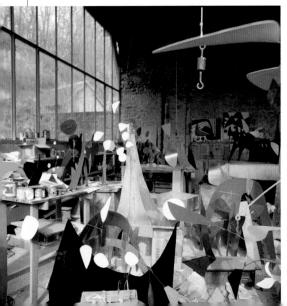

Four Units Unequal David Smith, 1960, height 196.8 cm (77 ¹/₂ in), stainless steel, Private Collection.

Studio of Alexander Calder

The monumental steel structures and playful mobiles of Alexander Calder (page 438) were produced by all manner of industrial processes. Prefabricated steel parts were assembled and painted in his busy studio.

INSTALLATION ART

Installation art effectively inverts the principles of sculpture. Whereas sculpture is designed to be viewed from the outside as a self-contained arrangement of forms, installations frequently envelop the viewer in the space of the work. The viewer enters a controlled environment which may utilize constructed, found, and ready-made forms as

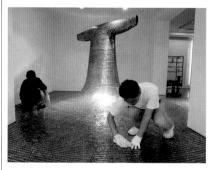

The Forked Forest Path Olafur Eliasson, 1998, Eastbourne, UK: Towner Art Gallery. Eliasson's gallery installations usually evoke the natural world with lighting effects contributing sunlight, fog, or rainbows.

well as light or projected imagery and sound. Installation-based art is related to conceptual art in that it frequently challenges the viewer's habitual spatial and cultural expectations.

Installations can be playful, solemn, or alarming, ranging from meticulously detailed reconstructions of everyday reality to memorials to the dead. They played an important role in the Italian Arte Povera movement of the 1960s and 1970s (page 425). Significant recent practitioners have included German artists Joseph Beuys (page 453) and Rebecca Horri (page 466) and French artist Christian Boltanski (page 466).

Some/One Do-Ho Suh, 2002. The Korean artist installs his piece, made of thousands of nickel military dogtags at the Serpentine Gallery, London.

CONCEPTUAL ART

The credit – or the blame – for modern conceptual art is often laid at the door of Marcel Duchamp (page 367), whose Dadaist, anti-aesthetic view of art led him to exhibit "readymade" or "found" objects, giving them absurd and provocative titles. Duchamp's mischief sanctioned a new role for the artist as a purveyor of concepts independent of any craft. Some artists have now taken conceptual art to the extreme of presenting text alone so that any visual component of the art is generated solely in the mind of the viewer.

Hat Rack and Urinal Marcel Duchamp, 1917, metal and ceramic, Private Collection. Two of Duchamp's most famous readymades, the hat rack and urinal were recreated more than once by the artist. The urinal gained huge notoriety when the first version was exhibited in New York in 1913, titled Fountain and signed R. Mutt.

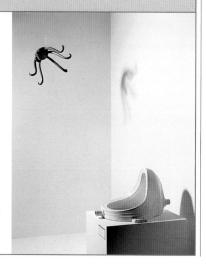

Modern media

Much of today's art aims to subvert the audience's expectations about art and life, often in a spirit of parody or pastiche. In the pursuit of originality, contemporary artists have turned to almost every conceivable means of communicating with an audience, including photography, flashing neon signs, film, and video. The 1970s saw a vogue for live performance and in many cases the artist's life or activities may be presented as a work of art. Other artists choose to rearrange the landscape to draw attention to our relationship with the environment.

PHOTOGRAPHY

Photography evolved from the camera obscura, a device for projecting an image through a small hole, which allowed artists to make an accurate tracing of a scene. In 1839 the development of light-sensitive emulsions enabled the "camera" to be used for black-and-white photography. While

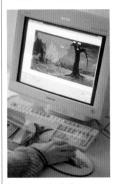

Image manipulation Computer technology has freed the photographer from the dark room and opened up new possibilities of creative image manipulation and editing. painters explored the new medium - often without acknowledging their debt to it - photography itself was accepted as a minor art form. In the 20th century it achieved higher status through photojournalism and the landscape photography of the likes of Edward Weston and Ansel Adams, Artists such as Man Ray (page 394), meanwhile, used photographic processes more experimentally. Successful contemporary artist include the German Andreas Gursky (page 473), who uses large format film, edits the photographs digitally, and produces huge prints. By contrast, American Nan Goldin (page 470) uses the camera in the spirit of intimate photojournalism.

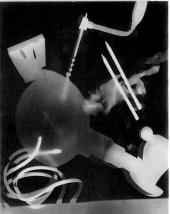

Rayograph Man Ray, 1923, 49 x 39.5 cm (19 ½ x 15 ½ in), photograph, Private Collection. Man Ray created his witty, negative Rayographs by placing a selection of objects on, or suspending them just above, light-sensitive photographic paper and then exposing the composition to light.

VIDEO ART

Video art developed from the art films made using 16 mm and 8 mm formats, notably by Andy Warhol's Factory studio in the 1960s. The invention of video opened up new possibilities with instant playback and in-camera editing. Video also allows artists to explore and manipulate the element of

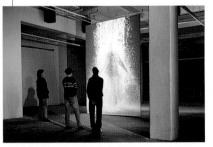

time in new ways. Artists can subvert the viewer's reading of time by cutting, montaging, slowing, and reversing sequences of images. Video is also used to document much performance-based work. A notable practitioner of video art in recent years has been the American Bill Viola (page 469), who produces video installations – some of them total environments that envelop the viewer in images and sound – as well as videotapes, sound environments, and electronic music performances.

The Crossing Bill Viola, 1996, video/sound installation, shown here at Grand Central Market, Los Angeles in 1997. Two screens are mounted back to back. On the one seen here the figure of a man is consumed by flames that rise from his feet. Simultaneously the other screen shows a deluge of water falling on the man from above until the figure is obliterated.

42

PERFORMANCE ART

The roots of modern performance art lie in the theatrical events staged by the Dadaists and Surrealists in the 1920s. In the 1960s and 1970s it was often associated with political protest in the form of "happenings". Performance art takes many forms. In 1961 French artist Yves Klein (pages 420–21) presented three nude models covered in his trademark blue paint, who moved their bodies around to leave prints on white paper. Other artists present their own actions or lives as art, for example the German artist Joseph Beuys (page 453),

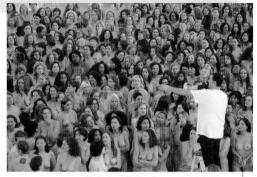

who on a trip to New York in 1974, spent some days in a cage with a coyote. Performance art differs from theatre in that it does not depend on narrative, but rather seeks to encourage the audience to question their assumptions about life, politics, and social and psychological relationships.

Nude Installation Spencer Tunick, 2003 Grand Central Terminus, New York. The artist directs his 450 models, who then arranged themselves into sculptural poses and formations. Nudity is a common feature of provocative performance art and happenings.

LAND ART

Andy Goldsworthy at work British artist Andy Goldsworthy (page 474) subtly rearranges natural materials. His ephemeral creations, such as the 13 huge snowballs he placed in London in 2000, sometimes last for just a few days. Man from the earliest times has interacted with the landscape to create forms that do not exist in nature, for example the elegant geometry of the formal garden. However, during the 1960s a number of American artists, such as Robert Smithson (page 462), wanted to heighten awareness of our relationship with the natural world by intervening in the landscape by means of thought-provoking constructions. The most dramatic interventions have been the massive enterprises of Christo and Jeanne-Claude (page 460) – curtains reaching across vast stretches of landscape as impressively as the Great Wall of China and his urban projects of wrapping buildings. Photography plays a crucial role in the success of land art since photographs will often be the only lasting visual record of an artist's work, such as the lines created by Richard Long (page 468) in remote, inaccessible landscapes.

Surrounded Islands Christo and Jeanne-Claude, 1980–83, Miami, Florida: Biscayne Bay Eleven islands were surrounded with 603,850 sq m (6.5m sq ft) of mik woven polypropylene fabric.

THE HISTORY OF ART

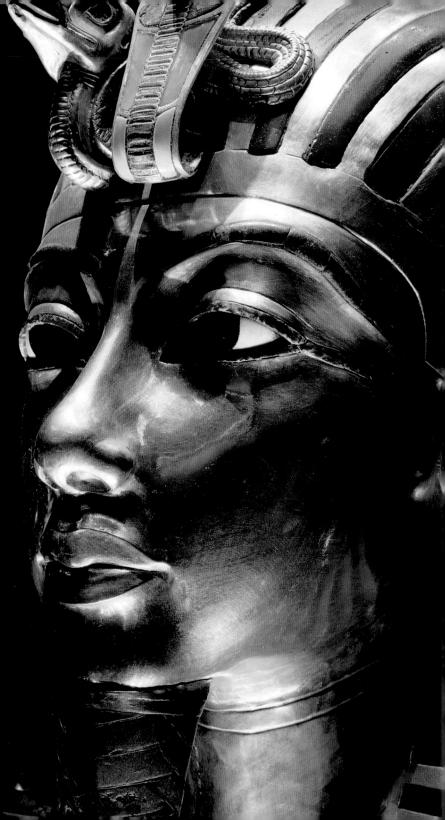

EARLY ART c.3000 bce-1300 ce

Artists, like children, are great borrowers and imitators and take delight in what they see in the world around them. However, curiosity and a desire to create do not in themselves produce works of art. So how do we identify that moment when what we choose to call "art" first appears as a significant activity?

The oldest known works of art to have been discovered in Europe are stone carvings, dating from perhaps 32,000 years ago. Found across Europe and Russia, they are rare survivals. It is no accident that carvings, inherently durable, should be the oldest surviving examples of human art. They are inevitably few in number, their survival almost entirely a matter of chance. The clues they offer as to the nature of the hunter-gatherer societies that produced them are tantalizing at best. But their claims to be considered art are undoubted. They satisfy the innate human need for aesthetic appeal, whether by means of craftsmanship, colour, or form.

Mask from mummy-case of Tutankhamun, c. 1340 nece, gold, enamel and semi-precious stones, height 54 cm (21 Xin), Cairo: Egyptian Museum. The artists of early civilizations, such as ancient Egypt, used the most precious materials to produce highly stylized depictions of rulers and their families. As important, they almost uniformly seem to have had a mystical, probably religious purpose. They make clear the enduring human need to understand – perhaps to appease – an uncertain and frequently hostile world by means of deliberately contrived objects.

STONE-AGE SCULPTURE

The best-known of these chance survivals is a tiny limestone figure of a woman. It was found in Austria and dates from between 32,000 and 27,000 years ago. The Venus of Willendorf, as this oddly misshapen figure is known, was almost certainly a fertility offering. At first sight, she appears to be just a crude caricature of the female form. Closer inspection reveals a remarkably rhythmic treatment allied to considerable technical sophistication on the part of her unknown creator. The taut curls that hug her head are not just closely observed but precisely rendered.

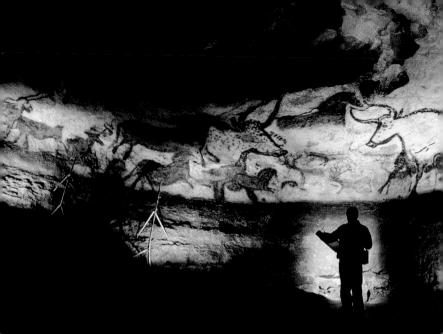

CAVE PAINTING

More spectacular by far are the cave paintings of southwest France and northern Spain. It is no surprise

that when the first was discovered, in 1879, it was widely assumed to be a fake. Virtuosity on such an epic scale was hard to reconcile with current beliefs about Stone Age man. Between about 25,000 and 12,000 years ago, during the peak of the last Ice Age, an astonishingly vigorous tradition of cave painting developed in which acutely observed The Great Hall, Lascaux, c. 15,000 BCE. Like the other Stone Age cave paintings in Europe, those at Lascaux survived because, once abandoned, they were then completely forgotten until rediscovered by chance.

> and brilliantly depicted animals – mammoths, bison, hyenas, and horses – were painted onto cave walls. A variety of materials, chiefly red ochre and charcoal, were used. These were applied by sticks, feathers, or moss, sometimes by hand. In almost every case the

> > Venus of Willendorf, c.30,000 BCE, limestone, height 11.5 cm (4 ½ in), Vienna: Naturhistorisches Museum. The carving's swelling limbs and breasts invest it with a strong sexual quality.

TIMELINE: EARLY ART

c.25,000 Stylized female figurines made throughout Europe; first cave paintings (France and Spain)

c.10,000 Retreat of glaciers; larger mammals extinct c.7000 Pigs domesticated (Anatolia); farming spreads to SE Europe c.5000 Cereal farming villages in western Europe; copper first used (Mesopotamia)

5,000

c.5500 Bandkeramik pottery produced (C Europe); metallurgy discovered (SE Europe) c.4500 Megalithic tombs built in western Europe

10,000

c.9000 Earliest evidence of wheat cultivation (Syria)

35,000 BCE

c.35,000 Homo sapiens sapiens in Europe; Neanderthals extinct 25,000 1 c.20,000 Peak of last Ice Age

most spectacular images were created deep inside the caves. That their purpose was religious – part fearful, part celebratory - can scarcely be doubted. That they constitute everything that we understand today as art is no more in question. Curiously, there are almost no representations of humans: those that do appear, in contrast to the immediately recognizable animals, are schematic and crude, more like a child's attempt to draw a person.

CITIES AND CIVILIZATION

Perhaps 5,000 years ago, the world's first civilizations were forming in the Near East. As settled agriculture began, reinforced by the domestication of goats and sheep, so surplus food production permitted the development of divisions of labour and the emergence of ruling classes, often priestly. At the same time, cities began to appear. These were organized societies, self-aware, technically sophisticated, and literate, that recognized how artistic images could be pressed into service on their behalf. Impelled by a need to justify themselves to their gods or to assert their dominance over their subjects. a series of rulers commissioned

images that would underline their status and their right to rule.

The earliest of these civilizations was Sumer, in modern-day Iraq. What has survived – fragments of pottery, a handful of battered marble figures – shows this to have been a society with a well-developed sense of the power of visual images. Yet more remarkable is a product of Sumer's successors, the Akkadians, who from

> Akkadian Ruler, c.2300 BCE, bronze, height 36 cm (14 in), Baghdad: Iraq Museum. This head, tentatively identified as Sargon I, would originally have had jewels placed in its eye-sockets.

about 2300 BCE united much of Mesopotamia in a single empire. The bronze head of an Akkadian ruler, cast between 2,300 and 2,200 BCE, is not just a technical triumph but a defining image of a hierarchical ruler: remote and magnificent.

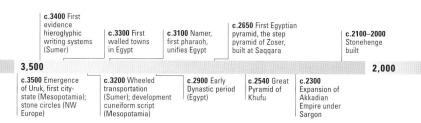

ANCIENT EGYPT c.3000 – 300 bce

Ancient Egyptian art precisely reflected the rigidly hierarchical society from which it developed. It placed a premium on lavish materials and epic scale and, above all, it echoed ancient Egypt's obsession with death and the afterlife. Once established, its forms hardly changed for almost 3,000 years. Such tenacious conservatism is matched only by the similarly inward-looking civilization of China.

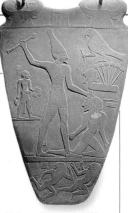

Palette of Narmer, *c.3000* BCE, schist carved in low relief, Cairo: Egyptian National Museum.

Writing in the 4th century BCE, Plato claimed there had been no change in Egyptian art for 10,000 years. If his chronology was faulty, he nonetheless touched on a central truth: that the art of ancient Egypt has a near-unique continuity. The Palette of Narmer, which celebrates the first pharaoh, Narmer, who unified

KEY EVENTS

c.3100 BCE	Early Dynastic period (to 2686 все): Egypt unified under Narmer; Memphis made capital; hieroglyphic writing developed
2686 BCE	Old Kingdom (to 2181 BCE)
c.2540 BCE	Construction of the Great Pyramid of Khufu
2180 BCE	First Intermediate Period (to 2040 BCE): centralized rule dissolves
2040 BCE	Middle Kingdom (to 1730 BCE)
1730 BCE	Second Intermediate Period (to 1552 BCE): much of Egypt ruled by Hyksos, an Asiatic people
1552 BCE	New Kingdom (to 1069 BCE): Egyptian power at its height: new capital founded at Thebes
1166 BCE	Death of Ramses III, last great pharaoh
1069 BCE	Third Intermediate Period (to 664 BCE)
664 BCE	Late Period (to 30 BCE)
332 BCE	Egypt conquered by Alexander the Great

Egypt around 3100 BCE, already contains many of the essential elements of this fixed tradition. Perhaps the most striking is the pose in which Narmer is depicted. Head, arms, and legs are in profile, with legs characteristically splayed. Yet in an obvious anatomical distortion, his chest faces directly outward. Exactly the same pose can be found in works produced 2,500 years later. Although individual details are rendered with great precision, the overall effect is anything but naturalistic. Egyptian art was almost

entirely symbolic, intended to convey precise meanings, in this case the triumph of Narmer over his enemies. The sizes of the figures denote status: the larger the figure, the greater its importance nakedness also indicated inferiority). Though the figures stand on a common ground, there is no attempt to represent the space they occupy naturalistically.

Bird-scarab pectoral from Tutankhamun's tomb, c.1352 BCE,

gold, semi-precious stones, and glass paste), Cairo: Egyptian National Museum.

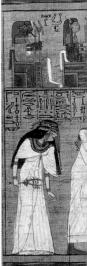

The deceased is ushered into the hall of judgement

HIERARCHY AND SYMBOLISM

Because its rulers were considered gods, their "eternal well-being" was dependent on preserving their mortal remains with as much splendour as possible. Hence the deliberate grandeur of the pyramids and,

later, the vast tombs at Thebes. Complex and absolute rules governed how the pharaohs should be represented in art. The imperturbably blank features of the four giant seated statues of Ramses II guarding the entrance to his temple at Abu Simbel express this formal monumentality

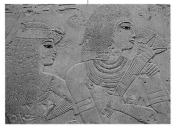

Relief from tomb of Ramose, c.1350 BCE, *limestone, Thebes.* Originally, when painted, its impact would have been still more remarkable.

just as the gold head of Tutenkhamun underlines the premium placed on precious metals and craftsmanship.

There were exceptions. The less important the subject – slaves, dancing girls, or musicians, for example – the more naturalistically they could be depicted. Further, for a brief period in New Kingdom Egypt, above all during the

Weighing of the Heart against the Feather of Truth, c. 1250 BCE, painted papyrus, London: British Museum. This scene is found in every Book of the Dead. reign of the Akenaten (1379–1362 BCE), who shocked the priesthood by banishing all gods other than Aten (the "disc of the sun"), a slight relaxation of this otherwise absolute formality is evident. In the tomb of Akenaten's chief minister, Ramose,

> is a relief of the brother of Ramose and his wife carved not just with extraordinary delicacy and skill but also with a hint, if nothing more, of genuine humanity.

More typical of the Egyptian attitude to art are the many surviving examples of the parchment known

as the *Book of the Dead*. This was a book of spells, placed in a tomb and intended to guide the dead through the afterworld. Not only are the figures – gods and humans – depicted following exact conventions, but the hieroglyphs inserted above and between them, themselves essentially pictorial, contain equally precise and detailed instructions.

> Pantheon of Egyptian gods headed by Horus

The god Thoth records the result of the weighing of the heart

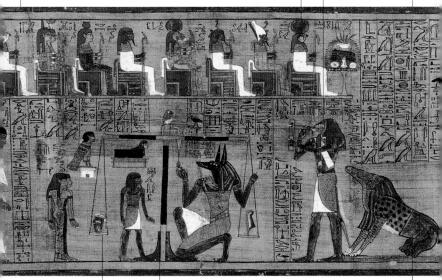

The heart is weighed against a feather in the other scale Anubis, the jackalheaded god supervises the weighing of the heart The "Eater of the Dead", a monster that swallows the heart of the deceased if it proves too heavy

EARLY ART

THE EARLY AEGEAN WORLD

С.2000 - 500 ВСЕ

Between about 2000 and 1150 BCE, two distinctive though related early Greek civilizations were established in the eastern Mediterranean: by the Minoans on the island of Crete and, perhaps 400 years later, by the more warlike Mycenaeans on the Greek mainland. The reasons for their later disappearance remain unclear, but by the beginning of the first millennium a new fully Greek culture was emerging.

Both Minoan Crete and Mycenae were stratified, literate societies, presided over by elites. They appear to have enjoyed substantial agricultural surpluses and to have had extensive trading links. What was originally assumed to be the labyrinth at the palace of Knossos, the principal centre of power in Crete (though nothing is known of its rulers), was in fact a huge storage area for wine, grain, and oil.

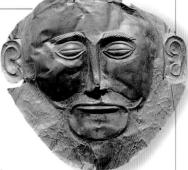

Mycenaean death mask from royal tomb, c.1550 BCE, gold, Athens: National Archaeological Museum.

That Minoan Crete was a society with a taste for luxury and a highly developed visual sense is clear from the decoration of its palaces and villas. Frescoes of ships, landscapes, animals, and cavorting dolphins convey an expressive delight in the natural world. The best-known are those of youths and girls bull-leaping. Though this practice may have had a religious significance – bulls are a

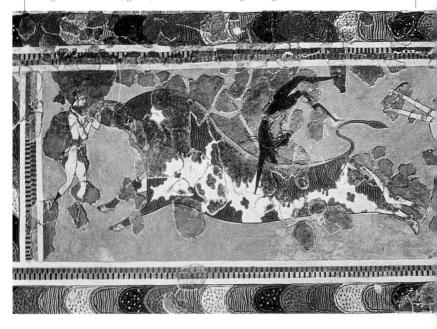

recurring theme in Minoan art – overridingly these images suggest an exuberant pleasure in physicality.

The palaces and villas of Minoan Crete were successively rebuilt, perhaps following natural disasters such as the volcanic eruption that wiped out the Minoan colony on the island of Thera in the mid-17th century BCE. But this apparently unwarlike world was also threatened from outside. Around 1450 BCE Minoan Crete fell victim to the Mycenaeans from mainland Greece.

MYCENAEAN CULTURE

The heavily fortified remains at Mycenae itself underline just how much this was a society presided over by an aggressive warrior elite. Yet, as the remarkable gold death mask of a Mycenaean ruler demonstrates, theirs was a world that was not just materially rich but capable of great technical sophistication.

With the collapse of these first Aegean civilizations, probably in the face of invasions from the north, for over 400 years Greek culture effectively disappeared. Almost nothing is known of this "Dark Age". Yet, by about 800 BCE a new, very different Greek world was emerging. Though politically fragmented, it came to enjoy an exceptionally strong sense

not just of its identity but also of its intellectual superiority.

In the visual arts, there were two key developments: a trend towards an idealized naturalism and the adoption of the male nude as its chief subject. It is a measure of the dominance of Greek cultural values that, to

Bull-leaping fresco, c.1500 BCE, Athens: National Archaeological Museum. One of the prize discoveries when the palace of Knossos (below) was excavated in the early 1900s.

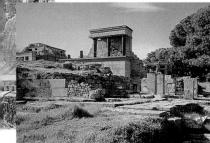

KEY EVENTS

c.2000 BCE	Minoan civilization established on Crete; palace of Knossos built
c.1600 BCE	Linear B script comes into use on Crete
c.1500 BCE	Mycenaeans become dominant power on Greek mainland
c.1450 BCE	Collapse of Minoans; Mycenaeans take control of island
с.1150 все	Collapse of Mycenaean Greece
c.1000 BCE	Greek colonists migrate to Asia Minor and eastern Aegean
776 BCE	First pan-Hellenic athletics festival, Olympia
с.750 все	First evidence of use of Greek alphabet; Homer's <i>Iliad</i> first written down
с.700 все	Beginning of Archaic period; emergence of city-states

Western eyes at least, these have come to seem obviously desirable goals. In fact, they express values no culture outside the West has ever particularly esteemed. To most societies, for example, nakedness was a clear indication of servility.

The Greek obsession with the male nude began in the 7th

century BCE. Over 100 life-size (or larger) statues known as kouroi (vouths) have survived. Though formalized all face rigidly forward, with hands clenched and one foot in front of the other (evidence of Egyptian influences) - they demonstrate a new interest in naturally rendered anatomical detail. By the 5th century BCE, they would give rise to a naturalism unprecedented in the history of art.

Kouros, c.540 BCE, height 105 cm (41 in), marble, Paris: Musée du Louvre.

EARLY ART

CLASSICAL GREECE c.500 – 300 bce

Between the 5th century and 100 BCE, when it was absorbed by Rome, Greece evolved ideals in art, philosophy, mathematics, literature, and politics that would exercise an extraordinary hold on subsequent Western beliefs. That it did so in the face of external threats and internal turmoil makes this achievement all the more remarkable.

Red-figure vase, (c.450 BCE), height 48 cm (18⁷/8 in), ceramic, Paris: Louvre Museum. The vase shows a Hoplite returning from war.

Victory over the Persians in 490 BCE and again in 480 BCE left Athens clearly the strongest of the Greek city-states. Despite the debilitating and eventually

disastrous Peloponnesian War against rivals Sparta between 431 and 404 BCE, culturally at least the city would retain its leading role even after the rise of Macedonia in the following century. Fifth-

Centaur Triumphing over a Lapith, 447–432 BCE, marble, London: British Museum. The relief (below) was part of the frieze on the south side of the Parthenon (left). It was removed by Lord Elgin in the early 1800s.

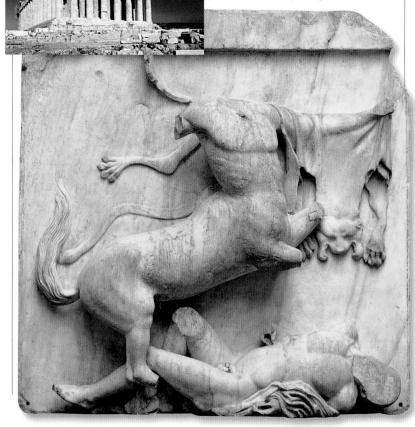

century BCE Athens saw an astonishingly fertile burst of artistic creation, establishing an artistic canon that would not only dominate the Roman world but, when rediscovered by Renaissance Europe, would constitute an absolute artistic standard for a further 400 years.

Only a handful of fragments of Greek paintings have survived; many Greek sculptures are known only from Roman copies or written descriptions; and what architecture still exists is extensively ruined. But enough remains to make clear the extraordinary artistic impact of Classical Greece. The Parthenon, begun in 447 BCE, is the supreme example. Today, even stripped of its sculpture, its crumbling grandeur constitutes an emphatic statement of the lucid priorities that drove the Classical Greek world. Originally, brilliantly painted and embellished with statuary, its impact would have been more remarkable still.

GREEK SCULPTURE

The Parthenon's sculptures fall into three groups. On the triangular pediments at either end of the building were large-scale free-standing groups containing numerous figures showing the birth of Athena and her struggles with Poseidon for control of Attica; below these as well as along both sides were nearly 100 individual reliefs of struggling figures (men and centaurs; Greeks and Amazons; gods and giants); behind the outer colonnade and running round the entire building was a relief, 160 m (525 ft) long, depicting the Great Panathenaia, a religious festival held every four years in honour of Athena.

Even badly damaged, the Parthenon sculptures reveal the confidence and technical mastery of their creators. These are wholly convincing figures, dramatically grouped and heroically conceived. Other examples of Classical Greek sculpture are better preserved. The slightly more than life-size bronze Boy from Antikythera combines calm elegance with technical sophistication

Boy from Antikythera,

c.340 BCE, height 194 cm (76 in), bronze, Athens: National Archaeological Museum.

> in ways that were genuinely new, infusing the naturalistic with the ideal to produce a supremely selfconfident image of a god-like youth. The sculpture manages the rare feat of being both supremely rational and yet

at the same time extraordinarily sensual. Descriptions of Greek painting suggest it, too, reached comparable levels of technical achievement. The Roman frescoes at Pompeii were almost certainly heavily influenced by Greek originals. Perspective, foreshortening and the naturalistic representation of figures all seem to have been mastered in ways that would not reappear until

Renaissance Italy. Greek vases reinforce the point. Though painted on curved and small-scale surfaces, their decoration contains complex and ambitious groups of figures in settings which have a real sense of space and depth.

KEY EVENTS

505 BCE	Democracy established in Athens
490 BCE	Greeks defeat Persians at Marathon
480 BCE	Greeks defeat Persians at Salamis and Plataea
478 BCE	Confederation of Delos founded; later transformed into Athenian empire
461 BCE	Beginning of domination of Athenian political life by Pericles
447 BCE	Parthenon begun (completed 432)
431 BCE	Peloponnesian Wars between Athens and Sparta (to 404)
399 BCE	Athenian philosopher Socrates condemned to death for corrupting youth
385 BCE	Plato returns to Athens; opens Academy
384 BCE	Birth of Aristotle

56

EARLY ART

HELLENISTIC GREEK ART C.300 - 1 BCE

In 336 BCE, Alexander the Great began his blaze of conquest across the Middle East and Egypt. His empire fragmented after his death, but the cultural impact of Greece on these vast territories proved enduring. This process of "Hellenization" was further boosted by the Romans, who, by the 1st century BCE, had exported Greek artistic traditions across the whole Mediterranean.

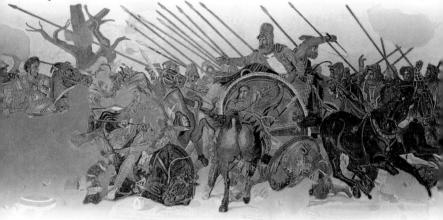

Alexander and his successors

implanted Greek cultural values across a vast swathe of the ancient world. Rather like the city-states of 5th-century Greece, these new Greek kingdoms were political rivals but shared a common cultural inheritance. A huge programme of new city building was begun in Asia Minor, the Near East, Mesopotamia, and North Africa. Alexandria, Antioch, and Pergamum for instance are all Hellenic cities. Greek prestige was enhanced, too, by learning. The library at Alexandria was the most famous in the ancient world. The influence of Aristotle, who died in 322 and had been Alexander's tutor.

The Battle of Issus (detail), 1st century BCE, mosaic, Naples: Museo Archeologico Nazionale. This mosaic from Pompeii is a Roman copy of a Greek original. The young Alexander (left) defeats Persian King Darius (centre).

extended over the entire period and beyond. In the face of this huge expansion of the Greek world, the original city-states of Greece itself were overshadowed politically, but retained much of their cultural status.

Though Hellenistic art continues a clear line of development from the Classical period, with naturalism again the chief concern, there are important differences. The most obvious is that the restraint of Classical Greek art gives way to a sense of movement and drama. One reason may have been that increasing technical mastery led artists to set themselves harder problems to solve. But there is a

> Dying Gaul, Roman copy of Greek original of c.230 BCE, marble, Rome: Pinacoteca Capitolina. The original was created shortly after the kingdom of Pergamum defeated an army of invading Gauls in 230 BCE.

sense, too, that the Hellenistic world needed a more emphatic style of art to underline the fact of its conquests. Where on the Parthenon, for example, civic piety set the tone, on the Alexander Sarcophagus, a sumptuous marble tomb carved probably in 310 BCE for the ruler of Sidon, not only is there a sense that technical mastery is being celebrated for its own sake, a clear note of triumphalism creeps in. One side of the sarcophagus is a battle scene in which the figure of Alexander, clad in a lion-skin, is accorded the sort of heroic treatment previously reserved only for gods.

A NEW TREND IN SCULPTURE

The Altar of Zeus at Pergamum, perhaps the most famous work from the entire period, embodies another key characteristic: scale. The base of the platform on which the altar stands contains a frieze 2.3 m ($7^{1/2}$ ft) high and fully 90 m (295 ft) long. On the upper level is a second frieze 1.5 m (5 ft) high and 73 m (240 ft) long. The vigour of the carvings, with their writhing, interlocking figures, is far removed from the placid assurance of the Classical period.

The expressiveness of heroic figures such as these found a different outlet in the almost equally well-known *Dying Gaul*. The stoic dignity with which he accepts

KEY EVENTS

336 BCE	Accession of Alexander the Great; begins conquest of Persia
332 BCE	Alexander conquers Egypt; lays foundations of Alexandria
323 BCE	Death of Alexander sparks break-up of his empire
322 BCE	Death of Aristotle
302 BCE	Final fragmentation of Alexander's empire
c.230 BCE	Original bronze of <i>Dying Gaul</i> cast, Pergamum
с.175 все	Altar of Zeus at Pergamum begun
168 BCE	Start of Roman expansion into eastern Mediterranean
146 BCE	Greece and North Africa fall under Roman rule
133 BCE	Pergamum bequeathed to Rome

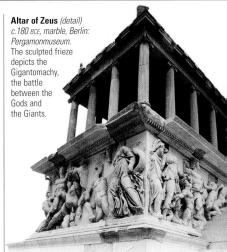

his fate makes clear an interest in the individual that was reflected in the development of lifelike portraiture. This was partly prompted by the teachings of Aristotle. Whereas in Classical Greece individual worth was automatically equated with physical perfection, now personality was judged at least as important. The mid-3rdcentury bronze statue of a philosopher, possibly Hermarchus, portrays an ageing and crumpled figure. But his obvious nobility of spirit makes it clear that the sculpture is intended as a sympathetic portraval, a point that is emphasized by his physical frailty and decrepitude.

OSTENTATION

The Hellenistic world also placed a premium on luxurious and elaborate surface decoration, an interest later fully shared by the luxury-loving Romans. The 4thcentury Derveni krater is not just a technical tour de force but an object of conspicuous ostentation.

Derveni krater, late 4th-century BCE, height 86 cm (34 in), gilded bronze, Thessalonik: Archaeological Museum. This enormous krater (vessel for mixing wine and water) was found at Derveni in northern Greece. The shoulders are decorated with statuettes, while the body has repoussé reliefs of Dionysus, Ariadne, and other mythological figures.

EARLY ART

Laocoön

Hagesandrus, Polydorus, and Athenodorus c.42-20 BCE

Few Greek statues exercised a greater hold on the Renaissance imagination than the *Laocoön*. In part, this was due to the dramatic circumstances of its chance discovery in Rome in 1506, when Renaissance interest in Greek statuary was reaching a peak; in part, to the heroic nobility of its expressive, struggling figures.

The *Laocoön* is thought to have been carved in the second half of the 1st century BCE. This means it belongs to the very end of the Hellenistic period. Stylistically it derives from the Altar of Zeus at Pergamum of around 150 years before. It is an astonishingly accomplished work, acutely observed and highly finished. Overwhelmingly its impact The

stems from the sense of heightened and tragic emotion generated by its contorted, writhing figures. This kind of dramatic, large-scale treatment had a significant impact on Michelangelo and on later artists of the Roman Baroque. The statue illustrates an incident in Virgil's account of the Trojan Wars, the Aeneid. Laocoön was a Trojan priest punished by Poseidon, who sent two snakes to kill him and his sons, after he had urged the Trojans to reject the apparent Greek peace offering of a wooden horse. According to Pliny, the group was carved by three sculptors, Hagesandrus, Polydorus, and Athenodorus.

energy to the composition

The twist of the muscular

torso adds dynamism and

The flanking figures of the sons create a triangular composition, balancing and anchoring it

The figure of the son who is on the point of death is contrasted with the continuing, desperate struggles of the father and the other son.

TECHNIQUES

Despite its technical sophistication and complex interlocking figures, the work is only intended to be viewed from the front. It is essentially conceived in one plane, almost like a relief. It has been suggested that the figure of the elder son (right) may have been added later. He is physically separated from the other figures and also carved from a separate block. As with all Antique statues, it would originally have been painted.

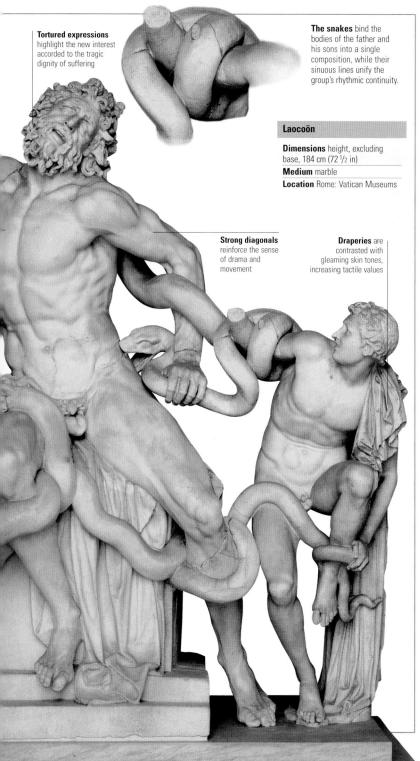

EARLY ART

IMPERIAL ROME C.27 BCE - C.300 CE

Uniquely among the leading powers of the ancient world, Rome developed only a limited artistic language of its own. Roman architecture, like Roman engineering, was never less than bold, but Roman painting and sculpture were derived largely from

Greek models. However potently Rome projected images of its political power, the visual means it used to do so were second-hand.

Roman art was largely imitative

and utilitarian. Greece provided Rome with a huge range of models to adapt to

its own ends. Yet rather than acting as a stimulus, the result was an apparently permanent Roman inferiority complex in the face of the Greek artistic achievement and the stifling of independent Roman schools of art. Hence the lifelessness traditionally and, on balance, rightly attributed to Roman art.

The 1st-century CE Medici

Venus, for example, is just one of 33 surviving Roman copies of the Hellenistic original. Greek sculptures

KEY EVENTS

264 BCE	Rome completes conquest of Italy; first Punic War (to 241 BCE)
218 BCE	Second Punic War (to 201 BCE): Hannibal invades Italy
149 BCE	Third Punic War (to 146 BCE): Carthage destroyed by Roman army
46 BCE	Julius Caesar appointed dictator (assassinated 44 BCE)
27 все	Octavian becomes first Roman emperor (as Augustus); dies 14 cE
13–9 BCE	Ara Pacis Augustae created, Rome
79 CE	Pompeii and Herculaneum destroyed after eruption of Vesuvius
113 CE	Trajan's Column built, Rome
117 CE	Death of Emperor Trajan: Roman empire at its greatest extent
161–180 CE	Equestrian statue of Marcus Aurelius cast, Rome

Ara Pacis, 13–9 BCE, marble, Rome. The frieze shows members of Augustus's family and state officials. The man in the detail (left) is Marcus Agrippa, the emperor's son-in-law.

weren't just copied by the Romans, they were actively recycled. Greek poses recast in Roman garb were

pressed into service to reinforce Roman power. At its most extreme, this practice allowed a kind of off-the-peg shopping whereby heroic Greek figures, available in a variety of sizes, could be supplied headless, the buyer supplying his own, easily installed, portrait head.

This kind of pragmatism is illustrated by the celebrated late-2nd-century CE equestrian statue of Marcus Aurelius. Arm outstretched, head turned slightly to the side, his pose is just one of numerous Roman reworkings of the 5th-century BCE statue of Doryphorus, itself known only from Roman copies. What was originally an idealized image of male beauty has been slightly clumsily converted into a vehicle stressing Roman imperial might and the god-like person of the emperor.

Even the much earlier Ara Pacis Augustae (Altar of Augustan Peace), whilst seeking to stress the continuity between the rule of the Emperor Augustus and the earlier Roman republic, is obviously dependent on Greek models, above all in its use of a continuous large-scale frieze of figures. The virtues they seek to embody may be Roman; the manner in which they do so is unambiguously Greek.

ROMAN PAINTING

In Imperial Rome the love of luxury, severely disapproved of by those seeking a return to the stern values of the republic, tended to equate opulence with quality. This was a world in which more almost always meant better.

Most of the surviving examples of Roman painting are from Pompeii (preserved thanks to the eruption that obliterated the

city in 79 CE). These offer crucial clues to the earlier Greek painting on which they were modelled. In contrast to what is known of these Greek originals, the paintings at Pompeii seem to have been almost exclusively decorative murals for expensive villas. Landscapes and

Nile in Flood (detail) c.80 BCE, mosaic, Palestrina: Museo Archeologico Prenestino. The Romans followed Greek models to produce magnificent floor mosaics.

Equestrian statue of Emperor Marcus Aurelius c.175 cc, height 350 cm (138 in), gilded bronze, Rome: Musei Capitolini.

> seascapes augmented by complex architectural settings using sophisticated illusionistic devices seem to have been the preferred subjects. As ever in the imperial Roman world, there was a premium on presentation over content. The surviving murals were clearly painted by journeymen, in most cases Greeks – superior interior decorators rather than artists as the Greeks would have understood the term.

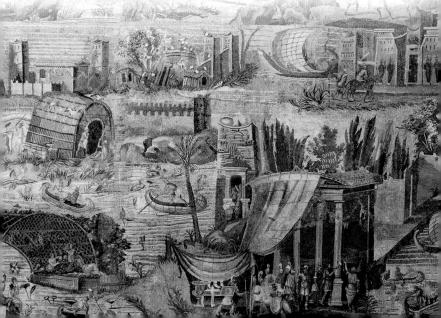

LATE ROMAN & EARLY CHRISTIAN ART c.300 – 450 ce

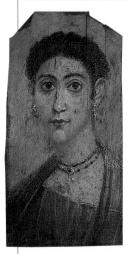

As Rome's empire was eroded, Roman art increasingly departed from the naturalistic ideals it had inherited from the Greeks. In turn, these vigorous but less sophisticated artistic models were adapted by the early Christian Church in the search for a visual language appropriate to its theological needs.

Mummy-case portrait from Fayum, encaustic on wood, London: British Museum. A tradition of Roman-style portrait painting continued in Egypt through the 2nd and 3rd centuries cE.

The Arch of Constantine in Rome, built by the Emperor Constantine early in the 4th century, neatly encapsulates the move away from the rationalism of Greece. As well as reliefs carved in the reign of Constantine himself, the arch incorporates a series of sculptured reliefs from earlier periods. The choice of these was deliberate: all come from the reigns of well-loved emperors with whom Constantine wished to identify, so as to legitimize his rule. The early reliefs are all carved in the fully naturalistic tradition inherited from Greece. The later reliefs, by contrast, contain figures that almost deliberately seem to caricature their more elegant predecessors: stumpy and badly proportioned, almost all shown in profile. In the same way, foreshortening and other devices to create a sense of space are totally ignored. The contrast is so great there is a sense that these reliefs are almost

flaunting their deliberate abandonment of the Greek visual tradition.

RADICAL CHANGE

Constantine's reign marked a crucial moment for Rome. His decision in 330 to move the capital of the empire from Rome to Constantinople (modern Istanbul) confirmed an existing shift of political and economic power to the east. His legitimization of Christianity in 313

KEY EVENTS

312 CE	Constantine confirmed as emperor
313	Edict of Milan: Constantine legitimizes Christianity in Roman Empire
325	Council of Nicaea called by Constantine to resolve theological differences within Church
329	St Peter's basilica, Rome, completed
330	Constantine dedicates Constantinople as new capital of Roman Empire
391	Emperor Theodosius imposes Christianity on Roman Empire as sole religion
395	Death of Theodosius: Roman Empire definitively split into East and West
410	Visigoths under Alaric sack Rome
455	Vandals under Gaiseric sack Rome
476	Deposition of Romulus Augustulus, last Roman emperor in the west

had consequences that were equally momentous. What had been a minor sect, frequently persecuted, now enjoyed the full weight of imperial patronage. Constantine's decision was overridingly political: he used the Church as a central point around which the empire could regroup, hence the urgency with which he set out to reconcile rival Christian sects. The challenge thereafter was to find visual means to express the Christian message. Inevitably, Roman, which is to say pagan, prototypes were used. The basic form of churches themselves came from secular Roman buildings known as basilicas, large oblong halls, often arcaded with aisles and an apse at the far end.

CHRISTIANITY AND ART

There was a longrunning controversy as to whether God the Father could be represented or whether this would

Roundel from the Arch of Constantine This medallion, which shows a sacrifice being made to Apollo, dates from the reign of Hadrian (117–138 cE). It was taken by Constantine from an earlier monument to decorate his triumphal arch in Rome, erected c.315 cE.

constitute idolatry. No such strictures applied to the figure of Christ himself, it being a central tenet of Christianity that Christ had been made man. However, there was little agreement as to how he should be shown: young, old, stern, benign, even bearded or beardless. Although many scenes from the life of Christ were depicted quite early on, these never included the Crucifixion, a form of death reserved for the lowest class of criminal. Even the cross itself was only slowly adopted as a universal symbol. In the absence of surviving paintings, early Christian statuary and mosaics provide the only clues as to how these questions

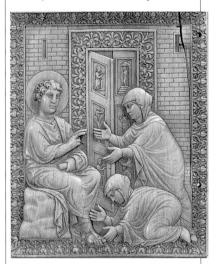

Holy Women at the Tomb of Christ c.400, ivory, Milar: Castello Sforzesco. Mary, the mother of Jesus, and Mary Magdalene worship the risen Christ, who is portraved as a young, beardless man in Roman dress.

were resolved. The sumptuous mid-4thcentury sarcophagus of Junius Bassus, for example, has two tiers, each containing five scenes of sharply carved if crudely realized figures. In both a youthful Christ occupies the central scene. His pose in the upper tier, seated with arms outstretched in benediction, derives directly from an imperial Roman tradition.

A similar fusion of pagan forms and Christian subject matter is evident in an ivory of around 400 depicting the *Holy Women at the Tomb of Christ*. Again, if the figures are slightly awkwardly rendered, they clearly stem from the earlier Greek tradition.

EARLY ART

BYZANTINE ART C.500 - 1200 CE

Vastly richer than the beleaguered Western Empire and increasingly drawn towards the east, the Byzantine Empire evolved a new and elaborate visual language dominated by complex religious imagery. It marked an near absolute break with the Classical Greek inheritance that had driven earlier Roman art.

The most important

64

subject of Byzantine art was Christianity. As the teachings of the Church were codified, precise rules came to govern how they could be depicted. Gestures and even colours came to acquire precise and unvariable meanings.

Among the earliest examples of Byzantine art are the glittering, near otherworldly mosaics in the Church of San Vitale in Ravenna in Italy. They are important not just as an emphatic assertion of the vigorous (if short-lived)

Justinian reconquest – the attempt by the Eastern Emperor Justinian to recreate a unified Roman Empire in the face of the barbarian conquests in the west – but as a supreme example of the new sensibilities of the Byzantine world. The dominant image, over the altar, is of a luminous, seated Christ, flanked by angels and donors. But hardly less remarkable is that of Justinian and his

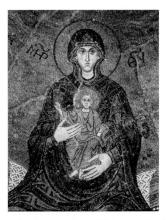

Madonna and Child, 12th century, mosaic in vaulto detail), Trieste: Cathedral of St. Just. The Byzantine tradition that Mary should be depicted wearing a blue robe was carried over into Western art.

retinue. This portrait of the splay-footed emperor, part gangster, part man of destiny, is one of the most compelling images in western art. Justinian's Church of Hagia Sophia in Constantinople projects this mood of fierce piety even more strikingly. Even today, almost 600 years after the Ottoman conquest of Byzantium in 1453 when what was then still the largest church in Christendom

> became, as it remains, a mosque, its glinting mosaics and vast, shadowy recesses evoke an astonishing sense of the grandeur and mystery at the heart of imperial Byzantium.

The later formality of the Byzantine tradition

Byzantine capitals in Church of S. Vitale, Ravenna, 6th

century. The interiors of Byzantine churches were richly decorated with mosaics, gilding, and reliefs, but not statues, which were not venerated as icons.

Christ Pantocrator, late 11th century, mosaic, Monastery church, Daphni (Greece). The figure of "Christ ruler of all", his left hand holding the Bible, the right hand raised in blessing, remains a ubiquitous icon of the Orthodox Church.

> "the Mother of God", she became a central figure of Byzantine, and later of western, Christian art.

FAR-REACHING INFLUENCE

An image such as the 6th-century panel painting of the Virgin and Child from the Monastery of St. Catherine in the Sinai Peninsula, Egypt, highlights a further, central fact of Byzantine art: that religious "icons" (literally "images") were increasingly valued as aids to contemplation. Small and often portable, they would exercise a profound influence on the spreading world of "orthodox" Christianity ("orthodox" because sanctioned by the Byzantine Church). The conversions of Bulgaria is 064 are kiewer Basia is 0000 et al.

Church). The conversions of Bulgaria in 864 and Kievan Russia in 988 to this distinctive brand of Christianity were crucial in expanding its reach and in implanting it in new lands.

KEY EVENTS

532	Hagia Sophia begun in Constantinople (consecrated 537)
533	Justinian launches reconquest of West Roman Empire
c.547	Mosaics in San Vitale Ravenna
555	Byzantine conquest of Italy and southern Iberia complete
558	Dome of Hagia Sophia collapses (rebuilt by 563)
692	Trullan Council sanctions use of figures of Christ in art
726	Emperor Leo III bans worship of religious images, provoking "iconoclast" crisis
751	Ravenna, last Byzantine possession in Italy, falls to Lombards
843	Triumph of Orthodoxy: religious images officially promoted
864	Mission of Cyril and Methodius begins spread of orthodoxy in eastern Europe
1054	Final schism between Roman and Orthodox churches

belies just how inventive it originally was. The glowering mosaic figure of Christ Pantocrator, "Christ the ruler of all", staring down from the dome of the monastery church of Daphni in Greece, is an exceptionally potent image of an implacable God. It was in Byzantium, too, that the Virgin Mary was developed as one of the key icons of Christian art. In part this was a matter of doctrine. Yet once established in the 5th century that it was precisely her virginity that made her

Emperor Justinian I and his Retinue, c.547 cc, mosaic, Ravenna: S. Vitale. Flanked by imperial officials, generals, and high-ranking members of the clergy, Justinian is portrayed as the political, military, and religious leader of the Byzantine Empire.

CELTIC, SAXON & VIKING ART c.600 - 900

Northern Europe after the collapse of the Roman Empire has traditionally been seen as entering a "dark age" lost in impenetrable obscurity: marginal, shadowy, and violent. Yet drawing on earlier Celtic traditions and increasingly becoming part of the Christian world, it produced exceptionally vivid and sophisticated works of art.

The discovery at Sutton Hoo in 1939 of the burial goods of an early Anglo-Saxon king, generally agreed to be Raewald, ruler of East Anglia, transformed people's understanding of emerging Anglo-Saxon England. Raewald died around 625, not much

more than 200 years after the Romans had abandoned Britain. Yet among the objects found in his grave were a Byzantine bowl and gold coins from Gaul, evidence of long-range trading contacts. At the same time, the treasure highlights a world poised between a pagan past and a Christian future. Already Christianity was penetrating Britain, from Ireland and from the Continent. Once these rival traditions had been reconciled in 664 by the Synod of Whitby, Britain came firmly within the orbit of the Roman Church.

Viking ship's figurehead c. 825, height 12.7 cm (5 in), wood, Oslo: Universetets Oldsaksamling. This intricately carved dragon's head was among the grave goods found in a burial mound excavated in 1904. Belt buckle from Sutton Hoo, early 7th century, gold, London: British Museum. Inlaid with garnets and coloured glass, the piece shows clear affinities with – the intricately intertwined patterns of Celtic jewellery and illuminated manuscripts.

N D V D THE MAKE THE D THE REAL PROPERTY AND A D THE REAL PROPERTY AND A

THE VIKINGS

By contrast, the Viking world as it emerged over the next 200 years was at first genuinely beyond Rome's reach. Nonetheless, drawing on the same Celtic roots that are obvious at Sutton Hoo, it, too, produced works of art of a remarkable and immediately recognizable potency. The 9th-century carved dragon ship's figurehead, found in a burial mound at Oseberg in Norway, is evidence of a warrior society capable of exceptional craftsmanship.

KEY EVENTS

563	Irish monastery established at lona
597	Mission of papal emissary St. Augustine to England
c.650	Lindisfarne Gospels
664	Synod of Whitby: Roman Christianity adopted in England
731	Bede completes his Ecclesiastical History of England
c.790	First Viking raids on western Europe
c. 800	Book of Kells

The Book of Kells c.800

The monastery established in 563 on the remote island of Iona off the west coast of Scotland was one of a handful of isolated Dark Age Irish Christian communities that were responsible for an extraordinary outpouring of Celtic Christian art, above all a series of sumptuous illuminated manuscripts.

The Book of Kells, produced at Iona in about 800 and taken to Ireland for safekeeping when the Viking raids began, is the most famous product of the fusion of Celtic art and Christian subject matter. It is a book of verses. interspersed with extracts from the Gospels. The thousands of hours of patient labour lavished on it represented an act of worship just as much as the examination of it was intended to induce a mood of contemplation. Among its innovations was the use of richly decorated and elaborate capital letters at the start of each passage.

Triskele – three legs radiating from a central point – are a recurring motif in Celtic art

The capitals – Chi and Rho – are first two letters of the Greek word for Christ and are one of the oldest Christian symbols

Interlaced patterns are a key characteristic of Celtic decorative art; they may have been influenced by Roman floor mosaics

The complexity of the patterning is similar to contemporary Celtic jewellery

urpano

Naturalistic details – human heads, animals, and birds – are dotted among the swirling, swooping line work.

Book of Kells

Dimensions 33 x 25 cm (13 x 10 in) Medium ink on vellum Location Dublin: Trinity College Library

EARLY ART

MEDIEVAL ART OF NORTHERN EUROPE c.800 – 1000

By the 8th century, the Frankish Empire had become the most successful of the new states formed after the collapse of Rome. It reached its largest extent under Charlemagne in the early 9th

century when it covered France, Germany, the Low Countries, and most of Italy. Charlemagne also sparked a cultural revival that decisively influenced the development of later medieval art.

On Christmas day 800, Charlemagne, king of the Franks, was crowned emperor of a new Roman empire by Pope Leo III in St. Peter's in Rome. It was a deliberate assertion of Rome reborn. In the event, Charlemagne's empire would prove vulnerable, its unity destroyed after his death in destructive dynastic quarrels. But his longer-term legacy proved remarkably enduring. In extending his rule deep into Germany, territories the Romans had been unable to subdue were brought within western Christendom. In the 10th century, Saxony, conquered and forcibly Christianized by Charlemagne after a

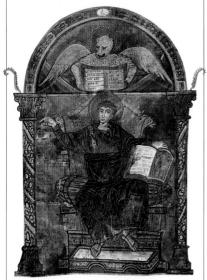

St. Mark from Carolingian Gospel Book c.800, purple vellum, Abbeville: Bibliothèque Municipale. The strange-looking creature framed by the arch is the winged lion, symbol of St. Mark the Evangelist.

KEY EVENTS

771	Charlemagne sole ruler of Frankish Empire
772	Conquest of Saxony begun; complete 802
774	Lombardy brought within Charlemagne's empire
792	Imperial (Palatine) Chapel begun at Aachen; completed 805
800	Coronation of Charlemagne in Rome
814	Death of Charlemagne
843	Treaty of Verdun divides Carolingian Empire into three
845	Paris sacked by Vikings
875	Charles the Bald crowned first Holy Roman Emperor
910	Foundation of Benedictine abbey at Cluny, France
936	Accession of Otto I as Holy Roman Emperor

savage 30-year campaign, had become a major centre of early medieval art and religious teaching. In effect, a nascent German state had been created. In the same way, the western half of the fractured empire would subsequently emerge as France. A shift of Europe's political and cultural centre of gravity was taking place, away from the Mediterranean towards the north.

CULTURAL RENEWAL

Charlemagne's promotion of Latin not only helped preserve Roman texts that might otherwise have been lost, it established a common language among Europe's elites and strengthened the authority of the Roman Church.

would endure throughout the Middle

Ages. As early as the 6th century, Pope Gregory I had affirmed the didactic purpose of religious imagery: "What scripture is to the educated, images are to the ignorant." Under Charlemagne, narrative images of this kind

Cross of Gero c.970, height 187 cm (73 5/8 in), oak, Cologne Cathedral. Unlike Byzantine art, western European religious art stresses the suffering of Christ.

An example of the artistic outpouring generated by the Carolingian renovatio (renewal) is a Gospel book produced at the city of Aachen, Charlemagne's capital, early in the 9th century. Its Classical origins are clear. The image of St. Mark, framed by a triumphal arch, is not just an obvious celebration of the evangelist, it is a clear attempt to imitate the richness of the late Roman world. In reality, however, it looks forward to the Middle Ages rather than back to Rome. There is no Roman precedent for the double-jointed twist

of the evangelist's right wrist any more than there is for his oddly angled feet. As important was the development of a narrative tradition in religious art that

Book cover 8th century, silver gilt and ivory, Cividale del Friuli: Museo Archeologico. The carving of the Crucifixion shows Longinus thrusting his spear into the dead Christ's side.

became a fixed part of the western tradition. An early 9th-century ivory panel, subsequently used as the cover of devotional volume known as the Pericopes (meaning simply "extracts") of Henry II, set within an elaborately jewelled frame, contains three scenes, dominated by the Crucifixion, in an obvious narrative sequence. Similar painted scenes, only faded fragments of

which survive, are known to have

decorated Carolingian churches. This depiction of the Crucifixion is an early example, its provenance hard to unravel, of what would become almost the single most important Christian image in medieval Europe: Christ not just on the cross but clearly human, suffering unbearable agonies. The so-called Cross of Gero, carved around 970 and now in Cologne Cathedral, encapsulates this new, tortured sensibility.

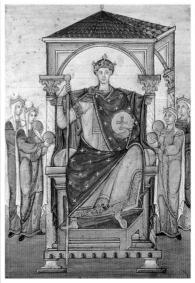

Otto II, Holy Roman Emperor c.985, illumination on vellum, Chantilly: Musée Condé. Otto, the second Saxon Emperor, ruled 967-983. He married a Byzantine princess. The four women offering homage to the emperor represent the four parts of his empire.

69

70

EARLY ART

ROMANESQUE & EARLY GOTHIC ART

c.1000 - 1300

Despite external threats, whether Viking, Magyar, or Muslim, by about 1000 the Christian states of Europe had begun a slow process of recovery. At the heart of their regeneration was the Church, the only pan-European body in Christendom. Early medieval art, increasingly lavish, in architecture above all, was almost exclusively religious.

The foundation of a new monastery at Cluny in central France in 910 sparked a hugely important reform of the western Church. Under its second abbot, St. Odo, Cluny extended its control over a number of other monastic foundations. In the process, they were not merely reinvigorated themselves but the Church as a whole became much more expansive and assertive. One consequence was a programme of new church building across much of western Europe.

Nave of Pisa Cathedral 1094. Pisa was one of the powerful maritime republics of medieval. Italy. Wealth from trade funded the city's beautiful Romanesque cathedral.

Rose window c.1224, stained glass, south wall of Chartres Cathedral.

ROMANESQUE ARCHITECTURE

Quite rapidly, a new architectural language, the Romanesque, came into being. As a reflection of the new power of the Church, these were buildings that were deliberately magnificent and, in many cases, much larger than anything yet seen in Europe. The cathedral of Santiago de Compostela, for example, built around 1120, possesse this austere gravity in abundance. There is a heaviness to its massive walls and immense tunnel vaults that emphatically projects the new self-assurance of the Church. At much the same time, in France, a new manner of sculptural decoration was created. At Autun Cathedral, for example, the tympanum, the area immediately above the main entrance, is crowded with figures dominated by Christ in the centre. The subject depicted, as it is on almost all later such carvings, is the Last Judgement, a reminder to worshippers entering the building of their mortality. The vigour and elegance of this teeming scene, filled with demons, angels, the damned, and the saved, the whole presided over by the serene figure of Christ, makes clear the revitalization of European sculpture, an art form almost abandoned after the fall of Rome. As with all medieval sculpture, originally it would have been painted.

THE GOTHIC

In 1144 Abbot Suger, abbot of the monastery of St. Denis just outside Paris, presided over the consecration of the rebuilt choir of the abbey church. That this is a radically different type of structure is obvious. Structurally, there is nothing new – its ribbed vaults and pointed arches had appeared in a number of earlier buildings - vet St. Denis has a unity, the whole lit by what Suger memorably called "the liquid light if heaven", that is quite different. Gothic art was more than just an extension of the Romanesque. It was different in every important sense, a visual language expressly designed to celebrate the central place of the Church in an increasingly confident European society. This was not a world looking back to Rome. Self-aware and increasingly self-assured, it sought to create its own towering monuments to God. The early Gothic cathedrals with their soaring verticals reaching up to pointed arches were triumphant assertions of a new sensibility that equated massive building projects with personal piety. It was a style that reached maturity at Chartres, begun in 1194, and

KEY EVENTS

1031	Beginning of Christian reconquest of Spain	
1065	Earliest known stained glass in Europe, at Augsburg cathedral, Germany	
1066	Norman conquest of England	
1077	Emperor Henry IV forced to seek absolution from Gregory VII, reinforcing papal authority	
1085	Third abbey church at Cluny, the largest in the world, begun	
1088	First university in Europe established, at Padua, Italy	
1096	First Crusade (to 1099)	
1098	Foundation of Cistercian order in France	
1137	Rebuilding of St. Denis: first properly Gothic building	
1147	Second Crusade (to 1148)	
1154	Accession of Henry II unites much of France and England	

Romanesque capital c.1135. The pilgrimage church of Ste. Madeleine in Vézelay in the Burgundy region has many fine examples of Romanesque carving.

climaxed at Amiens, begun in 1220, and the Sainte-Chapelle in Paris (1243–48), where the floor-to-ceiling stained-glass windows are both a technical tour de force and an exultant celebration of a new monarchy certain of its own power.

The self-confidence of this world found other outlets. The mid-12th-

century illustration of St. John from the Gospel of Liessies, for example, probably painted by an English illustrator in the Low Countries, projects a similar certainty of its own worth: stylized, lavish, and elegant. It is a compelling example of the self-belief that underpinned the art of medieval Europe.

Gothic carvings, Chartres Cathedral These Old Testament figures, flanking the central door of the the west facade, date from the late 12th century.

c.1300 - 1500

GOTHIC AND EARLY RENAISSANCE c.1300-1500

The word "Renaissance" (meaning "rebirth") was first used in the 15th century to describe a revival in Classical learning. At the same time, "Gothic" was used to describe a style of architecture regarded as barbaric, the creation of the Goths who had destroyed the glories of art and architecture in the Roman Empire.

t was only in the 19th century that "Renaissance" was used to explain the cultural flowering of the 14th and 15th centuries that launched the intellectual framework and artistic traditions of the modern world. Yet politically, socially, and economically the soil from which the Renaissance grew could hardly have seemed more barren.

When in 1346, the Black Death, carried by ship-borne rats from the Orient, began to wipe out one third of Europe's population, it seemed just the latest in a series of traumatic events. In the previous century, huge areas of eastern Europe had been seized by the Mongols. Between 1315 and 1319, there had been a run of catastrophic harvests. At the same time, the southeast of the continent was being menaced by the aggressively expanding Ottomans.

Europe looked ill equipped to deal with these threats. Technologically inferior and politically fragmented, it appeared destined to remain at the mercy of more powerful neighbours. In addition, it was wracked by periodic bouts of savage internal warfare. Edward III's attempted conquest of France in 1337 began over 100 years of brutal conflict between England and France. Meanwhile, the Catholic Church was divided by a period of schism.

RECOVERY THROUGH TRADE

Yet in the face of these enormous handicaps Europe staged a comeback. A sense of pan-European identity began to emerge, principally as the result of commerce. Throughout the Middle Ages, trade routes had been consolidated. By the end of the 14th

Camera degli Sposi Andrea Mantegna, fresco, 1465–74, Mantua: Palazzo Ducale. The virtuoso use of perspective, combined with Classical motifs, demonstrates the enthusiasm with which the Gonzaga family, the rulers of Mantua, embraced the new art and learning.

74

century, a network of sea and land routes linked much of the continent. Money and goods were exchanged, but so were ideas, and together these led to a general rise in prosperity. Venice and Genoa, city-states grown rich on trade with the Orient, led the way, but others were quick to imitate them. For example, the establishment of the Hanseatic League in 1360 created a series of northern European cities that could rival the traditionally dominant Mediterranean. Equally important was the establishment by Hans Fugger in Bavaria in 1380 of a banking network that in time would make the Fuggers the richest family in Europe.

The Triumph of Death (detail) Pieter Brueghel the Elder, c.1562, oil on panel, 117 x 162 cm (46 x 63 3/4 in) Madrid: Museo del Prado. The ravages of the Black Death were indiscriminate: the rich were as vulnerable as the poor.

ITALY

Nevertheless it was in Italy that the Renaissance achieved its fullest flowering. It was here that the physical remains of the ancient world

> - notably sculpture and architecture were most numerous and so most easily studied. Also the newly rich city-states believed that they needed to embody the spirit of the Roman Empire itself. Florence, by the early 15th century the most powerful of these city-states, consciously chose to see itself as the direct heir of Rome. Financed by its own indigenous

GOTHIC ART

TIMELINE: c.1300 - 1500

c.1300 Venetians 1380 Foundation of 1389 Battle improve Brenner international of Kosovo: Pass, facilitating 1337 Start of 100 banking system by Ottomans Years' War between Hans Fugger in gain control trade with England and France Augsburg, Germany northern Europe of Balkans 1300 1350 1378 The Great 1387 Medici 1304-12 1360 1346 First occurrance Scrovegni of Black Death; in Hanseatic Schism: rival bank founded. Chapel, Padua, three years reduces League popes in Rome Florence painted by Giotto Europe's population founded and Avignon (to 1417) by one third

"Gothic" describes principally a style of architecture common in Northern Europe between 1100 and 1500. It also includes the decorative art of the period, which was usually highly ornamental with realistic detail, but without any overall scheme of representation. In its later years Gothic art became increasingly decorative and elegant with sophisticated patterns and rhythms, and when used by Italian painters is called "International Gothic". Roettgen Pietà, c. 1300, limewood (originally painted), height 89 cm (35 in) Bonn: Rheinisches Landesmuseum.

banking dynasty, the Medici, Florentine artists not only proclaimed the superiority of Classical antiquity but asserted that it represented a golden age of creativity whose spirit needed to be revived in the present, and they condemned the recent past as a dark age. At the same time, European thought was becoming more questioning and freethinking. People began to look for rational explanations of the physical environment and human behaviour. and were ready to reject the dogmatic propositions and blind faith that controlled the elaborately complex medieval world. Painters, sculptors, and architects were at the forefront in instigating these fundamental changes. When Brunelleschi demonstrated how perspective could be represented schematically on a flat surface, he was conscious that he was unifying science, philosophy and art, and was thus looking ahead to a world in which all three would be, and would look, permanently different.

POISED FOR EXPANSION

The most decisive contribution to this new spirit of enquiry was the invention of moveable type by Johannes Gutenberg in Germany

Dome of Florence Cathedral Completed by Filippo Brunelleschi in 1434, the dome of Florence Cathedral was an emphatic statement of civic pride in which science was used to produce architecture of outstanding beauty.

1421–44 Brunelleschi's Foundling Hospital, Florence, first properly classical building of the Renaissance

1400

1415 Burning of Jan Hus for heresy provokes religious wars in Bohemia y Santa Maria f Novella, e Florence

1429 Joan of

revival in 100

Arc sparks

Years' War

French

1425

Masaccio's

Holy Trinity.

1434 Dome of Florence cathedral completed 1454 Gutenberg Bible, oldest known book printed with moveable type

1450

1453

Constantinople

falls to Ottomans;

France ends 100

Years' War

fall of Bordeaux to

1450 Alliance of Florence, Naples, and Milan dominates north and central Italy 1492 Muslim Granada falls to Spain; Columbus's first Atlantic crossing

1469 Lorenzo de Medici (the Magnificent) assumes control of republic of Florence

in the 1450s. This sparked an unprecedented revolution in the speed, ease, and cost of the spread of information and ideas. When Christopher Columbus crossed the Atlantic in 1492 he opened new horizons and at the same time confirmed that

Europe had moved from the shadowy margins of the world to occupy centre stage.

Nicola and Giovanni Pisano

⊖ 13TH - 14TH CENTURIES PUITALIAN

Pisa; Siena; Perugia; Pistoia; Padua
 sculpture

Nicola (c.1220-c.1284) and Giovanni (c.1245-c.1314/19) were father and son. Nicola (also called Niccolò) founded a workshop, at which Giovanni was a pupil. Worked together, but each retained a distinct individual style. Pioneers of the Gothic style. Renowned for their religious stonework, such as altars and pulpits. The Fontana Maggiore in Perugia is the most famous of their joint works. They are credited with bringing a previously unseen naturalism to stone sculpture. KEY WORKS Nativity (pulpit), 1265-68 (Siena Cathedral); Madonna and Child, c.1305 (Padua: Cappella dei Scrovegni); Madonna, c.1315 (Prato Cathedral)

Bernardo Daddi

⊖ c.1290-c.1349 P ITALIAN

■ Florence Ø oils, fresco ■ London: Courtauld Institute of Art 2 \$2,562,000 in 2004, *Coronation of the Virgin* (oils)

A younger contemporary of Giotto, who was possibly Daddi's teacher. Blended Giotto's tough realism with the sweetly lyrical qualities of Sienese artists (such as Ambrogio Lorenzetti). Look for smiling Madonnas, cute children, flowers, and Polyptych with the Crucifixion and Saints Bernardo Daddi, c. 1348, approx. 155 x 217 cm (61 x 85% in), tempera and gold leaf on panel, London: Courtauld Institute of Art.

draperies. Creator of popular, easy-tolook-at, small-scale portable altarpieces. Then, as now, art that is kind to the eye and mind tends to have a wide following. **KEY WORKS** Arrival of St. Ursula at Cologne, 1330 (Los Angeles: J. Paul Getty Museum); The Marriage of the Virgin, c.1330–40 (London: National Gallery); Martyrdoms of Sts. Lawrence and Stephen, c.1330 (Florence: Santa Croce)

Jehan Pucelle

⊖ c.1300-c.1350 P FRENCH

France; Italy; Belgium 🚺 illumination

Pucelle was an eminent illuminator of manuscripts and a master miniaturist; recognized as such in his lifetime. Owned an influential workshop in Paris at the start of the 14th century. Travelled to Italy and Belgium to learn new techniques. A favourite of the French court, his works were expensive and purchased by nobility and royalty. Pucelle's works are renowned for being more realistic in their depiction of human features than those of the traditional, "flat" icon painters. KEY WORKS Belleville Breviary, 1323-26 (Paris: Bibliothèque Nationale); Hours of Jeanne d'Evreux, 1325-28 (New York: Metropolitan Museum of Art)

Limbourg brothers

Paul (or Pol), Herman, and Jean Limbourg were pioneering illuminators who trained as goldsmiths and then worked for the great French patron of the period, Jean, Duc de Berry, at a time of great political turmoil. They were born in the Netherlands, where their father was a wood carver. Through the influence of an uncle, who was a painter, they were sent to train in Paris. Paul was probably the head of the workshop, but it is not possible to distinguish his hand from those of his brothers.

Their two great works are *Les Belles Heures* and *Les Très Riches Heures*. They used old forms (illustrated Books of Hours – personal prayer books) but with fresh and stunningly innovative illustrations – scenes of everyday life (courtiers and peasants), unusual biblical events, first-hand observation from life, and landscapes of real places (such as the Duc's châteaux). Their brilliant colours and meticulous technique marry perfectly with their subjects.

Their best-known work is the "Months" from *Les Très Riches Heures* because they are most accessible to a secular society and look wonderful in reproduction. Note how they used contemporary advanced Italian ideas such as landscape background (one of the brothers went to Italy); and anticipated Netherlandish art – story-telling, fine detail, and observation. Their work and patronage reflect the notion

that, for the wealthy, commissioning and collecting art is a celebration of God's glory and an act of true devotion. **KEY WORKS** *The Nativity*, c.1385–90 (Paris: Bibliothèque Nationale); *Les Très Riches Heures*, 1413–16 (Chantilly, France: Musée Condé); *The Anatomy of Man and Woman*; c.1416 (Chantilly, France: Musée Condé)

Death, One of the Four Riders of the Apocalypse Paul (or Pol) Limbourg, c.1413–16, illumination on vellum, Chartilly (France): Musée Condé. Note the fine detail – an obsession of the brothers.

7th-15th centuries

"Illumination" is the term used to describe the hand-painting and handwriting of books decorated with motifs in rich colours. Characteristically, the initial letter of a page is much larger than the others and furnished with images and bold colours. The use of gold and vivid hues of red, blue, and green are employed. Other styles may include elaborate borders around the text or small pictorial scenes. The medium is often associated with religious books.

Illuminated "P" by Bartolomeo di Fruosino, 1421

State:

GOTHIC AND EARLY RENAISSANCE

Taddeo Gaddi

⊖ c.1300-c.1366 PU ITALIAN

 Florence oil: fresco in Florence: Santa Croce (Baroncelli Chapel frescoes)
 \$3,114,000 in 1991, *The Bromley Davenport Altarpiece – The Man of Sorrows, Sts. Peter, Francis, Paul, and Andrew* (oils)

He was Giotto's principal follower (and godson?). Gaddi popularized Giotto's tough realism by making it decorative, adding anecdotal details, and emphasizing the storytelling side of picture making. **KEY WORKS** Annunciation to the Shepherds, c.1328 (Florence: Santa Croce); Madonna and Child Enthroned, 1355 (Florence: Galleria degli Uffizi); The Entombment of Christ, c.1360–66 (New Haven: Yale University Art Gallery)

Cimabue (Cenni di Peppi)

⊖ c.1240-1302 PU ITALIAN

 ☑ Florence; Rome
 ☑ oils; tempera; fresco; mosaic
 ☑ Pisa: Cathedral (apse mosaic)

The most prominent artist working in Florence at the end of the 13th century, Cimabue was a contemporary of Dante. Traditionally said to be Giotto's teacher – i.e. it is claimed that he initiated the

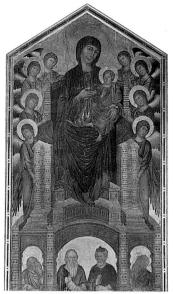

Madonna and Child Enthroned with Eight Angels and Four Prophets (or Maestà) Cimabue, c. 1280, 385 x 223 cm (151½ x 87½ in), tempera on wood, Florence: Galleria degli Uffizi.

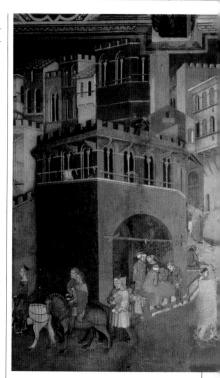

move from the static "old" and "unreal" Byzantine style to the "modern" and "realistic" style, with more credible 3-D space, human form, and emotion. So many works have been attributed to him that his name has almost come to represent a group of like-minded artists rather than an individual, though we know he existed.

KEY WORKS Maestà, 1280–85 (Florence: Galleria degli Uffizi); Madonna and Child Enthroned with Two Angels and Sts. Francis and Dominic, c.1300 (Florence: Palazzo Pitti); Christ Enthroned between the Virgin and St. John the Evangelist, 1301–02 (Pisa Cathedral)

Duccio di Buoninsegna

⊖ ACTIVE 1278–1319 🕫 ITALIAN

Key early Sienese painter, Duccio influenced all those that followed (just as Giotto influenced Florentine artists).

He tells a story with tenderness and humanity. He is not as innovative in style or technique as Giotto, who was his

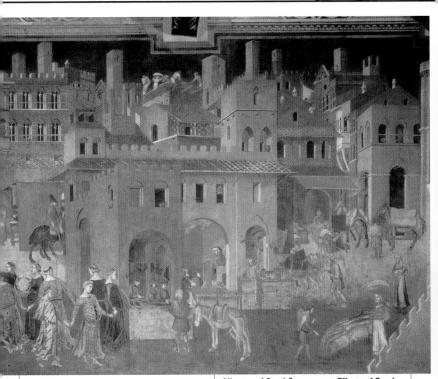

contemporary, but he is a better narrator of events. Look at the way the people act and react together, and the way he uses the setting as part of the narrative. The perspective and scale may be haywire, but the buildings still look real and livedin, and may be arranged so as to divide up the constituent parts of the story.

He paints no-nonsense (slightly sceptical?) faces with long, straight noses, small mouths, and almond-shaped eyes, which can be rather sly. His hand gestures help tell the story. He makes decorative use of colour, notably blue, red, and pale green. Some of the oddities or quirkiness can be explained because his style is not actually of the Renaissance: it is essentially Byzantine and Gothic – that is, old-fashioned, but with a new twist, rather than completely new like Giotto's.

KEY WORKS Maestà, c.1308 (Siena: Museo dell' Opera Metropolitana); Nativity, c.1308–11 (Washington DC: National Gallery of Art); The Apostles Peter and Andrew, c.1308–11 (Siena: Museo dell'Opera Metropolitana); The Holy Women at the Sepulchre, c.1308–11 (Washington DC: National Gallery of Art) Allegory of Good Government: Effects of Good Government in the City (detail) Ambrogio Lorenzetti, c. 1338–39, 296 x 1398 cm (116 /x x 550 % in), fresco, Siena: Palazzo Pubblico.

Lorenzetti brothers

ACTIVE c.1319–1348
 ITALIAN
 Siena; Florence
 Florence
 Fresco; oils
 \$906,630 in 2001, Crucifixion with
 Two Martyrs (oils) by Pietro Lorenzetti

Siena's Pietro (1320–c.1348) and Ambrogio (1319–c.1348), followed in the steps of Duccio di Buoninsegna, but with more realism and expression. They had shadowy lives (there is a difficult chronology for extant work) and both died of plague. Ambrogio's work is warmer and less solemn than his brother's; his most important works are the frescoes of *Good* and *Bad Government* (Palazzo Pubblico, Siena) – the first Italian paintings where landscape is used as background.

KEY WORKS The Charity of St. Nicholas of Bari, Ambrogio Lorenzetti, 1335–40 (Paris: Musée du Louvre); Scenes from the Life of Blessed Humility, Pietro Lorenzetti, c.1341 (Florence: Galleria degli Uffizi)

Giotto di Bondone

\varTheta c.1267–1337 🔎 ITALIAN

Florence; Padua; Naples; Assisi; Rome;
 Milan M fresco; oils Adua: Cappella dei
 Scrovegni. Assisi: S. Francesco. Florence: S. Croce

The painter who brought a new level of realism to art, which would establish the framework for Western art until 20thcentury Modernism changed the rules.

Despite humble beginnings as the son of a farmer, Giotto became an educated and cultivated man, who grew rich and important in Florentine society. An unsubstantiated story tells how he was discovered by chance by the great painter Cimabue who saw the boy Giotto sketching his father's sheep. Giotto then became Cimabue's apprentice. He lived through a period when Florence was becoming one of Europe's most important and influential cities.

WHAT TO LOOK FOR

Giotto's innovation was in the way he portrayed supposedly real-life events to appear as though enacted by lifelike people expressing believable emotions and occupying recognizable settings and spaces. He looked, painted what he saw, and then opened up a "window on the world". The impact, even now, is one of directness, simplicity, accessibility, and believability. In other words, his

paintings are about life.

Look for his outstanding features: faces expressing genuine emotion; meaningful gestures; strong, selfexplanatory storylines (like early silent movies, you only have to look to know exactly what is going on); the sense of space around and between the figures; how shape and movement of incidentals, such as trees and rocks, support the main action or emotion; large bones, well-built, solid figures. But notice also where he finds problems

"When I see the Giotto frescoes at Padua I do not trouble myself to recognize which scene of the life of Christ I have before me, but I immediately understand the sentiment which emerges from it. For it is the lines, the composition, the colour."

Campanile of the Duomo, Florence Giotto designed the Campanile in 1334, and construction was finished in 1359, 22 years after his death. Here it is viewed from the top of the Duomo.

81

Cappella dei Scrovegni, frescoes, Padua Giotto di Bondone, c. 1305. The climax of the chapel's glorious decoration is the large fresco of the Last Judgement on the west wall.

that are difficult for him to resolve; for example, he had no knowledge of perspective or anatomy, and a convincing sense of weightlessness (e.g. flying angels) eluded him.

Giotto's key monument is the Scrovegni (or Arena) Chapel in Padua (c.1304–13), which is decorated from floor to ceiling with a complex arrangement of selfcontained scenes, most memorable for their emotional and spiritual impact. **KEY WORKS** *Stigmata of St. Francis*, c.1295–1300 (Paris: Musée du Louvre); *The Lamentation of Christ*, c.1305 (Padua: Cappella dei Scrovegni); *The Virgin and Child*, c.1305–06 (Oxford: Ashmolean Museum); *Enthroned Madonna with Saints and Angels*, c.1305–10 (Florence: Galleria degli Uffizi)

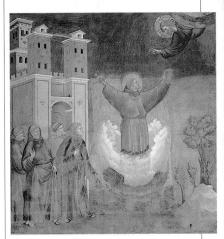

The Ecstasy of St. Francis Giotto di Bondone, 1297–99, 270 x 230 cm (106% x 90% in), fresco, Assisi: S. Francesco. One of the frescoes depicting "The Legend of St. Francis", who had died less than 80 years earlier.

Simone Martini

One of the leading painters from Siena and a follower of Duccio. Although he experimented with new ideas (such as perspective), he was essentially a largescale, decorative illustrator, not least of illuminated manuscripts.

Look for the qualities you might see in illuminated manuscripts (despite the difference in scale): glowing colour; lively drawing; a precise, closely worked line; meticulous observation of detail; rhythmic, flowing, golden draperies. Simone's allconsuming emphasis was on decoration for sumptuous overall effect.

It is interesting to compare his work with that of his exact contemporary, Giotto, because, lovely as it is, it lacks everything that is in Giotto: Simone's figures are artificial, with convoluted poses and gestures; faces are stylized and without genuine emotion; the storytelling lacks deep meaning; everything is arranged decoratively, not to create ideas of space, form, and movement. Simone's work was a final chapter of the past; Giotto's was the future. KEY WORKS Maestà, 1315 (Siena: Palazzo Pubblico); Death of St. Martin, c.1326 (Assisi: Lower Church); The Angel and the Annunciation, 1333 (Florence: Galleria degli Uffizi); Apotheosis of Virgil, 1340-44 (Milan: Biblioteca Ambrosiana); Christ Discovered in the Temple, 1342 (Liverpool: Walker Art Gallery)

Ugolino di Nerio

⊖ ACTIVE 1317-27 № ITALIAN

He was Sienese, and also known as Ugolino da Siena. A close follower of Duccio, and with a similar style, but narrative is less well focused, colours are less clear, and the faces and gestures lack Duccio's precision.

Madonna Enthroned between Adoring Angels Lorenzo Monaco, c. 1400, 32.4 x 21.2 cm (12% x 8% in), panel, Cambridge: Fitzwilliam Museum.

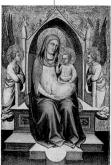

KEY WORKS *St. Mary Magdalene*, c.1320 (Boston: Museum of Fine Arts); *The Betrayal of Christ*, c.1324–25 (London: National Gallery)

Lorenzo Monaco

⊖ c.1370-1425 PU ITALIAN

 Image: Forence
 Image: Ima

Lorenzo was born in Siena, but seems to have spent all his professional life in Florence. A highly gifted monk (*monaco* is Italian for "monk"). Creator of altarpieces and illuminated manuscripts (look for a love of detail; fine technique; luminous blues, reds, golds; rhythmical, decorative line). His poetic imagination strove to

unite the natural with the supernatural, and decorative Gothic with Giotto's realism. Happiest when working on a small scale – predella panels and manuscripts. **KEY WORKS** *The Nativity*, 1409 (New York: Metropolitan Museum of Art); *Madonna and Child*, 1413 (Washington DC: National Gallery of Art); *The Adoration of the Magi*, c.1422 (Florence: Galleria degli Uffizi)

с.1300-1500

Gentile da Fabriano

€ 1370-1427 PU ITALIAN

☑ Fabriano; Florence; Venice
 ☑ oils; fresco
 ☑ \$497,624 in 1986, *The Annunciation* (oils)

He was an Italian painter, named after his birthplace, Fabriano in the Marches. One of the foremost artists of his day, he was the most accomplished exponent of the International Gothic style. Worked all over Italy. Most of his work is either lost or destroyed.

His preference was to turn a work of art into a highly luxurious object (a characteristic of the International Gothic style), rather than a window on the world (Renaissance). His works could almost be fabulous textiles woven with gold thread.

As well as using traditional techniques such as tooled gold, and with a liking for patterned textiles and static figures, he also experimented with light, space, and narrative. He created delicate, unreal figures with pink cheeks. Paid great attention to natural detail – animals, birds, plants – which he recorded with delicacy and sympathy.

KEY WORKS Virgin and Child Enthroned, c.1395 (Berlin: Staatliche Museum); Coronation of the Virgin, 1420 (Los Angeles: J. Paul Getty Museum); Adoration of the Magi, 1423 (Florence: Galleria degli Uffizi); The Nativity, 1423 (Los Angeles: J. Paul Getty Museum) The Presentation in the Temple (from the Altarpiece of the Adoration of the Magi) Gentile da Fabriano, 1423, 26.5 x 66 cm (10½ x 30 in), oil on panel, Paris: Musée du Louvre.

Stefano di Giovanni Sassetta

€ 1392-1450 P ITALIAN

🖸 Siena; Florence 🛛 🖉 oils

The best painter of early Renaissance Siena. Combined the old decorative style of the International Gothic with the new ideas from Florence.

Look for his charming, uninhibited qualities – the kind that children show when making a picture: a delight in storytelling; lots of physical activity; spaces and perspective that don't quite work; sudden attention to unexplained detail; unsophisticated, decorative colours.

Note the bright little eyes with prominent whites and, sometimes, faces with wide-eyed expressions; prissy, bow-shaped lips, and curious harp-shaped ears; also observe stylized crow's-feet on older male faces. **KEY WORKS** *St. Margaret*, c.1435 (Washington DC: National Gallery of Art); *San Sepolero Altarpiece*, 1437–44 (London: National Gallery); *The Madonna and Child Surrounded by Six Angels*, c.1437–44 (Paris: Musée du Louvre); *The Meeting of St. Anthony and St. Paul*, c.1440 (Washington DC: National Gallery of Art)

Pisanello (Antonio Pisano)

⊖ c.1395–1455 🕫 ITALIAN

He was very popular with princely courts as a painter, decorator, portraitist, and medallist, but few works now survive.

His work has qualities similar to those of illuminated manuscripts. It is good for an inconclusive art-historical debate: is he the late flowering of the International Gothic style or the pioneer of early Renaissance? (It is more profitable to forget the debate and just enjoy what you can, when you can.)

Notice his fascinating direct observation from life, and meticulous, fresh draughtsmanship, especially of animals, birds, and costumes. He painted flat, decorative backgrounds like tapestries, using fresh colours. His portraits have distinctive profiles, which relate to his pioneering of the art of the portrait medal – a medium at which he excelled.

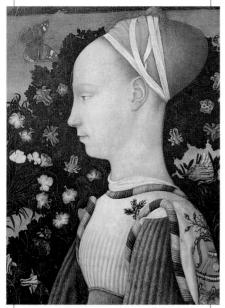

Portrait of Ginevra d'Este Antonio Pisano Pisanello, c.1436–38, 43 x 30 cm (17 x 11% in), tempera on wood, Paris: Musée du Louvre. Notice how the leaves, flowers, and butterflies combine to create a rich tapestry effect.

The Last Judgement Stephan Lochner, 1440s, 122 x 171 cm (48 x 67% in), oil on wood, Cologne: Wallraf-Richartz-Museum. Exquisite colouring and minute detail are characteristic of Lochner's work.

KEY WORKS The Annunciation, 1423–24 (Verona: San Fermo); St. George and the Princess of Trebizond, 1437–38 (Verona: Santa Anastasia)

Masolino da Panicale

⊖ c.1383-1447 № ITALIAN

 Florence; Rome; Hungary i oils; fresco i Rome: San Clemente (fresco cycle). Como (Italy): Castiglione Olona
 \$270,000 in 1995, Prophet or Evangelist (oils)

Best remembered as collaborator of Masaccio, he was recognized as a painter of great distinction. He had a graceful figure style, learned by working with the sculptor Lorenzo Ghiberti, and made skilful use of perspective. He was an accomplished modeller of flesh and hair, and had an interest in everyday details.

KEY WORKS Madonna of Humility, c.1415–20 (Florence: Galleria degli Uffizi); St. John the Evangelist and St. Martin of Tours, c.1423 (Philadelphia: Museum of Art); St. Liberius and St. Matthias, c.1428 (London: National Gallery)

Giovanni di Paolo

"The El Greco of the Quattrocento." Sienese painter who adopted a deliberately old-fashioned style, in reply to the influential "modern" style of Duccio. Developed a charming, decorative, and convincing narrative style, in which the spaces, perspective, scale, emotions, and logic of the "real" world are deliberately ignored. **KEY WORKS** *St. John the Baptist Retiring into the Wilderness*, c.1453 (London: National Gallery); *The Feast of Herod*, c.1453

(London: National Gallery); *The Nativity* and the Adoration of the Magi, c.1455–59 (Paris: Musée du Louvre)

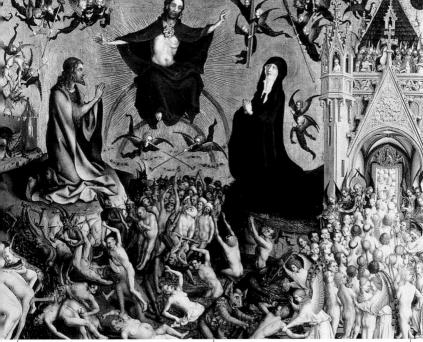

Stephan Lochner

⊖ c.1400-51 P GERMAN

🖸 Cologne 🚺 oils 🛅 Cologne

A shadowy early German painter about whom little is known and to whom few works are attributed for certain. The leading master of his time in Cologne, where he worked from 1442 until his death. Author of religious works of soft, rounded figures with slightly silly, chubby faces; glowing colours; rich, gold

backgrounds; somewhat fussy, natural, and anecdotal detail. KEY WORKS The Virgin in the Rose Bush, c.1440 (Cologne: Wallraf-Richartz-Museum); Annunciation, c.1440-45 (Cologne Cathedral); Sts. Matthew, Catherine of Alexandria, and John the Evangelist, c.1445 (London: National Gallery)

The Moses Well Claus Sluter. late 14th century, height of figures 180 cm (70% in), stone, Dijon: Chartreuse de Champmol. Symbolic well surrounded by statues of Moses and other Old Testament prophets.

Claus Sluter

⊖ c.1350-c.1405 P DUTCH

🔟 Dijon; Brussels 🛛 🗕 sculpture

A sculptor and a founder of the Burgundian School. Hugely influential on the development of northern European sculpture. Born in Haarlem. Worked in Brussels, before moving to France. For 21 years, lived in Dijon as chief sculptor of Philip the Bold, Duke

of Burgundy. His work is characterized by fine draperies, silken-looking hair, and realistic human figures. Look for ordinary mortals introduced into religious works standing alongside divine figures. **KEY WORKS** Portal of the Chartreuse de Champmol, 1385-93 (Dijon); Arms of a Virgin or a Magdalene, 14th century (Dijon: Musée Archéologique); Fragment of Crucified Christ, 14th century (Dijon: Musée Archéologique)

86

THE EARLY RENAISSANCE

Three major principles underlined the Renaissance (literally, rebirth) in early 15th-century Italy: a renewed, more systematic study of Classical Antiquity in the belief that it constituted an absolute standard of artistic worth; a faith in the nobility of man (Humanism); and the discovery and mastery of linear perspective. Together, they made up a revolution in Western art.

STYLE

From the start, Renaissance artists, especially those based in its birthplace, Florence, were conscious that their work represented a decisive break with the immediate past. The change came first – and most obviously – in sculpture. Ghiberti's panel for a new set of bronze doors for Florence Baptistry owes a direct and immediate debt to Roman models. Figures are modelled naturalistically; the sense of space is equally marked.

The Sacrifice of Isaac Lorenzo Ghiberti, 1402, 53.3 x 43.4 cm (21 x 17 in), bronze, Florence: Museo Nazionale del Bargello. The frame may still be Gothic, but the key elements of the Renaissance are unmistakably present e.g. the muscular Isaac derived from Classical originals.

SUBJECTS

Though religious subjects continued to predominate, there was an increasing interest in secular subjects. Gozzoli's mid-century *Procession of the Magi* artfully combined the two. His Magi are portraits of his patrons, the Medici, surrounded

The Procession of the Magi (detail) Benozzo Gozzoli, 1459, fresco, Florence: Palazzo Medici-Riccardi. The richly garbed figure on the white horse is Lorenzo de' Medici, commandingly certain of his worth in every sense.

by numerous retainers, on a procession that is more regal than religious. If the shimmering, jewel-like picture surface looks back to the International Gothic, the figures and landscape are just as clearly products of the Renaissance.

KEY EVENTS

c.1427	Masaccio completes frescoes in Brancacci Chapel, Santa Maria del Carmine, Florence, the first great Renaissance fresco cycle
1424	Ghiberti completes first set of Florence Baptistry bronze doors; more commissioned
1434–64	Florence ruled by Cosimo de' Medici
1445	Johannes Gutenberg's Bible, first printed book in Europe (Germany)
1452	Publication of Alberti's <i>De Re Aedificatoria</i> , first comprehensive treatise to set out principles of Classical architecture
1469–92	Lorenzo (the "Magnificent") de' Medici rules Florence

15th century

WHAT TO LOOK FOR

The two most obvious technical triumphs of Renaissance painting were the ability to portray convincingly naturalistic figures in equally convincingly realized illusionistic spaces. Piero della Francesca, author of three mathematical treatises, epitomized both developments. He

The architectural details – ceiling of the semi open-air structure and rich floor tiles – are painted exactly The vanishing point is precisely calculated: exactly on the centre line of the painting, dividing it in two, a quarter of the way up

constructed exceptionally elaborate perspective schemes while his figures have an overwhelming sense of assured monumentality. Yet however rational his paintings may be, ultimately what marks them is a distinctively haunting sense of serene detachment.

> The Flagellation of Christ Piero della Francesca, c.1470, 58.4 x 81.5 cm (23 x 32 in), oil and tempera, Urbino: Galleria Nazionale delle Marche. A great and enigmatic masterpiece.

The statue

immediately above Christ's head provides clear evidence of Piero's interest in the Antique. Its precise meaning remains disputed but its soft modelling is ravishingly well done. TECHNIQUES Piero's palette, consistently cool and clear, is a key element in the curious air of mystery that pervades his work. Flesh tones (which use a

base of green paint), no less than

limpid skies, are realized with

remarkable economy.

The flagellation is carried out

Pontius Pilate gazes impassively

with hardly any animation. On

the left, the seated figure of

at Christ's punishment

The significance of the three figures in the foreground has been endlessly questioned. Who are they, and why are they so detached from the flagellation?

Lorenzo Ghiberti

⊖ c.1378-1455 🕫 ITALIAN

Florence; Siena
 sculpture; glass
 \$245,679 in 2000, Madonna and Child (sculpture)

He was a sculptor, goldsmith, designer, and writer. Born and worked in Florence; also worked in Siena. Renowned in his lifetime as the best bronze-caster in Florence. Famous for the bronze doors of the Baptistry in Florence. Also produced stained glass and sculptures. Opened a large, influential workshop; pupils included Donatello. Married Marsilia c.1415; two sons, Tommaso and Vittorio, both worked in the studio.

Look for rich decoration and elegance of sculpting. His relief work is defined by clean lines and plenty of activity, with the eye drawn by fluid drapery, movement in the landscape, and ornate carving. Fusion of classical artistic style with realism. **KEY WORKS** *The Sacrifice of Isaac*, 1402 (Florence: Museo Nazionale del Bargello); *Joseph in Egypt* (Porta del Paradiso), 1425–52 (Florence: Baptistry)

Masaccio (Tommaso Giovanni di Mone)

Florence
 Florence: Brancacci Chapel (fresco cycle); Santa Maria Novella

The greatest of the early-Renaissance Florentines, he revolutionized the art of painting during his short lifetime and was the bridge between Giotto and Michelangelo. Masaccio means "Big ugly Tom". He left very few known works.

His deeply moving pictures can plumb the most basic and profound of human emotions. He painted believable and dignified human figures, expressing qualities of feeling, emotion, and intellectual curiosity that are as relevant today as 500 years ago. His simple, wellordered compositions, in which the human figure is the central feature, accord with the Renaissance principle that human beings are the measure of all things.

The individual expressions on the faces show minds and emotions at work – enquiring, doubting, suffering – also expressed simultaneously through gestures and hands (but why are the

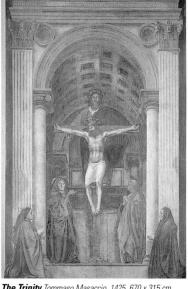

The Trinity Tommaso Masaccio, 1425, 670 x 315 cm (263% x 124 in), fresco (post restoration), Florence: Santa Maria Novella. This piece was covered over in 1570 with a panel painting by Vasari, and only rediscovered in 1861.

hands so small?). Creates believable spaces, which human figures dominate with authority. Uses light to model draperies and figures (instead of outline, so helping them to look real). Masaccio was the first painter to understand and use scientific perspective; the same is true for foreshortening.

KEY WORKS *Crucifixion*, 1426 (Naples: Museo di Capodimonte); *The Expulsion from Paradise*, c.1427 (Florence: Santa Maria del Carmine)

Fra Filippo Lippi

⊖ c.1406-69 PU ITALIAN

 Image: Tuscany
 Image: Tesco; tempera; oils
 Image: Spoleto:

 Cathedral (frescoes); Prato: Cathedral (frescoes); Prato: Cathedral (frescoes);
 Image: Spoleto:

 Series)
 Image: State and the spole state and the sp

An important early-Renaissance Florentine whose work forms a bridge between Masaccio and Botticelli.

His sincerely-felt religious works expressed worship of God by sensitive interpretation of the New Testament and by mastery of all the chief technical interests and developments of the period (all of them, including the artist's skill,

being a gift from God): perspective; landscape; proportion; communication between human figures; finely painted decorative detail; carefully drawn drapery folds.

Look for the chubby figures with slightly glum youthful faces, and eyes that look as though they never blink. Note his love of rich detail – marble floors, gold grounds, decorated costumes. **KEY WORKS** *Virgin and Child*, c.1440–45 (Paris: Musée du Louvre); *The Annunciation*, c.1448–50 (London: National Gallery); *Madonna and Child with Stories of the Life of St. Anne*, c.1452 (Florence: Palazzo Pitti); *The Adoration with the Infant Baptist and St. Bernard*, c.1459 (Berlin: Staatliche Museum)

Fra Angelico

⊖ c.1387-1455 P ITALIAN

Florence; Fiesole; Orvieto; Perugia; Rome
 fresco; tempera; oils
 Florence: Convent of
 San Marco (fresco series)
 \$1,080,537 in 2003,
 St. Peter and St. Thomas Aquinas by the Cross (oils)

He was a Dominican friar whose work combines old-fashioned (Gothic) and progressive (Renaissance) ideas. His paintings interpret the Christian message with directness, enthusiastically telling the story of God's goodness. They are delightfully happy, attractive, and holy, and have great innocent purity – as though he saw no evil in the world (perhaps he didn't.)

There is disarming and childlike innocence in the detail: youthful, happy faces with peaches and cream complexions and pink checks; everyone is busy doing something. Angelico takes evident pleasure in colours (especially pink and blue) and things that he has observed closely, such as flowers. He uses old-fashioned gold embellishments and modern perspective with equal enthusiasm; his soft draperies have highly detailed borders.

KEY WORKS Noli me Tangere, 1425–30 (Florence: Convent of San Marco); The Annunciation, 1435–45 (Madrid: Museo del Prado); The Virgin and Child Enthroned with Angels and Saints, c.1438–40 (Florence: Convent of San Marco); The Mocking of Christ, c.1439–43 (Florence: Convent of San Marco)

The Beheading of St. Cosmas and St. Damian Fra Angelico, c.1438–40, 37 x 46 cm (14% x 18 in), tempera on panel, Paris: Musée du Louvre. After previous failed attempts on their lives, the twin martyrs were finally killed.

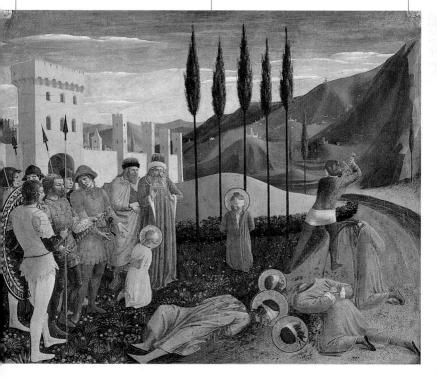

David

Donatello c.1435-53

This piece was created for the Medici, and was first mentioned in the report of the marriage of Lorenzo il Magnifico (1469). It stood in Florence's Palazzo Medici, paired with a statue of Judith and Holfernes. Both works told of the death of oppressors – a warning to enemies to keep away.

Donatello's David was a move away from traditional religious imagery. One of the first nude statues of the Renaissance; the homoeroticism is instantly apparent, as is the innovative twisting pose about the hips, known as "contrapposto". Although David stands with the head of Goliath at his feet, the figure does not seem capable of the great strength or violence needed to have killed the giant. Goliath's helmet displays Donatello's ability to sculpt in relief.

Donatello probably trained as a goldsmith. As a result, he was particularly skilled at working with bronze with fine detail and highly polished surfaces.

David

Medium bronze Height 158 cm (62½ in) Location Florence: Museo Nazionale del Bargello In his right hand is the sword which decapitates Goliath

He stands on a laurel wreath, symbol of victory and power David's expression is strangely dreamy and contemplative

> In his left hand, David holds the sling he used to bring down Goliath

Many Florentines were shocked by the statue's nudity

Donatello

€ 1386-1466 PU ITALIAN

Unquestionably the greatest sculptor of the early Renaissance. Born in Florence, travelled widely. Famous throughout Italy.

Essentially, he reinvented the art of sculpture just as other contemporaries were reinventing the art of painting. His innovations and discoveries were profoundly influential on Michelangelo. He had complete mastery of sculpture in bronze, stone, wood, and terracotta, and nothing escaped his extraordinary capabilities: relief sculpture, nudes, equestrian statues, groups of figures with single figures seated or standing. Was able to bring sculpture to life by his ability to tell a story, to combine realism and powerful emotion, and give his figures a sense of more than mere objects of beauty for passive contemplation, but creations filled with energy and thought, ready to spring into action.

Physically strong and rough, prone to anger, he was a popular member of Florentine society and close to his patron, Cosimo de Medici. Careless with money, unmarried, and probably homosexual, he was well known for choosing only goodlooking boys as studio apprentices. **KEY WORKS** *St. Mark*, 1411 (Florence: Or San Michele); *St. George*, c.1415 (Florence: Museo Nazionale del Bargello); *Zuccone*, c.1436 (Florence: Museo dell'Opera del Duomo)

Luca della Robbia

⊖ c.1399-1482 🕫 ITALIAN

 Florence Sculpture; ceramics
 Florence: San Miniato al Monte
 \$254,839 in 2002, Madonna and Child with Saints (sculpture)

His full name was Luca di Simone della Robbia; he came from a large family of artists and artisans. Prolific sculptor of the early Renaissance. A warm personality who gave practical help to struggling artisans. Trained in textiles and as a goldsmith before sculpture. Worked in stone and terracotta. Follower of the humanistic movement. Patronized by the Medici; also patrons in Naples, Portugal, and Spain. Achieved fame and wealth through glazed terracotta artworks. Set up successful studio in Florence; keeping the formula of his tin glazes a secret. Worked closely with his nephew Andrea della Robbia (1435–1525).

Look for rich colour and luminous tin glazes, strict attention to detail, and an awareness of the properties of draperies and metalwork reflected in his sculpture. His scenes are thick with symbolism and the faces expressive.

KEY WORKS The Resurrection, c.1442–45 (Florence: Museo Nazionale del Bargello); Roundels of the Apostles, c.1444 (Florence: Pazzi Chapel)

Domenico Veneziano

⊖ c.1400-61 PU ITALIAN

Perugia; Florence D tempera; fresco
 London: National Gallery. Florence: Galleria
 degli Uffizi

He was an important and very influential Venetian who worked in Florence. Almost nothing is known about him now and there are only a few known works surviving. He was more interested in constructing with light and colour than with modelled form and perspective. **KEY WORKS** *St. John in the Desert*, c.1445 (Washington DC: National Gallery of Art); *The Martyrdom of St. Lucy*, c.1445–48 (Berlin: Staatliche Museum)

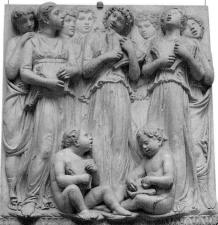

Cantoria (choir gallery, detail) Luca della Robbia, c. 1432–38, 100 x 94 cm (39% x 37 in), marble, Florence: Museo dell'Opera del Duomo. The carvings illustrate the 150th Psalm and depict angels, boys, and girls in song.

92

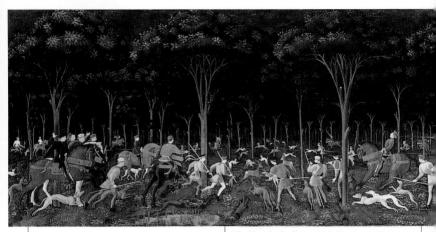

Paolo Uccello

⊖ 1397-1475 № ITALIAN

Florence Determinant
 Florence: Santa Maria Novella; Duomo (frescoes); Galleria degli Uffizi

He was a Florentine painter, born Paolo di Dono and nicknamed *Uccello* ("the bird"). His works are instantly recognizable by the schematic use of perspective and foreshortening.

His over-theoretical application of the science of perspective tends to swamp all other considerations, and can make his work look rather wooden and the figures toy-like. But the sheer enthusiasm and gusto with which he used perspective stops his pictures from becoming dry and boring. His wife, however, complained that he loved his perspectives more than her.

Does he use a single viewpoint for the perspective, or are there several? Forget

perspective and foreshortening for a moment, and enjoy his strong sense of design and attention to decorative detail. Sadly, many of his works are in very poor condition. They are also often hung at the wrong height in galleries so that his carefully worked out perspective effects are visually ruined. (If necessary, sit or lie on the floor and work out the proper viewpoint.)

KEY WORKS *The Crucifixion*, mid-1430s (New York: Metropolitan Museum of Art); *Battle of San* **The Hunt in the Forest** Paolo Uccello, c.1465–70, 75 x 178 cm (29% x 70 in), oil on canvas, Oxford: Ashmolean Museum. One of Uccello's greatest works, which demonstrates his fascination with perspective. The leading stag (centre) is the focus of the "vanishing point".

Romano, c.1455 (Florence: Galleria degli Uffizi); St. George and the Dragon, c.1460 (London: National Gallery); The Flood, 1447–48 (Florence: Santa Maria Novella)

Benozzo di Lese **Gozzoli**

⊖ c.1421-97 № ITALIAN

☑ Florence; Orvieto; Rome; Pisa ☑ fresco; tempera ☑ Florence: Palazzo Medici-Riccardi (fresco series); Galleria degli Uffizi ☑ \$36,750 in 1993, *Study of Male Nude* (drawing)

Down-to-earth early-Renaissance Florentine. A good craftsman who enjoyed what he saw. Originally trained as a goldsmith, he worked in his early years with Ghiberti on the doors of the Baptistry

in Florence.

Gozzoli was a painter of high-quality altarpieces and predella panels. He liked crowded scenes, which enabled him to show off a combination of brilliant, decorative qualities, and carefully observed solid figures, with no-nonsense faces and expressions.

The Triumph of St. Thomas Aquinas Benozo di Lese Gazoli, c.1470–75, 230 x 102 cm (90½ x 40¼ in), tempera on panel, Paris: Musée du Louvre. The saint is enthroned between Aristotle and Plato.

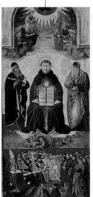

 $c\;.\;1\;3\;0\;0-1\;5\;0\;0$

Gozzoli's figures have good hands (with long fingers) and good feet, and are firmly placed on the ground. Note how well he arranges crowds, and has a propensity to paint the tops of heads, particularly if bald, or with a hat or helmet. **KEY WORKS** Procession of the Magi, 1459-61 (Florence: Palazzo Medici-Riccardi); The Dance of Salome, 1461-62 (Washington DC: National Gallery of Art); Madonna and Child with Saints, 1461-62 (London: National Gallery);

The Raising of Lazarus, c.1495 (Washington DC: National Gallery of Art)

Andrea del Verrocchio

⊖ c.1435-88 P ITALIAN

Florence Sculpture; tempera; oils
 \$30,910 in 1953, Madonna and Child (oils)

The son of a brickmaker, he trained with a goldsmith, whose name he took. Became a leading Florentine painter, goldsmith, and (principally) sculptor. Had a work-shop where Leonardo da Vinci trained. Authentic paintings by him are very rare.

His altarpieces show an overall mood and style of refinement, grace, freshness, and delicate idealism. They have a dreamy, faraway atmosphere, which is reflected

in the eyes and expressions on the faces. He portrayed two types of face or body: epicene youth and craggy, tough warrior. Also painted similarly fresh, delicate landscapes and skies that contrast with craggy outcrops and rocks. Look for clear, sharp outlines and bright colours.

Note his love of fine detail, showing in

Equestrian Monument to

Bartolomeo Colleoni Andrea del Verrocchio, 1490s, height 395 cm (155½ in), bronze, Venice: Campo Santi Giovanni e Paolo. The work was a competitive challenge to Donatello. expensive fabrics decorated with gold thread and jewellery. Notice the bowshaped lips pressed together; the stylized curly, wiry hair; the refined hands touching each other or others; poses that imply movement through weight being placed on one foot or one leg. His figures seem modelled and conceived as sculpture. **KEY WORKS** *Putto with Dolphins*, c.1470 (Florence: Palazzo Vecchio); *Tobias and the Angel*, 1470–80 (London: National Gallery); *Beheading of John the Baptist*, 1477–80 (Florence: Museo dell' Opera del Duomo); *The Baptism of Christ*, c.1478–80 (Florence: Galleria degli Uffizi)

Piero di Cosimo

с.1462-с.1521 Р	ITALIAN
-----------------	---------

 Image: Porence
 Image: Oils
 Image: Status
 Image: Status
 Status</

He was an out-of-the-ordinary early-Renaissance Florentine who led a bohemian lifestyle and was fascinated by primitive, prehistoric life. He was a prime example of the artist as a craftsman.

He painted portraits, altarpieces, and mythologies. Especially endearing and memorable are his love of animals and birds, his observations of nature, and his storytelling. His strange, mythological fantasy pictures are unique; they are entirely fanciful and can have disturbing suggestions of struggle and violence. Nobody knows what they mean or why they were painted, so we are free to interpret them as we like.

> How do you interpret the strangely ambivalent role played by the animals in his pictures? Note the charming landscape details that look as though they have come out of a woven medieval tapestry. Many of his works were done as decorative panels for furniture (such as *cassoni*) or rooms, hence their clongated shape.

> > KEY WORKS The Visitation with St. Nicholas and St. Anthony Abbot, c. 1490 (Washington DC: National Gallery of Art); A Satyr Mourning over a Nymph, c. 1495 (London: National Gallery); Allegory, c. 1500 (Washington DC: National Gallery of Art)

Pollaiuolo brothers

⊖ c.1432-98	PU ITALIAN
Elorence	oils: sculpture: engravings

Antonio (c.1432–98) was a shadowy figure who, with his brother Piero (c.1441–96), ran one of the most successful workshops in Florence.

They had a pioneering interest in anatomy and landscape, choosing subjects to display these interests and skills to the full, notably anatomy – the male, nude or semi-naked, doing something that shows straining muscles and sinews. Shows front, side, and back views in the manner of an anatomical analysis (they are said to have dissected corpses to study anatomy – a daring and risky venture at the time).

They also painted detailed landscapes and had an interest in spatial recession, but their work jumps abruptly from foreground to background. They never worked out how to use the middleground. **KEY WORKS** *Hercules and the Hydra*, c.1470 (Florence: Galleria degli Uffizi); *Portrait* of a Woman, c.1470 (Milan: Museo Poldi Pezzoli); *Apollo and Daphne*, c.1470–80 (London: National Gallery)

Battle of the Ten Naked Men Antonio Pollaiuolo, c. 1465–70, 38.3 × 59 cm (15/x× 23/4 in), engraving, Florence: Galleria degli Uffizi. This work shows the artist's mastery of depicting the human body in motion.

Cosimo **Rosselli**

⊖ 1439-1507 🕫 ITALIAN

 Florence; Rome Areas calls; fresco
 \$489,000 in 1998, Crucifixion with Madonna, John the Baptist, Mary Magdalen, Andrew and Francis (oils)

He was a well-known early-Renaissance Florentine, but firmly in the second division. He painted run-of-the-mill religious works. His figures have stylized, obsessively painted hair and a curiously tired and drawn look around the eyes. **KEY WORKS** *Virgin and Child with an Angel*, c.1470 (Boston, USA: Museum of Fine Arts); *Portrait of a Man*, c.1481–82 (New York: Metropolitan Museum of Art)

Luca Signorelli

⊖ c.1441-1523 🕫 ITALIAN

Signorelli was intense and gifted, but outclassed by Raphael and Michelangelo.

His religious and secular subjects were chosen to make the most of his interest in dramatic (overdramatic?) compositions. Observe the movement, muscles, and gestures in his figures –

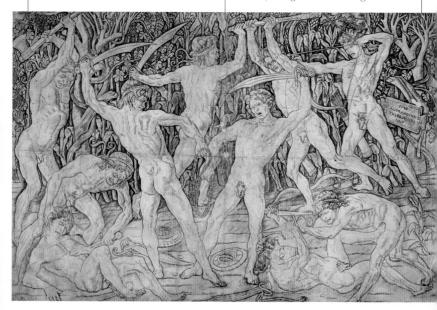

 $C \, . \, 1 \, \, 3 \, \, 0 \, \, 0 - 1 \, \, 5 \, \, 0 \, \, 0$

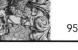

but sometimes there is too much of this and the paintings are overcrowded. Good draughtsmanship.

He emphasized the sculptural quality of the figures to the point where they sometimes look as though they have been carved out of wood. (Michelangelo always showed flesh and blood.) He painted hands that look distorted by arthritis and mouths with set expressions.

KEY WORKS The Holy Family, 1486–90 (London: National Gallery); The Circumcision, c.1491 (London: National Gallery); St. Agostino Altarpiece, 1498 (Berlin: Staatliche Museum)

Domenico Ghirlandaio

€ 1449-94 PU ITALIAN

Florence; Pisa; Rome i fresco; oils; tempera
 Florence: Santa Maria Novella; Santa Trinità.
 Rome: Sistine Chapel (all fresco series)
 \$318,000 in 1980, San Pietro Martire (oils)

Florentine painter who achieved success with a solid, old-fashioned yet realistic storytelling style. His most famous pupil was Michelangelo.

His frescoes were commissioned as decoration for important public buildings. Consequently many are still in situ. He used contemporary settings, dress, manners, faces, and portraits to illustrate religious subjects. Look for homely, domestic pictures, which could be illustrations to a story – a forerunner of the Dutch and 19th-century genre.

He painted serious, well-fed, middleclass people, like the patrons who commissioned these works. His figures have long hands, wrists, and legs. In tempera he uses long, widely spaced strokes that follow the main curves and contours. Do not confuse with his brother David (1452–1525), who was left-handed and so used hatching that goes from top left to bottom right. **KEY WORKS** A Legend of Sts. Justus and Clement of Volterra, c.1479 (London: National Gallery); Birth of John the Baptist, 1479–85 (Florence:

The Visitation Domenico Ghirlandaio, 1491, 172 x 165 cm (67% x 65 in), tempera on panel, Paris: Musée du Louvre. Mary, pregnant with Jesus, visits her cousin Elizabeth (pregnant with St. John the Baptist).

Santa Maria Novella); Birth of the Virgin, 1479–85 (Florence: Santa Maria Novella); Portrait of an Old Man and a Boy, c.1485 (Paris: Musée du Louvre)

Filippino Lippi

⊖ c.1457-1504 PU ITALIAN

Florence; Rome
 Florence: Santa Maria Novella. Rome: Santa
 Maria sopra Minerva (both cities for fresco series)
 \$2m in 2005, Penitent Mary Magdalen (oils)

The son of Filippo Lippi. Successful, but stylistically outdated in his later years.

His religious subjects show all the standard technical qualities of early-Renaissance Florentine painting (see Filippo Lippi). He painted important fresco series and a few portraits.

Observe his sweet, young faces with soft eyes; good male bone structure; forward inclination of heads. Note his wonderful hands and fingers, which really do look as though they touch, feel, and grasp. **KEY WORKS** *The Adoration of the Kings*, c.1480 (London: National Gallery); *The Vision of St. Bernard*, c.1486 (Florence: Badia Fiorentina)

"Ghirlandaio ... was created by Nature herself to become a painter."

GIORGIO VASARI

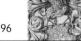

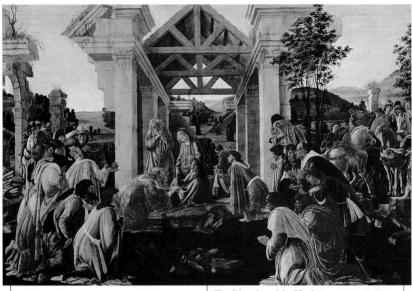

Alessandro Botticelli

● 1445-1510 P ITALIAN

Florence; Rome I tempera; fresco
 Florence: Galleria degli Uffizi
 \$1.2m
 in 1982, Portrait of Giovanni di Pierfrancesco de' Medici (oils)

Known as Sandro, Alessandro di Mariano Filipepe Botticelli was a major Florentine artist, at a key moment, who emphasized ornament and sentiment rather than scientific observation and realism.

He painted deeply-felt religious pictures and pioneering large-scale mythologies. Note the way he portrays the human figure (on its own, in relationship to others, or in crowd scenes) – always with great dignity, strange and distant, with dream-like unreality and distortions. One of the great draughtsmen of all time. His later work is odd and retrogressive because he retreated into the past, unable to cope with Florence's turbulent descent into social and political turmoil.

His subjects have wonderful bone structure – especially in their cheeks and noses, long and refined hands, wrists, feet, and ankles – and beautifully manicured nails; they have fine and crisply drawn outlines like tense wires. Notice his fascination with pattern – in elaborate materials, hair, and crowds, **The Adoration of the Magi** Alessandro Botticelli, 1481, 70 x 104 cm (27½ x 41 in), tempera and oil on panel, Washington DC: National Gallery of Art. Botticelli may have painted this while in Rome working on the Sistine Chapel.

which he turns into designs of shape or colour, or both. He found ideas like scientific perspective of no interest; instead, he cleverly combined old Gothic decorative styles with new, classical, and humanist ideals. **KEY WORKS** *The Madonna of the Magnificat*, c.1480–81 (Florence: Galleria degli Uffizi); *Virgin and Child with Eight Angels*, c.1481–83 (Berlin: Staatliche Museum); *La Primavera* (see pages 98–99); *The Birth of Venus*, c.1484 (Florence: Galleria degli Uffizi)

Lorenzo di Credi

⊖ c.1458-1537 P ITALIAN

■ Florence ■ oils; tempera ■ \$1.1m in 1995. *St. Ouirinus of Neuss* (oils)

A minor Florentine who had a similar style to the early works of fellow pupil, Leonardo da Vinci; they attended Verrocchio's workshop together. Lorenzo was a painter of altarpieces and portraits. Technically competent, but his style was lifeless and lacked individuality. Used an unpleasant, high-key palette with orange/gingery tone. Draperies and flesh both have the same squashy appearance; shows odd, upturned thumbs and toes. $C\ .\ 1\ 3\ 0\ 0\ -\ 1\ 5\ 0\ 0$

The story goes that in 1497, influenced by the teachings of the fanatical friar Savonarola, Lorenzo destroyed many of his works featuring profane subjects. **KEY WORKS** *The Annunciation*, c.1480–85 (Florence: Galleria degli Uffizi); *Venus*, c.1490 (Florence: Galleria degli Uffizi)

Pietro Perugino

⊖ c.1445-1523 № ITALIAN

 Perugia () fresco; oils; tempera
 \$5.58m in 1990, Albizzi Pietà, Dead Christ with Virgin Mary and other Figures (oils)

He was a hardworking, prolific, middleranking painter from Perugia, Umbria, hence his nickname: his real name was Pietro Vannucci. Trained in Florence. Raphael was trained in his workshop.

His religious pictures are painted in a soft, pretty, simplified, and sentimental (oversweet?) style, which tends to become routine – he reused figures from other compositions. His portraits can be very good, tough, and direct. His work declined in quality in later years.

Look for slender figures with gently tilting heads and the weight on one foot; oval-faced Madonnas; delicate fingers and a genteelly crooked little finger; lips pressed together, the bottom one fleshy; feathery trees and skies, milky on the horizon, graduating to deep blue at the zenith. **KEY WORKS** *Crucifixion with the Virgin, St. John, St. Jerome, and Mary Magdalene,* c.1485 (Washington DC: National Gallery of Art); *Mary Magdalene,* 1490s (Florence: Palazzo Pitti)

Bernardino di Betto Pinturicchio

⊖ c.1454-1513 PU ITALIAN

 Perugia; Rome; Siena
 fresco; tempera; oils
 Rome: Vatican Museums.
 Siena: Piccolomini Library of the Cathedral 2 \$300,000 in 2001, Madonna and Child (oils)

The last serious artist from Perugia and Umbria. He was probably a pupil of Perugino. Highly skilled, prolific, ambitious, but not at forefront of new ideas. Ultimately second rank.

Pope Pius II Canonizes St. Catherine of Siena Bernardino di Betto Pinturicchio, 1503–08, fresco, Siena: Cathedral. Note the brilliant colours, ornamental detail, and fanciful charm in this work.

He was a master of fresco painting and supremely skilled at fitting his decorative scheme to the space of the room. Hence he gives a particularly vivid sense of looking through the wall at a busy, bustling scene, full of incident. Enjoy his intense and childlike realism, attention to detail, and love of storytelling – and believe you have walked into the daily life of Umbria in the 15th or 16th century.

Notice his carefully planned and executed perspectives (geometric and aerial); his facility in recording almost microscopic details he has observed in nature. Uninhibited love of colour. He painted lavish and brilliant decorative borders, which influenced Raphael. **KEY WORKS** *St. Catherine of Alexandria with a*

> Donor, c.1480–1500 (London: National Gallery); Borgia rooms frescoes, 1492–95 (Rome: Vatican); Virgin and Child between St. Jerome and St. Gregory the Great, c.1502–08 (Paris: Musée du Louvre)

> St. Sebastian Pietro Perugino, c.1495, 53 x 39 cm (21 x 15 in), tempera and oil on panel, St. Petersburg: Hermitage Museum. The artist's name is painted in gold lettering on the arrow embedded in the saint's neck.

La Primavera

Alessandro Botticelli c.1482

La Primavera (Spring) shows the garden of Venus, the Goddess of Love. From 1434 to 1737, Florence was controlled by the wealthy Medici family, and the painting was probably commissioned by Lorenzo di Pierfrancesco de' Medici (1463–1503) to hang in a room adjoining the wedding chamber of his townhouse.

Sandro Botticelli was the principal painter in Florence in the second half of the 15th century. His refined, feminine style found favour with the Florentine intelligentsia in the troubled times in which they lived. His masterpieces were his large mythological paintings, which promoted a particular type of divinely inspired beauty, combined with complex literary references.

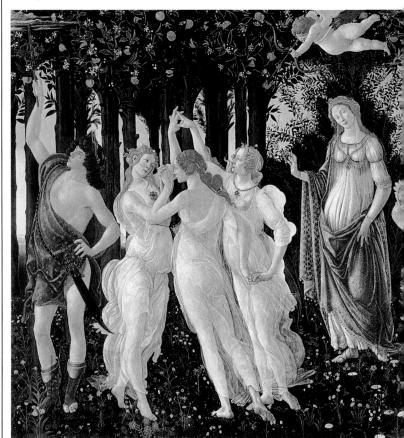

Mercury, the messenger of the gods, uses his caduceus – a wand entwined with snakes – to hold back the clouds so that nothing can blight the eternal spring of Venus's garden Venus is shown wearing the characteristic headdress of a Florentine married woman – a reference to the nuptial theme of the painting

Flora, the Goddess of Flowers, is the principal figure on the right-hand side of the painting. She tiptoes across the meadow of flowers, the embodiment of peauty, strewing blossoms around her

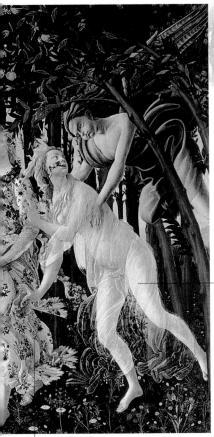

The Goddess Flora has particular significance for Florence (Firenze) – the "City of Flowers"

La Primavera

Medium tempera on panel Dimensions 203 x 314 cm (80 x 123 in) Location Florence: Galleria degli Uffizi

Botticelli perfected a style in which crisp line was paramount. The intertwined hands, intricate drapery folds, and flowing hair of the Three Graces displays his skill to the full. Their pointed faces, long necks, sloping shoulders, curving bellies, and slender ankles embody the ideal of feminine beauty in Renaissance Florence.

The blue, winged figure is one of Botticelli's most imaginative inventions. It is the ghostly Zephyrus, God of the West Wind and herald of Venus. He is pursuing his lover, Chloris.

Behind Flora, Botticelli shows her courtship with Zephyrus. When Zephyrus fell in love with Chloris, he pursued the startled nymph and took her as his bride, transforming her into the goddess Flora. Botticelli ingeniously, if somewhat artificially, shows how Flora emerged from the courtship

TECHNIQUES

Flora's gown is decorated with flowers that are slightly raised to imitate embroidery. Botticelli was fascinated by decoration and stylized pattern. Other examples are the "halo" of foliage that is silhouetted against the sky around Venus, and the carpet of flowers.

Piero della Francesca

⊖ 1420-92 🕫 ITALIAN

Sansepolcro; Florence; Arezzo; Urbino
 fresco; tempera; oils
 Borgo Sansepolcro:
 Museo Civico. Arezzo: San Francesco

One of the greatest masters of the early Renaissance. Acted as town councillor in his beloved native Sansepolcro; currently very much in fashion. Few works remain and many are severely damaged.

His religious works and portraits have special qualities of stillness and a dignified screnity resulting from deep Christian belief, and a humanist interest in man's independence and observation of the world. Had a passionate fascination with mathematics and perspective, which he used to construct geometrically exact spaces and strictly proportioned compositions. Loving, instinctive feel for light and colour.

His figures and faces are reserved, aloof and self-absorbed (a reflection of Piero's own slow, hard-working, intellectual character?). Was interested in new ideas and experiments as a means of reaching greater spiritual and scientific truths. Look for his ability to fill mathematical spaces with light; his meticulous mastery of technique (fresco, tempera, oil, and precise line). Nothing was left to chance - he recorded everything with total certainty and care. KEY WORKS Madonna della Misericordia, c.1445 (Borgo Sansepolcro: Museo Civico); The Story of the True Cross, c.1452-57 (Arezzo: San Francesco); The Baptism of Christ, 1450s (London: National Gallery); The Flagellation of Christ, c.1460s (Urbino: Galleria Nazionale delle Marche)

Resurrection of Christ Piero della Francesca, c.1463, 225 x 205 cm (89 x 81 in), fresco, Borgo Sansepolero: Museo Civico. The painting was commissioned for a place in Italy called "Town of the Holy Sepulchre".

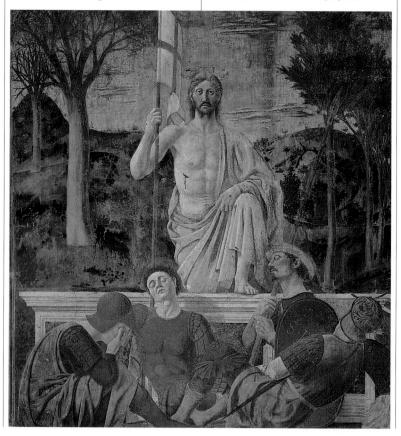

⊖ 1435-95 🕫 ITALIAN

 ☑ Sansepolcro; Siena ☑ tempera; oils ☑ London: National Gallery
 ☑ \$88,780 in 1990, Madonna and Child with Holy Bishop, Young Martyr, and Two Angels (oils)

One of the most prolific and popular painters of the Sienese School. In contrast to contemporary Florentines, he had a rather awkward and traditional style. His work

shows the influence of modern ideas (perspective, foreshortening, movement, expression) uncomfortably combined with old-fashioned ones (gold grounds, figures placed one above the other, elaborate decoration). Look out for open mouths, flowing draperies; experiments with foreshortening. **KEY WORKS** *Christ Crowned*, c.1480–95 (London: National Gallery); *Saint Sebastian*, c.1480–95 (London: National Gallery); *The Crucifixian*, c.1490 (San Francisco: De Young Museum)

Vecchietta

 Italy
 ▲ tempera; fresco; illumination; sculpture

 Image: Signa: Palazzo Piccolomini
 ▲ \$152,497

 in 2000, St. James (polychrome wood)
 ■ \$152,497

He was an architect, painter, sculptor, goldsmith, and engineer. Also called by his birth-name, Lorenzo di Pietro (known by his nickname of "Vecchietta" from c.1442 onwards). Born and worked in Siena; influenced by Florentine art world. Far ahead of his peers in Siena in terms of understanding lighting and its painterly properties. Adept at working both in miniature and on a large scale. He also produced illuminated manuscripts, including the illuminations for Dante's Divine Comedy. In the 1430s, he was commissioned by Cardinal Branda Castiglione to paint a series of frescoes in Lombardy; he continued to paint frescoes for the rest of his career. In the 1450s, he met Donatello, who had a strong influence on his sculptural techniques.

Madonna and Child with Sts. Catherine and Christopher Matteo di Giovanni, 1470, 62 x 44 cm (23% x 17%in), panel, Moscow: Pushkin Museum. The artist's style is elecant. decorative, and linear.

Towards the end of his life, he designed, built, and decorated an ornate burial chapel for himself and his wife Francesca inside Santa Maria della Scala, in Siena. Look for Vecchietta's precise brushwork, densely

populated scenes in his frescoes, an understanding of foreshortening, and forward-thinking lighting techniques. His figures are always realistically portrayed, with faces recreated without idealism; his works sometimes characterized by his self-portrait as one of the figures. His works also demonstrate his architectural training: look for intricately detailed buildings and architectural details in his paintings and sculptures. KEY WORKS Madonna and Child Enthroned with Saints, 1457 (Florence: Galleria degli Uffizi); Assumption of the Virgin, c.1461-62 (Pienza Cathedral); St. Catherine, c.1461-62 (Siena: Palazzo Pubblico); The Resurrection, 1472 (New York: Frick Collection); The Risen Christ, 1476 (Siena: Santa Maria della Scala)

Pope Pius II (1405–64) Crowned by Two Cardinals Vecchietta, 1458–64, tempera on panel, Siena: Palazzo Piccolomini. The use of foreshortening suggests the influence of Florentine art.

The Madonna of Humility adored by Leonello d'Este Jacopo Bellini, 1407–50, 60 x 40 cm (23%x 15% in), oil on panel, Paris: Musée du Louvre. The figure on the left is the

donor who commissioned the painting.

Jacopo **Bellini**

⊖ c.1400-70 PU ITALIAN

Florence; Venice I tempera;
 oils Paris: Musée du Louvre.
 London: British Museum (sketchbooks) \$\$ \$67,185 in 1998,
 Santa Lucia (oils)

Not much is known about him. Very little of his work survives other than sketchbooks. Progressive – was interested in latest artistic developments such as perspective, landscape, and architecture. **KEY WORKS** Madonna and Child, 1448 (Milan: Pinacoteca di Brera); Sketchbooks, c. 1450 (London: British Museum/Paris: Musée du Louvre); Madonna and Child Blessing, 1455 (Venice: Gallerie dell'Accademia); Saint Anthony Abbot and Saint Bernardino of Siena, 1459–60 (Washington DC: National Gallery of Art)

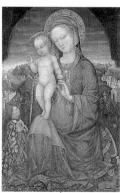

Gentile Bellini

Sender Disk, leinpera Sessarion attended by two brothers of the Scuola della Carità in Prayer with the Bessarion Religuary (oils)

He was Giovanni's brother. Much respected in his own lifetime. He was noted especially for panoramic views of his native Venice, peopled with crowds and

processions; thus established a subject and tradition that reached its apogee in Canaletto. Many works have perished. **KEY WORKS** Portrait of Doge Giovanni Mocenigo, c.1480 (Venice: Museo Correr); Sultan Mohammed II, c.1480 (London: National Gallery); Miracle at Ponte di Lorenzo, 1500 (Venice: Gallerie dell'Accademia)

Procession in St. Mark's Square Gentile Bellini, 1496, 367 x 745 cm (144/x 239% in), oil on carvas, Venice: Gallerie dell'Accademia. One of a series of nine Venetian paintings showing the Miracles of the Cross.

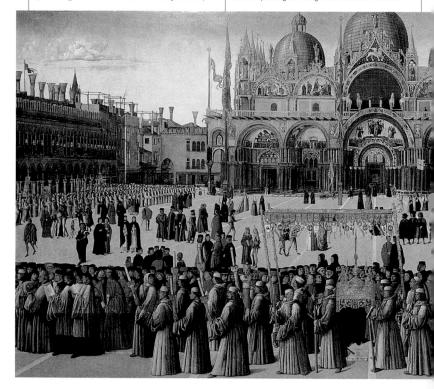

Giovanni **Bellini**

● c.1430-1516
 ▶ ITALIAN
 № Venice
 ▲ oils; tempera
 ▲ Venice: Accademia and various churches
 ▶ \$1,237,500 in 1996, Virgin and Child with Male Donor, Landscape Beyond (oils)

One of the supreme masters of the early Renaissance and the Father of Venetian painting. The best known of a distinguished

family of painters. Among the first to exploit oil-painting technique in Venice.

Known for his altarpieces, portraits, and, above all, the depiction of light – beautifully and carefully observed, lovingly and accurately recorded, and always warm. His work sings of the harmonious relationship that should exist between man, nature, and God. The profound mood and spirituality of his religious pictures results from his belief in God's presence in light and nature.

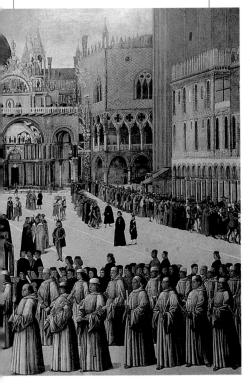

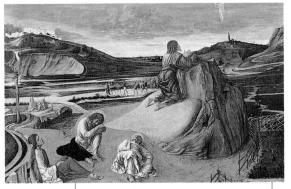

Agony in the Garden Giovanni Bellini, c. 1460, 81 x 127 cm (32 x 50 in), tempera on wood, London: National Gallery. The painting shows Bellini's sensitive gift for understanding and representing light, as well as a keen awareness of figures in space.

His figures respond to light and often turn their faces and bodies towards it, in order to enjoy its physical and spiritual benefits. Is he the first painter who really looked at clouds and studied their structure and formation? Notice his love of detail in rocks, leaves, architecture, and rich

> materials such as silks. Note how his style becomes softer as he gets older (a natural trait in most humans?). No outlines, just gradations of tone.

Bellini's influence on Venetian painting was enormous. He was appointed offical painter to the republic in 1483, and almost all of Venice's eminent painters during the next generation are believed to have trained in his workshop. **KEY WORKS** St. Francis in the Wilderness. c.1480 (New York: Frick Collection); Barbarigo Altarpiece, 1488, (Murano: San Pietro Martire); The Madonna of the Meadow, c.1501 (London: National Gallery); The Doge Leonardo Loredan, 1501-04 (London: National Gallery); San Zaccaria Altarpiece, 1505 (Venice: San Zaccaria)

> "Giovanni Bellini is very old but still the best of all ..." ALBRECHT DÜRER, 1506

104

Antonello da Messina

⊖ c.1430-79 № ITALIAN

 ☑ Messina; Naples; Milan; Venice ☑ oils; tempera ☑ London: National Gallery. Paris: Musée du Louvre ☑ \$367,400 in 2003, Madonna and Child with a Franciscan Monk. Ecce Homo in a trompe l'oeil (oils)

He was from Messina, Sicily. Made a key visit to Venice in 1475–76. One of the pioneers of oil painting in Italy.

He combined Italian interests (sculptural modelling, rational space, and man-themeasure-of-all-things characterization) with northern European obsessions (minute detail and unadorned reality). He had a marvellous ability to observe and paint light, and created wonderful portraits and faces that seem to live and breathe, showing bones under the skin and an intelligence behind the eyes that looks and answers back. Sense that he shines both an intellectual and a physical spotlight on his subjects.

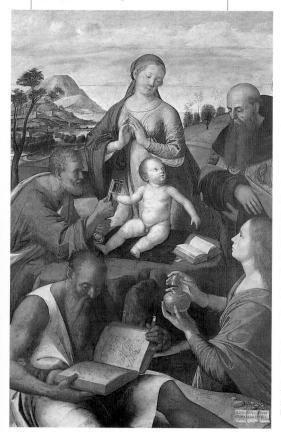

"Once this new secret that Antonello had brought from Flanders into the city of Milan had been understood, Antonello was admired and cherished by those magnificent noblemen for as long as he lived."

He had a wonderful ability to recreate the appearance and feel of the skin – differentiating between lips, a stubbly or shaven chin, a hairless check – eyebrows, hair, the liquid surface of an eye (can only be done with oil paint and requires supreme technical mastery). Oil-paint equation: learns technique from northern artists in Naples and hands it on to clever

> Venetians, such as Bellini. It is very likely that he used a magnifying glass – and it is worth using one when looking at his paintings.

> KEY WORKS Christ Blessing, 1465 (London: National Gallery); Virgin Annunciate, c.1465 (Palermo: Galleria Nazionale); Portrait of a Man, c.1475 (London: National Gallery); St. Jerome in his Study, c.1475 (London: National Gallery)

Vivarini family

ACTIVE 15™ CENTURY
 ITALIAN
 Venice
 Oils; tempera
 London: National Gallery
 \$130,000 in 1990, Head of St.
Francis (oils) by Antonio Vivarini

They were a Venetian family. Antonio (c.1415–84) and his younger brother, Bartolomeo (c.1432–c.1499) created

Madonna and Child with Sts. Peter, Jerome, and Mary Magdalene with a Bishop Alvise

Vivarini, 1500, oil on panel, Amiens (France): Musée de Picardie. Notice the way in which the baby Jesus is set in the absolute centre of the painting, his pale skin drawing the eye towards him.

Monument to Doge Pietro Mocenigo Pietro Lombardo, 1476–81, Istrian stone and marble, Venice: SS. Giovanni e Paolo. As part of the tomb of Pietro Mocenigo, this intricate monument features 15 life-size marble figures.

old-fashioned, large polyptych altarpieces with stiff figures and elaborate carved frames. Antonio's son, Alvise (c.1445–1505) produced more modern work in the style of Bellini. Good example of traditional craftsmen's business producing work to please conservative clientele.

KEY WORKS The Madonna with the Blessed Child, c.1440 (Venice: Gallerie dell'Accademia); Sts. Francis and Mark, 1440–46 (London: National Gallery)

Lombardo family

⊖ 15TH – 16TH CENTURIES
 P
 ITALIAN

■ Italy ■ sculpture ■ St. Petersburg: Hermitage Museum. New York: Metropolitan Museum of Art

Pietro Lombardo (c.1435-1515), architect and sculptor, worked in several Italian cities before moving to Venice, c.1467. He set up a workshop, employing large numbers of apprentices. His sculptor sons, Tullio (c.1455-1532) and Antonio (c.1458-1516), were among his pupils. Pietro was instrumental in bringing the Renaissance to Venice, reworking Florentine ideas about Classical antiquity into a Venetian ideal. His most famous work was rebuilding the Doge's palace (1498). By the 1480s, Tullio and Antonio were recognized as sculptors in their own right, often commissioned for tomb sculptures and religious pieces. Tullio collected Classical statues and is noted for poetic portraits like reliefs inspired by Roman grave portraits. Both of them worked for the courts of Northern Italy (see page 106). Pietro's grandsons continued as architects and sculptors well into the 16th century.

KEY WORKS *Adam*, Tullio Lombardo, c.1493 (New York: Metropolitan Museum); *Monument to Andrea Vendramin*, Pietro & Tullio Lombardo, c.1493 (Venice: SS. Giovanni e Paolo)

Carlo **Crivelli**

 ACTIVE 1457 - 93 № ITALIAN
 Wenice; Marche Region (Italy); Croatia 1 tempera
 London: National Gallery. Milan: Pinacoteca di Brera
 \$840,000 in 1988, Madonna and Child at a Marble Parapet (oils)

> He was an average Venetian artist with a self-conscious, old-fashioned style.

> Crivelli's work shows an extraordinary and obsessive attention to detail, a system that virtually overwhelms everything else. His strange, hard, dry, linear

strange, hard, and, and, and style makes the figures look real but unreal (a bit like biological specimens); similarly with the architecture, his buildings look like painted stage sets rather than the real thing.

Note the lined faces with bags under the eyes and bulging veins on hands and feet. The real yet unreal-looking fruit and garlands, which have complicated symbolic meanings, resemble marzipan cake decorations.

KEY WORKS Madonna and Child Enthroned with Donor, c.1470 (Washington DC: National Gallery of Art); St. Michael, c.1476 (London: National Gallery)

The Annunciation with St. Emidius Carlo Crivelli, 1486, 207 x 146.5 cm (81½ x 57½ in), tempera and oil on canvas, London: National Gallery. Painted for the Annunciation Church at Ascoli Piceno, Italy.

THE COURTS OF NORTHERN ITALY

During the Renaissance, being an artist could be a lucrative career. Most artists worked solely for commission and survived through patronage of the aristocratic courts. Italy was divided into city states or principalities and almost every city, large or small, had a system of artistic patronage. Among the most important of the large cities north of Florence were Mantua and Urbino.

In Mantua, the ruling family were called Gonzaga (prominent from the 14th to 17th centuries). Their court artists included Andrea

It has been suggested that Piero della Francesca, court painter to the 1st Duke of Urbino, partially designed the Palace at Urbino. Mantegna and the Lombardi. Urbino came to artistic prominence in the 15th and 16th centuries, soon outshining the earlier established courts. With the naming of Federigo da Montefeltro (1422–82) as the 1st Duke of Urbino, the region became a centre for artistic excellence. The Duke showed a partiality for Flemish art, but his most famous court painter was a fellow Italian, Piero della Francesca.

Ercole de' Roberti

⊖ c.1450-96 PU ITALIAN

 Ferrara; Bologna
 tempera
 Milan:
 Pinacoteca di Brera (for the Madonna Enthroned with Saints altarpiece, 1480)

His most famous post was as court painter to the d'Este family in Ferrara. Shadowy figure, with very few works firmly attributed to him.

Look for meticulous, fine detail and poetic sensibility; the careful placing

of figures in space – well-proportioned with good movement. He was interested in perspective, architectural details, and the way buildings are constructed. **KEY WORKS** *St. Jerome in the Wilderness*, c.1470 (Los Angeles: J. Paul Getty Museum); *St. John the Baptist*, c.1478–80 (Berlin: Dahlem Museum); *The Wife of Hasdrubal* and *Her Children*, c.1480–90 (Washington DC: National Gallery of Art)

Cima da Conegliano

♀ c.1459−c.1517 № ITALIAN W Venice Ø oils M London: National

Gallery 🔀 \$84,948 in 1992, Madonna and Child in Landscape (oils)

He was a successful but minor Venetian,

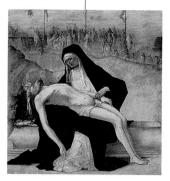

content just to follow others. "The poor man's Bellini" – similar use of light, but harder and less subtle. Works best on a small scale, when his crispness comes

Pietà Ercole de' Roberti, c. 1490–96, 34.4 x 31.3 cm (13½ x 12½ in), oil and tempera on panel, Liverpool: Walker Art Gallery. An altarpiece predella. to the fore. Good light; satisfying blue mountains; intense faces; general air of busyness; slightly comical, frozen poses (as when a photographer says "hold it"). **KEY WORKS** *Madonna with the Orange Tree*, 1487–88 (Venice: Gallerie dell'Accademia); *The Annunciation*, 1495 (St. Petersburg: Hermitage Museum); *Virgin and Child*, c.1505 (London: National Gallery)

Andrea Mantegna

€ 1431-1506 № ITALIAN

 Image: Padua; Mantua; Rome
 Image: Padua; Padua

He was a precocious, highly individual master of the early Renaissance who worked for the dukes of Gonzaga at Mantua. An austere intellectual.

Mantegna's panel paintings are highly individual interpretations of standard Renaissance subjects such as altarpieces and portraits. He had a dry, scholarly style, which became obsessed with detail, especially when it came to the archaeology of classical antiquity and geology (but scholars do get obsessed by minutiae). His frescoes are wonderful large-scale schemes for churches and villas. Pioneering printmaker – with superb engraving technique, which suited his style perfectly.

Notice the extraordinary outcrops of rock and the way he could make everything (even human flesh) look like carved stone (late monochrome works consciously look like bas-relief sculpture). Stunning mastery of scientific perspective and foreshortening – seen at its most impressive (in situ) in his large, decorative schemes, which are more relaxed than the panel paintings.

KEY WORKS *St. James Led to His Execution*, c.1455 (Padua: Ovetari Chapel, Church of the Eremitani); *St. Sebastian*, c.1455–60 (Vienna: Kunsthistorisches Museum)

The Dead Christ Andrea Mantegna, 1480s, 68 x 81 cm (26% x 31%), oil on canvas, Milan: Pinacoteca di Brera. Mantegna's first teacher (Squarcione) criticized his work for "resembling ancient statues... rather than living creatures". The just reply is that his figures resemble both.

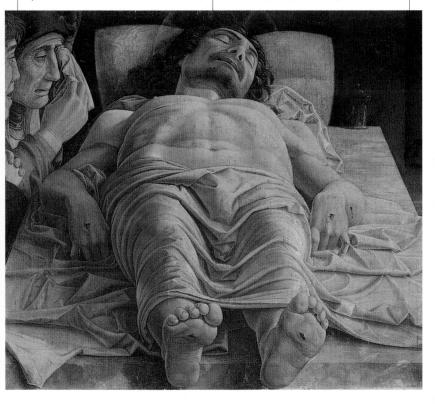

THE NORTHERN RENAISSANCE

At the same time that the Renaissance was emerging in Italy, an equally significant artistic flowering was occurring in the Low Countries. Art in northern Europe was not "re-born" in the sense of rediscovering an Antique past. But it was crucially reinvigorated, above all by the development and almost immediate maturity of a new medium: oil painting.

STYLE

Oil painting was not the only important innovation introduced in the Low Countries. Of almost equal significance was easel painting. The notion, still prevalent today, of paintings as self-contained, independent of their settings, was being born. The combination was revolutionary. Unlike tempera and fresco, oil dries slowly, allowing precise reworkings; it can be applied in tiny increments before drying to a hard, brilliant finish. Painted onto durable and largely non-absorbent woods such as oak, the result is highly detailed and lustrously jewel-like. As early as the 1430s, painters such as van Eyck had developed a form of linear perspective the equal of that devised in Italy, but arrived at pragmatically rather than theoretically. It was augmented by aerial perspective, the gradual softening of colours to suggest more distant objects.

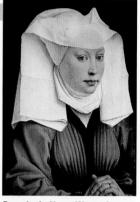

Portrait of a Young Woman in a Pinned Hat Rogier van der Weyden, c.1435, 47 x 32 cm (18½ x 12¾ in), oil on oak, Berlin: Gemäldegalerie.

SUBJECTS

Religious subjects dominate the art of the period, but they are always given an earthly, hard-edged precision. There is no lack of opulence – in draperies, settings, or landscapes – but where

the Italian Renaissance is characterized by unworldly idealism, northern European painting of the same date has an almost unnervingly clear-eyed and dispassionate directness.

St. Jerome in a Rocky Landscape Joachim Patenier, 1515–24, 36 x 34 cm (141% x 131% in), oil on oak, London: National Gallery. Patenier, later widely imitated, was the first painter to make landscapes his principal subject.

KEY EVENTS

1432	Completion of van Eyck's monumental Ghent Altarpiece
1450	Presumed visit by Roger van der Weyden to Rome and Florence
1456	Van Eyck's spreading fame is confirmed by Neapolitan account of his achievements
1475	Hugo van der Goes's <i>Portinari Altarpiece</i> (see page 116) despatched to Florence

c.1420-1520

WHAT TO LOOK FOR

Figures seem always to have been painted from life. There is a growing stress on domestic detail. This may frequently be loaded with allegorical or other allusive meanings, but the sense that everyday objects – and by extension everyday life – are worthy of being precisely rendered for their own sake is central. In this work, van Eyck piles detail upon detail to create an entirely believable world.

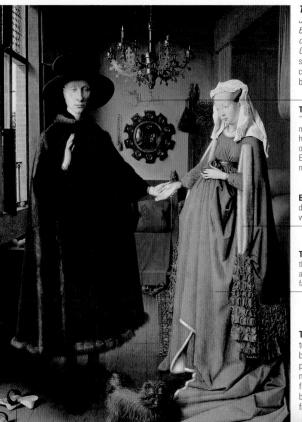

The Arnolfini Portrait Jan van Evck. 1434, 82 x

Gall eyck, 1434, *B2 x* 60 cm (32 x 23 in), oil on oak, London: National *Gallery*. The work's exact subject, though it clearly concerns a wedding or betrothal, is unknown.

The Latin text reads: "Van Eyck was here." It may mean he was a witness or he was "here" in the sense of creating the painting. Either way, it underlines the new status claimed by artists

Both figures are very richly dressed, a statement of wealth and social status

The bride is in green, the colour of fertility. Is she already pregnant or merely fashionably attired?

The convex mirror is a technical triumph. Window, bed, ceiling, and the two principals are shown from new angles, and two other figures are visible. The border shows ten scenes from the life of Christ.

Neither figure wears shoes, an indication that they are on sacred ground

TECHNIQUES

Van Eyck's use of oil allowed him to achieve an extraordinary level of detail. Every object in the painting is depicted with the same concentrated clarity. **The dog** may be a symbol of fidelity or lust. The bed is similarly suggestive

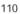

Jan van Eyck

⊖ c.1390-1441 P NETHERLANDISH

He was an artist-cum-diplomat in service of Philip the Good, Duke of Burgundy. Obscure origins. Only known work is from 1430s onwards. Key exponent of Netherlandish art and oil painting.

He was the first painter to portray the merchant class and bourgeoisie. His work reflects their priorities, such as having their portraits painted; taking themselves **A Man in a Turban** Jan van Eyck, 1433, 25.5 x 19 cm (10 x 7X in), oil on oak, London: National Gallery. The detailed depiction of the headdress and the way it sits on the head suggest that it may have been studied separately.

seriously (as donors of altarpieces, for example); art as the imitation of nature; art as evidence of painstaking work and of craftsmanship; prosperity and tidiness; wariness; restrained emotion. He had a brilliant oil-painting technique, which he was the first to perfect – luminous, glowing colours, and minute detail.

His three-quarter pose of face brought new realism to portraiture. He painted Madonnas that look like housewives, and

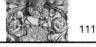

saints that look like businessmen. Notice his precise delineation of all facial features, especially the eyes. He was fascinated with ears (they are miniature portraits) and by folds and creases in cloth. Also note the fall of light that unifies the objects and models them. Convincing but empirical perspective. Inscriptions on paintings and rich symbolism. **KEY WORKS** *The Annunciation*, c.1425–30 (Washington DC: National Gallery of Art); *Ghent Altarpiece (The Adoration of the Lamb)*, 1432 (Ghent: St. Bavo's Cathedral); *The Arnolfini Marriage*; 1434 (London: National Gallery)

Robert **Campin** (Master of Flemalle)

€ c.1378-1444 POINETHERLANDISH

Tournai (Belgium)oilsLondon: National Gallery

A shadowy figure whose identity is difficult to pin down. Attributions are rare and speculative. One of the founders of the Netherlandish School.

His devotional altarpieces and portraits are painted with the concentrated intensity that you get in a diminishing mirror (do visual intensity and detail equal spiritual intensity and commitment?). Virgin and Christ child are shown as down-to-earth people in everyday settings – not idealized, but presented in a way that creates a fascinating three-way tension between realism, symbolism, and distortion, which Campin is able to manipulate with the greatest subtlety.

Notice his acute powers of observation, especially in the way things (such as window shutters) are made, how light catches a corner, how drapery falls, or flames look. Uses light to isolate objects. The odd perspective is worked out experimentally, not scientifically. Use a magnifying glass to examine the extraordinarily fine detail; don't forget to look out of his windows at what is happening in the street. Objects and details usually contain or imply much complex symbolism.

KEY WORKS Entombment, c.1420 (Private Collection); A Woman, c.1430 (London: National Gallery); The Virgin and Child before a Firescreen, c.1430 (London: National Gallery); St. Barbara, 1438 (Madrid: Museo del Prado)

Rogier van der Weyden

⊖ c.1399–1464 PU NETHERLANDISH

C.1300-1500

 Tournai (Belgium); Brussels 1 oils
 Madrid: Museo del Prado; Escorial. Berlin: Staatliche Museum 2 \$71,442 in 1938, Dream of Pope Sergius (oils)

The greatest and most influential northern painter of his day. Set the standard by which the rest are judged. Brussels-based. Worked for the dukes of Burgundy. Had a large workshop and was much imitated.

Look for the presence of Christ in contemporary life and powerful tension between reality and unreality. The meticulous detail of cloths, clothes, fingernails, and hair; faces drawn from life; anecdotal detail create an illusion of reality. But the stiff poses, cramped spaces, and static expressions are wholly unreal. Is it this tension that draws the eye so magnetically into the drama and the serious aspiration of the religious message (itself an interplay of the real and unreal)?

"Van Eyck's eye was at one and the same time a microscope and a telescope."

ERWIN PANOFSKY

Note also his superb portraits, each with minute, natural individuality - especially the fingernails, knuckles, red-rimmed eves, and stitches on clothing. He was also fascinated by architectural and sculptural detail. See how he uses facial expression and poses that are appropriate to the emotion expressed, showing tearstreaked faces and an understanding of grief; observe how one figure echoes the poses and gestures of another, as if in emotional sympathy. He adopted a softer, more relaxed style after 1450 (Italian influence after visit to Rome). **KEY WORKS** St. Luke Drawing the Virgin, 15th century (St. Petersburg: Hermitage Museum); Descent from the Cross, c.1435 (Madrid: Museo del Prado); Triptych: The Crucifixion, c.1440 (Vienna: Kunsthistorisches Museum); Francesco d'Este, c.1455 (New York: Metropolitan Museum of Art); Portrait of a Lady, c.1455 (Washington DC: National Gallery of Art)

The Deposition

Rogier van der Weyden c.1435-40

This altarpiece is a masterpiece of early Netherlandish painting. The northern European artists brought an intensity of emotional expression and a minuteness of realistic detail to their work, which give it a quite different character and appearance to that of their Italian counterparts. This painting is the central panel of a triptych.

Many northern altarpieces at this time were made with carved wooden figures set in shallow box-like spaces. Van der Weyden seems to have accepted this convention, but through the new medium and technique of oil painting he has brought the figures to life.

The artist heightens the sense of tension by forcing the eye and mind to reconcile conflicting qualities. Much of the painting detail is intensely realistic, such as the red-rimmed eyes and the tears on the faces. This conflicts with the highly unnatural composition in which the almost life-size figures are hunched and packed into a narrow space beneath a tiny crucifix. The shrine-like background shown in the painting concentrates the viewer's attention on the figures and avoids the distractions of a true-to-life setting.

Set against a plain gold background, *The Deposition* has an overriding sense of dramatic power about it. Van der Weyden was a master of depicting human emotion, and his religious painting reflects the strength of his personal conviction. His work had a profound effect on the course of art throughout Europe.

The Deposition

Medium oil on panel Dimensions 220 x 262 cm (86% x 103% in) Location Madrid: Museo del Prado

The skull represents Adam, who is thus symbolically present. Adam was cast out of Paradise after eating the forbidden fruit. Christ sacrificed himself on the cross to redeem the world from Adam's original sin.

Mary, wife of the disciple Cleopas – she was supposedly present at the Crucifixion St. John the Evangelist stoops to comfort Mary, Christ's Mother, who swoons with grief

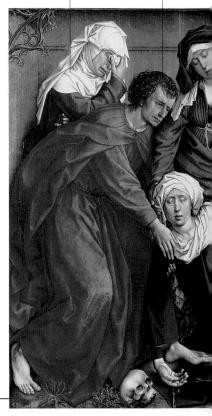

TECHNIQUES

Notice the intriguing conflict between the deep emotion of the picture and the artist's ability to look at an area such as the cloak of Nicodemus and record every detail with dispassionate objectivity.

Joseph of Arimathea, holding Christ's corpse,

was permitted to take the body down from the cross and lay it to rest

Van der Weyden was a celebrated portrait painter. The expressions of grief are highly individual. The face of St. John, for example, is grave yet restrained as he struggles to control his emotions.

Trickles of blood and marbled flesh tones of the dead Christ are contrasted with the white of the linen

A follower of Christ holds a jar of ointment – the attribute of St. Mary Magdalene, who appears inconsolably anguished

and any

inconsolably angui

Dieric Bouts

⊖ c.1415-78 P NETHERLANDISH

■ Louvain (Belgium) ■ oils in 1980, *The Resurrection* (oils)

Also known as Dirk Bouts. Possibly a pupil of Rogier van der Weyden. Very little is known about him and few attributable works exist. He created altarpieces, narrative scenes, and portraits. Solemn, restrained paintings with beautifully observed detail and painstaking craftsmanship. His static figures are exaggeratedly slender and graceful, and often set in landscapes of exquisite beauty. Lovely details of rocky backgrounds and shimmering light. KEY WORKS The Annunciation, 1445 (Madrid: Museo del Prado); Portrait of a Man, 1462 (London: National Gallery); Justice of the Emperor Otto, 1470-75 (Bruges: Musées Royaux des Beaux-Arts)

Hell Dieric Bouts, 1450, 115 x 69.5 cm (45½ x 27½ in), oil on wood, Lille: Musée des Beaux-Arts. This work was mistakenly believed to be part of a documented but destroyed triptych by Bouts of the Last Judgement. The panel is one of a pair displayed in the Musée des Beaux-Arts; the other depicts Paradise.

Portrait of a Man Hans Memling, 1480s, 33 x 25 cm (13 x 9½ in), oil on wood, Florence: Galleria degli Uffizi. Memling's gentle and occasionally sentimental style made him a popular acquisition for 19th-century collectors.

Hans Memling

⊖ c.1430-94	PO FLEMISH	
🛛 Bruges	🖉 oils 🛍 Bruges: Memling	
Museum 🎾	\$265,200 in 1992, The Virgin	
and Child Ent	throned with Two Angels (oils)	

Also known as Hans Memlinc. A prolific, Bruges-based successor to van der Weyden, from whom he borrowed a repertoire of motifs and compositions.

His large altarpieces are rather too rigid, with stiff figures like statues. He was better at small devotional pictures (full of life, with good space) and small portraits (he learned from manuscript illuminations). Liked soft textures (his drapery has soft, not crisp, folds); soft hair; soft landscapes and smooth, rounded, demure, idealized faces. Decorative, rather than intense, style.

Look out for his interesting skies of intense blue, melting to white on the horizon; clouds like chiffon veils; small, almost unnoticeable birds; pronounced eyelids. His motifs such as garlands of fruit and flowers held by putti are borrowed from the Italian Renaissance (from Mantegna?).

KEY WORKS Portrait of a Man with an Arrow, c.1470–75 (Washington DC: National Gallery of Art); The Virgin and Child with an Angel, c.1470–80 (London: National Gallery); Bathsheba, c.1482 (Stuttgart: Staatsgalerie)

 $C\,.\,1\,\,3\,\,0\,\,0\,-\,1\,\,5\,\,0\,\,0$

Petrus Christus

⊖ ACTIVE 1444-72/3 PU FLEMISH

■ Bruges ● oils ■ Bruges: Musées Royaux des Beaux-Arts ● \$182,400 in 1995, *The Virgin and Child* (oils)

He was a major painter from Bruges, follower of van Eyck, and influenced by van der Weyden. Underrated.

His intimate, small-scale religious works and portraits are organized and painted with meticulous detail. Note especially his interest in space and light: liked deep space; placed figures in the corners of rooms to suggest both space and intimacy. He was the first northern painter to understand and use Italian single-point perspective.

Robes have elaborate, crisp drapery, with folds arranged decoratively, often flipped back to show a lining or undergarment in contrasting colour, sometimes brightly outlined. Note how Christus uses brownish rather than pink flesh tones and favours red and green colour schemes.

He organized broad areas of tone and filled in on top with meticulous detail, which makes cleaning and restoration especially risky.

KEY WORKS The Man of Sorrows, mid-15th century (Birmingham, UK: Museums and Art Gallery); Edward Grimston, 1446 (London: National Gallery); The Last Judgement, 1452 (Berlin: Staatliche Museum); Virgin and Child with Sts. Jerome and Francis, 1457 (Frankfurt: Städelsches Kunstinstitut); A Young Lady, c.1470 (Berlin: Staatliche Museum)

Jan Provost

⊖ c.1465-1529 PU FLEMISH

Valenciennes (France); Antwerp; Bruges
 oils
 \$380,000 in 1990, The Nativity (oils)

He was a major original early-northern Renaissance painter – pre-Italian influences. Met Dürer in 1521; follower of Massys. Painter of altarpieces, with figures that are lifelike (for the time). Look for his precise drawing (he trained as a miniaturist); delicate modelling; good colour; long fingers bent at second joint; tender faces with wide cheeks and prominent lower lip; airy landscapes. **KEY WORKS** *The Crucifixion*, c.1495 (New York: Metropolitan Museum of Art); *A Christian Allegory*, c.1500 (Paris: Musée du Louvre); *The Virgin in Glory*, 1524 (St. Petersburg: Hermitage Museum); *The Last Judgement*, 1525 (Bruges: Municipal Museums)

The Money Lender and his Wife Quentin Massys, 1514, 74 x 68 cm (29½ x 26½ in), oil on panel, Paris: Musée du Louvre. The painting's attention to meticulous detail forms a clear and satisfying artistic parallel with the couple's evident obsession with material possessions.

Quentin Massys

⊖ c.1466-1530 PC FLEMISH

Antwerp; Italy
 Oils
 Courtauld Institute of Art
 S403,200
 in 1988, *The Virgin at Prayer* (oils)

Also known as Quentin Metsys. Important painter of unknown origins. Brought Italian refinement to northern realist tradition (visited Italy; admired Leonardo's way with soft light and his interest in the contrast between ugliness and beauty). Best known for animated portraits of tax collectors, bankers, merchants, and wives, with understated satire (the influence of Erasmus, whom he met?). Opulent details. **KEY WORKS** *St. Anne*, 1507–09 (Bruges: Musées Royaux des Beaux-Arts); *Portrait of a Canon*, c.1515 (Private Collection); *The Adoration of the Magi*, 1526 (New York: Metropolitan Museum of Art)

116

Hugo van der Goes

 Image: Construction of the second second

He was an obscure genius about whom little is known (spent his last years in a monastery, going mad). Only work known for certain to be by him is the *Portinari Altarpiece* (c.1475), which was commissioned for a chapel in Florence and introduced Italian artists to new ideas and techniques they had never seen before: oil paint, fine natural detail, and different symbolism.

The *Portinari Altarpiece* is of an unusually large scale for a Netherlandish painting (commissioned to be standard size of Italian triptych); there are Portinari men (members of a prosperous Florentine mercantile family) in the left panel, women in the right (each with patron saints); the composite central panel has Virgin and Child (naked child on floor is a northern idea), Joseph and shepherds (an Italian idea); the Magi are at the back of the right panel.

The kneeling man (right panel) is Tomasso Portinari (agent in Bruges for the Medici bank – he was reckless and the bank was closed). The kneeling woman (right panel) is his wife, Maria. The men look troubled; the women have fashionably high foreheads and pale faces. The very wobbly space and odd

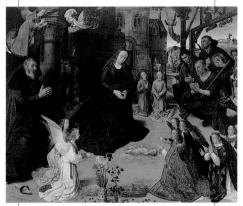

The Adoration of the Shepherds Hugo van der Goes, c.1476, 254 x 305 cm (100 x 120 in), oil on panel, Florence: Galleria degli Uffizi. The centre panel from the Portinari Altarpiece.

changes of scale in the central panel perhaps suggest the artist was in difficulty with such a large-scale work? Much symbolism: scarlet lily as blood and passion of Christ; discarded shoe as holy ground; purple columbine as Virgin's sorrow, and so on.

KEY WORKS Death of our Lady, c.1470 (Bruges: Municipal Museums); The Fall of Man, c.1475 (Vienna: Kunsthistorisches Museum); Portrait of a Man, c.1475 (New York: Metropolitan Museum of Art); The Adoration of the Magi, 1470s (Bath, UK: Victoria Art Gallery)

Jan **Gossaert**

⊖ c.1478-c.1532 P FLEMISH

■ Netherlands; Rome ■ oils ■ London: National Gallery ■ \$1.5m in 1998, Madonna and Child Enthroned Accompanied by Six Music-making Angels (oils)

Also called Jan Mabuse. He had a crucial role in the development of Netherlandish painting by introducing Italianate ideas (albeit a bit derivative). From Mauberge in Hainault, hence the name Mabuse.

His work is a fascinating (sometimes uncomfortable) synthesis of: 1) northern skills and vision – acute observation; fine oil technique; clear, precise draughtsmanship à la Dürer; and 2) after visit to Rome in 1508–9, Italian aspirations – idealization of figures and faces; perspective; classical architecture and details; firm modelling, and subtle shading with light. Had a more

> conservative portrait style. **KEY WORKS** *Neptune and Amphitrite*, 1516 (Berlin: Staatliche Museum); *Adam and Eve*, c.1520 (London: National Gallery); *A Nobleman*, c.1525–28 (Berlin: Staatliche Museum)

Joachim Patenier

⊖ c.1480-c.1525 P FLEMISH

Antwerp
 Antwerp

Also known as Joachim Patinir. The first painter to make landscape the principal theme. His works

have a bird's-eye viewpoint, with improbably craggy inhabited mountains, blue distances with heavy clouds and

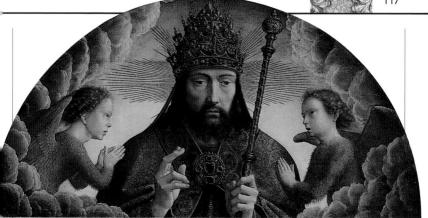

God the Father Blessing Gerrit David, 1506, 101 x 128 cm (39% x 50% in), oil on panel, Paris: Musée du Louvre. Gerrit David's work was neglected for centuries, and "rediscovered" in the second half of the 19th century.

cold seas, and tiny-scale hermits, holy families, sometimes with Christ tucked in somewhere – fantasy at its most endearing. High-quality, detailed technique. There are few attributed works, but he had many imitators. **KEY WORKS** *Rest on the Flight to Egypt*, c.1515 (Minnesota: Minneapolis Institute of Arts); *The Baptism of Christ*, c.1515 (Vienna: Kunsthistorisches Museum); *The Penitence of St. Jerome*, c.1518 (New York: Metropolitan Museum of Art)

Joos van Cleve

⊖ c.1490-1540 PU NETHERLANDISH

■ Antwerp; France ■ oils ■ \$350,000 in 1993, Christ on Cross with Mary, Mary Magdalen, and St. John the Evangelist (oils)

He was a popular, Antwerp-based painter of devotional altarpieces and portraits. Combined tradition (finely detailed northern technique, overloaded symbolism, stiffly posed figures and draperies) with progressive ideas (landscapes and rocky formations, Italian-style modelling with light, extravagant costumes, detailed surfaces). Note cosy, homely details. KEY WORKS Foris Vezeleer, c.1518 (Washington DC: National Gallery of Art); The Last Judgement, c.1520-25 (Minnesota: Minneapolis Institute of Arts); Virgin and Child with Angels, c.1520-25 (Liverpool: Walker Art Gallery); The Annunciation, c.1525 (New York: Metropolitan Museum of Art)

Gerrit **David**

● 1484–1523 P NETHERLANDISH

 Image: Antwerp
 Image: One of the original stress of the original stress of the origin feeding the Child from a Bowl of Soup (oils)

Also known as Gerard David. Last great Netherlandish painter in tradition of van Eyck's and van der Weyden's meticulous realism. Worked in Bruges and Antwerp.

David was a painter of altarpieces and portraits. He loved exact details of objects and faces. Had a conscious awareness and acknowledgement of the Netherlandish tradition in which he was placed (and that was coming to an end). Fascinated with landscape and townscape, placing figures naturally and at ease within them – his landscapes are especially fine. Spaces are open and relaxed, not crowded, which gives a feeling of calm, poise, and harmony with nature and God.

Notice how the Italian influence on his work increases progressively and inexorably, but never takes over completely; moves from love of particular detail to more generalized storytelling. Note the individualism of each tree with detailed leaves. His characters have modest, solemn, but seemingly expressionless, faces. Splendid, subtle, rich colours, harmoniously woven together. His paintings remind us that fine craftsmanship and skill are Godgiven talents, and that he worshipped God by exercising his.

KEY WORKS Christ Nailed to the Cross, c.1481 (London: National Gallery); The Annunciation, 1506 (New York: Metropolitan Museum of Art); A Rest during the Flight to Egypt, c.1510 (Madrid: Museo del Prado)

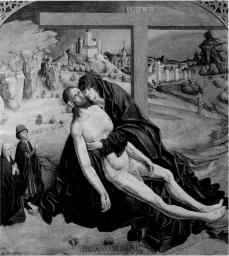

Pietà with Two Donors Fernando Gallego, c.1470, 118 x 122 cm (46½ x 48 in), tempera on panel, Madrid: Museo del Prado. Note the Northern influences: rigid poses, sorrowful expressions, and carefully depicted landscape.

Fernando Gallego

⊖ c.1440-c.1507/10 № SPANISH

Image: SpainImage: Oils; frescoImage: Oils; frescoImage: Oils; Musée duLouvreImage: Spain\$221,200 in 1989, Pentecost (oils)

His birth and death dates are shrouded in mystery, surprisingly for an artist whose importance was recognized in his own lifetime. Credited as the "master" of Castilian painting and at the centre of the Hispano–Flemish movement. Spent 14 years (1479–93) painting the ceiling in the Old Library at Salamanca University. Towards the end of his life, Gallego's palette changed from bright tones to muted shades, such as the use of a flat yellow instead of gold.

Look for paintings thick with symbols, figures with obviously Spanish features, and Gallego's use of realism, which is often uncomfortable. Strong use of gold and sumptuous draperies and jewellery. Markedly northern European in contrast to Italian paintings of the same era. **KEY WORKS** *The Virgin, St. Andrew, and St. Christopher,* c.1470 (Salamanca Cathedral, Spain); *San Idelfonso* (retable), c.1475–80 (Zamora Cathedral, Spain); *Epiphany,* c.1480–90 (Barcelona: Museu Nacional d'Art de Catalunya); *Pietà,* 1490 (Los Angeles: J. Paul Getty Museum); *Virgin and Child with Parrot,* 1468–1507 (Paris: Musée du Louvre)

"Art teaches us not only what to see, but what to be." BERNARD BERENSON

Pedro Berruguete

He was court painter to King Ferdinand and Queen Isabella. Strongly influenced by Italian Renaissance and Flemish art. Works include the decoration of the palace at Urbino. His art greatly influenced the Castilian style, even after his death. Taught his son, Alonso (c.1488-1561), to paint and sculpt. Alonso, whose style showed the influence of the early Italian Mannerists, became court painter to Charles V. KEY WORKS Virgin of the Milk (Virgen de la Leche), c.1465 (Museo de Bellas Artes de Valencia); St. Peter the Martyr, c.1494 (Madrid: Museo del Prado); Death of St. Peter the Martyr,

late 15th century (Madrid: Museo del Prado); St. Dominic Presiding over an Auto Da Fé, late 15th century (Madrid: Museo del Prado)

Jean Fouquet

⊖ c.1415-c.1481 PU FRANCE

France; Italy
 oils; illumination; chalks
 Chantilly (France): Musée Condé

Also spelt "Foucquet". He was master painter and illuminator allied to the royal court in Tours. One of the most important French painters of his time, although, sadly, little survives as testimony. Greatly influenced by Italian Renaissance. He was famed for bringing the Renaissance to France. Travelled to Italy c.1446-48. Lived and worked in Tours for the rest of his life. Married and had at least two sons (birth dates unknown). Appointed Peintre du Roi in 1475, a post he held until death. Had a large workshop which produced important illuminated manuscripts. The style of his illuminations drew richly on his Italian experiences; the local surroundings of Tours were inspiration.

KEY WORKS Portrait of the Ferrara Court Jester Gonella, c.1442 (Vienna: Kunsthistorisches Museum); Estienne Chevalier with St. Stephen, c.1450 (Berlin: Staatliche Museum); Self-Portrait, 1450 (Paris: Musée du Louvre); Hours of Simon de Varie; 1455 (Los Angeles: I. Paul Getty Museum)

Jean Bourdichon

● 1457-1521 P FRENCH

France i illumination; sculpture; oils
 Paris: Bibliothèque Nationale. Los Angeles:
 J. Paul Getty Museum

A prolific illuminator, painter, gold- and silversmith, and designer. Born, lived, and worked in Tours; appears never to have travelled abroad. Seemingly a diplomatic and jovial man, he was a great favourite with a long line of French royalty, from Louis XI to Francis I. Appointed Peintre du Roi in 1481. His wages from the royal court allowed him to become a wealthy landowner and ensured his family financial security. Had a workshop in the castle of Plessis-les-Tours and employed a large number of assistants. Little of his work is documented. Most renowned for illuminated manuscripts, of which his most famous work is the illuminated Grandes Heures for Queen Anne of Brittany. KEY WORKS Book of Hours, 1480 (Los Angeles: J. Paul Getty Museum); Visitation, 1480 (Los Angeles: J. Paul Getty Museum); Coronation of the Virgin, 1480 (Los Angeles: J. Paul Getty Museum)

Jean Hey

⊖ 15TH - 16TH CENTURIES PU UNKNOWN

France; Netherlands oils
 Paris: Musée du Louvre

Also known as Hay. A painter whose birth and death dates are a mystery, but his art is known around the last quarter of the 15th

century, when he was living in France. His name suggests he or his parents originated from the Netherlands or Belgium; his art

was greatly influenced by the Netherlandish style. In his lifetime he was respected and appears in the 1504 list of "Greatest Living Painters", compiled by Jean Lemaire de Belge. Another artist about whom very little is known today was nicknamed the "Master of Moulins"; some believe Hey and the Master were the same person, others are sceptical. KEY WORKS Margaret of Austria, c.1490 (New York: Metropolitan Museum of Art); The Virgin and Child Adored by Angels, c.1490 (Bruges: Musées Royaux des Beaux-Arts): Portrait presumed of Madeleine de Bourgogne presented by St. Madeleine, c.1490-95 (Paris: Musée du Louvre): Madonna with Saints and Donors, c.1498 (Moulins Cathedral); Charlemagne and the Meeting at the Golden Gate, c.1500 (London: National Gallery)

Anne of Brittany with St. Anne, St. Ursula, and St. Helen Jean Bourdichon, c. 1503–08, illumination on vellum, Paris: Bibliothèque Nationale. From the Grandes Heures of Anne of Brittany, Bourdichon's close-up technique placed large figures in the foreground.

Hieronymus Bosch

○ c.1450-1516
 P NETHERLANDISH
 Hertogenbosch (Netherlands)
 O oils
 Madrid: Museo del
 Prado
 \$62,300 in 1977,
 The Temptation of the Holy
 Antonius (oils)

Bosch is the last, and perhaps the greatest, of the medieval painters. Much admired in his lifetime, especially by ardent Catholics such as Philip II of Spain, who was an avid collector.

Best known for his complex, moralizing works, of which the central theme is the sinful depravity of man, human folly, deadly sin (notably lust), the seductive temptations of the flesh, and

the almost inevitable fate of eternal damnation (salvation is possible but only with the greatest difficulty). Like hellfire sermons, they are a complete contrast to the Renaissance view of man controlling a rational world. Also produced more conventional religious works.

Probably the greatest fantasy artist ever, his works show bewildering detail and unique imagery of part-animal, parthuman creatures; visions of depraved

The Garden of Earthly Delights:

Hell Hieronymus Bosch, c.1510–15, 219 x 96 cm (86/x X3/x), oil on panel, Madrić Museo del Prado. The right wing of a triptych, showing detailed scenes of anguish and humiliation against a backdrop of mayhem.

activity and torture. Not drug-induced but illustrations of ideas and images in wide circulation at the time. Brilliant rapid technique and luminous colour: flecked highlights and chalk underdrawing. Was influenced by ornate manuscript illumination. Acute, intricate intensity reflects his belief that he was depicting certainty and reality, not fantasy. Bosch had no real successor

until Bruegel (see page 157). **KEY WORKS** *Death and the Miser*, c.1485–90 (Washington DC: National Gallery of Art); *The Ship of Fools*, c.1490–1500 (Paris: Musée du Louvre); *Christ Mocked*, c.1490–1500 (London: National Gallery); *The Path of Life*, c.1500–02 (Paris: Musée du Louvre)

Triptych of the Temptation of St. Anthony

Hieronymus Bosch, c.1505, 132 x 120 cm (52 x 47 in), oil on panel, Brussels: Musées Royaux. St. Anthony of Egypt was tempted by demons and erotic visions.

$C\ .\ 1\ 3\ 0\ 0\ -\ 1\ 5\ 0\ 0$

Mathis Grünewald

⊖ c.1470-1528 № GERMAN

Mainz (Germany) Ø oils
 Colmar (France): Unterlinden
 Museum (*The Isenheim Altarpiece*)

Also known as Neithardt (after his adopted son, Andreas) or Gothardt. Obscure, austere, religious fanatic who painted works of powerful, spiritual intensity. Now regarded as one of the all-time great painters, but overlooked until the 20th century. Successful both as an artist and engineer. Worked for the Archbishop of Mainz. Died of the plague.

His overwhelming masterpiece – *The Isenheim Altarpiece* – is in Colmar, near Strasbourg. His altarpieces express his single-minded religious fervour (he became a Lutheran) but are full of visual contradictions and anachronisms, especially imagery lacking precedent or following. Little interest in "realism" or "modern" Renaissance ideas – his style has more in common with the medieval world and with 20th-century German Expressionism (which he influenced).

Grünewald distorted scale to convey emotion or significance. He used intense colours, ranging from pitch black to bright yellow, to express mood. His

distorted bodies and anguished hands and feet express inner torment or suffering. The settings range from the bare and almost abstract to the highly detailed. The demons come out of an imagined medieval hell and are mixed with faces or details that have the qualities of first-hand observation of the Italian Renaissance. **KEY WORKS** The Isenheim Altarpiece (see pages 122-123); The Small Crucifixion, c.1511-1520 (Washington DC: National Gallery of Art); Saints Erasmus and Maurice, c.1520-24 (Munich: Alte Pinakothek)

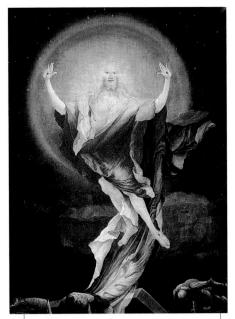

The Resurrection of Christ Mathis Grünewald, c.1512–16, oil on panel, Colmar (France): Unterlinden Museum. From the right wing of the many-panelled Isenheim Altarpiece, which was intended to give support to patients in Isenheim's Anthonite monastery hospital.

Tilman Riemenschneider

⊖ 1460-1531 🕫 GERMAN

☐ Germany ☑ sculpture ☑ \$420,000 in 1985, Young Woman with Long Hair and Wearing a Hat (sculpture)

Major figure in German art history. Renowned as the first sculptor in limewood who produced altarpieces finished in a monochrome brown glaze rather than multicoloured polychrome. His works are mainly religious: altarpieces, reliefs, busts, and life-size statues, characterized by strong Gothic symbolism and realistic carving. Successful in his own time, became very wealthy, owning land - including vineyards. Married three times; had five children. He lost his fortune in 1525 after backing the wrong side in a peasants' revolt against the Prince Bishop. KEY WORKS St. Jerome and the Lion, c.1490 (Ohio: Cleveland Museum of Art); Seated Bishop, 1495 (New York: Metropolitan Museum of Art); Virgin of the Annunciation, end of 15th century (Paris: Musée du Louvre); Holy Blood Altarpiece, c.1501 (Rothenburg: St. Jacob's Church)

Crucifixion (from The Isenheim Altarpiece)

Mathis Grünewald c.1510–15

Grünewald's altarpiece was commissioned as the focus of the high altar of the chapel in the monastery of St. Anthony, at Isenheim near Strasbourg. Plague was the killer disease of the time and the monastery also contained a hospice where plague victims were cared for by the monks of the Anthonite Order.

The victims had no hope of recovery, and this image was intended to bring them comfort and to reinforce their faith – the message is that Christ, whose broken body is shown covered in sores like those caused by the plague, understands their condition and suffers with them and for them.

The figures on the left, Christ's Mother, Mary, and St. John the Evangelist – whom Christ asks to take care of his Mother – are nearly always present in Crucifixion scenes and display extreme mental anguish as they witness Christ's agony. The plague victims who knelt before this altar would have been able to associate with this vision of earthly and human suffering.

In many Crucifixion scenes the crown of thoms is depicted almost as an ornament adoming the head of a serene, unblemished Christ figure. Here, it is unequivocally a cruel instrument of torture, which, along with his bleeding side and wrenched arms, intensifies the sense of Christ's suffering.

Crucifixion

Medium oil on panel

Dimensions 500 x 800 cm (198 x 312 in) Location Colmar (France): Unterlinden Museum The wooden cross strains to bear the weight of Christ, adding to the emotional tension and anguish of the scene

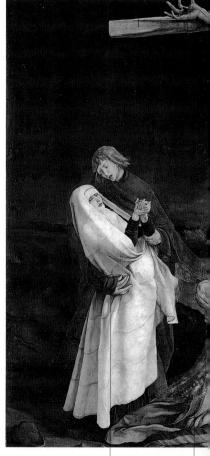

Christ's favourite disciple, St. John the Evangelist, comforts Mary, the Mother of Christ, who is dressed in symbolic white Mary Magdelene is the fallen woman who anointed Christ's feet

123

TECHNIQUES

1.11.17.1

Grünewald's work is charged with emotional intensity heightened by his sublime skill with colour. The illuminated saints at the base of the cross radiate their own mysterious light and the red of the two St. Johns' robes is almost incandescent.

Christ's hands express his intense physical and spiritual pain. Note the expressive hand gestures of all the other figures.

The size of the figures reflects their importance – Christ is the largest and Mary Magdelene is the smallest. This device was no longer employed by the majority of artists – one reason why this work is called the last great medieval altarpiece

> The background of the painting is dark and threatening. Darkness has fallen onto the earth as described in the Gospels. Only those features that are essential to the spiritual message are included

The stoic figure of the Bantist

or the baptist of the baptist side of the painting. The Gospels tell us that John was beheaded by Herod long before the Crucifixion. His presence symbolizes the message of mankind's redemption. The words above his arm are "He must increase but I must diminish"

Christ's agony is depicted by his broken feet, his pierced skin, and his unbearably stretched arms The lamb of God represents Christ's sacrifice in shedding his blood for the salvation of mankind St. John the Baptist holds a book representing the scriptures, which refers to the sacrifice of Jesus

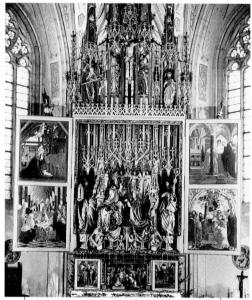

The St. Wolfgang Altarpiece Michael Pacher, 1471–81, wood with polychromy/oil on panel, St. Wolfgang Parish Church, Austria. Pacher's use of light and shade on the altarpiece create the impression of unlimited depth.

Veit Stoss

⊖ c.1445-1533 P GERMAN

🖸 Nuremberg; Kraków 🚺 sculpture

Muremberg: Bamberg Cathedral

№ \$60,627 in 1992, Madonna and Child (oils)

Prominent German sculptor; also a painter and engraver. Renowned for his wood sculptures – with Riemenschneider, the greatest wood-carver of his age – executed in a unique, truly expressive style. Had a modest workshop in which he trained his apprentices – among them his sons – to a high standard. Produced only a handful of paintings and engravings, and none are as noteworthy as his sculpture. His rare paintings (only four are known) are characterized by a tame palette of muted colours. His most famous piece of stone sculpture is the altarpiece at Nuremberg's Bamberg Cathedral.

KEY WORKS The Death of the Virgin, 1477–89 (Kraków: Church of St. Mary); Mourning Virgin, c.1500–10 (New York: Metropolitan Museum of Art); Raphael and Tobias, 1516 (Nuremberg: Germanisches Nationalmuseum); The Annunciation, 1518 (Nuremberg: Parish Church of St. Lorenz); Crucifix, 16th century (Nuremberg: Parish Church of St. Lorenz)

Michael Pacher

Pacher was a panel-painter and wood-carver, although nothing is known of his training. He is believed to have been German. but it is conceivable that he was Austrian. The work he produced is strongly influenced by Italian art, suggesting he may have travelled to Italy. He is credited with melding Germanic and Italian techniques, and thus influencing the future of Northern European art. He died at Salzburg, but most of his career was spent at Bruneck (Brunico) in the South Tyrol. KEY WORKS St. Anne with the Virgin and Child, 15th century (Barcelona:

Museu Nacional d'Art de Catalunya); The Annunciation, 1465–70 (Munich: Alte Pinakothek); The Virgin and Child Enthroned with Angels and Saints, c.1475 (London: National Gallery); Altarpiece of the Four Latin Fathers, c.1483 (Munich: Alte Pinakothek)

Martin Schongauer

⊖ c.1430-91 № GERMAN

☑ Colmar (France)
 ☑ tempera;
 oils; engravings
 ☑ \$146,138 in 1998,
 Carrying the Cross (works on paper)

Son of a goldsmith who settled in Colmar, Alsace. In his day he was probably the most famous artist in Germany. Especially well known in his lifetime for his engravings, with precise lines and convincing volumes. Borrowed from Flemish techniques and ideas (especially from van der Weyden). Much influenced by Dürer. He concentrated on religious subjects and about 115 plates by him are known. His later work has a more delicate, soft touch – his gracefulness became the stuff of legend.

KEY WORKS Madonna in the Rose Garden/Madonna of the Rose Bower, 1473 (Colmar: St. Martin's); The Large Carrying of the Cross, c.1474 (St. Petersburg: Hermitage Museum); The Crucifixion with Soldiers Sharing Christ's Clothes, c.1480 (St. Petersburg: Hermitage Museum)

Hans Baldung Grien

⊖ c.1484-1545 P GERMAN

Strasbourg; Freiburg-im-Breisgau (Germany)
 oils; woodcuts
 Freiburg Cathedral
 \$448,000 in 1978, The Virgin as Queen of Heaven (oils)

Painter and engraver from Strasbourg. May have trained with Dürer. Especially gifted at visionary themes, which incorporate the elemental and supernatural, and sometimes the gruesome and macabre. His early subjects tended to be religious; his later work is secular. Good draughtsmanship; intense colour. He also produced very highquality woodcuts with strong chiaroscuro. KEY WORKS The Three Ages of Man and Death, c.1510 (Madrid: Museo del Prado); Coronation of the Virgin, c.1512 (Freiburg Cathedral); Girl and Death, 1517 (Basel, Switzerland: Kunstmuseum); The Bewitched Groom, 1544 (Berlin: Staatliche Museum)

Lucas Cranach (the elder)

Vienna; Wittenberg, Augsburg (Germany)
 oils Mienna: Kunsthistorisches Museum
 \$7.92m in 1990, Portraits of Kurfürst Herzog Johann von Sachsen and of his Son (oils)

He was a leading figure of the German Renaissance. Worked for the Electors of Saxony in Wittenberg, although his style remained essentially provincial rather than international (Italian). Large, active studio. Staunch Protestant.

He painted impressive and solid court portraits, being especially good at old men's faces. Most notable for the strange, unique, and capricious pictures of female mythological subjects, which have a compelling power and character. These women are curiously reminiscent of the brittle, present-day high-fashion posed and posing models who strut along the catwalk. Both wear outrageous designer creations, and have hard little faces and faraway looks. He makes us adopt the role of voyeur.

Note the sloping shoulders; small, round breasts; feet turned out; long arms and legs; one leg twisted over another; prominent navels; crazy hats and clothes; rings on fingers; feathers; jewelled collars; rocky landscapes, and armour. Hard, glassy eyes, sometimes with strange highlights; manipulative hands; greedy, calculating facial expressions. **KEY WORKS** *A Princess of Saxony*, c.1517 (Washington DC: National Gallery of Art); *Judith with the Head of Holofernes*, c.1530 (Vienna: Kunsthistorisches Museum); *Cupid Complaining to Venus*, c.1530s (London: National Gallery)

The Nymph of the Fountain Lucas Cranach (the elder), 1534, 51.3 x 76.8 cm (20½ x 30½ in), oil on panel, Liverpool: Walker Art Gallery. A teasing diaphanous wisp of silk simultaneously covers and reveals the nymph's loins.

126

Albrecht Dürer

● 1471-1528 ₪ GERMAN

The greatest northern artist of the Renaissance. Born (four years before Michelangelo) in Nuremberg, he was prolific, tenacious, immensely ambitious, and very successful. He travelled widely in Europe and went on key visits to Italy in 1494 and 1505. Follower of Luther. Fused northern European and Italian styles and had a profound influence on art, both north and south of the Alps. Many thousands of his works survive to this day.

LIFE AND WORKS

His goldsmith father, who came from Hungary and trained in the Netherlands, taught Dürer the technique of engraving and an admiration for van Eyck and van der Weyden. He had rich, patrician patrons who encouraged him to travel,

"There lives no man upon the earth who can give a final judgement upon what the most beautiful shape of man might be; God only knows that." ALBRECHT DÜRER

and he established his own busy workshop in Nuremberg. His marriage was unhappy and childless. His social pretensions, artistic ambitions, and his unusual degree of self-consciousness are revealed in his numerous self-portraits.

STYLE

Highly gifted but selfconscious as a painter, he was greater, more at ease, and more innovative as a printmaker:

Self-Portrait at the Age of Twenty-eight 1500, 67.1 x 48.7 cm (26% x 19% in), oil on panel, Munich: Alte Pinakothek. Dürer portrays himself as an image reminiscent of Christ.

produced powerful woodcuts and pioneering engravings. Was a brilliant draughtsman and painted exquisite watercolours. His portraits have strong lines; curious, lopsided faces with enlarged eyes that have liquid surfaces; beautiful, strong hands and feet. He was fascinated by landscape, plants, and animals, and anything unusual. Also look for objects as symbols.

WHAT TO LOOK FOR

Uniquely and subtly synthesized (often in the same work) characteristics of the old northern or medieval tradition and the new

> Italian and humanist discoveries. Look for northern features – apocalyptic imagery; emotional expression; complexity of design; crisp, angular line; minute observation of detail. Note also the Italian features – strong, dignified, composed, assured figures and faces; soft, rounded modelling; classical architecture;

> > A Young Hare 1502, 25 x 23 cm (9³/x 9 in), watercolour on paper, Vienna: Graphische Sammlung Albertina. Dürer's watercolours were created for his own pleasure.

同

Altarpiece of the Rose Garlands 1506, 162 x 194.5 cm (63½ x 76½ in), oil on panel, Prague: National Gallery. This painting was Dürer's first attempt at a single-panel altar, though its compositional structure is more like a triptych.

perspective and foreshortening; New Testament subjects; nudes. **KEY WORKS** The Four Horsemen of the Apocalypse, c.1497–98 (Virginia: Museum of Fine Arts); Great Piece of Turf – Study of Weeds, 1503 (Vienna: Graphische Sammlung Albertina); Virgin and Child Holding a Half-Eaten Pear, 1512 (Vienna: Kunsthistorisches Museum); Johannes Kleberger, aged 40, 1526 (Vienna: Kunsthistorisches Museum)

Melancolia 1514, 24.2 x 19.1 cm (9½x 7½ in), engraving, London: British Museum. The numbers in the top right of the engraving form a "magic square", with the two middle cells of the bottom row giving the date of the engraving: 1514.

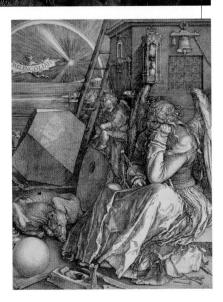

127

HIGH RENAISSANCE AND MANNERISM c.1500-1600

The 16th century saw the establishment of an ideal that would be followed by all self-respecting European rulers until the 20th century, and accounts in no small measure for the great flowering of European art. It was twofold: be strong and fearless in battle, and a generous and knowledgeable patron and protector of the arts.

These principles were set out in one of the best-selling books of the 16th century, *Il Cortegiano* ("The Book of the Courtier") by Baldassare Castiglione, a diplomat from Urbino, Italy. Written in 1514 and first published in 1528, it summarized what had already been established as an ideal of behaviour for monarchs, nobles, and ladies.

ESTABLISHED POWERS

By 1511, Europe had four major powers, each led by strong-willed men who did indeed fight hard and use art to display and reinforce their power and ambition. The fall of Constantinople in 1453 effectively left the Roman Church as the sole effective defender of Christendom. A succession of energetic popes made

The Delphic Sibyl (detail from Sistine Chapel ceiling) Michelangelo, 1508–12, fresco, Rome: Vatican Museums. The Papacy cleverly combined Classical and Biblical authorities to assert its political and spiritual leadership. Rome an artistic showpiece that proclaimed this spiritual and political reality. Europe's most powerful temporal ruler was the Habsburg Holy Roman Emperor, Charles V, who controlled Spain, Austria, the Low Countries, and southern Italy. Francis I of France was determined that his country should compete with both these powers, while Henry VIII of England also wanted his nation, with its new ruling dynasty, to be a major player on the European stage.

At first there was a certain equilibrium between these rival power blocks, and their wish to outdo each other culturally, with virtually no limit on expense, was profoundly beneficial for the arts. Indeed, the achievements of the artists of the High Renaissance marked a high point that subsequent generations constantly revered and tried to emulate. But by the late 1520s warfare engulfed Europe, the Church began to fragment, and the Theatrum Orbis Terrarum: Map of the World by Abraham Ortelius, 1574. The pace of European exploration after the 1490s was exceptionally rapid. Even in the first decade of the 16th century, the African coastline was accurately known. By the second half of the century, the outline of the American continent was assuming recognizable shape.

intellectual certainties predicated on the perception of a universe in which the Earth was at the very centre, and the Mediterranean at the centre of the world, also fractured.

DISINTEGRATION

What had started as cultural rivalry degenerated into destructive warfare. In 1525, Francis I invaded Italy. In the course of the ensuing conflict, Charles V's army sacked Rome in 1527, burning and destroying what had become the finest city in the

world. Meanwhile, the Catholic Church was severely weakened by the crisis sparked by Martin Luther in 1517. His supporters had intended to strengthen the Church by stamping out corruption. Instead they created a permanent split between an emerging Protestant north and a Catholic south, and unleashed a campaign to destroy art treasures with Catholic

REFORMATION

Title Page, the Great Bible, 1539. Printing was crucial in spreading the Reformation, as the Bible became available in vernacular languages, in this case English, instead of Latin.

When in 1517 Martin Luther nailed his 95 Theses to a church door in Wittenberg, his aim was simply to protest against the corruption of the Church, especially in the sale of indulgences. But his further writings struck such a chord with anti-papal feeling that the pope's authority was rejected across much of northern Europe. Many German princes, as well as the kings of Denmark and Sweden, were rapidly won over to

> the Lutheran doctrine, then Henry VIII of England – albeit for political rather than theological reasons – broke with Rome in 1534.

TIMELINE: 1500 - 1600

	1500 Portuguese discovery of Brazil (Cabral)	1509 Spanish settlement of C America begun invention of the watch, German	;	1519 Habsburg Charles V elected Holy Roman Emperor		1522 First circumnavigation of the globe completed (Magellan and del Cano)	1545 Council of Trent called to counter threat of Protestantism	1549 Direct Portuguese rule imposed on Brazil
	1500		1520			1540		
		1508–12 Michelangelo paints Sistine Chapel ceiling	Lut The abu	7 Martin her's 95 eses attacks uses of holic Church		1527 Sack of Rome Cortés conquers c Empire	1534 Act of Supremacy: Henry VIII of England breaks with Rome	1543 Of the Revolution of Celestial Bodies published, Copernicus

C.1500 - 1600

connections. This north-south divide gave a savage twist to the rivalries between the continent's leading powers. In 1565, a vicious, protracted conflict began in the Low Countries. where the Habsburgs were determined to crush an anti-Catholic revolt and reimpose their own rule.

With the Council of Trent. summoned in 1545, the Catholic Church committed itself to restoring its former supremacy, but in reality power was shifting away from Italy. By the mid-16th century, after an audacious act of conquest, Spain found itself in control of much of South America, and the staggering wealth gained as a result made it the richest country in Europe. By the end of the century, both England and France had established footholds in North America.

MANNERISM

The voyages of discovery showed that the world was much larger than had been imagined and full of curious new lands and creatures. In 1543, Copernicus published his proof that the Sun, not the Earth, was the centre of our planetary system. Long-held scientific beliefs were being challenged as well as religious ones. Against this turbulent background, it is no surprise that the self-confidence of the art of the High Renaissance gave way to the uncertainties of Mannerism, whose principal characteristics were a deliberate flouting of rules and wilful eccentricity and distortion.

Château de Chambord, Loire Valley Francis I's desire to emulate the cultural superiority of Italy found potent expression in the lavish châteaux of the Loire Valley. Chambord, begun in 1519, is the largest, 1,800 workmen were employed in its construction over 12 years.

1559 Treaty of Cateau Cambrésis: France forced to concede Habsburg supremacy in Italy

1560

1570

Italy

1565 Dutch Revolt

claimed by Spain

starts: extended attempt

to gain independence

from Spain; Philippines

Palladio's Four Books of Architecture,

Publication of

1572 St Bartholomew's Day Massacre: slaughter of French Protestants in Paris

Armada: attempted conquest of Protestant England by Spain

1580

1571 Battle of Lepanto: Ottoman navy defeated by united Christian fleet 1588 Spanish

1600

1598 Edict of Nantes ends 30-year religious war in France

Leonardo da Vinci

 1452-1519 № ITALIAN
 Florence; Milan; France
 oils; drawings; sculpture; fresco Paris: Musée du
 Louvre (Mona Lisa). London:
 Royal Collection (drawings)
 \$10,360,001 in 2001, Horse and Rider (works on paper)

Unique, perhaps lonely, genius. The universal Renaissance man: scientist,

inventor, philosopher, writer, designer, sculptor, architect, and painter. Had such a fertile mind that he rarely completed anything, and there are relatively few paintings by him. Changed the status of the artist from artisan to gentleman. Pivotal in the creation of the High Renaissance period of Florentine art.

LIFE AND WORKS

Leonardo was born in Vinci, near Florence, the illegitimate son of a notary at a time when illegitimacy was a serious stigma. This may have been a factor that led him to become detached from others. Two Horsemen after 1481, 14.3 x 12.8 cm (5% x 5 in), metal point drawing, Cambridge: Fitzwilliam Museum. An example of Leonardo's life-long fascination with animals.

Leonardo trained with Verrochio but much of his life was spent working at the courts of foreign dukes and princes who, at times, were at war with Florence. The Medici ignored him entirely.

After 1483 he worked for Ludovico Sforza, Duke of Milan, but returned to Florence following the French invasion of Milan in 1499. Between 1500 and 1516, he produced many of his most famous

"The mind of the painter should be like a lookingglass that is filled with as many images as there are objects placed before him."

LEONARDO DA VINCI

The Virgin of the Rocks c. 1508, 189.5 x 120 cm (74 x 47 in), oil on panel, London: National Gallery. Painted for the Milanese Foundation of San Francesco Grande. This is the second version created by da Vinci, showing the infant St. John the Baptist adoring the infant Christ accompanied by an angel.

paintings. He spent his last years in the service of Francis I of France and, according to legend, died in the king's arms near Amboise in the Loire Valley. Leonardo's most remarkable legacy is his notebooks filled with writings and sketches in which he explored his private thoughts about art and science, observations from nature, and diagrams for visionary scientific and mechanical projects.

STYLE

Leonardo had an insatiable curiosity to find out how everything operates. He then put this into practice (as witness his keenly observed anatomical drawings and his plans for flying machines, and so on). His paintings are multilayered, investigating these subjects; they also explore beauty, ugliness, spirituality, man's relationship with nature and God, and "the motions of the mind" (psychology). He was technically inventive, but careless.

WHAT TO LOOK FOR

Why is the *Mona Lisa* (see page 138) so important? It created a sensation (c.1510) because it was lifelike in a way that had

> never been seen before. It comprises a brilliant bag of technical and perceptual innovation (the use of oil paint, a relaxed pose, soft and shadowy figure with no outlines, two landscapes) and demands that the viewer's imagination should supply the inner meaning and missing visual detail. It set a new standard – and it reaffirms that art you have to interact with creatively is always best.

KEY WORKS Ginevra de'Benci, c.1474 (Washington DC: National Gallery of Art); Cecilia Gallarani/The Lady with an Ermine, c.1483 (Kraków: Czartoryski Museum); Mona Lisa, c.1510 (Paris: Musée du Louvre)

The Last Supper 1495–97 (post-restoration), 460 x 880 cm (181 x 346% in), mixed media fresco, Milan: Santa Maria delle Grazie. More than a depiction of one event, the fresco refers to other episodes narrated in the Gospels.

Raphael (Raffaello Sanzio)

⊖ 1483-1520 P ITALIAN

"Il Divino". A child prodigy who died young, but one of the greatest masters of the High Renaissance and therefore of all time. Profoundly influential; helped raise the social status of artists from craftsmen to intellectuals.

He had complete mastery of all Renaissance techniques, subjects, and ideas, and used and developed them with apparent ease: deep, emotional, and intellectual expression; total Christian belief; harmony; balance; humanity; superb draughtsmanship. In short, he projected an ideal at almost every level – which is why he was held up as the model for all ambitious artists until the overthrow of academic art by the Modern Movement.

Notice how everything has a purpose, especially how he uses contrast to

Pope Leo X with Cardinals Giulio de' Medici and Luigi de' Rossi Raphael (Raffaello Sanzio), 1518–19, 154 x 119 cm (60% x 46% in), oil on wood, Florence: Galleria degil Uffizi.

heighten our perception and feeling (one of the oldest and most successful devices):

stern men and sweet women: stillness and movement; contemplation and activity; curved line and straight line; tension and relaxation. Observe too the continuity in his works – how a gesture, pose, or movement begun in one part of the body, or in one figure, is carried a stage further in another. **KEY WORKS** The School of Athens, 1510-11 (see page 139); Madonna of the Chair, c.1513 (Florence: Galleria degli Uffizi); Bindo Altoviti, c.1515 (Washington DC: National Gallery of Art); Portrait of Baldassare Castiglione, pre-1516 (Paris: Musée du Louvre)

The Sistine Madonna Raphael (Raffaello Sanzio), 1513, 265 x 196 cm (104% x 77% in), oil on canvas, Dresden: Gemäldegalerie. This was Raphael's first major work on a theme that was to become a central feature of his art – the Madonna and Child. He reworked the subject with constant variation and invention.

Sebastiano del Piombo

⊖ c.1485-1547 P ITALIAN

 Wenice; Rome
 Moils; fresco
 Rome: Villa Farnese (fresco series)
 S695,400 in 1987, Portrait of Pope Clement VII (oils)

Venetian ex-patriot and Titian's contemporary, who settled in Rome when Michelangelo and Raphael were there. In 1531 obtained the sinecure of keeper of the papal seal (made from lead, or "piombo", hence his nickname).

He excelled at painting portraits – which can be magnificent. Otherwise he flirted with (relative) failure. He achieved a certain marriage of muscularity and poetry, which makes his figures look like soulful athletes, but the compositions, colour, and figures became overblown as he strove unsuccessfully to keep up with his friend Michelangelo.

Look for rather fierce-looking, muscular people, with good strong hands; dramatic gestures and plenty of foreshortening. Interesting use of perspective. Rich colour and landscape backgrounds maintain his links with Venice. Is it a misfortune to be talented but not outstanding in an epoch of giants? Do they cause you to live in their shadow and diminish your talent? Or do they inspire you to reach heights you would otherwise not have achieved? **KEY WORKS** The Daughter of Herodias, 1510 (London: National Gallery); Fall of Icarus, c.1511 (Rome: Villa Farnese); Portrait of a Woman, 1512 (Florence: Galleria degli Uffizi); Flagellation, 1516-21 (Rome: S. Pietro in Montorio); Raising of Lazarus, c.1517-19 (London: National Gallery)

Fra Baccio della Porta Bartolommeo

⊖ c.1474 – 1517 🕫 ITALIAN

Florence in oils in Paris: Musée du Louvre
 \$2.1m in 2001, Nativity (oils)

Major Florentine painter who influenced the change in style between the early and High Renaissance.

His large-scale, elaborate altarpieces of throned Madonnas with the Christ child show the main characteristics of the High Renaissance style – monumental, solemn, balanced, with dignified compositions and figures. Bartolommeo replaced the intensely observed detail of the early Renaissance with generalizations (notice it especially in faces and drapery) and idealization.

Look for well-fed people with a tendency to chubby checks, double chins, and a self-satisfied look. Observe landscapes that look prosperous and well farmed. Warm colour and light. **KEY WORKS** *Portrait of Savonarola*, c.1495

(Florence: Convent of San Marco); Marriage of St. Catherine, 1511 (Paris: Musée du Louvre); Mother of Mercy, 1515 (Lucca, Italy: Academy)

Andrea del Sarto

•	1486-1530	PU ITALIAN	
ρ	Florence; Fo	ontainebleau	fresco; oils
2	\$1m in 2000). Madonna ai	nd Child (oils)

The last significant Florentine High Renaissance painter. Influenced in subjects, style, and technique by Leonardo, Raphael, and Michelangelo. Synthesized those influences to produce handsome, monumental, religious pictures and portraits, which are harmonious in colour, well balanced, grand in conception and scale, but lack real emotional depth and originality. **KEY WORKS** *Punishment of the Gamblers*, 1510 (Florence: SS. Annunziata); *Madonna of the Harpies*, 1517 (Florence: Galleria degli Uffizi)

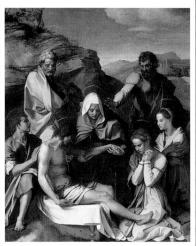

Lamentation over the Dead Christ Andrea del Sarto, 1524, 238 x 198 cm (93¾ x 78 in), oil on wood panel, Florence: Palazzo Pitti. Forced to flee from the plague, del Sarto painted this for the convent where he took refuge.

Michelangelo Buonarroti

⊖ 1475-1564 PU ITALIAN

 Image: Properties of the second s

The outstanding genius (and infant prodigy), who cast his influence over all European art until Picasso broke the spell and changed the rules. Sculptor first, painter and architect second. Workaholic, melancholic, temperamental, lonely. Also argumentative and belligerent; he found relationships with others difficult.

He was born near Florence, the son of a minor official with noble lineage, and showed his talent at an early age. He had a profound belief in the human form (especially that of the male) as the ultimate expression of human sensibility

and beauty. His early work shows the human being as the measure of all things: idealized, muscular, confident, quasi-divine. Gradually that image becomes more expressive, more human, less perfect, fallible, and flawed. Never a natural painter – he **The Last Judgement** 1538–41, 1463 x 1341 cm (576 x 528 in), fresco, Vatican City: Sistine Chapel. In the centre of the composition, Christ raises the good with his right hand and dismisses the damned with his left.

conceived the figure in sculptural terms and used light to model it, so it could be the design for shaping a block of marble.

In his paintings he uses fiery reds, oranges, yellows against grey or blue; employs a wet-in-wet oil paint technique. Look for: tempera hatching, reminiscent of a sculptor exploring volume; brilliant draughtsmanship exploring outline, contour, and volume; beautiful and expressive hands; twisting poses, full of latent energy; faces expressing the full range of human emotions. He was endlessly inventive – never repeats a pose (although he borrows some from famous Greek and Roman sculptures).

KEY WORKS The Entombment, c.1500-01 (London: National Gallery); David, 1501-04 (Florence: Gallerie dell'Accademia); Sistine Chapel ceiling frescoes, 1508-12 (Rome: Vatican Museums)

> Holy Family with St. John (Doni Tondo) 1504–05, diameter 120 cm (47 in), oil on panel, Florence: Galleria degli Uffizi.

Pietà

Michelangelo 1500

Michelangelo was only 25 when his *Pietà* was unveiled at St. Peter's Basilica in Rome. In this superb work, he removed the subject

Pietà

C.1500 - 1600

Medium marble

Dimensions height 174 cm (68½ in); width at base 195 cm (76¾ in) Location Rome: St. Peter's Basilica

from its usual sphere. More than a lofty religious symbol, far removed from normal life, it has become a real moment in human existence: a sculpture that invites the viewer to share Mary's grief.

Michelangelo took the study of anatomy very seriously. As an adolescent he befriended a priest who allowed him access to dead bodies lying in rest at the church before being buried. The dead Christ of the *Pietà* is a testimony to many hours spent studying genuine corpses, giving the work a realism most other sculptors were unable to attain. Michelangelo did not believe that his Christ should appear superhuman; he wrote that there was no need to conceal the human behind the divine. The work ensured his reputation as one of the Renaissance's finest artists.

> Michelangelo's close study of anatomy is apparent in this mastery of the human form

The sorrowing face of the Madonna is an inspired union of classical idealism and Christian piety.

> Mary's outstretched hands show an acceptance of her fate

Christ's veins are distended, emphazing how recently the blood flowed in his body

The Pietà was sculpted from one single block of marble, taken from the quarries at Carrara

THE HIGH RENAISSANCE

The years between about 1500 and the Sack of Rome in 1527 saw a prodigious outpouring in Italy in all the visual arts. In Rome, under the energetic patronage of an exceptionally able (and self-promoting) pope, Julius II, Raphael and Michelangelo simultaneously created works of startling novelty. In Venice, the celebrated Titian redefined the possibilities of painting.

STYLE

Idealization is the benchmark but it manifests itself in different ways. For Raphael it meant heroic confidence, technical sophistication, and grace. Similar elegance allied to acute psychological insight and astonishingly close observation of the natural world are obvious in Leonardo. Both Michelangelo and Titian pioneered more personal if no less heroic styles, the former astoundingly audacious in his vision of the male form, the latter above all in his mastery of colour.

The Emperor Charles V on Horseback in Mühlberg Titian, 1548, 332 x 279 cm (131 x 110 in), oil on canvas, Madrid: Museo del Prado. Drama, idealization, and huge scale are unified by brilliant colouring and daring brushwork.

SUBJECTS

The visionary goal of High Renaissance art was a perfect union of the human and divine, Christian and pagan Antique, nature and imagination. Thus the male nude "made in God's image", the central motif of Michelangelo's painting and sculpture, heroic and often deliberately distorted, has an extraordinary power, which the Church used to convey a

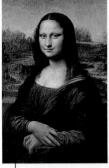

spiritual ideal. Yet though religious subjects generally remained preeminent, other subjects – whether Classical scenes,

Mona Lisa Leonardo da Vinci, c. 1503 – 05, 77 x 53.5 cm (30 ½ x 21 in), Paris: Musée du Louvre. Praised by Giorgio Vasari because it "appeared to be living flesh rather than paint"

landscapes, or portraits – became increasingly important, significantly widening the repertoire of Western art. Titian's *poesie*, lyrical and dreamlike "visual poems", began to explore the relationship between the human figure and landscape.

KEY EVENTS

1498	Milan – Leonardo completes his huge, psychologically penetrating <i>Last Supper</i>
1503	Michelangelo completes <i>David</i> in Florence the largest statue carved since Antiquity
1506	Foundation stone of Bramante's new (and in the event never finished) St. Peter's laid by Julius II
1508–12	Michelangelo's almost single-handed epic labour on the ceiling of the Sistine Chapel, Rome
1528	Renaissance ideals defined by Castiglione in <i>The Book of the Courtier</i>

c.1500-1527

WHAT TO LOOK FOR

The greatest triumph of the High Renaissance was the rebuilding of St. Peter's in Rome and its decoration through the leadership of Pope Julius II. As a complement to Michelangelo's religious theme in the Sistine Chapel, Raphael decorated the Pope's library with four subjects: Philosophy, Theology, Poetry, and Law. For his interpretation of Philosophy, Raphael drew exclusively on the inspiration and precedents of Greek and Roman Antiquity.

The architectural setting was based on designs by Bramante, the leading Classical architect in Rome

inculur

Plato and Aristotle, silhouetted against the sky, are awarded the dominant positions in the picture

C.1500-1600

The School of Athens

Raphael, 1509–11, base 772 cm (304 in), fresco, Vatican: Stanza della Segnatura

Euclid, giving a geometry lesson, was a portrait of Bramante

Pythagoras, the great Greek mathematician, demonstrates his propositions

TECHNIQUES

Each figure is a masterful, expressive portrait and each group a model of statuesque harmony and continuous graceful movement. The colour scheme, too, is serene and harmonious. Heraclitus was a portrait of Michelangelo, then working on his Sistine ceiling

Raphael included a selfportrait, an indication of the growing status accorded artists

Raphael was

renowned in his own day for his ability to include a huge variety of complex poses and realistic expressions in a single work. Many hundreds of preliminary drawings were made from life.

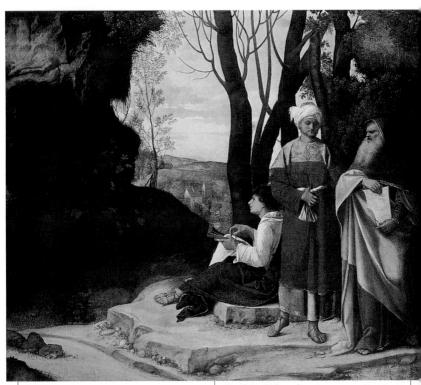

Giorgione

⊖ c.1476-1510 PU ITALIAN

☑ Venice ☑ oils ☑ \$6,795 in 1957, Caesar Enthroned Receives Head of Pompey (oils)

Also known as Giorgio Barbarelli or Giorgio da Castelfranco, he was the young, short-lived genius of the Venetian School, who ranks in achievement, significance, and importance with the greatest of Renaissance painters. Few works are known to be his for certain.

His small-scale, mostly secular, pictures are consciously poetic, lyrical, and mysterious – carefully observed portraits of youthful and sensitive young men being beautiful. Dream-like landscape settings. *The Sleeping Venus* and *The Tempest* opened the door for the development of the nude, landscape, and mythological painting on which so much of Western art has depended.

To own an authentic Giorgione has been one of the supreme ambitions of collectors since the Renaissance, so just think how many pictures have falsely or mistakenly had the label "Giorgione" **The Three Philosophers** Giorgione, c. 1509, 121 x 141 cm (47³/x 55³/in), oil on canvas, Vienna: Kunsthistorisches Museum. Giorgione was patronized by collectors who enjoyed poetic ambiguity.

attached to them (and still do?). It is impossible to identify a recognizable technique (so few works known for certain, plus wicked restorations, and overcleanings). Look for that indefinable, dreamy Giorgione mood, plus a passion for observing the real world. **KEY WORKS** Old Woman, c.1502–03 (Venice: Gallerie dell'Accademia); *The Tempest*, 1505–10 (Venice: Gallerie dell'Accademia); *The Sleeping Venus*, 1508–10 (Dresden: Gemäldegalerie)

Jacopo Palma Vecchio

■ Venice ■ oils ■ \$293,400 in 1991, Sacra Conversazione – Madonna and Child with St. John the Baptist and St. Catherine (oils, double-sided)

Short-lived (for an artist), well-regarded painter of the greatest period of Venetian art, of the same generation

Lady with a Lute Jacopo Palma Vecchio, c. 1520–25, 97 x 71 cm (38% x 28 in), Private Collection. Palma Vecchio's sensuous portraits of women were eagerly bought by wealthy Venetians, but few survive.

as Titian. His less good grandnephew was Palma Giovane (1544–1628).

His high-quality pictures are well executed and decorative, but have the misfortune to be emotionally empty (the fate of many artists who just fail to reach the first

rank). Had great success with half-lengths of sumptuous blondes masquerading as goddesses and saints (high Venetian fashion of the day).

Look for skilful drawing, pleasingly soft and harmonious colouring, mastery of all the skills of perspective and the human figure, etc. But his most elaborate works, however, seem to be no more than an accumulation of small-scale visions and fine details, and lack the boldness and grandeur that they seem to be striving for.

KEY WORKS Portrait of a Poet, c.1516 (London: National Gallery); A Blonde Woman, c.1520 (London: National Gallery); Venus and Cupid, c.1523–24 (Cambridge: Fitzwilliam Museum); Judith, 1525–28 (Florence: Galleria degli Uffizi)

Vittore Carpaccio

⊖ ACTIVE 1490-1523 PU ITALIAN

Notable Venetian storyteller with an eye for homely, factual detail, crowds, and processions. Set his religious and mythological stories within images of his own familiar Venice and thus chronicled his own times. Carpaccio's faithful representation of the visible world is composed of many tiny parts. Not a pioneer, but a forerunner of later

Dream of St. Ursula (detail) Vittore Carpaccio, 1495, 23 x 23 cm (9 x 9 in), tempera on canvas, Venice: Galleria dell'Accademia. Carpaccio painted a series of works showing an unusually domesticated interpretation of the martyrdom of St. Ursula.

domestic genre painters and recorders of the Venetian scene, such as Canaletto. **KEY WORKS** *The Dismissal* of the English Ambassadors, 1495 (Venice: Gallerie dell' Accademia); *The Flight into Egypt*, c.1500 (Washington DC: National Gallery of Art); *Young Knight in a Landscape*, 1510 (Madrid: Museo Thvssen-Bornemisza)

Dosso **Dossi**

C.1500-1600

⊖ c.1479-1542 P	ITALIAN
-----------------	---------

☑ Venice; Mantua; Ferrara ☑ oils ☑ \$3.7m in 1989, Allegory with Male and Female Figure (oils)

Somewhat obscure Venetian painter in mould of Titian and Giorgione – moody, poetic, sensuous, using rich light and colour. He painted myths, allegories, portraits, lush landscapes, and frothy trees. Had a liking for animals. Few works remain, most of which are badly damaged. It is fashionable to say he is wonderful – he ought to be, but he is somehow ungainly and gauche. **KEY WORKS** *Sibyl*, c.1516–20 (St. Petersburg: Hermitage Museum); *Melissa*, 1520s (Rome: Galleria Borghese); *Circe and her Lovers in a Landscape*, c.1525 (Washington DC: National Gallery of Art)

Lorenzo Lotto

Minor and uneven Venetian with a difficult personality. Was much travelled. He died a forgotten man.

His portraits, altarpieces, and allegories have sumptuous colours and a rich, robust style, but are often uncomfortable compositions with overcramped spaces and inexplicable changes of scale. He never quite made all the parts work together. There are influences from many of his contemporaries, but too many borrowings that he never fully absorbs, so that his work can look like a mishmash of everyone else. At times it even comes close to caricature.

He was at his best in portrait painting, especially conjugal double portraits. He liked searching, soulful expressions and was obsessed by hand gestures and fingers. Works have uncertain anatomy, but good landscape details and bold modelling with light. Look for the stunning oriental carpets in his paintings of interiors. Was much admired by Bernard Berenson, who made a detailed study of his work. **Key WORKS** *The Annunciation*, 1520s (Recanati, Italy: Church of Sta Maria sopra Mercanti); *St. Catherine*, c.1522 (Washington DC: National Gallery of Art)

Paolo Veronese

⊖ c.1528-88 P ITALIAN

Also known as Paolo Caliari, he is one of the major Venetians and one of the greatest-ever creators of decorative schemes. So called because he came from Verona. He had a huge output.

See his work in situ – in one of his large-scale decorative schemes, such as a Venetian church or a nobleman's villa. Don't look for

profound meaning or a deep experience; let your eye have a feast and enjoy the glorious visual and decorative qualities. Try to spot some of the illusionistic tricks and remember that these works were intended to go hand in hand with a particular building – with its space, architectural detail, and light.

Look for the posh people (his clients), surrounded by their servants, rich materials, and classy architecture. Look at the faces. Have they become bored by too much good living and leisure? These are the last days of the really good times for the Venetian Empire. Is that why the dogs and animals often seem more alive than the people? The Madonnas and deities he portrays are no more than Venetian nobility in fancy dress. **KEY WORKS** Allegory of Love, I (Unfaithfulness), c.1570s (London: National Gallery); The Finding of Moses, c.1570–75 (Washington DC: National Gallery of Art)

Vincenzo Catena

⊖ c.1480-1531 PU ITALIAN

■ Venice 0 oils 2 \$185,000 in 1995, Madonna and Child with Two Angel Musicians and Landscape Beyond (oils)

Reputable second-rank Venetian. Good middle-of-the-road painting – uninspired figures and composition, but well-observed light and attractive colours. Everything looks swept meticulously clean – because cleanliness is next to godliness? **KEY WORKS** Madonna and Child with the Infant St. John the Baptist, c.1506–1515 (London: National Gallery); St. Jerome in his Study, c.1510 (London: National Gallery); Christ Bearing the Cross, c.1520–1530 (Vienna: Liechtenstein Museum)

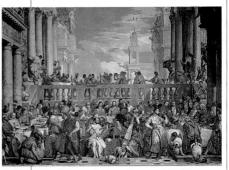

Marriage at Cana Paolo Veronese, 1563, 666 x 990 cm (262 % x 389 %), oil on canvas, Paris: Musée du Louvre. The scene is a fantasy interpretation of the occasion when Christ turned water into wine.

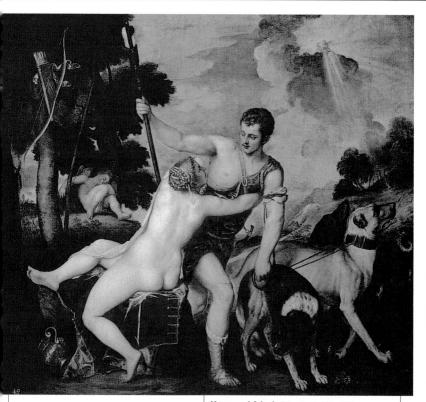

Titian

⊖ c.1487-1576 P ITALIAN

Venice; Rome D oils; fresco D Madrid:
 Museo del Prado. Vienna: Kunsthistorisches
 Museum. London: National Gallery
 \$12,376,000 in 1991, Venus and Adonis (oils)

Named Tiziano Vecellio, but better known by the shortened version. He was the supreme master of the Venetian School and arguably the greatest painter of the High Renaissance and of all time. Probably a pupil of Giovanni Bellini. Also worked with Giorgione. One of the few painters whose reputation has never gone into eclipse or been overlooked.

He had a miraculous ability with rich colour and luscious paint, and was constantly innovative, using new subjects or brilliant reinterpretations. Had a Shakespearean response to the human condition, showing us tragedy, comedy, realism, vulgarity, poetry, drama, ambition, frailty, spirituality – and always convincingly. He was a genius at creating a psychological relationship between **Venus and Adonis** Titian, 1553, 107 x 136 cm (42 x 53½ in), oil on canvas, Madrid: Museo del Prado. Titian's sensuous colour tones accentuate the soft and shimmering beauty of the lovers' flesh.

figures so that the space between them crackles with unspoken messages.

Study the faces and the body language – portraits with a thrilling likeness (who was it I met or saw who was just like that?); also idealization and understanding of the hidden secrets of his subjects' characters. Was he too wise or discreet to tell quite all that he knew? Gods and saints seem to be as much human as divine (and therefore understandable and approachable). Titian never belittled anyone or anything. Superman is the measure of all things.

KEY WORKS Christ Appearing to the Magdalen (Noli me Tangere), c.1512 (London: National Gallery); Portrait of Ranuccio Farnese, 1542 (Washington DC: National Gallery of Art); Diana Surprised by Actaeon, 1556–59 (Edinburgh: National Gallery of Scotland); The Flaying of Marsyas, c.1570–75 (Kromeriz, Czech Republic: Château Archiépiscopal)

144

Bacchus and Ariadne

Titian c.1522-23

Titian's crowning achievements are his mythological *poesie* (poems). This early work was one of a series commissioned by Alfonso d'Este, the duke of Ferrara, in northern Italy, to decorate an alabaster pleasure chamber at his country house.

Titian chooses

to focus on the electrifying moment when Ariadne, daughter of King Minos of Crete, meets Bacchus, the god of wine, and they fall in love at first sight. He later married her, and she was eventually granted immortality.

There is an overriding sense of ordered chaos about the painting. Although the scene is crowded, Titian has worked out the composition with great care. Bacchus's right hand is at the centre of the painting where the diagonals intersect. The revellers are all confined to the bottom right. Bacchus and Ariadne occupy the centre and left. Bacchus's feet are still with his companions, but his head and heart have joined Ariadne.

The greatest painter of the Venetian school, Titian was based in Venice for his entire life, inspired by its magical union of light and water. He was one of the most successful painters in history, famous for his ability to inject his pictures with moments of crackling psychological energy of the kind that pervades this work. He was also the Renaissance master of colour, and this painting's rich, glowing brilliance reflects its passionate subject.

TECHNIQUES

This close-up detail of Ariadne shows Titian relishing two of the special qualities of oil paint: translucent, lustrous colour, and fine, precise detail.

After falling in love,

Bacchus took Ariadne's crown and threw it into the sky where it became the constellation Corona Borealis.

Ariadne has been

abandoned by her lover Theseus, whom she helped to escape from the Minotaur's labyrinth

Bacchus's chariot

was traditionally pulled by leopards, signifying his triumphant return from his conquest of India. Titian uses artistic licence by employing cheetahs for the task

The muscular figure shown wrestling with the snakes is based on a

Celebrated antique Roman statue of the Trojan priest Laocoôn (who was killed by sea serpents), which was unearthed in 1506 (see pages 58–59). The statue's rediscovery caused a sensation, and many artists, including Raphael, incorporated crossreferences to it in their work. A maenad crashes cymbals together in a riotous procession The longing glance that this maenad exchanges with the satyr contrasts with the intense expressions of the main characters This drunken satyr, crowned and girdled with vine leaves, waves the leg of a calf above his head

Bacchus and Ariadne

Medium oil on canvas Dimensions 175 x 190 cm (69 x 75 in) Location London: National Gallery

MANNERISM

c.1520-1600

Mannerism is the name given to the predominant artistic style of the period bridging the High Renaissance and the Baroque. The term comes from the Italian *maniere*, meaning "manner" or "style". The cradle of Mannerism was Rome, where the style was developed by artists influenced by the late works of Raphael and Michelangelo. The movement was finished throughout Europe by c.1700.

SUBJECTS AND STYLE

Mannerism was a reaction to social, political, and religious upheaval. The art of the period became violent, excitable, unnerving, often with a nightmarish, conflicting style; a huge step away from the harmony of High Renaissance. Key figures include Rosso Fiorentino, Jacopo Pontormo, Tintoretto, El Greco, Agnolo Bronzino, and Girolamo Parmigianino. After the violent Sack of Rome in 1527, Mannerism spread throughout

Italy, as terrified artists fled from the city. The style's subjects include religious

Self-Portrait in a Convex Mirror Girolamo Parmigianino, c.1523–24, diameter 24.4 cm (9% in), oil on wood, Vienna: Kunsthistorisches Museum

scenes viewed from an unusual aspect; portraits whose sitters wear unexpected expressions; and mythological or allegorical scenes, often characterized by a sinister form of symbolism.

WHAT TO LOOK FOR

Look for distorted or elongated figures, artificial poses, complicated or obscure subject matter, tense symbolism, deliberate distortion of space, vivid

colour, unreal textures, deliberate lack of harmony and proportion, voyeuristic sexual scenes. Faces are rich with expression. Figures look deliberately tense or as though suspended halfway through an action. In sculpture, look for sense of movement, realism, exaggerated postures, strongly muscled anatomy. In architecture, look for anti-classicism and distortion of the viewer's expectations.

KEY EVENTS

1520	Death of Raphael. His later works were considered the beginning of Mannerism
1527	Sack of Rome. Spreads Mannerism across Italy and into France
c.1528	Jacopo Pontormo finishes his <i>Deposition</i> , a Florentine altarpiece in the Mannerist style
1534–40	Girolamo Parmigianino paints <i>The</i> <i>Madonna of the Long Neck</i> (see page 150)
1541	Birth of El Greco

Cosimo de' Medici (II Vecchio) Jacopo Pontorno, 1518, 86 x 65 cm (33¾ x 25¾in), tempera on wood, Florence: Galleria degli Uffizi. A posthumous portrait of Cosimo il Vecchio (1389–1464), founder of the Medici dynasty.

$c\;.\;1\;5\;0\;0-1\;6\;0\;0$

147

Giulio Romano

⊖ c.1496-1546 № ITALIAN

🔟 Rome; Mantua 🛛 🚺 chalks; fresco; oils

Also known as Giulio Pippi. Architect and painter; a major exponent of Mannerism. Studied under and worked with Raphael; strongly influenced by his later style, and also by the work of Michelangelo. After Raphael's death, Giulio finished several of his commissions. Also a pornographer – designed a series of celebrated and notorious pornographic engravings. Threatened with prison in Rome, Giulio moved to Mantua under protection of Gonzaga family; most famous architectural work is Mantua's Palazzo del Tè.

In paintings, look for a similar style to Raphael, but exaggerated; also look for realism, muscular anatomy, and a strong sexual overtone. In architecture, look for deliberate "mistakes": missing expected features, such as central motifs; optical illusions, for instance, columns that are sturdy but look ready to tumble; or stonework left rough, instead of being smoothly carved and finished.

KEY WORKS Crowning of the Virgin (Madonna of Monteluce), c.1505–25 (Rome: Vatican Museums); Mary Magdalene Borne by Angels, c.1520 (London: National Gallery); The Holy Family, c.1520–23 (Los Angeles: J. Paul Getty Museum); The Fall of the Giants, 1532–34 (Mantua: Palazzo de Tè)

Madama and Child Guida Romana e 1520 - 40, 105 v

Madonna and Child Giulio Romano, c.1530–40, 105 x 77 cm (33% x 30% in), oil on wood, Florence: Galleria degli Uffizi. The Christ child reaches for grapes – a symbolic reference to the Eucharist, the central Christian sacrament.

which was dedicated to Cosimo de' Medici. Despite inconsistencies, errors, and an overwhelming bias in favour of Michelangelo, it remains an important source for students of Renaissance art.

Vasari's writings have now outshone his other works, but in his time he was a highly successful painter, often decorating the houses of the aristocratic. Also a respected architect – most famous for designing the Uffizi art gallery in Florence. **KEY WORKS** *Paul III Directing the Continuence* of *St. Peter's*, 1544 (Rome: Palazzo della

> Cancelleria); Uffizi offices (finished by others), 1560–80 (Florence); *The Prophet Elisha*, c.1566 (Florence: Galleria degli Uffizi); *The Attack on the Porta Camolia at Siena*, 1570 (Florence: Museo Ragazzi)

The Annunciation Giorgio Vasari, c. 1564–67, 216 x 166cm (85 x 65% in), oil on panel, Paris: Musée du Louvre. This intimate scene formed the centre panel of a triptych for the dominican church of Santa Maria Novella at Arezzo.

Giorgio Vasari

● 1511-74 P ITALIAN
 ■ Florence ■ fresco; oils

He was a Mannerist painter, architect, writer, art historian, and collector. A popular, entertaining man – and an inveterate gossip – whose patrons were said to have enjoyed his storytelling ability as much as his art. Most famous for his volumes of biography, *Lives of the Artists* (1550; reprinted and extended in 1568),

Jacopo Pontormo

⊖ 1494-1557 PU ITALIAN

 Image: Tuscany
 Image: Oils; fresco
 Image: Florence:

 Galleria degli Uffizi and churches. Paris: Musée
 du Louvre (for drawings)
 Image: Sa2m in 1989,

 Portrait of Duke Cosimo I de' Medici (oils)
 Image: Sa2m in 1989,

He was also known as Jacopo Carucci. A Florentine, from Pontormo. Nervous, hysterical, solitary, melancholy, slow, capricious, and hypochondriacal, he was also a talented painter (good enough, anyway, to have studied with Leonardo). Taught Bronzino.

He painted altarpieces, religious and secular decorative schemes for churches and villas, and portraits. Took Michelangelo's and Dürer's classicism and energy and contorted them into beguiling works with irrational compositions – figures in complicated but frozen poses – and bright, high-key colours (acid greens, clear blues, and pale pinks). He was consciously radical and experimental – in line with his temperament and the political and social moods of his time. Brilliant drawings. Very good portraits –

"Sometimes when he went to work he would fall into such deep thought that he came away at the end of the day without having done anything but think."

with clongated and arrogant poses, and sharp observation of character. Pontormo was one of the originators of the wayward style now known as Mannerism. (Like most good artists he did not care what style he painted in – he just got on with it.) Out of fashion in the 18th and 19th centuries, but has returned to favour in the 20th and 21st. (The word "Mannerism" was not invented or defined until the 20th century.) **KEY WORKS** *The Visilation*, 1514–16 (Florence: SS. Annunziata); *Deposition*, c.1528 (Florence: Santa Felicità, Cappella Capponi); *Portrait* of *Duke Cosimo I de' Medici*, c.1537 (Malibu:

An Allegory with Venus and Cupid Agnolo Bronzino, c.1540–50, 146.5 x 116.8 cm (57% x 45 in), oil on panel, London: National Gallery. Designed for King Francis I of France, the meaning of Bronzino's allegory is unclear.

J. Paul Getty Museum); *Portrait of Maria* Salviati, c.1537 (Florence: Galleria degli Uffizi); *Monsignor della Casa*, c.1541–44 (Washington DC: National Gallery of Art)

Agnolo Bronzino

⊖ 1503-72 № ITALIAN

□ Tuscany ↓ oils Florence: Galleria degli Uffizi; Palazzo Vecchio \$410,750 in 1996, *The Meeting of Joseph and Jacob in Egypt* (drawing)

He was best known for his aloof and icy portraits. Court painter to the Grand Duke of Tuscany. Humble background.

Painted portraits of brittle artificiality – he lived in an age when artifice and striking poses reigned supreme. He sums it up with rare beauty: note the body language of the poses and faces, which communicate such arrogance, contempt, or insolence; and the equally arrogant ease of his technique, with its superb facility, deliberately complex and artificial compositions, and intense, insolent colours.

Look for flesh that seems to be made of porcelain (as smooth as the people he portrays). Notice the elongated faces and bodies, and eyes that can often seem vacant, like those of a child's doll. Look also for more rarely seen allegories and religious works with intricate designs, involving many figures whose poses are deliberately stolen from Michelangelo. **KEY WORKS** *A Lady with a Dog*, c.1529–30 (Frankfurt: Städelsches Kunstinstitut); *The Panciatichi Holy Family*, 1540 (Florence: Galleria degli Uffizi)

Benvenuto **Cellini**

● 1500-71 PU ITALIAN

Italy; France sculpture; engraving
 Florence: Museo Nazionale del Bargello

A sculptor and engraver, and pupil of Michelangelo. Unpleasant, arrogant, sadistic, and violent, Exiled from Florence for duelling. Committed more than one murder. Rumoured to have crucified a man and watched him die in order to sculpt a realistic Christ on the cross. Many influential patrons, including Francis I and Cosimo de' Medici. Bisexual - imprisoned twice for sodomy, but also fathered four children. Wrote an entertaining autobiography. Many of his famous works are monumental, but these lack the precision and excellence of his smaller pieces, such as Francis I's golden saltcellar. KEY WORKS Saltcellar, called the "Saliera", 1540-43 (Vienna: Kunsthistorisches Museum); Nymph of Fontainebleau, 1542-43 (Paris: Musée du Louvre)

Giambologna

1529-1608 № FLEMISH
 № Belgium; Italy
 № Sculpture
 London: Victoria &
 Albert Museum

Also called Giovanni da Bologna or Jean de Boulogne. Mannerist sculptor; capable of producing both miniatures and monumental statues with equal ability. Patronized by the Medici.

20

Famous for the Fountain of Neptune in Bologna and the equestrian statue of Cosimo de' Medici in Florence. His works were hugely influential on the future of sculpture. Studied in Antwerp before arriving in Italy c.1550 to study. Lived in Rome before settling in Florence. **KEY WORKS** Samson Slaying a Philistine, c.1561–62 (London: Victoria & Albert Museum); The Fountain of Neptune, 1563–66 (Bologna: Piazza del Nettuno); Florence Triumphant over Pisa, c.1575 (Florence: Museo Nazionale del Bargello); Hercules and the Centaur, 1594–1600 (Florence: Loggia dei Lanzi)

Giovanni Battista Moroni

⊖ c.1525-78 № ITALIAN

 Albino; Bergamo () oils () Condon: National Gallery () \$1,101,440 in 1995, Portrait of Prospero Alessandri (oils)

Son of an architect. Artist from Bergamo who is best remembered as an accomplished painter of low-key,

realist portraits, with good precise detail, in which the sitters are allowed to speak for themselves without

too much manipulation by the artist. Had a wide range of sitters, including middle and lower classes. Possessed a strong preference for painting figures silhouetted against a plain background.

KEY WORKS Portrait of a Gentleman, c.1555–60 (London: National Gallery); Portrait of a Lady, c.1555–60 (London: National Gallery); Portrait of a Man, mid-1560s (St. Petersburg: Hermitage Museum); Portrait of a Bearded Man in Black, 1576 (Boston: Isabella Stewart Gardner Museum)

The Rape of the Sabines

Giambologna, c.1583, height 414 cm (163 in), bronze, Florence: Galleria dell'Accademia. A brilliant resolution of the problem of uniting several figures in a single sculpture.

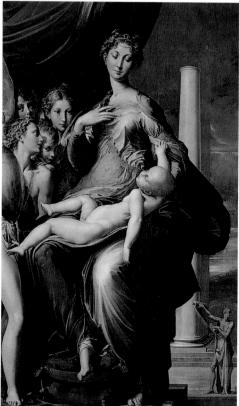

The Madonna of the Long Neck Girolamo Francesco Maria Mazzola Parmigianino, 1534–40, 215 x 132 cm, (84% x 52 in), oil on canvas, Florence: Galleria degli Uffizi. This work is a union of artificial elegance and spirituality.

Girolamo Francesco Maria Mazzola **Parmigianino**

€ 1503-40 PU ITALIAN

 Parma; Rome; Bologna ☑ fresco; oils; engravings; drawings
 London: British
 Museum (drawings)
 \$1,272,000 in 1995,
 Madonna and Child (oils)

He was short-lived, precocious, much admired ("Raphael reborn") and very influential. From Parma, in northern Italy – like his contemporary, Correggio.

Look for beautifully executed, refined, elegant, contrived, and precious works. He was especially great as a portraitist, projecting a cool, reserved, and enigmatic image. His religious and mythological paintings are a paradoxical combination of real and unreal. His art starts with acute observations from life, which he then transforms into fantasies – like a musical composer making variations on a theme. He also produced small-scale panel paintings, large frescoes, and brilliant, prolific drawings.

Notice the recurrent bizarre, elongated human figures, their impossibly long necks, and knowing looks (especially in his late work, which was considered very beautiful at the time). Look for the distorted and convoluted perspectives and variety of scales (his style was the epitome of Mannerism). Had a sophisticated line in erotica. His drawings are full of energy, movement, and light; he loved drawing as an activity for its own sake, as well as a tool.

KEY WORKS Self-Portrait in a Convex Mirror, c.1523 (Vienna: Kunsthistorisches Museum); Vision of St. Jerome, 1527 (London: National Gallery)

Antonio Correggio

⊖ c.1494-1534 PUITALIAN

 Parma Dioils; drawings Parma (churches, public buildings). London: British Museum (drawings) S2 \$322,000 in
 1987, Christ in Glory flanked by Putti on Clouds (works on paper)

Once hugely revered and popular (especially in 17th and 18th centuries), and consequently very influential. Now no longer well known: his virtues are completely out of fashion. Most important works are in Parma, northern Italy.

His works are full of genuine charm, intimacy, and tender emotion, and occasional sentimentality. Chose subjects from mythology and the Bible, and had a lyrical and sensitive style; everything (though immensely accomplished and not unambitious) is gentle – light, colour, foreshortening. Compositions are complex but satisfying, with easyto-read subjects displaying pleasing anatomy and relationships, youthful faces, and sweet smiles. Invented the idea of light radiating from the Christ child.

The in-situ decorations in Parma are forerunners of the over-the-top

 $c\,.\,1\,5\,0\,0-1\,6\,0\,0$

illusionistic decorations in Baroque Rome 100 years later (the link from one to the other was Lanfranco). See how he turns the ceiling into an illusionistic sky and then makes exciting things happen in it (Mantegna did this first and Correggio followed him). The charming, sentimental side derives from Leonardo and influenced French Rococo, Liked wistful faces and idealized profiles. Many fine drawings. KEY WORKS The Mystic Marriage of St. Catherine, c.1510-15 (Paris: Musée du Louvre); Judith, 1512-14 (Strasbourg: Musée des Beaux-Arts); Venus, Satyr, and Cupid, 1524-25 (Paris: Musée du Louvre); Venus with Mercury and Cupid, c.1525 (London: National Gallery)

Paris Bordone

⊖ 1500-71 PU ITALIAN

🔟 Italy; France; Germany 🛛 🚺 oils 🖬 Venice: Gallerie dell' Accademia

Venetian painter of portraits, religious works, landscapes, and mythological genre scenes. Strongly influenced by Giorgione and his teacher, Titian (despite disliking the latter intensely). Worked for King Francis I of France; important member of the first Fontainebleau School. His works, although facially realistic and finely detailed, demonstrate a problem with anatomy and perspective. **KEY WORKS** *Rest on the Flight into Egypt*, 1520–30 (London: Courtauld Institute); *The Presentation* of the *Ring of St. Mark to the Doge*, c.1535 (Venice: Galleria dell' Accademia)

Jacopo **Bassano**

⊖ c.1517-92 № ITALIAN

 Bassano; Venice
 Image: Constraint of the sense of

Best-known member of the prominent Venetian da Ponte family, who lived at Bassano (where grappa is made).

He was a painter of standard religious subjects, chosen for their power and drama. Note how he interpreted them to make the best of his interest in stocky peasants, animals, stormy mountain landscapes, and spectacular lighting.

Note how Bassano packs great drama into small spaces – which is why everyone seems to be in such a hurry, and either moving into the picture space or trying to get out of it. Beautifully painted hands and arms; striking light; marvellous, urgent handling of paint, which reflects the drama of the scene as though Bassano were part of it.

KEY WORKS *The Good Samaritan*, c.1550–70 (London: National Gallery); *Sheep and Lamb*, c.1560 (Rome: Galleria Borghese)

Federico Barocci

⊖ 1526-1612 № ITALIAN

 Urbino (Italy); Rome
 Image: Source of the second secon

Barocci was an Urbino-based painter of sentimental religious pictures, who suffered from terrible ill health (at times, evident in his work). Sugar-plum colours and soft forms (he was one of the first artists to use chalks), sweetly-faced Madonnas, and well-handled crowds. His work lacks bite, like cheap, sweet wine – all fruit and sugar, without acidity. **KEY WORKS** *Rest on the Flight to Egypt*, 1570–73 (Vatican: Pinacoteca); *Madonna del Popolo*, 1576–79 (Florence: Galleria degli Uffizi)

The Circumcision of Christ Federico Barocci, 1590, 356 x 251 cm (140 x 98% in), oil on canvas, Paris: Musée du Louvre. The significance of the circumcision is that it is the first occasion on which Christ shed his blood.

Jacopo Robusti Tintoretto

⊖ 1518-94 🕫 ITALIAN

☑ Venice
 ☑ oils; drawings
 ☑ Venice:
 Scuola di San Rocco; Ducal Palace; Accademia
 ☑ \$825,000 in 1994, *The Raising of Lazarus* (oils)

His father was a dyer (*tintore*) – hence his nickname, Tintoretto. Very little is known about his life. Although unpopular and unscrupulous, he was one of the major Venetian painters in the generation following Titian; he is said to have trained briefly with the greatest painter of the Venetian School. Very prolific, he was a formidable draughtsman, too.

In his monumental and vast religious works and mythologies, everything was treated with the drama, verve, panache, scale - and sometimes the absurdity of grand opera. Tintoretto used a model stage and wax figures to design his extraordinary and inventive compositions. His late religious work tended to be gloomy. His thick, hasty brushwork and exciting lighting show his passionate involvement in his creations. He painted

Susanna Bathing Jacopo Robusti Tintoretto, 1555–56, 146.5 x 193.6 cm (57 ½ x 76 ½ in), oil on canvas, Vienna: Kunsthistorisches Museum. A popular subject as it provides an excuse for female nudity.

portraits of notable Venetians but his busy studio produced many dull efforts.

When you find an extraordinary or off-centre composition, try standing or kneeling to one side so that you view the work from an oblique angle: he designed many works to be seen in this way, especially if they were big works for the small or narrow spaces of Venetian churches, where the congregation would be both kneeling and looking up or

forward to works hung on the side wall. Poor anatomy in

some portraits – hands that don't belong to the body. **KEY WORKS** Summer, c.1555 (Washington DC: National Gallery of Art); The Woman who Discovers the Bosom, c.1570 (Madrid: Museo del Prado); Christ at the Sea of Galilee, c.1575–80 (Washington DC: National Gallery of Art)

St. George and the Dragon

Jacopo Robusti Tintoretto, c. 1570, 158 x 100 cm (62% x 39% in), oil on canvas, London: National Gallery. Such a small scale is unusual.

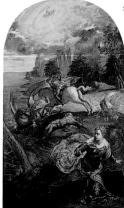

Rosso Fiorentino

Real name, Giovanni Battista di Jacopo. Unconventional, eccentric painter. Highly talented early Mannerist and pupil of Andrea del Sarto. Member of first Fontainebleau School. Born and worked in Florence, before moving to Venice, Rome, and France. Works include large number of religious scenes (famous for his *Musical Angel*, now in the Uffizi) as well as excellent portraits. Also worked in stucco, decorating the palace in Fontainebleau with painting and stucco decorations. Official painter of Francis I in 1532–1537; died in Paris. Credited with taking Italian Mannerism to France.

Look for lots of movement, bold colours, prominent muscles, faces filled with expression, and dreamlike sequences that have a strange realism to them. **KEY WORKS** *Portrait of a Young Man Holding a Letter*, 1518 (London: National Gallery); *Musical Angel*, c.1520 (Florence: Galleria degli Uffizi); *The Virgin and Child with Angels*, c.1522 (St. Petersburg: Hermitage Museum)

Francesco Primaticcio

⊖ c.1504-70 № ITALIAN

 Italy; France ☑ oils; fresco; stucco
 Château de Fontainebleau ☑ \$424,600
 in 1990, Ulysses Shooting through the Rings (works on paper)

Painter, born and trained in Bologna. Worked with Giulio Romano in Mantua. In 1532, he moved to France under patronage of Francis I. Became assistant to Rosso Fiorentino and appointed official art buyer to the king. Settled in Fontainebleau (and died in France), but returned to Italy regularly on art-buying trips. After death of Fiorentino, Primaticcio took over as leader of Fontainebleau School. After death of Francis I, worked for Henry II as Surveyor of Works.

Look for paintings and stucco, in high relief, characterized by sensuality, overcrowded scenes, tiny heads, and elongated, elegant limbs. Influenced by Mannerism, Michelangelo, Cellini, and Correggio; look for anatomical correctness, but over-muscled figures. **KEY WORKS** *The Rape of Helen*, 1530–39 (County Durham, UK: Bowes Museum); *Study of God*, 1555 (Los Angeles: J. Paul Getty Museum)

c.1530-1560 & c.1589-1610

FONTAINEBLEAU

The royal palace at Fontainebleau, near Paris, fostered two brilliant schools of decoration and architecture. The first – and most influential – was established by King Francis I in the 1530s. Francis (1514–47) employed a variety of artists and artisans: painters, poets, designers, sculptors, writers, printmakers, architects, stucco workers, gold- and silversmiths, and textile workers. Most of the early workers, such as Fiorentino and Primaticcio, came from Italy, thereby spreading Italianate art to northern Europe.

The second Fontainebleau School was established by Henry IV in 1589, after a period of great social and political unrest in France. Principal painters included Toussaint Dubreuil, Martin Fréminet, and Ambroise Dubois.

Former apartments of Anne de Pisseleu, Duchesse d'Étampes Francesco Primaticcio, 1533–44, Château de Fontainebleau. The influence of the Manneris tyle seen here spread quickly throughout northern Europe.

Francois Clouet

⊖ c.1510/16-72 PU FRENCH

🖸 France 🚺 oils; drawings 🖬 Chantilly (France): Musée Condé

Portrait painter, miniaturist, and draughtsman; from family of painters. Often confused with his father, Jean Clouet, who trained him; both were favourites of Francis I and both nicknamed "Janet" or "Jehannet". Ran large, successful studio. Appointed court painter to Francis I in 1541 and remained so for Henry II, Francis II, and Charles IX; retired in 1570. Strongly influenced by the Italianate paintings of first Fontainebleau School. Painted portraits of the nobility as well as allegorical landscapes. Famous portrait of Francis I - lavish with gold - has been attributed to both François and Jean Clouet.

Look for meticulous detail, rich decoration, attention to contemporary fashions, natural-looking facial features, and realistic expression.

KEY WORKS François I, King of France, c.1540 (Florence: Galleria degli Uffizi); Pierre Quthe, 1562 (Paris: Musée du Louvre); Lady in her Bath, c.1570 (Washington DC: National Gallery of Art)

Niccolò dell'Abbate

⊖ c.1512-71 PU ITALIAN

🔟 Modena; Bologna; France 🚺 oils; stucco 🛅 Bologna: Palazzo Pozzi 🛛 🔀 \$134,400 in 1998, Portrait of a Young Man Wearing a Plumed Hat (oils)

Italian-born decorator of palaces and portrait painter. He trained in his birthplace, Modena, and later developed a mature style in Bologna. He had a refined, elaborate, mannered, and artificial style playing with fantasy landscapes and themes of love. Settled in France in 1552 to work for the royal court. He was a key link figure between Correggio and Parmigianino (who influenced Niccolò with his elegant figure style), and the French classical landscape painters, such as Claude and Poussin (whom Niccolò influenced). He also painted portraits in both Italy and France. KEY WORKS Landscape with the Death of Eurydice, c.1552 (London: National Gallery); The Continence of Scipio, c.1555 (Paris: Musée du Louvre)

Charles IX François Clouet, 1550-74, 25 x 21 cm (91/5 x 81/4 in), oil on wood, Vienna: Kunsthistorisches Museum. At the time of painting the young French king was only aged 11 but had already been reigning for a year. Clouet's portrait invests the young face with firmness and maturity, whilst retaining the bloom of youth.

Toussaint **Dubreuil**

€ 1561-1602 P FRENCH

France D fresco; oils

Dubreuil was a painter and draughtsman who had a strong association with the second Fontainebleau School. He was apprenticed to Médéric Fréminet, father of Martin Fréminet. Appointed Premier Painter to Henry IV. Worked for the king in Fontainebleau and Paris; unknown to have left France. Little of his work survives, but his reputation as a talented painter remains intact.

Dubreuil designed large-scale tapestries and painted murals and frescoes, mainly of mythological and classical subjects. He is best known for the frescoes to be found in the Tuileries Palace, Paris. In his lifetime he was famed for painting murals in the Louvre - all destroyed by fire in 1661. Credited with forging the link between Mannerism and Classicism. KEY WORKS Angélique and Médor, 16th century (Paris: Musée du Louvre); Dicé gives a Banquet for Francus, c.1594-1602 (Paris: Musée du Louvre); Hyante and Climène at their Toilette. c.1594-1602 (Paris: Musée du Louvre); Hyante and Climène offering a Sacrifice to Venus, c.1594-1602 (Paris: Musée du Louvre)

El Greco

 ● 1541-1614
 Image: GREEK/SPANISH

 Image: Crete; Italy; Toledo (Spain)
 Image: Green of the Green

Real name Domenikos Theotocopoulos. He was born in Crete. Trained in Venice but worked in Spain, hence the name El Greco (the Greck). At once intense, arrogant, intellectual, and spiritual. A one-off, with a bewilderingly wide range of sources. Favoured by Philip II of Spain until he fell out of favour in 1582.

Art historians can have a good time trying to piece together the sources: directly applied colour (Titian), writhing figures (Michelangelo and Parmigianino), fragmented spaces and jewel-like acid colours (Byzantine mosaics and icons). But to touch the real El Greco, you have to forget this, and enter the spiritual world of visionary Christianity. Only then will you appreciate his genius and the significance of his superb technical skills.

The clongated figures, hands, feet, and faces are not intended to describe; rather to reveal the inner spirit. The soaring compositions are about the ascent from the material to the divine. The strange colours are a reflection and

The Burial of Count Orgaz, from a Legend

of 1323 EI Greco, 1586–88, 488 x 360 cm (192 x 141¼ in), oil on carvas, Toledo: Church of Santo Tomé. The faces of the mourners for the saintly Count are clearly portraits of contemporary gentlemen of Toledo. The boy who is standing in the bottom left-hand corner may be EI Greco's eldest son.

The Resurrection El Greco, 1584–94, 275 x 127 cm (108½ x 50 in), oil on canvas, Madrid: Museo del Prado. This painting is a good example of the visionary style that so displeased the Spanish monarch Philip II, causing El Greco to lose all of his royal patronage.

revelation of spiritual light. He believed that otherworldly appearances were a better aid to devotion than naturalism. El Greco excelled as a portraitist, painting mainly ecclesiastics or gentlemen; his works reveal the essence and idea of a person rather than a strict likeness. Look for the thrilling

draughtsmanship and the tense probing line that outlines his forms. **KEY WORKS** St. Joseph and the Christ Child, 1597–99 (Toledo: Museo de Santa Cruz); Madonna and Child with St. Martina and St. Agnes, 1597–99 (Washington DC: National Gallery of Art); Laocoön, c.1610 (Washington DC: National Gallery of Art)

Maerten van Heemskerck

⊖ 1498-1574 PUDUTCH

 Haarlem; Italy
 ioils; engravings
 Cambridge: Fitzwilliam Museum
 \$652,219 in 1987, Half-length Portrait of a Woman (oils)

Leading Haarlem painter of his day. His works were portraits, altarpieces, and mythologies. Van Heemskerck was totally transformed by a visit to Rome, 1532–36. Look for classical profiles; Michelangelesque, muscular figures; emotional (unrealistic) faces, gestures, and colours (hot reds, strong pinks, turquoise blue). Adopted Italian idealization rather than northern realism. **KEY WORKs** *The Crucifixion*, c.1530 (Detroit Institute of Arts); *Portail of a Lady with a Spindle and Distaff*, c.1531 (Madrid: Museo Thyssen-Bornemisza)

Pieter Aertsen

⊖ c.1508-75 P DUTCH

Antwerp 🚺 oils 🔀 \$317,042 in 1998, Parable of Royal Wedding (oils)

Painter of altarpieces and large-scale peasant subjects. Monumental genre and still-life scenes (such as a butcher's shop) that have a religious subject hiding in the background. Good at modelling with light in the Italian manner. Likes movement. A Bruegel without the humour and moral observation; a Rubens without the panache and power. **KEY WORKS** Market Scene, c. 1550 (Munich: Alte Pinakothek); Butcher's Stall with the Flight into Egypt, 1551 (University of Uppsala, Sweden); Cook in front of the Store, 1559 (Bruges: Musées Royaux des Beaux-Arts)

Family Group Maerten van Heemskerck, 1530, 118 x 140 cm (45½ x 55 in), oil on wood, Kassel (Germany): Staatliche Museen. This portrait is in a vigorous and relatively sober style and dates to before Heemskerck's visit to Rome. He spent most of his life in Haarlem and became Dean of the Painters' Guild.

"There are countries where they paint worse than in Flanders, but Flemish painting attempts to do so many things well that it does none well."

Marten de Vos

⊖ c.1531-1603 PU FLEMISH

Leading painter in Antwerp. He combined Flemish realism and detail with Italianate subjects, grandeur, and idealization (visited Rome, Florence, and Venice 1552–58). Painted altarpieces (vertical, with elegant, elongated figures);

> portraits (worldly Flemish burghers and plain backgrounds); and mythologies (large in scale, ambitious, and decorative). **KEY WORKS** *St. Paul Stung by a Viper on the Island of Malta*, c.1566 (Paris: Musée du Louvre); *Antoine Anselme and his Family*, 1577 (Bruges: Musées Royaux des Beaux-Arts); *Abduction of Europa*, c.1590 (Bilbao: Museo de Bellas Artes)

The Adoration of the Shepherds

Pieter Aertsen (studio of), 16th century, 84.5 x 113.7 cm (33 ½ x 44 ½ in), oil on panel, Private Collection. Many Aertsen altarpieces were destroyed in the Reformation riots.

Pieter Bruegel (the elder)

⊖ c.1525-69 P FLEMISH

 Image: Antwerp; France; Italy; Brussels
 Image: Oils;

 drawings
 Image: Vienna: Kunsthistorisches

 Museum
 Image: S4.56m in 2002, Drunkard

 Pushed into the Pigsty (oils)
 Image: S4.56m in 2002, Drunkard

Nicknamed "Peasant" Bruegel because of the subject matter of his paintings, not his character. Leading Flemish artist of his day whose subjects reflected contemporary religious and social issues. Paved the way for Dutch masters of the 17th century. Spelled his name Brueghel until 1559, then dropped the "h".

Brilliant works and accurately observed commentaries on the appearance and behaviour of the ordinary people of his day – like a first-rate stage play or TV soap opera. They are powerful because, as well as enjoying the existence and minutiae of his day and age, we can recognize ourselves – especially when he illustrates human follies, greed, and misdemeanours. Like all great artists, Bruegel speaks simultaneously about the personal and the universal.

Bruegel's bird's-eye views place us outside his world (we look down godlike, distanced, and superior); then by

The Tower of Babel (detail) Pieter Bruegel (the elder), 1563, 114 x 155 cm (45 x 61 in), oil on panel, Vienna: Kunsthistorisches Museum. An attempt to build a tower so tall it would reach up to Heaven.

Hunters in the Snow – February Pieter Bruegel (the elder), 1565, 117 x 162 cm (46 x 63% in), oil on canvas Vienna: Kunsthistorisches Museum. This famous series of depictions was commissioned by Niclaes Jonghelinck.

the fineness and charm of detail he draws us into it – we are simultaneously in his world and apart from it. Clear outlines and detail lead the eye through each picture. Early work (from Antwerp) is busy and anecdotal; later work (from Brussels) is simpler and more consciously and artistically composed and organized. Saw the Alps in 1552–53 on his way to Italy. **KEY WORKS** Netherlandish Proverbs, 1559 (Berlin: Staatliche Museum); The Gloomy Day, 1565 (Vienna: Kunsthistorisches Museum); The Wedding Feast, c.1567–68 (Madrid: Museo del Prado)

Albrecht Altdorfer

⊖ c.1480-1538 PU GERMAN

 Austria; Regensburg (Germany)
 oils; engravings
 Munich: Alte Pinakothek
 \$7,021 in 1998, Jahel and Sisera (woodcut)

Mainly a painter of altarpieces. Their most notable features are strange, visionary landscapes with eerie light effects, and in which wild nature is in control, with man taking second place. Small output. Gave up painting to go into local government. **KEY WORKS** *Christ Taking Leave of his Mother*, c.1520 (London: National Gallery); *St. Florian Altar*, c.1520 (Linz, Austria: Monastery of St. Florian; Florence: Galleria degli Uffizi)

Bartholomeus Spranger

€ 1546-1611 PU FLEMISH

Belgium; Italy; France; Austria; Czech Republic **()** fresco; oils; drawings

Painter, draughtsman, and etcher; exponent of late Mannerist style. Key figure of Northern European Mannerism. Born in Antwerp, worked in France, then moved on to Rome. where he studied under Taddeo Zuccaro. He was appointed court painter to the Pope in 1570. In Vienna he worked for Emperor Maximilian II. Then he moved on to Prague, where he stayed for the rest of his life. Became court painter to Emperor Rudolf II in 1581. His works were mainly of mythological or allegorical subjects. Very popular in northern Europe and hugely influential on Haarlem school.

Works are typical of the late Mannerist period. Look for a glut of nudes, improbable poses, a sensual style, luminosity of skin tone, and exaggerated features. His paintings are also filled with rich colours, finely executed small details, such as jewels, fruit, and flowers, and detailed decorations, such as on background furniture.

KEY WORKS Christ, the Saviour of the World, 16th century (Montauban, France: Musée Ingres); Diana and Actaeon, c.1590–95 (New York: Metropolitan Museum of Art); The Adoration of the Kings, c.1595 (London: National Gallery); Venus and Adonis, c.1597 (Vienna: Kunsthistorisches Museum); Allegory of Justice and of Prudence, c.1599 (Paris: Musée du Louvre)

Beheading of Saint Catherine Albrecht Altdorfer, c.1505–10, 56 x 36 cm (22 x 14½ in), oil on panel, Vienna: Kunsthistorisches Museum. Altdorfer appealed to German humanists wanting to revive native German traditions.

Adam Elsheimer

⊖ 1578-1610 P GERMAN

Venice; Rome Oils; engravings; drawings
 Munich: Alte Pinakothek Status
 \$450,000 in
 \$450,000 in

Popular, early practitioner of small-scale, ideal landscapes. Spent his working life in Italy. Very influential on artists such as Rubens, Rembrandt, and Claude. Lazy – should have painted more pictures.

Full of the kind of remarkable precision and detail that you see when looking down the wrong end of a telescope. All his works are painted on copper plates, which allows such fine detail (he must have had brushes with only one bristle).

Often used several sources of light in one picture, such as sunset and moon, daylight and torchlight. Painted charming trees, which look like parsley.

KEY WORKS Saint Christopher, 1598–99 (St. Petersburg: Hermitage Museum); The Baptism of Christ, c.1599 (London: National Gallery); St. Paul on Malta, 1600 (London: National Gallery); Nymph Fleeing Satyrs, c.1605 (Berlin: Staatliche Museum); The Flight into Egypt, 1609 (Munich: Alte Pinakothek)

Giuseppe Arcimboldo

⊖ 1527-93 № ITALIAN

Milan; Vienna; Prague oils
 Stockholm: Nationalmuseum \$\$1.3m
 1000, Reversible Anthropomorphic Portrait of a Man Composed of Fruit (oils)

Best known for fantastical faces and bodies made up of vegetables, trees, fruits, fish, and the like – he had the type of artistic curiosity produced in times of cultural and political upheaval (as much in the late 20th century as in the late 16th century). Worked mostly in Prague for Rudolf II, who was addicted to alchemy and astrology. Arcimboldo returned to Milan in 1587. **KEY WORKS** *Fire*, 1566 (Vienna: Kunsthistorisches Museum); *The Librarian*, 1566 (Balsta, Sweden: Skoklosters Slott); *Spring, Summer, Autumn*, and *Winter* (series of four), 1573 (Paris: Musée

du Louvre)

Water Giuseppe Arcimboldo, 1566, 66.5 x 50.5 cm (26% x 20 in), oil on canvas, Vienna: Kunsthistorisches Museum. The Four Elements – Earth, Air, Water, and Fire – were popular subjects for series paintings.

Hans Holbein (the younger)

⊖ c.1497/8-1543 P GERMAN/SWISS

Germany; Switzerland; France; England
 oils; drawings
 Windsor Castle (England):
 Royal Collection
 \$1,957,500 in 1984,
 Portrait of a Scholar (watercolours)

Painter and designer, chiefly celebrated as one of the greatest of all portraitists. Holbein was forced to leave Switzerland because of the Reformation. He came to England and established himself successfully as the propaganda portrait painter of the era of Henry VIII. He died of the plague, and very little is known about his life.

He was famous above all for his portraits (many of his early religious works were destroyed during the Reformation). There are interesting parallels with official court photographs of the mid-20th century, such as the work of Cecil Beaton: masterly, memorable, posed, officially commissioned images – in sharp focus – of the monarch and ruling officials, which are self-chosen icons of the political and constitutional

Lady with a Squirrel and a Starling

Hans Holbein (the younger), c.1526–28, 56 x 39 cm (22 x 15½ in), oil on panel, London: National Gallery. The animals in the painting may allude to the the family coat of arms of the sitter, Anne Lovell.

system. Also produced more informal and flattering (but never too relaxed) soft-focus images of high society that surrounded the court.

Note the way he draws and models with light (as does a photographer); the remarkable sharp focus detail (stubble on a chin, fur); intense lighting; wonderful feel for structure of a face and personality inside it. Portraits before mid-1530s are full of objects (sometimes symbolic); later they are flattened designs on a dark background (like postage stamp images?). The famous album of 80 drawings at Windsor contains the lovely, soft-focus, informal portraits.

KEY WORKS Portrait of a Woman, c.1532–35 (Detroit Institute of Arts); *The Ambassadors*, 1533 (London: National Gallerv):

Christina of Denmark, c.1538 (London: National Gallery); Edward VI as a Child, c.1538 (Washington DC: National Gallery of Art)

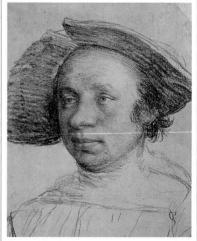

Portrait of a Youth in a Broad-brimmed Hat Hans Holbein (the younger), c. 1524–26, 24.5 x 20.2 cm (9 × x 8 in) chalk on paper, Derbyshire (UK): Chatsworth House. The artist learned his three-colour pastel technique in France.

Hans **Eworth**

⊖ c.1520−c.1574 🔎 FLEMISH

■ Netherlands; England ■ oils ■ London: Courtauld Institute ■ \$91,800 in 1984, *Portrait* of *Margaret Clifford* (oils)

Antwerp-born. Arrived in England in 1549. Difficult to identify. Look for very pale faces with tight, hard eyes; carefully observed and outlined figures, encased in lavish costumes and jewellery.

Queen Mary I Hans Eworth, 1554, London: Society of Antiquaries. Painted shortly after her marriage to Philip II of Spain, Mary wears his gift of the famous Peregrina pearl.

KEY WORKS Sir John Luttrell, 1550 (Private Collection); Portrait of Elizabeth Roydon, Lady Golding, 1563 (London: Tate Collection); Portrait of a Lady, c.1565–68 (London: Tate Collection)

Nicholas Hilliard

 England; France Watercolours
 London: Victoria & Albert Museum
 \$292,000 in 2002, Portrait of a Lady Wearing a Black Dress and Hat (miniature)

The son of an Exeter goldsmith, he trained as a jeweller. Principal portrait painter during the reign of Elizabeth I. Hilliard was especially "A vacant mind invites dangerous inmates, as a deserted mansion tempts wandering outcasts to enter and take up their abode in its desolate apartments." NICHOLAS HILLIARD

known for miniatures, which he produced in quantity to pay the bills for a large family. His reputation extended to France, which he visited c.1577–78.

Look for innovative oval format, symbolism, French elegance, fine outline. Life-size portraits of Elizabeth I exist. **KEY WORKS** *Queen Elizabeth I*, c.1575 (London: National Portrait Gallery); *Robert Dudley, Earl of Leicester*, 1576 (London: National Portrait Gallery); *Young Man Among Roses*, c.1590 (London: Victoria & Albert Museum)

Isaac Oliver

⊖ c.1565-1617 P BRITISH

 England; Venice Autorolours; drawings
 London: Victoria & Albert Museum 2 \$60,000
 in 1996, Young Gentleman in Black Silk Doublet, Black Earring (watercolour miniature)

Son of a Huguenot goldsmith who settled in England in 1568. Painter of miniatures (portraits, and mythological and religious images). Was a pupil of Hilliard, but adopted a different style, with strong shadows. His life revolved around the courts of Elizabeth I and James I. A

visit to Venice in 1590s led to softer style and richer colours. **KEY WORKS** *Charity*, c.1596–1617 (London: Tate Collection);

Lodovick Stuart, 1st Duke of Richmond, and 2nd Duke of Lennox, c.1605 (London: National Portrait Gallery)

Portrait of Robert Devereux, Earl of

Essex Isaac Oliver, c.1590s, miniature, watercolour on vellum, Beauchamp Collection, UK. Devereux (1566–1601) was a favourite of Queen Elizabeth I.

THE BAROQUE ERA c.1600-1700

"Baroque" was first used disparagingly to describe something artificially extravagant and complex. Only relatively recently has it been used to denote the art and architecture of the 17th century – an era that saw the creation of some of the most grandiose and spectacular buildings, paintings, and sculpture in the history of art.

The spectacular art and architecture of the period was reminiscent of grand opera, an art form that developed in 17thcentury Italy. Artists too assumed a grandeur not known before, sometimes adding to their role of creative practitioner that of impresario, art dealer, courtier, and diplomat.

IDEOLOGICAL DIVISION

The reasons for this extravagance lay in societies pulled apart by deep ideological and religious divisions. On one side were those fiercely committed to the absolute authority of the Catholic Church and the "Divine Right of Kings" with their requirements of unquestioning obedience. On the other were those

Fountain of the Four Rivers Gianlorenzo Bernini, 1651, marble and travertine, Piazza Navona, Rome. The magnificence of Bernini's sculptural projects was inspired by a belief that, through art, he was expressing the absolute authority of God and the Catholic Church. committed to Protestant reform and a belief in self-determination personally and nationally. The former used art without restraint to overwhelm and impress, creating such wonders as the Baroque churches and fountains of Rome and the palace of Versailles outside Paris. The latter disapproved of all worldly show, destroying religious art, whitewashing the interiors of churches and dispersing royal and noble collections.

The consequences of this ideological struggle are most clearly seen in three places. In England, Charles I's unyielding insistence on his divine right to rule led to his execution in 1649, the dispersal of his art treasures, and the institution of a Puritan Commonwealth that rejected any form of aesthetic experience. In the Netherlands, the Habsburgs attempted to stem the tide of Protestant revolt, finally conceding and then formally recognizing a

compromise which split the Low Countries in two: a Protestant north (Holland) and a Catholic south (Flanders). The new republic of Holland, mercantile and bourgeois, was able

The Hanging, after engraving by Jacques Callot (1592-1635), oil on canvas, Clermont-Ferrand: Musée Bargoin. Callot's series of engravings "The Miseries of War" illustrated many of the horrors of the Thirty Years' War.

to strengthen and expand its trading empire, especially in the East Indies. This new wealth funded a magnificent flowering of art. What the Dutch wanted were landscapes, seascapes, still lifes, and genre scenes of everyday life to hang on the walls

of their townhouses, and which they could buy and sell like other commercial goods.

RISE OF FRANCE In central Europe the Austrian Habsburgs faced another Protestant revolt, this

time in Bohemia. By 1618, this had given rise to general warfare, with other powers sucked in according to their religious affiliations: the Baltic powers, Denmark and Sweden, on the Protestant side against the Habsburgs and their Catholic allies. Religion was

the starting point but by the 1630s the war had become a trial of strength between France and the Habsburgs. The Thirty Years' War, as it was afterwards known, was the most brutal yet fought in Europe, carving a swathe of destruction across Germany and leaving perhaps one million dead. In some areas, 40 per cent of the population was killed. It ended in 1648, with France emerging as the most powerful state in Europe. This new dominance was brilliantly exploited by Louis XIV, whose direct personal

Chapelle Royale, Versailles Louis XIV's chapel was begun by royal architect Jules Hardouin-Mansart in 1689. During services the upper balcony was reserved for the royal family, while the nobles stood below.

SCIENCE IN THE 17TH CENTURY

In the course of the 17th century, European monarchs, as well as being generous patrons of the arts, also became patrons of the sciences, in particular astronomy and physics. State backing was given to science in England in 1662 when the Royal Society was established. A French equivalent, the Académie Royale des Sciences, followed in 1666.

The century was characterized by an accelerating scientific revolution. The telescope, the microscope, the slide rule, the thermometer, and the barometer were all invented before 1650. As early as 1609, the Italian

Visit of Louis XIV to the Académie Royale des Sciences in 1667

By the mid-17th century, it was clear that scientific advances would play a key role in the development of states. Official patronage duly followed.

reign lasted 54 years. He asserted his authority by controlling his court from his own vast creation, the largest palace in Europe, Versailles. His brand of absolutist rule – centralizing and martial, visually spectacular and rigidly ceremonial – created a style of kingship that was increasingly imitated at other European courts, notably by Peter the Great in Russia.

A NEW STYLE OF MONARCHY In the end the extravagance of Baroque art and architecture and the beliefs that it sought to promote were unsustainable. The future would lie not with unquestioning faith and obedience but with self-reliance. By then end of the century Spain was in decline politically and economically, central Europe was exhausted and devastated, and the Papacy forced to accept that it would have to live with rival Christian churches. France continued to prosper, but the soon-tore-emerge power was England, which was evolving a new form of constitutional monarchy and which was destined to supersede Holland as the world's leading trading nation.

As well as discovering the laws of motion and gravity, Newton wrote a comprehensive treatise on optics.

scientist Galileo Galilei used a telescope to discover four moons of Jupiter. He made other important observations that confirmed the Copernican theory of the Solar System. By the end of the century, Sir Isaac Newton in England had laid the theoretical foundations of the new science of physics.

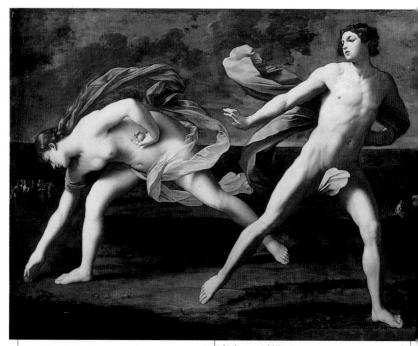

Guido Reni

⊖ 1575-1642 P ITALIAN

 Image: Bologna; Rome
 ▲ oils; fresco

 Image: Bologna: Pinacoteca
 ▲ \$2.44m in

 1985, David with the Head of Goliath (oils)

One of the principal Bolognese masters. Greatly inspired by Raphael, he was much admired in the 17th and 18th centuries, and much despised in the 20th.

THE SCHOOL OF BOLOGNA

c.1550-1650

Bologna never achieved the artistic preeminence of Florence, Venice, or Rome, but nonetheless this ancient university town made a significant contribution to the arts of Italy and Europe. Situated midway between Florence and Venice, the School of Bologna drew inspiration from both, creating its own distinctive style. In particular, Bolognese artists tried to synthesize Florentine classicism with Venetian theatricality, seen most successfully in the works of Carracci, Domenichino, Guercino, and Reni. The Bolognese School style was much imitated in the 18th century, but has been despised for most of the 20th.

Atalanta and Hippomenes Guido Reni, c.1612, 206 x 297 cm (81 x 117 in), oil on canvas, Madrid: Museo del Prado. Atalanta the virgin huntress would challenge her suitors to a race in which losing was punishable by death. Hippomenes distracted her by dropping three golden apples given to him by Venus and thus overtook her.

Reni's style was much influenced by his visits to Rome, the first of which came soon after 1660. His images of intense and idealized (unreal and artificial) emotional experiences are usually religious. His mythological works do not have the same levels of intensity, but are highly polished pieces. He himself was very beautiful but remained celibate – two qualities that are reflected in his paintings, which convey a remote and unapproachable beauty. Are they too self-consciously slick, posed, and theatrical for popular 20th-century taste?

Look for eyeballs rolling up to heaven (as a means of signalling intensity of feeling), and surprisingly subtle and sensitive paint handling.

KEY WORKS Deianeira Abducted by the Centaur Nessus, 1621 (Paris: Musée du Louvre); Susannah and the Elders, c.1620 (London: National Gallery); Lady with a Lapis Lazuli Bowl, c.1630s (Birmingham: Museums and Art Gallery); St. Mary Magdalene, c.1634–42 (London: National Gallery)

C.1600 - 1700

Annibale Carracci

● 1560-1609 № ITALIAN

 Bologna; Rome
 fresco; oils
 Rome: Farnese Gallery. Windsor Castle (England): Royal Collection (for drawings)
 \$2m in 1994, Boy Drinking (oils)

Born in Bologna, lived in Rome from 1595. Most talented member of a brilliant trio (with brother Agostino and cousin Ludovico). Revived Italian art from doldrums that followed Michelangelo. Victim of change of fashion from around 1850.

The arguments for his greatness are that he is as good as Raphael (brilliant draughtsmanship, observation of nude, harmonious compositions); as good as Michelangelo (anatomical knowledge, heroic idealization – his frescoes in the Farnese Palace are on a par with Michelangelo's in the Sistine Chapel); and as good as Titian (richness of colour). He was original: he invented caricature and his early genre scenes and ideal landscapes are full of fresh observation. Influenced Rubens and Poussin.

The Holy Women at Christ's Tomb Annibale Carracci, c.1597–98, 121 x 145.5 cm (47½ x 57½ in), oil on canvas, St. Petersburg: Hermitage Museum. All the figures are from studies of live models. The arguments against his greatness are that he was too eclectic – merely a plagiarist with no originality, the whole less than the individual parts. Look who his followers were – the awful Bolognese School. But, look for a large number of

Fishing Annibale Carracci, 1585–88, 136 x 253 cm (53% 99% in), oil on canvas, Paris: Musée du Louvre. He created the ideal landscape, in which a noble classical vision of nature becomes the setting for a narrative.

wonderful drawings, full of humour and personal touches. He had a strong belief in drawing and observing from life as an answer to sterile academicism – to the point of establishing a school to teach it – a belief shared in a different way by Impressionists, especially Cézanne. He gave up painting almost entirely in 1606. **KEY WORKS** *The Butcher's Shop*, 1580s (Oxford: Christ Church Picture Gallery); *Domine Quo Vadis?*, 1601–02 (London: National Gallery)

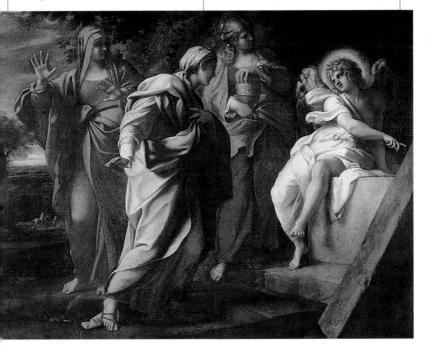

The Last Sacrament of St. Jerome Domenichino, 1614, oil on canvas, Rome: Vatican Museums. St. Jerome was one of the four fathers of the Christian Church. The Host is the symbolic centre of the scene.

Domenichino

● 1581-1641 PU ITALIAN

 Bologna; Rome; Naples
 fresco; oils;

 drawings
 Windsor Castle (England)

 \$3m in 2000, Rebuke of Adam and Eve (oils)

Bologna-born, worked in Rome and Naples. Small in stature (Domenichino means "little Dominic"). Look for idealization that is influenced by Raphael and antiquity (unlike his contemporary Caravaggio). Harmonious classical landscapes with mythological themes. Figures with expressive gestures that symbolize emotion but do not embody expression. He was a fine draughtsman (Windsor Castle's Royal Library has a superb collection of his drawings) and an excellent portraitist.

KEY WORKS Monsignor Agucchi, c.1610 (York: City Art Gallery); Landscape with Tobias Laying Hold of the Fish, c.1617–18 (London: National Gallery); St. Cecilia with an Angel Holding Music, 1620 (Paris: Musée du Louvre)

Giovanni Lanfranco

⊖ 1582–1647 🕫 ITALIAN

 Parma; Rome; Naples intersco; oils
 Rome: Churches of S. Andrea della Valle and S. Carlo ai Catinari. Naples: Chapel of S. Gennaro (Duomo); Church of S. Martino
 \$822,331 in 2003, *Crucifixion* (oils)

Key figure who established the enthusiasm for large-scale illusionistic decoration of churches and palaces in Rome and Naples. He painted crowds of figures on clouds floating on ceilings, with extreme foreshortening and brilliant light. Huge scale, excessive, inspiring his work needs to be seen in situ. KEY WORKS Elijah Receiving Bread from the Widow of Zarephath, c.1621-24 (Los Angeles: J. Paul Getty Museum); Moses and the Messengers from Canaan, 1621-24 (Los Angeles: J. Paul Getty Museum); Assumption of the Virgin, 1625-27 (Rome: S. Andrea della Valle); Ecstacy of St. Margaret of Cortona, c.1630s (Florence: Palazzo Pitti)

Christ and the Woman of Samaria Giovanni Lanfranco, 1625–28, 75 x 86 cm (29½ x 33½), oil on canvas, Oxford: Ashmolean Museum. A decorative interpretation of Christ's meeting with a prostitute.

с.1600-1700

Orazio **Gentileschi**

⊖ 1563-1639 № ITALIAN

☑ Italy; Paris; England
 ☑ 100 Italy; Paris; Paris; England
 ☑ 100 Italy; Paris;

Greatly esteemed Tuscan. Born in Pisa, but settled in Rome in 1576. Much influenced by Caravaggio, but without his wild energy and imagination; he domesticated Caravaggio's excesses. Look for large-scale, decorative works, simplified subjects and compositions, cool colours, sharp-edged draperies, and unconvincing realism. In 1626 he became court painter to Charles I of England, a safe choice artistically. KEY WORKS The Lute Player, c.1610 (Washington DC: National Gallery of Art); Annunciation, c.1621-23 (Turin: Galleria Sabauda); Lot and his Daughters, 1622 (J. Paul Getty Museum, Los Angeles); Cupid and Psyche, 1610s (St. Petersburg: Hermitage Museum)

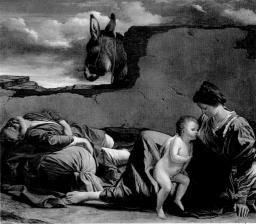

Rest on the Flight into Egypt Orazio Gentileschi, c.1615–20, 175.6 X 218 cm (69 X 85% in), oil on carvas, Birmingham (UK): Museums and Art Gallery. The use of harmonious blues and yellows is typical of Gentileschi.

Alessandro Algardi

1598–1654
 ITALIAN
 Rome; Bologna
 Sculpture
 \$37,500 in
 2005. Hercules Mounting the Pyre (works on paper)

Best sculptor in Baroque Rome after Bernini. They were great rivals and Algardi's studio seized control when Bernini was briefly out of favour with Pope Innocent X's court for shoddy work on St. Peter's. More obsessed than Bernini with classical ideal and the philosophy of the "Antique", so his work is more solid, permanent, and psychologically real than transitory fluidity of Bernini. Figures heavily classical in stance, robust, muscular, powerful. Pieces often symbolically crafted with attention to classical geometry and line. Preferred nobleness of cool white marble to Bernini's subtle colour-play. He preserves the differences between painting and sculpture. His marble reliefs became prototype for supplanting painted altarpieces with sculptured ones. His intense classicism influenced French Baroque development and he became a great friend of Poussin. KEY WORKS Portrait of Gaspare Mola, late 1630s (St. Petersburg: Hermitage Museum); Tomb of Leo XI, 1634-44 (Rome: St. Peter's); Decapitation of St. Paul, 1641-47 (Bologna: S. Paolo); Pope Liberius Baptizing the Neophytes, 1645-48 (Paris: Musée du Louvre)

Caravaggio

His full name was Michelangelo Merisi da Caravaggio. The only major artist with a serious criminal record (hooliganism and murder). Died of malarial fever at the age of 38. Contemporary of Shakespeare (1564–1616). Immensely influential.

LIFE AND WORKS

From his native Bologna he moved to Rome in 1592 where two distinct phases in his career occurred: an early period (1592-99) where he learned from the examples of the High Renaissance and the Antique; and a mature period (1599-1606) where he rejected decorum and turned to an exhilarating realism, displaying a complete disregard for proprieties and accepted rules. Nonetheless, he was well-received in Papal circles and executed many important Church commissions. He lived in a state of hyperexcitement, both in life and in his art. In 1606, at the height of his success, his tempestuous character led him into a murderous brawl over a wager on a tennis match. He was forced to flee to Malta, where, after another fight, he moved on to Sicily. Wounded in Palermo, he died near Naples while waiting for a Papal pardon. It arrived three days after his death. His many followers took up his mantle, ensuring his contribution to the future development of art, notably in Naples, Spain, and the Netherlands, and echoes of his influence are to be found in the works of artists as diverse as La Tour, Rembrandt, and Velasquez.

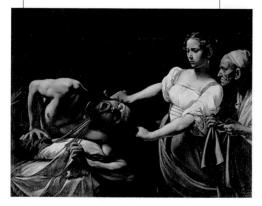

STYLE

He is known for sensational subjects, in which severed heads and martyrdom are shown in gory detail, and young

> men display charms that suggest decadence and corruption (his tastes were heterosexual, and his girlfriend a prostitute). His biblical subjects show immense moments of dramatic revelation, and his use of peasants and street urchins as models for Christ and the saints caused deep offence to many. His technique is equally

Judith and Holofernes 1599, 145 x 195 cm (57 x 76% in), oil on canvas, Rome: Palazzo Barberini. Caravaggio's interpretation emphasizes real life drama and shock rather than the symbolism of virtue defeating sin.

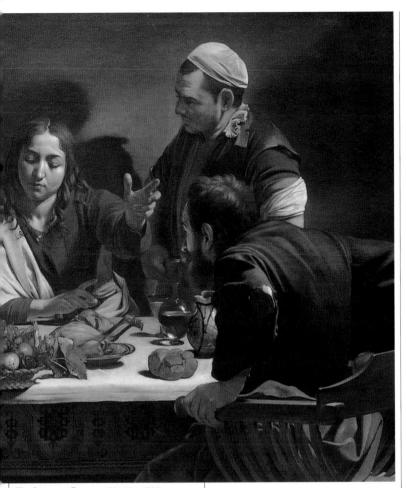

The Supper at Emmaus 1601, 141 x 196.2 cm (55½ x 77¼ in), oil and tempera on canvas, London: National Gallery. Caravaggio painted a second, more subdued version of this work five years later.

sensational and theatrical, with tense compositions, masterly foreshortening,

and dramatic lighting with vivid contrasts of light and shade (*chiaroscuro*). His later work, after 1606, was hastily executed and is more contemplative and less forceful.

WHAT TO LOOK FOR

His early works tend to be quite small, with halflength figures, and still-life compositions. Later, his

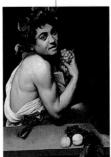

figures gained plasticity, and shadows became richer and deeper. Still-life details can contain symbolic meaning e.g. fruit that is full of wormholes. Also look closely at the modelling of flesh to observe the range of subtle rainbow colours used.

> KEY WORKS Calling of St. Matthew, 1599–1600 (Rome: S. Luigi dei Francesi); The Conversion of St. Paul, 1601 (Rome: S. Maria del Popolo); The Incredulity of St. Thomas, 1601–02 (Florence: Galleria degli Uffizi)

> **The Sick Bacchus** 1591, 67 x 53 cm (26½ x 20½ in), oil on carvas, Rome: Galleria Borghese. Most of the early erotic works were commissioned by high-ranking Church dignitaries.

172

Bartolommeo Manfredi

⊖ 1582-c.1622 🕫 ITALIAN

Rome O oils In Florence: Galleria degli Uffizi. Art Institute of Chicago
 \$65,854 in 1989, *Still Life with Grapes, Pomegranates, and Figs* (oils)

Little-known artist who was a successful imitator and follower of Caravaggio. Painted decadent everyday scenes as well as mythological and religious subjects. Preferred allegorical themes of conflict and discord. Style more rough and ready than his celebrated master but copies Caravaggio's theatrical lighting effects and also foreshortens the action so viewer feels an accomplice to the scene. Along with fellow Caravaggisti like Valentin, with whom Manfredi was often confused, he influenced northern artists who staved in Rome, e.g. Honthorst and Terbrugghen. KEY WORKS Cupid Chastized, 1610 (Art Institute of Chicago); Allegory of the Four Seasons, c.1610 (Ohio: Dayton Art Institute); Cain Murdering Abel, c.1610 (Vienna: Kunsthistorisches Museum); The Fortune Teller, c.1610-15 (Detroit Institute of Arts); The Triumph of David, c.1615 (Paris: Musée du Louvre)

(London: Dulwich Picture Gallery); The Liberation of St. Peter by an Angel, c.1622–23 (Madrid: Museo del Prado)

Artemisia **Gentileschi**

Daughter of Orazio Gentileschi, she was a better painter. Her tendency towards bloodthirsty themes was probably related to her own dramatic life, including being raped at 19 and tortured during the subsequent court case to see if she was truthful. Chose dramatic subjects, often erotic, bloody, and with a woman as victim or gaining revenge. Stylistically close to Caravaggio - made powerful use of foreshortening and chiaroscuro. She was the first female member of the Florentine Academy. KEY WORKS Judith Slaying Holofernes, c.1620 (Florence: Galleria degli Uffizi); Self-Portrait as the Allegory of Painting, 1630s (Royal Collection)

Guercino

⊖ 1591-1666 PU ITALIAN

 Image: Bologna; Rome
 Image: Bologna; Rome
 Image: Bologna; Forsco

 Image: Windsor (England): Royal Collection
 (for drawings)
 Image: Bologna; Forscollection

 (for drawings)
 Image: Bologna; Bologn

Full name Giovanni Francesco Barbieri Guercino, Came from Bologna, was self-taught and successful in his day. Now regarded as one of the most important 17th-century Italian artists, but was neglected until recently. At his best in his early work, which is lively, natural, and has exciting light and strong colour; also produced wonderful drawings. The Bolognese Pope summoned him to Rome in 1621; thereafter he lost his spontaneity and became boringly classical. "Guercino" means "squint-eved".

KEY WORKS The Dead Christ Mourned by Two Angels, c.1617–18 (London: National Gallery); The Woman Taken in Adultery, c.1621

Judith and her Maidservant Artemisia Gentileschi, 1612–1613, 114 × 93.5 cm (44½ × 36½ in), oil on canvas, Florence: Palazzo Pitti. These depictions of Old Testament heroines such as Judith appealed greatly to private collectors throughout Europe.

ur Grapes,

Gianlorenzo Bernini

● 1598-1680 PU ITALIAN

■ Naples; Rome Sculpture; oils \$\$ \$206,700 in 1981, David with the Head of Goliath (oils)

A devoted Roman Catholic for whom art was the emotional inspiration and glorification of godliness and purity. Although gifted as a painter, he despised the medium, regarding sculpture as the "Truth". Bernini set sculpture free from its previous occupation with earthly gravity and intellectual emotion, allowing it to discover a freedom, which permitted it to move, soar, and have a visionary and theatrical quality, which it had never had before.

A child prodigy, he had a sparkling personality, brilliant wit, and wrote comedies - qualities that shine through his work in sculpture. He was a virtuoso technically, able to carve marble so as to make it appear to move and come to life or have the delicacy of the finest lace. He epitomizes the Baroque style with its love of grandeur, theatricality, movement, and passionate emotion, and his finest works are to be found in Rome where he was the favourite artist of the Catholic Church.

At his best he blends sculpture, architecture, and painting into an extravagant theatrical ensemble, nowhere more so than in his fountains, where the play of water and refractions of light over his sculptured forms of larger-than-life human figures and animals creates a vision that is literally out of this world. **KEY WORKS** The Rape of Proservine, 1621-22 (Rome: Galleria Borghese); David, 1623 (Rome: Galleria Borghese); Constanza Buonarelli, 1635 (Florence: Museo Nazionale del Bargello); Cornaro Chapel (see pages 174-175); The Blessed Lodovica Albertoni, 1671-74 (Rome: S. Francesco a Ripa)

Apollo and Daphne

C.1600 - 1700

Gianlorenzo Bernini, 1622–25, height 243 cm (95% in), marble, Rome: Galleria Borghese. Bernini's unprecedented life-size masterpiece depicts the chaste nymph, Daphne, turning into a laurel tree, while Apollo, the Sun god, pursues her in vain.

Cornaro Chapel

Gianlorenzo Bernini 1645–52 The centrepiece of the lavishly decorated but intimate and candlelit Baroque Church of Santa Maria della Vittoria in Rome is the Cornaro Chapel. It contains one of Bernini's most ambitious works, created to resemble a miniature theatre.

Commissioned by Cardinal Federigo Cornaro, the chapel is a stunning amalgam of painting, sculpture, and architecture. Theatrically lit by a hidden window behind the altar, the divine light of God pours down on swooning Teresa at the very climax of her spiritual ecstasy. It is as though she is on a visionary cloud. The central figure group is of marble and gilded wood, and gilt bronze rays symbolically represent the power of divine light. High above are vaulted painted heavens, while below, the Cornaro family, in privileged front-row loggia boxes, are observers of this spectacle. Bernini stuck faithfully to St. Teresa's spiritual account of an angel piercing her heart with an arrow of divine love - her mystical union with Christ.

TECHNIQUES

No sculptor before Bernini used light to accomplish an illusion of life in 3-D sculpture. Unlike diffused light of the Renaissance, this directed light accentuates the poised moment of action. Warming reds and yellows in the lower human zone balance the religious purity of the white marble group.

The angel looks adoringly at St. Teresa, ready to plunge his arrow into her heart for a second time

The elaborate and carefully calculated setting brilliantly heightens the full visual impact of the white marble figure group. Made from rich polychrome marble, it presents a spectacular climax that is both architectural and spiritual.

Bernini's attention to detail can be seen in the precise carving of the little finger of the angel's left hand

Bernini's ability to make marble seem like flowing drapery was one of his most exceptional skills

Modern interpretations draw parallels between the appearance of the angel and Cupid, the son of Venus with his love-laden darts. This emphasizes the seemingly sexual quality of the saint's mystical experience.

Cornaro Chapel

Medium marble, gilded wood, bronze Height 350 cm (137% in) Location Rome: Santa Maria della Vittoria

THE BAROQUE ERA

Salvator Rosa

⊖ c.1615-73 № ITALIAN

Naples; Rome; Florence is oils; engravings
 \$696,000 in 1992, Portrait of Artist Wearing
 Doublet, Cap, Torn Glove, and Sword (oils)

One of the first wild men of art – quarrelsome, anti-authority, self-promoting, lover of the macabre. Poet, actor, musician, satirist. Now best remembered for large, dark, stormy, fantastic mountainous landscapes and unpleasant witchcraft scenes (both much collected in the 18th and early 19th centuries). He was said to have fought by day and painted by night.

KEY WORKS *The Return of Astraea*, 1640–45 (Vienna: Kunsthistorisches Museum);

Self-Portrait Salvator Rosa, c.1641, 116.3 x 94 cm (45% x 37 in), oil on canvas, London: National Gallery. The Latin inscription below Rosa's hand means "Be quiet, unless your speech be better than silence." He painted a companion portrait of his mistress Lucreia whom he portrayed as one of the Muses of Poetry.

 $C\,.\,1\,6\,0\,0-1\,7\,0\,0$

Human Fragility, c.1656 (Cambridge: Fitzwilliam Museum); The Spirit of Samuel Called up before Saul by the Witch of Endor, 1668 (Paris: Musée du Louvre)

Pietro da Cortona

€ 1596-1669 PU ITALIAN

 Rome; Florence fresco; oils; stucco
 Rome: Palazzo Barberini; Santa Bibiana
 \$391,200 in 1991, Wooded River Landscape with Cascades and Men Dragging Net (drawing)

Virtuoso architect, decorator, and painter, much sought after by Catholic grandees in Italy and France. Known as key creator of Roman High Baroque

and for large-scale, extreme, illusionistic paintings where ceilings open up into a bold, dramatic, rich theatre of space, colour, human activity, architecture, learned allusion, and spiritual uplift.

KEY WORKS Allegory of Divine Providence and Barberini Power, 1633–39 (Rome: Palazzo Barberini); Glorification of the Reign of Urban VIII, 1633–39 (Rome: Palazzo Barberini); Allegories of Virtue and Planets, 1640–47 (Florence: Palazzo Pitti)

The Martyrdom of St. Paul, c.1656–59 (Houston: Museum of Fine Arts); Clorinda Rescuing Sofronia and Olindo, c.1660 (Los Angeles: J. Paul Getty Museum)

Luca Giordano

c.1634 – 1705 № ITALIAN
 Naples; Florence; Venice; Madrid
 oils; drawings; fresco \$\$453,600
 in 1997, *The Raising of Lazarus* (oils)

The most important Italian decorative artist of the late 17th century. Prolific and energetic, created very theatrical, large-scale work; successful decorator of palaces (especially ceilings). Loved

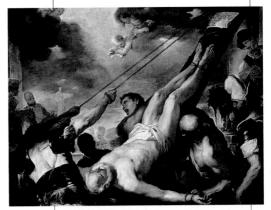

Mattia **Preti**

⊖ c.1613-99 № ITALIAN

 Rome; Naples; Malta Arcsin fresco; oils
 \$1,185,000 in 1989, The Liberation of St. Peter (oils)

Accomplished painter of large-scale decoration that successfully combines the realism of Caravaggio and the theatricality of grand Venetian painting (it sounds unlikely, but he showed it could be done and thereby had much influence on the development of exuberant Baroque decorations). **KEY WORKs** *Concert*, c.1630 (St. Petersburg: Hermitage Museum); *The Mariage at Cana*, c.1655–60 (London: National Gallery);

The Crucifixion of St. Peter Luca Giordano, c. 1660, 196 x 258 cm (77% x 101%in), oil on carvas, Venice: Gallerie dell'Accademia. A dramatic representation of St. Peter, the leader of the 12 disciples of Christ, who was crucified upside down by Nero in 64 cε.

mythological subjects, which enabled him to emphasize dramatic action, bold compositions, contrasts of light and dark, silhouettes, violence and lust, and subjects that polarize good and evil. Giordano's last work was the Treasury Chapel ceiling of S. Martino, Naples. Nicknamed "Luca Fa Presto" (Luke works quickly). **KEY WORKS** *The Fall of the Rebel Angels*, 1666 (Vienna: Kunsthistorisches Museum); *Allegory*, 1670 (Los Angeles: J. Paul Getty Museum); *Death of Seneca* c.1684 (Paris: Musée du Louvre)

"Rosa is a great favourite with novel writers, particularly the ladies."

JOHN CONSTABLE

THE BAROQUE

The dominant style of the 17th century, used by the Catholic Church to proclaim its continuing power – hence the best examples are to be found in Italy, Spain, France, Austria, Southern Germany, and Central Europe. Also loved by Absolute Monarchs who wanted to emphasize their worldly authority and the riches of their possessions and lifestyle.

STYLE

Fontana del Moro Gianlorenzo Bernini, 1653, stone, Rome: Piazza Navona. Originally designed in 1576 by Giacomo della Porta, the Fontana del Moro was then altered by Bernini in 1653. He designed the central statue of a muscular Moor holding a dolphin. The tritons blowing shells, from which water exits, are 19th-century additions. "The style of absolutism" was used by the Catholic Church as a means of harnessing the magnificence of art to influence the largest possible audience. Exploiting the ideas of Classicism and religious doctrine, work was to be visually stunning and emotionally engaging to reflect the new Counter-Reformation confidence of the Church. The subsequent boldness of the artists' styles translates as huge freestanding sculptures, exaggerated decorations, intensely lit, emotional oil paintings with grand operatic-style themes, and a new architecture, planned round a series of geometrically controlled spaces to create an animated grandeur. Its hallmarks are illusion, movement, drama, rich colour, and pomposity.

SUBJECTS

Religious subjects were paramount, especially the lives of saints and martyrs. These included recent saints such as St. Ignatius Loyola, founder of the Jesuits, and the Spanish mystic St. Teresa of Ávila (both canonized in 1622). Mythological characters, such as the chaste nymph Daphne or Proserpine, raped by Pluto, were used to illustrate religious ideals of purity. Statues of allegorical figures -Peace, Faith, Modesty, Chastity - were also common. Portraits tended to be bombastic and self-consciously dramatic. However, the everyday also found a place with scenes that included taverns, card players, and water sellers.

KEY EVENTS

1595	Annibale Carracci summoned from Bologna to decorate Farnese Palace, Rome
1601	Caravaggio paints the first of two versions of <i>The Supper at Emmaus</i>
1629	Bernini appointed architect of St. Peter's and of the Palazzo Barberini
1634	Charles I's Banqueting House, London: ceiling by Rubens completed
1663	Bernini's colonnaded piazza in front of St. Peter's
1669	Louis XIV orders massive reconstruction programme at Versailles

c.1590-1700

WHAT TO LOOK FOR

The best example of secular Baroque decoration is Carracci's rarely seen frescoes for the vault of the sculpture gallery of the Farnese Palace in Rome. To complement the outstanding Farnese collection of Antique sculpture, Carracci

All the figures are based on studies of live models Landscape shows Mount Ida, where Anchises traditionally met the beautiful Venus Venus disguised herself as a mortal and seduced Anchises. Their child was Aeneas, the founder of Rome

created on the vaulted ceiling a picture

stories from Ovid's Metamorphoses. The

resulting effect is one of the triumphs

of the Baroque ambition to marry

architecture, painting, and sculpture.

gallery of mythological scenes illustrating

Venus and Anchises Annibale Carracci, 1597–1604. Part of Carracci's frescoed cycle depicting The Loves of the Gods. Anchises captures the heart of goddess Venus.

Anchises was a Trojan shepherd. He is shown in the act of removing Venus's sandal Venus wore jewels and sweet-smelling perfume. The couch belonged to Anchises

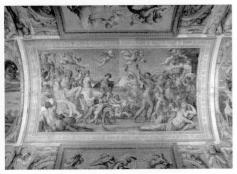

Cupid, the son of Venus, is nearly always shown as a pretty, curly-haired boy who is present whenever love is in the air.

The central panel depicts the triumph of Bacchus and Ariadne, for which the artist made a detailed study of Classical reliefs. So disappointed was Carracci by the small fee he received for the work that he took to drink, and died aged only 49.

Nicolas Poussin

\varTheta c.1593-1665 🔎 FRENCH

 Paris; Rome
 Image: Comparison of the second sec

Founder of French classical painting. Immensely influential on French artists up to (and including) Cézanne, presenting the standard to be lived up to.

LIFE AND WORKS

Son of a French farmer, became inspired when an artist arrived to decorate his village church. Struggled in early years through poverty and ignorance until, during a trip to Paris, engravings of Raphael's works exposed him to Italian High Renaissance, so set off for Rome. Except for two years as court painter to Louis XIII (1640–42), he worked in the epicentre of Baroque Italy, though more at home with his classical style. Did not survive to see his style glorified by the French Academy in the late 17th century.

STYLE

His paintings, usually biblical or from Greco-Roman antiquity, are severe, intense, and intellectual in subject matter,

> "Painting is the lover of beauty and the queen of the arts." NICOLAS POUSSIN

> > Portrait of the Artist

1650, 97 x 73 cm (38 x 29 in), oil on canvas, Paris: Musée du Louvre. A grave Poussin makes no concession to vanity in his portraiture. style, and references: complex allegorical subjects with a moral theme; constant references to classical antiquity; a hidden geometrical framework of verticals, horizontals, and diagonals into which the figures are placed and by which they are tied together.

WHAT TO LOOK FOR

Note how the figure groups are positioned flat on the surface of the picture, like a carved bas relief (another classical reference).

The figures, although notionally in motion, have the stationary quality of

Arcadian Shepherds c. 1648–50, 58 x 121 cm (33% x 47% in), oil on canvas, Paris: Musée du Louvre. The shepherds examine an inscription whose meaning is "Even in Arcadia, I [Death] am ever present."

 $C\ .\ 1\ 6\ 0\ 0\ -\ 1\ 7\ 0\ 0$

The Rape of the Sabines c. 1637–38, 159 cm x 206 cm (62% x 81 in), oil on canvas, Paris: Musée du Louvre. Worried about the declining birth rate, Romulus, Rome's founder, arranged a feast that resulted in young Romans marrying Sabine maidens.

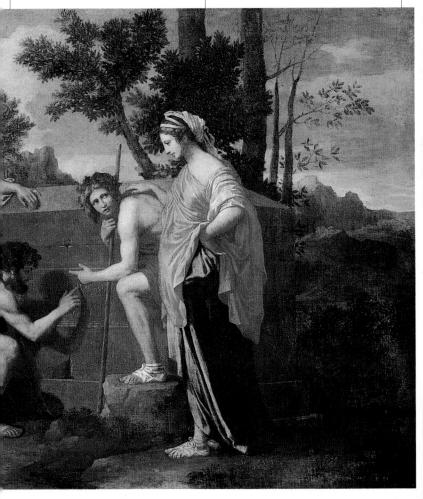

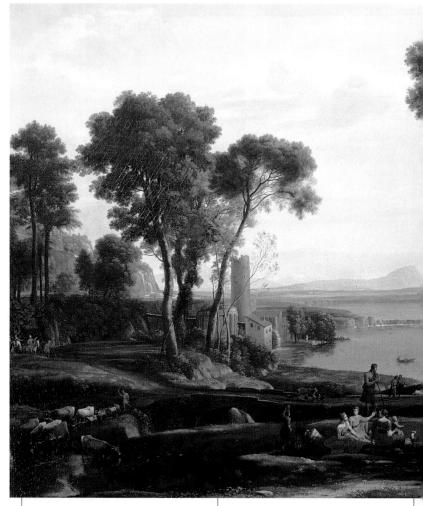

Moïse Valentin

⊖ c.1593-1665 P FRENCH

🔃 Rome 🚺 oils 🛅 Paris: Musée du Louvre

Son of an Italian. From Boulogne in France, he settled in Rome. His life is obscure but most of his known work dates after 1620. One of the Caravaggisti, loved the plebeian side of art, continuing the master's style. Probably met his friend Poussin in Rome but was more emotional, dramatic. Preferred seedy, bawdy scenes. **KEY WORKS** Christ and the Adulterss, 1620s (Los Angeles: J. Paul Getty Museum); The Expulsion of the Money-Changers from the Temple, c.1620–25 (St Petersburg: Hermitage Museum)

Claude Lorrain

⊖ c.1600-82 P FRENCH

 Rome; Naples; Lorraine (France)
 ioils
 London: National Gallery; British Museum (drawings). Paris: Musée du Louvre
 \$1.86m in 1999, Evening Landscape with Mercury and Battus (oils)

Also called Le Lorrain or Claude Gellée. Originator of the pastoral or picturesque landscape. Immensely influential and popular, especially in the 18th and early 19th centuries. Worked in and around Rome. Claude's landscapes and seascapes are enjoyable on two levels: as exquisite depictions in their own right and as a poetic setting for the staging of

mythological or religious scenes. Notice how he moves your eye from side to side across the picture in measured steps via well-placed figures, buildings, or paths (coulisse), and at the same time takes you from warm foreground to cool, minutely detailed distance (aerial perspective).

Magical painter of light – the first artist to paint the sun itself. Uses a formula of well-proven, balanced compositions and colours to produce a serene, luminous, calm, and harmonious atmosphere – although somewhere in the airless heat there is usually a refreshing breeze: a rustle in the tree tops, an unfurling flag, the sails of a boat in the far distance, or birds gliding on a current of air.

Landscape with the Marriage of Isaac

and Rebekah Claude Lorrain, 1648, 149 x197 cm (58 x 77 in), oil on canvas, London: National Gallery. The Old Testament story lends artistic respectability to this pastoral landscape.

KEY WORKS The Judgement of Paris, 1645–46 (Washington DC: National Gallery of Art); Landscape with Hagar and the Angel, 1646 (London: National Gallery); Landscape with Ascanius Shooting the Stag of Silva, 1682 (Oxford: Ashmolean Museum)

Phillippe de Champaigne

⊖ c.1602-74 PU FRENCH

Brussels; Paris D oils 2 \$423,077 in 2003, Annunciation to Maria (oils)

Born in Brussels; arrived in Paris in 1621. Brilliant, successful painter of portraits and religious pictures at the court of Louis XIII (favoured by Cardinal Richelieu). Champaigne had a unique, memorable style, which combines over-the-top Baroque grandeur with severe, crisp, detailed, colourful, authoritarian austerity – you believe it should not be possible, but he showed that it could be done.

KEY WORKS Triple Portrait of Cardinal Richelieu, 1642 (London: National Gallery); Moses with the Ten Commandments, 1648 (St. Petersburg: Hermitage Museum); Ex Voto, 1662 (Paris: Musée du Louvre)

Gaspard Dughet

⊖ c.1615-75 PU FRENCH

 Rome Dils; drawings; engravings
 \$108,000 in 1994, Italianate Wooded River Landscape with Fishermen on Boat (oils)

He was the brother-in-law of Poussin. Very popular in the 18th century, but few works can be confidently attributed to him. Produced decorative landscapes in which he sometimes tries almost too hard to combine the heroic qualities of Poussin with the pastoral features of Claude. Ought to be very good, but frequently disappoints.

KEY WORKS Landscape with Herdsman, c.1635 (London: National Gallery); A Landscape with Mary Magdalene Worshipping the Cross, c.1660 (Madrid: Museo del Prado); Classical Landscape with Figures, c.1672–75 (Birmingham, UK: Museums and Art Gallery)

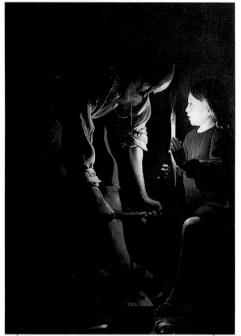

St. Joseph the Carpenter Georges da La Tour, c. 1640, 130 x 100 cm (51% x 39%), oil on canvas, Paris: Musée du Louvre. These humble settings for religious scenes were inspired by a Franciscan-led religious revival.

Georges de La Tour

⊖ c.1593-1652 P FRENCH

■ Lorraine (France) ■ oils ■ \$3,094,000 in 1991, *Blind Hurdy-Gurdy Player in Profile* (oils)

Shadowy figure with few attributed works, many in poor condition. In fashion with art historians, who are in the process of reconstructing his oeuvre. Major master or overrated enigma?

His work has two points of focus: peasant scenes (pre-1630s); nocturnes with spectacular handling of candlelight (post-1630s). Also painted cardsharpers and fortune-tellers. Beware of copies and imitations passing as the real thing.

Note how he paints peasants and saints with unnerving realism: wispy, greasy hair; lined brows and convincing old, dry skin; distinctive horny finger nails and peasant hands; sinister, cunning, piggy eyes. Used strong and beautiful *chiaroscuro* and lighting, and flat, non-existent backgrounds. Unconvincing when painting young flesh – the faces are wooden and mask-like. Master at creating virtuoso candlelight effects (such as the way it makes a hand look translucent).

KEY WORKS *Job and his Wife*, 1632–35 (Epinal, France: Musée Départemental des Vosges); *The Repentant Magdalen*, c.1635 (Washington DC: National Gallery of Art); *St. Jerome*, c.1639 (Musée de Grenoble)

Le Nain brothers

⊖ c.1588-1677 PU FRENCH

🔟 Laon (France); Paris 🛛 🗕 oils

Paris: Musée du Louvre 2 \$194,922 in 1990, *Three Musicians Playing the Lute* (oils) by Mathieu Le Nain

Antoine (c.1588–1648), Louis (c.1593–1648), and Mathieu (c.1607–77). Painters of largescale mythologies, allegories, and altarpieces, but best known for smaller-scale portrayals of peasant groups sitting in an interior, doing nothing much, with dignity. Note

the style; sensitivity when handling light and colour; pleasing and detached powers of observation. Difficult to assign works as all signed their work by surname only. They were admired by Cézanne. **KEY WORKS** A Landscape with Peasants, Louis Le Nain, c.1640 (Washington DC: National Gallery of Art); Four Figures at a Table, Le Nain brothers, c.1643 (London: National Gallery)

François Girardon

⊖ 1628-1715 P FRENCH

 Image: Paris, Rome
 Image: Sculpture
 Image: Paris: Palace

 of Versailles; Musée du Louvre. Los Angeles: J. Paul

 Getty Museum
 Image: Sculpture
 Paris: Palace

 of Proserpine (sculpture)

Studied antiquities in Rome. Returned to dominate Sun King Louis XIV's sculptural projects, including decoration of Louvre, with distinct classical style. Unified muscular bodies. Lyrical with careful contrast of gesture and pose. Preferred Poussin's painting as chief influence rather than his sculptor counterparts. On death owned 800 sculptures, second biggest collection after King's. **KEY WORKS** *Apollo Tended by the Nymphs*, c.1666 (Château de Versailles); *Monument to Cardinal Richelieu*, 1675–77 (Paris: Sorbonne Church)

184

$c\,\,.\,1\,\,6\,\,0\,\,0-1\,\,7\,\,0\,\,0$

185

José Ribera

⊖ 1591-1652 P SPANISH

Naples olis; engravings; drawings
 Naples: Museo di Capodimonte. Madrid:
 Museo del Prado St. Sartholomew (oils)

Spanish-born, in 1616 Ribera settled in Spanish-owned Naples where he was known as "Lo Spagnoletto". Naples was one of the main centres of the Caravaggesque style at this time. He was the major Neapolitan painter of the 17th century. Particularly good at martyrdom, shown through powerful images of resigned suffering. Sometimes the subject matter is repelling, but the

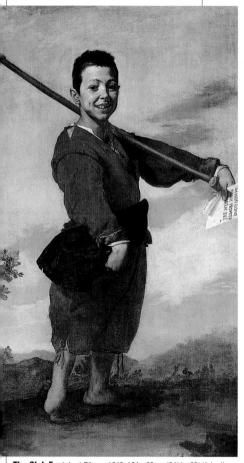

The Club Foot José Ribera, 1642, 164 x 92 cm (64% x 36% in), oil on canvas, Paris: Musée du Louvre. In his late work Ribera softens his dramatic lighting, adopting a looser style with gentler modelling and airy harmonious tones.

technique is exquisite and this results in an almost unbearable "can't look but must look" tension. He makes brilliant use of *chiaroscuro* and tenebrism (light coming from a single source above), and was an early exponent of realism – his saints and philosophers are real people from the streets of Naples. Observe his marvellous painting of textures and surfaces.

He paints old men's faces wonderfully, with convincing, leathery flesh faces, necks, and hands. Notice how the brushstrokes follow the contours of the flesh, across a brow, down an arm. He couldn't do convincing women's or boy's flesh and faces, though. Is his brighter, Venetianstyle palette that he adopted from the

1630s a step forward or a step backward? Be aware that many pictures have darkened with time. **KEY WORKS** Martyrdom of St. Bartholomew, c. 1630 (Madrid: Museo del Prado); Apollo Flaying Marsyas, 1637 (Bruges: Musées Royaux des Beaux-Arts); Isaac Blessing Jacob, 1637 (Madrid: Museo del Prado)

Francisco de **Zurbarán**

● 1598 – 1664
 № SPANISH
 № Seville; Madrid
 № Naples: Museo di Capodimonte.
 Madrid: Museo del Prado
 № \$1.9m in 1998, *St. Dorothea* (oils)

"The major painter between Velasquez and Murillo" (read this as code for good, not great). His principal patrons were Spanish religious orders. His most characteristic works are of saints and monks in praver or meditation. Like Caravaggio, his work has a hard-edged realism. employs strong chiaroscuro effects, and demonstrates a smooth technique and care for precise detail. It has dramatic visual impact, but generally lacks convincing emotion. Died out of fashion and in financial difficulty. KEY WORKS Beato Serapio, 1628 (Hartford, Connecticut: Wadsworth Atheneum); St. Margaret, 1630-34 (London: National Gallery)

Juan de Arellano

⊖ c.1614-76 🕫 SPANISH

Pre-eminent Spanish flower painter of the 17th century. Detailed, skilful works, often executed and designed as pairs. Shows bouquets in baskets, on rough stone plinths, or in vases of crystal or metal, with a careful balancing of red, white, blue, and yellow. His later work is more loosely painted, with full-blown flowers and curling leaves.

KEY WORKS Garland of Flowers with Landscape, 1652 (Madrid: Museo del Prado); Irises, Peonies, Convolvuli, and other Flowers in an Urn on a Pedestal, 1671 (London: Christie's Images)

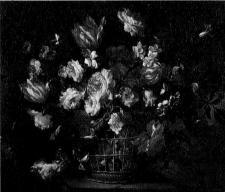

Still Life of Flowers in a Basket Juan de Arellano, c.1671, 84 x 105.5 cm (33 x 41½ in), oil on canvas, Bilbao: Museo de Bellas Artes. Spain has a long tradition of still-life painting, influenced by Netherlandish art.

Bartolomé Murillo

➡ 1617-82 ₱ SPANISH

 Image: Seville Seville: San Francisco;

 S. Maria la Blanca. London: Dulwich Picture

 Gallery (for genre)

 Image: St. Joseph and Christ Child (oils)

Regarded until about 1900 greater than Velasquez and as good as Raphael. Now the poor man's Velasquez. Born and bred in Seville. Pious family. Produced acres of soft-focus sentimental religious pictures for the home market. Fewer, better, genre scenes (good line in ragamuffins), done for the export market. Good portraits.

A Murillo revival campaign is currently under way. It is easy to extol his confident, masterly way with colour, paint handling light, and strong composition. The genre scenes are appealing as subjects; they influenced Reynolds and Gainsborough. Uphill struggle to find virtue in the overly sweet and sometimes sickly religious pictures – maybe being widowed at 45 made him excessively misty-eyed about young mothers and children. KEY WORKS The Young Begear, c.1645 (Paris:

Musée du Louvre); *The Virgin of the Rosary*, c.1649 (Madrid: Museo del Prado)

Claudio Coello

⊕ 1642–93
 ₱ SPANISH

Italy, Madrid 2 oils Madrid: Museo
 del Prado. St. Petersburg: Hermitage Museum
 \$4.8m in 2000, Portrait of Fernando Valenzuela
 (oils)

Deeply influenced by Rubens, van Dyck, and Titian whose works were in Spanish Royal collection and studied for seven years in Italy. Painter to Charles II in 1683. Often complex and complicated works, fussy with exaggerated detail. Preempting Rococo. Employed loose brushstrokes, brilliant palette, and moody lighting. Masterpieces are his Titian-style portraits, particularly of Charles II, capturing degeneracy of last Hapsburg ruler of Spain. **KEY WORKS** *Self-Portrait*, 1680s

(St. Petersburg: Hermitage Museum); *The Repentant Mary Magdalene*, 1680s (St. Petersburg: Hermitage Museum)

Juan de Valdés Leal

Seville; Cordoba 2 oils; engravings
 \$1,261,000 in 2004, Sacrifice of Isaac (oils)

Spanish painter and engraver. Founded the Seville Academy of Painting with Murillo. Religious painter with fixation on the macabre. Vibrant colouring and dramatic lighting, vivid movements, volatile, verging on the operatic. Loved swirling forms, draperies, grand gestures. Anticipates the decorative exuberance of the 18th-century Rococo style. **KEY WORKS** *The Assumption of the Virgin*, 1658–60 (Washington DC: National Gallery of Art); *The Immaculate Conception of the Virgin*, *with Two Donors*, c.1661 (London: National Gallery)

186

$C \, . \, 1 \, 6 \, 0 \, 0 - 1 \, 7 \, 0 \, 0$

1599–1660
 SPANISH
 Seville; Madrid; Italy
 Madrid: Museo del Prado.
 London: National Gallery
 \$8.1m in 1999, St. Rufina (oils)

Diego Rodríguez de Silva y Velázquez was the great Spanish painter of the 17th century whose life and work were inextricably linked with the court of King Philip IV. He wasn't a prolific artist but was precocious; while still in his teens he painted pictures that display powerful presence and total technical mastery. He was very influential on late-19th-century French avant-garde painting.

Observe the extraordinary and unique interweaving of grandeur, realism, and intimacy, which ought to selfcancel, but result in some of the finest official portraits ever painted. Notice the grand poses, characters, and costumes; eagle-eyed observation (he never flatters or idealizes); and a feeling of sensual intimacy through the use of seductive colours and paint handling. His religious

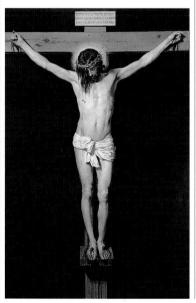

Waterseller of Seville Velasquez, c. 1620, 106.7 x 81 cm (42 x 31½ in), oil on canvas, London: Wellington Museum. Gifted to the Duke of Wellington by the king of Spain for his victory over Napoleon's army.

and mythological paintings sometimes fail to convince because he was simply too realistic in his work.

He had a great sensitivity to light, which is recorded with pin-sharp accuracy in his early work and evoked by loose, flowing paint in later work. See how he makes ambiguous and mysterious use of space, which has the effect of drawing the viewer into the picture and therefore closer to the figures. Is better with static, solitary poses than with movement or people supposedly communicating with each other. Sensational colour harmonies (especially pink and silver) in his late work. KEY WORKS The Forge of Vulcan, 1630 (Madrid: Museo del Prado); The Surrender of Breda, 1634-35 (Madrid: Museo del Prado); Las Meniñas, (see pages 188-189): Francisco Lezcano, 1636-38 (Madrid: Museo del Prado)

Christ on the Cross Velasquez, c.1631–32, 248 x 169 cm (96 x 66 ½ in), oil on canvas, Madrid: Museo del Prado. An early work showing the continuing influence of Spanish polychrome sculpture.

187

Las Meniñas

Diego Velasquez 1656

As an ambitious courtier, Velasquez needed to be an expert in observation and manipulation. In this remarkable and influential group portrait of the Infanta Margarita and her maids of honour (*las meniñas*), he displays all his cunning as an artist and politician.

Velasquez plays an elaborate and artificial game with our perception, and the relationships in the portrait. He portrays himself on the left, painting on a large canvas, but why is he there and what is on the canvas? It cannot be that he is painting a portrait of the Infanta, since he stands behind her. The answer is in the mirror at the end of the room. It reflects the King and Queen, who must therefore be posing for Velasquez. The little Infanta has come into the room to look at them. By working this way, Velasquez has reversed all the rules and expectations of portraiture.

Velasquez achieved a very special sharpness of characterization in his portraiture. We can still see the childlike vulnerability in the Infanta Margarita's features despite her knowingness.

TECHNIQUES

Velasquez developed a technique whereby the details of a painting come into focus only at a certain distance. The lace cuffs worn by the maid of honour are nothing more than losse brushstrokes that suggest rather than describe.

The maid of honour on the left proffers a red terracotta jug on a gold plate to the Infanta, which probably would have contained cold perfumed water

Velasquez wears a royal decoration, the cross of the Order of Santiago (St. James), which was not given to him until three years after the date of the picture. The image of the cross on the artist's chest was added to the painting two or three years later, at the behest of the connoisseur king, who did much to promote painting to the status of the liberal arts.

Dwarves and clowns

provided entertainment at Court, and often feature in the paintings by Velasquez. Another court favourite, Mari-Bárbola, stands behind the dog. Her grim features and dark dress serve to accentuate the Infanta's delicate beauty

The Court Jester Nicolasito playfully treads on the huge sleepy mastiff. Such a detail helps to develop a feeling of spontaneity in this painting

The Infanta Margarita, the future Empress, is the central figure in the painting. She was just five years old when *Las Meninas* was painted

A second maid of honour

awaits the child's orders. Behind her a nun and a priest converse in the shadows. Their presence is a reminder of the power of the Church

Las Meniñas

 Medium oil on canvas

 Dimensions 318 x 276 cm

 (125 x 108½ in)

 Location Madrid: Museo del Prado

Frans Snyders

⊖ 1579-1657 P FLEMISH

Antwerp; Italy
 Antwerp: Rockox
 House. Madrid: Museo del Prado
 Statum
 Selling Vegetables and Fruit (oils)

The undisputed master of the Baroque still life. Became as rich and successful as his clients and so was able to consume and enjoy the produce he painted. Prolific and much imitated – there are many wrong attributions. Son of an innkeeper.

Look for market scenes; pantries; largescale still lifes that literally groan and overflow with fruit, vegetables, and fish, flesh and fowl, both alive and dead. Look also for the odd symbol of successful bourgeois capitalism, such as rare imported Wan Li Chinese porcelain. After 1610 he painted hunting scenes,

Pantry Scene with a Page Frans Snyders, c. 1615–20, 125 cm x 198 cm (49% x 78 in), canvas, London: Wallace Collection. Snyder's paintings are often allegories representing the five senses or the four physical elements.

but his best and most freely painted work came after 1630 – geometrically structured compositions, which contain fluidity, rhythm, balance, harmony, rich colour.

He was much influenced by his visit to Rome in 1608. Collaborated with other artists (for example, he sometimes added the still life or animal component of the image/narrative to Rubens's work). There is possible symbolism in the details (grapes as Eucharist, for instance); plus moralizing messages, proverbs, or animal fables. If you visit the market area of Brussels today, you will see shops and restaurants with just such lavish displays of produce – he painted embroidered reality, not far-fetched fantasy. **KEY WORKS** *Still Life with Dead Game, Fruits, and Vegetables in a Market*, 1614 (Art Institute of Chicago); *Hungry Cat with Still Life*, c.1615–20 (Berlin: Staatliche Museum); *Wild Boar Hunt*, 1649 (Florence: Galleria degli Uffizi)

Jacob Jordaens

⊖ 1593-1678 P FLEMISH

Antwerp is oils; watercolours; gouache
 The Hague: Huis ten Bosch is \$2.8m in
 2001, Portrait of Rogier le Witer. Portrait of his
 Wife Catharine (oils, a pair)

Leading painter in Amsterdam after the death of Rubens, whose style he emulated (was an assistant for Rubens). By comparison his work seems hectic and badly organized, without any clear visual and emotional focus. Best when not being too ambitious (for instance,

> in genre scenes). Produced good portraits. Large output from commissions, but quantity took precedence over quality. He also etched and made designs for tapestries. The work of the last two decades of his life is more subdued. **KEY WORKS** *The Artist and his Family in a Garden*, c.1621 (Madrid: Museo del Prado); *The Four Evangelists*, c.1625 (Paris: Musée

du Louvre); The Lamentation,

c.1650 (Hamburg: Kunsthalle)

Roelandt Savery

- 1576-1639 ₱ FLEMISH

Amsterdam; Prague; Vienna; Utrecht i oils; watercolours
 London: National Gallery
 \$2.24m in 2001, Still Life of Iris, Tulip, Rose, and other Flowers Flanked by Lizard (oils)

Prolific, successful, much travelled (France, Prague, Vienna, the Alps). He finally settled in Utrecht. Painted landscapes – the wooded and mountainous scenes are notable for their brilliant cool blues. Also flowers and mythologies. Best known for his painting of animals, which he studied from life (including the dodo in Rudolph II's menagerie). Good landscape etchings.

KEY WORKS Flowers in a Niche, 1603 (Utrecht: Centraal Museum); Bouquet of Flowers (the Liechtenstein Bouquet), 1612 (Vienna: Liechtenstein Museum); Landscape with Birds, 1622 (Prague: National Gallery)

Sir Peter Paul Rubens

€ 1577-1640 P FLEMISH

Antwerp; Rome; Paris Disit; drawings;
 chalks Im Munich: Alte Pinakothek. Antwerp
 \$68.4m in 2002, Massacre of the Innocents (oils)

Extraordinary, widely travelled, gifted man of many talents: painter, diplomat, businessman, scholar. The greatest and most influential figure in Baroque art in northern Europe. Had a huge output and a busy studio with many assistants, including van Dyck. He was *the* illustrator of the Catholic faith and divine right of kings.

His large-scale set-piece works, such as altarpieces and ceiling decorations, must be seen in situ in order to experience their full impact and glory. However, do not overlook his many sketches and drawings, which are miracles of life and vigour, and the genesis of the major works. Rubens's work is always larger than life, so enjoy the energy and enthusiasm he brought to everything he saw and did. Was never hesitant, never introspective. A wonderful storyteller.

There are three possible themes to explore in Rubens's work: 1) Movement – inventive compositions with energetic diagonals and viewpoints; colour contrasts and harmonies that activate the eye; figures at full stretch both physically and emotionally. 2) Muscles – gods built like Superman, muscular Christianity in which well-developed martyrs suffer and die with enthusiasm. 3) Mammaries – he never missed a chance to reveal a choice breast and cleavage. Note also the rosy,

Hélène Fourment in a Fur Wrap Sir Peter Paul Rubens, 1636–38, 176 x 63 cm (69 % x 24% in), wood, Vienna: Kunsthistorisches Museum. Rubens's second wife (who was aged 16 when they married in 1630) was the ideal female model for his art.

blushing cheeks, and the business-like eye contact in the portraits.

In his later years Rubens developed a new interest in landscape painting. **KEY WORKS** Samson and Delilah (see pages 192–193); The Life of Maria de Medici series, c.1621–25 (Paris: Musée du Louvre); The Garden of Love, 1632–34 (Madrid: Museo del Prado); The Judgement of Paris, 1635–38 (London: National Gallery)

Battle of the Amazons and Greeks (detail) Sir Peter Paul Rubens, c.1617, 121 x 166 cm (47% x 65% in) oil on panel, Munich: Alte Pinakothek. Rubens was in Italy from 1600–08 and this work shows the lasting influence of his study of Greco-Roman and Italian Renaissance art.

Samson and Delilah

Sir Peter Paul Rubens c.1609

Rubens was only 31 years old when he painted this magnificent work, which resonates with the enthusiastic and energetic talent that brought him honours and riches. The picture tells the Old Testament story (Judges 16) of the downfall of Samson, the superhuman Israelite warrior who was the scourge of the Philistines.

Samson's ruin was caused by his lust for the Philistine Delilah, who beguiled him into revealing the secret source of his strength – his uncut hair. The artist depicts the tense moment when the first lock is cut and the soldiers prepare to gouge out the Israelite's eyes. When his hair grew back, Samson used his returned strength to destroy the Philistines' temple, sacrificing his own life while taking his revenge.

The picture was painted for a close friend and patron, Nicolaas Rockox, who was a rich and influential alderman. It was designed to hang high on the wall above the mantelpiece of the Great Saloon of his Antwerp townhouse.

Cheeks flushed with pleasure, Delilah reclines languidly. The tilt of her head echoes the statue of Venus above

The intricate and intertwined hands holding the scissors are a brilliant visual metaphor for the deceitful and elaborate plot to cause Samson's downfall. The barber performs his task with deep concentration.

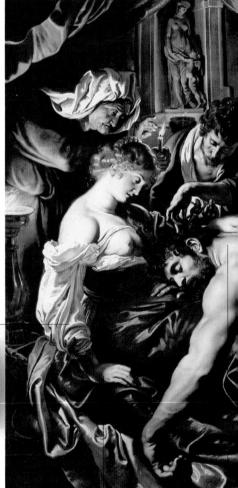

Each of the main characters has specific hand gestures that reveal their mental and physical state The sweep of Samson's back leads the eye up to the climax of faces of the leading characters

192

TECHNIQUES

Note Rubens's expert use of light on Delilah and her flowing clothing. An intense, almost-white beam shoots from behind over her shoulder, emphasizing her pale, flawless skin and the shimmering glossiness of the rich, red gown that she wears.

Rubens's chiaroscuro treatment of light was strongly influenced by Caravaggio (see pages 170–171)

Samson's enormous muscular frame was inspired by the work of Michelangelo (see page 136) The picture is strewn with rich materials and colours – silks, satins, and embroidery in vibrant reds and golds

The faces of the Philistines are illuminated from below by a flaming torch. Entering stealthily through the doorway, they are carrying the sharpened stakes that they will use to put out Samson's eyes.

Ine dominant colour in the lower left of the painting is a rich and vibrant red, set off against warm browns and gold, and Rubens's marvellously translucent flesh tones.

Samson and Delilah

Medium oil on wood Dimensions 185 x 205 cm (73 x 80% in) Location London: National Gallery

Sir Anthony van Dyck

⊖ 1599-1641 PU FLEMISH

☑ Antwerp; Italy; England
 ☑ oils; drawings
 ☑ London: National Gallery. Edinburgh: National Gallery of Scotland
 ☑ \$1.24m in 1989, Portrait of Mary, Princess Royal (oils)

Antwerp-born infant prodigy from a family of silk merchants. Best remembered for his portraits, especially those of the

ill-fated Court of King Charles I of England (who was beheaded in 1649). He died relatively young.

As well as portraits, look for religious and mythological subjects (the stock in

King Charles I of England out Hunting Sir Anthony van Dyck, c.1635, 226 x 207 cm (104 /× 81 // in), oil on canvas, Paris: Musée du Louvre. Van Dyck painted 38 portraits of Charles I, of which this is the finest. The king awarded him a knighthood in recognition of his talents.

trade of all artists of the time). Also painted rare landscape watercolours. His brilliant but restrained technique reflected the elegance, fineness, and impeccable taste and breeding assumed by his sitters – those subtly elongated fingers, bodies, noses, and poses, and the rich but unflashy silks and satins. Even his martyrs suffer with perfect manners.

Notice that air of aristocratic privilege (still around today). Van Dyck set

the ultimate role model, much copied in (notably British) portraiture and life: the aloofness, disdain, and reserve adopted by people wishing to appear consciously set apart. These faces never smile; they know their duty and they will fight to retain their privileges to the end (the Divine Right to Rule). He painted wonderfully sensitive images of children. Realistic details, especially hair. **KEY WORKS** Portrait of Charles V on Horseback, 1620 (Florence: Galleria degli Uffizi); Geronima Brignole Sale and her Daughter Amelia, c.1621-25 (Genoa: Palazzo Rosso); James Stewart, Duke of Richmond with Lennox, 1635-36 (Private Collection); A Lady as Erminia, Attended by Cupid, c.1638 (Oxfordshire: Bleinheim Palace)

David Teniers (the younger)

⊕ 1610-90
 ₱ FLEMISH

 Antwerp; Rome; Brussels iois
 London: Courtauld Institute; Wallace Collection
 \$4,185,000 in 1999, Archduke Leopold Wilhelm and the Artist, Archducal Gallery (oils)

Teniers is best remembered for his lively small-scale paintings of peasant and guardroom scenes (and depicting them misbehaving, as in *Boors Carousing*). After 1651, also known for his detailed views of the painting galleries of Archduke Leopold Wilhelm (Regent of the Netherlands). Later work is weak. **KEY WORKS** *The Kitchen*, 1646 (St. Petersburg: Hermitage Museum); *An Old Peasant Caresses a Kitchen Maid in the Stable*, c.1650 (London: National Gallery); *Peasants Making Musie*, c.1650 (Vienna: Liechtenstein Museum)

A Village Festival in Honour of St. Hubert and St. Anthony Pieter Brueghel (the Younger), 1632, 118.1 x 158.4 cm (46½ x 63½ in), oil on panel, Cambridge: Fitzwilliam Museum.

Pieter Brueghel (the younger)

⊖ 1564-1638 PU FLEMISH

Antwerp 🚺 oils; tempera 🚺 in 2001, *Village Kermesse* (oils)

🞾 \$4.9m

He was the elder son of "Peasant" Bruegel. Made copies and imitations of his father's work. Later did fashionable hellfire scenes, which gave him the nickname "Hell" Brueghel (he also retained the "h" in his name). **KEY WORKS** *Fight between Carnival and Lent*, c.1595 (Bruges: Musées Royaux des Beaux-Arts); *The Adoration of the Magi*, c.1595–1600 (St. Petersburg: Hermitage Museum)

Jan Brueghel

⊖ 1568-1625 PU FLEMISH

He was the second son of "Peasant" Breugel, nicknamed "Velvet" Breughel (also retaining the "h" in his name). Produced flower paintings, landscapes, and allegories with rich, velvety textures; very finely painted. He is known to have sometimes worked with Rubens. **KEY WORKS** *The Battle of Issus*, 1602 (Paris: Musée du Louvre); *Forest's Edge (Flight into Egypt)*, 1610 (St. Petersburg: Hermitage Museum); *The Earthly Paradise*, 1610 (Madrid: Museo del Prado)

DUTCH REALISM

Seventeeth-century Holland consciously developed a new type of art. Small-scale, well made, and often full of symbolism and anecdotes, its principal subjects were secular and focused on the present day – landscapes, still lifes, and genre scenes that recorded their daily activities. They also had a liking for portraits but these too tended to be small-scale and distinctly bourgeois in character.

STYLE

The content of Dutch Realism reflected everyday domestic tastes: sensitive and unpretentious scenes, usually painted with a close attention to detail. This new style of art was made to decorate and please, but it was also created for financial gain. Investing in works of art was a major activity, and trading in works of art was commonplace at all levels of society.

River Landscape with Peasants Ferrying Cattle Salomon van Ruysdael, 1633, oil on panel, Private Collection. These early works are similar in style to Van Goyen.

SUBJECTS

National pride was the main subject. For example, landscapes, although rarely accurate descriptions of exact places, celebrate the particular qualities of the Dutch countryside: flat, neatly cultivated lands with grey skies, heavy with rain. Canals and shipping feature large, including naval battles and storms at sea, both of which threatened their

prosperity. Being a nation of market gardeners, they painted superb flower pieces. Still lifes are

The Flea-Catcher (Boy with his Dog)

Gerard Terborch, c.1655, 34.4 x 27.1 cm (13½ x 10¾in), oil on canvas, Munich: Alte Pinakothek.

KEY EVENTS

1602	Dutch East India Company founded		
1610	Utrecht School established. Group including Terbrugghen also returns from Rome excited by realism		
1616	Frans Hals, <i>alla prima</i> pioneer, painting directly onto canvas, wins fame with Dutch "Civic Guards" group portrait		
1648	Holland becomes an independent republic		
1650	650 Founding of the Delft School with Vermeer as leading exponent		
1659	659 Major late Rembrandt self-portrait. First artist to practise self-portraiture as special		

full of rich and exotic goods, with glass often in evidence, as it was one of their luxury industries. Domestic scenes are full of themes of love, sexual morality, cleanliness, and household economy and order.

1600s

WHAT TO LOOK FOR

Nothing in Dutch art is ever quite what it seems, not even in a still life. The exotic objects, snuffed-out candles, and empty jugs are symbolic of the essential emptiness of earthly possessions, and often there is a skull or other symbol

The Vanities of Human Life

Harmen Steenwyck, c. 1645, 39 x 51 cm (15½ x 20 in), oil on oak, London: National Gallery. A visual sermon based on the Book of Ecclesiastes. The shaft of light highlights the central object – the human skull, a principal reminder of mortality; light is a Christian symbol of the eternal

of death – a *momento mori* – a reminder that even for the richest citizen, there is no escape from the inevitability of death. What is ostensibly an object for visual enjoyment is, in fact, a sober Calvinist discussion.

C.1600-1700

A ghostly Roman emperor's face is just visible on the urn, a reminder of the earthly powers and glory death takes away

TECHNIQUES

Dutch painters were the first to establish a tradition of still-life painting: Steenwyck's subject gives him ample scope to show off his technical mastery, attention to detail, and evocation of reflected light on surfaces.

The Japanese sword is a symbol of worldly power, indicating that even the might of arms cannot defeat death

The shell is a symbol

of worldly wealth – it would also have been a rare and prized possession in the 17th century. But riches too are a vanity: "As he came forth of his mother's womb, naked shall he return to go ... and shall take nothing of his labour" (Eccl. 5:15) The vanity of knowledge is represented by a book, symbol of the human quest for the acquisition of knowledge and learning

Frans Hals

Stay-at-home self-portraitist who never moved from Haarlem in the Netherlands. One of the first masters of the Dutch School (preceded Rembrandt). Although successful, he was constantly in debt (because he had eight children?).

Painter of portraits and group portraits (especially of the "Civic Guards", all-male social clubs) and of members of the newly established Dutch republic, who usually look pink-cheeked, well fed, well dressed, happy, and prosperous. Also painted single genre figures of children and peasantry. Was very influential in the late 19th century

The Laughing Cavalier Frans Hals, 1624, 83 x 67 cm (32% x 26% in), oil on canvas, London: Wallace Collection. The picture is inscribed "AETA.SVAE 26/A" 1624" (his age, 26, the year 1624), but the identity of the sitter remains unknown.

when his style, having been totally out of fashion, became much admired by young artists such as Manet.

His exciting, lively, but simple poses are full of animation. He had a unique (for the time) sketchy painting technique, straight onto the canvas, with broad brushstrokes and bright colours, adding to the sense of vivacity; yet he still captured the appearance and feel of different textures: plump flesh, pink cheeks, the shimmer of silk and satin, the intricacy of lace and embroidery. Masterly command of beautifully observed, well-formed, expressive eyes. **KEY WORKS** *Toung Man with a Skull*, 1626–28 (London: National Gallery); *Mad Babs*, c.1629–30 (Berlin: Staatliche Museum); *Portrait of Willem Coymans*, 1645 (Washington DC: National Gallery of Art); *Portrait of a Man*, early 1650s (New York: Metropolitan Museum of Art)

Daniel Mytens

The major portrait painter in England before van Dyck. Dutch-born and trained. Arrived in London around 1618 and worked for Charles I. Painted elegant. rather stiff, formally posed portraits (but with insight into personality), which introduced a hitherto unknown level of realism to English art. His best works are his later full-length portraits, which are powerful, assured, and fluent. KEY WORKS Henry Wriothesley, 3rd Earl of Southampton, c.1618 (London: National Portrait Gallery); King James I of England and VI of Scotland, 1621 (London: National Portrait Gallery); Endymion Porter, 1627 (London: National Portrait Gallery)

Pieter Lastman

⊖ 1583-1633 P DUTCH

Masterdam; Italy
 Amsterdam; Italy
 Museum of Fine Arts
 S230,000 in 1985,
 Hagar and the Angel (oils)

Chiefly remembered as Rembrandt's most influential teacher. Painted lush, narrative pictures, full of gesture, and facial expression (see Rembrandt), but spoiled by over-fussy, anecdotal detail. **KEY WORKS** *Abraham on the Way to Canaan*, 1614 (St. Petersburg: Hermitage Museum); *Juno Discovering Jupiter with Io*, 1618 (London: National Gallery)

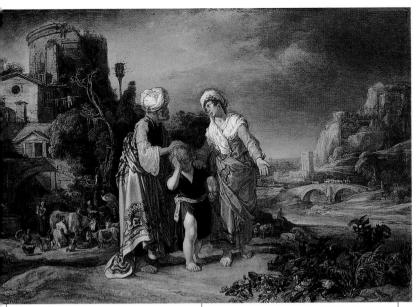

The Expulsion of Hagar Pieter Lastman, 1612, oil on panel, Hamburg: Kunsthalle. The drama of the moment when Abraham banished Ishmael (his first son) and Hagar (his mother) is accompanied by an extensive landscape of equally dark mood.

Hendrick Terbrugghen

⊖ 1588-1629 PUDUTCH

Utrecht; Rome 🚺 oils 🛍 Amsterdam: Rijksmuseum 😰 \$1,460,000 in 1985, *Lute Player Carousing with a Young Woman* (oils)

The most important painter of the Utrecht School, who was deeply influenced by Caravaggio's subjects and style (he spent ten years in Italy). On his return to the Netherlands he became with Honthorst the leader of the Caravaggism associated with the Utrecht School. His early work has hard, raking light, which throws detail into sharp relief. His later work is softer and quieter, sometimes to the point of stillness and silence. Was fascinated by reflected light. The rediscovery of his sensitive and poetic paintings has been part of the general reappraisal of Caravaggesque art in the 20th century. KEY WORKS Flute Players, 1621 (Kassel, Germany: Staatliche Kunstsammlungen); St. Sebastian Tended by Irene and her Maid. 1625 (Oberlin, Ohio: Allen Memorial Art Museum); The Annunciation, 1629 (Amsterdam: Stedelijk Museum)

Jan Davidsz de Heem

Utrecht-born, he lived and worked in Antwerp from 1636. Was famous and successful with his still-life paintings of flowers and groaning, exquisitely laid tables. Had many pupils and imitators. **KEY WORKS** *Still Life with Books*, 1628 (The Hague: Mauritshuis Museum); *Fruit and Rich Tableware on a Table*, 1640 (Paris: Musée du Louvre); *A Table of Desserts*, 1640 (Paris: Musée du Louvre)

Still Life of Fruit and Flowers (detail) Jan Davidsz de Heem, c. 1640s, oil on canvas, Burnley, Lancashire: Towneley Hall Art Gallery. His style became more exotic and opulent after moving to Antwerp.

Rembrandt

⊖ 1606-69 P DUTCH

 Netherlands
 oils; etchings; drawings
 Amsterdam: Rijskmuseum. The Hague: The Mauritshuis Museum
 \$26,460,000 in 2000,
 Portrait of a Lady aged 62, Perhaps Aeltje Pietersdr,
 Uylenburgh, Wife of Johannes Cornelisz (oils)

His full name was Rembrandt Harmensz van Rijn. Generally considered to be the greatest, but most elusive, Dutch master. He created prolific, stunning masterpieces, treasured in galleries worldwide. However, the Rembrandt Commission currently argues over how many works he painted, which is ultimately a flawed enterprise: you cannot resolve disputed attributions by majority vote in committee. Also one of the great printmakers, developing the exciting, new, free-flowing techniques of etching into copper rather than the heavier, surface-scratching of engraving.

LIFE

Born in Leiden. Son of a miller but, reflecting Dutch social engineering of the period, his modest parents recognized the importance of education, so he was sent to Leiden University. Unlike the Utrecht School founders and Rubens, he never visited Italy to drink at the fountains of Baroque but had access to High Renaissance works and was taught by Dutch "Caravaggio in a tea cup" artist, Pieter Lastman, who had worked in Italy.

Studies of Old Men's Heads and Three Women with Children (detail)

Rembrandt, c. 1635, ink on paper, Birmingham (UK): The Barber Institute of Fine Arts. From a group of rapid sketches using thin pen strokes.

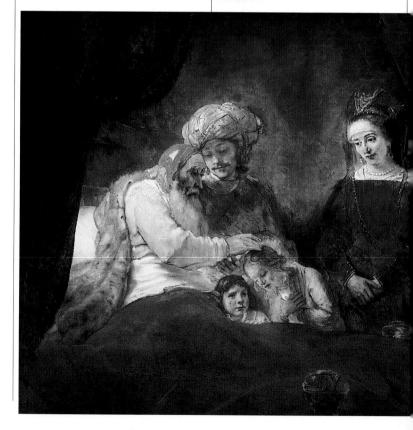

His personal life was increasingly touched with tragedy. At first money rolled in, thanks to marrying a successful art dealer's cousin, which resulted in wealthy portrait commissions and quickly won renown. He inherited his wife's fortune on her early death but later his popularity declined, resulting in debt, bankruptcy, and loss of his grand house and massive personal art collection. His beloved son, Titus, and housekeeper common-law wife saved him from ruin but when they died (Titus at the age of 27), he was left lonely and poor in his old age, dying 11 months later in Amsterdam.

SUBJECTS AND STYLE

His subjects were biblical history (his preference), portraits, and landscapes. He had a unique ability to find all humanity beautiful, in a way that can evoke deep, heart-rending emotions. He never flinched, even in front of the toughest subjects (the Crucifixion, or his own face). In fact he is seen as art's

> first major self-portraitist as a recognized speciality. His direct honesty and intense personal scrutiny over the years reveals an ageing face of a true human being, not beautiful but with penetrating realism. And this is the secret to his other works. Faces and gestures are the key he was fascinated by the way faces reveal inner states of mind, and how hand and body language convey emotion. He was also interested in showing emotional crises and moral dilemmas - you sense that he has experienced the intense feelings he portrays.

WHAT TO LOOK FOR

Observe his emotional manipulation of light and shade – light being warming, purifying, revealing, spiritual; shadow being the domain of the unexplained, the threatening, the evil. He was enthralled by

Jacob Blessing the Children of

Joseph Rembrandt, 1656, 175.5 x 210.5 cm (69 x 82½ in), oil on canvas, Kassel (Germany): Gemäldegalerie. One of Rembrandt's greatest achievements as a history painter.

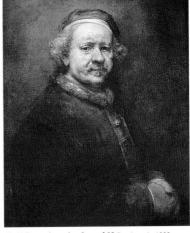

Self-Portrait at the Age of 63 Rembrandt, 1669, 86 x 70.5 cm (33% x 27% in), oil on canvas, London: National Gallery. This is one of the last of over 75 self-portraits – paintings, drawings, and prints.

the activity of painting; early work is detailed, later work is looser in style. His palette is distinctive: rich, warm, earthy, and comforting. He was intrigued by human skin, especially the fleshy areas around the eye and nose in old faces (no other artist has ever painted them with such care and so convincingly). **KEY WORKS** Saskia as Flora, 1635 (London: National Gallery); The Blinding of Samson, 1636 (Frankfurt: Städelsches Kunstinstitut); *Joseph Accused by Potiphar's Wife*, 1655 (Washington DC: National Gallery of Art); Vase with Flowers, c.1670 (The Hague: Mauritshuis Museum)

The Three Crosses Rembrandt, 1653, 38.1 x 43.8 cm (15 x 17½ in), etching, Cambridge: Fitzwilliam Museum. One of Rembrandt's best etchings: a complex, crowded work, with a stunning exploitation of light and shade.

Gerritt **Dou**

➡ 1613-75 ₱ DUTCH

 ☑ Leyden (Netherlands)
 ☑ oils
 ☑ Paris: Musée du Louvre. Budapest: Museum of Fine Arts
 ☑ \$2,030,864 in 2001, *The Dentist* (oils)

Also known as Gerard Dou. Remembered as Rembrandt's first pupil (age 15). Small-scale works with fine detail, high, glassy finish, brilliant colours, focused light and shade (he trained initially as an engraver and glass painter). A conjurer's world, dedicated to self-conscious illusion. obsession with surface show, skilful special effects, and hidden symbolism. **KEY WORKS** Astronomer by Candlelight, 1655 (Los Angeles: J. Paul Getty Museum); Woman at a Window, 1663 (St. Petersburg: Hermitage Museum); The Hermit, 1670 (Washington DC: National Gallery of Art)

The Village Grocer Gerrit Dou, 1647, 38.5 x 29 cm (15 x 11% in), oil on panel, Paris: Musée du Louvre. Dou often used this composition of figures engaged at a window.

Govaert Flinck

•	1615-60	ρø	DUTCH	
μ	Amsterda	am	🖉 oils	Amsterdam:
Ri	iksmuseun	n. L	os Angele	s: I. Paul Getty Museun

\$325,000 in 1996, Young Man Holding Ottoman Short Sword (oils)

> A pupil of Rembrandt in the 1630s and strongly influenced by him in style and subject matter, but his works are generally lighter, more elegant, and less serious or gloomy. Flinck was prolific and much esteemed in his own day. Recent revival of interest due to reattributions by the Rembrandt Commission so that several so-called Rembrandts are now said to be by Flinck.

t a window. **KEY WORKS** Countryside with Bridge and Ruins, 1637 (Paris: Musée du Louvre); Young Shepherdess with

Flowers, c.1637–40 (Paris: Musée du Louvre); Angels Announcing the Birth of Christ to the Shepherds, 1639 (Paris: Musée du Louvre)

Ferdinand Bol

 ● 1616-80
 ▶ DUTCH

 Mansterdam
 ③ oils
 ■ Amsterdam: Rijksmuseum.

 Munich: Alte Pinakothek

 ▶ \$200,000 in 1998, Portrait of Young Woman Holding Leather Fan (oils)

Bol was a pupil of Rembrandt. Working very much in the master's style, to whom his works have often been attributed (Rembrandt being more prestigious and much more valuable). Liked the formula of sitters posing by an open window.

Portrait of a Husband and Wife Ferdinand Bol,

1654, 171 x 148 cm (67½ x 58½ in), oil on canvas, Paris: Musée du Lourre. In 1669, Bol married a rich widow and, as a consequence, he seems to have given up painting.

$c\,\,.\,1\,\,6\,\,0\,\,0\,-1\,\,7\,\,0\,\,0$

Did allegories and history paintings for public buildings. Possessed a dark early style that becomes lighter after c.1640. **KEY WORKS** *Jacob's Dream*, 1642 (Dresden: Gemäldegalerie); *David's Dying Charge to Solomon*, 1643 (Dublin: National Gallery of Ireland)

Carel Fabritius

● 1622-54 P DUTCH

 Amsterdam; Delft D oils London: National Gallery. Amsterdam: Rijksmuseum
 \$771,428 in 1985, Mercury and Argos (oils)

Had a tragically short life, and less than ten authenticated works are known, but they show great variety. Immensely talented – Rembrandt's best pupil, and a highly original and distinctive painter. Painted portraits, still lifes, genre, perspectives. Died in a gunpowder explosion in Delft, near his studio, which destroyed most of his work.

Used thick impastoed paint next to thin glazes (like Rembrandt). Preferred cool colours to Rembrandt's dark reds and browns. Sometimes silhouetted a dark figure against a light background (Rembrandt preferred vice versa). An Eavesdropper with a Woman Scolding Nicolaes Maes, 1655, 46.3 x 72.2 cm (18½ x 28½ in), oil on panel, London: Harold Samuel Collection. Maes succeeded best when combining humour and complicity.

KEY WORKS The Beheading of John the Baptist, c.1640 (Amsterdam: Rijksmuseum); The Goldfinch, 1654 (The Hague: Mauritshuis Museum)

Nicolaes Maes

⊖ 1632-93 P DUTCH

 Image: Dordrecht (Netherlands); Antwerp
 Image: Oils

 Image: Dordrecht: City Museum. Budapest: Museum

 of Fine Arts
 Image: S708,400 in 1994, Old Woman

 Making Lace in Kitchen (oils)

Best known for his early genre paintings which often show kitchen life below stairs, or old women asleep (very popular at the time). Later in life went in for small, elegant, French-style portraits. Used strong *chiaroscuro* (he was a pupil of Rembrandt) and soft focus. Liked painting kitchen utensils. Good, but not great. **KEY WORKS** *The Mocking of Christ*, c.1650s (St. Petersburg: Hermitage Museum); *A Young Woman Sewing*, 1655 (London: Harold Samuel Collection)

"The Dutch had no imagination, but they had extraordinary taste and an infallible feeling for composition."

VINCENT VAN GOGH

THE BAROQUE ERA

Gerrit van Honthorst

1590–1656 DUTCH
 Italy; Utrecht; London 2 oils; fresco
 London: National Gallery 2 \$434,000
 in 1999, Portrait of Laughing Violinist (oils)

Only member of the Utrecht School to establish an international reputation. Studied in Rome 1610–12. Much favoured by royal and aristocratic patrons for his history paintings and allegorical decorations. Best remembered now for winter) are characterized by a feeling of natural, unstagey open space and atmosphere. He showed good detail, especially in the anecdotal figures going about their daily business. Also a prolific etcher and draughtsman. **KEY WORKS** Winter Games on the Town Moat, c.1618 (Munich: Alte Pinakothek); A Winter Landscape, 1623 (London: National Gallery); Villagers Skating on a Frozen Pond, 1625 (Washington DC: National Gallery of Art)

Supper with the Minstrel and his Lute Gerrit van Honthorst, c. 1619, 144 x 212 cm (56½ x 83½ in), oil on canvas, Private Collection. This use of artificial light and silhouettes greatly influenced the young Rembrandt.

striking treatment of illumination by artificial light – especially good when he hides light source and plays with silhouette. **KEY WORKS** Christ Before the High Priest, c.1671 (London: National Gallery); Christ in the Garden of Gethsemane (The Agony in the Garden), c.1671 (St. Petersburg: Hermitage Museum); Christ Crowned with Thorns, 1620 (Los Angeles: J. Paul Getty Museum)

Esaias van de Velde

⊖ c.1591-1630 🕫 DUTCH

■ Haarlem; The Hague ③ oils ■ Amsterdam: Rijksmuseum ≥ \$450,000 in 1990, Rocky Landscape with Travellers and Horsemen on Path (oils)

One of the founder members of the realist school of Dutch landscapes. His soft, monochromatic scenes (often in

Willem **van de Velde** (the elder)

⊖ 1611-93 № DUTCH

 Leyden (Netherlands); London I oils; pen and ink Amsterdam: Rijksmuseum
 \$975,000 in 1998, Dutch Harbour in a Calm with Small Vessels Inshore (works on paper)

Talented maritime painter, but eclipsed in popular esteem by his oil-painter son. His principal achievements are drawings of ships and small craft and pen paintings in ink on white canvas or oak panel. The paintings have meticulous, accurate detail. He spent much time at sea with the Dutch fleet. Emigrated with family to England (c.1672) to escape political confusion in Holland.

KEY WORKS Figures on Board Small Merchant Vessels, 1650 (Los Angeles: J. Paul Getty Museum); Dutch Ships Near the Coast, 1650s (Washington DC: National Gallery of Art); The Battle of Terheide, 1657 (Amsterdam: Rijksmuseum)

Sea Battle of the Anglo-Dutch Wars Willem van de Velde (the vounger), c. 1700, oil on canvas, New Haven: Yale Center for British Art. Both the elder and vounger van de Veldes were official naval war artists to the English crown. The Anglo-Dutch wars (1652-84) were about control of trade routes.

Willem van de Velde (the younger)

● 1633-1707 P DUTCH

Leyden (Netherlands); London 🚺 oils Amsterdam: Rijksmuseum. Los Angeles: J. Paul Getty Museum 🚺 \$2,349,000 in 1999, The Morning Gun, Small English Man-o-War Firing a Salute (oils)

Precocious son of hard-working maritime-painter father. His early work concentrates on accurately drawn and carefully placed fishing vessels on tranquil seas. After 1670 he produced portraits of particular ships, naval battles, and storms at sea. His later work (after 1693) was more freely painted. Worked extensively from his father's drawings. KEY WORKS Ships in a Calm Sea, 1653 (St. Petersburg: Hermitage Museum); Dutch Vessels at Low Tide, 1661 (London: National Gallery); Ships off the Coast, 1672 (Vienna:

Liechtenstein Museum)

Jan van Goyen

⊖ 1596-1656 PUDUTCH Levden (Netherlands); Haarlem; The Hague 🚺 oils 🛅 St. Petersburg: Hermitage Museum, Paris: Musée du Louvre \$1,874,500 in 1998, Village on the Banks of River with Ferryboat and Peasants (oils)

One of the most important Dutch landscape painters. Prolific and much imitated. Had many pupils. Repeated same motifs frequently - Dordrecht,

sand dunes, ships, and Nijmegen River. Painted in subdued browns and greys, enlivened by a flash of red or blue. His paintings have attractive light, space, air, and cloud movement. Uses high viewpoint and low horizon. Likes gnarled oaks. **KEY WORKS** Skaters in Front of a Medieval Castle, 1637 (Paris: Musée du Louvre); A Windmill by a River, 1642 (London: National Gallery); Fort on a River, 1644 (Boston: Museum of Fine Arts)

Pieter Jansz Saenredam

● 1597-1665 P DUTCH

Haarlem O oils: chalks: watercolours Amsterdam: Riiksmuseum, London: National Gallery 🔊 \$1.65m in 2004, Haarlem, Interior of the Nieuwe Kerk (oils)

Supremely gifted painter of architecture - both specific buildings in Dutch towns and interiors of identifiable churches (the once decorated Gothic buildings that were whitewashed to satisfy the Protestant belief in plainness). Made meticulous preliminary drawings and measurements. The light-filled church interiors are a metaphor for universal laws of mathematics and optics.

> **KEY WORKS** Interior of the Marienkirche in Utrecht, 1638 (Hamburg: Kunsthalle); Interior of St. James's Church in Utrecht. 1642 (Munich: Alte Pinakothek)

River Landscape with Ferries Docked Before

a Tower Jan van Goyen, 1640s, 64.1 x 94 cm (251/4 x 37 in), oil on panel, Private Collection. The castle is real, the setting imaginary.

205

Adriaen van Ostade

● 1610-84 P DUTCH

☑ Haarlem ☑ oils; drawings; watercolours
 ☑ St. Petersburg: Hermitage Museum.
 Amsterdam: Rijksmuseum ☑ \$5,432,000
 in 2004, Peasants Carousing and Dancing
 Outside Inn (oils)

Haarlem-born specialist in good-natured, uncritical, lowlife scenes of peasants having a good time in their hovels or taverns. Rich, earthy colours suit the mood. Both the peasants' behaviour and Ostade's technique improve as his work develops (perhaps marrying a well-to-do woman toned down his style and subjects).

Adriaen's brother and pupil, Isaak (1621–49), chose similar peasant subjects in his early work. Later on he developed a line in silvery-grey landscapes, with good atmosphere and busy human activity. The Piper Adriaen van Ostade, c. 1650s, oil on canvas, London: British Museum. Ostade was a prolific painter (over 800 are known) and a skilled watercolourist and etcher. All his works found a ready market.

KEY WORKS Rustic Concert, 1638 (Madrid: Museo del Prado); A Peasant Courting an Elderly Woman, 1653 (London: National Gallery); An Alchemist, 1661 (London: National Gallery).

Salomon van Ruysdael

⊖ c.1600-70 P DUTCH

Haarlem
 Ansterdam:
 Amsterdam:
 Rijksmuseum
 2 \$3,465,000 in 1997,
 Extensive River Landscape (oils)

Prolific and well-known painter of landscapes and riverscapes. Uncle of the better known Jacob van Ruisdael. He painted scenes that sum up a

preconceived idea of Holland (water, flat

lands, big skies) – applying a standard formula that was very popular with Dutch collectors. There are also a few late still lifes with hunting themes.

The riverscape formula that he employed inventively juggles the following elements: compositions that always have a diagonal axis; mature trees

 $C\,.\,1\,6\,0\,0-1\,7\,0\,0$

on a river bank; rowing boats with fishermen; sailing boats with flags; cows; buildings on horizon (town, windmill, church); cloudy skies; evening light on horizon; reflections in water. He painted with broad, sweeping brushstrokes, using thin paint on a light ground; the grain of the panel often shows through. **KEY WORKS** Sailboats on the Wijkermeer, c.1648 (Berlin: Staatliche Museum); Landscape with Medieval Castle, 1652 (Vienna: Liechtenstein Museum); Dutch Landscape with Highwayman, 1656 (Berlin: Staatliche Museum)

Aert van der Neer

⊖ 1603-// PO L	UTCH
🗖 Amsterdam	🖸 oils 🖬 St. Petersburg:
Hermitage Museu	m 🔁 \$3,528,000 in 1997, Winter
Landscape with F	igures on Path and Ice (oils)

Specialist in night scenes (gloomily imaginative, with ghostly full moon or lit by burning candles) and winter landscapes (atmospheric, with pale cold colours and lots of skaters). Oddly unsuccessful as a painter. Also failed as an innkeeper and went bankrupt. **KEY WORKS** Sports on a Frozen River, c.1600 (New York: Metropolitan Museum of Art); River View by Moonlight, c.1645 (Amsterdam: Rijksmuseum)

Philips **Koninck**

⊕ 1619-88
 ₱ DUTCH
 ■

🖸 Rotterdam; Amsterdam 🚺 oils

London: National Gallery 2 \$1,404,000 in 1992, Panoramic River Landscape (oils)

Pupil of Rembrandt who learned from the master's landscape etchings and went on to produce a formula for large-scale, panoramic landscapes of Holland: high viewpoint; horizon across middle; scudding clouds; small figures to increase sense of vast space; alternating bands of light and dark to give receding space. Good, but not great.

KEY WORKS Wide River Landscape, 1648 (New York: Metropolitan Museum of Art); An Extensive Landscape, 1666 (Edinburgh: National Gallery of Scotland)

Panoramic Landscape Philips Koninck, 1665, 138.4 x 166.4 cm (54% x 65% in), oil on canvas, London: Harold Samuel Collection. The equal division of open sky and landscape is typical of this artist.

Philips Wouvermans

⊖ 1619-68 P DUTCH

 ☑ Haarlem
 ☑ oils
 ☑ Dresden: Royal College.
 London: National Gallery. Paris: Musée du Louvre
 ☑ \$1.57m in 2001, Landscape with Stag Hunt in Full Cry, Fording a Stream (oils)

Small-scale landscapes of horsemen, battle or hunting scenes (note trademark white horse). Unpretentious decorative art at its best. Popular. Simple compositions – clear, white sky; harmonious, hilly landscape; foreground figures; elegant colouring. **KEY WORKS** *Horses Being Watered*, 1656–60 (St. Petersburg: Hermitage Museum); *Landscape with Bathers*, 1660 (Vienna: Liechtenstein Museum)

Paulus Potter

€ 1625-54 PU DUTCH

Best painter of cows (also horses, sheep, goats). Noted for a few life-sized animal pictures, but more at ease on a small scale. Good at weather, atmospheres, observation of light. Also vanitas-type still lifes. **KEY WORKS** *Cattle and Sheep in a Stormy Landscape*, 1647 (London: National Gallery); *The Wolf-Hound*, c.1650 (Las Vegas: Guggenheim Hermitage Museum)

Hendrick Avercamp

0	1585-	-1634	ρø	DUTCH

Amsterdam 2 oils; watercolours
 Windsor Castle (England): Royal Collection
 \$7.75m in 2004, Winter Scene (oils)

Mute painter from Kampen in Holland. Specialized in atmospheric winter scenes, usually in a landscape with bare trees, a pink castle, and a happy throng on the ice and snow. Uses high horizons and warm-coloured buildings that intensify the coldness of sky and snow; the thin painting of his figures gives them vitality and movement.

KEY WORKS Winter Scene at Yselmuiden, c.1613 (Geneva: Musée d'Art et d'Histoire); Fishermen by Moonlight c.1625 (Amsterdam: Rijksmuseum)

Jacob van Ruisdael

⊖ 1628-82 PUDUTCH

Haarlem; Amsterdam i oils i Amsterdam:
 Rijksmuseum. London: National Gallery
 \$4,268,000 Two Undershot Watermills
 with Men Opening Sluice (oils)

Jacob van Ruisdael was the principal Dutch landscape painter of the second half of the 17th century. His earliest known works date from 1746. He was prolific and about 700 known paintings are happily attributed to him.

Winter Scene with Skaters near a Castle Hendrik Avercamp. c. 1608–09, diameter 41 cm (16% in), oil on panel, London: National Gallery. These winter scenes were painted in the studio, from sketches for sale in the local art market.

Melancholic, he was nephew to the landscape painter Salomon van Ruysdael (c.1600–70; the different spelling occurs regularly in their signatures) and had a second career as a surgeon. His work has a certain amount of stock imagery although he can be quite inventive within the formula: mountains, waterfalls, beaches and dunes, seascapes, and winter scenes. Essentially, his paintings are descriptive (no hidden symbolism) with a yearning for grandeur. Before 1650, he worked on panel but subsequently painted on canvas.

He favours skies with rain clouds and flying birds (not convincing – it looks like a stage backdrop). He is more naturalistic than his predecessors and it is possible to identify species of trees in his paintings (note how he likes rotten trees and broken branches). He is also attracted to massive forms and often uses a low viewpoint to silhouette features against the sky. His work is painted on dark priming and, as a result, has dark tones.

KEY WORKS Panoramic View of Haarlem, c.1660s (London: Harold Samuel Collection); The Jewish Cemetery, c.1660 (Dresden: Gemäldegalerie); Forest Scene, c.1660–65 (Washington DC: National Gallery of Art); Oaks by a Lake with Watermills, c.1665–69 (Berlin: Staatliche Museum)

The Young Bull Paulus Potter, 1647, 236 x 339 cm (93 x 133 ½ in), oil on canvas, The Hague: Mauritshuis Museum. This is Potter's most monumental work. His father owned a factory for stamping and gilding leather.

Aelbert Cuyp

Θ	1620-91	ρu	DUTCH

Son of a painter, Cuyp married a wealthy widow in 1658 and neglected his art for local politics.

He produced some of the most beautiful landscapes and riverscapes ever painted. Using Italianate, golden light (which he took entirely from Italian paintings) he transformed his native Holland (especially Dordrecht) into a fantasy dream world, which epitomizes the start or end of a perfect day. The patrician classes who commissioned and collected his work appreciated the qualities of order, stillness, security, clarity, everything and everyone in their appointed place, harmony with nature, a sense of proprietorship and timelessness.

The light floods in from the left, casting long, soft shadows (surprising how few definite shadows there are). Note how the golden light catches just the edges of plants, clouds, or animals, with highlights laid on in thick, impastoed paint. He uses a warm palette of earthy golds and browns contrasted with cool, silvery skies and foliage. Nice ambiguities and easily overlooked details, such as birds in flight; is it morning or evening? He was much loved and collected in England. KEY WORKS The Sea by Moonlight, c.1648 (St. Petersburg: Hermitage Museum); Sunset after Rain, 1648-52 (Cambridge: Fitzwilliam Museum); A Distant View of Dordrecht with a Milkmaid and Four Cows. c.1650 (London: National Gallery)

A Herdsman with Five Cows by a River Aelbert Cuyp, c.1650, 45 x 74 cm (17½ x 29 in), oil on wood, London: National Gallery. Works like these were produced on commission for wealthy members of Dordrecht society.

209

Gerard Terborch

⊖ 1617-81 P DUTCH

 Image: Amsterdam; Haarlem; England; Italy; Spain;

 Germany
 Image: Optimized and the state of t

Precocious and successful, Terborch (or Ter Borch) was one of the finest and most inventive masters of the Dutch School. His small-scale, very beautiful, restrained, and gentle genre scenes show self-absorbed moments of a mundane world being raised to immortality by art. One senses from the acuity of his observation and the minute care with which he applies the paint that he viewed this world, its people, its foibles, its ordinariness, and its objects (not forgetting the dogs) with the greatest of affection and pleasure.

Look for harmonies of brown, gold, and yellow, and silver and grey-blue, exquisitely balanced against dark backgrounds; his love of detail; the rendering of fabrics and the way clothes are made; his ability to draw us quietly into his intimate world and leave a lingering question over the secrets or affections that are being shared; his love of a lady's neck and the light reflecting off a surface. See how he uses gentle symbolism but without overt moralizing. **KEY WORKS** The Swearing of the Oath of Ratification of the Treaty of Münster, 1648 (London: National Gallery); The Message, c.1658 (Lyon: Musée des Beaux-Arts); A Lady at her Toilet, c.1668 (Detroit Institute of Arts)

Jan van der Heyden

⊖ 1637-1712 P DUTCH

A prosperous inventor and designer of fire engines and lighting, painting was a secondary activity for van der Heyden, who is best known for still lifes and meticulous, small-scale topographical and *capriccio* (see page 234) views of towns in the Netherlands and Rhineland.

Famous for dexterous painting of walls and masonry, he sets warm, sharp, detailed bricks against blue skies and fluffy white

cloud – satisfying contrasts of warm and cool, hard and soft. A typical composition is of buildings closing in on one side with an open area leading out of the picture on the other – another good use of contrast. **KEY WORKS** A View in Cologne, c.1660–65 (London: National Gallery); The Inn of the Black Pig at Maarsseveen, c.1668 (Los Angeles: J. Paul Getty Museum)

Meyndert Hobbema

● 1638-1709 P DUTCH

Last of the major Dutch landscape artists of the 17th-century golden age, he gave up professional painting when he married in 1668 and became a wine gauger instead. His range is generally limited to repetitive scenes of finely painted dark landscapes with watermills and cottages round a pool, overgrown trees, and occasional figures. **KEY WORKs** A Stream by a Wood, c.1663 (London: National Gallery); A Watermill, c.1665–68 (Amsterdam: Rijksmuseum)

Jan Steen

⊖ c.1626-79 PU DUTCH

Steen, one of the best and most important Dutch genre painters, ran a tavern and owned a brewery. His lively, crowded scenes of taverns, feasts, and households with stock characters and facial expressions (rather like a TV soap opera – and maybe his works fulfilled a similar need), were prolific and popular. Watch out also for portraits, mythological scenes, religious works, and landscapes.

The lively and easy use of flowing, juicy fresh colours (rose red, blue-green, pale yellow) adds to the paintings' vitality and reflects their character. Full of symbolism, the genre scenes carry an unambiguous (sometimes heavy-handed) message about drunkenness, idleness, promiscuity, etc. **KEY WORKS** *A Young Woman Playing a Harpsichord*, c. 1659 (London: National Gallery); *Skittle Players Outside an Inn*, c.1660–63 (London: National Gallery) **The Christening Feast** (detail) Jan Steen, 1664, 87.8 x 107 cm (34 ½ x 42 in), oil on canvas, London: Wallace Collection. The complex symbolism indicates that the "father" holding the baby is a cuckold.

Pieter de Hooch

 ● 1629-83
 № DUTCH

 Delft; Amsterdam
 ♪ oils

 London: National Gallery
 ♪ \$6.24m in 1992, Courtyard of House in Delft with Young Woman and Two Men (oils)

Pieter de Hooch is a perennially popular Dutch master and one of the bestknown and best-loved genre painters. It is known that he died insane but, otherwise, little is known of his life.

His best and most widely known work dates from his years in Delft (1654– c.1660/61), and generally depicts sunny courtyards and sunlit interiors, celebrating well-behaved middle-class life. Before

1655 he painted lowlife peasant and soldier scenes. From Delft, he moved to Amsterdam and, after 1665, portrayed rich interiors with a bogus view of pseudo-aristocratic life. His very late work (1670s) is feeble but his best work bears a similarity to that of Vermeer (see page 213), who was his talented contemporary in Delft.

Observe the way he plays with, and enjoys, space and light - he creates views from one room or area to another and uses the geometric patterns of the tiled floors and courtyards to construct the illusion of space, flooding them with warm light and leaving the foreground uncluttered. His compositions are carefully designed with well-placed verticals, horizontals, and diagonals, and he uses carefully worked-out geometric perspective, usually with a single vanishing point. He also makes discreet use of symbols and emblems. KEY WORKS The Pantry, c.1658 (Amsterdam: Rijksmuseum); Two Soldiers and a Woman Drinking, c.1658-60 (Washington DC: National Gallery of Art); A Dutch Courtyard, c.1660 (Washington DC: National Gallery of Art)

Jan **Both**

⊖ c.1618-52 P DUTCH

 ☑ Utrecht ☑ oils ☑ London: Wallace Collection
 ☑ \$1.96m in 2000, Italianate Evening with a Muleteer and Goatherds on a Wooded Path (oils)

Dutch landscape painter who studied in Rome and introduced the Italianate Arcadian landscape, à la Claude, to Holland. More detailed and literal than Claude (see page 182), he does not usually make references to classical mythology. **KEY WORKS** Italian Landscape, c.1635–41 (Cambridge: Fitzwilliam Museum); Bandits Leading Prisoners, c.1646 (Boston: Museum of Fine Arts)

Gabriel Metsu

⊖ 1682-1749 P DUTCH

High-quality painter of intimate, smallscale scenes of well-ordered, polite Dutch households, whose carefully organized compositions and meticulous technique and palette reflect the lifestyle of the Dutch bourgeoisie. Many of the objects and still-life details are symbolic; if there is lettering or a document, it is meant to be read as part of the meaning of the picture (a neat way of drawing you into the intimacy and secrecy of the scene).

Note his liking for dark interiors – rooms with windows closed or curtains drawn, or a dark corner. His palette is warm and personal, especially using reds and browns. **KEY WORKS** *The Prodigal Son*, 1640s

(St. Petersburg: Hermitage Museum); A Soldier Visiting a Young Lady, 1653 (Paris: Musée du Louvre); A Dead Cock, c.1655–59 (Madrid: Museo del Prado)

Jan Weenix

🔟 Amsterdam; Düsseldorf 🛛 🙋 oils

London: Wallace Collection 😰 \$456,000 in 1995, Dead Hare on Plinth by Urn, Fruit, Birds, Boy Bearing Fruit (oils)

Son of Jan Baptist Weenix (1621–63) who called himself Giovanni Battista after his trip to Italy 1642–1646. His son never visited Italy but continued his father's

Still Life Jan Weenix, c.1690, 49.5 x 38.1 cm (19% x 15 in), oil on canvas, Leeds: City Art Gallery. Weenix's early still lifes caught the eye of the Elector Palatine, who employed him in Düsseldorf from 1702–14.

popular Italianate seaports and courtyard scenes. He also painted hunting trophies and still lifes, and was skilled at textures, such as silk, marble, silver, and glass. **KEY WORKS** *The White Peacock*, 1692 (Vienna: Liechtenstein Museum); *Falconer's Bag*, 1695 (New York: Metropolitan Museum of Art); *Portrait of Peter I*, c.1697 (St. Petersburg: Hermitage Museum)

Jan van Huysum

⊖ 1682-1749 P DUTCH

 Masterdam
 Moise Paris: Musée du Louvre
 S3.2m in 1992, Flowers in a Terracotta Vase on a Marble Plinth (oils)

One of the most prolific flower painters, he gained an impressive international reputation. Ornamental bouquets of asymmetrical flower arrangements, not necessarily of the same season. Smooth enamel-like paint; cool tones; vivid blues and greens. A few fruit pieces and landscapes. Whenever possible, he worked directly from life rather than from studies. **KEY WORKS** *Hollyhocks and Other Flowers in a Vase*, c.1702–20 (London: National Gallery); *Flowers and Fruit*, 1723 (St. Petersburg: Hermitage Museum); *Still Life with Flowers*, 1723 (Amsterdam: Rijksmuseum)

212

€ 1632-75 P DUTCH

Delft [] oils
 Amsterdam: Rijksmuseum.
 The Hague: Mauritshuis
 Museum. Washington DC:
 National Gallery of Art
 \$2.7m in 1990, Cupid
 Disarmed by Venus (oils)

Now regarded as the finest Dutch genre painter. Unrecognized in his own lifetime. Forgotten until the end of the 19th century.

Only 35 works known for certain. With a few memorable exceptions, he constantly reworked

the same theme: the corner of a room, but with a unique, exquisite, tantalizing observation of the organization of space, light, and enigmatic human relationships.

Look closely: nothing is quite in focus – visually and emotionally he selects that tantalizing fraction of a second just before something that is anticipated but not yet fully perceived or understood

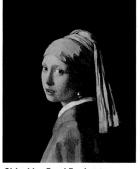

Girl with a Pearl Earring Jan Vermeer, c. 1660–61, 46.5 x 40 cm (18% x 15% in), oil on canvas, The Hague: Mauritshuis Museum. In the 1880s this famous work was sold in Holland for the equivalent of 25 pence.

becomes clear and resolved, and in its full realization, so often disappointing. By stopping short he requires the individual eve and imagination to supply what it most desires to see and feel. This is perceptual and poetic creativity, along with manipulation of breathtaking skill and sensitivity. Makes the eye linger over the seemingly innocent but precisely calculated interplay of cool blues and sensuous vellows and whites. KEY WORKS Kitchen Maid.

1656–61 (Amsterdam: Rijksmuseum); *Woman Holding a Balance*, c.1664 (Washington DC: National Gallery of Art); *Lady Standing at the Virginal*, c.1670 (London: National Gallery)

View of Delft Jan Vermeer, c.1660–61, 100 x 117 cm (39/x 46 in), oil on canvas, The Hague: Mauritshuis Museum. It is likely that Vermeer used a camera obscura, which projects a slightly fuzzy image. The work was much admired by Marcel Proust.

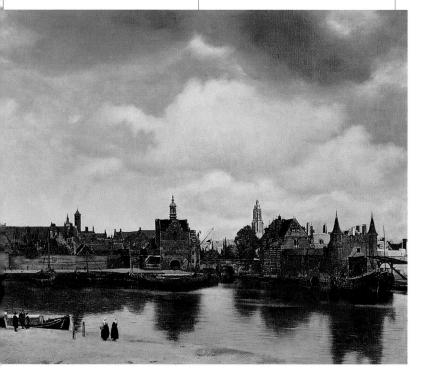

The Artist's Studio

Vermeer c.1665

This is one of Vermeer's later and most ambitic fulfilment of many years of experience, meticul craftsmanship, observation, study, and discussio two levels: visually, it is a very subtle and intrica of space and light; intellectually and emotionall allegory about the art of painting.

Typical of Vermeer is the intimate glimpse of the relationship between two people, meticulous observation of light, and precise handling of colour. Vermeer often used the placing of a chair in the foreground, the regular pattern of a slate and marble floor, and the interplay between two figures, like variations on a theme. The painting has also had an interesting history - in 1677 Vermeer's family petitioned the courts to prevent it from being auctioned to pay the artist's debts. It changed hands several times, and during World War II it was confiscated from its Austrian owners by Adolf Hitler who hung it in his private rooms at Berchtesgaden.

The source of light is hidden behind a heavy curtain that is drawn aside to reveal the artist at work. Note how Vermeer turns highlights, especially on the curtain and the chairs, into delicate beads of light, not unlike pearls

The Muse of History

carries a trumpet, which symbolizes the fame that can be achieved by an artist. Vermeer may be suggesting that an artist's fame need no longer rest with traditional history painting but can be achieved with new subjects, such as genre painting

The line of the tabletop draws the viewer's eye in to the painting towards a vanishing point positioned just below the bulbous finial of the map's roller bar

The model represents Clio, the Muse of History, whose attributes are the wreath of laurel and a book in which she records all heroic deeds. The nine Muses were the goddesses of inspiration in the arts and sciences. Vermeer confirms the status of painting as a liberal art.

The Artist's Studio

Medium oil on canvas Dimensions 120 x 100 cm (47 x 39½ in) Location Vienna: Kunsthistorisches Museum

The chandelier is decorated with the twoheaded eagle of the Hapsburgs, the Spanish royal family. The lack of candles refers to their waning power. The Northern Dutch provinces gained full independence from Spain in 1648.

The roof beams create

a strong horizontal pattern continued by the map's roller bars. The underlying structure of horizontals and verticals gives the picture its mood of stability and calm

a Mali

The vertical crease marks the frontier between Protestant Holland and Catholic Flanders; the latter was still under the political control and cultural influence of Spain

The artist's easel points with new confidence towards the new republic of Holland

The painter is not dressed in the clothes of his own day, but wears a 15th-century costume. It would seem that Vermeer is connecting the art of his own era with the art of the time of the great masters van Eyck (see page 110) and van der Weyden (see page 111)

TECHNIQUES

Vermeer uses the tiles like stepping stones to lead the eye into the composition. The line is reinforced by the angle of the tabletop.

216

William Dobson

Brief career as a painter to the doomed court of Charles I at Oxford. Only 50 known paintings: nothing known pre-1642. Robust, direct style. Half-length portraits: red-faced, earthy, conservative male subjects with classical allusions and visual references, which emphasize the sitter's learning or bravery (or both). **KEY WORKS** *The Executioner with the Baptist's Head*, c.1630s (Liverpool: Walker Art Gallery); *Portrait of the Artist's Wife*, c.1635–40 (London: Tate Collection)

Sir Peter Lely

 ● 1618-80
 PDUTCH/BRITISH

 ■ Haarlem; London
 ② oils
 ■ London:
 National Maritime Museum, Greenwich;
 Hampton Court Palace
 ② \$1,328,000 in
 2003, Chesterfield Portrait, two boys, probably
 Philip Stanhope and brother Charles (oils)

German-born of Dutch parents, whose family name was van der Faes, Lely settled in England in the early 1640s. He was the principal portrait painter for Charles II, and especially notable for his

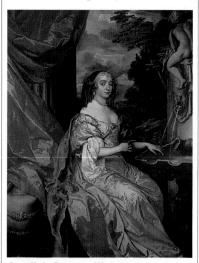

Anne Hyde, Duchess of York Sir Peter Lely, c.1660s, 182.2 x 143 cm (71½ x 56½ in), Edinburgh: Scottish National Portrait Gallery. The first wife of James II was reputedly more clever than beautiful.

fashionable, female portraits, which show richly dressed, slightly raffish-looking women with heavy eyes and long, mobile fingers. Studio assistants were responsible for much poor-quality work in his name.

A few very fine early works show his talent for landscape and observation of unimportant faces. When on form, he had a wonderful feel for light. **KEY WORKS** *Trial by Fire*, 1640s–50s (St. Petersburg: Hermitage Museum); *Two Ladies of the Lake Family*, c.1660 (London: Tate Collection); *Barbara Villiers*, *Duchess of Cleveland*, c.1665 (Private Collection)

John Michael Wright

⊖ 1617-94 🕫 BRITISH

A talented Catholic portrait painter who spent the 1640s and 1650s in Rome and France, and learned the virtues of allegory and elegance. A direct contemporary of Lely, he established a successful practice during the reigns of Charles II and James II but his more direct and realistic style never quite suited fashionable taste. He died in poverty.

KEY WORKS Elizabeth Claypole (née Cromwell), 1658 (London: National Portrait Gallery); Thomas Hobbes, c.1669–70 (London: National Portrait Gallery)

Sir Godfrey Kneller

€ 1646-1723 P GERMAN/BRITISH

Amsterdam; Italy; England [] oils
 London: National Portrait Gallery [] \$263,754
 in 1997, Portrait of King George I of England (oils)

German-born, but had settled in England by the age of 30. Became principal state portrait painter from the reign of Charles II to George II. Established a successful formula (polite, mask-like faces with repetitive mouths and eyes) that emphasized status rather than realism or personality. Many sub-standard works were produced by studio assistants. **KEY WORKS** *Portrait of John Banckes*, 1676 (London: Tate Collection); *King Charles II*, 1685 (Liverpool: Walker Art Gallery)

 ● 1648 – 1720
 P BRITISH/DUTCH
 IR Rotterdam; London
 I Sculpture
 Surrey (England): Hampton Court.
 Sussex (England) Petworth Park
 S \$140,000 in 1995, Psalm 48, King David Playing Harp, St. Cecilia an Organ

England's most famous woodcarver of all time. Born of English parents in Rotterdam, he arrived in England c.1670/71. Very distinct personal style his sculptures seem organically alive. His theme was often cascades: fruit, leaves, flowers, birds, fish, which tumbled down furniture, paneling, even chimneys and walls. This famous cravat (right), à la Venetian needlepoint, was so realistic that an overseas visitor was convinced it was the standard dress of an English gent. Writer Sir Horace Walpole often wore it as a joke. Royal patrons included Charles II, William III, and George I, as well as major stately homes where his work is found today.

KEY WORKS Marble font c.1680s (London: St. James's Church, Piccadilly); Ceiling, c.1680s (Suffolk: Petworth House)

"There is nothing on earth so terrible as English music except English painting." HEINRICH HEINE

Sir James Thornhill

● 1675-1734 P BRITISH

 England I oils; fresco I London: Greenwich, National Maritime Gallery \$42,000 in 1999, *Capriccio with Saint Paul before Agrippa* (oils)

Ambitious and successful. The only English painter of fashionable, illusionistic Baroque wall and ceiling paintings for public buildings (including the Painted Hall of Wren and Hawksmoor's naval hospital in Greenwich, London) and country houses. Retired from painting in 1728 to become an MP and country squire. Produced quality work, but it lacks the necessary histrionic drama and excess (the British always believed that foreigners do that sort of thing better).

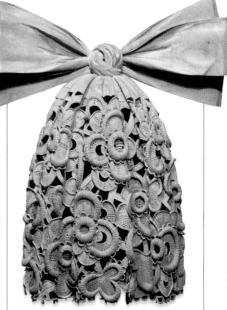

Woodcarving of a Cravat Grinling Gibbons, c.1690, linnewood, London: Victoria & Albert Museum. This intricately carved piece meticulously imitates Venetian needlepoint lace, and once belonged to 18th-century collector Sir Horace Walpole.

KEY WORKS Thetis Accepting the Shield of Achilles from Vulcan, c.1710 (London: Tate Collection); Time, Truth and Justice, c.1716 (Manchester: City Art Gallery)

Michael Dahl

⊖ 1659-1743 P SWEDISH/BRITISH

 London
 Dils
 London: National Portrait Gallery; Tate Collection \$88,920 in 1989, View of Olyo Farm, Valdres (oils)

Born in Sweden, settled in London in 1689. Produced competent portraits of aristocracy, royalty, and the literati. Languorous, elegant style, but poor characterization. Good on draperies; used diffused, silvery tones and short brushstrokes. Kneller's principal competitor. Dahl was prolific and successful. His earlier works are best. **KEY WORKS** Self-Portrait, 1691 (London: National Portrait Gallery); Unknouen Woman, formerly knouen as Sarah Churchill, Duchess of Marlborough, 1695–1700 (London: National Portrait Gallery)

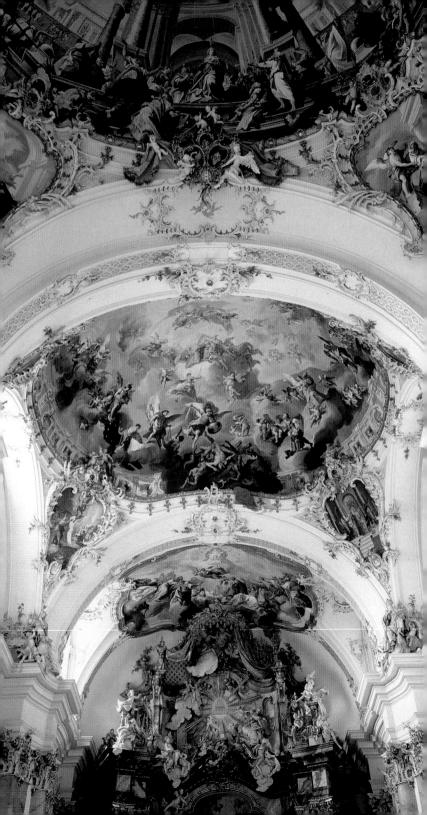

FROM ROCOCO TO NEO-CLASSICISM c.1700-1800

The 17th century had been a period of religious confrontation and warfare. By contrast, the 18th century, the Age of Reason, was a period of relative calm in which all the arts developed a refinement and elegance – often small in scale – suited to satisfying simple human needs and longings, rather than supporting ideologies.

t the heart of 18th-century thought and politics was the Enlightenment – a belief that human reason would resolve political and religious dilemmas, explain the workings of the world, the universe, and human nature, and create harmonious relationships in which superstition, tyranny, slavery, and oppression would be eliminated. This emphasis on "a pursuit of happiness" manifested itself in many ways: family life, children, and conjugal love became important; so did education, travel, industriousness, town planning, landscape gardening, parties, music, reading, discussion, food, comfort, and convenience. The Enlightenment also liked intellectual and emotional dualities, not as competing ideologies that would fight

Interior of Abbey Church, Ottobeuren, Bavaria In the 18th century Germany staged a cultural recovery. Spectacular church interiors were created from a blend of Baroque architecture and Rococo decoration. each other to the death, but to emphasize that choice was part and parcel of human fulfilment. Thus the art, literature, and philosophy of the 18th century are full of references to the differences between sense and sensibility, frivolity and morality. reason and emotion, indulgence and sobriety, sensuality and self-denial. This duality is equally well represented in the two principal artistic styles of the century: the Rococo with its light-hearted subjects, delicate colours, and asymmetric curves emphasizing frivolity, and sensuality, and Neo-Classicism with its serious historical subjects, straight lines, and precise outlines prioritizing morality and self-denial.

FRANCE AND ENGLAND

The principles of the Enlightenment were also reflected in the politics of the two major powers, France and England, but expressed in surprisingly

different ways, and with very different outcomes. English ideas were filtered though a prism of robust middle-class pragmatism; French ideas through one of theory, philosophical speculation, and aristocratic otherworldliness.

Both nations benefited from scientific discoveries, population growth, and agricultural revolutions. Both also had substantial colonial territories - chiefly in India and North America – backed by powerful military and naval forces. However Anglo-French rivalry was more than just a question of power politics. As important, each stood for a fundamentally different approach to government. Catholic France remained committed to the absolutist model of kingship established by Louis XIV. Protestant England, more properly Britain after its formal

James Watt rotary steam engine

Britain's technological lead in the second half of the 18th century gave it a decisive advantage over its European trading rivals. Industrialization boosted productivity and lowered costs. Cry of Liberty and the Departure for the Frontier Le Sueur brothers, 1792, print, Musée de la Ville de Paris. The French Revolution brought 10 years of political chaos to France, during which the king and his family were executed and Europe was plunged into war.

unification with Scotland in 1707, was rapidly evolving an early form of parliamentary rule. After 1763, with the end of the

Seven Years' War, Britain's superiority was clear. France had been ejected from India and North America and British naval superiority, the linchpin of its maritime empire, was emphatically confirmed.

TIMELINE: 1700 - 1800

1703 Foundation of St Petersburg by Peter the Great

1700

1704 Grand Alliance forces under duke of Marlborough defeat French at Blenheim 1714 Hanoverian succession in Britain

1720

1715 France ruled by regency of Philippe II, duc d'Orléans, upon death of Louis XIV **1729** Bach's St. Matthew Passion first performed

1735 War of the Polish Succession becomes Europe-wide conflict (to 1738) 1751 Diderot begins publication of L'Encyclopédie (to 1780)

1740

1740 Frederick II (the Great) of Prussia launches War of Austrian Succession (to 1748)

INDEPENDENCE AND REVOLUTION British self-confidence received a stinging rebuff with the Declaration of Independence in 1776 by the American colonists. It was the clearest possible statement of the political and

philosophical principles of the Enlightenment, modelled on the examples of both France and England, and it succeeded in creating what would eventually grow into a new world power. Britain recovered. Having lost her American colonies, she simply went on to build a second worldwide empire, an Anglo-Scottish enterprise that defined a British national identity, and added enormous riches to a land already grown fat on modern agriculture, and about to reap the economic benefits of an industrial revolution.

France, on the other hand. was a country that was kept unsteadily afloat by a volatile combination of aristocratic privilege, corruption, and debt, the whole centred on an inept monarchy. In the end this fatally flawed structure fell apart in the turmoil of the French Revolution f 1789. The revolutionary rallying cry of "Liberty, Equality,

Fraternity" soon became hollow words, as the bloodshed and tyranny of the "Terror" and then the dictatorship of Napoleon usurped the Enlightenment principles that the Revolution had sought to establish.

Goethe in the Campagna Johann Heinrich Wilhelm Tischbein, 1787, oil on carvas, 164 x 206 cm (64 1/2 x 81 in), Frankfurt: Städelsches Kunstinstitut. Like many other Bth-century writers and artists, Goethe visited Italy to seek inspiration among the Classical ruins.

Elsewhere in Europe the Austrian Habsburgs (Empress Maria Theresa), Prussia (Frederick the Great), and Russia (Catherine the Great) were all growing in influence and power, even if they lacked the global reach of France and England. Poland was on the verge of extinction. Italy and Habsburg Spain were subsiding, the latter despite its still huge Latin American empire. Ottoman Turkey was also shrinking in terms of power and territory, reduced by the end of the century to little more than an impotent bystander.

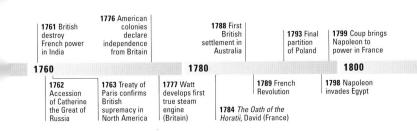

Jean-Antoine Watteau

⊖ 1684-1721 PU FRENCH

 Paris O oils; chalk O Paris: Musée
 du Louvre. London: Wallace Collection
 \$3,234,000 in 2000, Le Conteur, Artist from the Commedia dell'Arte in a Landscape (oils)

The most important French painter of the first half of the 18th century. Created a fresh, new, unassuming style, which was badly needed at the time.

LIFE AND WORKS

Watteau came from a poor family and had indifferent health throughout his short life. From a Flemish town ceded to France from the Spanish Netherlands, he trained as a scene painter at the Paris Opéra from c.1702–07. He then went to work for the curator of the Luxembourg Palace. There he had access to Rubens's *Marie de Medici* series, which was a major

"With a material art he has realized the miracle of representing a domain that it seemed only possible to evoke with music."

CAMILLE MAUCLAIR ON WATTEAU

influence, even though his own style was far more light and delicate.

He entered the French Academy in 1717 with *A Journey to Cythera* (right), which could not be fitted into any existing category and for which he received the new title of "peintre de fêtes galantes", a variant of the term "fête champêtre" or "outdoor feast", which had been applied to the 16thcentury outdoor scenes of Giorgione (see page 140) and the Gardens of Love found in medieval manuscripts.

Two years later, in 1719, he went to London, possibly to consult a famous physician, but the grim English winter aggravated his condition and he died of TB in 1721. His last great work was a shop sign known as *L'Enseigne de Gersaint*, 1721 (Berlin: Staatliche Museum).

STYLE

He is famous for inventing the *fete galante* or "courtship party"– a sort of stage set and dream world of perfectly mannered human love and harmony with nature,

> grounded in an acute observation of reality. Never sentimental, there is a melancholy that is sometimes accredited to his poor health.

> His forms are often half-suggested and require completion in the imagination (as in love, where a half-spoken sentence or a snatched glance can be made to mean everything). His statues seem about to become flesh and blood and join the human activity. The very titles of his works, *Conversation, Breakfast in the Open Air, Rural Pleasures*, become the spirit of the Rococc: daring, airy, carefree exuberance.

> Pierrot: Gilles 1721, 185 x 150 cm (72% x 59 in), oil on carvas, Paris: Musée du Louvre. The character Pierrot: Gilles comes from the form of Italian improvised comedy known as commedia dell'arte. A laughing stock, this moumful clown is the rejected lover and pitiable fool.

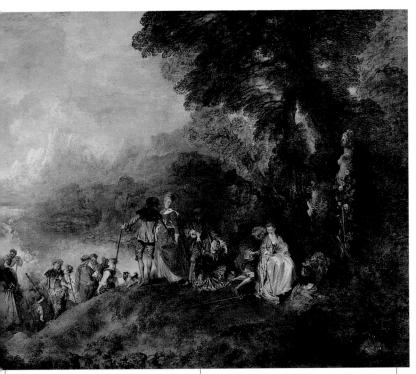

A Journey to Cythera 1717, 129 x 194 cm (51 x 76½ in), oil on carvas, Paris: Musée du Louvre. It is not clear from Watteau's composition whether the party is about to go to, or is departing from, the island of Cythera, the birthplace of Venus.

At his death he was developing a more sober blending of his early Flemish realism with his playful *fete galante*.

Curators now find that many of Watteau's paintings are in poor condition, probably due to his careless techniques concerning his materials. However, he made exquisite red-and-black chalk drawings, gouaches, and pastels done from life, which he used as a repertoire for his paintings. These numerous drawings, which he bound in large volumes, have become important references. During the French Revolution and with Neo-Classicism, his

reputation suffered, but his colour-flecking techniques influenced Delacroix and the later Post-impressionists.

WHAT TO LOOK FOR

Gesture, light, and facial expression, which he used to counterpoint frivolity with a melancholy, suggesting the deeper issues of humanity. His delicate brushwork and pastel colours perfectly echo his subject. **KEY WORKS** *The Scale of Love* c.1715–18 (London: National Gallery); *The Faux Pas*, 1717 (Paris: Musée de Louvre); *Italian Comedians*, c.1720 (Washington DC:

National Gallery of Art)

Head of a Negro c.1710–21, chalk on paper, London: British Museum. Watteau was a master of the French technique, trois crayons, a combination of red, black, and white chalks set down separately on tinted paper. It is possible that he learned this method studying Rubens's drawings.

Jean Chardin

€ 1669-1779 P FRENCH

 ■ Paris
 ● oils
 ● Paris: Musée du

 Louvre
 ● \$2.3m in 1989, Fish, Vegetables,

 Pots, and Cruets on a Table (oils)

Diligent artist, widowed. Exemplified in paint the best qualities of the Age of Reason, producing exquisite small still lifes and genre scenes that demonstrate harmony of order, sober colour, pleasure in simplicity and relationships.

Note his loving observation of light and handling of paint. Subjects and style reflect his modest, open personality with love of craftsmanship. The surfaces and textures of the still lifes are so believable that you want to touch them - you know exactly what everything is and where it is in space. The genre scenes crystallize moments of simple, restful intimacy, such as childish pleasures, Experience teaching Youth, the dignity of domestic labour, etc. Simple, easy-to-understand symbolism. KEY WORKS The House of Cards, c.1735 (Washington DC: National Gallery of Art); The Young Schoolmistress, c.1735-36 (London: National Gallery)

Nicolas Lancret

€ 1690-1743 P FRENCH

Paris D oils Paris: Musée du Louvre. London: Wallace Collection 2 \$740,000 in 1997, Huntsman and his Servant (oils)

Lancret was a chief follower of Watteau's style, but his own style was more prosaic – he painted only the day-to-day (albeit

Still Life Jean Chardin, c.1732, 16.8 x21 cm (6% x 8½/in), oil on panel, Detroit Institute of Arts. Although a member of the prestigious Royal Academy in Paris, Chardin was criticized for not attempting more ambitious subjects. The son of a master carpenter, and a man of simple tastes, he instead preferred to perfect what he knew he could do best.

elegant) reality, whereas Watteau could transform reality and endow it with the magic of poetry and dreams. His works have a cruder colour than Watteau's. Liked theatre subjects. Popular with aristocratic collectors. **KEY WORKS** *The Four Ages of*

Man: Maturity, 1730–35 (London: National Gallery); Dance before a Fountain, c.1730–35 (Los Angeles: J. Paul Getty Museum)

Jean-Baptiste Pater

Watteau's pupil. Had similar subjects and style, but his drawing and use of colour lack confidence. His work hasn't got the depth of feeling and the richness of colour that is the hallmark of Watteau. **KEY WORKS** *Les Baigneueses (Women Bathing)*, (St. Petersburg: Hermitage Museum); *The Dance*, (London: National Gallery); *Chinese Hunt*, 1736 (Paris: Musée du Louvre)

François **Boucher**

● 1703-70 P FRENCH

A key artist of the sumptuous, profligate, overindulgent *ancien régime* of Louis XV. A favourite of Madame de Pompadour. Epitomizes the full-blown Rococo style.

Creator of lavish images of, and for, a world of narcissistic, self-indulgent luxury, namely the French royal court of the mid-18th century (this does not stop them being wonderful paintings). Most

magnificent with his depictions of the classical gods, who (according to Boucher) enjoyed a similar lifestyle; also heavily sentimental pastoral and genre scenes. In addition, he designed for the royal tapestry works and porcelain factories and became King's Painter in 1765.

Notice the acres of soft, pink flesh set among frothy and false vegetation; lavish silks, satins, and lace in the portraits – all painted with great technical skill and caressing sensuality; a brilliant marriage between his patrons' needs (the subject matter) and style and technique – one of the hallmarks of great painting. **KEY WORKS** *The Breakfast*, 1739 (Paris: Musée du Louvre); *Diana Bathing*, 1742 (Paris: Musée du Louvre); *Reclining Girl*, 1751 (Munich: Alte Pinakothek)

Jean-Baptiste **Greuze**

€ 1725-1805 P FRENCH

Paris
 Paris

Best known for his sentimental storytelling genre pictures and titillating images of young children, which were part of his later work. Early on he had aspirations as a history painter. Played to a pre-French Revolution audience that turned luxury and idleness into an art form. Became very successful but fell into obscurity with the revolution and died in poverty. Had an unpleasant personality.

His overriding feature is excess of emotion – overexpressive faces and overdramatic gestures. You know what feeling he was trying to convey (or do you, in fact?) but, like bad acting, it can seem so false you may well be moved to laughter rather than tears.

Many weaknesses: false emotion, bad composition, poor drawing, unattractive colour. In fairness, he did make some striking portraits, which are good and worth looking for.

KEY WORKS Broken Eggs, 1756 (New York: Metropolitan Museum of Art); Boy with Lesson Book, c.1757 (Edinburgh: National Gallery of Scotland); The Laundress, 1761 (Los Angeles: J. Paul Getty Museum); Spoilt Child, 1765 (St. Petersburg: Hermitage Museum)

Le Geste Napolitain Jean-Baptiste Greuze, 1757, 73 x 94.3 cm (28½ x 37 in), oil on canvas, Massachusetts: Worcester Art Museum. Greuze's anecdotal scenes were popular with a novel-reading public, and he played up to their enthusiasms by selling engravings of his works and elaborating their themes in notes in exhibition catalogues.

THE ROCOCO

By the early 18th century, the heroic certainties of the Baroque were giving way to the elegant intricacies of the Rococo (from the French "rocaille", meaning "shellwork", a recurring motif in Rococo interior decoration). A conspicuously courtly painting style, it appealed to sophisticated, aristocratic patrons. As a reflection of a supremely cultivated society, it was briefly supreme.

STYLE

Light colours and deft brushwork predominate, with a premium on highly finished, shimmering surfaces in which the depiction of gorgeous fabrics, melting skin tones and luxuriant landscape backgrounds often overgrown, never threatening is relished for its own sake. In the hands of its most outstanding exponents - the French painters Boucher and Fragonard, the Italian Tiepolo – the result is a captivating, idealized world, elegant and seemingly effortless. Draperies flow, limbs intertwine, smiles entice and eyelids flutter. Allure is everything.

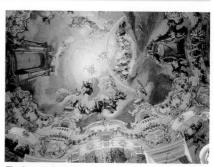

The Last Judgement (ceiling fresco) Johann Baptist Zimmermann, c. 1746–54, fresco and stucco, Wies (Germany): Wieskirche. German artists fused architecture and painting to create light-filled interiors, which soar into visions of heaven.

"Education de l'Amour" (modelled by Etienne Falconet after Boucher), c. 1763, 30.5 cm (12 in), porcelain. The subject matter, self-evidently sexual, is as typical as the handling: eroticism meets highly finished treatment.

Sophisticated 18th-century society placed a premium on intimacy. It was a shift in taste precisely reflected by Rococo art, above all in France. In place of the large scale of the Baroque, whether antique or religious, Rococo painting concentrated on aristocratic dalliance, small scale and highly wrought. Antiquity became a matter of scantily clad shepherdesses, bosoms daintily exposed, ravished by muscular young giants. The Rococo rarely lent itself to religious subjects, but Tiepolo successfully linked the two.

KEY EVENTS

1702	Flemish-born Watteau arrives in Paris	
1714	Death of Louis XIV	
1717	Watteau paints his elegiac A Journey to Cythera (see page 223)	
1750	Tiepolo spends three years at Würzburg. Completes the decorative cycle in 1752–53 with fresco of the Continents, the world's largest painting, over the main staircase	
1775	Boucher appointed director of the French Academy	
1767	Fragonard paints his airy masterpiece, The Swing (see page 228)	

c.1700-1780

WHAT TO LOOK FOR

Boucher epitomized the gorgeous colours, highly finished surfaces, and technical sophistication of the Rococo. It was an art that was self-consciously pleasing, reflecting the privileged aristocratic world that brought it into being. As early as the

Putti underline classical origins of this scene as well as its essential unreality **Soft background lighting** focuses attention on the principal figures in this tableau

mid-18th century, the Rococo was being criticized for these apparent frivolities; by the French Revolution in 1789, what was left of Rococo sentiment had been obliterated. Yet at its best it encapsulated much more than aristocratic frippery.

> Precise painting of an apparently naturalistic setting highlights new interest in landscape

To seduce Erigone,

Bacchus transformed himself into a bunch

of grapes. She

swoons as her arm

touches the fruit

Bacchus and Erigone François Boucher 1745, 99 x 134.5 cm (39 x 53 in), oil on canvas, London: Wallace Collection. For Boucher, classical myths made most sense when transformed into scenes of ravished innocents. Seduction, here aided by the (fatal) promise of wine, is a recurring theme.

TECHNIQUES

Darkened leaves are lit so that they appear iridescent at the edges from the light of the shaded sun. Similar light plays seductively on the girls' exposed breasts.

Flesh tones are precisely and lovingly rendered, exemplified in Erigone's delicate, elegant legs, sensually curved and exposed.

Jean-Honoré Fragonard

⊖ 1732-1806 PU FRENCH

Paris; Rome; France Di oils; chalks Di Paris:
 Musée du Louvre. London: Wallace Collection
 \$7,776,000 in 1999, Le Verrou (The Bolt) (oils)

Precocious, successful – much favoured by the *ancien régime* for his easy-to-enjoy, virtuoso, and titillating private paintings. Rejected the trappings of official art. Died in poverty after the French Revolution.

The participants in his pictures of love and seduction may be in contemporary dress, from mythology, or have no clothes at all. He likes pink cheeks and heaving bosoms, sidelong glances, passionate embraces, and futile resistance. Even his drapery, landscape backgrounds, foliage, and clouds froth with equal erotic intensity.

His exciting, nervous, but confident style suits his subjects; his seductive pink-and-green palette and soft, dappled light prefigure Renoir. Paints hands with long, sensuous fingers. Note the lap dogs and fleshy statues ready to join the fun. Look for occasional early works in a "correct" official style – which he soon rejected.

The Swing (Les hasards heureux de l'escarpolette) Jean-Honoré Fragonard, 1767, 81 x 65 cm (32 x 25¼ in), oil on canvas, London: Wallace Collection. The trees were inspired by Tivoli Gardens.

KEY WORKS *Bathers*, c.1765 (Paris: Musée du Louvre); *Young Girl Reading*, c.1776 (Washington DC: National Gallery of Art); *The Stolen Kiss*, c.1788 (St. Petersburg: Hermitage Museum)

Carle van Loo

● 1705-65 P FRENCH

■ Rome; Paris ■ oils ■ Paris: Musée du Louvre ■ \$250,000 in 2000, Venus Requesting Vulcan to Make Arms for Aeneas (oils)

Also known as Charles-André van Loo. Most successful member of a family that dominated French painting in the mid-18th century, but is now, rightly, forgotten – his success owing more to quantity than quality. Royal portraits, huge altarpieces, some boudoir scenes. His nephew, Louis Michel (1707–71), is now rated as highly. **KEY WORKS** *The Grand Turk giving a Concert to his Mistress*, 1727 (London: Wallace Collection); *Aeneas Carrying Anchises*, 1729 (Paris: Musée du Louvre)

Sebastiano Ricci

⊖ 1659-1734 PU ITALIAN

 Image: Wight of the state of the state

Decorative painting at its best. Standard mythological and religious paintings. An engaging eyeful of easy compositions, fresh colour, and attractive people. No pretentious intellectualizing or moralizing. Worked in the Venetian tradition.

KEY WORKS The Rape of the Sabine Women, c.1700 (Vienna: Liechtenstein Museum); Esther before Ahasuerus c.1730 (London: National Gallery)

Marco Ricci

● 1676 – 1729
 № ITALIAN
 № Italy; England
 № oils;

drawing Windsor Castle (England): Royal Collection. Washington DC: National Gallery of Art 24478,500 in 2001, An Opera Rehearsal (oils)

Nephew of Sebastiano. Worked in England 1708–16 and collaborated with his uncle on religious

Ships in a Gale Marco Ricci, c.1705–08, 92 x 124.5 cm (36% x 49 in), oil on canvas, Indianapolis: Museum of Art. Ricci was widely travelled, and was employed in London and Venice to create stage sets.

and mythological pieces. Developed his own line of fresh, frothy, light-filled fantasy or semi-topographical landscapes. **KEY WORKS** *Fishing Boats*, 1715 (Los Angeles: J. Paul Getty Museum); *Landscape with Ruins*, 1725 (Los Angeles: J. Paul Getty Museum)

Rosalba Giovanna Carriera

⊖ 1675-1758 № ITALIAN

🔟 Venice; Paris; Vienna 🛛 🚺 pastels

 Dresden: Gemäldegalerie. London: Victoria & Albert Museum 2 \$105,000 in 1998, Female Personification of Summer (works on paper)

Known for her highly successful portraits in pastels, which cleverly combine delicacy and graciousness with spontaneity, plus a judicious realism that neatly negotiates the fine divide between honesty and flattery. She was much sought after by the rich and fashion-conscious as she took her artistic skills round the capital cities of Europe. She inspired Maurice-Quentin de La

> Tour to use pastel. **KEY WORKS** Self-Portrait with a Portrait of her Sister, 1709 (Florence: Galleria degli Uffizi); Young Lady with a Parrot, c.1730 (Art Institute of Chicago)

Caterina Sagredo Barbarigo as "Bernice" Rosalba Giovanna Carriera, c.1741, 44.5 x 31.8 cm (17½ x 12½ inl, pastel on paper mounted on canvas, Detroit Institute of Arts. One of the last works the artist produced; in 1745 she went blind.

Giovanni Battista Pittoni

 ● 1687-1767
 № ITALIAN

 № Venice
 Ø oils
 M Venice: Gallerie dell'

 Accademia
 № \$443,005 in 1990, Omphale (oils)

Poor man's Tiepolo. Had a flashy, richly coloured, loosely painted style, which is more a mishmash of earlier Venetian artists and borrowings from Tiepolo than truly original. His work – religious, historical, and mythological subjects – was much sought after in his lifetime, both at home and abroad, demonstrating that commercial and critical success is sometimes (often?) achieved by showing off, rather than through talent. **KEY WORKS** *St. Prosdocimus Baptizing Daniel*, 1725 (York: City Art Gallery); *An Allegorical Monument to Sir Isaa Newton*, 1727–29 (Cambridge: Fitzwilliam Museum)

The Delivery of the Keys to St. Peter Giovanni Battista Pittoni, c.1710–67, 82 x 42 cm, (32½ x 16½ in), oil on canvas, Paris: Musée du Louvre. Christ entrusts the keys of heaven to the disciple, Peter, watched by cherubs.

Giovanni Antonio Pellegrini

⊖ 1675-1741 🕫 Italian

Wenice; England; Paris
 Paris: Musée du Louvre
 \$489,000
 in 1998, Venus, Cupid, and Faun (oils)

Well-travelled (Germany, Vienna, Paris, Netherlands, England) Venetian painter. Bright, appealing, airy, illusionistic, decorative compositions on a large scale (very much the Venetian tradition, but brought up to date), which were influential in creating a fashion and demand for this type of work, especially in England. **KEY WORKS** *Rebecca at the Well*, 1708–13 (London: National Gallery); *The Mariage of the Elector Palatine*, 1713–14 (London: National Gallery); *Bacchus and Ariadne*, c.1720–21 (Paris: Musée du Louvre)

Giambattista **Tiepolo**

⊖ 1696-1770 🕫 ITALIAN

Full name Giovanni Battista Tiepolo. Last of the great Venetian decorators in the Renaissance tradition. Easy-going, happily married to Francesco Guardi's sister, quick, and astonishingly gifted. Was successful, sought after, and rich, but his work is now out of fashion and very underrated.

His great decorative schemes *in situ* (Venice, the Veneto, Würzburg, Madrid) are a truly miraculous combination of fresco and architecture on a vast scale, where walls and ceilings seemingly disappear to reveal a celestial, luminous, shimmering vision of happily radiant gods, saints, and historical and allegorical figures in an epic fantasy world. They constitute one of the greatest artistic experiences of all time.

Observe his brilliant storytelling and perspectival illusion. He has a confident, resolute technique and uses luminous colours. Large-scale schemes were the result of teamwork (the painting of the architectural settings being especially crucial). The preliminary sketches show a deft, delicate technique with flickering dark outlines, which weave under and over colour, giving life and crispness. He loves rich textures, doe-eyed females,

Abraham and the Three Angels Giambattista Tiepolo, c. 1720–70, oil on carvas, Venice: Scuola Grande di San Rocco. The Bible tells how the prophet Abraham offered a meal to three angels, representing the Trinity.

muscular men, theatrical gestures – but always avoids cliché and frivolity. **KEY WORKS** *Queen Zenobia Addressing her Soldiers* c.1730 (Washington DC: National Gallery of Art); *Apollo in his Sun Chariot* (see pages 232–233); *The Olympus*, c.1750s (Madrid: Musco del Prado); *Allegory of the Marriage of Rezzonico to Savorgnan*, 1758 (Venice, Ca' Rezzonico: Museo del Settecento)

"... the last, and most refined, stage of illusionistic ceiling decoration is represented by its greatest master, Giovanni Battista Tiepolo."

H. W. JANSON

Giandomenico Tiepolo

€ 1727-1804 PU ITALIAN

Son of Giambattista, with whom he worked on major projects and whose style he successfully imitated. He flourished in his own right (but without his father's celestial inspiration and vision), preferring scenes of everyday life and witty anecdote. Skilled draughtsman and printmaker. **KEY WORKS** The Mariage of Frederick Barbarossa, c.1752–53 (London: National Gallery); The Building of the Trojan Horse, c.1760 (London: National Gallery); Horseman with Punchinellos, second half of 18th century (St. Petersburg: Hermitage Museum)

Pietro Longhi

•	1702-	-85	ρu	ITALIAN	
---	-------	-----	----	---------	--

 ☑ Venice
 ☑ oils; chalks
 ☑ Venice:

 Querini-Stampalia Galleria
 ☑ \$775,000

 in 2005, *Ridotto in Venice* (oils)

Italian counterpart to Lancret and Hogarth (see pages 224 and 238) in that he successfully caught the 18thcentury taste for small-scale scenes of everyday life – in his case, Venetian goings-on from aristocracy to lowlife. They still sparkle with spontaneity and sharp, dispassionate observation. **KEY WORKS** Theatrical Scene, c.1752 (St. Petersburg: Hermitage Museum); The Display of the Elephant, 1774 (Houston: Museum of Fine Arts)

Exhibition of a Rhinoceros at Venice Pietro Longhi, 1751, 60 x 47 cm (23% x 18% in), oil on canvas, London: National Gallery. The rhino is exhibited for the amusement of revellers, one of whom brandishes its sawn-off horn.

Apollo Bringing the Bride

Giambattista Tiepolo 1750-51

Tiepolo was the most celebrated fresco painter of the 18th century, famed for his seemingly ceaseless invention, astonishing fluency, and ability to tackle huge decorative schemes in record time. Among his most startling works are those at the Residenz, or palace, of the worldly Prince-Bishop of Würzburg.

The French court at Versailles was emulated by rulers in many parts of Europe. That at Würzburg in Bavaria was unusual only in attracting arguably the greatest Rococo architect, Balthasar Neumann, and its most accomplished frescoist, Tiepolo, as well. Together, they created an astonishingly sumptuous decorative programme. The settings of Tiepolo's frescoes were always crucial. He may have relished his mastery of illusionistic techniques for its own sake. But as important, they allowed him to create works that extend the real space of these vast settings into his imaginary, painted world. Typically, he displays a bravura disregard for historical accuracy. Twelfth-century Germany - scene of the Burgundian princess Beatrice's arrival for her marriage to Emperor Frederick Barbarossa – is transmuted into a sky-borne 16th-century Venice.

With exceptional daring, large ares of cloud-flecked sky are left blank, increasing the sense of heroic expansiveness

Two other, no less magnificent, frescoes by Tiepolo complete the decorative cycle of the Imperial Hall

Though only a

fragment of a building is shown, and from a steeply angled perspective, it implies a strongly imagined architectural setting

The merging of painting and setting makes the fresco seem an extension of the elaborate space

Beatrice is accompanied by the Sun God, Apollo, who escorts her in his chariot to her wedding. Appearing luminescent in her majestic matrimonial splendour, she is dressed as though in a painting by Veronese, the 16th-century Venetian painter, who exercised a profound influence on Tiepolo.

Apollo Bringing the Bride

Medium ceiling fresco Dimensions 6.97 x 14.07 m (22 % x 46 % ft) Location Würzburg Palace: Imperial Hall

"He paints a picture in less time than it takes another to grind his colours."

COUNT CARL GUSTAV TESSIN

Pale, limpid colours add luminosity and underline the airy magnificence of the sky

TECHNIQUES

Fresco was peculiarly well suited to Tiepolo's technique. Because the plaster dries rapidly, the paint has to be applied at speed. This demands an exceptionally sure touch, encouraging the deft, flickering style he excelled at.

Allegorical figures usher Apollo and Beatrice towards the princess's future husband

Tiepolo suspends reality to create a convincing parallel world

Clouds and figures spill over the frame of the fresco into the real space of the room

Tiepolo revels in his mastery of extreme foreshortening and the drama and excitement it projects. These magnificent horses testify to his virtuosity, apparently able to tackle any subject in the absolute certainty that it can be invested with his unique brand of epically elegant heroism.

Giovanni Paolo Panini

⊖ c.1691-1765 PU ITALIAN

Bologna; RomeAll oils\$3,843,000in 2004, Interior of St. Peter's, Rome (oils)

Also known as Pannini. Highly successful view painter, contemporary of Canaletto, who anticipated Neo-Classical taste. Born in Piacenza and trained in the school of stage designers in Bologna. Worked in Rome, and was much admired by the French. Had a good line in picturesque, ancient ruins, and views and events in modern Rome. His drawings were much sought after in his day.

KEY WORKS Roman Ruins with Figures, c.1730 (London: National Gallery); The Sermon of St. Paul Amid the Ruins, 1744 (St. Petersburg: Hermitage Museum); Roman Ruins with a Prophet, 1751 (Vienna: Liechtenstein Museum)

THE GRAND TOUR 18th century

Once-in-a-lifetime tour around Europe to see the major sights and works of art, and to experience life and broaden horizons. It was very much the done thing in the early 18th and 19th centuries, especially for young English gentlemen, who would return home with quantities of works of art with which they filled their country homes. An elegant portrait painted in Rome by the Italian artist Batoni was the typical Grand Tour souvenir-cum-status symbol. **Ruins with Figures** Giovanni Paolo Panini, 38.1 x 27.9 cm (96% x 70% in), oil on canvas, Wilton (UK): Wilton House. Panini trained in architectural drawing. He was married to a Frenchwoman.

Giovanni Antonio Canaletto

⊖ 1697-1768 🕫 ITALIAN

Venice; London i oils; drawings; engravings
 Royal Collection. London: National Gallery.
 Dresden: Gemäldegalerie i \$16m in 1992,
 The Old Horse Guards, London, from St. James's
 Park, with Figures Parading (oils)

The most famous Venetian view painter of the 18th century. Instantly recognizable. He was much loved and collected by English Grand Tourists, and also painted views of England.

His early views of Venice (during the 1720s and 1730s) are the best, being surprisingly subtle and poetic (later works tend to become mechanical and dull). Stunning use of perspective and composition (he may have used a camera obscura). Views are not of reality, but cunning fictions. One of the few painters who has been able to capture not just the light and feel of Venice, but also the pageantry and history of a once-great empire in its dying years. See the way he enlivens perspective with crisp, accurate, architectural details and opens up a scene by using several different viewpoints in one work. Shows clever use of light and shade: judicious balance of both with razor-sharp shadows and an exciting, unexpected fall of light on a wall. Delightful, original, anecdotal (figure) details and first-hand observation; sense of something (unseen) happening around the corner. Also produced exciting, fluent drawings and sketches. KEY WORKS The Stonemason's Yard, 1726-30 (London: National Gallery); Rome: The Arch of Constantine, 1742 (Windsor Castle, England: Royal Collection); London, St. Paul's Cathedral, 1754 (New Haven: Yale Center for British Art): A View of the Ducal Palace in Venice, pre-1755 (Florence: Galleria degli Uffizi)

The Basin of San Marco on Ascension Day

Giovanni Antonio Canaletto, c. 1740, 122 x 183 cm⁷(48 x 72 in), oil on canvas, London: National Gallery, Every year on Ascension Day the Doge of Venice went to the Lido to perform a ceremony whereby Venice was "married" to the Adriatic Sea. The Doge's golden barge is moored ready.

Francesco Guardi

● 1712-93
 № ITALIAN
 № Venice
 № oils; drawings
 № \$13,943,218 in 1989, View of the Giudecca and the Zattere, Venice (oils)

Prolific Venetian view painter and best-known member of a family of painters, Guardi was widely collected in the 18th century, but his paintings sold for half the price of Canaletto's.

His charming Venetian scenes capture the spirit of the city more by atmosphere and mood than by topographical accuracy. The cool, misty, relaxed, small-scale style is in complete contrast with the intense, busy, sharp, and bigger-scale style of Canaletto (their works are usually hung together).

Note the inaccurate perspective and seeming indifference when people or buildings get out of scale; suppression of detail; loose, flickering style of painting; and hazy, cool colours and sombre palette. **KEY WORKs** *A Seaport and Classical Ruins in Italy*, 1730s (Washington DC: National Gallery of Art); *St. Mark's Square*, c.1760–65 (London: National Gallery); *Venice: The Grand Canal with the Riva del Vin and Rialto Bridge*, c.1765 (London: Wallace Collection); *View of the Venetian Lagoon with the Tower of Malghera*, c.1770s (London: National Gallery); *An Architectural Caprice*, 1770s (London: National Gallery)

View of Warsaw from the Royal Castle

Bernardo Bellotto, 1772, oil on canvas, Warsaw: National Museum. Bellotto's views of Warsaw were used in the reconstruction of the city after 1945.

Landscape with Ruins Francesco Guardi, c. 1775, 72 x 52 cm (281/x 201/x in), oil on canvas, London: Victoria & Albert Museum. Guardi had a liking for capricci – fantasy townscapes with real and imaginary buildings.

Bernardo Bellotto

⊖ 1720-80 № ITALIAN

 Image: Venice; Dresden; Warsaw
 Image: Oils

 Image: Dresden: Gemäldegalerie. Warsaw:

 National Museum
 Image: S5,642,000 in

 1991, Fortress of Königstein (oils)

A nephew of Canaletto, from whom he learned his trade, Bellotto left Italy in 1747 because of family problems, never to return. His colouring is generally more sombre than his uncle's.

He painted views of northern European towns, commissioned by the old-fashioned, aristocratic patrons who ruled them and

who employed him on a salary as court painter (Dresden, Vienna, Warsaw).

His impressive, large-scale works are distinguishable from Canaletto's by their different subject matter and cooler, blue-green, silvery palette (he painted on darkly primed canvases). Less imaginative use of space (used only a standard singleviewpoint perspective), but a better response to trees and vegetation. His anecdotal detail is good , but the figurepainting is more crude than Canaletto's. **KEY WORKS** Dresden, the Frauenkirche and the Rampische Gasse, 1749–53 (Dresden: Gemäldegalerie); The Neustadter Market in Dresden, 1750 (Dresden: Gemäldegalerie); Architectural Capriccio, c.1765 (San Diego Museum of Art)

Francesco Zuccarelli

€ 1702-88 PU ITALIAN

 Rome; Venice; England i oils
 Royal Collection. Glasgow Art Gallery
 \$313,500 in 1997, Wooded Landscape with Washerwomen by River (oils)

A Florentine painter of Venetian-style high quality, Zuccarelli produced sugary, softly coloured, easily painted pastoral landscapes and cityscapes. Was much admired by collectors of his day (especially the English, who favoured his soft, Rococo style and made him a founder member of the Royal Academy). Once spoken about An Italianate River Landscape Francesco Zuccarelli, 105.3 x 89.8 cm (41 ½ x 35½ in), oil on carvas, London: Christie's Images. Zuccarelli's work was usually made to become part of a decorative room setting.

in the same breath as Canaletto, he is now virtually forgotten. **KEY WORKS** Landscape with a Woman Leading a Cow, 1740s (St. Petersburg: Hermitage Museum); Landscape with the Education of Bacchus, 1744 (Los Angeles: J. Paul Getty Museum); Landscape with Shepherds, 1750 (Los Angeles: J. Paul Getty Museum)

Pompeo Girolamo Batoni

⊖ 1708-87 № ITALIAN

■ Rome ■ oils ■ \$625,800 in 1993, Portrait of Sir Charles Watson (oils)

He was a highly successful portrait painter, especially of English visitors to Italy on the Grand Tour. Polished and finely painted work, careful attention to detail (lace, stitches in clothing), with beautiful results. Established a formula that favoured stock poses with smart clothes, ruins in the background, and dogs at the feet – or both. He knew exactly what his snobby clientele wanted and provided them with it. **KEY WORKS** Christ in Glory with Four Saints, 1736–38 (Los Angeles: J. Paul Getty Museum); Time Orders Old Age to Destroy Beauty, 1746 (London: National Gallery)

William Hogarth

⊖ 1697–1764 🕫 BRITISH

 Image: Decoder of the second seco

Hogarth is considered the "father of English painting". He was a quirky, argumentative anti-foreigner, with a tough childhood. Talented both as a painter and printmaker, he laid the foundations that led to Reynolds and the Royal Academy.

Hogarth is best known for his portraits (individual and group) and modern, moral subjects – slices of contemporary life, which were often developed as a series (for instance, *The Rake's Progress* and *Marriage à la Mode*). In neither does he idealize or criticize; he shows people and their behaviour for what they are.

Brilliant as a storyteller. Also a very fine handler of paint, producing confident drawing and colour-rich textures. Painted attractive, open faces in portraits and was especially good representing children.

Marriage à la Mode: VI, The Lady's Death William Hogarth, c.1743, 70 x 91 cm (27½ x 35½ in), oil on canvas, London: National Gallery. The final grimly comic scene in a story of a disastrous fashionable marriage.

Self-Portrait William Hogarth, engraving, Private Collection. Hogarth helped to establish the first permanent public display of English art at the Foundling Hospital in central London.

Showed engaging, anecdotal details and "warts and all" realism, but we are left to draw our own moral conclusions. **KEY WORKS** *The Strode Family*, 1738 (London: Tate Collection); *The Graham Children*, 1742 (London: National Gallery); *The Shrimp Girl*, c.1745 (London: National Gallery)

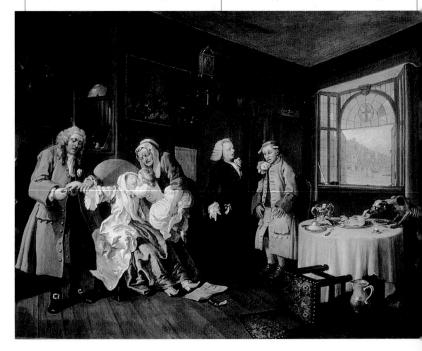

Arthur Devis

⊖ 1711-87 PU BRITISH

■ London; Lancashire ■ oils ■ \$478,800 in 1989, Portrait of Mr. and Mrs. Robert Dashwood of Stanford Hall, Nottinghamshire (oils)

Small-scale family conversation pieces with doll-like figures (he used dolls as models), neatly dressed and arranged in their houses and parks. Successful with the newly emerging middle classes. Gives us a charming and authoritative insight into 18th-century society. **KEY WORKS** *Jacob Bacon and His Family*, c.1742–43 (New Haven: Yale Center for British Art); *Portrait of a Lady*, c.1750–51 (London: Tate Collection)

Sir Joshua Reynolds

⊖ 1723-92 P BRITISH

 ■ London; Devon; Italy
 ● oils
 ● London:

 National Gallery; Tate Collection
 ● \$13,348,000

 in 2000, Portrait of Omai, Standing in a Landscape,

 Wearing Robes and a Headdress (oils)

Best known for his portraits. Raised the status of portraiture, the arts generally, and the social standing of artists in Britain. A discriminating collector of old-master prints and drawings. Well connected, and the first President of the Royal Academy.

His principal achievement is the brilliant way he used allusion and cross-references to enhance the dignity of his sitters and turn portraiture into a type of history painting, with lots of references to classical mythology, antique statues, and architecture. His sitters are often in the poses of well-known examples of Greek and Roman sculpture or the Madonna and Child. Was especially good with children, but terrible as a "history" painter.

He made inventive use of hands and gesture to bring life and character to his figures. In 1781 he went to Flanders and Holland, and afterwards one can see the influence of Rubens and Rembrandt on his work. Had poor technique – his pictures are often in bad condition because of his use of inferior materials such as bitumen and carmine.

KEY WORKS Self-Portrait Shading the Eyes, 1747 (London: National Portrait Gallery); Commodore Keppel, 1753–54 (Greenwich, London: National Maritime Museum); Lady Caroline Howard, 1778 (Washington DC: National Gallery of Art)

Allan **Ramsay**

⊖ 1713-84 PU BRITISH

 London; Italy is oils; drawings
 \$760,000 in 1993, Portrait of Sir Edward and Lady Turner seated holding Lace and Basket (oils)

Interesting and successful Scottish portrait painter who worked mainly in London, from 1739. His early work is often very laboured and derivative, and his official full-length portraits are rather wooden. His later work, from the 1760s onwards, is better. At his best with small and intimate three-quarter-length portraits, especially of women; these have a lovely softness, charm, and delicacy.

The turn of the head on the body gives life to the figures, in spite of repetitive and unimaginative poses. His intensity of observation is worthy of the best still-life painters: note the detail on costumes; the careful painting of objects; the eyes, where even the colour of the iris is noted exactly; the beautiful use of light. **KEY WORKS** *Richard Mead*, 1740 (London: National Portrait Gallery); *Norman "The Red Man"*, 22nd *Chief of Macleod*, c.1747 (Isle of Skye, UK: Dunvegan Castle); *Miss Janet Shairp*, 1750 (Aberdeen: Art Gallery and Museums)

Master Thomas Lister (The Brown Boy) Sir Joshua Reynolds, 1764, 231 x 139 cm, (91 x 55 in), oil on canvas, Bradford (UK): Art Galleries and Museums. The pose mimics an Antique statue of Mercury.

Thomas Gainsborough

● 1727-88 P BRITISH

Best known for his portraits (which he could sell), his heart was more in landscapes (difficult to sell). Fashionable and successful. An amorous man.

Born in Sudbury, Suffolk, he went to London in 1740 and studied engraving before setting up as a portrait painter in 1752. Gainsborough's sensibility and instinct, and his imaginative, experimental craftsmanship were the antithesis to Reynolds's intellectualism and bad technique. His portraits after 1760 are of natural, untheatrical poses – Mr. and Mrs. Andrews Thomas Gainsborough, c.1749, 71 x120 cm (28 x 47 in), oil on canvas, London: National Gallery. The newly married couple sit in their estate whose topography is precisely recorded.

thinly, freely, and sketchily, enabling him to capture the shimmer of silks and satins, the rustle of breeze-touched foliage, the natural blush on a girl's cheek, or rouge on a matron's face. There are parallels with early Mozart (1756–91): interweaving of structure and texture; light-hearted seriousness; physical pleasure in being alive. His early works lack the easy relaxation of the later works; they are charming but the portrait figures look like dolls and the landscapes concentrate on detail rather than atmosphere.

No fan of literature, his only great interest outside of painting was music. **KEY WORKS** *"The Blue Boy"*, c.1770 (San

gorgeous best clothes and hats, sympathetic observation and response to character in a face (especially that of a pretty woman). His landscapes are imaginary, lyrical, poetic – a conscious escape from a hard day's labour. Lovely, free chalk drawings. Also prints.

Wonderful paint handling, used very

Marino: Huntingdon Art Collections); Portrait of Anne, Countess of Chesterfield, c.1777 (Los Angeles: J. Paul Getty Museum); Mrs. Richard Brinsley Sheridan, c.1785 (Washington DC: National Gallery of Art)

The Painter's Daughters Chasing a Butterfly

Thomas Gainsborough, c.1759, 113.5 x 105 cm (44³/₃ x 41 in), oil on canvas, London: National Gallery. Observed with love, aged 7 and 11.

Gavin Hamilton

Scottish-born, resident in Rome; archaeologist, painter, picture dealer. A pioneer of the international, archaeological, and severely intellectual branch of Neo-Classicism, but outpaced by other, better, painters. Also painted portraits and conversation pieces endowed with an austere charm. **KEY WORKS** Dawkins and Wood Discovering the Ruins of Palmyra, 1758 (Edinburgh: National Gallery of Scotland); Achilles Lamenting the Death of Patroclus, 1763 (Edinburgh: National Gallery of Scotland); Agrippina Landing at Brundisium with the Ashes of Germanicus, 1765–72 (London: Tate Collection)

Johann Zoffany

⊖ c.1734-1810 P GERMAN/BRITISH

 Rome; London; Florence; India i oils
 \$4,480,000 in 2001, Dutton Family in the Drawing Room of Sherborne Park, Gloucestershire (oils)

Also known as John Zoffany. Germanborn painter who established his career in Rome and London from 1760. He lived in India from1783 to 1789, and made a fortune painting native princes and British colonialists. His delightful, informal group portraits are his best works – they capture the ease and prosperous confidence of Georgian upper-class society. Look for good anecdotal details such as costumes, and sporting, artistic, and literary activities. **KEY WORKS** *The Academicians of the Royal Academy*, 1772 (Royal Collection); *The Tribuna of the Uffizi*, 1772–77 (Royal Collection); *Charles Townley's Library at 7*, *Park Street, Westminster*, 1781–83 (Burnley, UK: Towneley Hall Art Gallery)

James Barry

0	1741-	-1806	ρø	BRITISH	
					-

London; Italy 🚺 oils 🎦 \$18,000 in 1990, *Venus Anadyomene* (oils)

Highly gifted Irish-born history painter who became a professor at the Royal Academy, only to be expelled in 1799 after a series of quarrels. Aimed for the top: large-scale history painting on the scale of Raphael's Vatican frescoes. Was so paranoid and pretentious as a person that he ruined his opportunities and died lonely and unloved.

KEY WORKS The Progress of Human Culture, 1777–83 (London: Royal Society of Arts); Portrait of Samuel Johnson, c.1778–80 (London: National Portrait Gallery)

The Drummond Family Johann Zoffany, c. 1769, oil on canvas, New Haven: Yale Center for British Art. Zoffany's portraits were popular with George III and Queen Charlotte, who became his patrons.

Angelica Kauffmann

⊖ 1741-1807 № SWISS

 Image: Rome; London
 Image: Rome; London
 Image: Rome; Rome;

Best known for work done during her stay in England (1765–80), when she was very successful with elegant, delicate portraits, history paintings, and decorations, in the style of Reynolds, for Adam houses. She was partial to sentimental figures with pink faces and cheeks.

KEY WORKS Ariadne Abandoned by Theseus, 1774 (Houston: Museum of Fine Arts); Self-Portrait Hesitating Between the Arts of Music and Painting, 1775 (Yorkshire, UK: Nostell Priory)

Richard Cosway

⊖ 1742-1821 🕫 BRITISH

■ England ■ watercolours; oils ■ London: National Portrait Gallery ≥ \$49,500 in 1998, Group Portrait of the Children of Edmund Boyle, 7th Earl of Cork (oils)

Best remembered as the most fashionable and outstanding miniaturist of the 18th century. Look for long, aquiline noses with very noticeable nostrils and shadows under the nose. A few unsuccessful large-scale oils. Married Maria Hadfield (1759–1838), a successful Irish/Italian painter, miniaturist, and illustrator. Friend of the Prince of Wales (later Prince Regent).

KEY WORKS *Self-Portrait*, c.1770–75 (New York: Metropolitan Museum of Art); *Group of Connoisseurs*, 1771–75 (Burnley, UK:

Towneley Hall Art Gallery); Portrait of Mrs. Marley, c.1780 (Washington DC: Hillwood Museum and Gardens); Unknown Lady of the Sotheby or Isted Families, c.1795 (Cambridge: Fitzwilliam Museum)

Sir Henry Raeburn

1756–1823
 IP BRITISH
 Edinburgh; London Control of Sir George
 \$270,000 in 1995, Portrait of Sir George
 Stewart Mackenzie, 7th Baronet (oils)

Best-ever Scottish portrait painter. No-nonsense character, just as happy playing golf or speculating in property (went bankrupt). He was the first Scots painter to be knighted.

Note the matinée-idol style of portraiture – heroic stances and soft focus with "alone but self-assured" poses, often against dramatic skies and landscape backgrounds. His work is at its best with handsome, strong-jawed male figures, looking vaguely dishevelled and adopting the stern, faraway look. He was never at home with female sitters, who often look dull and plain, but was very good with children. Figures are bathed in light and animated by brilliant, inventive, theatrical play of light over face and costume.

Look for pink faces and rich colours. He has a strong, confident, broadly brushed technique using square brushes straight onto coarse canvas, without underdrawing – he paints directly from life, with carefully observed tones and shadows. His best works have no alterations or reworkings – he becomes messy and clumsy when he is forced to make changes. His no-nonsense, confident method is in harmony with the temperament he sees in (or imposed on?) his sitters. Note single dab of bright highlight on noses.

KEY WORKS Miss Eleanor Urquhart, c.1793 (Washington DC: National Gallery of Art); William Glendonwyn, c.1795 (Cambridge: Fitzwilliam Museum); Isabella McLeod, Mrs. James Gregory, c.1798 (Aberdeenshire: Fyvie Castle); Mrs. Scott Moncrieff, c.1814 (Edinburgh: National Gallery of Scotland)

Portrait of Sir Walter Scott Sir Henry Raeburn, c.1810, 75.5 x 59 cm (29% x 23% in), oil on canvas, Private Collection. Scott's "Waverley" novels made him the most important and influential Scottish novelist.

THE ENGLISH LANDSCAPE TRADITION

From as early as 1750, a distinctive tradition of landscape painting was emerging in England, partly a reflection of 18th-century English landscape gardening, the subtle re-ordering of nature for aristocratic patrons in imitation of the classical landscapes of 17th-century painters like Claude Lorrain. In the hands of a series of exceptional painters, it developed into a rich celebration of a distinctively English approach to nature.

SUBJECTS AND STYLE

The wonte rouse, chersea Inomas Gruh, 1800, watercolour on paper, Private Collection. Turner greatly admired Gritin's brilliant watercolour technique and later said "Had Tom Girtin lived, I would have starved."

WHAT TO LOOK FOR

Precisely rendered and closely observed details contrast with flat, pale skies. Similarly, the impact of man, in buildings as much as in landscaped parklands, is seen as a complement to nature rather than an intrusion. This is a landscape that is fundamentally benign and tranquil, a reflection of the similarly well-ordered English society that produced it.

valued above the dramatic. It is then

no surprise that the majority of these

works were small in scale.

Landscapes were rarely regarded as an end in themselves. Rather, they were considered evidence of the divine harmony of nature, in particular of its domestication in an England that was increasingly prosperous and selfconfident. At any rate in the 18th century, the prevailing mood was accordingly almost always contemplative and calm. The intimate and the ordered were

London from Greenwich Hill John Robert Cozens c.1731, watercolour and black ink, New Haven: Yale Center for British Art. Cozens strongly influenced Girtin and Turner, who made copies of his works.

Richard Wilson

⊖ c.1713-82 P BRITISH

🖸 Wales: London: Italy () oils Cardiff: National Museum of Wales, London: Tate Collection. Oxford: Ashmolean Museum 🛛 🔊 \$286,900 in 1996, Welsh Landscape with Cottages Near Lake (oils)

The first major British landscape painter, he produced lovely, direct topographical views and sketches, which were influenced by Dutch masters. He is especially known for successful set-piece works that are a synthesis of idealized classical formulae and actual places. His work shows great sensitivity to light, notably during and after his visit to Italy 1750-57, but it can become overfamiliar and repetitious.

of which an idea, such as a landscape, might develop (still worth trying, as the Surrealists realized).

KEY WORKS The Valley of the Rhone, 1746 (London: Tate Collection); A Blot: Landscape Composition, 1770-80 (London: Tate Collection); Mountain Landscape with a Hollow, c.1770 (Washington DC: National Gallery of Art)

John Robert **Cozens**

🔟 Italy; Switzerland 🛛 🖉 watercolours; drawings 😥 \$444,000 Cetera, Gulf of Salerno, Italy (works on paper)

Alexander's melancholic son; also a landscape painter. Well travelled (Alps,

Snowdon Richard Wilson, c.1760s, oil on canvas, Nottingham: City Museums & Galleries. Wilson was especially attracted to the Welsh countryside, which he transformed into visions of classical Arcadia.

KEY WORKS Caernarvon Castle, c.1760 (Cardiff: National Museum of Wales); The Valley of the Dee, c.1761 (London: National Gallery); Lake Albano, 1762 (Washington DC: National Gallery of Art)

Alexander Cozens

⊖ 1717-86
 P RUSSIAN/BRITISH

🔟 Russia; Rome; England 🛛 🗕 drawings \$631,800 in 1997, After Rain (oils)

English landscape draughtsman. Born in Russia, but educated in Rome. Watercolour landscapes and etchings. Fascinated by systems, and famous for his method of using accidental blots on a piece of paper as a visual inspiration out

Italy, Naples). Wonderful early watercolours, prefiguring those of Turner, in which he shows how a landscape can be a vehicle for emotion and mood when made with imagination and inventive techniques. Luminous skies full of atmosphere, space, and light. In 1793 he went insane.

KEY WORKS Satan Summoning his Legions, c.1776 (London: Tate Collection); Sepulchral Remains in the Campagna, c.1783 (Oxford: Ashmolean

Museum); Two Great Temples at Paestum, c.1783 (Oldham, UK: Lees Collection)

Thomas Girtin

⊖ 1775-1802 P BRITISH

🔟 UK; Paris 🛛 🖉 watercolours; oils \$468,000 in 1990, Jedburgh Abbev from the South-East (watercolours)

Potentially a rival to Turner, but died of consumption aged 27. Painted brilliant watercolours that pushed the interpretation of landscape and watercolour technique through to new frontiers. Had a wonderful sense of colour and of the noble grandeur of nature. KEY WORKS Village Along a River Estuary in Devon. 1797-98 (Washington DC: National Gallery of Art); Lindisfarne, c.1798 (Cambridge: Fitzwilliam Museum); The White House at Chelsea, 1800 (London: Tate Collection)

C.1700 - 1800

William Marlow

● 1740-1813 P BRITISH

 England; France; Italy
 Watercolours; oils; drawings
 London: Tate Collection
 \$92,960 in 1989, Distant View of Rome with Vatican and Castel Sant'Angelo (oils)

Successful, topographical painter in watercolour and oils. Much travelled in the UK, France, Italy. Produced successful Grand Tour souvenir views, seascapes, river scenes, and portraits of country houses. Created satisfying, balanced compositions and was able to capture the cool light and well-ordered topography of England, as well as the intense light and rougher topography of Italy. KEY WORKS The Pont Royal, Paris c.1765-68 (Cambridge: Fitzwilliam Museum); View of the Tiber and the Ripetta with St. Peter's in the Distance, c.1768 (Northamptonshire, UK: Boughton House); A Post-House near Florence, c.1770 (London: Tate Collection)

Jacques Philippe de Loutherbourg

⊖ 1740-1812 P FRENCH/BRITISH

France; England D oils; drawings
 \$264,793 Scene de Patinage à Hyde Park (oils)

Strasbourg painter and stage designer who settled in England in 1771 and produced stagey landscapes and seascapes. Important as a link between the old Arcadian classical landscape The Pont du Gard, Nîmes William Marlow, c.1767, 38 x 56 cm (15 x 22 in), oil on canvas, London: Charles Young Fine Paintings. Marlow travelled in France and Italy in 1765–66, painting Grand Tour souvenir views.

traditions and the new realism and Romanticism of Turner and Constable. He also painted battle scenes and biblical subjects in an energetic style. One of the first to celebrate the delights of English native scenery. **KEY WORKS** Landscape with Cattle, c.1767 (London: Dulwich Picture Gallery); A Midsummer's Afternoon with a Methodist Preacher, 1777 (Ottawa: National Gallery of Canada); Travellers Attacked by Banditti, 1781 (London: Tate Collection); The Falls of the Rhine at Schaffhausen, 1788 (London: Victoria & Albert Museum)

Battle Between Richard I Lionheart (1157–99) and Saladin (1137–93) in Palestine Jacques Philippe de Loutherbourg, c. 1790, oil on canvas, Leicester: New Walk Museum. The artist loved drama and designed stage sets for Drury Lane Theatre, London.

FROM ROCOCO TO NEO-CLASSICISM

Joseph Wright

⊖ 1734-97 P BRITISH

 ☑ London; Derby; Italy
 ☑ oils
 ☑ London: National Gallery; Tate Collection. Derby (England): Museum and Art Gallery
 ☑ \$1,625,000 in
 1984, Mr. and Mrs. Thomas Coltman about to Set Out on a Ride (oils)

Known as the "Wright of Derby". Talented and versatile painter, but out of the mainstream. Developed new and original subjects: night scenes, scientific experiments, and early industrial forges. His paintings often have unusual light effects and offer fascinating insights into the Age of Reason and nascent Industrial Revolution. He painted goodish, occasionally great, portraits.

KEY WORKS *Two Boys Fighting over a Bladder*, c.1767 (Private Collection); *An Experiment on a Bird in the Air Pump*, 1768 (London: National Gallery); *Mrs. John Ashton*, c.1769 (Cambridge: Fitzwilliam Museum)

David Allan

€ 1744-96 P BRITISH

 Italy; London; Edinburgh ☐ oils;
 drawings 2 \$109,120 in 1992, Portrait of Three Boys Wearing Windsor Uniform (oils)

The Scottish Hogarth, he was deeply influenced by a visit to Rome. Wanted to be remembered as a history painter (*de rigueur* at the time, but not his forte); was a successful portrait painter and established the tradition of Scottish genre paintings with anecdotal illustrations of Scottish life and history. **KEY WORKS** A Neapolitan Music Party, c.1775 (Private Collection); The Connoisseurs, 1783 (Edinburgh: National Gallery of Scotland); John, the 4th Duke of Atholl and His Family, c.1773 (Private Collection)

George Stubbs

⊖ 1724-1806 P BRITISH

☑ Northern England; Rome; London
 ☑ oils
 ☑ \$4,611,000 in 1995, Portrait of the Royal Tiger (oils)

The greatest-ever painter of the horse, hunting, racing, and horsebreeding. Also painted scenes of rural life. Successful, with powerful patrons, but always a loner. His book, *Anatomy of the* *Horse* (1766), is one of the most remarkable published works of art and science.

His deep, personal fascination with the anatomy and character of the horse touched something more widespread and profound: man's relationship with nature (wholly dependent on the horse until the invention of mechanical power) – plus the mid-18th-century belief in rational investigation as a means of understanding the natural world and comprehending the qualities of beauty. Produced wonderful, measured, modest pictures, which exemplify the saying "beauty is truth, truth beauty".

His paintings are models of rational beauty: subtle, careful, half-concealed geometry of horizontal and vertical structures around which play curving cadences (like Mozart); loving observation

"Beauty is truth, truth beauty, That is all ... ye need to know."

JOHN KEATS

of space, anatomy, and the unspoken relationship between animal and man. Stunning draughtsmanship. The exquisite, harmonious, gentle colour has too often been tragically destroyed by insensitive cleaning and restoration.

KEY WORKS Mares and Foals, 1762 (London: Tate Collection); Mares and Foals beneath Large Oak Trees, c.1764–68 (Private Collection); Cheetah and Stag with Two Indians, c.1765 (Manchester: City Art Gallery)

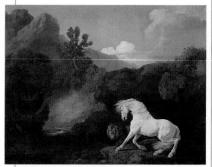

A Horse Frightened by a Lion George Stubbs, 1770, 94 x 125 cm (37 x 49 in), oil on carvas, Liverpool: Walker Art Gallery. Stubbs's inspiration was not real life but an Antique sculpture he saw in Rome in 1754.

с.1700-1800

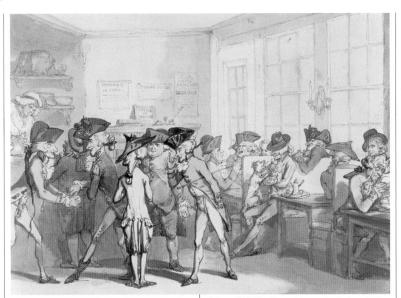

Thomas Rowlandson

⊖ 1756-1827 P BRITISH

England; France; Germany; the Low Countries
 drawings; prints
 \$91,800 Place des
 Victoires, Paris (works on paper)

Prolific draughtsman and printmaker; chronicler of 18th-century life and morals. Had huge technical facility, eager enthusiasm for life, and a great eye for detail and character. Expressed all his observations with admirable economy of line. Walked the tightrope between observation and caricature with skill. **Key WORKS** *Bax-Labhy Loungers*, 1785 (Los Angeles: J. Paul Getty Museum); *The Dinner*, 1787 (St. Petersburg: Hermitage Museum)

Jacques-Laurent Agasse

⊖ 1767-1849 PU SWISS

 Switzerland; Paris; England is oils
 Geneva: Musée d'Art et d'Histoire
 \$5.81m in 1988, Two Leopards Playing in the Exeter Change Menagerie (oils)

Swiss-born, Paris-trained (by J. L. David, and as a vet), worked in England. He was known for his faithfully observed, meticulously executed paintings

Miss Casenove on a Grey Hunter Jacques-Laurent Agasse, c. 1800, 30.5 x 25.5 cm (12 x 10 in), oil on canvas, Private Collection. The artist was much influenced by Stubbs in subject matter and technique. A French Coffee House Thomas Rowlandson, 1790s, 23 x 33 cm (9 x 12½ in), pen and ink with watercolour on paper, Cambridge: Fitzwilliam Museum. Revolutionary France was a popular target for British caricaturists.

of animals and their owners or keepers. A truly great painter, but had a small output and died poor and unknown; animals were not considered a serious art subject (and still aren't, even today). **KEY WORKS** *Sleeping Fox*, 1794 (Private Collection); *The Nubian Giraffe*, 1827 (Windsor Castle, England: Royal Collection)

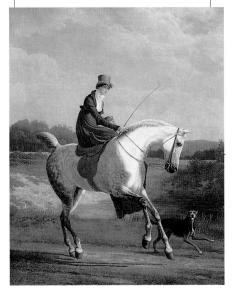

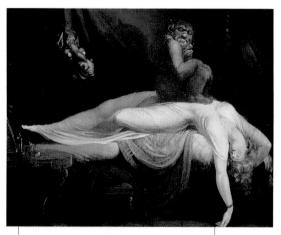

Henry Fuseli

 ● 1741 – 1825
 ■ SWISS/BRITISH
 ■ England; Italy
 ■ oils; drawings
 ■ \$1,162,000 in 1998, Satan Starting from the Touch of Ithuriel's Lance (oils)

Also known as Johann Heinrich Füssli. Swiss-born eccentric. Inspired by Michelangelo, Shakespeare, and Milton. Highly dramatic interpretations of literature in which facial expression and intense, overdeveloped body language is all. A defective technique has ruined many of his oil paintings.

Fuseli produced wonderful drawings; he also had a special line in female cruelty and bondaged males. Was obsessed with women's hair. **KEY WORKS** *Lady Macbeth Sleepwalking*, c.1784 (Paris: Musée du Louvre); *Oedipus Cursing His Son, Polynices*, 1786 (Washington DC: National Gallery of Art)

William Blake

⊖ 1757-1827 P BRITISH

London; Sussex A engravings; watercolours; drawings A condon: Tate Collection; British Museum 2 \$3.5m in 2004, *The Good and Evil Angels Struggling for Possession of a Child* (pen and watercolours)

Genuine visionary Romantic – truly inspired and driven by inner voices and sights, difficult to understand. Impoverished. Neglected in his lifetime.

He had an extraordinary originality in imagery, technique, and symbolism. An artist who created mostly small(ish) works The Nightmare Henry Fuseli, 1781, 101 x 127 cm (39½ x 50 in), oil on canvas, Michigan: Detroit Institute of Arts. The woman represents Fuseli's lost love, Anna Landolt.

on paper – watercolours and drawings – and a combination of these with print techniques (engraving). Blake's imagery and symbolism are highly personal but at heart is the wish to express his dislike of all forms of oppression. Championed creativity over reason; love over repression; individuality over state

conformity. Believed in the liberating power of the human spirit.

Look for idealized human figures with spiritual expressions, and a fascination with fire and hair, which are similarly stylized. Uses biblical sources, especially from the Old Testament.

KEY WORKS Frontispiece to Visions of the Daughters of Albion, 1795 (London: Tate Collection); Newton, 1795 (London: Tate Collection); Job and his Daughters, 1799–1800 (Washington DC: National Gallery of Art); Ghost of a Flea, 1819–20 (London: Tate Collection)

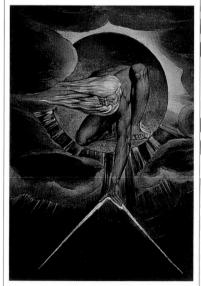

The Ancient of Days William Blake, 1824, 23 x 17 cm (9 x 6% /m), etching with watercolour, pen, and ink on paper, Manchester: Whitworth Art Gallery, Blake's God is an oppressive lawmaker imprisoning the imagination.

Giovanni Battista Piranesi

⊖ 1720-78 № ITALIAN

 Image: Rome
 Image: Rome and Ro

Architect, archaeologist, and printmaker (etchings). Venetian-born. Settled in Rome in 1740, and made a reputation from popular prints of ancient and modern Rome. Used inventive imagery, which moved from archaeological exactitude to dramatic, overwhelming Romantic grandeur, made all the more powerful by a brilliant technique and a mastery of perspective, light, and shade. His most original works are images of fantastic prisons (1745-61), which are Surrealist before time. His etching work was continued by his son, Francesco. KEY WORKS Round Tower, c.1749 (St. Petersburg: Hermitage Museum); The Gothic Arch, c.1749 (Washington DC: National Gallery of Art); The Well, 1750-58 (Washington DC: National

Anton Raphael Mengs

● 1728-79 P GERMAN

Gallery of Art)

Dresden; Rome O oils; fresco 2 \$275,745 in 2003, *The Adoration of the Shepherds* (oils)

"The German Raphael", one of the founders of Neo-Classicism and one of the foremost artists of his day. Worked in Germany, Italy, and Spain, and was a committed teacher, with an active studio. Wrote an influential theoretical treatise.

He is proof that having all the right credentials – being well taught, well thought of in official circles, and obeying all the currently correct aesthetic principles – does not lead to lasting fame. His religious paintings, mythologies, and portraits consciously aimed to contain the best of Raphael (expression), Correggio (grace), and Titian (colour). In a way they do, but in spite of their competence they also end up looking lifeless and contrived.

Note his paint surface that looks like polished lacquer. His compositions and poses are so carefully calculated as to be merely stagey: notice how in the portraits the head often turns in one direction while the hands and body turn in the other. Painted flesh and faces that look impossibly and perfectly healthy. Rich

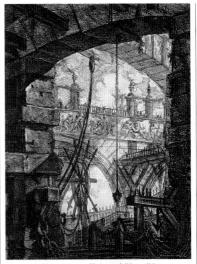

Carceri d'Invenzione (Prisons) Plate IV Giovanni Battista Piranesi, 1760, 54.5 x 41.5 cm (21½ x 16½ in), etching, Hamburg: Kunsthalle. Piranesi was also a successful restorer and dealer in Roman art and artefacts.

textures and colours (especially a velvety royal blue, rich bottle-green, and dusky pinks). His portraits are now considered better than his history paintings. **KEY WORKS** *Parnassus* (ceiling fresco), 1761 (Rome: Villa Albani); *Noli me Tangere*, 1771 (London: National Gallery); *The Immaculate Conception*, 1770–79 (Paris: Musée du Louvre)

Franz Xaver Messerschmidt

⊖ 1736-1783 P AUSTRIAN

☑ Munich; Graz; Vienna; Bratislava
 ☑ sculpture
 ☑ Vienna: Österreichische Galerie
 ☑ \$4,300,000
 in 2005, *III-humoured Man* (sculpture)

Sculptor, trained by his uncles, whose Baroque busts won early approval with the Austrian Court. Later he became deeply influenced by famous Roman Republican heads after a visit to Rome and his style became more Neo-Classical. Famous for his "Character Heads", a series of busts, many self-portraits, in which he explored facial distortions and grimaces after he started to suffer from delusions and paranoia. He thought the work would help heal and protect him from evil spirits. **Key WORKs** Character Heads: The Gentle, Quiet Sleep; The Hanged; The Lecher, The Arched Ezil, 1770–83 (Vienna: Österreichische Galerie)

NEO-CLASSICISM

Neo-Classicism was a deliberate reaction against the decorative priorities of the Rococo. It was a self-conscious return to what were thought the absolute, severe standards of the ancient world. On the whole, it generated huge, dreary paintings of "improving" history subjects., but its most brilliant exponent, the painter David, radically fused contemporary political concerns with a new artistic language.

STYLE

The German theorist and art historian, Johann Winckelmann, decisively influenced Neo-Classicism, persuasively advocating the "noble simplicity and calm grandeur" of ancient art, Greek especially. Typically, Neo-Classical works became measured, grave, and selfconsciously noble. Colour schemes are often sombre, though with brilliant highlights. Paint is applied with smoothly precise consistency. Light falls evenly, draperies are simple and chaste, poses invariably sternly heroic.

Paulina Bonaparte Borghese as Venus Antonio Canova, 1808, marble, Rome: Galleria Borghese. Canova, who settled in Rome after 1779, was the most influential Neo-Classical sculptor. To Greek purity he brought an exceptionally finished technique.

SUBJECTS

Overwhelmingly, subjects from Classical literature and history were favoured. Religious subjects always co-existed uneasily with Neo-Classicism, not surprisingly since the vast majority of Classical art was pagan. Greece and Republican (not Imperial) Rome furnished most subjects. Self-sacrifice and selfdenying heroism were recurring themes, underlining the supposed moral worth and superiority, and thus truth, of ancient art.

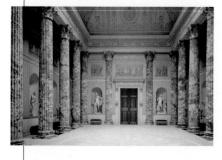

KEY EVENTS

1738	Excavations begin at Herculaneum, and at Pompeii in 1748		
1755	Publication of Winckelmann's Thoughts on the Imitation of Greek Works of Art		
1775	1775 Jacques-Louis David visits Rome, remaining there until 1780		
1789	French Revolution begins. The Bastille, symbol of the ancien régime, is stormed		
1806	Work begins on the Arc de Triomphe by sculptor Claude Michel Clodion		
1815	Restoration of the French monarchy and final overthrow of Napoleon at Waterloo		

Kedleston Hall, Derbyshire, c. 1760, interior of the marble hall designed by Robert Adam, showing alabaster columns and plasterwork by Joseph Rose. Following a visit to Rome in 1754, the Scot Robert Adam actively sought to emulate the grandeur of ancient Roman building in a series of opulent and imposing English houses, such as Kenwood House, Hampstead, and Bowood House, Wiltshire.

1770-1830

WHAT TO LOOK FOR

This landmark painting was the high point of Neo-Classical painting, and is a deliberate celebration of the art, life, and stern moral values of Republican Rome. Authoritative, heroic, and impeccably composed, it is also a statement about moral and political ideals. Three brothers (the Horatii) swear allegiance to the Roman Republic, but are also bound by ties of love to an enemy family, the Curatii. They choose loyalty to the state over personal emotion.

The helmets, swords, and togas are copied from known Roman examples The dominant colour of the male grouping is a vivid red, the colour of passion and revolution Each of the three Doric arches frames a group of figures, suggesting both their isolation and their ties to each other

The Oath of the Horatii Jacques-Louis David, 1784,

330 x 425 cm (130 x 167 in) oil on canvas, Paris: Musée du Louvre. The picture became a rallying cry for the French Revolution. Ironically, it had been commissioned by Louis XVI.

TECHNIQUES

Despite its massive size, The Oath of the Horatii is painted with the fine and polished technique usually found in a small Dutch still life.

Sabina (right) is one of the Curatii, but married to one of the Horatii. Camilla (left), a Horatii, is betrothed to a Curatii. She will be killed by her brother for lamenting her lover's death.

The shadow of death is cast by the men over the women and innocent children

Jean-Antoine Houdon

⊖ 1741-1828 🕫 FRENCH

One of the most important French sculptors of the 18th century. Born and died in France; studied in Rome after receiving the Prix de Rome in 1761. Famed in his lifetime throughout Europe and America. Survived the French Revolution. The majority of his works are portrait busts. Famously commissioned to sculpt George Washington, for which he visited North America. Influenced by the Baroque before becoming a Neo-Classicist; his works emulate the busts of ancient Greece and Rome. KEY WORKS St. Bruno 1767, (Rome: S. Maria degli Angeli); Morpheus, 1777 (Paris: Musée du Louvre); George Washington as the

Modern Cincinnatus, 1788 (Richmond: Virginia State Capitol); Diana, the Huntress, 1790 (Paris: Musée du Louvre)

Louis-François Roubiliac

€ 1702-62 PU FRENCH

England; Germany; France Sculpture
 Cambridge: Trinity College
 \$1.53m in
 1990, Bust of Alexander Pope (marble)

Born in France but worked mainly in England, where he became the greatest sculptor of his time. Made his name sculpting statues of famous men and ornate tombs. Pupil of the Baroque sculptor Balthasar Permoserin in Germany. His works are characterized by a vitality seldom seen in those of his contemporaries, as though his statues are simply pausing in the middle of an action. **KEY WORKS** *George Frederic Handel*, 1738 (London: Victoria & Albert Museum); *Sir Isaac Newton*, 1755 (Cambridge: Trinity College)

Comte Joseph-Marie Vien

€ 1716-1809 PU FRENCH

☑ France; Rome
 ☑ oils
 ☑ Paris:
 Musée du Louvre
 ☑ \$450,544 in 2004,
 Woman Leaving the Baths (oils)

One of a happy band of competent artists who bridge the gap between styles (Rococo and Neo-Classicism, in his case) without establishing a significant place in either. Delicate, whimsical works, softly Neo-Classical in subject and setting, but Rococo in mood and lack of seriousness. **KEY WORKS** *Dedalus in the Labyrinth Attaching the Wings to Icarus*, 1754 (Paris: Musée du Louvre); *Love Fleeing Slavery*, 1789

(Toulouse: Musée des Augustins)

Jacques-Louis David

€ 1748-1825 PU FRENCH

VOLTATRE

Paris; Rome; Brussels i oils; drawings; chalks i Paris: Musée du Louvre
 \$5,542,000 in 1997, Portrait of Suzanne le Peletier de Saint-Fargeau (oils)

Passionate, volatile character – an artistic Napoleon (dictatorial, austere, inflexible). Deeply

François-Marie Arouet Voltaire

Jean-Antoine Houdon, 1781, height 133.5 cm (55 ½ in), marble, Paris: Bibliothèque de la Comédie Française. This likeness of the writer was commissioned by Voltaire's niece, Madame Denis.

involved in the politics of French Revolution and Napoleonic Empire. Died in exile in Brussels. Founder of French Neo-Classical painting, but was an arts administrator as well as a creative genius.

If you want authority in art – this is it. He applies the precision of the painter of miniatures on a massive scale. Stern moral and artistic rules: behind the theatre and storytelling is the ideological commitment to art as a public and political statement in the service of the state. Body language and facial expressions used as drama. No place for ambiguity: what you see and feel are as precise and as clear as can be.

Observe his attention to detail, especially in hands, feet, tassles, armour, and stones. His flesh is as smooth as porcelain, with Napoleon Crossing the Alps on 20th May 1800 Jacques-Louis David, 1803, 267 x 223 cm (105 x 87% in), oil on canvas, Château de Versailles. Four separate versions exist, differing only in the colouring of the cape.

never a hair in sight. Portraits of victors of the French Revolution have direct, busybody eyes. Even shadows and light seem to have been disciplined and regimented. Love of antiquity and archaeological accuracy (Roman noses everywhere). You have to experience the sheer physical size of the big set pieces at first hand. **KEY WORKS** *The Oath of the Horatii*, 1784–85 (Paris: Musée du Louvre); *The Death of Socrates*, 1787 (New York: Metropolitan Museum of Art); *Death of Marat*, 1793 (Bruges: Musées Royaux des Beaux-Arts); *Madame Récamier* c.1800 (Paris: Musée du Louvre)

Antonio Canova

⊖ 1757-1822 PU ITALIAN

☑ Italy; France; Austria
 ☑ sculpture
 ☑ Possagno (Italy): Museo Canova. Venice:
 Museo Correr. St. Petersburg: Hermitage Museum
 ☑ \$547,200 in 1995, *Bust of a Lady* (marble)

The leading Neo-Classical sculptor, certainly the most celebrated; enjoyed huge fame across Europe and was widely credited with reviving "lost art" of sculpture and frequently compared with best of the ancients. Combined astonishingly accomplished technique – best works are highly finished – with rare talent for human figure, females especially, in a variety of winningly graceful poses. Many group sculptures can only be

"Canova ... invented a new type of ideal beauty, closer to our taste than that of the Greeks" STENDHAL, 1824

appreciated in the round, i.e. from different viewpoints, so no longer dependent on architectural settings. Highly significant that many later works were created for museums rather than patrons, underlining the changing status of the artist. Born Treviso, moved to Venice, where opened studio in 1774. Visited Rome and Naples in 1780 as his interest in Neo-Classicism developed; settled permanently in Rome in 1781. Enjoyed early success with monuments to popes Clement XIV (1782-87) and Clement XIII (1787-92). In 1797, the French invasion forced him into exile in Vienna, but in 1802 he accepted commissions from Napoleon after visiting Paris. Canova's most famous work was of Napoleon's sister, Pauline Borghese,

Cupid and Psyche Antonio Canova, 1796–97, height 150 cm (59 in), marble, Paris: Musée du Louvre. Canova was fascinated by hands and fingers. in 1808 (see page 250). After 1815, visited Paris again overseeing return of looted Italian art, with side trip to London. In 1817, a grateful pope granted him title of Marchese (marquis) of Ischia. **KEY WORKS** Daedalus and Icarus, 1779 (Venice: Museo Correr); Theseus and the Minotaur, 1781–83 (London: Victoria & Albert Museum); Theseus Slaying a Centaur, 1780s (Vienna: Kunsthistorisches

Museum); The Penitent Magdalene, 1796 (Genoa: Palazzo Bianca); Pauline Borghese as Venus (see page 250)

Claude-Joseph Vernet

⊖ 1714-89 № FRENCH

 Image: Rome; France
 Image: Oils
 Image: Oils
 Image: Oils
 Paris: Musée

 de la Marine
 Image: State State

Established a successful formula for rather stagey, evocative views of Italianate landscapes, coastlines, and especially shipwrecks, much admired by 18th-century collectors. His major project (commissioned by Louis XV) was 16 views of major French seaports (1753–65). **KEY WORKS** *View of Naples*, 1748 (Paris: Musée du Louvre); *The Town and Harbour of Toulon*, 1756 (Paris: Musée du Louvre); *Shipwreck*, 1759 (Bruges: Groeninge Museum)

Bertel Thorvaldsen

⊖ c.1770-1844 PO DANISH

☑ Rome; Denmark
 ☑ sculpture;
 oils
 ☑ Copenhagen: Thorvaldsens
 Museum. Stockholm: National Museum
 ☑ \$331,250 in 2003, Mythological
 Figures (sculpture)

Thorvaldsen is Denmark's most important Neo-Classicist. Ranked alongside Canova, although his works lack the Italian's sensitive surfaces. His career took off with the statue *Jason* with the Golden Fleece. Stationed mainly in Rome, he preferred to work from copies The Storm Claude-Joseph Vernet, 1777, oil on canvas, Avignon: Musée Calvet. Vernet married an Englishwoman, and many of his clients were British Grand Tourists.

instead of employing live models. A museum was built in his honour in Copenhagen (1839–48). **KEY WORKS** *The Triumph of Alexander the Great*, 1810s (Preston, UK: Harris Museum and Art Gallery); *Hebe*, 1806 (Copenhagen: Thorvaldsens Museum)

Elisabeth Vigée-Lebrun

⊖ 1755-1842 P FRENCH

 France; Russia; England i oils
 Paris: Musée du Louvre i \$735,347 in 1984, La Duchesse de Gramont-Caderousse en Vendangeuse (oils)

Successful portraitist in last years of the *ancien régime*; member of the French Academy. Best at sentimental, lushly coloured portraits of fashionable women (allegedly painted Marie Antoinette 25 times). Left France in 1789 to tour Europe. Wrote a good autobiography. **KEY WORKS** *Hubert Robert, Artist,* 1788 (Paris: Musée du Louvre); *Madame Perregaux,* 1789 (London: Wallace Collection)

Portrait of a Young Woman Elisabeth Vigée-Lebrun, c.1797, 82.2 x 70.5 cm (32½ x 27¾ in), oil on canvas, Boston: Museum of Fine Arts. The artist organized famous parties at which guests wore Greek costume.

Benjamin West

● 1738-1820 ₱ AMERICAN	•	1738-1820	P AMERICAN
------------------------	---	-----------	------------

 ☑ USA; Italy; England ☑ oils ☑ London: National Portrait Gallery. Washington DC: National Gallery of Art. Boston: Museum of Fine Arts.
 New YorK: Metropolitan Museum of Art
 ☑ \$2.6m in 1987, Portrait of Sir Joseph Banks (oils)

Pennsylvania-born and the first American artist to achieve international recognition. Trained and based in Europe after 1760, he became the second President of the Royal Academy, London (after Joshua Reynolds), and was employed by George III (who lost the American colonies). His work is an acquired taste for modern eves.

His art is second-hand – derived, if not exactly copied, from others. He had the enviable ability of anticipating the next fashion and was thus always successful and in the public eye. His early large works often portray obscure literary subjects and have a stiff, rather flat, wooden style that caught the taste for the Neo-Classical.

From 1770 onwards, he cleverly adapted Neo-Classicism by delivering the same heroic message using modern rather than ancient history – this was popular with the public and collectors, and shook up less progressive artists. He later anticipated Romanticism by introducing melodramatic subjects of death and destruction with powerful contrast of light and shade. He was also a popular portraitist. **KEY WORKS** *Venus Lamenting the Death of Adonis*, late-18th century (Pittsburgh: Carnegie Museum of Art); *Colonel Guy Johnson*, c.1775 (Washington DC: National Gallery of Art); *The Burghers of Calais*, 1789 (Windsor Castle, England: Royal Collection)

John Singleton Copley

⊖ 1738-1815 P AMERICAN

The greatest American painter of the colonial period. Self-taught. Slow, earnest, timid, indecisive as a person but assured, talented, and pioneering as a painter. Son of poor Irish immigrants, he married well (the daughter of a rich Tory merchant).

с.1700-1800

Had two separate and successful careers and styles. Pre-1774, in Boston, established himself as the leading portrait painter. Decisive, high-quality, sober works, which show his own and his sitters' liking for empirical realism. Precise (overhard?) line, clear detail and enumeration of material objects, severe light and dark contrasts. In 1774 he left Boston, disliking politics, fearful that he would be dubbed a pacifist and Tory hanger-on.

Note how he adapted to the grandmanner style of portrait painting (more decorative, pompous, and frothy) after his visit to Italy. It did his portraiture no good, but he achieved great success in London with huge-scale modern-history paintings (heroic actual events presented as though they were moral tales from Ancient History). Late, melancholic decline as he went out of fashion and felt exiled (he never returned to the USA). KEY WORKS Paul Revere, c.1768-70 (Boston: Museum of Fine Arts); The Copley Family, 1776-77 (Washington DC: National Gallery of Art); Watson and the Shark, 1778 (Washington DC: National Gallery of Art); The Three

Youngest Daughters of George III, 1785 (Windsor Castle, England: Royal Collection)

Ralph Earl

€ 1751-1801 P AMERICAN

☑ USA; England ☑ oils
 ☑ New York: Metropolitan
 Museum of Art ☑ \$210,000 in
 1996, Portrait of John Phelps (oils)

Prominent member of a family of craftsmen and artists; loyalist who left for England in 1778, returning in 1785. Notable for portraits of Connecticut patrons – typically, a plain likeness in their own familiar setting. His sketches of the sites of the battles of Lexington and Concord were turned into popular prints. Bigamist, carouser, failed businessman.

The Death of General Wolfe Benjamin West, c.1771, 43.2 x 61 cm (17 x 24 in), oil on panel, Private Collection. An episode from the conquest of Quebec, 1759. Wolfe died at the moment of victory.

THE RISE OF AN AMERICAN SCHOOL mid-18th century

From the mid-18th century, a number of painters appeared in Colonial America. This may have been a measure of growing American prosperity but the colony's cultural insecurity was underlined by the fact that they all trained in Europe, falling under the influence of Neo-Classicism. The best known, Benjamin West, settled permanently in England. As late as 1784, when the State of Virginia commissioned a statue of George Washington, it turned to a Frenchman, Jean-Antoine Houdon. A distinctively American school did not emerge until the 19th century.

KEY WORKS The Striker Sisters, 1787 (Ohio: Butler Institute of American Art); Dr. David Rogers, 1788 (Washington DC: National Gallery of Art); Mrs. Noah Smith and her Children, 1798 (New York: Metropolitan Museum of Art)

Gilbert Stuart

⊖ 1755-1828 P AMERICAN

 ☑ USA; London; Dublin
 ☑ oils
 ☑ Boston: Museum of Fine Arts. Washington DC: Museum of Fine Art. New York: Metropolitan Museum of Art
 ☑ \$900,000 in 1986, Portrait of John Jay (oils)

Penniless, uneducated son of a Rhode Island tobacconist. Was a heavy drinker, often in debt, bad-tempered, and addicted to snuff. Was also a highly successful portrait painter and America's first virtuoso exponent of the grand manner.

He learned his trade in Edinburgh (1772) and London (1775) as an assistant to Benjamin West. Produced Romantic, dignified portrait images of independence and self-assurance, softly modelled and silhouetted against a plain background. Painted almost every contemporary of note, especially Washington. Of his 114 portraits of Washington, only three were made from life; the rest are replicas.

Characteristic features and touches are a pinkish-green palette; a white dot on the end of a shiny nose; light shining on a forehead; and rapid execution without preliminary drawing. **KEY WORKS** *The Skater*, 1782 (Washington DC: National Gallery of Art); *George Washington and Martha Washington* 1796 (Boston: Museum of Fine Arts)

ROMANTIC AND ACADEMIC ART c.1800-1900

The art of the 19th century was complex and multifaceted. Radical new styles were invented that delighted some and caused deep offence to others. Old styles were revived or combined in unexpected ways. Some artists followed the market, motivated by money; others were willing to starve for the purity of their art.

Romanticism was embraced by those who wanted to redefine the place of art and humankind in a rapidly changing world. Academicism was supported by those who resisted change and wanted art to maintain the cultural and social status quo. These attitudes to the art of the era reflect the complex politics of the 19th century.

THE NAPOLEONIC ERA

In Europe the decisive event of the early part of the century was the resurgence of France under the galvanizing influence of Napoleon. What had begun in 1789 as a struggle for liberty evolved into a war of conquest. In 1812, at the height of Napoleon's success, French rule extended across almost the whole of

The Turkish Bath (detail), Jean-Auguste-Dominique Ingres, 1863, oil on canvas, diameter 198 cm (78 in), Paris, Musée du Louvre. Ingres embodies 19th-century taste for Classical academic style combined with exotic Orientalism. western Europe. Only Britain, Portugal, and Scandinavia remained free of French control.

NATIONALISM AND REVOLUTION

Napoleon's defeat in 1815 restored Europe's pre-revolutionary status quo, but ideas of liberty, once planted, proved tenacious. Growing demands for self-rule by oppressed minorities saw Belgium, Greece, Serbia, and Romania emerge as independent nations by the end of the century. Popular nationalism also drove the unification of Italy (after 1859) and of Germany (after 1866).

There was fierce reaction against self-rule by conservative regimes, above all the multi-national Austrian Empire. These conflicting ideologies clashed in 1848 when Poles, Czechs, and Hungarians rose against their Austrian rulers, engulfing central and eastern Europe in revolution. France, which had already seen the abdication of

one king in 1830, was also swept by popular uprisings, forcing a second king to abdicate and the inauguration of a new republic. In 1852, this was replaced by the Second Empire under Napoleon III, Napoleon's nephew.

The crushing defeat of France in the Franco-Prussian War of 1870–71 provided the final impetus for the unification of Germany. In its wake,

PHOTOGRAPHY

Photography was first demonstrated to the wider world by Louis-Jacques-Mandé Daguerre in 1839. In its early years it was used principally for studio portraits, mimicking those painted for the wealthy at a fraction of the cost. Gradually, however, it replaced drawing as the most immediate method of making a record of visual

Napoleon Giving Orders before Austerlitz Antoine-Charles Horace Vernet, 1808, oil on canvas, 380 x 645 cm (150 x 254 in), Château de Versailles. The memory of Napoleon influenced French politics throughout the 19th century.

Germany's southern states committed themselves to the powerful new Prussiandominated German Empire and, following the

downfall of Napoleon III, France established the Third Republic.

INDUSTRIALIZATION

Britain became increasingly aloof from European affairs, preoccupied with its vast empire and the consequences of industrialization. First Britain, and then Europe after 1850, were changing

MUYBRIDGE PHOTOGRAPHS OF A JUMPING HORSE

appearance. In the 1870s, US-based English photographer Eadweard Muybridge, using a battery of cameras with fast shutter-speed, began to make studies of horses and humans in motion. This allowed people to see for the first time the action of a galloping horse.

EARLY DAGUERRE CAMERA FROM THE 1840S

TIMELINE: 1800 - 1900

	1804 Napoleon declares himself emperor of France	1812 Napoleo defeated in R		1837 Acces	1839 Photographs by Louis Daguerre exhibited in Paris sion of Queen ctoria (Britain)	1848 Nationalist uprisings in central Europe repressed; last French king deposed
1800		·	1820			1840
180 Spanish French flee defeated a Trafalga	- defeated at Wa t Congress of t restor	iterloo; Vienna es pre-	Charles 2 and ac more libe	dication of X in France ccession of eral regime his-Philippe	1838 Invention of first electric telegraph (Britain)	1852 Accession of Napoleon III

261

rapidly from rural to urban societies amid great social upheaval. Britain had set the pace but France, and, significantly, Germany proved ever more effective rivals. Huge new industrial cities appeared, with railways, steam ships, and the electric telegraph causing a revolution in communications. After the trauma of the Civil War of 1861–65, America established a new, confident identity and continued to expand westwards adding new states to the Union. It too became a major industrial power.

EUROPE AND THE WORLD

At the same time an important shift in attitude towards Europe's overseas colonies took place. Originally the The Crystal Palace in Hyde Park, London Built for the Great Exhibition of 1851, the iron-and-glass structure was 563 m (1,848 ft) long. Industrial processes and goods were displayed from all round the world.

goal had been trade rather than territory. After about 1870 empire in itself came to be seen as desirable. Europe's states engaged in a frenzied race to take over as much of the globe as they could.

The impact of these enormous changes was highly significant for continental European art especially in France, though less so for Britain and America. From 1870 onwards the principles that had governed the western tradition for over 400 years began to dissolve. The Modern was being born.

ROMANTIC AND ACADEMIC ART

Francisco Goya

 ● 1746-1828
 ▶ SPANISH
 ▶ Spain; France
 ▶ Oils; engravings; drawings
 ▶ Madrid: Museo del Prado.
 London: British Museum (prints)
 ▶ \$7.02m in 1992, Bullfight – Suerte de Varas (oils)

A solitary and lonely figure, Goya became stone deaf aged 48. He produced a wide range of powerful work, and was one of the greatest portrait painters of all time. He influenced several French 19th-century painters, especially Manet (see page 307).

LIFE AND WORKS

Born in Saragossa. Full name Francisco di Goya y Lucientes. Went to Madrid in 1763. Visited Italy c.1770–71, returned to work on the cathedral in Saragossa in 1772. In Madrid by 1775 and in 1776 began drawing tapestry cartoons for the Royal factory. Became principal court painter in 1799, which was also the year he completed his *Los Caprichos* series. Following the Napoleonic invasion of Spain in 1808, he worked for the Frenchheld Spanish court until 1814. Painted *The Disasters of War* series 1810–14. Was then pardoned by reinstated Ferdinand VII. Retired to Bordeaux in 1824.

STYLE

An admirer of the French Enlightenment, his overriding interest was appearance and behaviour. He understood youth and age, hope and despair, sweet innocence, and the worst aspects of man's inhumanity to man. His art is about Spain and its

The Clothed Maja c.1800, 95 x 190 cm (37½ x 78½ in), oil on canvas, Madrid: Museo del Prado. Goya painted a nude and a clothed Maja, causing him to be denounced to the Inquisition for obscenity.

 $c\;.\;1\;8\;0\;0-1\;9\;0\;0$

obsessions. He is hauntingly memorable because he is never judgemental (simply showing human behaviour as it is), and because his work is always beautiful to look at, even when the subject matter is horrific.

His portraits are untraditional. With Goya one has the uneasy sensation that the relationship between viewer and sitter is reversed; they examine you and your views on human behaviour as much as you scrutinize them.

WHAT TO LOOK FOR

Intensity and introspection; drama; untraditional, free, impressionistic paintwork. grey tones against colour. **KEY WORKS** *Therese Louise de Sureda*, c.1803–04 (Madrid: Museo del Prado); *The Duke of*

Here Neither, Plate 36, The Disasters of War 1810–14, published 1863, 15.8 x 20.8 cm (6% x 8% in), etching, Private Collection. Goya created a series of 82 prints showing the brutality of war.

Wellington, 1812–14 (London: National Gallery); The Third of May 1808, 1814 (Washington DC: National Gallery of Art)

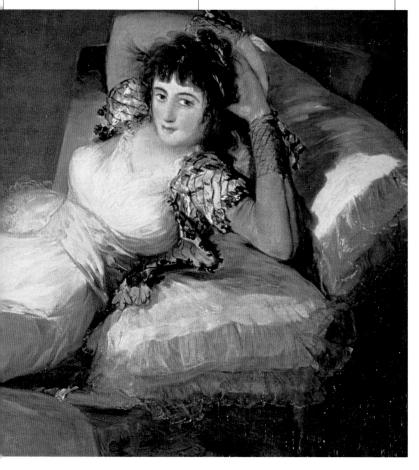

Antoine-Jean Gros

⊖ 1771-1835 P FRENCH

David's most famous pupil and the most successful painter of the early Napoleonic period. Despite Neo-Classical background, he was a crucial precursor of Romanticism. Had David's ability to manage huge-scale compositions with many figures, yet drew his subject matter from modern life, not the Antique. Best known work is *Napoleon in the Plague House at Jaffa* (1804), which portrays Napoleon as a Christ-like figure surrounded by dying French troops. Loose, brilliant handling of paint, strong contrasts of light and shade, and interest in Eastern exoticism. Later works increasingly sterile. Eventually driven to suicide.

KEY WORKS Sappho at Leucate, 1801 (Bayeux: Musée Baron Gérard); Napoleon on the Battlefield at Eylau, 1808 (Paris: Musée du Louvre)

Portrait of Madame Bruyère Antoine-Jean Gros, 1796, 79 x 65 cm (31 x 25 in), oil on canvas, Bristol: City Museum and Art Gallery. Painted in Genoa, where the sitter's husband was president of the French Chamber of Commerce.

Anne-Louis Girodet-Trioson

● 1767-1824 P FRENCH

Also known as Anne-Louis Girodet de Roucy or Roussy. Male painter of aristocratic portraits, associated with the court of Napoleon I. Renowned for refusing to paint faces he did not find psychologically interesting. A talented, capable, and in-demand painter who gave up art in his mid-40s after inheriting a large sum of money. Became a writer. **KEY WORKS** *The Sleep of Endymion*, 1792 (Paris: Musée du Louvre); *Napoleon Bonaparte Receiving the Keys of Vienna at the Schloss Schönbrunn*, 13th *November 1805*, 1808 (Château de Versailles)

Jean-Auguste-Dominique Ingres

● 1780-1867 PU FRENCH
🔟 Paris; Rome; Florence 🛛 🚺 oils;
drawings 🛅 Paris: Musée du Louvre.
Montauban (France): Musée Ingres
\$2,132,492 in 1989, Jupiter and Thetis (oils)

One of the major heroes of French art and the master of high-flown academic illusionism. Great admirer of the Italian Renaissance and Raphael. Tortured, uptight personality.

His work conveys total certainty – his subjects were well established and officially approved: portraits, nudes, and mythologies, all painted with the high "finish" required by the Academy. He created the most manicured paintings in the history of art – everything carefully arranged (hair, hands, poses, clothes, settings, faces, smiles, attitudes, even light) – and some of the most exquisite drawings ever made, with a total mastery of line and precise observation.

Notice the way he (usually but not always) manipulated this artificial idealism and fused realism with distortion, so that the end result is alive and thrilling, and never dead academicism: chubby hands with tapering fingers (can look like flippers), strange necks, and sloping shoulders. He had an interest in mirrors, painting figures that are reflected in mirrors; maybe his (and his society's) whole world was that glassy reality/ unreality of the looking glass? KEY WORKS La Grande Odalisque, 1814 (Paris: Musée du Louvre); The Apotheosis of Homer, 1827 (Paris: Musée du Louvre); Madame Moitessier, 1856 (London: National Gallery)

The Valpinçon Bather Jean-Auguste-Dominique Ingres, 1808, 146 x 98 cm (57% x 38% in), oil on canvas, Paris: Musée du Louvre. To produce artistic harmony, the body is distorted; for example, the back is too long.

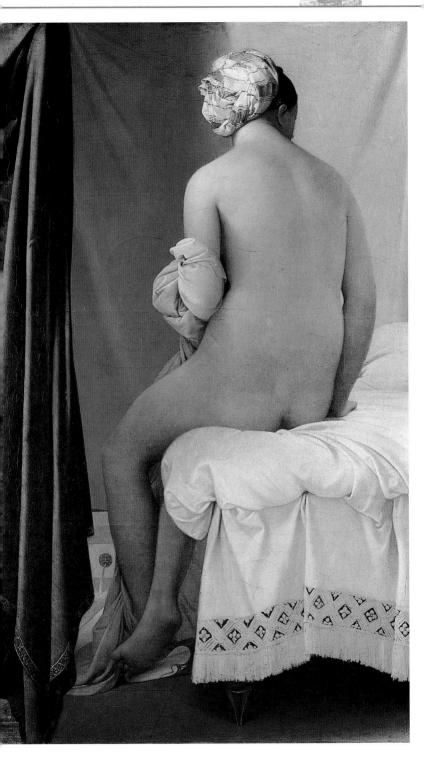

266

ROMANTICISM

As the rationalism promised by the Enlightenment dissolved in the bloodletting of the French Revolution, artists struggled to come to terms with a world that had plunged from apparent certainty into chaos. Perhaps predictably, the results were mixed. Heroic individualism defined Romanticism. It also marked a decisive break with the conformities of the past.

STYLE

It is no surprise that Romanticism resists neat categorization; a single definition is impossible. Self-expression in the modern sense – that the artist is not just

uniquely well equipped to see into the human soul but has a duty to do so – inevitably led to a huge variety of artistic styles. The desire to see everything as larger than life frequently expressed itself in bold colour, vigorous brushwork, and themes of love, death, heroism, and the wonders of nature. It appealed particularly to northern European temperaments and flourished most creatively in Germany, Britain, and France.

Couvent du Bonhomme, Chamonix J. M. W. Turner, c.1836-42, 24.2 x 30.2 cm (9½ in x 12 in), watercolours, Cambridge: Fitzwilliam Museum. The artist turned the calm certainties of later 18th-century English landscape painting upside-down. Colours exploded, brushwork knew no limits.

SUBJECTS

Heightened emotions dominated. Artists turned away from the logical and rational, allowing themselves freedom to express raw, usually suppressed feelings. Movement, colour, and drama were actively championed, exoticism favoured. This was a world of vast, elemental

KEY EVENTS

1789	French Revolution
1793	Execution of Louis XVI: apparent triumph of new liberal French political order is followed by the Terror
1798	Wordsworth and Coleridge publish <i>Lyrical Ballads</i> , key doctrine of Romantic feeling; Schlegel coins term "romantic poetry"
1799	Napoleonic coup: Bonaparte becomes First Consul (1804 Emperor)
1814	Constable's <i>Stour Valley and Dedham</i> <i>Church</i> appears same year as Goya's great anti-war polemic <i>The Third of May</i>

forces, frequently destructive, almost always beyond the reach of man to control. Landscapes became larger, brooding, and more threatening. For the first time, the subconscious was recognized as a mainspring of human activity. In stark contrast to the optimism of the 18th century, humanity was seen as puny, and subservient to nature.

Monk by the Sea Caspar David Friedrich, 1809, 110 x 172 cm (43% x 67% in), oil on canvas: Berlin Staatliche Museum. Friedrich excelled in images of an implacable nature under whose vast skies man inevitably shrank.

18th and 19th centuries

WHAT TO LOOK FOR

The Romantics believed in the freedom of the individual. They were not interested in compromise – better to be a heroic success or a total failure. Géricault's masterpiece encapsulates these virtues and takes art into the realm of political protest. It theatrically recreates a real-life incident when the captain of a shipwrecked French frigate saved himself and abandoned the passengers and crew. Here the survivors see the vessel that will save them. The story and the painting scandalized the French nation. Whereas David's art (page 252) encouraged service to the state, Géricault castigates the state for abandoning those who serve.

The tattered remains of a billowing sail contrast with the menace of an approaching wave Emotions are deliberately played on. A distraught father grieves over his dead son A silhouetted figure against a dramatic sky features in many of Géricault's works

TECHNIQUES

The dark, sombre mood of the painting is not entirely deliberate. Géricault used bitumen, a tar-based pigment, to add lustre to his colour scheme. Once dry, it decays. The picture is not just fading, it is slowly disintegrating before our eyes.

The Raft of the Medusa Théodore Géricault, 1819, 491 x 716 cm (193 x 282 in), oil on canvas, Paris: Musée du Louvre. Géricault's huge painting was intended to be deliberately challenging – to a complacent state presided over by a newly restored monarchy as much as to a smug bourgeoisie.

The face of death. In pursuit of authenticity, Géricault visited the local hospital, *L'Hôpital* Beaujon, to make detailed studies of the sick and dying. He even took a severed head and an assortment of limbs from the morgue back to his studio in the Faubourg du Roule.

ROMANTIC AND ACADEMIC ART

Eugène Delacroix

€ 1798-1863 P FRENCH

 Paris; England; Morocco lo oils; drawings; pastels lo Paris: Musée du Louvre; Palais Bourbon; Palais Luxembourg; Saint Sulpice; Musée Delacroix lo \$7,765,500 in 1998, Choc de Cavaliers Arabes (oils)

Small in stature but big in spirit – the fashionable, fiery hero of French Romanticism. Allegedly the illegitimate son of the aristocrat/diplomat, Talleyrand. Was willing to shock with strong subject matter and vigorous style, and often did.

He chose big, romantic subjects where the linking theme is heightened emotion, especially through sexuality, struggle, and death. Inspired by literature (Dante, Byron), current politics, historical events, wild animals, North Africa (visited in 1832). Before the 1830s he produced set-piece works for the official Salon (now mostly in the Louvre). Had complex working methods, which produced much preliminary work, often sketches: these are what you will most often see outside Paris.

He uses colour as the main means of expression: colour and the play of light keep the eye moving, without a specific point of focus or climax. Loves rich material and texture, lush reds, and intense, coppery greens. His later work exploited colour theory and used complementary

Scenes from the Massacre of Chios Eugène Delacroix, 1824, 419 x 354 cm (165 x 139% in), oil on canvas, Paris: Musée du Louvre. Directly inspired by the slaughter of the Greek population of Chios by the Turks.

colours and the colour wheel. After 1833 his major works are set-piece official commissions (for the Bourbon Palace, for instance), which can only be seen *in situ*. His *Journal* is essential reading. **KEY WORKS** Orphan Girl at the Cemetery, 1824 (Paris: Musée du Louvre); The Death of Sardanapalus, 1827 (Paris: Musée du Louvre); Odalisque, 1845–50 (Cambridge: Fitzwilliam Museum); The Barque of Dante, 1882 (Paris: Musée du Louvre)

Richard Parkes Bonington

● 1802-28 P BRITISH

Paris; England; Venice Ø oils; watercolours Mathematical London: Wallace Collection Ø \$\$564,400 in 1987, The Palazzi Manolesso-Ferro on the Grand Canal, Venice (oils)

The English Delacroix, with whom he worked closely. Died of consumption, aged 26. Lovely, small-scale, fresh, luminous oils and watercolours of picturesque places (Normandy, Venice, Paris), and costume history pieces, all done with consummate skill and ease. Works to savour and enjoy. A genius and a sad, early loss.

KEY WORKS Venetian Campanili, c.1826 (Maidstone Museum and Art Gallery); The Corsa Saint' Anastasia, Verona, with the Palace of Prince

The Undercliff Richard Parkes Bonington, 1828, 13 x 21.6 cm (5 x 8% in), watercolour on paper, Nottingham: City Museums and Galleries. Watercolour sketches were made on summer travels to be used in the studio in winter.

Maffet, 1826 (London: Victoria & Albert Museum); Venice: the Piazza S. Marco, c.1828 (London: Wallace Collection)

Théodore Géricault

● 1791-1824 P FRENCH

 Image: Paris; Italy; England
 Image: Ima

A true Romantic: he was unorthodox, passionate (about horses, women, and art), temperamental, depressive, virile, and inspiring. Had an early death (fell off a horse). Was wealthy and only painted when he felt like it. Was hugely influential on Delacroix.

Géricault had two main subjects: horses and moments of danger or uncertainty (and often combined both). His early work was much influenced by Rubens (rich colour and movement) and Michelangelo (muscles and monumentality). Scandalized French art and the political establishment, and changed the rules of art with *The Raft* of the Medusa – the first rendering of a contemporary political subject in a manner truly comparable with the grandest history painting (see page 267). His talents extended further: he was also a producer of stunning, innovative lithographs.

Géricault's compositions are memorably simple: he often uses silhouette against a dramatic sky and lifts the eve up to a single point of climax near the top of the picture. He depicts soulful human beings and horses (the expression in the horse's eye is the same as in the human's) – note his trick of turning the human face one way and the horse the other. His strong sense of colour and lively paint handling were sometimes ruined by the use of bitumen and poor-quality technique (was a lazy student, should have studied harder). **KEY WORKS** A Horse Frightened

by Lightning, 1813–14 (London: National Gallery); Officer of the Hussars, 1814 (Paris: Musée du Louvre); The Raft of the Medusa, 1819 (Paris: Musée du Louvre); The Madixoman, 1822–23 (Lyon: Musée des Beaux-Arts)

Portrait of a Woman Addicted to Gambling Théodore Géricault, c.1822, 77 x 65 cm (30½ x 25½ in), oil on canvas, Paris: Musée du Louvre. A psychiatrist encouraged Géricault to paint portraits of the insane.

Liberty Leading the People

Eugène Delacroix 1830

Leader of the French Romantic Movement in painting, a close friend of Baudelaire and Victor Hugo, Delacroix's own life is like that of the hero of a romantic novel. With restless energy but frail health, he had many love affairs yet remained unmarried. He died alone, exhausted by his artistic labours.

This highly controversial painting

commemorates the political uprising in Paris in July 1830, when Parisians took to the streets for three days in revolt against the greedy and tyrannical regime of the king, Charles X. Delacroix had high hopes for the critical reception of this work, but he was disappointed. The proletarian emphasis was considered so dangerous that the painting was removed from public view until 1855. Delacroix's use of colour here is uncharacteristically subdued but serves to heighten the brilliance of the saturated tones

of the flag.

All classes of society, except the dyed-in-the-wool monarchists, supported the revolution. Delacroix conveys this by displaying a variety of hats worn by the streetfighters – top hats, berets, and cloth caps are all represented.

TECHNIQUES

Delacroix often used short, broken brushwork, anticipating artists such as Monet (see page 310). He also investigated the juxtaposition of colours to increase their individual richness and vibrancy. His journals document his insights into colour theory.

Delacroix shows dying and dead men, victims of the battle, their faces and bodies picked out by the dramatic halo of light shining behind Liberty. To the right lie two soldiers; many soldiers refused to fire on their fellow citizens – some even joined the rebel ranks

Liberty Leading the People

Medium oil on canvas Size 330 x 425 cm (129 x 169 in) Location Paris: Musée du Louvre

Emerging from the

gunsmoke are the towers of Notre Dame. On one of the towers flies the tricolour. Delacroix was in Paris during the three-day revolution but did not play an active part.

The tricolour flag was a symbol of the 1789 Revolution and Delacroix knew it would bring to mind the glories of the early Napoleonic Empire

> Liberty wears a Phrygian cap, a symbol of freedom during the French Revolution. Women played a leading role in the street fighting of the 1830 revolution

> **Delacroix** balances realistic detail with a powerful abstracted composition – a pyramid rising up to the right hand of Liberty

The young patriot

to the right of Liberty represents a popular hero named Arcole, who was killed in the fighting around the Hôtel de Ville. He also prefigures the popular character Gavroche in Victor Hugo's *Les Misérables*.

A mortally wounded citizen strains with his dying breath to take a last look at Liberty. His arched pose is a crucial element in the pyramidal composition. Significantly, the artist echoes the colours of the tricolour flag in the dying patriot's clothing The artist's signature is written boldly in symbolic red with the date 1830. Shortly after this he visited Morocco, finding Arab civilization more exciting than the dead history of the ancient world

Caspar David Friedrich

⊖ 1774-1840 🕫 GERMAN

 ☑ Copenhagen; Dresden ☑ oils; drawings; watercolours ☑ St. Petersburg: Hermitage
 Museum ☑ \$3,213,000 in 1993, Spaziergang in der Abenddämmerung (A Walk at Dusk) (oils)

Now the best-known German Romantic landscape painter, but neglected in his day. Friedrich came into his own later, influencing late-19th-century Symbolists.

Born at Greifswald, near the Baltic coast, but later settled permanently in Dresden. Although a meticulous and careful painter of small pictures, he was full of big ideas. His Romantic relationship with nature was intensely spiritual and Christian, and loaded with symbolism. His work is also full of yearning: for the spiritual life beyond the grave; for greatness; for intense experience. Studied nature's details closely, but all his landscapes are imaginary or composite – painted out of his head, not sitting in front of nature.

Look for his symbolism, for instance, oak trees and Gothic churches as representing Christianity; dead trees as death and despair; ships as the transition from the here and now to otherworldliness; figures

Winter Landscape Caspar David Friedrich, c.1811, 33 x 45 cm (13 x 17% in), oil on canvas, London: National Gallery. Shoots of grass push through the snow to symbolize the hope of Resurrection.

looking out of windows or at the horizon as yearning. Times of day and the seasons, when one state is about to become another. Sunrise turning to sunset, or winter turning to spring as spiritual transition and hope of resurrection. **KEY WORKS** *The Cross in the Mountains*, 1808 (Berlin: Staatliche Museum); *Monk by the Sea*, 1809 (Berlin: Staatliche Museum); *The Polar Sea*, 1824 (Hamburg Kunsthalle)

The Stages of Life Caspar David Friedrich, c.1835, 72.5 x 94 cm (28½ x 37 in), oil on canvas, Leipzig: Museum der Bildenden Künste. The five ships correspond to the figures on the shore, each at a different stage of life's journey.

Peter von Cornelius

● 1783-1867 PU GERMAN

🔟 Italy; England 🛛 🚺 oils; fresco Hamburg: Kunsthalle 🛛 🎦 \$8,852 in 1990, Eros with the Eagle (oils)

Responsible for bringing frescoes back into prominence in the 19th century. His early works are Neo-Classical, but later works evince the influence of German Gothicism. Spent several years in Rome (from 1811), where he joined the Nazarenes (see box below). Commissioned by Louis I of Bavaria to paint the frescoes in Munich's Glyptothek (1819-30), the museum of ancient art designed by Leo von Klenze. Visited England in 1841 to advise on frescoes for the new Houses of Parliament, Also worked on frescoes for Frederick William IV of Prussia in Berlin but the project was cancelled after the revolution in 1848. Cornelius was also an accomplished book illustrator, most notably of Faust.

KEY WORKS The Vision of the Rabenstein, 1811 (Frankfurt: Städelsches Kunstinstitut); Joseph Interpreting Pharaoh's Dream, 1816–17 (Berlin: Nationalgalerie); The Recognition of Joseph by his Brothers, 1816-17 (Berlin: Nationalgalerie)

Philipp Otto Runge

● 1777-1810 P GERMAN

Germany; Denmark 🚺 watercolours; chalks; pen and ink 🖬 Hamburg: Kunsthalle \$151,773 in 1995, Study of Lily (works on paper)

Born in Germany, where he spent most of his short life (died at 33). Studied at the Copenhagen Art Academy for two years. Also a musician and lyricist. He knew Freidrich (see opposite) and met Goethe. His art brought him little fame in his lifetime, but he was recognized posthumously for his sharp - often naïve - style and vivid use of colour. Greatly interested in the properties of colour, he wrote a hugely influential treatise about it, Die Farbenkugel (The Colour Sphere), which has remained pivotal to the study and teachings of colour.

Runge was interested in trying to express the harmony of the universe and painted pantheistic, mythical subjects as

Self-Portrait Philipp Otto Runge, 1802, 37 x 31.5 cm (14½ x 12½ in), oil on canvas, Hamburg: Kunsthalle. Runge

hoped to create a new art that would fill the voids created by Revolution and the collapse of the old certainties.

well as portraits. Look for intense (often symbolic) colour, and the use of local German landscapes as background to religious and genre paintings. KEY WORKS The Lesson of the Nightingale, 1804-05 (Hamburg Kunsthalle); The Hülsenbeck Children, 1805-06 (Hamburg: Kunsthalle); The Child in the Meadow, 1809 (Hamburg: Kunsthalle); The Great Morning, 1809-10 (Hamburg: Kunsthalle)

THE NAZARENES c.1818-1840s

A group of Roman Catholic German and Austrian painters who were brought together in Vienna as the Lukasbrüder (Brotherhood of St. Luke) in 1809 by art students Friedrich Overbeck and Franz Pforr. They wished to revive German religious art in the manner of Perugino, Dürer, and the young Raphael. From 1810, they lived and worked in a monastery in Rome, where they welcomed others who shared their ideals of intensely spiritual subject matter and the religious properties of light. They were nicknamed the Nazarenes and they dressed like monks. They were a major influence throughout Europe, including the early Pre-Raphaelites.

John Trumbull

€ 1756-1843 P AMERICAN

 ☑ USA; London
 ☑ oils
 ☑ Washington DC: Capitol Collection. Yale (USA): University Art Gallery
 ☑ \$260,000 in 1986, Portrait of John Adams (oils)

Ambitious, pretentious, unfortunate (blessed with an uncanny sense of bad timing), and finally embittered. The first college graduate (Harvard) in the USA to become a professional painter (although his parents thought art to be a frivolous and unworthy activity).

His main aim was to excel in history painting, but this was going out of fashion. He took as his subjects the recent history of the triumphs of revolutionary American colonies. Completed eight of a projected series of 13 and was commissioned by an unenthusiastic Congress to do four for the rotunda of the Capitol in Washington. Struggled to achieve success – had to earn his way as a portrait painter, which he disliked.

Look for stagey compositions, theatrical lighting, and good, convincing faces done from life. (In another age he would have gone to Hollywood to make B-movies.) Why the bad timing? He served with Washington, but then went to London and was arrested and very nearly executed in reprisal for the hanging of a British agent in America; he was imprisoned instead. Went back to the USA, then returned to London in 1808 but any hope of success was dashed by the war of 1812. His last work was his autobiography, published in 1841. KEY WORKS Patrick Tracy, c.1784-86 (Washington DC: National Gallery of Art); Signing the Declaration of Independence, July 4th, 1776,

1786–1820 (New Haven: Yale University Art Gallery); *The Sortie Made* by the Garrison of Gibraltar, 1789 (New York: Metropolitan Museum of Art); *Mrs. William Pinkney* (Ann Maria Rodgers), c.1800 (San Francisco: Fine Arts Museums)

Portrait of Alexander

Hamilton John Trumbull, c. 1806, 77 x 61 cm (30¼ x 24¼ in), oil on canvas, Washington DC: White House. The man who founded the First Bank of the United States.

Emmanuel Gottlieb Leutze

● 1816-68
 PI AMERICAN/GERMAN

USA; Düsseldorf 🚺 oils; drawings 🖬 New York: Metropolitan Museum of Art. Washington DC: Smithsonian Institute 😰 \$400,000 in 2004, *General Ulysses S. Grant in his Tent* (oils)

German-born, Philadelphia-raised, he returned to Düsseldorf in 1841 to study history painting and stayed there (making

"No subject can be proper that is not generally interesting. It ought to be either some eminent instance of heroick action or heroick suffering."

Edward Hicks

● 1780-1849 P AMERICAN

Hicks had a Quaker upbringing in Pennsylvania (and became a Quaker minister in 1811). Initially, he learned the trade of decorative coach painting. An otherwise untrained artist with a primitive style, he is best known for his *Peaceable Kingdom* paintings illustrating Washington Crossing the Delaware River, 25th December 1776 Emanuel Gottlieb Leutre, 1851 (copy of an original painted in 1848), 378.5 x 647 cm (149 x 254% in), oil on canvas, New York: Metropolitan Museum of Art. The original work was damaged by fire in 1850.

Isaiah 11:6–9 (words are sometimes inscribed round the picture) – the belief in a peaceful coexistence. Quakers disapproved of art but illustrating Isaiah was acceptable.

He painted at least 60 different versions of Peaceable Kingdom between 1816 and 1849. The animals' expressions change from tense and fearful to sad and resigned, reflecting the current political divisions among the Quakers; in the background William Penn concludes a treaty with the Indians. Late in his life Hicks also painted depictions of the Declaration of Independence and Washington crossing the Delaware River. KEY WORKS The Falls of Niagara, c.1825 (New York: Metropolitan Museum of Art); Noah's Ark, 1846 (Philadelphia: Museum of Art); The Cornell Farm, 1848 (Washington DC: National Gallery of Art)

THE NORWICH SCHOOL

An important English school of artists founded by John Crome that grew from the Norwich Society of Artists (founded 1803). The group produced landscapes, coasts, and marine scenes from around Norwich and Norfolk, and favoured outdoor painting, as opposed to studio work. They used both oils - as favoured by Crome and watercolours - favoured by John Sell Cotman, who took over as president after Crome's death. From 1805 until 1833, an annual exhibition was held in Norwich (the only exceptions being the years 1826 and 1827). This school was 19th-century England's only successful attempt at establishing a regional artistic scene, in emulation of the many Italian examples. It was a provincial school in every aspect as the artists were actively patronized by local wealthy families, who bought their works and hired them as drawing tutors. Artists of the Norwich School continued working through the 1880s.

The Marl Pit John Sell Cotman, c. 1809-10, 30 x 26 cm (113/4 x 101/4 in), watercolour on paper, Norwich: Castle Museum & Art Gallery. Cotman's early watercolours are noted for their simplicity and translucency.

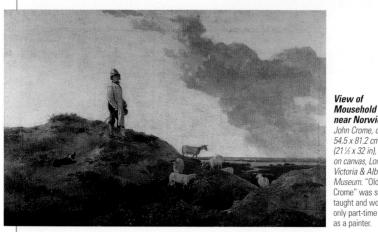

View of Mousehold Heath. near Norwich John Crome, c.1812, 54.5 x 81.2 cm (21 1/2 x 32 in), oil on canvas, London: Victoria & Albert Museum. "Old Crome" was selftaught and worked

John Varley

● 1778-1842 P BRITISH

🔟 London 🛛 🚺 watercolours 🛛 🖄 \$79,040 in 1996, Views of Bamburgh Castle, Northumberland (watercolours)

Sublime Romantic watercolour painter, whose landscapes are contemporaneous with Turner's and who similarly began the development from topographical drawings to fully developed watercolour painting. Was most influential as a teacher (of Linnel, Cox, Holman Hunt et al).

KEY WORKS View of Bodenham and the Malvern Hills, Herefordshire, 1801 (London: Tate Collection); A Half-Timbered House, c.1820 (Boston: Museum of Fine Arts)

"No two days are alike, not even two hours: neither were there two leaves alike since the creation of the world." JOHN CONSTABLE

1803-1880s

John Constable

⊖ 1776-1837 PC BRITISH

 Image: Suffolk; Hampstead
 Image: Oils
 Image: Oils
 Image: Oils

 National Gallery; Tate Collection; Victoria & Albert

 Museum
 Image: \$19,306,000 in 1990, The Lock (oils)

One of the great landscape painters who pioneered a new type of plein-air painting based on the direct observation of nature. He believed that nature, with its dewy freshness, sunlight, trees, shadows, streams, and so forth, was full of moral and spiritual goodness. He was a devoted family man.

Limited subject matter: he only painted the places he knew best. Seems to know every square inch of ground and all the local day-to-day activity. Note how the light in the sky and the fall of light on the landscape are directly connected (not so in Dutch landscapes). The sketches (not for public display) have a direct spontaneity, absent from the more laboured, finished paintings (especially the "six-footers") with which he hoped to make his reputation.

How does he get that sense of dewy freshness? Look at the way he juxtaposes different greens (full of subtle colour variation) and introduces small accents of red (the complementary colour) to enliven them. Note, also, the layering of clouds to create perspective recession; the figures, sometimes almost hidden in the landscape. Late work much more emotional, darker, more thickly painted. **KEY WORKS** *Dedham from Langham*, c.1813 (London: Victoria & Albert Museum); *Weymouth Bay*, 1816 (London: National Gallery); *Wivenhoe Park, Essex*, 1816 (Washington DC: National

Gallery of Art); Hampstead Heath, 1821 (Manchester: City Art Gallery); The Hay Wain (see pages 278–279)

Flatford Old Mill Cottage on the Stour John Constable,

c.1811, pen and wash, London: Victoria & Albert Museum. Constable combined a detailed objective study of nature with a deeply personal vision of his childhood scenery.

David **Cox**

€ 178	83 – 1859	PU BRIT	'ISH		
🖸 Bir	minghan	n; Londo	on; He	ereford	
Q Wa	tercolou	rs; oils	i E	Birmingham (Uk	<):
City A	rt Gallery	∕ ≯ \$	158,7	60 in 1997,	
Cross	ing Lanca	aster Sa	nds (\	watercolours)	

Well travelled (France, Flanders, Wales); lived in Hereford, London, Birmingham. Produced talented, small-scale, freely executed oils and watercolours that capture the spontaneity of rapidly shifting light and breezes, experienced in the open air. One of the few painters to make one feel wind and rain (the French Impressionists rarely, if ever, attempted it).

KEY WORKS *Moorland Road*, 1851 (London: Tate Collection); *Rhyl Sands*, c.1854 (London: Tate Collection)

James Ward

⊖ 1769-1859 P BRITISH

 Image: State Collection
 Image: State Collection</t

Brother-in-law of George Morland. Memorable mostly for large-scale pictures of animals, and landscapes bursting with Romantic drama and emotion, notably the vast *Gordale Scar* (Tate Collection) with bulging-eyed heroic cattle, exaggerated cliffs, and stormy skies. He was not appreciated in his time – died in poverty – although he was an inspiration to Géricault. **Key WoRKS** *Bulls Fighting*, c.1804 (London: Victoria & Albert Museum); *Gordale Scar*, 1811–15 (London: Tate Collection)

The Hay Wain

John Constable 1821

"Constable's Country" is now a much visited beauty spot and this image adorns many tourist souvenirs. Constable put all his efforts in to this picture but when first exhibited

it failed to sell, and the artist was hurt by the constant rejection of his work.

To many people, Constable's picture represents a nostalgic image of the English countryside, with mankind working in perfect harmony with nature, a golden age before the industrial problems of modern times. It is perfectly legitimate to read the picture in this way, but Constable was in fact trying to create a new subject matter for painting, but few of his fellow artists or collectors could accept it as serious art. At the time it was painted there was an economic depression in agriculture, with riots and farms burned down.

The carefully observed high, billowing clouds are a special feature of this part of eastern England, caused by water vapour drawn up from the nearby Stour Estuary

The cottage on the left is known, even today, as Willy Lot's cottage. He was a deaf and eccentric farmer who was born in the cottage and lived there for over 80 years; he would have been the inhabitant at the date of this picture

Constable was a slow worker,

and behind this work lie many small sketches made in the open air of this actual place. The finished picture was made in his studio in London as stated in his signature, which is included along the bottom edge of the painting.

TECHNIQUES

If you look carefully you can see that all areas of green are an interweaving of many different shades of green, and there are touches of red, such as in the figure of the man fishing. Red is the complementary colour to green, and so intensifies its impact. Similarly, Constable infuses the water with brown and orange hues.

Outside Willy Lot's cottage a woman is either collecting water or washing clothes in the estuary. The detail shows Constable's traditional palette of earth colours, and his highlights of thick white paint.

Constable avoids treating clouds merely as a backdrop and makes them an integral part of the picture The play of light and shadow over the land is consistent with the pattern of light and clouds in the sky

The water prevents the wheels from shrinking, which would cause the metal band around the rim to loosen

> The dog is an essential part of the composition, leading the eye towards the focus of interest, which is the hay cart. It was added quite late in the development of the picture.

In the far distance it is possible to see the haymakers in the fields carrying their scythes, and loading hay onto a cart

The Hay Wain

Medium oil on canvas Dimensions 130 x 185 cm (51 x 73 in) Location London: National Gallery

ROMANTIC AND ACADEMIC ART

Sir David Wilkie

♀ 1785-1841 ₱ BRITISH

🖸 Edinburgh; London 🚺 oils 🖬 Edinburgh; National Gallery of Scotland 🛛 🔊 \$544,000 in 2003, Spanish Girl (oils)

Scottish, direct, down-to-earth, and ambitious. His individual style, which embraced the narrative subjects of everyday life and loaded them with authentic detail, was very influential throughout Europe. His manner became more contrived and Romantic after a visit to the Continent in 1825–28 He was much admired by the Prince Regent (George IV) who bought Wilkie's paintings and ignored Turner and Constable.

Martin's work combines impressive scale and imagination with architectural detail and tiny figures. Impressive mezzotints. KEY WORKS The Bard, c.1817 (New Haven: Yale Center for British Art): The Eve of the Deluge, 1840 (Windsor Castle, England: Royal Collection); Great Day of his Wrath. 1851-53 (London: Tate Collection)

John Linnell

⊕ 1792 – 1882
 № BRITISH

England D watercolours: oils \$241,500 in 2003, Return of Ulvsses (oils)

Romantic landscape painter who was successful commercially. He provided artistic and financial support to Blake

and Palmer. Linnell was an eccentric. argumentative, radical non-conformist, best known for his rural landscapes, often showing labourers at work or rest. He believed that landscape paintings could carry a religious message – hence their intense visionary quality and style. **KEY WORKS** Leading a

Barge, c.1806 (London:

Tate Collection): Kensington Gravel Pits, 1811–12 (London: Tate Collection); Mid-day Rest, 1816 (Manchester: City Art Gallery)

Samuel Palmer

→ 1805-81 P BRITISH

London; Kent 🚺 watercolours; engravings Dundon: British Museum; Tate Collection. Oxford: Ashmolean Museum 2 \$1.02m in 2000, Oak Tree and Beech, Lullingstone Park (works on paper)

Child prodigy from Kent (the "Garden of England"). Had a very intense pastoral and Christian vision - nature as the gateway to a revelation of paradise. Made exquisite, magical, small drawings in the 1820s, with microscopic details. After his marriage in 1837, he turned to a less intense, classical, pastoral vision. KEY WORKS Self-Portrait, c.1825 (Oxford: Ashmolean Museum); Early Morning, 1825 (Oxford: Ashmolean Museum)

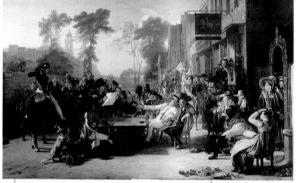

The Chelsea Pensioners Reading the Waterloo Dispatch Sir David Wilkie, 1822, 97 x 158 cm (38 1/4 x 62 ¼ in), oil on wood, London: Wellington Museum. The painting was commissioned by the Duke of Wellington.

KEY WORKS The Letter of Introduction, 1813 (Edinburgh: National Gallery of Scotland); Self-Portrait, 1813 (Pau: Musée des Beaux-Arts)

John Martin

● 1789-1854 P BRITISH

England; France D oils; engravings London: Tate Collection. Newcastle upon Tyne: Laing Art Gallery 🔀 \$2,415,000 in 2003, Pandemonium (oils)

Famous in his own day (but then went completely out of fashion). Overdramatic detailed representations of apocalyptic events from history - they anticipate the Hollywood spectaculars of Cecil B. de Mille. They win commendations for special effects rather than content.

J. M. W. Turner

● 1775-1851 P BRITISH

☑ London; France; Switzerland; Italy; Scotland
 ☑ oils; watercolours; engravings
 ☑ London:
 Tate Collection; Clore Gallery
 ☑ \$9,045,000
 in 1984, Seascape, Folkestone (oils)

The champion of Romantic landscape and seascape. The greatest British painter yet (apologies, Constable).

Observe his ability to portray nature in all her moods, from the sweetest and most lyrical to the stormiest and most destructive. He had a deep, personal response to nature, using a wide-ranging source of inspiration (from Scotland to Italy). Applied a remarkable range of working methods, with fascinating technical and stylistic innovation, Crichton Castle (Mountainous Landscape with a Rainbow) J. M. W. Turner, c.1818, 17.1 x 24 cm (6 ½ x 9 ½ in), watercolour over graphite on wove paper, New Haven: Yale Center for British Art.

especially in his watercolours and later work. Had a never-ending interest in light, and a deep reverence for the old masters, especially in his early work.

Look for the sun – where it is; what it is doing; its physical qualities as light, but also its symbolism (rising, setting, hiding, warming, frightening; of a bitter northern winter, of a balmy Mediterranean summer, and so on). His early "old master" style changes dramatically after his visit to Italy in 1819 (introducing a brighter palette, freer style and imagery). Note the detail in finished watercolours. Complex personal – sometimes secret – symbolism. He left sketchbooks that show his working process.

KEY WORKS Mortlake Terrace, c.1826 (Washington DC: National Gallery of Art); Norham Castle, Sunrise, c.1835–40 (London: Tate Collection); Snowstorm: Steam-Boat off a Harbour's Mouth, 1842 (London: Tate Collection); Approach to Venice, c.1843 (Washington DC: National Gallery of Art)

Rain, Steam, and Speed – The Great Western Railway J. M. W. Turner, c.1840, 90.8 x 121.9 cm (35 ½ x 48 in), oil on canvas, London: National Gallery. Turner was inspired by his own journey on a steam train.

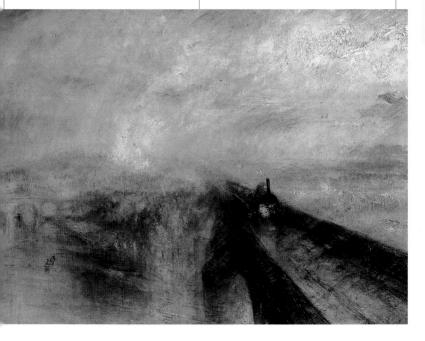

The Fighting Téméraire

J. M. W. Turner 1839

Turner lived in revolutionary times. At home, he witnessed the Industrial Revolution and the dawn of the steam age. Abroad, he observed the French Revolution and the rise and fall of the Napoleonic Empire. In this late work he explores both these themes, together with his Romantic response to the beauty of nature.

On 6th September 1838, Turner was a passenger on a steamboat from Margate with the sculptor W. F. Woodington when they witnessed the Téméraire being towed up the Thames from Sheerness to Rotherhithe to be broken up. Turner always carried a notebook in his pocket, and made sketches of this historic event, which he later transformed into this masterpiece. The famous ship had been part of Nelson's fleet, and her moment of glory had come in 1805 with distinguished service at the Battle of Trafalgar. Turner's art was at its best when it was inspired by a subject that resonated with history and with a sense of time, fate, and nature sweeping all before them.

> In 1877, correspondents to *The Times* attacked Turner's lack of accuracy, such as incorrect rigging, the sun setting in the east, and the mast of the steamer incorrectly shown behind the smokestack.

> > The silver light of a crescent moon, reflected in the water, illuminates the ship and gives it a ghost-like quality

The *Téméraire* was a ship of the line with 98 guns. She took her name from a French ship captured at Lagos Bay in 1759

The Fighting Téméraire

Medium oil on canvas Dimensions 90.7 x 121.6 cm (35% x 48 in) Location London: National Gallery

Turner is reported to have seen the Teinéraire on an evening with a blazing sunset. In his picture he exploits both the appearance and symbolism of the setting sun, heightening each by contrasting them with a delicate new moon, and by repeating the fiery glow of the sky in the burning gases streaming from the smokestack.

> Turner was able to use the recently discovered synthetic pigments such as chrome yellow to bring a new brightness and intensity to his palette

The picture was exhibited at the Royal Academy in

1839. The catalogue contained lines from Thomas Campbell's Ye Mariners of England: "The flag which braved the battle and the breeze, now no longer owns her."

Turner's treatment of light and handling of paint influenced the young Monet, who studied his works in London in 1870

Turner chose never to sell this picture. The National Gallery acquired it in 1856 as part of the Turner Bequest. The artist left a disputed will through which the nation received all his unsold works

The first paddlewheel steamboat was launched in 1783; the first steam warship in 1815 – both in Turner's lifetime

Although Turner's late works often received

harsh criticism, this composition was highly praised. *The Morning Chronicle* singled out the poignantly symbolic "gorgeous horizon"

TECHNIQUES

Turner combined his early training in watercolours with the scope for variation in texture of oils to form a style involving washes of great fluidity and impasto details to evoke different surfaces.

THE ACADEMIES

1562-late 19th century

Academies were the official institutions, funded by a princely ruler or a State, that arranged and promoted exhibitions, organized art education, and dictated rules and standards. Enormously influential between the mid-17th and late 19th centuries, the first academy was founded in Florence in 1562.

THE FRENCH ACADEMY

The academy par excellence was the French Royal Academy, founded in 1648 under Louis XIV and directed by LeBrun. It had a monopoly of exhibitions and hiring models for life classes, awarded scholarships, and established branches in provincial cities and in Rome. A remarkable example of the imposition of centralized bureaucracy on the arts, its example was widely followed, e.g. in Berlin in 1697, Vienna 1705, St. Petersburg 1721, Stockholm 1735, and Madrid 1752, as well as in many

THE 19TH CENTURY

Academies were at their most stultifying and conservative in the mid- to late 19th century, especially in France with its annual salon that was much patronized by Napoleon III and his Empress Eugénie. In many ways, their most important achievement was to provoke principalities and municipalities in Germany, Switzerland, Italy, and Holland. The exception was London where the Royal Academy was, and remains, private and independent.

Gloria Victis Marius Jean Antonin Mercie, 1874, height 140 cm (55½ in), bronze, Paris: Musée de la Ville. Archetypal academic sculpture.

young artists to react against them, e.g. Courbet, Manet, and the various Secession movements (see page 338).

Empress Eugénie (1826–1920) Surrounded by her Ladies-in-Waiting Franz Xavier Winterhalter, 1855, 300 x 402 cm (118¼ x 158¼ in), oil on canvas, Oise (France): Château de Compiègne.

Alexandre Cabanel

● 1823-89 PU FRENCH

 Paris [1] oils in Paris: Musée d'Orsay
 \$400,000 in 1993, Cleopatra Testing Poisons on those Condemned to Death (oils)

One of the pillars of the establishment of late 19th-century Paris. Conventional, fashionable, much sought after. Painted nudes, allegories, portraits. Now seen in true light – academic painting at its worst and most flatulent. Weak technique; sickly, garish colours; banal subjects. A warning that much-praised contemporary art can be dire (then and now). **KEY WORKS** *The Birth of Venus*, 1862 (Paris: Musée d'Orsay); *Death of Francesca da Rimini and Paolo Malatesta*, 1870 (Paris: Musée d'Orsay); *The Life of St. Louis*, 1870s (Paris: Pantheon)

William-Adolphe Bouguereau

● 1825 – 1905
 P FRENCH
 III France; Rome
 III oils
 III \$3.2m in 2000, La charité (oils)

Bouguereau was the archetypal conservative pillar of the French academic system in its final years, refusing to abandon the language and manners of a by-now debased Classical tradition.

He delighted his public with largescale theme paintings and a dazzlingly accomplished technique. However, his work now looks curiously stilted and unconvincing – a dinosaur of art history. His lofty rhetorical subject matter (for example, nude Venuses) invites us to suspend disbelief in reality, but his style, which apes the reality of photography, contradicts or denies the Cleopatra Testing Poisons on those Condemned to Death Alexandre Cabanel,

1887, oil on canvas, Private Collection.

invitation. Art that aspires to be this great requires a convincing unity between subject and style.

Smooth, hairless, firm flesh and rosy nipples, which

anticipate (inspire?) the airbrushed girlie pin-ups of World War II or *Playboy* magazine. His paintings of everyday peasant life are more convincing than his grander works because they do not aim so high (so cannot fall so low) and do not demand suspension of disbelief to the same degree. A recent revival of interest in his works has resulted in some massive prices at auction. **KEY WORKS** *Toung Girl Defending Herself Against Eros*, c.1880 (Los Angeles: J. Paul Getty Muscum); *A Little Shepherdess*, 1891 (London: Christie's Images); *Cupidon*, 1891 (London: Roy Miles Fine Painting)

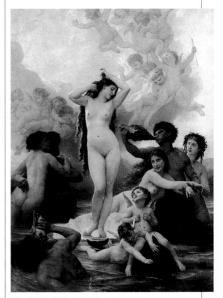

The Birth of Venus William-Adolphe Bouguereau, 1879, 300 x 218 cm (118/x 85% in), oil on canvas, Paris: Musée d'Orsay. Bouguereau's mythological paintings were avidly collected, and sold for huge prices.

Franz Xavier Winterhalter

⊖ 1805-73 P GERMAN

Paris a oils a London: Wallace Collection
 \$1.6m in 1997, Jeune fille de l'Ariccia (oils)

He was a smooth-mannered, highly popular Munich-trained portrait painter, notably of the European monarchy (English, Belgian, and French) in their 19th-century golden age. He captured their preferred self-image - royalty as bourgeoisie. His work brilliantly combines formality, intimacy, and anecdote, Was a rapid worker, straight onto canvas, with an effortless, impersonal style. Winterhalter also made lithographs. KEY WORKS Princess Leonilla, 1844 (Los Angeles: J. Paul Getty Museum); The First of May, 1851 (Windsor Castle, England: Royal Collection); Portrait of Princess Tatyana Alexandrovna Yusupova, 1858 (St. Petersburg: Hermitage Museum)

Hans Makart

A highly successful Viennese painter, Makart delighted his rich clientele by plundering the art of the great masters of the Venetian Renaissance and the 17th and 18th centuries to create decorative allegories and historical images that promised (but in the end, failed to deliver) great talent and emotional content. Despised by avantgarde artists such as Schiele and Klimt. **KEY WORK** *The Dream after the Ball*, 1870s (New York: Metropolitan Museum of Art); *The Triumph of Ariadne*, 1870s (Vienna: Österreichische Galerie); *Charlotte Wolter as the Empress Messalina*, c.1875 (Vienna: Historisches Museum der Stadt)

Sir Thomas Lawrence

● 1769–1830 № BRITISH I London; Europe I oils I Oxford: Ashmolean Museum I \$1,092,000 in

1988, Portrait of Prince Regent (oils)

The precociously talented son of an innkeeper, Lawrence went on to become the leading portrait painter of the day. Over-production led to uneven quality.

His paintings have style, elegance, and haughty confidence. He was the chosen portrait painter of the ruling class of the richest and most powerful nation on earth – they believed it and he confirmed it. They were also hungry for aesthetic experience; his portraits revealed this side of their personalities and gave a strong aesthetic thrill (they still do).

Observe the way he conveys the above: inventive, dramatic, self-conscious poses; flowing dresses, flowing hair; heads confidently turned on overlong necks, to show off; long arms; finely formed, sloping shoulders; rich colours; luscious, free-flowing paint applied with total confidence and sensual pleasure; above all, dark eyes, with crisp, white highlights that are deep pools of romantic experience and feeling.

KEY WORKS *Elizabeth Farren*, 1790 (New York: Metropolitan Museum of Art); *Mrs. Isaac Cuthbert*, c.1817 (Paris: Musée du Louvre);

Derby Day William Powell Frith, 1856–58, 101.6 x 223.5 cm (40 x 88 in), oil on canvas, London: Bonhams. When first exhibited, crash barriers were erected around the painting to hold back overexcited crowds.

287

Portrait of Arthur Wellesley (1769–1852), 1st Duke of Wellington Sir Thomas Lawrence, 1814, oil on canvas, London: The Wellington Museum. Lawrence painted portraits of all the European victors over Napoleon.

Samuel Woodburn, c.1820 (Cambridge: Fitzwilliam Museum); Sir John Julius Angerstein, c.1823–28 (London: National Gallery)

William Powell Frith

€ 1819-1909 PU BRITISH

A popular painter, admired by Queen Victoria, famous for his detailed,

panoramic chronicles of Victorian life (railway stations, races, the seaside). Refreshingly unpretentious. unambitious, and free from moral comment. Used photographs but was reluctant to admit it. Unwisely attempted to do history and moral paintings. **KEY WORKS** Othello and Desdemona, 1840-56 (Cambridge: Fitzwilliam Museum); Portrait of Charles Dickens, c.1850s (London: Victoria & Albert Museum); The Railway Station, 1862 (Surrey: Royal Holloway and Bedford New College)

Lord Frederic Leighton

Frankfurt; Rome; Paris; London i is;
 sculpture in London: National Gallery;
 Tate Collection. Wirral (UK): Lady Lever Art Gallery
 \$1,812,000 in 2000, The Bracelet (oils)

The first British painter to be made a Lord. Was educated in Europe. Aimed to be, and was called, the Michelangelo of his day. Adept at art politics and diplomacy. Very successful. Counted Queen Victoria among his buyers.

His works are immaculate and faultless in every way: they display wonderful technique and draughtsmanship; superb, sophisticated, and inventive handling of light, colour, composition; correct academic subject matter (portraits, biblical and mythological themes). So why are his works so often cold, aloof, and soulless? Because overt support for the status quo always wins support from those with most to lose – but lasting fame requires real innovation.

Look for borrowings from (also homages to) Michelangelo and from other great Italian and French masters (Titian, Ingres). Also notice the places where he lets go and, instead of playing the pompous, god-like, so-called great artist, is himself: sketches from nature, occasional quirky oil painting, joy at painting white textures. It is then that the warmth and freshness that is absent from his "official"

works begin to come across.

KEY WORKS Cimabue's Madonna Carried in Procession through the Streets of Florence, 1853-55 (London: National Gallery); On the Nile, 1868 (Cambridge: Fitzwilliam Museum); Athlete Struggling with a Python, 1874-77 (London: Tate Collection); Study of a Nubian Young Man. 1880s (London: Bonhams); Study, 1877 (Liverpool: Sudley House)

Garden of the Hesperides Lord Frederic Leighton, c.1892, oil on canvas, Wirral (UK): Lady Lever Art Gallery. Bought by the soap manufacturer Lord Leverhulme, the epitome of the successful Victorian businessman.

Sir Edwin Landseer

⊖ 1802-73 P BRITISH

London; Scotland [1] oils; sculpture; engravings
 London: Tate Collection; Victoria & Albert
 Museum [2] \$1,851,500 in 2003, Scene in
 Chillingham Park, Portrait of Lord Ossulston (oils)

Hugely successful and much admired by Queen Victoria, Landseer had a prolific output of sentimental portraits and animal and sporting pictures (particular affinity with Highland cattle, stags, lions, and polar bears). Was ideally in tune with his times – his animals express the key Victorian virtues: nobility, courage, pride, success, conquest, male dominance, and female subservience.

His small plein-air sketches, done on the spot, are as good as anything by Constable or French contemporaries. **KEY WORKS** *The Old Shepherd's Mourner*, 1837 (London: Victoria & Albert Museum); *Dignity and Impudence*, 1839 (London: Tate Collection)

Sir Lawrence Alma-Tadema

⊖ 1836-1912 P BRITISH

Netherlands; London Dils
 Los Angeles: J. Paul Getty Museum
 \$2.5m in 1995, The Finding of Moses (oils)

He was Dutch-born, naturalized British. Highly successful with the Victorian business classes for whom he produced fashionable, meticulously painted, erotic but safe fantasy images of the leisured classes of Greece and Rome – usually the women in private with their clothes off. Dedicated archaeologist. He used photographs and his own site drawings. **KEY WORKS** *Phidias and the Parthenon*, 1868 (Birmingham, UK: Museums and Art Gallery); *The Sculptor's Model*, 1877 (Private Collection)

Sir Luke Fildes

⊖ 1843-1927 P BRITISH

Liverpool; London; Venice is oils
 \$462,500 in 1992, The Village Wedding (oils)

A very successful and popular pillar of the establishment who freshened stale Victorian academic tradition with a whiff of acceptable new French ideas – loose paint handling, modern subjects, and an interest in light. Portraits, landscapes, social themes. His *Doctor* was one of the most internationally popular paintings of the late 19th century.

KEY WORKS Venetians, 1885 (Manchester: City Art Gallery); *Doctor*, 1891 (London: Tate Collection); *A Devotee*, 1908 (Manchester: City Art Gallery)

The Tepidarium Sir Lawrence Alma-Tadema, 1881, 24 x 33 cm (9½ x 13 in), oil on panel, Wirral, UK: Lady Lever Art Gallery. In the 1880s, Alma-Tadema's paintings often fetched higher prices than quality old masters.

John Frederick Lewis

London; Cairo
 watercolours; oils; engravings
 \$1.26m in 1996, Lilium Auratum (watercolours)

Best-known member of a prolific artistic dynasty, famous for his impressive scenes of Egyptian markets, bazaars, and harems, using intricate watercolour technique (clever use of gouache) and obsessive detail. Also produced less good oils. Early work has sporting, wildlife, and topographical subjects. Visited Spain and Morocco (1832–34); lived in Egypt (1841–51). KEY WORKS A Syrian Sheik, Egypt, 1856 (Cambridge: Fitzwilliam Museum); The Coffee Bearer, 1857 (Manchester: City Art Gallery); The Door of a Café in Cairo, 1865 (London: Royal Academy of Arts)

Indoor Gossip, Cairo John Frederick Lewis, 1873, 30.4 x 20.2 cm (12 x 8 in), oil on panel, Manchester: Whitworth Art Gallery. Lewis preferred the solitude of Egypt's deserts to the bustling social life of Cairo.

Christen Købke

● 1810-48 P DANISH

He was a short-lived (died of pneumonia), gifted painter who caught the prevailing Biedermeier middle-class taste for

River Bank at Emilliekilde Christen Købke, c. 1836, 19 x 31 cm (7½ x 12¼ in), oil on canvas, Paris: Musée du Louvre. Købke's famous lake scenes were painted in the studio from numerous outdoor drawings and sketches.

reassuring portraits of themselves and their dwelling places. The liveliest works are his sketches from nature (from which he made finished exhibition paintings). Travelled in Italy in 1838–40. He was rejected by the Academy.

The luminous calm hides a quiet national pride and strong sense of moral virtues. Both sentiments are essential Biedermeier qualities and are revealed in his attention to detail, emphasis on cleanliness and orderliness (which is probably unreal and overexaggerated), and understated symbolic details. **KEY WORKS** Portrait of Frederik Sødring, 1832 (Copenhagen: Hirschsprungske Samling); A View of a Street in Copenhagen, 1836 (Copenhagen: Statens Museum for Kunst); The Northern Drawbridge to the Citadel in Copenhagen, 1837 (London: National Gallery); A View of One of the Lakes in Copenhagen, 1838 (Copenhagen: Statens Museum for Kunst)

Richard Dadd

● 1817-86 № BRITISH 10 Bedlam, Broadmoor (UK) 10 oils

London: Tate Collection 2 \$2,775,000 in 1992, *Contradiction, Oberon, and Titania* (oils)

"Mad Dadd" murdered his father in 1843 and was locked up, but his doctors encouraged him to continue with his painting. Has recently become famous through his meticulous and obsessively detailed paintings of fairy subjects made in the 1850s.

KEY WORKS The Flight out of Egypt, 1849–50 (London: Tate Collection); Mercy: David Spareth Saul's Life, 1854 (Los Angeles: J. Paul Getty Museum); The Fairy Feller's Master-Stroke, 1855–64 (London: Tate Collection)

Thomas Cole

 Pennsylvania; New York; Catskill Mountains; Europe I oils I New York: Munson-Williams-Proctor Art Institute I \$1.3m in 2003, *Catskill Mountain Houses* (oils)

Cole was British-born (Bolton, Lancashire), but his family emigrated to the USA in 1818. Major figure in American art – founder of the Hudson River School and the tradition of the grand landscape. Romantic, conservative, melancholic, often at odds with a world given to fast-changing materialism.

His early picturesque Hudson River landscapes (done in the 1820s) interpret the American rural scene through the European conventions of the picturesque and sublime. His later work gets larger in scale and overlaid with literary and moralizing ideas, which he also expresses in verse and diaries. Combines landscape with biblical and historical themes, which to modern eyes can go completely over the top in the manner of bad operas or Hollywood spectaculars.

The reason for the earlier works is a genuine response to the beauties of relatively virgin US nature unsullied by too much tourism, development, or artistic interpretation (unlike Europe). The reason for the later work is his fear of the clash between this nature and an aggressive material culture, which he feared would gobble it up. "The Course of Empire" and "The Voyage of Life" predict the rise and fall of American culture. KEY WORKS Distant View of Niagara Falls, 1830 (Art Institute of Chicago); The Course of Empire: The Savage State, 1836 (New York Historical Society); View on the Catskill – Early Autumn; 1837 (New York: Metropolitan Museum of Art); Schroon Mountain, Adirondacks, 1838 (Ohio: Cleveland Museum of Art); The Notch of the White Mountains, 1839 (Washington DC: National Gallery of Art)

Frederic Edwin Church

→ 1826 – 1900 P
 → AMERICAN

 ☑ USA; Canada; South America
 ☑ oils
 ☑ New York: Metropolitan Museum of Art.
 Hudson (New York State): Olana State Historic
 Site
 ☑ \$7.5m in 1989, Home by the Lake, Scene in the Catskill Mountains (oils)

The greatest American landscape painter. Combined detailed observation of nature with the heroic, sublime vision of Romantics such as Turner. God-fearing and patriotic (and it shows).

His large-scale, stunning vistas or panoramas of North and South America have natural phenomena (Niagara Falls), mountains, and dramatic light (blood-red sunsets) to the fore. Uses high viewpoints, which give a birdlike feeling of being free to go anywhere, and combines this with the quasi-scientific observation of microscopic details – indicating his deep spiritual belief in the morality of Nature and presence of God in the largest and the smallest feature.

Note the thrilling shafts of light falling on the landscape; exquisite painting of

THE HUDSON RIVER SCHOOL

Loosely organized group of American painters whose founding father, Thomas Cole, painted picturesque views of the beautiful Hudson River Valley in Upper New York State in the 1820s, thereby establishing a new tradition for landscape painting in the USA. Most of the artists associated with the school travelled widely throughout the USA and worked in New York. They often painted the Hudson River landscape interspersed with other scenes taken from all over the country. The group's vigour waned after the Civil War (1861–65), but it was a great influence on the Luminist School that followed.

Scene from "The Last of the Mohicans" Thomas Cole, 1827, oil on canvas, New York: Fanimore Art Museum. This is one of four works inspired by James Fenimore Cooper's novel.

1820s-1870s

Cotopaxi Frederic Edwin Church, 1862, 122 x 216 cm (48 x 85 in), oil on canvas, Michigan: Detroit Institute of Arts. Church made two visits to South America, following in the footsteps of German explorer Alexander von Humboldt. He sketched Ecuador's Cotopaxi volcano in 1857.

distant mountains and waterfalls; and sharp, bright colours (used new, heavy, metal pigments). At his peak in the 1860s, he had a long, slow decline (suffered from bad rheumatism in his hands).

KEY WORKS South American Landscape, c.1856 (New York: Berry-Hill Galleries); Heart of the Andes, 1859 (New York: Metropolitan Museum of Art); Aurora Borealis, 1865 (Washington DC: National Gallery of Art); Niagara Falls, 1867 (Edinburgh: National Gallery of Scotland)

Martin Johnson Heade

€ 1819-1904 P AMERICAN

USA; Europe; South America 0 oils New York: Brooklyn Museum of Art \$1,750,000 in 1987, *Two Fighting Hummingbirds with Two Orchids* (oils)

Johnson Heade was an important Luminist and long-lived hack portraitist who "came good" after meeting Frederic Church in 1859. He is best known for his haunting landscapes of flat lands with low horizons. Author of simple, clear compositions – wide, open spaces where each element is placed with the utmost precision. Had a special ability to show that mysterious, ominous light that precedes a storm. Also remembered for his travels to Brazil where he did notable paintings of hummingbirds and orchids. **KEY WORKS** *Approaching Thunderstorm*, 1859 (New York: Metropolitan Muscum of Art); *Seascape: Sunset*, 1861 (Detroit Institute of Arts); *Rio de Janeiro Bay*, 1864 (Washington DC: National Gallery of Art)

Fitz Hugh Lane

→ 1804-65 P
 AMERICAN

Boston; Maine; Gloucester (USA)
 \$5m in 2004, Manchester Harbour (oils)

Leading member of the Luminist School. A master of the frozen moment when time apparently stops – creator of scenes of eerie unpopulated stillness with a golden light that suffuses all. Also finely detailed paintings of ships and coastlines. The visual equivalent of transcendentalism in literature – the search for the essence of a reality beyond mere appearance. **KEY WORKS** *The Golden State Entering New York Harbour,* 1854 (New York: Metropolitan Museum of Art); *Off Mount Desert Island,* 1856 (New York: Brooklyn Museum of Art)

> "The real voyage of discovery consists not in seeking new landscapes but in having new eyes." MARCEL PROUST

Albert Bierstadt

 USA
 Image: Solution of a state of a s

Bierstadt was German-born, but raised in Massachusetts. He painted large-scale landscapes of the American West during the era of early railroads, with low viewpoints, convincing but fanciful compositions, good anecdotal detail, and crisp use of light and shade. Did for the American West what Canaletto did for Venice. Also worked in Switzerland and Bermuda, Brilliant oil sketches. KEY WORKS Yosemite Valley, c.1863 (New York: Berry-Hill Galleries); A Storm in the Rocky Mountains, 1866 (New York: Brooklyn Museum of Art); Among the Sierra Nevada Mountains, California, 1868 (Washington DC: National Museum of American Art)

Thomas Moran

€ 1837-1926 P AMERICAN

USA; Europe; Mexico 🚺 oils 🖬 Bolton (UK): Museums, Art Gallery, and Aquarium 🔯 \$4.4m in 2004, *Mist in the Yellowstone* (oils)

He was a self-taught, Irish-English émigré raised in Philadelphia. Made his reputation after a pioneering visit to

The Grand Canyon of the Yellowstone Thomas Moran, 1872, 245.1 x 427.8 cm (96% x 168% in), oil on canvas, New York: Smithsonian Institute. Inspired after accompanying a government expedition to Yellowstone. Yellowstone (1871), depicting its natural grandeur in the style of Turner's Romanticism. His superb watercolours are built up from pencil underdrawing and were much influenced by Turner. He also painted scenes of Venice (Turner again), Long Island, and California. **KEY WORKS** *Nearing Camp, Evening on the Upper Colorado River,* 1882 (Bolton, UK: Museums, Art Gallery, and Aquarium); *The Much Resounding Sea*, 1884 (Washington DC: National Gallery of Art); *The River Schuylkill*, 1890s (Private Collection)

George Caleb Bingham

 Missouri i i oils i New York: Metropolitan Museum of Art i \$980,000 in 1978, *Jolly Flatboatmen No.2* (oils)

Born in Virginia and brought up in Missouri, he was the first significant painter from the Midwest. Had a decade of brilliant talent, 1845-55, painting scenes of the American frontier, and "jolly flatboatmen". Contrived simple compositions bathed in golden light. As formal as Poussin and as proudly documentary of his new Republic as any 17th-century Dutch master. KEY WORKS Ferrymen Playing Cards, 1847 (Missouri: St. Louis Art Museum); Country Politician, 1849 (San Francisco: Fine Arts Museum); Shooting for the Beef, 1850 (New York: Brooklyn Museum of Art); The Squatters, 1850 (Boston: Museum of Fine Arts)

The Blanket Signal Frederic Remington, c.1896, oil on canvas, Houston: Museum of Fine Arts. One of the Native Americans employed by the United States Army as irregulars, a military trend Remington strongly supported in the 1890s.

"Art is a she-devil of a mistress, and if at times in earlier days she would not even stoop to my way of thinking, I have persevered and will so continue."

Frederic Remington

€ 1861-1909 P AMERICAN

USA; Europe; North Africa Oils; sculpture New York State: Remington Art Memorial \$4.7m in 1999, *Reconnaissance* (oils)

The most famous painter of the cowboy West. Also made sculptures. Was haunted by the notion that he was a mere illustrator (which in truth he was), rather than a "proper" artist – his late works experiment unsuccessfully with Impressionism and arty ideas. Was pro the US cavalry, unsympathetic to Indians. Bigoted. Friend of Theodore Roosevelt.

Remington was a great myth-maker who liked to promote the idea that he was a former cowboy, US cavalry officer, but in fact he was Yale-educated and lived mostly in New York. His images of the "good" whites protecting "their" territory against the savage "foreign" Indians were consciously adopted by Hollywood cowboy movie directors. Reproductions of his illustrations in Harper's Weekly and other popular publications made him a household name throughout the US. Remington also spent time as a journalist, covering the Indian Wars of 1890-01 and the Spanish-American War (in Cuba) of 1898. Keen writer; published eight books.

KEY WORKS The Mexican Major, 1889 (Art Institute of Chicago); Aiding a Comrade, c.1890 (Houston: Museum of Fine Arts); The Advance-Guard, or the Military Sacrifice, 1890 (Art Institute of Chicago); Coming Through the Rye, 1902 (New York: Metropolitan Museum of Art)

Charles M. Russell

→ 1864 – 1926
 P AMERICAN

☑ Montana
 ☑ watercolours; oils; sculpture
 ☑ Montana: C. M. Russell Museum
 ☑ \$2.1m
 in 2001, *Disputed Trail* (oils)

He was the premier painter of the American West – alongside Remington but very different: Russell was self-taught, had genuinely worked as a cowboy, was sympathetic to Indians, and had a sense of humour. Good at working in oils, but superb in watercolour. He didn't hit his stride until 1900, but then got better and better. Was also a producer of high-quality sculptures.

KEY WORKS Indian Braves, 1899 (New York: Metropolitan Museum of Art); The Death Song of Lone Wolf, 1902 (Minnesota: Minneapolis Institute of Arts); Smoking Up, 1904 (New York: Metropolitan Museum of Art); The Wagons; 1910 (New York: Kennedy Galleries)

Winslow Homer

☑ USA; Paris; England
 ☑ Watercolours; oils
 ☑ New York: Metropolitan Museum of Art.
 Boston: Museum of Fine Arts
 ☑ \$4.4m in
 1999, Red Canoe (drawing)

Homer was one of the great 19th-century painters. He was able to interpret nature in a way that convincingly reflected the American pioneering spirit. Well travelled in the USA, England, and the Bahamas. He was self-taught.

Homer was a creator of highly satisfying, virile images: sea paintings of the Atlantic coast; images of down-toearth, practical people, especially when coping with adversity; modern women; robust children. Made a pragmatic exploration of light and colour, and produced strong, well-designed, and boldly painted pictures. Also painted exquisite, fresh, fluid watercolours. His work has a strong narrative content (it's no coincidence that he started out as a magazine illustrator), but he lifted his art beyond the ordinary by infusing it with a *Eight Bells* Winslow Homer, 1886, 64.5 x 77.2 cm (25% x 30% in), oil on canvas, Andover (USA): Addison Gallery of American Art. Homer lived for many years on the Atlantic seaboard in Maine.

sincerely felt, underlying moral message, and a subtle ambiguity of meaning.

His no-nonsense practical painting is completely in tune with its subject matter, time, and place. Has an enviable ability to simplify and leave out unnecessary detail. Uses strong contrasts of light and shade with assurance. Note the solid, unhesitating draughtsman and frequent use of a silhouetted figure, often in heroic attitude. He employs the imagery of children as a metaphor for the future of America. Note also the progression of his style and subjects as they grow larger, stronger, more confident, and freer with age and experience. KEY WORKS Snap the Whip, 1872 (Ohio: Butler Institute of American Art); Tending Sheep, Houghton Farm; c.1878 (Private Collection); The Herring Net, 1885 (Art Institute of Chicago); The Turtle Pound, 1898 (New York: Brooklyn

Museum of Art); The Sharpshooters, c.1900

(London: Christie's Images)

William Sidney Mount

€ 1807-68 P AMERICAN

New York (2) oils; drawings Detroit Institute of Arts (2) \$800,000 in 1983, The Trap Sprung (oils)

The premier genre painter of mid-19thcentury America. Lived in Long Island and produced scenes of rural life that appealed to New York city-dwellers. His images of farm life, horse dealing, musicmaking, and his sensitive portrayals of African-American farmers appealed to a public hungry for expressions of national self-awareness and self-consciousness. Clear, precise draughtsmanship and colours. **KEY WORKS** *Bar-room Scene*, 1835 (Art Institute of Chicago); *The Raffle (Raffling for the Goose)*, 1837 (New York: Metropolitan Museum of Art)

Albert Pinkham **Ryder**

beyond repair. He

(Ohio: Cleveland

Museum of Art)

 Image: New York
 Image: Oils
 Image: Ohio: Cleveland Museum

 of Art
 Image: State Sta

He was an erratic bohemian character who painted brooding, romantic scenes such as *Jonah and the Whale, Siegfried and the Rhinemaidens*, and boats on stormy moonlit seas. Used jewel-like colours and thick, cumbersome paint, but bad technique and the use of bitumen mean that most of his paintings are damaged Thomas **Eakins**

➡ Philadelphia; Paris ➡ oils ➡ Philadelphia: Museum of Art ➡ \$4.8m in 2003, Cowboys in the Badlands (oils)

He was Philadelphia-born and bred. Studied in Paris and Spain; was a gifted teacher at the Pennsylvania Academy. Said by some to be the greatest of all American artists, but he was little honoured in his lifetime. Pragmatic but difficult, unyielding personality. Keen boatman.

His frank, candid portraits are of people from a fairly narrow social circle. He had more interest in matters like status, achievement, and position in society than in personality – and responded best to achievers (he was one himself). His middle period (from 1869 onwards) features matter-of-fact successful professionals; his later period was more dreamy. Had a deep interest in science, medicine, and how things work. Employed human anatomy, motion, and perspective to make his pictures work.

Look for imaginative poses and movement; workman-like hands; rich, dark colour harmonies; atmospheric 19th-century interiors. He uses extra objects or incidents to tell the story behind a portrait, and light to animate compositions. Likes colour and emotion but is even more interested in shadows – notice how he uses them to create space.

was considered to represent the height of poetic sensibility and was somewhat of a guru figure for the likes of Hartley and Pollock. **KEY WORKS** Siegfried and the Rhinemaidens. 1888-91 (Washington DC: National Gallery of Art): The Forest of Arden, c.1888-97 (New York: Metropolitan Museum of Art); The Race Track (Death on a Pale Horse), c.1896-1908

Roadside Meeting Albert Pinkham Ryder, 1901, 38.1 x 30.5 cm (15 x 12 in), oil on canvas, Ohio: Butler Institute of American Art. Like many symbolist painters, Ryder was an admirer of the poet Edgar Allen Poe.

Has any other painter observed shadows so accurately? **KEY WORKS** The Biglin Brothers Racing, 1872 (Washington DC: National Gallery of Art); The Gross Clinic, 1875 (Philadelphia: Thomas Jefferson University); William Rush carving his Allegorical Figure of the Schuylkill River, 1877 (Philadelphia Museum of Art); The Swimming Hole, 1884-85 (Texas: Modern Art Museum of Fort Worth)

John **Ruskin**

⊖ 1819-1900 PU BRITISH

UK; Europe 🚺 watercolours 🖬 Venice: Scuola di S. Rocco 🔁 \$408,000 in 2003, *Bellinzona, Switzerland, Looking North towards the St. Gotthard Pass* (watercolours)

He was most important as a critic and writer. As a painter had a central belief in the supremacy of truth to nature (not the same as a slavish imitation of nature), but abandoned this belief after 1858. His intensely observed and detailed watercolours reflect his passion and knowledge of geology and architecture. **KEY WORKS** *J. M. W. Turner, RA*, c.1840 (London: Royal Academy of Arts); *View of Bologna*, c.1845–46 (London: Tate Collection)

Ford Madox Brown

⊖ 1821-93 PU BRITISH

 Antwerp; Paris; Rome; England
 Image: State of the state of the

Trained in France and was a close follower of the Pre-Raphaelites. Highly detailed work – landscapes painted in the open air and figurative works containing social commentaries on contemporary life, which reached out to intellectual political activists. Too idiosyncratic to be successful in his own day. **KEY WORKs** The Seeds and Fruits of English Poetry. 1845–51 (Oxford: Ashmolean Museum); Chaucer at the Court of Edward III, 1851 (Sydney: Art Gallery of New South Wales)

Dante Gabriel Rossetti

● 1828-82	PO BRITISH
🛛 London	oils; watercolours; drawings
🛅 London: 1	Tate Collection. Birmingham, UK:
City Art Galle	ery. Manchester: City Art Gallery
\$3,624,00	00 in 2000, Pandora (works on paper)

He was a painter, poet, and the leading Pre-Raphaelite. Had a complicated love life and died of alcohol and drug abuse.

He is best known for images of erotic femmes fatales painted from the 1860s onwards. Also went in for romantic medieval themes. Early Pre-Raphaelite work is rather awkward and stiff at times. His *femmes fatales* are characterized by luscious lips, sinuous hands, and thick, glistening hair. Brilliant draughtsman but his painting technique is a bit suspect. Look for works of much intensity (the most desirable state of existence for artistic folk at that time). Fine, detailed, and heavily worked watercolours. KEY WORKS Girlhood of Mary Virgin, 1849 (London: Tate Collection); Mary Nazarene, 1857 (London: Tate Collection)

Work Ford Madox Brown, 1852–65, 137 x 197.3 cm (54 x 77% in), oil on carvas, Manchester: City Art Gallery. Brown's picture is intended to encapsulate the appearances and activities of the different social classes.

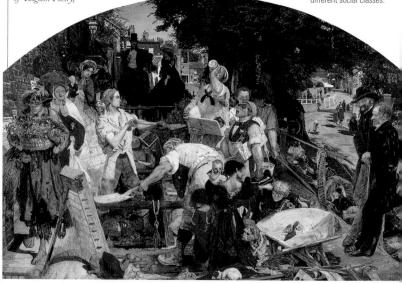

PRE-RAPHAELITES

Artistic movement stemming from the Pre-Raphaelite Brotherhood (PRB), an ambitious and confident group of seven male artists, aged between 19 and 23. They decided art had "gone wrong" around the time of Raphael and sought to return to ideals shared by artists before Raphael's time. The brotherhood was established in 1848 and lasted until c.1853. The movement was much more long-lived and wide-reaching.

SUBJECTS AND STYLE

Pre-Raphaelites drew their inspiration from literature, especially the Bible, Shakespeare, the Romantics, and contemporary poets, such as Browning and Tennyson. They were also inspired by medievalism, especially Malory's *Morte d'Arthur.* They developed their own paint colours and came up with a new technique of painting on a "wet white" background, so the colours shone with luminosity. Women feature heavily in their works, especially those of Dante Gabriel Rossetti and Edward Burne-Jones.

The Rescue Sir John Everett Millais, 1855, 21.5 x 83.6 cm (8½ x 33 in), oil on canvas, Melbourne: National Gallery of Victoria. Note his spectacular command of light, with faces lit up by the glow.

WHAT TO LOOK FOR

Vivid use of colour – sometimes exquisite, at other times gaudy. Scenes of chivalry and deep emotion; sentimentalism; strong literary references, with the same scene often painted by several artists; rich and quite obvious symbolism. They often used one another as models, so look for recognizable portraits and selfportraits among genre paintings. In early paintings seek out the stylized "PRB" monogram somewhere in the scene.

Isabella and the Pot of Basil William Holman Hunt, 1867, 60.7 x 38.7 cm (23 x 15 in), oil on canvas, Wilmington: Delaware Art Museum. Based on Keats's poem; the model was Holman Hunt's pregnant wife.

KEY EVENTS

1848	The Pre-Raphaelite Brotherhood holds its first meeting at 7 Gower Street, London
1850	The meaning of "PRB" revealed by mistake to a journalist
1855	Pre-Raphaelite paintings are shown at the Paris Exhibition
1857	Rossetti meets William Morris and Burne- Jones, a new generation of Pre-Raphaelites

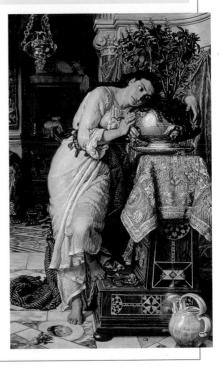

19th century

William Holman Hunt

→ 1827-1910 P
 BRITISH

🔟 England; Egypt; Palestine London: Tate Collection 2 \$2,72m in 1994. The Shadow of Death (oils)

D oils; watercolours

Hunt was a founder member of the Pre-Raphaelite Brotherhood and its most consistent exponent. Religious, obsessive, and stubborn, producing work with insistent moralizing and didactic themes. A true Victorian, who verges on greatness but whose obsession with detail and colouring can be intense to the point of unpleasantness.

KEY WORKS On English Coasts, 1852 (London: Tate Collection); The Scapegoat, 1854 (Wirral, UK: Lady Lever Art Gallery)

Sir John Everett Millais

🔟 London 🛯 🖉 oils; drawings 🛛 🛅 London: Tate Collection. Birmingham (UK): City Art Gallery. Liverpool: Walker Art Gallery. Manchester: City Art Gallery 🔊 \$3.04m in 1999, Sleeping (oils)

He was an infant prodigy who became extremely fashionable, rich, and famous. Founder member of Pre-Raphaelite Brotherhood and pillar of the Royal Academy (became its president in 1896).

> "Sometimes as I paint I may find my work becoming laborious. But as soon as I detect any evidence of that labour I paint the whole thing out." SIR JOHN EVERETT MILLAIS

His early work (up to the 1850s) was genuinely Pre-Raphaelite, with a meticulous tight style; strict observation of nature; choice of moral themes. The later work is more freely painted, with subjects overtly designed to catch the fashion of the times and sell well sentimental scenes, historical romances. portraits (he needed the money with eight children and a lavish lifestyle to support).

His virtuoso craftsmanship and attention to detail (natural and historical) makes it all look so easy. Look out for delightful, often humorous, sketches; note also the commercial prints made from his paintings. which sold as well as current-day rock group recordings.

KEY WORKS Ophelia, 1851-52 (London: Tate Collection); The Blind Girl, c.1856 (Birmingham, UK: Museums and Art Gallery); The Ransom, 1860-62 (Los Angeles: J. Paul Getty Museum)

John Brett

● 1830-1902 P BRITISH

🔟 England; Italy; Europe 🛛 oils 🛅 Liverpool: Walker Art Gallery 2 \$1,848,000 in 1989, Val d'Aosta (oils)

He was a devotee of Ruskin, emulator of Holman Hunt, resulting in early, intensely detailed, high-coloured landscapes that are a tour de force of precise observation and technique. Painting trips to Italy and the Alps (as approved by Ruskin). Commercially more successful with later works (especially panoramic views of the ocean), but they are flabby by comparison with his earlier works.

KEY WORKS Glacier of Rosenlaui, 1856 (London: Tate Collection); Florence from Bellosguardo, 1863 (London: Tate Collection)

Sir Edward Coley Burne-Jones

 → 1833-98
 P
 BRITISH
 🖸 England 🛛 🖉 oils; watercolours 💼 Birmingham: City Art Gallery 🛛 🔎 \$1.47m in 2001, Prince Entering the Briar Wood (oils)

A quiet, retiring, otherworldly painter, with a streak of calculating shrewdness. Famous and successful after 1877.

His paintings reflect his character and one aspect of the age he lived in. His early medieval and mythological subjects are heavily laden with mysticism and symbolism that look back to a "golden" age, chosen to fulfil a wish to escape from modern urban and industrial reality; yet the large-scale, precise style, fascination with materials and realistic details are very worldly, showing a personal (and typical Victorian) duality.

Highly developed sense of 2-D design (due to his closeness to William Morris, who encouraged him to become an artist

St. George and the Dragon Sir Edward Coley Burne-Jones, 1868, gouache on paper, London: William Morris Gallery. Burne-Jones worked closely with William Morris from 1855–59. This painting post-dates his visit to Italy with Ruskin in 1862.

instead of following a career in the Church) and a technique that shows a love of meticulous craftsmanship (due to his closeness to Ruskin). Was also influenced by early Renaissance art (such as Botticelli). Produced very successful designs for tapestry and stained glass; and illustrations for texts of medieval and classical legends. **KEY WORKS** *Music*, 1880s (New York: Roy Miles Fine Paintings); *King Cophetua and the Beggar Maid*, 1880 (London: Tate Collection)

George Frederick Watts

● 1817-1904 P BRITISH

- England; ItalyImage: Constant of the constant
- 2 \$1,121,800 in 1986, Hope (oils)

He aimed to emulate the grandeur and achievements of Titian and Michelangelo; known in his day as "England's Michelangelo". Produced portraits, allegories, and landscapes that reflect the influence of his two exemplars but can now seem pompous and overambitious. His portraits are his best work. **KEY WORKS** *Choosing*, 1864 (Private Collection); *Sir Galahad*, 1880s (Liverpool: Walker Art Gallery)

REALISM

The progressive movement in art and literature in the mid-19th century (especially in France). It began in earnest in 1855, with an exhibition of works by Gustave Courbet. Its centrepiece, *The Painter's Studio*, had been refused by the Universal Exhibition, so Courbet set up his own in a nearby tent. The artist produced a manifesto to go with his exhibition, which he entitled *Le Réalisme*.

STYLE

Realism was concerned with social realities, and wanted to show fact rather than ideals or aesthetics. It rejected Academic art as being too artificial, and Romanticism as being too concerned with the imagination. Realists wanted to cut through the cant of society – and not just in art; as such, the movement became a mechanism for social change, with a The Gleaners Jean-François Millet, 1857, 83 x 111 cm (33 x 44 in), oil on canvas, Paris: Musée d'Orsay. In 1857, Millet was described by one critic as "a great painter who walks in clogs the road of Michelangelo".

committed political agenda, being associated with new, democratic ways of thinking, with anti-establishment causes, and with championing individuals' rights. The movement was highly influential, spreading into Germany, Russia, the Netherlands, and the USA. Realism also influenced literary giants such as Tolstoy, Balzac, Zola, Dickens, and Flaubert.

> The losers include a Chinaman, a Jew, an Irishwoman, a poacher, a war veteran, and a labourer

> Wearing huntsman's dress is Napolean III, the effective dictator of the French Second Empire

SUBJECTS

Subject matter is diverse: portraits, landscapes, groups, genre scenes. Refusing to hark back to historic or pastoral idylls, Realism dealt with the harshness of life, such as human degradation and poverty, as well as with natural landscapes and human emotions. Whereas artists had traditionally romanticized the poor and their harsh existence, Realists wanted to depict the truth. Above all, Realists also painted what they saw in everyday life, rejoicing in the contrariness of the natural world. The movement had a strong following, with artists from other traditions often borrowing the ideas and language of Realism.

KEY EVENTS

	한번(17,1,1,1,1,1,1,1,1,1,1,1,1,1,1,1,1,1,1,
1848	Revolution in France; rise to power of Napoleon III
1850	Courbet's <i>Stonebreakers,</i> remarkable for its social realism, shown at Salon
1855	Universal Exhibition. Courbet mounts rival show, including <i>The Painter's Studio</i>
1863	Manet's <i>Le déjeuner sur</i> <i>l'herbe</i> at Salon des Refusés
1867	Publication of Emile Zola's first major realist novel, <i>Thérèse Raquin</i>

WHAT TO LOOK FOR

Courbet's masterpiece, although painted early in his career, is a manifesto of Realism in which he sets out his central beliefs and opinions. It shows his studio in Paris with three groups of figures. The artist is in the centre. To his right are his friends – "those who thrive on life". To his left are those who "thrive on death", not just his enemies (notably

> A figure in the pose of the Crucifixion. This "lay figure" symbolizes academic art, which Courbet rejected

the Head of State, Napoleon III), but also the evils he fought against, plus those exploited and oppressed by them, represented as the poor, the destitute, and the losers in life.

The Painter's Studio Gustave Courbet, 1855, 361 x 598 cm (142 x 235½ in) oil on canvas, Paris: Musée d'Orsay. We know a great deal about this work because Courbet described it in detail whilst he worked on it.

The plaster medallion of a woman's profile is one of very few props depicted in the studio Light enters through a window on the right side – the side of life. A skylight also lit the studio

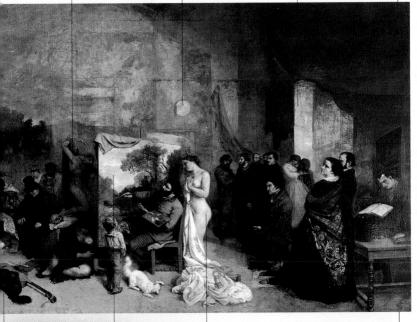

A large floppy hat with a feather, a cloak and dagger, and a guitar – the typical gear of the Romantic artist

On the easel is a large landscape, depicting the artist's homeland. The art establishment frowned upon such subject matter This woman represents naked truth guiding Courbet's brush

On a table to the left of the artist is a skull, which is the archetypal symbol of death. The skull is resting on top of a newspaper. This is Courbet's unambivalent comment on the critics who were extremely powerful in shaping 19th-century artistic opinion.

TECHNIQUES

The boy makes a crude sketch, uninhibited by rules or over-refined techniques. Courbet wanted his art to have similar qualities.

Henri Fantin-Latour

€ 1836-1904 P FRENCH

Trance	🔰 oils; prints	🟛 Paris: Musée
d'Orsay	🎾 \$3.2m in 2000,	Bouquet de fleurs (oils)

He was a painter of allegories inspired by music (especially Wagner), still lifes, and stodgy, wooden portraits with sitters who look distinctly uncomfortable or bored. Flowers and fruit are highly worked and end up looking artificial. Benefited from close connections with his more gifted artistic contemporaries. **KEY WORKS** *Flowers and Fruit*, 1865 (Paris: Musée d'Orsay); *Portrait of Edouard Manet*, 1867 (Art Institute of Chicago); *Still Life: Corner of a Table*, 1873 (Art Institute of Chicago)

Max Liebermann

⊖ 1847-1935 🕫 GERMAN

 Image: Germany; France
 I

A successful painter of middle-class daily life and places – updated replay of Dutch 17th-century and Biedermeier art.

Produced freely painted, not very difficult paintings, which reassured his clients and appeal to modern-day nostalgia. Used the earth-colour palette of the old masters, not the modern rainbow palette of the French Impressionists. **KEY WORKS** An Old Woman with Cat, 1878 (Los Angeles: J. Paul Getty Museum); Memorial Service for Kaiser Friedrich at Kösen, 1888–89 (London: National Gallery); The Ropewalk in Edam, 1904 (New York: Metropolitan Museum of Art)

James Tissot

€ 1836-1902 PU FRENCH

 ➡ France; London; Palestine ➡ oils; prints; drawings ➡ London: The Fine Art Society.
 Manchester: City Art Gallery ➡ \$4.8m in 1994, Le banc de jardin (oils)

He was French-born, but lived in London between 1871 and 1882, where he became a highly successful, fashionable painter of small-scale polished depictions of society (especially slim-waisted women) at play. Had a brilliant technique, which compensated for lack of depth and insight. His late religious conversion following the death of his much-painted mistress led to Bible illustrations.

A Country Brasserie, Brannenburg, Bavaria Max Liebermann, 1894, 70 x 100 cm (27½ x 39½ in), oil on canvas, Paris: Musée d'Orsay. Liebermann was regarded as a cultural enemy by the Kaiser because he admired modern foreign art (like French Barbizon and Impressionism), and rejected German nationalist and academic traditions.

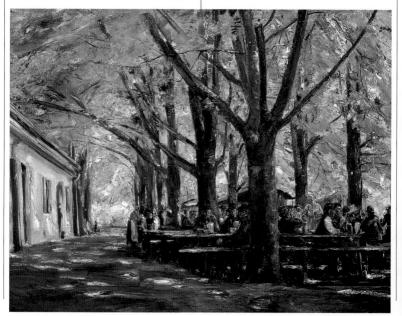

KEY WORKS London Visitors, c.1874 (Ohio: Toledo Museum of Art); Reading the News, c.1874 (London: Christie's Images); Inner Voices (Christ Consoling the Wanderers), 1885 (St. Petersburg: Hermitage Museum)

Carl Larsson

⊖ 1853-1919 P SWEDISH

☑ Sweden ☑ watercolours; oils; prints
 ☑ Stockholm: Nationalmuseum ☑ \$1,345,714
 in 1989, Near Kattegat (watercolours)

A key Swedish artist whose idealized illustrations of his own country cottage (rustic furniture, scrubbed floors, wife's **Portrait of MIIe. L. L.** James Tissot, 1864, 124 x 100 cm (48% x 39% in), oil on canvas, Paris: Musée d'Orsay. Tissot's art was attacked by the critics Oscar Wilde, Henry James, and John Ruskin, for its appeal to the *nouveaux riches*.

designer textiles, simplicity) were internationally influential and established the idea of the Scandinavian style. Earlier in his life he painted large-scale decorative, allegorical murals. Also portraits and self-portraits. Became manic-depressive after 1906. **KEY WORKS** Watering the Plants, Sitting Room – View Two, 1899 (Private Collection); The Midwinter Sacrifice, 1914–15 (Stockholm: National Museum); Indian Summer, c.1915 (Private Collection)

Jean-Baptiste-Camille Corot

⊖ 1796-1875 PU FRENCH

 ➡ France; England; Switzerland; Italy
 ➡ Paris: Musée du Louvre
 ▲ \$3.5m in 1984, La femme à la grande toque et à la mandoline (oils)

A major landscape painter of the 19th century. A bridge between the English landscape tradition and French Impressionism. Kind, gentle, and unusually unegocentric for an artist.

His late, best-known paintings (post-1860) – silvery green, soft focus, lyrical landscapes – are based on remembered emotions ("souvenirs") and sketches from nature. But notice, too, the earlier, artificial, more conventional (academic and sometimes ludicrous) landscapes; also enchanting figure paintings. Much copied and faked – there are said to be more "genuine" Corots in the USA than all the pictures he painted in his lifetime.

Unquestionably at his best with his small plein-air, on-the-spot sketches (called *pochades*). Shows wonderful observation of light and clouds in the sky and empirical exploration of space; note the way he tightens the soft focus with sharp dark accents of paint. **KEY WORKS** *The Forum Seen from the Farnese Gardens*, 1826 (Paris: Musée du Louvre); *Ville d'Aray*, c.1867–70 (New York: Brooklyn Museum of Art) Woman with a Pearl Jean-Baptiste-Camille Corot, c.1842, 70 x 55 cm (27½ x 21½ in), oil on canvas, Paris: Musée du Louvre. Corot has based the woman's pose – hands crossed over one another, head turned towards us – on Leonardo da Vinci's masterpiece the Mona Lisa.

Théodore Rousseau ■ 1812-67 PERENCH

🍽 France 🖉	oils 🛍 Chantilly (France):	
Musée Condé	🔊 \$485,000 in 2004, Soleil	
couchant sur l	es sables du Jean-de-Paris (oil	S)

An important pioneer of plein-air painting and principal figure of the Barbizon School (thereby linking Constable to Monet). He allowed nature to speak for itself, abolishing the convention of inserting human figures in order to animate or interpret the landscape. Trod a difficult and not always successful path between Romanticism and realism.

He was excited by woods and trees, and sought to convey both the spirit (Romanticism) and appearance (realism) of nature growing and vegetating. Distinguish between the small-scale sketches made on the spot and the larger detailed works made in the studio. Dramatic skies, such as one finds on autumn evenings. Some works have darkened with time.

KEY WORKS Sunset in the Auvergne, 1830 (London: National Gallery); Paysage panoramique, 1830–40 (Cambridge: Fitzwilliam Museum); Forest in Boisrémond; Cottage, 1842 (Los Angeles: J. Paul Getty Museum)

Eugène Boudin

● 1824-98 P FRENCH

Northern France
 Ioils; watercolours
 Le Havre: Musée des Beaux-Arts
 \$1,467,000 in 2003, Scène de plage (oils)

Best known for charming small-scale beach scenes of holidaymakers on the Normandy coast (Trouville), dressed up in their crinolines and bonnets on cloudy, breezy days. Had a sketchy style and was an exponent of plein-air spontaneity, a forerunner of the Impressionists (very influential on young Monet). Also painted scenes of Venice, Holland, and France. If you can't sense the breeze, it's probably not a Boudin.

KEY WORKS *Approaching Storm*, 1864 (Art Institute of Chicago); *The Beach at Tourgeville-les-Sablons*, 1893 (London: National Gallery)

Jean-François Millet

€ 1814-75 P FRENCH

Paris; England; Holland
 Dils; engravings
 London: National Gallery. Paris: Musée d'Orsay
 \$3.1m in 1996, The Wool Carder (oils)

The son of a Normandy farmer, who painted the final scenes of a rural world and lifestyle at the moment when it was beginning to disappear because of the industrialization of France.

His small-scale works describe a selfcontained world of humble people working on and with the land. He portrays, depending on your point of view, either the dignity or the cruelty of manual peasant labour. Shows a magical stillness, silence, and peace which is not overloaded with drama or symbolism.

Notice the low viewpoint, so you feel you are standing on the same level as the people you see. Freshly observed light; sense of direct contact with the land, the light, and the atmosphere. Works directly onto the canvas – so you can often see pentimenti (alterations), the way he worked

The Angelus Jean-François Millet, 1857–59, 55.5 x 66 cm (26 x 29 in), oil on canvas, Paris: Musée d'Orsay. This picture was a star exhibit at the Paris World Fair of 1867, and vast numbers of reproductions were sold.

PLEIN AIR PAINTING AND THE BARBIZON SCHOOL C.1840–1870

A group of progressive mid-19th century painters who worked in and around the French village of Barbizon near Paris. surrounded by the forest of Fontainebleau. The leader of the school was Theodore Rousseau, whose great innovation was to allow landscape and nature to speak for themselves without human intervention or presence. The group made landscape as important as portraiture and genre painting, and paved the way for Impressionism. The Barbizon painters promoted the concept of "plein air" painting, meaning paintings that were begun and completed in the open air instead of inside the studio, or studio paintings that consciously set out to capture on canvas the qualities and sensations of being outside in the open air.

the paint, and his carefully considered line. (It is as if his style and working methods were a sort of parallel with the way in which his peasants work the land.) **KEY WORKS** *The Winnower*, 1847–48 (London: National Gallery); *The Sower*, 1850 (Boston: Museum of Fine Arts); *Peasant Girls with Brushwood*, 1852 (St. Petersburg: Hermitage Museum)

Gustave Courbet

● 1819-77 P FRENCH

 ☑ France; Switzerland
 ☑ Oils
 ☑ Paris: Musée d'Orsay. Montpellier: Musée Fabre
 ☑ \$2.7m in
 1998, Portrait de Jo, la belle Irlandaise (oils)

Courbet was the radical scourge of corrupt Second Empire France and the tedious old-fashioned traditions of the French Academy. The major exponent of 19th-century realism.

He chose large-scale subjects (such as life, death, destiny, the ocean, the forest) and often produced physically large paintings. Brilliant, gutsy technique with thick, physical paint. Portrayed toughness and realism – real people carrying out unglamorous, everyday activities. Had an intimate knowledge of all the activities, people, and places he painted and valued down-to-earth, provincial life more highly than fashionable Parisian glamour.

His work can range from the most brilliantly inspired and executed to sloppy, uninspired, and bad painting. Note the "The sea's voice is tremendous, but not loud enough to drown the voice of Fame crying my name to the entire world."

very unusual rich green, especially in his landscapes – it is not artistic licence: in his beloved homeland (Ornans, near Besançon) the copper in the soil turns the vegetation that colour. The area is worth visiting for its stunning beauty, but also to see what it was that inspired him and how real his "realism" is. Note his prominent red signature – what a big ego! **KEY WORKS** *The Painter's Studio*, (see page 301); *The Source of the Loue*, 1864 (Washington DC: National Gallery of Art); *The Cliff at Etretat after the Storm*, 1869 (Paris: Musée d'Orsay); *The Sea*, 1872 (Caen: Musée des Beaux-Arts)

The Bar at the Folies-Bergère Edouard Manet, 1881–82, 97 x 130 cm (38 x 51 in), oil on canvas, London: Courtauld Institute of Art. Upper-class dandies like Manet rubbed shoulders with workers and prostitutes at the Folies-Bergère. The bottles (from beer to champagne) symbolize this interaction.

Edouard Manet

A hugely important, very influential, key figure in late 19th-century Paris. Spurned by official art circles, he was a father figure for the young avant-garde. Took Courbet's realism one step further.

His fascinatingly ambiguous subject matter and style portray modern (sometimes seamy) urban and suburban life and people, or parodies traditional themes dear to the heart of academic

artists. At his best he does both at the same time. He was unique in that he had a brilliant, very visual and sketchy painting technique, involving the use of large areas of flat colour. Has anyone ever used black so lusciously and with such visual impact?

His work is a paradoxical combination of intimacy and aloofness (one of Manet's personal characteristics was wanting to be accepted in official art circles but his whole approach to art and those in authority ensured that he wasn't). Thus many paintings show one or more people in a scene of great intimacy or drama, but someone is often withdrawn or preoccupied and not immediately involved in what is going on.

KEY WORKS Olympia (see pages 308–309); Still Life with Melon and Peaches, c.1866 (Washington DC: National Gallery of Art); The Fifer, 1866 (Paris: Musée d'Orsay); Gare Saint-Lazare, 1873 (Washington DC: National Gallery of Art); Madame Manet on a Blue Sofa, 1874, 1874 (Paris: Musée d'Orsay)

Honoré **Daumier**

•	1808-	79	ρø	FRENCH

po	France	Q print:	s; drawing	gs; oils;	scul	pture
Î	London:	Courtauld	I Institute (of Art	2 \$	2,235,000
in	1993, Le	fardeau -	la blanch	nisseuse	e (oi	IS)

Called the "greatest 19th-century caricaturist", but is much more because he reveals universal truths about the human condition. His subjects are French men and women living in a corrupt, greedy, bourgeois regime (French Second Empire), but the message is timeless.

His compelling images observe the absurdities and obsessions of husbands, wives, lawyers, politicians, artists, actors, etc. Had a prolific output: prints (he was a pioneer of lithography), especially, water-colours, sketches; some oil paintings after 1860 (he was never comfortable with the scale and technique – at his best with a smaller and more spontaneous scale and medium). Never judgemental or unkind, even though his work was censored. Went semi-blind in 1870.

Notice his captivating facial expressions, body language, hands – all speaking volumes. His use of light, shade, and atmosphere is as good as Rembrandt's. Works have a probing, lively line. He produced miraculous, small clay-model caricatures of politicians. Ignored the rich and famous, and was never successful commercially. Makes the everyday sublime and moving.

KEY WORKS The Laundress, c.1860 (Paris: Musée d'Orsay); The Print Collector, c.1860 (Glasgow Museums); Advice to a Young Artist, after 1860 (Washington DC: National Gallery of Art); The Studio, c.1870 (Los Angeles: J. Paul Getty Museum)

The Third-Class Carriage Honoré Daumier, 1864, 20.3 x 29.5 cm (8 x 11% in), watercolour, ink wash, and charcoal on paper, Baltimore: Walters Art Museum. Railways brought the rural poor to Paris seeking employment and a new life.

Olympia

Edouard Manet 1863

Edouard Manet never achieved his ambition: to be officially honoured as the true modern successor of the old masters. Coming from a well-to-do Parisian family, he was born to such a role. Good-

looking, charming, strong, worldly-wise, and very gifted, he was always at ease in society.

This picture was shown at the official Paris Salon of 1865. Manet was nervous about how it would be received, as his famous painting *Déjeuner sur l'Herbe* had already caused a scandal. *Olympia* caused a storm of outraged protest. It was seen not as a modern interpretation of a respected theme, but as a crude parody of a sacred artistic tradition going back to the greatest masters such as Titian and Goya (see pages 143 and 262–263). It was obvious to everyone that the reclining woman was not a goddess, but a prostitute.

The constant criticism and rejection of his work caused Manet to have a nervous breakdown in 1871. He considered *Olympia* to be his finest work, and he never sold it. When he died, it went to auction, but it did not find a buyer. In 1888, Sargent (see page 326) learned that Manet's widow was about to sell the painting to an American collector, and he warned Monet, who organized a public appeal to buy it for the Louvre.

TECHNIQUES

The candid style shows Manet at his best. He uses a bold composition with strong outlines to the forms. There is virtually no shadow or modelling with soft light. There is no fine detail, but the colour harmonies are very subtle. Some critics saw this style as merely incompetent when compared with that of lngres (see page 264), and it was described as being crude.

Manet mostly

used his family and friends to pose as models. Here he has employed a professional model, Victorine Meurent, aged 30. She became a painter herself, but ended life as an alcoholic

Black is one of the mo difficult of pigments for an artist to exploit as it can easily overwhelm ar kill all other colours and qualities. Manet is the great master of black: he was able to use it to bring a rich tonality and elegance to his work. Manet, who dressed wit

great care, habitually wore the black frock coa and silk top hat that was fashionable in his day.

The servant brings in flowers -

a gift from a previous admirer – but Olympia does not acknowledge her presence. She is ready and waiting for her next client: the spectator of the painting.

Manet was a master of still life, which he often painted for his own pleasure. The bouquet symbolically suggests the sweet pleasures offered by Olympia

The image of the reclining nude is one of the most revered in the old master tradition. Manet knew that his audience would understand his reference to Giorgione's *Sleeping Venus* (see page 140) Manet's creation is not the goddess Venus, but a young woman in a recognizable role. Her slipper dangles impatiently on her foot. She is explicitly naked with pearls at her neck and ears, and an orchid in her hair.

Olympia

Medium oil on canvas Dimensions 130 x 190 cm (51 x 75 in) Location Paris: Musée d'Orsay

Claude Monet

⊖ 1840-1926 🕫 FRENCH

France; London; Italy; Norway
 oils Paris: Musée
 d'Orsay; Musée Marmottan.
 Giverny (near Paris) for Monet's house, studio, and garden
 \$29,520,000 in 1998, Bassin aux nymphéas et sentier au bord de l'eau (oils)

The true leader of the

Impressionists – he was constantly exploring "What do I see and how do I record it in painting?"

Monet had a never-ending interest in observing and painting that most elusive quality, light – notably in the "Series" paintings, where he painted the same subject dozens of times, under different light conditions (the Rouen Cathedral, haystacks, scenes in London). Spent 40 years (the second half of his life) creating

The Japanese Bridge at Giverny Claude Monet, 1910–24, 89 x 100 cm (35 x 39/x in), oil on canvas, Paris: Musée Marmottan. In old age Monet's eyesight deteriorated because of cataracts and he depended on instinct and memory to paint his later works. Waterlily Pond Claude Monet, 1899, 88.3 x 93.1 cm (34% x 36% in), oil on canvas, London: National Gallery. One of a series of 18 paintings depicting the Japanese bridge in Monet's water garden.

his garden, at Giverny, from scratch – a subject that he could control in every detail (except the light). He would sit in the middle of it and paint it.

Stand back and enjoy the imagery – familiar and nostalgic for us now, but challenging and modern in its day. Or stand close up to his compositions and enjoy the complexity, texture, and interweaving of paint and colour. Note the thick, crusty paint, which gets thicker as the light gets more interesting - particularly when it catches the edges of objects. KEY WORKS The Petit Bras of the Seine at Argenteuil, 1872 (London: National Gallery); Impression: Sunrise (see page 312); The Haystacks, or The End of Summer, at Giverny, 1891 (Paris: Musée d'Orsay); The Houses of Parliament, London, 1904 (Paris: Musée d'Orsay); Waterlilies, 1908 (London: Christie's Images)

"There is something in painting which cannot be explained, and that something is essential. You come to nature with your theories, and nature knocks them all flat." PIERRE-AUGUSTE RENOIR

Pierre-Auguste Renoir

● 1841-1919 P FRENCH

France; Italy
 öils
 Philadelphia:
 Barnes Collection. Paris: Musée d'Orsay
 \$71m in 1990, *Le Moulin de la Galette* (oils)

Renoir was one of the first Impressionists, but soon developed an individual and un-Impressionist style. Most remembered for his lyrical paintings of pink, buxom young girls. Very prolific.

He is the greatest ever master of dappled light, which pervades all his work, giving it a seductive, sensual, and soft-focus quality. The early works have bite and observation; the late works become rather repetitive at times. Did he never become bored by all that comfortable, pink, female flesh, which

Bather Arranging her Hair

Pierre-Auguste Renoir, 1893, 92 x 74 cm (36 ½ x 29 in), oil on canvas, Washington DC: National Gallery of Art. Renoir was much influenced by Delacroix and Ingres. Socially conservative, he destroyed many works he deemed inadequate.

makes one think of soft feather cushions and Turkish Delight?

See how the sensuality of his technique marries with the subject matter: long, free brushstrokes of warm colour, which caress the canvas. Note the blushes on the cheeks and the obsession with small, firm breasts. The early works have cooler colours, more black, and less mush.

KEY WORKS The Gust of Wind, c.1872 (Cambridge: Fitzwilliam Museum); The Parisienne, 1874 (Cardiff: National Museum of Wales); The Boating Party (see

page 313); Girl Combing her Hair, 1907–08 (Paris: Musée d'Orsay)

Gustave Caillebotte

France
 Oils
 Paris: Musée d'Orsay
 \$13m in 2000, L'homme au balcon, boulevard
 Haussmann (oils)

He was a second-rate painter who knew what talent was (one of the first collectors of great Impressionist paintings), and who occasionally showed some in his own work.

Typical Impressionist subject matter and technique (very similar to Monet and Manet). Scenes of everyday contemporary Paris, especially street scenes with exaggerated, plunging perspectives. Interesting work but essentially derivative, and hampered by being too anecdotal – it could often be one of those illustrations for a 19th-century novel that visualize a specific phrase or sentence in the text.

Recognizable pink-green-blue-purple palette – often too strident and overdoes the purple. Cropped compositions influenced by photography.

KEY WORKS Rue de Paris, Wet Weather, 1877 (Art Institute of Chicago); View of Rooftops (Snow), 1878 (Paris: Musée d'Orsay); At the Café, Rouen, 1880 (Rouen: Musée des Beaux-Arts)

IMPRESSIONISM

Impressionism marked the birth of modern painting. It was never consciously revolutionary, its aim simply to depict the immediacy of the world with complete fidelity. Yet in seeing this as accidental, the product of transitory lighting conditions and chance moments, it prompted a strikingly different pictorial language that began the overthrow of the naturalistic tradition the Renaissance established.

STYLE

Impression: Sunrise Claude Monet, 1872, 48 x 63 cm (19 x 24¾ in), oil on canvas, Paris: Musée Marmottan. By painting rapidly, Monet aimed to capture fleeting moments. Impermanence of light and atmosphere are his real focus.

Delicate, mosaic-like brushstrokes in light, brilliant colours intended to capture an instant briefly glimpsed define Impressionism. The artists aimed at more than just spontaneity. By replacing tonal gradations - the gradual lightening or darkening of a colour to suggest shadows and depth with tiny dabs of pure colour, the Impressionists pointed the way to a new way of seeing. Yet although almost every major avant-garde French painter of the period was influenced by Impressionism, only Pissarro, Sisley, and Monet, the giant of the movement, remained consistently true to its goals.

SUBJECTS

The here and now dominated. Whether picnics, boating parties, still lifes, railway stations, city views, or sun-flooded landscapes vibrantly alive with colour, the emphasis was on the world immediately surrounding the painter.

KEY EVENTS

1869	Monet and Renoir establish key Impressionism characteristics, painting at Bougival on the Seine
1870	Monet and Pissarro in London, escaping Franco-Prussian war; joined by Sisley (1871)
1874	Critic derisively coins name "Impressionism" at first exhibition
1881	Renoir increasingly abandons Impressionism after visiting Rome
1886	Last Impressionist exhibition held
1890	Monet begins epic cycles, repainting same subjects in different conditions

The modern world became paramount. As important, the studio was abandoned for painting on the spot directly onto the canvas. Plein air (literally, "open

air") painting (see page 305) not only demanded an immediacy on the part of the painter – the speed of work necessary was a key reason for the fragmented, shimmering visual language of Impressionism – it naturally placed a premium on landscapes and outdoor scenes. It was a decisive rejection of the Academy's ponderous "official" history-painting.

> Little Dancer, Aged 14 Edgar Degas, 1880–81, height 97.8 cm (38½ in), polychrome bronze with muslin, satin ribbon and wood base, Private Collection. Impressionism exulted in the everyday. Degas excelled in exquisite, apparently random slices of life.

1860s-1880s

WHAT TO LOOK FOR

Impressionism was near universally derided as 'unfinished'. Critics complained that its subjects were trivial and its execution crude, an apparently deliberate flaunting of the accepted canons of Academic painting. Renoir's *Boating Party* encapsulates Impressionism's unshackled *joie de vivre*. It unapologetically celebrates

M. Fournaise (in the straw hat) was the proprietor of the restaurant

Baron Raoul Barbier, a close friend of Renoir's, is chatting to the proprietor's daughter

the pleasures of youth and summer. Yet his most enduring achievement was to combine the visual imperatives of Impressionism, above all in his quivering, feathery brushwork, with the traditions of European figure painting. However, his seeming spontaneity was the product of painstaking labour.

> Paul Lhote, wearing pince-nez glasses, flirts with the actress Jeanne Samary. He had a reputation as a ladies' man

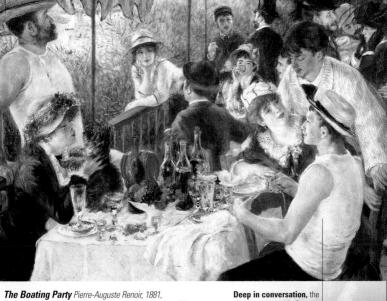

The Boating Party Pierre-Auguste Renoir, 1881, 129.5 x 173 cm (51 x 68 in), oil on canvas, Washington DC: Phillips Collection. Renoir artfully used Impressionistic techniques to create complex groups of rhythmically composed figures.

TECHNIQUES

Typically, Impressionists used canvases with white backgrounds. The result was an unprecedented luminosity that shone through their work, heightening colours, reinforcing deft brushwork.

Deep in conversation, the man in the straw hat is Gustave Caillebotte, a talented artist (see page 311)

Renoir was an accomplished still-life painter, and the debris of this meal is a sparking achievement. The spontaneity is deceptive, since he constantly reworked the painting.

Berthe Morisot

 Paris
 Image: Oils; watercolours
 Image: Oils; Musée

 Marmottan; Musée d'Orsay
 Image: Oils; Musée d'Orsay
 Image: Oils; Musée d'Orsay

 Cache-cache (oils)
 Image: Oils; Musée d'Orsay
 Image: Oils; Musée d'Orsay

She was a member of the Impressionists and effective hostess and go-between to the writers, poets, and painters in their circle. Attractive, free, delicate style derived from Manet (she married his brother, Eugène). Her works are, in effect, an autobiographical diary. **KEY WORKS** *The Harbour at Lorient*, 1869 (Washington DC: National Gallery of Art); *Portrait of the Artist's Mother and Sister*, 1869–70 (London: National Gallery)

Camille Pissarro

⊖ 1830-1903 PU FRENCH

 Image: France; England
 Image: Oils; watercolours;

 drawings
 Image: Paris: Musée d'Orsay. Oxford:

 Ashmolean Museum
 Image: Same and Same and

He was a reclusive, curmudgeonly, and unsettled artist who nonetheless takes his place as one of the major Impressionists and Post-Impressionists. Always an anarchist and always poor.

Pissarro chose a wide range of subjects: landscapes (Seine valley), modern cityscapes (Paris, Rouen – note the factory chimneys), still lifes, portraits, peasant scenes (especially laundresses). Was most confident in later work, but never really settled into a style with which he was completely at ease or that was completely his own. He progressed from dark, early

landscapes to Impressionism and to experiments with Divisionism, then back to Impressionism.

He often chose high viewpoints (such as cityscapes painted from windows). His developed palette is quite chalky and pale, with predominant greens and blues. Surfaces are thickly painted

The Bridge at Moret Alfred Sisley, 1893, 73.5 x 92.5 cm (29 x 38% in), oil on canvas, Paris: Musée d'Orsay. Sisley had to earn a living as a painter when the family business collapsed in 1870. (sometimes patchily) with a sketchy look, as if they could be worked further if he could decide what to do with them (a sign of his uncertainty?). Note the play of contrasts in content: rural against industrial; transient against permanent; natural against artificial; old against new; warm against cool.

KEY WORKS View from Loweciennes, 1869–70 (London: National Gallery); Autumn, 1870 (Los Angeles: J. Paul Getty Museum); The Climbing Path, L'Hermitage Pontoise, 1875 (New York: Brooklyn Museum of Art)

Alfred Sisley

Institute of Art; Tate Collection 23.2m in 2000, Un jardin à Louveciennes, chemin de l'Etarche (oils)

"The forgotten Impressionist" – the most underrated of the group, then and now.

Look for places, structures, and connections. Like Constable, Sisley only painted places he knew well and he particularly responded to the Seine and Thames valleys. He also liked wellstructured compositions (notice the verticals, horizontals, diagonals). Cleverly used structural details like roads and bridges to take the eye through the landscape and link all the parts together.

Note the interesting colour combinations (especially pinks and greens, blues and purples) to produce the sensation of light. **KEY WORKS** *Women Going to the Woods*, 1866 (Tokyo: Bridgestone Museum of Art); *Floods at Port Marly*, 1876 (Paris: Musée d'Orsay); *The Walk*, 1890 (Nice: Musée d'Art et d'Histoire)

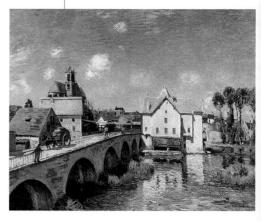

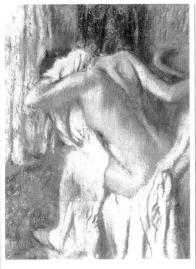

Edgar **Degas**

€ 1834-1917 PU FRENCH

 France; Italy
 oils; pastels; prints; sculpture
 Paris: Musée d'Orsay. New York:
 Metropolitan Museum of Art
 \$25.28m
 in 1999, Danseuse au repos (pastels)

Degas was one of the greatest draughtsmen of all time. Successfully bridged the gap between the old master tradition and modernity. Shy, haughty, conservative, and single.

Each picture shows a selfcontained and self-absorbed world, whatever the topic. Even when the subjects of his portraits make eye contact, they give nothing away. Ballet and racing scenes are a means of exploring complex space and movement. His technique, his extraordinary capacity for drawing, and attention to detail are equally self-absorbed – one of those rare, perfect unions between subject matter and means of expression.

Degas was fascinated by meticulous but innovative craftsmanship, and

The Star, or Dancer on the Stage Edgar Degas, c.1876–77, 60 x 44 cm (23½ x 17½ in), pastel on paper, Paris: Musée d'Orsay. His technique shows the same qualities of precision and balance as classical ballet. **Woman Drying Herself** Edgar Degas, c. 1888–92, 103.8 x 98.4 cm (49 x 38% in), pastel, London: National Gallery. Degas increasingly worked with soft waxy pastels as his eyesight deteriorated, depending on touch and feel.

experimented in many media: pastel, prints, and sculpture. Also was interested in photography – he borrowed and used the cut-off effect brilliantly. Worked and reworked the same subject or theme to achieve ever greater understanding and perfection. Notice how often he used the receding diagonal as the main armature for his compositions. Had astonishing colour sensitivity, even when he was old and nearly blind.

"Anyone can have a talent at 25. The difficulty is to have talent at 50!"

KEY WORKS Madame René de Gas, 1872–73 (Washington DC: National Gallery of Art); *The Millinery Shop*, 1884–90 (Art Institute of Chicago); *The Tub*, 1886 (Paris: Musée d'Orsay)

ROMANTIC AND ACADEMIC ART

Childe Hassam

 ● 1859–1935
 ■ AMERICAN

 Ш USA; Paris
 [] oils; prints
 [] New York:

 Metropolitan Museum of Art
 [2] \$7.2m in

1998, Flags, Afternoon on the Avenue (oils)

America's foremost Impressionist artist, Hassam painted more than 4,000 works (oil and watercolours). Best remembered for his late (post-1917) "flag paintings", where brightly coloured, richly painted flags at wartime parades act as an exciting visual motif and symbol of patriotism. In his earlier work the emphasis was on *contre-jour*.

Next to the French, the Americans were the best and largest group of Impressionists, but they were late in the day by 20 years – post-1890s, as they did not often visit Paris until the 1880s. Before that, they had tended to learn their art in Germany. **KEY WORKS** *Grand Prix Day*, 1887 (Boston: Museum of Fine Arts); *Evening in New York*,

c.1890 (Boston: Museum of Fine Arts); Manhattan's Misty Sunset, 1911 (Youngstown, Ohio: Butler Institute of American Art); Allies Day, May 1917 (Washington DC: National Gallery of Art); Avenue of the Allies, Great Britain, 1918 (New York: Metropolitan Museum of Art)

Mary Cassatt

€ 1844-1926 P AMERICAN

Paris D oils; prints New York: Metropolitan Museum of Art 2 \$3.7m in 1996, *In the Box* (oils)

The daughter of a wealthy Pittsburgh family, Cassatt settled in Paris. She mixed with avant-garde and helped American collectors spend their loot (very Henry James). A friend of Degas, she also helped the Impressionists. Produced attractive works with strong sense of design. courageous colour, and cropped angled viewpoints that capture personal, meaningful moments of the well-to-do. Spottable influences from Degas, Japanese prints, and Ingres. KEY WORKS Musical Party, 1874 (Paris: Musée du Petit Palais); Mother about to Wash her Sleepy Child, 1880 (Los Angeles County Museum of Art); Girl Arranging her Hair, 1886 (Washington DC: National Gallery of Art); The Bath, 1891 (Art Institute of Chicago)

William Merritt Chase

● 1849-1916 P AMERICAN

 Image: Munich; New York
 Image: Mouseum of Fine Arts
 Image: Mouseum of Sine Arts
 <t

Chase was a prolific and versatile artist from a prosperous Indiana background. Successful, gregarious, witty, flashy dresser, cultivated in the European manner (friend of Whistler). Developed two distinct styles, both direct and spontaneous: his early works are dark, heavy, elegant portraits (style learned in Munich); after 1890s they become light-filled French-Impressionist-style scenes of Long Island (Shinnecock).

Portrait of a Lady in Black William Merritt Chase, c. 1895, 182.9 x 91.4 cm (72 x 36 in), oil on canvas, Detroit Institute of Arts. Chase is best known for his spirited portraits and still lifes in oil.

At the Piano Theodore Robinson, 1887, 41.8 x 64.2 cm (16% x 251/4 in), oil on carvas, Washington DC: Smithsonian Institute. Known only as Marie, the true identity of Robinson's mysterious model remains unknown, despite her appearance in numerous works.

KEY WORKS At the Seaside, c.1892 (New York: Metropolitan Museum of Art); Portrait of Moses Swaim, 1867 (Indianapolis: Museum of Art); The Brass Bowl, 1899 (Indianapolis: Museum of Art)

Julian Alden Weir

● 1852-1919 P AMERICAN

Paris; USA (oils; watercolours; drawings
 New York: Metropolitan Museum of Art
 \$400,000 in 1987, Nassau, Bahamas (oils)

Weir was the most academically successful American Impressionist. He studied in Paris. Was conservative in technique and temperament. His early work was much influenced by Manet; later work is closer to Monet. Was most successful in his smaller works, particularly in watercolour and silverpoint. Became president of the National Academy of Design.

KEY WORKS Union Square, c. 1879 (New York: Brooklyn Museum of Art); Willimantic Thread Factory, 1893 (New York: Brooklyn Museum of Art); The Red Bridge, 1895 (New York: Metropolitan Museum of Art)

Theodore Robinson

→ 1852-96
 P AMERICAN

■ USA; France Ø oils New York: Metropolitan Museum of Art 2 \$1.9m in 1994, *Boats at a Landing* (oils)

Robinson was the leading American Impressionist painter. He made several visits to France between 1876 and 1892, and was a close friend of Monet, whom he had met at Giverny in 1887. Painted landscapes and vignettes of village and farm life. He found East Coast American light too bright compared with the light in France, and had difficulty painting it. He died relatively young, his later years marred by ill health and poverty.

In the USA he was a pioneer, but his Impressionist style is cautious by French standards – compositions are rather static, and the brushstrokes too carefully considered. He sometimes worked from photographs, which he used by squaring up – traces of the grid can occasionally be seen on the canvas.

KEY WORKS Self-Portrait, c.1884-87 (Washington DC: National Gallery of Art); Watching the Cows, 1892 (Youngstown, Ohio: Butler Institute of American Art); Miss Motes and her Dog Shep, 1893 (London: Christie's Images); Low Tide, Riverside Yacht Club, 1894 (Washington DC: National Gallery of Art)

Auguste Rodin

⊖ 1840-1917 № FRENCH

I France; Italy Sculpture France; Italy Sculpture Paris: Musée Rodin. San Francisco: Palace of the Legion of Honor \$4.4m in 1999, Eve (sculpture)

The glorious triumphant finale to the sculptural tradition that starts with Donatello. Rightly spoken of in the same breath as Michelangelo (although they were quite different: Michelangelo carved, Rodin moulded). Shy, workaholic, impoverished beginnings, untidy, friend of poets, physically enormous. Became an international celebrity and was deeply attractive to smart women.

He carried out an extraordinary and enriching hide-and-seek exploration with the processes of his art, and the relationship between intellectual and artistic creativity. His famous set-piece projects (such as *The Gates of Hell*) evolved over many years. Also sculpted portraits, nudes, and small models, which show ideas in evolution. Observe the ways he uses the fluidity of clay and plaster (even when cast in bronze), to release his figures, human feelings, and the unknown forces in nature. Was fascinated with biological procreativity. Note his stunningly beautiful recreation of (large) hands, embraces, kisses, and whole body poses as an expression of human libido and anima (he always worked from life, even when borrowing from antiquity or classics). Bases are important because he makes his figures grow out of them. Washes his figures in light (try and see them in natural light). He used studio assistants or commercial firms to make large-scale versions of his original models – what you see may never have been touched by Rodin (he wanted to disseminate his work widely).

Married his lifetime companion Rose Beuret in 1917 in Meudon, Paris, at the age of 77. Rose died two weeks later and Rodin nine months after. A cast of *The Thinker* overlooks his grave in Meudon. **KEY WORKS** *The Thinker*, 1880–81 (Private Collection); *The Gates of Hell*, 1880–1917 (Paris: Musée d'Orsay); *Andromeda*, c.1885 (Private Collection); *Sinner*, c.1885 (St. Petersburg: Hermitage Museum)

The Burghers of Calais Auguste Rodin, 1884–89, height 201.7 cm (79% in), bronze, Washington DC: Hirshhorm Museum. One of a number of casts of Rodin's original plaster model. It was commissioned by the city of Calais to commemorate six 14th-century civic heroes.

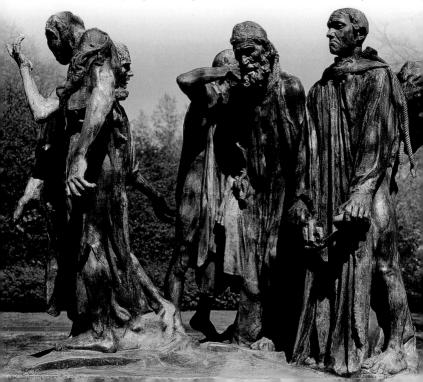

The Kiss

Auguste Rodin 1901-04

One of the most powerful sculptures ever created, its influence reached far into the 20th century. It is a perfect example of Rodin's ability to express intense emotion through the physicality of sculpture and is one of the great images of sexual love.

Originally part of Rodin's huge The Gates of Hell, the sculpture depicts the illicit lovers, Francesca da Rimini and Paolo Malatesta, whose story is told in poet Dante Alighieri's masterwork The Divine Comedy (1321). Francesca was stabbed to death by husband Giovanni as she exchanged her first kiss with his brother Paolo after falling madly in love with him. The statue eventually became an independent work because the blend of eroticism and pure happiness didn't fit The Gates's damnation theme.

Rodin's profound

knowledge of anatomy allowed him to incorporate subtle exaggerations and distortions in order to achieve his aim of rendering inner feeling through muscular movement

The Kiss exists in three different marble versions, none of which were carved by Rodin, accounting for the smooth, anonymous surface. This version was commissioned by a wealthy Bostonian collector living in England

The Kiss

Medium marble Height 182 cm (71 in) Location Paris: Musée Rodin. London: Tate Collection (copy)

The figures appear to emerge preformed from the stone. Rodin believed man and woman were one entity united through erotic love

The man leans

down, but depending on where you stand, either lover can look like the instigator

320

DIVISIONISM

1880s

Divisionism is the name for a way of painting, in which colour effects are obtained optically rather than by mixing colours on the palette: i.e. small areas of pure colour are put side-by-side on the canvas so that at a distance the eye cannot differentiate between them but mixes them together and so experiences another colour (optical mixing). More convincing as a theory than in practice. Seurat was its originator, but he died young, and so Signac became its chief promulgator. Pointillism is Divisionism as practised by Seurat, using small dots of colour.

Georges Seurat

 ● 1859-91
 № FRENCH

 II France
 I oils; drawings
 I New York:

 Metropolitan Museum of Art. Art Institute
 of Chicago
 I \$32m in 1999, A Sunday

 Afternoon on the Island of La Grande Jatte (oils)
 I \$12m in 1999, A Sunday

Seurat, a shy, reclusive man who died suddenly from meningitis aged 31, having produced very great work. The originator of Pointillism and Divisionism.

His subjects are modern life and places. His work can seem austere and rigid because he painted according to workedout theories, not what he saw or felt. He applied the latest ideas of colour and optical mixing – painting separate dots of pure colour on the canvas (Pointillism), which mix and vibrate in the eye and are intended to give the same sensation as light itself. Used a formula of lines to express emotion: upward diagonal = happiness; downward diagonal = sadness; horizontal = calmness. Colour theories don't work in practice because pigments lose their brightness and the mixing in the eye tends to end up as a grey mush. Why did he ignore the significance of vertical lines? He made wonderful drawings using soft black crayon on textured paper, and tiny, free, preliminary sketches for his big works. Used colour borders that complement the areas of colour in the picture. There is hidden symbolism and references to old masters in the set-piece figure paintings. KEY WORKS Model from the Back, 1887 (Paris: Musée d'Orsay); Port of Gravelines Channel, 1890 (Indianapolis: Herron Art Institute); The Circus, 1891 (Paris: Musée d'Orsav)

Paul Signac

Frenchman Signac was a patient follower and disciple of Seurat. Through his work and writings he was the chief promulgator of the theory and practice of Divisionism. He moved from observed outdoor scenes to studio-based subjects, and from small dots to larger brushstrokes. Good pleinair watercolours. His own work was overly theoretical and tidy, but despite this he influenced others (Matisse, for instance). He was a dogmatic man.

A keen yachtman, Signac spent a lot of time on the Mediterranean and Atlantic coasts; harbour scenes became his favourite subjects.

KEY WORKS *Gas Tanks at Clichy*, 1886 (Melbourne: National Gallery of Victoria); *Lighthouse*

at Groix, 1925 (New York: Metropolitan Museum of Art); Port of Concarneau, 1925 (Tokyo: Bridgestone Museum of Art)

A Sunday Afternoon on the Island of La Grande Jatte Georges Seurat,

1844–86, 207.5 x 308 cm (81½ x 121½ in), oil on canvas, Art Institute of Chicago. Seurat laboured extensively over this piece, reworking the original as well as numerous preliminary drawings and oil sketches.

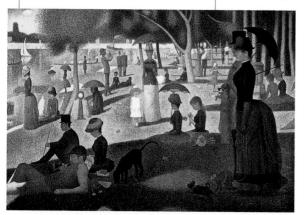

England; France
 London: Tate Collection. Glasgow:
 Hunterian Museum
 \$2.6m in 2000,
 Harmony in Grey, Chelsea in Ice (oils)

A small, egocentric, quarrelsome, witty, and dandy artist who was born in the USA, and later lived in Europe (France and England). Leading figure of the Aesthetic movement, he developed a new style of painting and role for the artist. Was a contemporary of Oscar Wilde.

Look for painting as an aesthetic object and experience – the subject matter taking second place to the visual pleasure of colour and form. Note the subtle harmonics of soft colour, carefully placed shapes, and suppression of detail. He chose simple subjects, expressive of mood. His portraits say little about the sitter's personality. Why was he so tentative? Was he never at ease with painting? Arguably his best works are his prints, in which he never lacked self-confidence.

The thin paint surface belies the fact that he worked and reworked his pictures, wiping away his efforts until he had reached his notion of perfection (which Mother and Child on a Couch James Abbott McNeill Whistler, c. 1870s, watercolour, London: Victoria & Albert Museum. Whistler wished his art to appear to be effortiess. The hidden reality was very different.

must have been agonizing for his portrait sitters). Some works are still in their original frames, designed by Whistler to harmonize with the painting. Look for his famous "butterfly" signature, which he used after 1870. Much influenced by Japanese art, Velasquez, and Manet (he had to be up to date and in the forefront of fashion), he became interested in Oriental art and decoration in general. Played a major role in introducing modern ideas to British art. KEY WORKS The White Girl, 1862 (London: Tate Collection); Nocturne: Blue and Gold, 1872-77 (London: Tate Collection); Arrangement in Grey and Black: Portrait of the Painter's Mother, 1871 (Paris: Musée d'Orsay); Nocturne in Black and Gold: The Falling Rocket (see page 323); Upright Venice, 1879-80 (Private Collection)

"If the man who paints [only what] he sees before him were an artist, the king of artists would be the photographer." JAMES ABBOTT MCNEILL WHISTLER

SYMBOLISM AND AESTHETICISM

From the mid-19th century, a literary cult developed in France that explored the mystical, the spiritual, and the morbid. It found an outlet in the visual arts in Symbolism, "the ambiguous world of the indeterminate", in the words of the painter Odilon Redon.

Across the Channel in England, it was echoed by Aestheticism.

SYMBOLISM

Prompted by the poet Théophile Gautier, who had argued for the rejection of conventional morality and the primacy of "pure sensation", a series of poets and painters in France increasingly elaborated a world in which imagination was allowed free rein. For Gustave Moreau, as to some extent for the more Classically minded Puvis de Chavannes, it was a means of infusing Academic figure painting with an allusive and richly imaginative new pictorial language. Odilon Redon, whose later painting was based directly on his dreams, went further still. Semi-human figures inhabit fantastic landscapes made more mysterious by brushwork that eventually approached the abstract.

ART FOR ART'S SAKE

The idea that art could be an end in itself with no higher purpose – whether moral, spiritual, or political – than the pursuit of pure "artistic sensation" reached a peak towards the end of the 19th century. In England, it was exemplified by the Aesthetic movement. Oscar Wilde was its best-known literary

The Cyclops Odilon Redon, c. 1914 (oil on canvas), Otterlo, Netherlands: Kröller-Müller Museum. Redon's highly personal vision later made him a hero of the Surrealists.

exponent, the American-born Whistler its chief (and most notorious) champion in the visual arts, going so far as a court appearance to defend the integrity of the movement. This was "a crusade on behalf of beauty", a "poetic passion", which utterly rejected utilitarianism in favour of the exquisite.

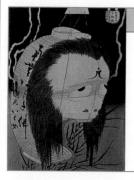

JAPANESE ART

The impact of Japanese prints on the transformation of the visual arts in Europe in the second half of the 19th century was crucial. Their use of everyday subjects, unusual viewpoints, tilted perspectives, bold, flat colours, and strong outlines amounted to a pictorial language entirely different to anything then known in the West.

Japanese Ghost Katsushika Hokusai, 1830s, woodblock, London: Victoria & Albert Museum. From series of One Hundred Stories, this features a man turned into a snake on his death, a theme that resonated with the Symbolists' obsession with spiritual transformation.

WHAT TO LOOK FOR

That colour and form, irrespective of their subject matter, could be expressive in themselves had been a commonplace since the days of Delacroix. But Whistler went much further. His nominal subject matter is dissolved until it becomes nothing but a complex interplay of colour and form infinitely delicately rendered. The result is a beguiling, haunting surface pattern.

The painting captures the drama and beauty of the fleeting instant in which a rocket explodes, scattering a shower of sparks into the night

Whistler was deeply influenced by Japanese prints, in particular their non-naturalistic handling of space and concentration on expressive surface patterns

Like the Impressionists, Whistler continually sought ways to represent immediacy and the infinitely changeable nature of light

Rapid brushwork, however painstakingly arrived at, conveys a sense of an instant captured, of the transient made permanent

TECHNIQUES

Rather than build up thick layers of paint, Whistler would wipe away his mistakes to leave only a thin film of transparent paint. The loose, light brushwork and subtle colour harmonies were influenced by Velasquez.

Whistler's unusual

signature has similarities with the collector's seals found on Chinese art. He was an enthusiastic and early collector of Oriental blue and white porcelain.

Gustave Moreau

● 1826-98
 № FRENCH
 № France
 ۩ oils; watercolours; drawings
 Paris: Musée Gustave Moreau
 № \$2.5m
 in 1989, Le poète et la sirène (oils)

An intense, talented, prolific, workaholic, and successful artist, determined to revive the tradition of history painting (actually in terminal decline) and to be a rival of the greatest old masters.

He was noted for erudite, imaginative, literary, and mythological subjects. His idiosyncratic style is halfway between the strange, fantasy world of Bosch and the surreal dream world of Max Ernst. His work is sometimes dark and mysterious, sometimes bright and shimmering, but always sinister, oozing romantic decadence and symbolism. Used deeply worked surfaces and textures with inventive impasto, glazes, and colours that unlocked his imagination.

He produced a huge quantity of sketches and watercolours; these preceded his finished oil paintings, either as experiments or to work out their final design and details. His late watercolours (and some unfinished oils) are as free and sketchy as modern abstraction. He was active at the same period as the Impressionists, who were everything he was not. A gifted teacher, he influenced many who seem impossibly far removed from his style (such as Matisse). Moreau was much influenced by a tour of Italy (1857–59).

KEY WORKS Diomedes Devoured by Horses, 1851 (Los Angeles: J. Paul Getty Museum); Orpheus, 1865 (Paris: Musée d'Orsay); Salome, 1876 (Paris: Musée Gustave Moreau); Hesiod and the Muse, 1891 (Paris: Musée d'Orsay)

Pierre Puvis de Chavannes

⊖ 1824-98 P FRENCH

 France i oils Paris: Hôtel de Ville (murals); Sorbonne University; Panthéon;
 Musée d'Orsay. Boston: Public Library (murals)
 \$850,000 in 1998, L'enfance de Sainte Geneviève (oils)

Puvis de Chavannes was internationally sought after in his day as the leading painter of large-scale murals to decorate public buildings. Worked on canvas, then affixed to walls. His smaller works were also admired by avant-garde painters such as Seurat, Gauguin, and Munch.

His statuesque figures in landscapes are the direct descendants of the great Classical tradition. He had a very recognizable dry technique, using a chalky white colouring with a stiff style that made his work look like a fresco. His was a valiant but ultimately unsuccessful attempt to make the Classical and Academic tradition relevant to the modern world. Tried to touch big emotions such as hope and despair, but missed the target; his work now looks at best decorative, at worst, lifeless.

His archaic, flat style searches for a "modern" simplification of form and colour, and a timeless monumentality for the figure, detached from literary connections; it was only in the next generation (Matisse) that this would be fully unlocked. To do his work full justice, it needs to be seen in situ in the elaborate Beaux-Arts Renaissance-revival buildings that he decorated (and which were themselves to be overtaken by the simplified architecture of Modernism). KEY WORKS The Beheading of St. John the Baptist, c.1869 (London: National Gallery); The Prodigal Son, c.1879 (Washington DC: National Gallery of Art); Young Girls by the Edge of the Sea, 1879 (Paris: Musée d'Orsay); The Poor Fisherman, 1881 (Paris: Musée d'Orsay); Woman on the Beach, 1887 (St. Petersburg: Hermitage Museum)

Odilon Redon

⊖ 1840-1916 P FRENCH

 France in oils; pastels; prints; drawings
 Washington DC: National Gallery of Art
 \$3.4m in 2004, Vase au guerrier japonais (works on paper)

Redon became one of the principal *fin de siècle* Symbolist artists, and was a Surrealist before his time.

His *oeuvre* divides in two: pre- and post-1894. His early small-scale black-andwhite drawings and prints had neurotic, introspective subject matter (he had a classic Freudian, unhappy childhood). After 1894 he overcame his neuroses and his art blossomed into radiant colour and joyful subject matter. His inspiration came from the inner mind, not the outer eye. Today, he is better known for his later work. His poetic, contemplative works have no specific meaning. His fascinating early subject matter anticipated Surrealism floating heads, curious creatures, strange juxtapositions, all drawn from the depths of the imagination (and from Symbolist writers such as Poe and Baudelaire). Observe his very fine drawing and print techniques, with beautiful tonal treatments. Later, he developed an exquisite pastel technique and the ability to produce saturated, unreal colours of astonishing richness and intensity. KEY WORKS The Trees, 1890s (Houston: Museum of Fine Arts); Ophelia Among the Flowers, c.1905-08 (London: National Gallery); The Shell, 1912 (Paris: Musée d'Orsay); Anemones and Lilacs in a Blue Vase, 1914 (Paris: Petit Palais)

Maurice Denis

⊖ 1870-1943 P FRENCH

 France; Switzerland I oils; fresco
 St. Petersburg: Heritage Museum
 \$467,087 in 2000, Les communiantes, la promenade au jardin (oils)

He was a leading Symbolist who led reaction against Impressionism. Driven by theory. Founder member of Nabis.

No realistic representation, insignificant subject matter; small-scale easel painting is king. The result is paintings with deliberately flat, decorative, stylized or Art Nouveau appearance; strange colours; trivial, everyday subjects. As effective (more so?) with his stage and costume design and book illustrations. A committed Catholic who applied his art to the service of church decoration. **KEY WORKS** *The Two Sisters*, 1891 (Amsterdam: Van Gogh Museum); *Gaulish Goddess of Herds and Flocks*, 1906 (Munich: Neue Pinakothek); *Orpheus and Eurydice*, 1910 (Minnesota: Minneapolis Institute of Arts)

Arnold Böcklin

→ 1827 – 1901 P
 Ø GERMAN

Switzerland; Germany; Italy is oils
 Basel (Switzerland): Kunstmuseum
 \$168,300 in 1993, Kentaurenkampf (oils)

Leading German Symbolist painter. Swiss-born, Düsseldorf-trained but most influenced by Italian art (especially Raphael). Meticulous craftsman of Classical, mythological figures in intense moody landscapes that are intended to trigger dream-like reveries. Very much the languid *fin de siècle* fashion, but now seems cloying and artificial. **KEY WORKS** *Pan in the Reeds*, 1857 (Munich:

Neue Pinakothek); Self-Portrait with Death as a Fiddler, c.1871–74 (Berlin: Staatliche Museum); The Isle of the Dead, 1883 (Berlin: Staatliche Museum)

Aubrey Beardsley

⊖ 1872-98 P BRITISH

■ England ■ drawings; prints ■ \$135,000 in 2004, Design for the front cover of *The Savoy*, No. 4 (works on paper)

A self-taught, tubercular, workaholic, master of the sinuous, sensual, erotic (sometimes pornographic), black-andwhite drawing and print. Brilliant but controversial. Art Nouveau illustrator. Highly original and gifted, capturing the essence of *fin de siècle* decadence. Had a boring private life – his eroticism was all in his mind. Died of tuberculosis at the age of only 25.

KEY WORKS Salome, 1892 (New Jersey: Princeton University Library); How King Arthur Saw the Questing Beast, 1893 (London: Victoria & Albert Museum); A Nightpiece, 1894 (Cambridge: Fitzwilliam Museum)

Thomas Wilmer Dewing

⊖ 1851–1938 P AMERICAN

USA 🚺 oils 💼 Washington DC: Sackler and Freer Galleries 😰 \$3.1 million in 2002, *Song* (oils)

A painter of accomplished works depicting elegant, stately, distant women in tastefully furnished interiors or wandering in lush, dreamy landscapes. They are often large in scale and were turned into Japanesestyle screens. Also produced studies for the above, pastels and silverpoints. Good example of Aestheticism – a pot-pourri of Pre-Raphaelites, Whistler, and Japan. Note the frames.

KEY WORKS The Letter, 1895–1900 (New York: Metropolitan Museum of Art); Lady with a Lute, 1886 (Washington DC: National Gallery of Art); The Gossip, c.1907 (Minnesota: Minneapolis Institute of Arts)

Walter Richard Sickert

⊖ 1860–1942 🕫 BRITISH

England; France; Italy
 in oils; prints
 London: Tate Collection
 \$286,000
 \$286,000
 in 1993, *Brighton Pierrots* (oils)

The leading British painter of the Impressionist and Post-Impressionist period, Sickert had personal links with French artists such as Degas. Style perhaps best described as a French idiom spoken with a very strong English accent.

He chose down-to-earth subjects – street scenes, cheap interiors, music halls, and prostitutes, and painted them in an earthy manner, without glamour, with a disregard for fashion, in a palette of muddy colours, and thick, heavily worked paint. He was fond of and used the sense of intimacy and unobtrusive observation that is one of the qualities of photography. The imagery for many late works was taken directly from newspaper photographs – a mistake, as it destroyed any sense of intimacy.

High-quality craftsman – his pictures are very carefully composed, sometimes with striking or unusual viewpoints, behind which lay much work and preliminary drawing. Note the careful and diligent application of paint in his work; his unusual colour combinations and interesting light effects. In his late work, look for the lines of the underlying grid he used for squaring up (enlarging) the photographs. Also made good etchings. **KEY WORKS** Interior of St. Mark's, Venice, 1896 (London: Tate Collection); La Hollandaise, 1906 (London: Tate Collection); Jack the Ripper's Bedroom, c.1906 (Manchester: City Art Gallery)

John Singer Sargent

€ 1856-1925 PU AMERICAN

France; England; USA i oils; drawings
 Washington DC: National Gallery of Art
 \$21m in 2004, Group with Parasols (oils)

Sargent was the last seriously successful portrait painter in the grand manner. Born in Florence, he lived mostly in

The Daughters of Edward Darley Boit John Singer Sargent, 1882, 221 x 221 cm (87 x 87 in), oil on canvas, Boston: Museum of Fine Arts. The painting was enthusiastically reviewed by Henry James in 1883.

Europe. He was very talented, successful, and rich. He captured the spirit of the golden age that perished in World War I.

In the 1880s and 1890s he succeeded with large-scale portraits of the *nouveaux riches* of the UK, USA, and France, showing them at their glittering best, in flattering and relaxed poses. After 1900, he painted the English aristocracy but made them more formal and aloof. Grew bored with faces and spoiled clientele: look for his preferred small-scale plein-air landscape sketches, intimate glimpses of family and friends, and rapid charcoal sketches. Also produced uninspired, time-consuming murals for public buildings in Boston (1890–1921).

He had a brilliant oil technique – his assured fluid paint and bold compositions match the confident faces and expensive well-cut clothes of his sitters. His real interest was in light (he was friendly with the Impressionists, especially Monet) and precise matching of tones. Was trained in Paris to use "au premier coup" technique – one exact brushstroke and no reworking. His watercolour technique was less assured. Influenced by Velasquez. His work successfully bridges the divide between the old masters and Impressionism.

KEY WORKS Madame X (Madame Pierre Gautreau), 1883–84 (New York: Metropolitan Museum of Art); Mrs. Adrian Iselin, 1888 (Washington DC: National Gallery of Art); The Bridge of Sighs, c.1905 (New York: Brooklyn Museum of Art)

Joaquin Sorolla y Bastida

● 1863-1923 P SPANISH

 Image: Spain; USA
 Image: Oils; prints
 Image: New York:

 Hispanic Society of America (murals)

 Image: Spain; Spai

Born and raised in Valencia, he was an accomplished, prolific, and internationally acclaimed painter with an easy, fluent style. Successfully bridged the divide between old masters and Moderns (like Sargent and Zorn). Sorolla y Bastida was a painter of beach scenes, landscapes, society portraits, and genre scenes; he had an enviable facility with light effects. Shows a nice balance between (social) realism and idealism. Painted directly onto canvas – fast. **KEY WORKS** *The Relic*, c.1893 (Bilbao: Museo de Bellas Artes); *Wounded Foot*, 1909 (Los Angeles: J. Paul Getty Museum); *Court of Dances*, 1910 (Los Angeles: J. Paul Getty Museum)

Girls from Dalarna Having a Bath Anders Zorn, 1908, 86 x 53 cm (33% x 20% in), oil on carvas, Stockholm: Nationalmuseum. Zorn did much to preserve the folk traditions of the Dalarna region, where he was born.

Anders **Zorn**

€ 1860-1920 P SWEDISH

 Sweden; Europe; USA Java Watercolours; oils; prints New York: Metropolitan Museum of Art
 \$2,608,000 in 1990, Les Baigneuses (oils)

Zorn was a prolific, talented, and very successful painter with a popular line in worldly-looking, fleshy nudes in plein-air settings. He also painted elegant portraits of the rich and famous. He had a virtuoso, free paint technique, which cleverly – like Manet – suggests 1) equality with the old masters (Titian) and the modern (the Impressionists); and 2) (false) spontaneity. Made brilliant watercolours, etchings, and the odd sculpture.

KEY WORKS Mrs. Walter Rathbone Bacon, 1897 (New York: Metropolitan Museum of Art); Hugo Reisinger, 1907 (Washington DC: National Gallery of Art); Mrs. John Crosby Brown, c.1900 (New York: Metropolitan Museum of Art)

POST-IMPRESSIONISM

late 19th/early 20th century

However liberating Impressionism was, its concentration on surface appearance and the moment inevitably limited its emotional range. From about 1880, a number of painters sought to fuse the new visual freedom generated by Impressionism with greater emphasis on form and content. The four giants of the Post-Impressionist era were Cézanne, Gaugin, Seurat, and Van Gough.

SUBJECTS AND STYLE

Modern life provides the dominant subject matter. Seurat pioneered a new monumentality, producing large-scale groups of figures painted using precise dots of paint, a technique known as divisionism. Cézanne

Landscape at Pont Aven

Paul Gauguin, 1888, oil on canvas, Private Collection. Gauguin developed his nonnaturalistic style during a stay in Pont Aven, Brittany.

world's underlying reality. Gauguin and Van Gogh both sought ways to express troubled,

achieved a similar sense of grave serenity by very different means, painstakingly reworking his paintings to reveal the

WHAT TO LOOK FOR

The sheer variety of styles covered by the term Post-Impressionism highlights a crucial feature of the period: that the absolute standards governing Western art established in the Renaissance no longer applied. This belief, which has remained unchallenged ever since, was the first claim that art was what the

Van Gogh's Bedroom at Arles Vincent van Gogh, 1889, oil on canvas, Art Institute of Chicago. This is the third version of the painting that Van Gogh produced. It was painted for his mother whilst recovering from a mental breakdown.

often dream-like emotions. Gauguin used flat colour and distorted perspective, Van Gogh harsh colours and strong outlines.

artist asserted it to be. Furthermore, "truth" in art did not have to mean naturalism, the attempt to show the world "as it actually is". This inevitably led to a wide diversity of styles with the result that the term Post-Impressionism can only really be applied to the period rather than a particular style. Where

Cézanne's work was intensely contemplative and minutely observed, Van Gogh's was tortured and highly expressive.

KEY EVENTS

1886	Van Gogh joins brother in Paris. Cézanne moves to Provence. Term "Neo-Impressionism" coined
1888	Van Gogh moves to Arles; after bouts of madness, shoots himself in 1890
1889	Norwegian Edvard Munch in Paris; <i>The Scream</i> (1893) combines northern brooding with Symbolist imagery
1891	Gauguin goes to Tahiti; returns to Paris 1893, then back to Pacific 1895
1895	Cézanne's first major show

Paul Gauguin

⊖ 1848-1903 P FRENCH

 France; Tahiti [] oils; sculpture; prints
 Washington DC: National Gallery of Art.
 St. Petersburg: Hermitage Museum. Paris: Musée d'Orsay 235m in 2004, Maternité II (oils)

Gaugin was a successful stockbroker who, at the age of 35, abandoned his career and family to become an artist. Yearned for the simple life and died, unknown, from syphilis, in the South Seas. Had a decisive influence on the new generation (including Matisse and Picasso).

His best work is from his visits to Pont Aven, in Brittany (especially in 1888) and from Tahiti in the 1890s. Powerful

subjects expressed with a strong sense of design: bold, flattened, simplified forms; intense, saturated colours. Constant search for a personal and spiritual fulfilment, which remained unsatisfied. Highly attracted to Tahitian feminine beauty, and many works are as full of sexual as well as spiritual yearning. Also produced interesting woodcarvings, pottery, and sculpture.

Although an acute observer of nature, he believed that the source of inspiration had to be

internal, not external (which sparked a major quarrel with Van Gogh). Hence, look for symbolic, not natural, colours; **Nevermore** Paul Gauguin, 1897, 60.5 x 116 cm (23% x 45% in), oil on canvas, London: Courtauld Institute of Art. Gauguin had a poetic ability to evoke moods that were haunting, ambiguous, and suffused with melancholy.

complex, sometimes biblical, symbolism. Plenty of scope for detective work on his visual sources, among them: South American art, Egyptian art, medieval art, Cambodian sculpture, Japanese prints, and Manet.

KEY WORKS Landscape, 1873 (Cambridge: Fitzwilliam Museum); The Vision After the Sermon, 1888 (Edinburgh: National Gallery of Scotland); Sunflowers, 1901 (St. Petersburg: Hermitage Museum); Primitive Tales, 1902 (Essen: Museum Folkwang); Riders on the Beach, 1902 (Essen: Museum Folkwang)

The Meal Paul Gauguin, 1891, 73 x 92 cm (28% x 36% in), oil on canvas, Paris: Musée d'Orsay. Rich colouring and distorted perspective combine to produce a work that is part still life, part enigmatic portrait of three Tahitian children.

Vincent van Gogh

● 1853-90 P DUTCH

Netherlands; England; France
 oils; drawings; engravings
 Amsterdam: Van Gogh Museum.
 Otterlo (Netherlands): Kröller-Müller
 Museum 2 \$75m in 1990,
 Portrait of Dr. Gachet (oils)

He was a happy child who became grim, impoverished, melancholic, difficult to love, and suicidal – but he painted

works that are now among the world's best known, best loved, and most expensive. He took up painting at the age of 27 and wanted his art to be a consolation for the stresses and strains of modern life. His subjects are wholly autobiographical, tracing every moment and emotion in his life. Whilst the popular image of Van Gogh is of the tormented

LIFE AND WORKS

Van Gogh came late to his artistic vocation, after years of unfulfilling careers, failed love affairs, poverty, and spiritual crises. Dismissed from his post as lay preacher for his too literal interpretation of Christ's command to give away worldly goods to the poor, he

Self-Portrait 1889, 65 x 54.5 cm (25% x 21% in), oil on carvas, Paris: Musée d'Orsay. Following his violent breakdown in Arles in May 1889, Van Gogh produced this painting in the asylum at St. Rémy four months later.

genius, he was also an educated, cultured man, who, despite the rapid pace of his output, put deep thought and planning into his art. found a new mission in art. His early subjects were Dutch peasants and workers, whose honest struggle he sought to portray. This moralistic tone disappeared from his later art, which, under the influence of Impressionism and Japanese woodcuts encountered on his move to Paris, developed into an expressive, swirling style. An unsuccessful attempt to found an artists' co-operative at Arles with Gauguin led to a breakdown (he cut off part of his left ear during a quarrel), and he briefly entered an asylum in 1889. Although an enormously productive period, his depression finally overcame him, and he died at his own hand, virtually unknown to the art world, leaving 800 paintings and 850 drawings, completing 200 paintings in last 15 months alone. His obsessive letters to his devoted brother, Theo, which often explain work in detail, formed the source material for the quickly emergent

cult that continues to grow around him.

STYLE

Van Gogh had an instinctive, self-taught, hurried style that is instantly recognizable. He used paint straight from the tube, applied as thick as furrows: strange perspectives; firm outlines, like a child's drawing; thrilling use of colour, which takes on a life of its own. He distorted form and colour in order to express inner feelings, moving away from the reproduction of literal visual appearances towards a symbolic and expressive synthesis. His swirling brushwork bristles with energy and emotional power.

Starry Night 1889, 73 x 92 cm (29 x 36 in), oil on canvas, New York: Museum of Modern Arv. At the time he was planning Starry Night, Van Gogh was reading a collection of poems by the American writer Walt Whitman, one of which uses similar imagery.

Sunflowers 1888, 92.1 x 73 cm (36½ x 28½ in), oil on canvas, London: National Gallery. One of a series of 12 sunflower paintings by Van Gogh, the majority of which were done during his stay in Arles.

He was able to endow inanimate objects with human personality (as did his favourite author, Charles Dickens), so that his yellow chair becomes a symbol or image of Van Gogh himself. He had a passionate belief in the importance of first-hand observation, which can be electrifying; but he also used colour symbolism, with vellow being especially significant in his works. He ranks with Cézanne and Gauguin as the greatest of the Post-Impressionist artists. KEY WORKS The Artist's Father, 1866 (Cambridge: Fitzwilliam Museum); Abduction, c.1867 (Washington DC: National Gallery of Art); French Street Scene with Access to a Vantage Point, 1887 (Amsterdam: Van Gogh Museum); Portrait of Armand Roulin, 1888 (Essen: Museum

> Folkwang); Young Peasant Girl in a Straw Hat Sitting in Front of a Wheatfield, 1890 (Private Collection)

Portrait of Doctor Paul Gachet, the Man with the Pipe 1890, 18 x 14 cm (7 x 6 in) atobios

(7 x 6 in), etching, Paris: Bibliothèque Nationale.

ROMANTIC AND ACADEMIC ART

Emile Bernard

● 1868-1941 P FRENCH

FranceImage: Second second

A close friend of Gauguin, Van Gogh, and Cézanne, Bernard painted his own competent versions of Gauguin's style (clear outline; solid, flat colour). Good, but not as good as he thought (although he did influence the Nabis). Most important now for his writings – especially interviews with Cézanne – and as the editor of Van Gogh's letters. In the 1920s he gave up painting and retired to Venice to write. **KEY WORKS** Buckacheat Harvest, 1888 (New York: Josefowitz Collection); Study of Breton Women, c.1888–90 (Quimper, France: Musée des Beaux-Arts); Breton Women on a Wall, 1892 (New York: Josefowitz Collection)

Paul Sérusier

● 1863-1927 P FRENCH

 Image: Image

His stiff, decorative style (firm outline, bright, flat colours, simplification) is largely indebted to Gauguin, with

The Talisman Paul Sérusier, 1888, 270 x 215 cm (160½ x 84½ in), oil on panel, Paris: Musée d'Orsay. Sérusier's landscape was named The Talisman because it was so influential in the development of Symbolism.

lesser borrowings from Egyptian and medieval art. Sérusier's favoured subject was Breton women at work. A disciple of Gauguin, who spread his ideas and was a founder member of Nabis. Wellheeled and popular with fellow artists, but was too hung up on theory – needed to loosen up his art.

KEY WORKS Farmhouse at Le Pouldu, 1890 (Washington DC: National Gallery of Art); Solitude, 1891 (Rennes: Musée des Beaux-Arts); Breton Landscape, 1895 (Boston: Museum of Fine Arts)

Félix Vallotton ● 1865-1925 P SWISS

France Disis; woodcuts; sculpture
 St. Petersburg: Hermitage Museum
 \$1,473,577 in 2000, On the Beach (oils)

There was a short period when he was at the forefront of new ideas (1890–1901), painting scenes of everyday life in original, simplified form (he disliked straight lines, preferred curves, round tabletops, etc.). Was influenced by Japanese prints and French Symbolists. Produced good, often satirical, prints; otherwise forgettable, traditional, realistic works.

KEY WORKS Seated Female Nude, 1897 (Musée de Grenoble); Interior, 1903–04 (St. Petersburg; Hermitage Museum); Woman in a Black Hat, 1908 (St. Petersburg; Hermitage Museum)

Henri Rousseau

France 🚺 oils; woodcuts; sculpture
Paris: Musée d'Orsay 🏼 🎘 \$4,023,000
in 1993, Portrait of Joseph Brummer (oils)

He was a minor customs official who took up painting on retirement to supplement his pension. He was lionized by the young avant-garde (Picasso et al) because of the childlike vitality of his work.

His work has an unconscious (genuine) naïvety. He painted like a child, but on a bigger scale. He had all the qualities of a child, including the "art is my favourite subject" enthusiasm; wobbly perspective; smiley faces; big signature; obsession with arbitrary detail (every leaf on a tree, or every blade of grass), and a desire to please. He usually worked around a simple idea with a central single object.

He did what most children grow out of, or are taught not to do; he is a reminder that we may flourish best and achieve unexpected recognition if we are what we are and do not constantly strive to be what we are not. **KEY WORKS** *Self-Portrait of Rousseau, from L'Ile Saint-Louis*, 1890 (Prague: National Gallery); *Artillerymen*, 1893–95 (New

York: Guggenheim Museum); *Child with a Puppet*, c.1903 (Winterthur, Switzerland: Kunsthalle); *Jaguar Attacking a Horse*, 1909 (Houston: Museum of Fine Arts)

Henri de Toulouse-Lautrec

● 1864-1901 P FRENCH

 Paris [1] oils; prints [1] Paris: Musée d'Orsay. Albi: Musée Toulouse-Lautrec
 \$13.2m in 1990, Danseuse assise aux bas roses (works on paper)

Toulouse Lautree was the epitome of the bohemian artist: the crippled aristocrat who haunted the Parisian cafés and brothels, and commemorated their inhabitants in art of supreme quality.

There is an extraordinary immediacy and tension in his work, resulting from his mastery of his subject matter and technique.

The prostitutes and drunks, although sometimes close to caricature, are shown without sentiment or criticism – he loved them and understood them. The brilliant, wiry draughtsmanship and thin, nervous paint seem to reflect

Le Divan Japonais Henri de Toulouse-Lautrec, 1892, 76.2 x 59.7 cm (30 x 23 ½ in), lithograph, Paris: Bibliothèque Nationale. Passionate about lithography, Toulouse-Lautrec created many lithographic posters advertising Montmartre nightlife. The Rugby Players Henri Rousseau, 1908, 100.5 x 80.3 cm (39% x 31% in), oil on canvas, New York: Guggenheim Museum. In 1908 Picasso organized a banquet with other avant-garde painters in Rousseau's honour.

their uncertain, shadowy world; you sense that he was part of that world, not just an observer.

The economy of the brushstrokes and the simplicity of the materials are as direct and basic

as his subjects. He used paint thinned with turpentine that allowed fine, rapid marks, and unprimed cardboard, which he did not try to disguise – exploiting its rawness and colour and the way it absorbs diluted oil paint.

KEY WORKS Woman Doing her Hair, 1891 (Paris: Musée d'Orsay); Quadrille at the Moulin Rouge, 1892 (Washington DC: National Gallery of Art); At the Moulin Rouge, 1892–95 (Art Institute of Chicago); Rue des Moulins, 1894 (Washington DC: National Gallery of Art)

Paul Cézanne

⊖ 1839-1906 PU FRENCH

 Image: Paris; Aix-en-Provence
 Image: Oils; watercolours; drawings

 Image: Oils; Philadelphia: Barnes Foundation.

 Paris: Musée d'Orsay
 Image: S55m in 1999, Rideau, cruchon et compotier (oils)

Cézanne is considered the Mother and Father of modern art. A solitary, pioneering, difficult workaholic. He thought that his life and work were failures.

LIFE AND WORKS

Cézanne's ambitious businessman father from Aix-en-Provence terrified his son, who was saved by his determined artistic sensibility. His father eventually allowed him to go to Paris to study art, giving him a small allowance, and later a fortune. Cézanne never had to sell his work to live – a rare privilege. In 1870 he married Hortense Figuet and they had one son, Paul.

Cézanne's early efforts were as inept as his social behaviour, and he was

rejected as "incompetent" by the École des Beaux Arts. His subsequent lifelong struggle to find a coherent way of painting resulted miraculously in work that became a key influence on Modern Art. His first one-man show in 1895 caused huge

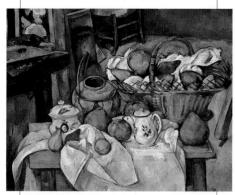

Still Life with Basket Paul Cézanne, 1888–90, 65 x 81 cm (25 % x 31 % in), oil on canvas, Paris: Musée d'Orsay. Cézanne worked so slowly that the fruit often rotted and he had to substitute plaster replicas.

excitement for young artists such as Matisse and Picasso.

His last years were marked by loneliness and ill health. Already suffering with diabetes, he died from pneumonia after being soaked in a downpour whilst painting outdoors.

STYLE

At the heart of Cézanne's painting was a determination to continue the highly disciplined French

Self-Portrait Paul Cézanne, c. 1873–76, 64 x 53 cm (25½ x 20½ in), oil on carvas, Paris Musée d'Orsay. Hailed by Picasso as "My one and only master ... father of us all."

Classical tradition epitomized by Poussin, but to do so outdoors and "from nature". In all his works he combines a remarkable faithfulness to what he observes with a deep awareness of his emotional response. His palette is usually restricted to earthy greens, reds, and blues,

and there may be an instinctive underlying grid-like structure, as if to hold the composition together and define the different areas.

Cézanne did not originate new subjects: rather his originality was in his way of

seeing and painting. For example, his landscapes often took him weeks or months to complete. The difficulty was that the detail was always changing as the light changed – and even as he moved position. In other words, there never came a moment when he deemed any work to be finished – one of the reasons for his sense of failure, and why he rarely signed his work.

WHAT TO LOOK FOR

His works have multilayered significance: central to Cézanne are the same (traditional) subjects painted

over and over again in a constant attempt to record accurately what he sees, to express what he feels, and to produce

an aesthetically satisfying picture. Not easy, as these goals are constantly changing and are often in conflict; he achieves it in the works of 1885–1901.

The Large Bathers Paul Cázanne, c. 1900–05, 208 x 249 cm ($81\% \times 98$ in), oil on carvas, Philadelphia: Museum of Art. The artist never painted from naked models; instead he assembled his nude compositions from photographs.

Montagne Sainte-Victoire with Trees and a House Paul Cézanne, 78 x 99 cm, (31 x 39 in), oil on canvas, Moscow: Museum of Modern Art of the West. Mt. St. Victoire is a well-known landmark near Aix-en-Provence, revisited frequently by Cézanne.

Cézanne's paintings have an extraordinary power, as though you were seeing through his own eyes.

Examine the marks that he makes – small, precise, beautiful, each in place for a reason. He only makes marks when he has seen and felt something. He also weaves the marks together to produce a harmony of colour and design. Every picture surface trembles with the thrill and anxiety of his intense seeing, feeling, and making. **KEY WORKS** *The Artist's Father*, 1866 (Cambridge: Fitzwilliam Museum); *Abduction*, c.1867 (Washington DC: National Gallery of Art); *Still Life*

with Apples and Oranges, c.1895–1900 (Paris: Musée d'Orsay); Le château noir, 1900–04 (Washington DC: National Gallery of Art)

Pierre Bonnard

⊖ 1867-1947 PU FRENCH

Image: Image: Second Second

He was one of the great masters of colour. If Matisse is the king of colour, Bonnard is the queen. Though less intellectual than Matisse, he shared his view that art should be a celebration of life and a source of visual joy.

Painted the places, rooms, and people that he knew most intimately, notably his neurotic, bath-obsessed wife, Marthe. Early work is progressive, later work is deeply personal and stands outside the mainstream. Lovely, free drawings that are masterpieces of observation. The paintings were done in his studio from memory and from black and white notes and sketches – all that glowing colour came out of his head.

Stand well back and see how he creates thrilling spaces (rich, textured foregrounds and hazy distances). Walk forwards and see how glorious colour harmonies take over (blues, violets, greens, with glowing pinks and oranges). When really close, let the detail of flickering brushwork and subtle colour weavings fill your eye. His work becomes brighter with age (unusual). **KEY WORKS** *The Letter*, c.1906 (Washington DC: National Gallery of Art); *Table Set in a Garden*, c.1908 (Washington DC: National Gallery of Art); *Bathing Woman, Seen from the Back*, c.1919 (London: Tate Collection)

Mother and Child Edouard Vuillard, 1900, 51.4 x 50.2 cm (201/x 191/in), oil on board, Private Collection. Vuillard never married, but remained deeply devoted to his widowed mother, who was a dressmaker.

The Almond Tree in Blossom Pierre Bonnard, 1947, 55 x 37.5 cm (21% x 14% in), oil on canvas, Paris: Musée National d'Art Moderne. Bonnard's last painting, which he was still perfecting whilst on his deathbed.

Edouard Vuillard

⊖ 1868-1940 PU FRENCH

Vuillard was a shy, highly talented painter and printmaker who was in the forefront of new artistic ideas up to 1900, after which he retreated into his own comfortable, intimate world.

He is best known for his glimpses of middle-class life – mostly cluttered domestic interiors. Had a nervous style, with busy surfaces that flicker with light or allow the image to build up like a mosaic. Was fascinated by repeating patterns, such as woven material or wallpaper. Rich, earthy palette. Warm sense of colour.

Pioneered simple design, strong colour, and energetic brushwork. An enthusiastic photographer – his works show this, having a snapshot-like quality. **KEY WORKS** Landscape: Window Overlooking the Woods, 1899 (Art Institute of Chicago); Vase of Flowers on a Mantelpiece, c. 1900 (Washington DC: National Gallery of Art) Portrait of Théodore Duret, 1912 (Washington DC: National Gallery of Art)

Sir William Nicholson

⊖ 1872-1949 P BRITISH

☑ England ☑ oils; prints ☑ \$246,750 in 2001, Le début de la rue Montagne Sainte-Geneviève (oils)

Nicholson was a highly accomplished painter of landscapes, portraits, and still lifes, with an easy, fluid, intimate style and a wonderful eye for observation, composition, colour, and light – and an ability to edit out the superfluous. Successful, and knighted for his achievements. Also made poster and theatre designs, and woodblock prints. Ben Nicholson's father.

KEY WORKS Beerbohm, 1905 (London: National Portrait Gallery); *The Lowestoft Bowl*, 1911 (London: Tate Collection)

Ferdinand Hodler

⊖ 1858-1918 PC SWISS

☑ Geneva
 ☑ oils
 ☑ Bern: Kunstmuseum
 2 \$2,705,727 in 1998, Lake Silvaplaner (oils)

A talented painter of monumental figure paintings, portraits, and landscapes.

He painted modern narratives and allegories with a confident drawing style and strong outlines. Powerful, intensified colour; his hatched brushstrokes and broken colour give optical vibrancy. Untroubled by self-doubt, but sometimes falls into the trap of the pompously overserious statement. Liked silhouetted figures or mountains against a sky. **KEY WORKS** *Tired of Life*, 1892 (Munich: Neue Pinakothek); *Silence of the Evening*, c.1904 (Winterthur, Switzerland: Kunstmuseum)

Lovis Corinth

→ 1858 – 1925
 P
 Ø GERMAN

☑ Germany; Paris
 ☑ oils; watercolours; prints
 ☑ Berlin: Staatliche Museum
 ☑ \$1,310,400 in
 2004, Walchensee, Morning Fog (oils)

His work is rarely seen outside Germany. Major figure who tried to reinvent the tradition of the old masters in a modern idiom. Ambitious, gifted, Prussian.

In his traditional style he painted established subjects (portraits, still lifes, mythologies), using an earth palette and influenced by old masters, especially Rembrandt and Hals. In his modern style he painted frank, direct interpretations. Free and expressive paint-handling – he used painting as a personal and emotional release. After a stroke in 1911, his work became increasingly loose, reflecting his physical handicap, awareness of death, isolation (he disliked Modernism), and melancholy at the defeat of the German Empire in 1918.

Impressively versatile, he produced stunning, small late watercolours and prints, which were easier to handle after his stroke and show thrilling emotional and technical invention. His plein-air landscapes (especially those around his house at Walchensee, Bavaria) hover between Impressionism and Expressionism and were a great commercial success in Berlin. Compositions in late works often lean curiously to the left. He painted a series of self-portraits every year on his birthday (after 1887).

KEY WORKS Nude Girl, 1886 (Minnesota: Minneapolis Institute of Arts); Centaurs Embracing, 1911 (London: Courtauld Institute of Art); Samson Blinded, 1912 (Berlin: Staatliche Museum); Magdalen with Pearls in her Hair, 1919 (London: Tate Collection); Self-Portrait with Straw Hat, 1923 (Basel, Switzerland: Kunstmuseum)

Carl Milles

Sweden; Europe; USA Sculpture
 Lidingö (Sweden): Millesgården St40,567
 in 1989, *The Small Water-Nymph* (bronze)

Greatest Swedish sculptor, and one of the most famous sculptors since Rodin (who was a big early influence). Best known for his large-scale fountains, which show his strong grasp of architecture. Widely travelled in Europe; later taught in the USA, where he did most of his best work.

Combined eclectic influences from his travels into highly individual style. Fused classical and Nordic cultures to create vigorous, unusual groupings. His figures are full of vitality, while his fountains are conceived as an architectural whole: figures must be viewed against the background of sky and water. **KEY WORKS** Folke Filbyter (Le cavalier de la légende), 1920s (Lidingö, Sweden: Millesgården); Fountain, 1936–40 (St. Louis, Missouri: Market Street); Orpheus Fountain, 1930s (Michigan: Cranbrook Art Museum); Pegasus and Bellerophon, 1940s (Iowa: Des Moines Art Center)

SECESSION AND ART NOUVEAU

In the 1890s, several groups of painters in Vienna, Munich, and Berlin sought to break away from the official academies and promote new ideas and styles. They labelled their new groupings Sezession, and their avant-garde exhibitions created considerable outrage and scandal. In the end, these groups were splintered by internal politics, leading to further breakaway groupings.

VIENNA SECESSION

Founded by Gustav Klimt, who aimed to put Vienna on the international stage artistically by pursuing new avant-garde ideas, with links to other progressive artists all over Europe. In particular, Klimt wanted to create a union between the fine arts of painting and sculpture and architecture, and the applied arts of design and decoration.

ART NOUVEAU

French for "new art"; also known as Jugendstil or Sezessionstil in Austria, and Stile Liberty in Italy. Art Nouveau describes a highly decorative style, most often seen in architecture and

the applied arts, which was at the forefront of fashion in the 1890s. It aimed to reject historical influences and create one encapsulating style for all the arts. The French-speaking version is organic and free-flowing; the German/Scottish version is geometric.

KEY EVENTS

VER GACRYM

1892	Rejection of Munch's early work by Berlin Artists' Association. German artists start Munich Secession	
1897	Klimt breaks away from the main Austrian academy and patron, Künstlerhaus, and establishes hugely successful exhibition (57,000 visitors) and magazine <i>Ver Sacrum</i>	
1899	Leading German Impressionist Max Liebermann starts Berlin Secession movement	
1900	First of Hector Germain Guimard's Art Nouveau designs for Paris Metro	

Sarah Bernhardt Alphonse Mucha, 1896, colour lithograph, Prague: Mucha Trust. Mucha was a Czech painter and designer who settled in Paris. His work was important in the development of French Art Nouveau.

DER-ZEIT-IHRE-KVNST-DER-KVNST-IHRE-FREIHEIV

-

Facade of Secession Building, Vienna The new home for art, designed and built in just six months in 1898, was a rejection of the traditional architectural styles of the Austro-Hungarian empire.

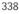

Gustav Klimt

♀ 1862 – 1918 № AUSTRIAN

 Austria
 Image: a constraint of the c

Klimt was the leading Viennese painter who broke away from convention to found the Viennese Secession movement and develop a highly original, sensitive style. Some of his most impressive projects were interior decoration.

The intense, introverted subject matter reflects Klimt's own personality (he was an oversexed workaholic), and *fin de siècle* Vienna (neurotic, idle, adulterous, gossipy, deeply conservative, but also packed with original talent and fresh ideas from Freud, Richard Strauss, Mahler, and so on). It also expresses his wish to explore modern sensibility and break free from old, stifling taboos and restrictions, and his wish to The Kiss Gustav Klimt, 1907–08, 180 x 180 cm (71 x 71 in), oil on canvas, Vienna: Österreichische Galerie. The couple are surrounded by a cloud of gold, intended as a symbolic expression of the power of love.

demolish the snobby distinction between the fine artist and the craftsman.

Klimt's brilliant, inventive technique reflects his training (at the School for Decorative Arts, where he learned craft techniques), and his fascination with Egyptian art (flat and decorative) and Byzantine art (gold and mosaic). Notice the sensitive hands, hidden faces, private symbolism - he worked through suggestion rather than description in order to touch the inner feeling rather than the outward show. KEY WORKS Judith, 1901 (Vienna: Österreichische Galerie); Hope II, 1907-08 (New York: Museum of Modern Art); Baby (Cradle), 1917-18 (Washington DC: National Gallery of Art)

MODERNISM c.1900–1970

Young artists and writers in Western Europe welcomed the dawn of the 20th century with excitement and great expectation. They hoped and believed it would usher in a new era fuelled by technological advances and democratic ideals that would result in economic and social improvements for the great majority of humankind.

rtists, architects, and engineers were to be at the heart of creating this brave new modern world that was to look different from anything seen before. In many ways their dreams were realized. The plethora of new styles and technical innovations that followed in rapid succession radically changed art and the environment, and testified to a freedom of thought and expression that was at times bewildering in its range and diversity.

REACTION

What the idealists failed to predict, however, was the effectiveness of those forces that would seek to destroy, and very nearly extinguish, these new freedoms. They could not foresee the fierceness of the political

Young Lady and Her Suite Alexander Calder, 1970, painted steel, height 10 m (33 ft), Detroit, Michigan. One of the dreams of the first generation of Modern artists and architects was the creation of an ideal city. confrontations or the terrifying destruction of human life and material heritage that would ensue.

THE WORLD WARS

The most terifying manifestations of the political struggle were the two World Wars (1914-18 and 1939-45). By 1919, after more than four years of debilitating warfare on the Western Front, Britain and France, the victors of World War I and the world's leading colonial powers, could still assert their dominant position in the world, despite the growing realities of American financial and political muscle. Germany, by contrast, was prostrate, politically and economically in turmoil, Austria-Hungary was destroyed as a single entity, and Russia launched on a communist experiment that would bring misery and death to millions. After 1929, the Western economies, including that of the mighty USA,

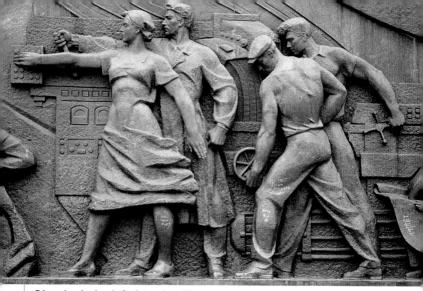

Frieze showing heroic Soviet workers, Moscow Soviet art, like Nazi art, was monumental and deeply conservative. Both regimes ruthlessly crushed any form of individual expression.

suffered catastrophic depression. Germany and the Soviet Union. meanwhile, set about establishing totalitarian regimes that were irreconcilably opposed in their political ideologies, but had many features in common.

Soon after Hitler began World War II in 1939, France was forced into ignominious surrender, and Britain into Churchillian defiance. In the end it was the unlikely alliance between American manufacturing might and Soviet manpower that secured a victory over Nazi Germany.

After 1945, Europe had to acknowledge the reality of American dominance within the Western world. Neither Britain nor France had been

able to contain the growth of pre-war fascism in Europe, or offer a creditable alternative to communism.

REVIVAL

The efforts of France and Britain after the war to hold on to their empires were clearly doomed. Europe entered a period of austerity and introspection. From the late 1940s it was the threat of conflict between the USA and the Soviet Union that defined international relations. Further, after 1949, a new factor was added to the balance of world power: the threat of nuclear war and humankind's complete self-destruction.

By 1970 the picture was very different. Whereas Germany in 1945 was a country reduced to rubble and occupied by its former enemies, its Western entity now boasted the largest economy in Europe. Over the

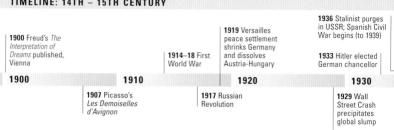

TIMELINE: 14TH - 15TH CENTURY

same period, almost every European country enjoyed an unprecedented period of economic growth. The roots of this lay in the even more spectacular buoyancy of the US economy in the 1950s and 60s. American financial aid to Western Europe, the Marshall Plan, launched in 1947, kick-started Europe's war-rayaged economies. and thereafter America's dynamism and its tempting vision of a consumer society, drove developments around the world. Even the economies of Sovietdominated Eastern Europe grew. The European Economic Community which started idealistically in 1957, slipped into strategies for securing

was most under threat or was a new discovery. At the end of the 19th century this meant France, and Paris became the capital of the avant garde, a role it retained until 1939. Germany, Russia, and Holland, and to a lesser degree Italy and Spain, made major contributions, but in Britain and the USA, where freedom of speech and conscience were taken for granted, Modern Art was of less interest. After 1945, as the USA became the standard bearer for the Western democracies, the centre of gravity shifted to New York, but perhaps what is most striking is the degree to which Modern Art and its early development in Europe and America is interlinked with the fight for

> Chrysler Building, New York This Art Deco skyscraper, a landmark of 20th-century architecture, was

during the Great Depression.

conceived in prosperity but opened

democratic freedom.

comfortable prosperity rather than achieving any great ideal.

INTERLINKING

Against this turbulent background, artistic innovation was, in fact, greatest in those places that had experienced foreign occupation, or where freedom of expression

Soviet postcard from World War II

Hitler suffers in the Russian winter as he runs from a hail of shells. All countries in the war used art to project their propaganda messages.

1939 German 1947 New York invasion of Poland takes over from sparks World War II Paris as the 1956 Anti-1962 Andy Warhol's Twenty-1969 US succeeds capital of Soviet uprising 1941 German invasion the artistic in Hungary five Colored in landing men on Marilyns, New York of Soviet Union the moon avant garde suppressed 1940 1950 1960 1970 1967 Year of "Flower 1957 Treaty of 1938 Hitler 1945 German surrender 1962 Power" and growing Rome: EEC created Cuban annexes Austria ends war in Europe; missile protests against war and border atomic bomb dropped on Hiroshima; Japanese 1955 Warsaw Pact crisis in Vietnam regions of established Czechoslovakia surrender

Henri Matisse

● 1869-1954 P FRENCH

Paris; Vence (South of France) i oils;
 sculpture; collage; drawings i Paris: Musée
 d'Art Moderne. Pennsylvania: Barnes Foundation
 \$17m in 2000, La robe persane (oils)

The King of Colour – he celebrated the joy of living through colour. Major hero of the Modern Movement and one of its founders. Professorial and social, but not convivial, and a bit of a loner.

LIFE AND WORKS

Matisse first studied law in Paris and worked as a legal clerk before taking up art studies at the influential Académie Julian and under Moreau at the Ecole des Beaux-Arts, where he met several of the future Fauves. In fact, he came to art late and almost by chance, when, aged 21, he was given a box of paints whilst recovering from an appendicitis operation. In the late 1890s he experimented with Divisionism and absorbed a deep knowledge of colour theory. In 1899, he turned to Cézanne. Although penniless, he bought from art dealer, Vollard, a small Cézanne Bathers which he kept all his life and used as inspiration at low or critical moments

Self-Portrait Henri Matisse, 1918, 65 x 54 cm (25% x 21% in), oil on carvas, Nice: Musée Matisse. A rare full painting of the master at work. Matisse usually hides small images of himself in intimate portraits of others.

of his career. Coming from the grey cold light of northern Europe, the discovery of the brightness and warmth of Mediterranean light, which he first experienced in Collioure, on the French-Spanish border in the summer of 1904,

Large Reclining Nude Henri Matisse, 1935, 66 x 92.7 cm (26 x 36½ in), oil on canvas, Maryland: Baltimore Museum of Art. He reworked this picture 22 times, altering the background and model's proportions until he was happy.

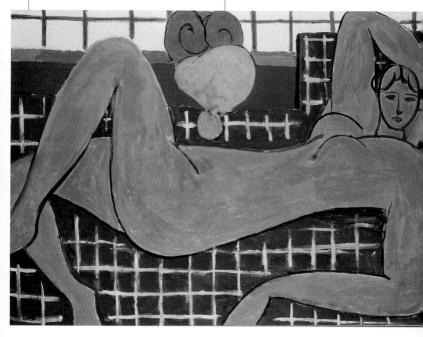

с.1900-1970

"I cannot copy nature in a servile way. I must interpret nature and submit it to the spirit of the picture."

was a revelation. From 1905-07, as the foremost Fauve painter, he was champion of the young avante-garde, and opened a school for young artists. His Notes of a Painter (published 1908) is one of the most important statements of the principles of modern art. At this period he also visited Morocco and came under the influence of Islamic and Persian art, both of which emphasize pattern and bold but subtle colour. In the 1920s, Matisse settled semipermanently in Nice, and his art continued to flourish with ever-increasing richness, and fascination with light and colour, even when a bedridden invalid, with very few false turnings. In many ways his later years are among his most fertile and inventive, as he experimented with paper cutouts and collages, the illustrations for Jazz and La Cirque, plus the stained glass windows and vestments for the Chapel of the Rosary at Vence, near Nice.

SUBJECTS AND STYLE

Look for his life-enhancing, joyous combination of subject matter (notably the open window, still life, and female nude), and his glorious colour which takes on a life of its own and is free to do its own thing, without necessarily imitating nature. Explored colour independently from subject matter and turned it into something you want to touch and feel. As a result he loved exploring the exotic, especially oriental fabrics and ceramics with their strong decorative feel and heightened colours. This is brilliantly explored through his superb Odalisque nudes of 1920-25. His late gouaches on paper cutouts enabled him to carve into colour. Also a brilliant and innovative printmaker (1952 being the year of his printed blue nudes, now still gracing the walls of many students as posters) and sculptor, sculpture often being an explorative extension of his painting.

WHAT TO LOOK FOR

His work explores the full range of what colour can do, by crowding, juxtaposing, intensifying, relaxing, purifying, heating, cooling. Look for white spaces around bright colours, allowing them to "breathe" and reach their full visual potential. The open brushwork is deliberate, to give movement and life to the colour and to register Matisse's own presence and activity. Matisse said he "dreamt of an art of balance and purity and serenity, devoid of troubling or depressing subject matter ... a mental soother ... like a good

Luxe, calme, et volupté (Luxury, Serenity, and Pleasure) Henri Matisse, 1904, 98 x 118 cm (38% x 46% in), oil on canvas, Paris: Musée d'Orsay. His hallmark piece when first exhibited, reminiscent of Cézanne's Bathers.

armchair". It was this apparent lack of aggression or need for controversy that puzzled Picasso. If in their earlier years they had competed for leadership of the avant-garde, in later life they kept a respectful distance, each aware of the other's innovations, even influenced by them, yet never in competition. To the end, Matisse's principal concern was always with colour, and the way it could be used to create form, emotion, and sensation. In his own words, "I am unable to distinguish between the feeling I have for life and my way of expressing it."

KEY WORKS The Joy of Living, 1905–06 (Pennsylvania: Barnes Foundation); Statuette and Vases on an Oriental Carpet, 1908 (Moscow: Pushkin Museum); The Black I–IV, 1909–c.1929 (London: Tate Collection); Reclining Nude, Back, 1927 (Private Collection); The Snail, 1953 (London: Tate Collection)

LES FAUVES

1900-07

The name was given to the movement at the 1905 Salon d'Automne exhibition held in Paris. Art critic of the review *Gil Blas*, Louis Vauxcelles, insultingly labelled the brightly coloured style of the paintings as the work of wild beasts (*fauves*). But the group, loosely formed around liaisons between the artists about the turn of the century, loved the term.

Matisse and Derain studied together in 1898 and Vlaminck, a friend of Derain, was introduced two years later. They were heavily influenced by Van Gogh and Cézanne, as well as the Pointillism of Seurat. Colour harmony is a central theme, although the dotted style eventually gave way, in the main, to wide choppy brushstrokes of stunning pure colour, freely applied in flat patterns. It embodied Derain's ideal of "colour for colour's sake". Now an object could generate its own brightness. The chief group members were Matisse, Dufy, Derain, Vlaminck, and Braque. One of the principal places of inspiration was Collioure in the South of France. By 1907, most of the artists had moved on to explore new personal ideals.

Charing Cross Bridge André Derain, 1906, 81.2 x 100.3 cm (32 x 39/k in), oil on carvas, Washington DC: National Gallery of Art. Derain was influenced by Monet's paintings of the River Thames.

Maurice de Vlaminck

€ 1876-1958 P FRENCH

He was both a volatile and boastful character who made a brief splash as one of the avant-garde Fauve artists in France c.1905–06. As a youth, he earned an income from his winnings as a racing cyclist, and from performing as an orchestral violinist. Painting was very much a secondary vocation at this time. He also wrote novels and his memoirs.

His early landscapes are full of colour, thickly and freely painted, and with strong simplified designs. They express the mood of adventure and experimentation that captured the imagination of progressive young French artists at the time. His later landscapes degenerated into a boring formula; superficially they look modern, but they are not.

Separate the subject matter (which is actually not very innovative) from the way it is painted (which is), and maybe question the reason for this balance between the old and new. He used a not very subtle palette of four colours – red, blue, yellow, and green – but wove them together to create a strong visual "fizz". **KEY WORKS** *The Blue House*, 1906 (Minnesota: Minneapolis Institute of Arts); *Tugboat on the Seine*, *Chatou*, 1906 (Washington DC: National Gallery of Art); *View of the Seine*, c.1906 (St. Petersburg: Hermitage Museum); *Still Life*, c.1910 (Paris: Musée d'Orsay); *The River*, c.1910 (Washington DC: National Gallery of Art)

Tugboat at Chatou Maurice de Vlaminck, 1906, 50 x 65 cm (19 x 25 in), oil on canvas, Private Collection. Vlaminck and André Derain were named the "Chatou Couple" after the Paris suburb where they painted together.

Albert Marquet

● 1875-1947 P FRENCH

France is its; watercolours; drawings
 Paris: Musée National d'Art Moderne
 \$1,309,549 in 1989, Le carnaval à Fécamp (oils)

Marquet was a disciple of Matisse, who developed an appealing and poetic style: strong, simple design; clear, harmonious colour; the elimination of unnecessary detail (Matisse compared him favourably with the Japanese artist Hokusai). He produced small-scale works in oil and watercolour. The scenes of Paris, around the Seine, and French ports are the most effective and popular.

KEY WORKS André Rouveyre, 1904 (Paris: Musée d'Orsay); Le Pont-Neuf, 1906 (Washington DC: National Gallery of Art); Winter on the Seine, c.1910 (Oslo: National Gallery)

André Derain

● 1880-1954 P FRENCH

He is best remembered as Matisse's main partner in creating Fauvist paintings in the South of France, in the early 20th

The Seine at Paris Albert Marquet, c.1907, 65 x 81 cm (25% x 31% in), oil on canvas, Private Collection. Fauvist Marquet is well known for his panoramic views of the Seine and various French ports, featuring docks, cranes, tugs, and ships at anchor.

century. He was one of the first artists to take an interest in African sculpture.

Derain's early works were extremely influential in the development of the use of colour in Modern art. Stayed (mostly) with traditional landscape themes, with an important series of views of London (River Thames) painted in 1906. Then he unwisely abandoned colour and concentrated on form. His later work is mediocre and currently overrated.

Early work is notable for attractive paint handling, open brushwork, and strong, confident compositions. He makes subtle use of colour, exploiting colour harmonies as well as colour contrasts, and placing half-tones and full tones together. Intensifies local colours, but never gets away from them (unlike Matisse). Thus skies are always blue, leaves green (Matisse skies can be yellow, green ... anything). **KEY WORKS** Portrait of Matisse, 1905 (London: Tate Collection); Charing Cross Bridge (see opposite); The Pool of London, 1906 (London: Tate Collection); Southern France, 1927 (Private Collection)

Les Demoiselles d'Avignon

Pablo Picasso 1907

This celebrated painting is now hailed as one of the most momentous paintings in the history of art. Yet, the often forgotten reality is that for 30 years it was known only to a handful of Picasso's friends and was hardly ever seen in public until purchased by MoMA in New York in 1938.

The painting explores,

although never fully resolves, a plethora of new ideas. Its significance is that through it Picasso decisively broke with his own past, with all the traditions of Western art, established himself as the undisputed leader of the avant-garde, and immediately launched into a period of astonishing and profoundly influential creativity. He had been planning a large figure piece, and had experimented with a brothel scene, from which this work evolved. The title (not chosen by Picasso, and he disliked it), refers to a notorious brothel in Barcelona.

This is the first indication from Picasso of an interest in still life. It would become a regular feature in his early Cubist paintings and throughout his life. It is also a theme that links him to Cézanne and Spanish art. Picasso always wanted to be seen as a reinventor of tradition rather than an iconoclast.

In 1907, Picasso was working in Montmartre, Paris, in a cramped and cluttered space with two dark rooms in an artistic colony known as the Bateau Lavoir, which was a building like a rabbit warren. This large canvas would have filled one entire wall of his studio.

Picasso would later turn this type of still-life imagery into small, brightly painted sculptures Picasso believed that art and the human figure could have a redemptive or "exorcizing" power. Here the target is prostitution and sexual disease

Les Demoiselles d'Avignon

Medium oil on canvas Dimensions 244 x 233 cm (96 x 92 in) Location New York: Museum of Modern Art

с.1900-1970

TECHNIQUES

After seeing Cézanne's work in the autumn of 1906, Picasso began to experiment spatially with flat, splintered planes and patterns of light and dark rather than rounded volumes to create a sense of, rather than an illusion of, space and form.

The faces of these figures were repainted after Picasso had a "revelation" about African sculpture at the Ethnographic Museum in Paris in 1907

Early Iberian sculpture influenced the faces of the figures. In March 1907 Picasso acquired two such pieces that had been stolen from the Musée du Louvre

This figure begins to explore what would become a hallmark of Cubism: the combination of different viewpoints and profiles in a single figure

CUBISM

1907–1918

Cubism was the most significant art and design innovation of the 20th century, similar in effect and consequence to the invention of the internal combustion engine, manned flight, and wireless communications – all of them developed at about the same time. The principles of Cubism were worked out in 1907–1914.

PICASSO AND BRAQUE

The movement's inventors were Picasso and Braque. Their early Cubist works were all small scale, with conventional subjects such as still life, landscape, and the human figure. The great innovation was use of fragmented and choppedup forms, creating an effect like a jigsaw that has been put together with the pieces wrongly joined. The works of 1910–11 are given the

label "Analytical Cubism", and used monochromatic paint on canvas. In the works after 1912, they stuck on the contents of wastepaper baskets in addition – this development is known as "Synthetic Cubism".

Woman with a Guitar (Ma Jolie) Pablo Picasso, 1911, 100 x 65 cm (39/x z5% in), oil on canvas, New York: Museum of Modern Art. The woman in the title is Picasso's mistress Eva Gouel (also known as Marcelle Humbert).

PRINCIPLES

Cubism rewrote the rules and expectations as to how paintings and sculpture could be made. Paintings were no longer like a window, but a forum where almost anything might happen.

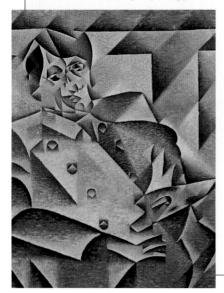

Sculpture was to be open and transparent rather than a solid object. Any sort of material, however humble or everyday, could be used to make art. In the eyes of the Cubists, art was to be about cumulative experience rather than mere observation.

KEY EVENTS

1907	Picasso's <i>Les Desmoiselles d'Avignon</i> (see pages 348–349) introduces the principle of collapsing form and figure distortion
1909	Braque and Picasso work closely as a team to create first "Analytical Cubist" works
1911	Picasso's <i>The Guitar</i> first sculpture made by constructing parts rather than reducing
1913	Birth of collage and <i>papier collés</i> as "Synthetic Cubism" evolves
1918	Cubism's effects influence Italian and Russian Futurist/Orphic movements

Portrait of Pablo Picasso Juan Gris, 1912, 93 x 74 cm (36% x 29% in), oil on canvas, Art Institute of Chicago. Gris wanted to acknowledge Picasso as the father of the historic new artistic era.

Georges Braque

 ● 1882-1963
 ▶ FRENCH

 ▶ Paris
 ▶ oils; mixed media

 ▶ \$8.64m in 1986, Femme lisant (oils)

Braque was one of the most innovative and majestic painters of the 20th century. He built on the example of Cézanne and the 18th century to lift decorative painting (especially still life) to new heights.

He was one of the key early leaders of the avantgarde. Produced important Fauve paintings, and then invented Cubism with

Picasso. Later work concentrates on still life, the human figure, and studio interiors. Be totally at ease to enjoy the way he develops the language of Cubism, and his instinct for colour, texture, and paint. This is work that delights the eye, in the way romantic music delights the ear, and touches the heart rather than the intellect.

Cubist innovations included the use of letters, *papiers collés*, sand mixed with paint, and trompe-l'oeil wood graining. Braque used rich, earthy colours and images built up layer by layer. His works show a wonderful sense of controlled freedom as he moves images and details around to create lyrical harmonies of colour, line, and shape (he loved music and you can sense it going through his head as he paints). Late work famous for the bird image as a simple symbol of human spiritual aspiration.

KEY WORKS Landscape near Antwerp, 1906 (New York: Guggenheim Museum); Café-Bar, 1919 (Basel, Switzerland: Kunstmuseum); Le Guéridon, 1921–22 (New York: Metropolitan Museum of Art); Still Life: Le Jour, 1929 (Washington DC: National Gallery of Art)

Juan **Gris**

→ 1887 – 1927
 P
 ■ SPANISH

☑ Paris
 ☑ oils; sculpture; collage
 ☑ London: Tate Collection
 ☑ \$7.7m in 2002, Pot de géranium (oils)

He was third in the hierarchy of the inventors of Cubism (after Picasso and Braque), concentrating mainly on still life.

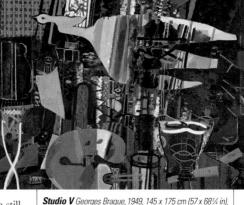

Studio V Georges Braque, 1949, 145 x 175 cm (57 x 68% in), oil on canvas, Private Collection. The artist rarely left the intimate world of his studio for subject matter, transforming everyday objects, such as guitars, tabletops, and fruit bowls into masterpieces of colour and form.

Gris moved to Paris from Spain in 1906, and in his formative years he drew witty pieces for various publications. It wasn't until 1910 that he turned to painting as a serious vocation.

He had a masterly reinterpretation of the traditional still life. Stand back and see how his meticulously crafted, stylish, highly decorative pictures look like expensive jewellery; they are often (and very effectively) shown in elaborate frames like mounts for brooches. Stand close to them and play the Cubist game of piecing together the final image from the fragmented images and clues.

He often used a dark palette to great effect, especially blacks and blues. His works have complex geometric designs and grids, with the images slipping in and out of the different planes. Playful use of lettering and speckled patterns. His brilliant and inventive papier collés get better as they get older, browner, and more antique. Somehow reminiscent of French 18th-century marguetry furniture and its fine craftsmanship? KEY WORKS Violin and Playing Cards, 1913 (New York: Metropolitan Museum of Art); Bottle of Rum and Newspaper, 1914 (New York: Guggenheim Museum); Fantômas, 1915 (Washington DC: National Gallery of Art); Still Life, 1917 (Minnesota: Minneapolis

Institute of Arts)

Fernand Léger

€ 1881-1955 PU FRENCH

 France; USA


Léger was one of the giants of the Modern Movement and an ardent believer in the moral and social function of art and architecture. Refreshingly cheerful and extrovert.

His ambition was to create a new democratic art for and about ordinary people. He achieved it through strong, straightforward imagery, style, and technique: the modern, blue-collar worker and his family at work and play, plus the machine-made objects of their world. Shows muscular happiness and spiritual joy in an ideal world where work and play become one (if it can be so for children, why can it not be so for adults?).

He was simple but not simplistic. He had a modern, moral message, which was romantic and idealistic but also challenging (a fresh restatement of "man the measure of all things"). He produced simple images and designs that contain sophisticated spatial and colour relationships. Also made beautiful and strong drawings, stage sets, tapestries, murals, films, books, and posters – he Two Women holding a Pot of Flowers Fernand Léger, c. 1920s, oil on canvas, Private Collection. Léger often painted two women together, exploring their forms and using flowers as symbols of fertility.

believed art should touch and transform all corners of everyday life. Portrayed hands as pieces of machinery. His early Cubist work was pioneering.

KEY WORKS The Smokers, 1911–12 (New York: Guggenheim Museum); The Wedding, 1912 (Paris: Musée National d'Art Moderne); The Mechanic, 1920 (Ottawa: National Gallery of Canada); The Two Sisters, 1935 (Berlin: Staatliche Museum)

Julio González

⊖ 1876-1942 🕫 SPANISH

Spain; France Sculpture; drawings; oils
 Amsterdam: Stedelijk Museum. Paris: Musée
 National d'Art Moderne Statutional d'Art Moderne Sculpture
 Komme gothique (sculpture)

He was one of the first artists to use iron as a sculptural medium. Taught by his goldsmith/sculptor father how to use metals, but spent his early years mainly as a painter.

After meeting Picasso in Barcelona, González moved to Paris where he was reacquainted with his fellow countryman and they struck up a lifelong friendship. Making jewellery and metalwork occupied González up until the 1920s, but at the age of 50 he made a total commitment to sculpture, concentrating specifically on welded metal as a material. Look for semi-abstract works on a grand scale, incorporating Picasso's brutal humour. **KEY WORKS** Woman with Hair in a Bun, 1929–34 (Art Institute of Chicago); Head Called "The Rabbit", 1930 (Madrid: Reina Sofia National Museum); Daphné, 1937 (Madrid: Reina Sofia National Museum)

Jacques Lipchitz

⊖ 1891-1973 🍽 FRENCH

I France; USA I sculpture I New York: Museum of Modern Art I \$1.4m in 1989, *Figure* (sculpture)

A talented sculptor of Lithuanian origin, Lipchitz settled in Paris in 1909 and emigrated to the USA in 1941. He was an early, sensitive, and personal interpreter of Cubism in traditional

materials (plaster, stone, terracotta, and bronze) in the 1920s. This led to a more figurative, arabesque style; then to a flirtation with Surrealism and, finally, complex Symbolism. He was always original, if sober and monumental. **KEY WORKS** *Man with a Guitar*, 1916 (New York: Museum of Modern Art); *Seated Figure*, 1917 (Ottawa: National Gallery of Canada); *Mother and Child*, 1949 (Alabama: Birmingham Museum of Art)

Frank **Kupka**

● 1871-1957 P FRENCH/CZECH

Kupka was a natural anarchist who settled in Paris at the age of 24 and stayed for ever. He was one of the first to create a true abstract art, characterized by solid, geometric blocks of colour. He had the potential to develop as a great pioneer of abstraction, but lacked an underlying philosophical drive and the single-minded dedication to fulfil it – he was distracted by too many ideas. **KEY WORKS** *Planes by Colours, Large Nude*, 1909–10 (New York: Guggenheim Museum); Vertical and Diagonal Planes, c.1913–14 (New York: Metropolitan Museum of Art); The Coloured One, c.1919–20 (New York: Guggenheim Museum)

Raoul Dufy

● 1877-1953 P FRENCH

France is its; watercolours; drawings
 Paris: Musée d'Art Moderne de la Ville de Paris
 \$2.8m in 2004, *Fête à Sainte-Adresse* (oils)

He was a talented painter who in the early days might have made the big time with Braque and Matisse – but who lacked their grit. Best known for accomplished, colourful, decorative works, much admired by fashionable *beau monde* of 1920s and 30s. Free, linear drawing; clear, floating colours; easy subjects such as horse racing and yachting. Prints and tapestry designs. **KEY WORKS** *Portrait of Suzanne Dufy, the Artis's Sister*, 1904 (St. Petersburg: Hermitage Museum); *The Baou de Saint-Jeannet*, 1923 (London: Tate Collection)

The Regatta at Covves Raoul Dufy, 1934, 82 x 100 cm (32% x 39 in), watercolour on paper, Private Collection. Dufy was not interested in art theories or questioning the meaning of life. His vivacious art, which included book and stage design, was much praised in the 1930s–1950s.

Maurice Utrillo

He was a popular painter known for not very challenging, crustily painted views of Montmartre, characterized by sharp perspectives and deserted streets. His best work was c.1908–16. Later work is less gloomy and contains small figures. Had a personal history of mental instability. **KEY WORKS** *Saint-Denis Canal*, 1906–08 (Tokyo: Bridgestone Museum of Art); *Marizy-Sainte-Geneviève*, c.1910 (Washington DC: National Gallery of Art)

Georges Rouault

● 1871-1958 P FRENCH

France D oils; drawings
 St. Petersburg: Hermitage Museum

\$1.6m in 1990, *Fille de cirque* (oils)

Rouault was an important French painter with a highly individual style. An unhappy loner who deliberately stood outside the mainstream of Modern art.

He chose losers and the exploited as his subjects, expressing through them his bleak view of life and the activities and rituals used by human beings as they prey on each other in a struggle for survival. He was one of the very few committed Christian artists of the 20th century.

His dark palette reflected his gloomy subjects. Uses faces to convey expression. The black outlines and his choice of colours give a deliberate appearance of stained glass to his paintings – there is an icon-like quality in his figures. **KEY WORKS** *Les Filles*, 1904 (St. Petersburg: Hermitage Museum); *Nude with Raised Arm*, 1906 (St. Petersburg: Hermitage Museum); *Christ in the Outskirts*, 1920 (Tokyo: Bridgestone Museum of Art)

Kees van Dongen

⊖ 1877-1968 P FRENCH

Paris doils doise Moscow: Pushkin Museum
 \$5.3m in 2004, Femme fatale (oils)

He was Dutch-born but considered an honorary Frenchman (settled in Paris 1897). Best remembered for the work he produced from 1905 to 1913: they are genuinely original, boldly painted works, in saturated vibrant colours, which made him one of the leading Fauve painters and placed him almost on a par with Matisse. His later work is lively, but repetitive and unimaginative. **KEY WORKS** *The Red Dancer*, 1907 (St. Petersburg: Hermitage Muscum); *Woman in a Black Hat*, 1908 (St. Petersburg: Hermitage Muscum)

Robert **Delaunay**

● 1885 – 1941
 P FRENCH
 Prance; Spain; Portugal
 P oils
 New York: Guggenheim Museum
 \$4.7m in 1991, Premier disque (oils)

Delaunay was one of the pioneers of modern art. Sought new types of subject matter and made an early breakthrough to abstract painting. Much supported by Russian-born wife, Sonia, who produced equally talented art in a similar style, and was also a theatre and textiles designer.

His early work takes modern themes such as cities, the Eiffel Tower, manned flight, and football. Delaunay used colour in a free and highly inventive way, most famously in his discs, which are abstract, lyrical, full of light and pleasure, and intended to celebrate the emotional and joyful impact of pure colour. **KEY WORKS** *Red Eiffel Tower*, 1911 (New York: Guggenheim Museum); *Simultaneous Open Windows*, 1912 (London: Tate Gollection); *Homage to Blériot*, 1914 (Basel, Switzerland: Kunstmuseum)

Marc Chagall

⊕ 1887-1985
 ₱ RUSSIAN/FRENCH

☑ France; Russia
 ☑ oils
 ☑ Nice: Musée Marc
 Chagall
 ☑ \$13.5m in 1990, Anniversaire (oils)

He was a Russian-born Hasidic Jew whose inspiration was his early cultural roots.

His unique and personal marriage of subjects, themes, and quirky, personal style perpetuate an enduring air of childlike innocence and wonder. He was very prolific – paintings, prints, ceramics, stained glass, murals – which inevitably leads to uneven quality. Best paintings generally early and pre-1950; worst work is sugary, sentimental, and slight (but has never lost its popularity). Chagall concentrated on major stained-glass projects after 1950. Do the odd floating heads and bodies and his combination of simultaneous events in one picture reflect his own strange, peripatetic life and consequent cultural eclecticism? **KEY WORKS** *The Fiddler*, 1912–13 (Washington DC: National Gallery of Art); *Paris through the* Window, 1913 (New York: Guggenheim Museum); *The Rooster*, 1929 (Madrid: Museo Thyssen-Bornemisza); *War*, 1917, 1964–66 (Zurich: Kunsthaus)

The Juggler Marc Chagall, 1943, 132 x 100 cm (52 x 39% in), oil on canvas, Private Collection. Chagall settled in France in 1914. His art combines Russian folk art, Cubist fragmentation, and Expressionist colour.

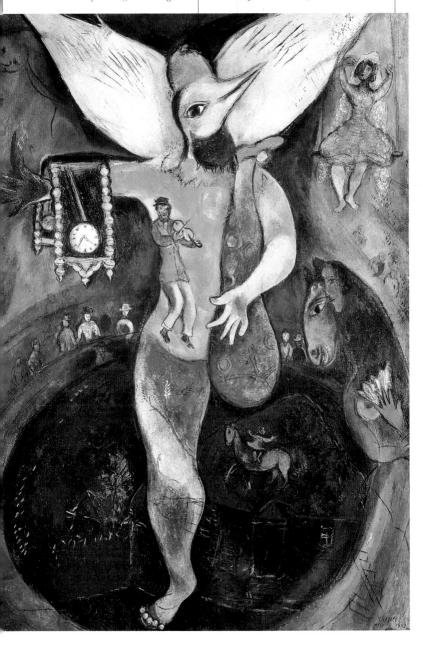

Bird in Space

Constantin Brancusi 1923

A wonderful simplification of form and deeply sacred approach to his work made Brancusi highly influential in the development not only of 20th-century sculpture but of abstract art generally.

Often seen as the pinnacle of Brancusi's work, this gleaming, highly polished bronze stands five feet tall, simply but gracefully capturing the gentle elegance of a bird in flight. Some see it as a bird lifting into the air, others as a gigantic golden feather denoting the whole motion of flight. Its Minimalist poise and haunting presence creates a meditative stillness. Brancusi, a Romanian who settled in Paris, always sought to achieve a mystic symbolism in his work, fascinated by universal symbols of life and fertility. He made 28 versions of this piece.

Bird in Space

 Medium
 bronze

 Height
 144 cm (56 % in)

 Location
 New York: Metropolitan

 Museum of Art
 Metropolitan

Constantin Brancusi

⊖ 1876 – 1957
 P ROMANIAN/FRENCH

Paris Active active active active partial partiap partial partial partial partial partial partial

Brancusi was a seminal figure in 20thcentury art, with a profound influence on sculpture and design. Born into a Romanian peasant family, settled in Paris in 1904. Student of Rodin. Remained indifferent to honour and fame.

His work shows tireless refinement and search for purity. Constant reworking of selected themes – children, human heads, birds, modular columns. Interested in abstract ideals such as the purity of primordial (simple) forms, but was never an abstract artist – a reference to a recognizable nature is always present. Nothing symmetrical or geometrical means this graceful turning bronze captures an innate sense of flight-like motion

The light beautifully catches the yellow bronze as the sculpture starts to widen out and commence its gentle turn

"Simplicity is not an end in art but we arrive at simplicity in spite of ourselves."

CONSTANTIN BRANCUSI

The stone base is a wonderful contrast in texture and colour to the lightness of the metal

Emphasis on the inherent qualities of materials. Touches something very basic in the human psyche. As soothing as the sound of the waves of the sea.

Endless pleasure can be derived from the contemplation of pure line, simplicity of form (such as an egg shape), light reflecting off surfaces, materials unadorned and unadulterated. Notice the bases that are an integral part of the whole work. His studio became a work of art in its own right because of the way he grouped his work in it to bring out comparisons and reflections of light.

KEY WORKS The Kiss, 1909 (Paris: Montparnasse Cemetery); Princess X, 1916 (Paris: Musée National d'Art Moderne); Mademoiselle Pogani, 1920 (Paris: Musée National d'Art Moderne); Maquettes for the Endless Column, 1937 (Paris: Musée National d'Art Moderne)

THE SCHOOL OF PARIS

1900-1950

From 1900 to 1950 Paris was the centre of artistic innovation and attracted artists, collectors, dealers, and connoisseurs from all over the world. All the major innovations from Cubism to Surrealism originated in Parisian studios, and could be first seen there in avant-garde exhibitions. This diversity of styles, artists, and activity has been labelled loosely as "Ecole de Paris" (School of Paris).

Chaïm Soutine

● 1894-1943 P FRENCH

He was a Lithuanian-born Jew who worked in Paris. Undisciplined, tragic, and depressive. Unknown in his own lifetime although was recognized and supported by a few dedicated collectors.

Look for portraits, landscapes, and flayed carcasses. He had a wide emotional range – from angelic choirboys to dead meat. At a distance the paintings look controlled and neat, but close up the churning distortions and paint handling become dominant.

He had acute colour sense and produced lovely harmonies of colour. His work shows uncontrolled distortion, but this is not arbitrary. Cracked painting surfaces show the speed with which he worked, painting over layers not yet dry. Many influences, such as Cézanne and El Greco.

KEY WORKS Self-Portrait, 1916 (St. Petersburg: Hermitage Museum); Landscape at Ceret, c.1920 (London: Tate Collection); Side of Beef, 1925 (Buffalo: Albright-Knox Art Gallery)

Amedeo Modigliani

⊖ 1884-1920 🍽 ITALIAN

He was a neurotic, spoilt, tubercular, drug-addicted, woman-beating, povertystricken but talented pioneer who achieved a genuine and satisfactory synthesis between the priorities of the old masters and those of modern art.

Modigliani created very recognizable portraits and splashy nudes, both highly stylized, simplified, painterly, poetic, decorative, and moody. Notice the inclined heads with long faces on long necks; elongated noses; almond-shaped eyes with a glazed and far-away stare, which show the influence of his original, gifted, carved stone sculptures and his study of African and Oceanic art. Good sculptures. Sensitive drawings.

He had many influences: African art; Art Nouveau; Matisse-like simplification; Cézanne- and Cubist-like fragmentation of space around the figures; Picasso-like intensity and confident, fluent line. Would he have gone on to greater things or was he burned out? His early death probably saved his reputation.

KEY WORKS *Head*, c.1911–12 (London: Tate Collection); *Paul Guillaume*, 1916 (Milan: Galleria d'Arte Moderna); *Chaïm Soutine*, 1917 (Washington DC: National Gallery of Art); *Nude on a Blue Cushion*, 1917 (Washington DC: National Gallery of Art)

Jeanne Hébuterne in a Yellow Jumper Amedeo Modigliani, 1918–19, 100 x 65 cm (39 ½ x 25½ in), oil on canvas, New York: Guggenheim Museum. She was the artist's common-law wife and frequent subject.

EXPRESSIONISM AND ABSTRACTION

Expressionism and Abstraction were key early trends in the development of Modern Art, and their influence continues in full force to the present day with many different individual styles. Early practitioners wanted art to become more like music, conveying emotion and meaning by suggestion, heightened sensation, and free association, rather than by description of forms and appearances.

EXPRESSIONISM

Any style that conveys heightened sensibility through distortion of e.g. colour, drawing, space, scale, form, and/or intense subject matter, or a combination of these. Expressionism was a particularly strong tendency in German art as a way of facing up to the spiritual and social crises that arose at the time of World War I.

Storm Tide in Hamburg Oskar Kokoschka, 1962, 90 x 118 cm (35¾ x 46½ in), oil on canvas, Hamburg: Kunsthalle. Painted in the year of his Tate Gallery retrospective.

ABSTRACTION

A true example of abstract art has intellectual or emotional meaning (or both), but does not represent or imitate any visible object or figure. Good abstract art is not easy to get to grips with, but it will reward the effort involved. You may need to see a large

KEY EVENTS

1910	Kandinsky paints his first abstracts
1911	Kandinsky writes the abstract artists' chief treatise <i>On the Spiritual in Art</i> and establishes Blaue Reiter group
1914	Outbreak of World War I. Several artists are killed in action, including Franz Marc and August Macke
1919	Weimar Republic takes control in Germany Period of cultural and artistic diversity. Egon Schiele dies in influenza pandemic
1934	Expressionism condemned as "degenerate art" by Nazi party

number of works together as well (for example, in an exhibition devoted to the artist) in order for you to begin to see fully and understand what the artist is trying to put over. One piece in a mixed show is often – frankly – meaningless, because all that you can hope to notice are the eye-catching or superficial qualities of the work.

Faultier Franz Marc, 1912, 14.3 x 21.4 cm (5% x 8% in), woodcut, Hamburg: Kunsthalle. In 1911 Marc embarked on a series of paintings of animals; these have since become the cornerstone of his reputation.

early 20th century

WHAT TO LOOK FOR

Starting out as a figurative painter, Wassily Kandinsky was among the first to create a truly abstract art in which colour and form take on an expressive life of their own. Painted at the height of his creative powers, this work

> Red was described as giving "the impression of a strong drum beat", whereas green was "the attenuated sounds of a violin"

encapsulates his theories about the emotional properties of shape, line, and colour. It was painted after he settled in Germany for the second time. He left his academic posts in Russia disillusioned with the outcome of the Revolution.

> For Kandinsky, horizontal lines were "cold and flat", verticals "warm, strong, and yellow", right angles "cold, controlled, and red"

Black Frame

Wassily Kandinsky, 1922, oil on canvas, Paris: Musée National d'Art Moderne. Painted just after Kandinsky began teaching at the Bauhaus.

The artist contrasts curved lines, which are "mature", with angular lines, which are "youthful"

A painting such as this should not be analyzed intellectually but allowed to reach those parts of the brain that connect with music

According to Kandinsky's theories, yellow possesses a capacity to "attain heights unbearable to the eye and the spirit"

TECHNIQUES

Works such as this were planned and executed with the utmost care and precision by Kandinsky. Colours, angles, and the places where lines touched and planes overlapped had to be absolutely exact.

Kandinsky was

interested in the connections between art and music. He could literally "hear" colours, a quality that is known as synaesthesia.

Egon Schiele

⊖ 1890-1918 P GERMAN

 Vienna (1) oils; watercolours; drawings
 Washington DC: National Gallery of Art
 \$18,871,000 in 2003, *Krumau Landscape, Town and River* (oils)

An intense, tragic, short-lived genius whose art expressed his own self-destructive personality and the claustrophobic introspection of Sigmund Freud's Vienna. He died, together with his pregnant young wife, in the great flu epidemic.

His art concentrates on sexually intense subjects, including portraits, self-portraits, and (at end of his life) religious works. Look for isolated, single figures, often shown in silhouette; couples or groups of figures in highly charged relationships; bodies in contorted positions; gaunt faces lost in inner thoughts; cityscapes in Art-Nouveau style. A precocious, gifted draughtsman, he also made many drawings and watercolours. His paintings have a tense, nervous, probing outline, rapidly filled with colour, which gives them a strong sense of immediacy and urgency.

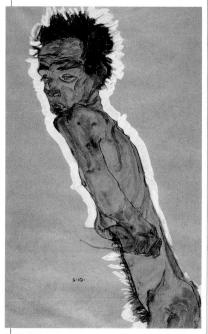

Self-Portrait Nude Egon Schiele, 1910, 110 x 35.5 cm (43 x 14% inl), oil on carvas, Vienna: Graphische Sammlung Albertina. Schiele often isolates his figures against a plain background – like specimens on a dissecting table.

His work can still extract a genuine gasp, if not the shock or horror of 100 years ago. It attracted fierce opposition from conservative society, and Schiele was arrested and imprisoned on the charge of depraving children. He was, however, recognized and successful in advanced circles. He saw the human figure or spirit as animal rather than moral. Insisted on absolute freedom for creative individuality and self-determination.

KEY WORKS Mourning Woman, 1912 (New York: Museum of Modern Art); Houses on the River (The Old Town), 1914 (Madrid: Museo Thyssen-Bornemisza); Embrace, 1917 (Vienna: Österreichische Galerie)

Edvard Munch

1863–1944 P NORWEGIAN
 Oslo; Paris; Berlin O oils; prints; woodcuts
 Oslo: Munch Museum; National Gallery
 \$6,627,000 in 2002, Haus in Aasgaardstrand (oils)

The best-known Norwegian and Scandinavian painter, and a forerunner of Expressionism. His early life was tortured by sickness, death, insanity, rejection, unhappy love affairs, and guilt – a textbook case for Freud.

Observe the way he worked through his neuroses in his paintings. The best, most intense, works are before his nervous breakdown in 1908. They are full of recognizable (almost clichéd) images of isolation, rejection, sexuality, and death, but he had a rare ability to portray such intimate emotions in a universal way, so that we can recognize and even come to terms with our own inner fears, as well as being able to touch his. He made anxiety beautiful.

The sketchy, unfinished style, using scrubby paint (with scratch marks from the handle of the brush), alongside simple and balanced compositions reveals much of his inner uncertainty and search for peace and stability. Look for intense colour combinations, strange flesh colours, an obsessive interest in eyes and eye sockets, phallic symbols. His woodcuts, which exploit the grain of the wood, are some of the most accomplished things he did. **KEY WORKS** *The Sick Child*, 1885–86 (Oslo: National Gallery); *Starry Night*, 1893 (Los Angeles; J. Paul Getty Museum); *Madonna*, 1893–94 (Oslo: Munch Museum)

C.1900-70

The Scream

Edvard Munch c.1893

Munch's *The Scream* – one of the world's most recognizable paintings – was part of his *The Frieze of Life*, "a poem about life, love, and death". The project occupied him for much of his life: an attempt to find pictorial means to represent inner turmoil and angst.

Much like Van Gogh, by whom he was deeply influenced, Munch devised a startling visual language to give expression to the neuroses that dogged his life: despair, rejection, and loneliness.

Lurid reds, greens, and yellows fill the sky, their unnaturalness a striking metaphor for the central figure's despair

The composition is simple: the strong, unsettling diagonal of the bridge and rail contrasting with the opposing diagonal of the water. The horizon is relatively high and strongly emphasized. The principal figure is placed firmly in the centre of the picture

TECHNIQUES

Paint is applied with a seemingly violent action – often with the brush handle – creating a potent sense of restlessness and distortion. The apparent haste with which the picture was painted is deceptive; it was planned and executed meticulously.

The Scream

Media oil, tempera, and pastel on cardboard Dimensions 91 x 73 cm (35 x 29 in) Location Oslo: National Gallery

The obvious primal quality of *The Scream* – Munch in fact painted two versions – conveys this profound sense of alienation and nightmare with shocking directness.

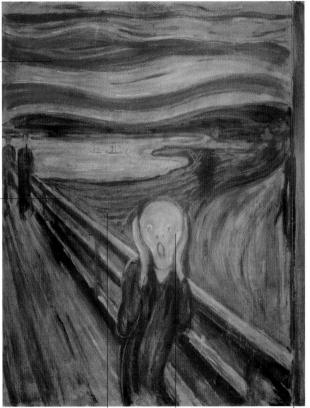

A near formless landscape suggests a world dissolving into chaos. Like the vivid sky, these patterns prefigure fully abstract painting Staring, hollow eyes on a skull-like face are a recurring feature of Munch's deeply disturbed figures

Emil Nolde

Munich: Paris: Germany: Asia

oils; watercolours; prints; engravings

2 \$2.9m in 2002, Blumengarten (oils)

radical-regressive complexity. He

was very interested in non-European "primitive" art, but believed in racial

Deebüll, Germany: Stiftung Ada und Emil Nolde

A pioneering Expressionist and member

of Die Brücke, Nolde's art hides a unique

purity and the concept of a master race.

This was Expressionism done with flair. He shares Expressionism's strengths (spontaneity, passion, visual challenge) and weaknesses (too strident, soon runs out of steam). Creator of landscapes, seascapes (his best work), and figure painting. Uses bright, clashing colours and thick paint, resulting in simplification and a conscious crudeness. Had an instinct for colour; most apparent when his work

His early work was on the cutting edge of the avant-garde, but he never developed to sustain his original levels of Expressionist

is seen from a distance.

1905-13

Important avant-garde group of German Expressionists based in Dresden, founded by Kirchner, Schmidt-Rottluff, Heckel, and Fritz Blevl. They expressed radical political and social views through modern, urban subject matter or landscapes and figures. Later associated artists included Nolde, Pechstein, and Van Dongen. They were influenced by the latest Parisian ideas and primitive non-European art. Look for bright colours, bold outlines, and deliberately unsophisticated techniques (most of the group were without proper training). Influential in the revival of the woodcut as an expressive medium.

they rejected his art – perhaps he was (sadly) a curious case of arrested development, artistically and politically? **KEY WORKS** *Young Black Horses*, 1916 (Dortmund: Museum am Ostwall); Orchids, 1925 (Private Collection): The Artist and his Wife, c.1932 (Detroit Institute of Arts)

Otto Müller

● 1874-1930 P GERMAN

🔟 Germany 🚺 prints; oils 🟛 Berlin: Brücke Museum 🛛 🎦 \$1.62m in 1997, Zigeunerinnen am Lagerfeuer (oils)

Müller was an important but short-lived contributor to the German avant-garde. 1906-14 (Die Brücke). Powerful images of nudes in landscape. "Primitive", rough texture, bold outline and colour, deriving from Matisse and the Cubists. Painted gypsy subjects after 1920.

KEY WORKS Two Bathers, c.1920 (Washington DC: National Gallery of Art); Adam and Eve, 1920-22 (San Francisco: Fine Arts Museums)

Ernst Ludwig **Kirchner**

⊖ 1880-1938 P GERMAN

Dresden; Berlin; Frauenkirch (Switzerland) prints; oils; sculpture 🖬 Davos (Switzerland): Kirchner Museum. Berlin: Brücke Museum \$4,704,000 in 2003, Akte in der Sonne, Moritzburg (oils)

A key member of Die Brücke, Kirchner was sensitive, prone to mental and physical breakdown (terrible war experiences). Expressed the schizophrenic mood of his times in a highly charged,

The Dancers Emil Nolde, 1920, oil on canvas, Stuttgart: Staatsgalerie. Nolde had been much influenced by a visit to New Guinea in 1913, saying "Everything which is primeval and elementary captures my imagination."

c.1900 - 70

"Everyone who renders directly and honestly whatever drives him to create is one of us."

ERNST LUDWIG KIRCHNER, DIE BRÜCKE MANIFESTO

tense, Expressionist style. Had a sketchy, wiry technique, making use of heightened, intensified colour. Committed suicide. **KEY WORKS** Artillerymen, 1915 (New York: Guggenheim Museum); Self-Portrait as a Soldier, 1915 (Ohio: Allen Memorial Art Museum)

Max Pechstein

 ● 1881–1955
 № GERMAN
 № Dresden; Berlin; Palau Islands
 (South-East Asia)
 № prints; oils; engravings
 № Berlin: Brücke Museum
 № \$1,261,600 in 1997, Seated Girl (oils)

A leading member of Die Brücke, Pechstein was a painter and engraver who also designed decorative projects and stained glass. Was called "the Giotto of our time". Characteristic flat style, using pure, unmixed colours and lyrical subjects of figures, nudes, and animals in landscape. Influenced by Matisse and Oceanic art. Commercially successful, he

alienated his fellow avant-garde artists. **KEY WORKS** *Nelly*, 1910 (San Francisco: Museum of Modern Art); *Seated Nude*, 1910 (Berlin: Staatliche Museum)

Erich Heckel

⊖ 1883-1970 🕫 GERMAN

Dresden; Berlin; Flanders; Lake Constance
 prints; engravings
 Berlin: Brücke
 Museum
 \$1,584,000 in 2000, Dangast,
 Village Landscape (oils)

Heckel was a leading German Expressionist (member of Die Brücke). Untrained. Painted powerful, pessimistic images of nudes, portraits, sickness, and anguish with a corresponding fierce and angular style, using strident colours. His landscapes are more decorative.

KEY WORKS *Two Bathers*, c.1920 (Washington DC: National Gallery of Art); *Adam and Eve*, 1920–22 (San Francisco: Fine Arts Museums)

Berlin Street Scene Ernst Ludwig Kirchner, 1913, 121 x 95 cm (47½ x 37½ in), oil on canvas, Berlin: Brücke Museum. Kirchner moved to Berlin in 1911 and became fascinated by the edginess of street life.

Karl Schmidt-Rottluff

⊖ 1884–1976 PC GERMAN

A leading German Expressionist and member of Die Brücke, noted for his instinctive, forceful, angular, monumental style, which uses consciously harsh colour and aggressive simplification. His later style (after 1945) is softer and more fluid, but still involves intense colour. Made powerful woodcuts and lithographs. Reviled by the Nazis. **KEY WORKS** *Gap in the Dyke*, 1910 (Berlin: Brucke Museum); *Red Tower in the Park*, 1910 (Frankfurt: Städel Museum)

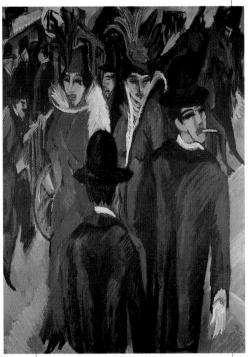

Wassily Kandinsky

€ 1866-1944 PURUSSIAN

 Image: Munich; Russia; Weimar (Germany);

 Paris
 Image: Image:

One of the pioneers of the Modern Movement and reputedly the painter of the first abstract picture. Lived in Germany 1896–1914 and 1923–33, and taught at the Bauhaus in the 1920s.

He worked slowly from increasingly simplified figurative work through to sketchy abstracts and then hard-edge abstract. Had a complex, multifaceted personality. For example, he cultivated an intellectual rather than instinctive approach to art, backed up by much theoretical writing, but at the same time he had a strong physical sensitivity to colour, which he could hear as well as see (a phenomenon called synaesthesia).

Stand close to the paintings, let them fill your field of vision, then try to relax the eye and the mind so the colour and shapes reach that part of the brain that responds to music – don't analyze them, but float into them and let yourself go. If you have never looked at a picture this way before, it can often be a strange, exhilarating, spiritual experience, but it will need time and patience. **KEY WORKS** *St. George I*, 1911 (St. Petersburg: Hermitage Museum); *Improvisation 31 (Sea Battle)*, 1913 (Washington DC: National Accent in Pink Wassily Kandinsky, 1926, 100 x 80 cm (39/ x 31/xin), oil on canvas, Paris: Musée National d'Art Moderne, Painted in the same year that the Bauhaus published his major treatise Point and Line to Plane.

Gallery of Art); *Black Frame*, 1922 (Paris: Musée National d'Art Moderne); *Several Circles*, 1926 (New York: Guggenheim Museum)

Gabriele Münter

⊖ 1877-1962 P GERMAN

Louisseldorf; Munich
 Munich:
 Lenbachhause
 S600,000 in 2000, Kind
 mit Puppe (oils)

Strongly influenced by Fauvism, Münter was a leader of Der Blaue Reiter Group and Kandinsky's partner and mistress from 1903 until 1914. During this time she painted bold, expressive, original, and colourful still lifes and landscapes. She broke for good from Kandinsky in 1917 and ceased to paint.

KEY WORKS Interior, 1908 (New York: Museum of Modern Art); View From her Brother's House in Bonn, 1908 (Madrid: Museo Thyssen-Bornemisza); Future (Woman in Stockholm), 1917 (Ohio: Cleveland Museum of Art)

с.1900-70

Franz Marc

Munich: Paris 🚺 oils 🖬 New York: Guggenheim Museum 🔊 \$7.59m in 1999, Der Wasserfall: Fraeun unter einem Wasserfall (oils)

The son of a Munich painter, Marc was a key member of the Der Blaue Reiter group. Author of richly sourced, very personal art, which explores a vision of a unified world in which animals and the rest of nature exist in perfect harmony. Combined progressive French Cubist structure; Matisse-like expressive colour; Kandinsky's spiritualism, and oldfashioned, German Romantic notions of nature. By 1914 he had become more abstract. Was killed in action at Verdun. KEY WORKS The Tiger, 1912 (Munich: Städtische Galerie); Animals, 1913 (Moscow: Pushkin Museum); The Mandrill, 1913 (Munich: Staatsgalerie Moderner Kunst)

Little Blue Horse Franz Marc, 1912, 58 x 73 cm (223/4 x 283/4 in), oil on canvas, Saarbrüken (Germany): Saarland Museum. Marc thought that animals had an inherent innocence that gave them access to greater truths than humans, and that their fate paralleled the apocalyptic future to be visited on mankind

DER BLAUE REITER 1911 - 14

An important, loosely grouped association of avant-garde German Expressionists, based in Munich. Kandinsky and Marc were the key members, but the group included Klee, Macke, and Münter. Their name, meaning "The Blue Rider", came from the Kandinsky painting used on the cover of their Almanac. They wanted to

put spiritual values into art and used abstraction. simplification, and the power of colour as a means of doing this.

The Almanac of 1912

included articles and illustrations by Der Blaue Reiter artists and the composer Arnold Schoenberg, and even a play by Kandinsky.

"A work of art is a parable, it is man's thought, an autonomous idea of an artist." AUGUST MACKE

August Macke

Berlin: Paris: Munich: Tunisia 🚺 oils; watercolours 🖬 Bonn: Kunstmuseum \$3,744,000 in 2000, Market in Tunis (oils)

A leading German Expressionist of Der Blaue Reiter group and the most French in outlook and expression - a joyful, rather than anguished, agenda (Rhinelanders are more cheerful?). Made lyrical use of clear, vibrant colour and figurative subject matter. A possibly great talent, but he died, aged 27, in the first German offensive in World War I. KEY WORKS Garden on Lake Thun, 1913 (Bonn: Städtisches Kunstmuseum); Woman in a Green Jacket, 1913 (Cologne: Museum Ludwig); Lady in a Park, 1914 (New York: Museum of Modern Art); Promenade (with Half-Length of Girl in White), 1914 (Stuttgart: Staatsgalerie)

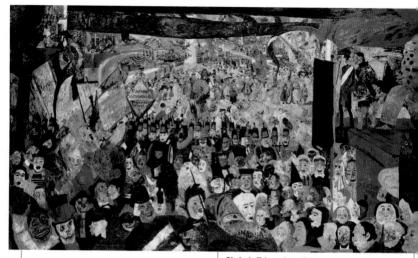

James Ensor

- Ostend; Brussels 🚺 oils; engravings
- Dostend: Museum of Fine Arts
- \$705,600 in 2004, Bons Juges (oils)

A talented loner remembered for his eccentric, brightly coloured, nervously painted, and macabre imagery (skulls, skeletons, self-portraits, suffering Christ), much of it deriving from childhood memories of objects in his parents' souvenir shop. Best work between 1885 and 1891 (he tends to repeat himself after that). Belated recognition. Highquality drawings and engravings. **KEY WORKS** *Still Life with Ray*, 1892 (Bruges: Musées Royaux des Beaux-Arts); *Still Life with Sea Shells*, 1923 (Boston: Museum of Fine Arts)

Käthe Kollwitz

⊖ 1867-1945 P GERMAN

 Berlin; Flanders; Russia Prints; sculpture; woodcuts; watercolours; engravings Berlin: Käthe-Kollwitz-Museum \$149,063 in 2003, Self-Portrait (watercolours)

From a family of strong moral and social convictions, Kollwitz became one of the great printmakers (especially of black-and-white woodcuts). Also a sculptor. She placed emphasis on strength: of emotion, of the human body (she saw it as Christ's Triumphant Entry into Brussels James Ensor, 1888, 258 x 431 cm (101% x 169% in), oil on canvas, Los Angeles: J. Paul Getty Museum. An early masterpiece motivated more by a belief in the future triumph of Socialism than in Christian religion.

monumental), and gave importance to expressive hands and faces. Chose personal themes – mother and child, son's death (World War I), self-portraits. She was politically committed, a social reformer (but never revolutionary), and much honoured (except by the Nazis). **KEY WORKS** Weavers' Revolt Series, 1895–98 (Berlin: Käthe-Kollwitz-Museum); Peasants' War Series, 1902–08 (Berlin: Käthe-Kollwitz-Museum); The Widow I, the Mothers, and the Volunteers, 1922–24 (New York: Museum of Modern Art)

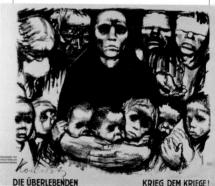

The Survivors; War against War; Anti-War Day 21 September 1924 Käthe Kollwitz, 1924, print, Florida: Holocaust Museum. The poster was published by the International Federation of Trade Unions, Amsterdam.

367

Oskar **Kokoschka**

⊖ 1886-1980 P GERMAN

Vienna; Dresden; Prague; London; Switzerland
 oils; prints; watercolours
 London:
 Courtauld Institute of Art
 \$2.7m in 1989,
 Dresden, Neustadt I (oils)

From the same generation as Sigmund Freud, also from Vienna, he was best known for his powerful Expressionist portraits and self-portraits, very freely painted and rich in colour. Also painted landscapes and townscapes. Responded best to strong, famous faces and views. A deep-thinking, deep-feeling humanist. **KEY WORKS** Bride of the Wind, 1914 (Basel, Switzerland: Kunstmuseum); Jerusalem, 1929–30 (Detroit Institute of Arts)

Francis Picabia

€ 1879-1953 P FRENCH

Paris; USA; Barcelona; Côte d'Azur Dioils; mixed media Mew York: Museum of Modern Art 2 \$4.15m in 1990, Petite Udnie (oils)

He was a quixotic, anarchic character, best remembered for his involvement with Dada. He flirted with Cubism, Expressionism, and Surrealism. His most effective work was in his "machine style" phase (1913–1920s), when he used the inspiration of technical drawings to produce telling images that comment ironically on man's relationship with machines (often with erotic overtones). **KEY WORKS** *I See Again in Memory My Dear Udnie*, 1914 (New York: Museum of Modern Art); *Very Rare Picture on Earth*, 1915 (New York: Guggenheim Museum)

Marcel Duchamp

⊖ 1887-1968 P FRENCH

Paris; New York oils; sculpture; mixed media
 Philadelphia: Museum of Art
 \$1.6m in 2002, *Bicycle Wheel* (sculpture)

The father of Conceptual art, Duchamp was applauded as one of the great gurus and heroes of the Modern Movement, but his work is possibly one of its greatest bores (it is possible to achieve both at the same time).

The ragbag of his few works are now icons of the Modern Movement (notably the urinal; see below). None are very interesting to look at per se, but Duchamp was the first to propose that the interest and stimulus of a work of art can lie solely in its concept or intellectual content – it doesn't matter what it looks like, as long as you can pick up the message.

To speak ill of Duchamp is to invite the wrath and derision of the entire modern art establishment. However, although he was significant in his day, in all honesty his work is quite limited and now looks distinctly tired. Not quite a case of the Emperor's clothes, but time to say that the suit is now threadbare and oldfashioned. A brilliant, charming but arrogant, intellectual thug who continues to mesmerize and intimidate the art world from beyond the grave. **KEY WORKS** Nude Descending Staircase, No.2, 1912 (Philadelphia: Museum of Art); The Bride, 1912 (Philadelphia: Museum of Art); Fountain (replica), 1917 (London: Tate Collection); In Advance of the Broken Arm, 1945 (New Haven: Yale University Art Gallery)

DADA

The first of the modern anti-art movements, with strands in Europe and New York. Its prominent figures (Arp, Duchamp, Ernst, Man Ray, and Picabia) deliberately used the absurd, banal, offensive, and tatty to shock and to challenge all existing ideas about art, life, and society. The name (French for "hobby-horse") was probably chosen by randomly inserting a penknife into a dictionary.

Fountain (Urinal) (replica, original lost), Marcel Duchamp, 1917 (remade 1964), height 61 cm (24 in), porcelain, London: Tate Collection. Made for a US exhibition; the artist had decamped to America in 1915.

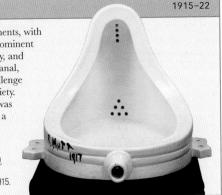

Kurt Schwitters

⊖ 1887-1948 🕫 GERMAN

 □ Hanover; Norway; UK
 □ collage; mixed

 media; oils; sculpture
 □ Hanover: Sprengel

 Museum
 □ \$327,800 in 1993, Merzbild mit

 Kerze (sculpture)
 □

He was a pioneering, poetic, romantic loner who used the fragments no one

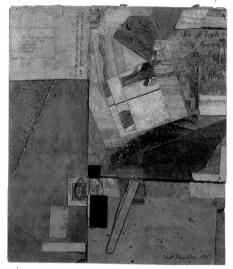

YMCA Flag, Thank You, Ambleside Kurt Schwitters, 1947, mixed media, Kendal, Cumbria (UK): Abbot Hall Art Gallery. The title refers to the English Lake District, where the artist settled in 1945.

bothered with to make sense of a world that he found politically, culturally, and socially mad – Germany from 1914 to 1945. Schwitters ran a successful, pioneering advertising agency from 1924 to 1930. Died in England as a refugee. Was influential, especially in the 1960s and 1970s.

His small-scale "Merzbilder" collages were created in great number and with extraordinary care, both in composition, content, and arrangement. He used material that he, literally, picked up in the streets of his native Hanover. His work of 1922–30 is more consciously constructed (and influenced by Russian Constructivism and Dutch De Stijl). Produced a few high-quality, traditional paintings and sculptures as a deliberate contrast to his avant-garde activities.

His early roots were in Dada, but he was never political, polemical, or satirical.

His work is always personal or autobiographical – the artist as sacrificial victim or spiritual leader. His major (manic) project was "Merzbau" – a whole building filled with personal *objets trowels* – a collage gone mad. (It was destroyed by Allied bombs in 1943; a successor near Oslo was destroyed by fire in 1951.) Poignant attempt to create a new beauty

on the ruins of German culture. **KEY WORKS** Merzbild 5B (Picture-Red-Heart-Church), 1919 (New York: Guggenheim Museum); Merz 163, with Woman Sweating, 1920 (New York: Guggenheim Museum); Merz Picture 32A (The Cherry Picture), 1921 (New York: Museum of Modern Art); Flight, 1946 (Kendal, Cumbria, UK: Abbot Hall Art Gallery)

Jean (Hans) **Arp**

•	1886-1966	PU FRENCH	
ρ	France; Ger	many; Switze	erland
٥	collage; scu	Ilpture; oils	2,671,23
in	2003, Femm	e (sculpture)	

A poet, painter, and sculptor as well as an experimenter, best remembered for wood reliefs, cardboard cutouts, torn paper collages, and (after 1931) stone sculptures. His early work is

modest in scale and appearance. Arp liked simplicity, biomorphic shapes, and chance. Took natural forms and sought

Head Jean (Hans) Arp. 1929, 67 x 56.5 cm (26 ½ x 22 ½ in), relief, Private Collection. Arp regarded his simplified shapes as emblems of natural growth and forms, using light-hearted inspiration from plants, animals, and man.

to perfect their shape and inner spirit. Founder of Dada and Surrealism. **KEY WORKS** Collage with Squares Arranged According to the Laws of Chance, 1916–17 (New York: Museum of Modern Art); Birds in an Aquarium, c.1920 (New York: Museum of Modern Art)

John **Heartfield** (Helmut Herzfelde)

⊖ 1891-1968 P GERMAN

☐ Berlin; London [] photomontage ☐ New York: George Eastman House [2] \$7,920 in 2000, Family, Sunday Walk (watercolours)

An artist and journalist, founder of Dada in Berlin in 1910, Heartfield is perhaps best known for developing political photomontage in Berlin in the 1920s and 1930s. Took refuge in England from 1938 to

1950. Settled in East Germany from 1950.

He had an intense social and political commitment (left wing, anti-Nazi), and anglicized his name as a protest against German nationalism. Original manipulator of media imagery and lettering, producing biting and memorable satire, highly expressive of its age.

Notice the economy of means: Heartfield knew exactly what he wanted to say and went for the jugular with one

simple, unforgettable image – less is more. KEY WORKS Adolf the Superman: Swallows Gold and Spouts Junk, 1920 (Berlin: Akademie der Künste); Five Fingers has the Hand, 1928 (New York: Smithsonian Cooper-Hewitt National Design Museum)

Max Ernst

⊖ 1891-1976 P GERMAN

 Image: Bonn; Cologne; Paris; New York
 Image: prints; collage; sculpture; oils

 Image: Sculpture; oils
 Image: Bruhl, Germany:

 Max Ernst Museum
 Image: Sculpture; Sculp

One of the leading Surrealists, Ernst lived in France after 1921 (and in the USA from 1941 to 1953). After serving in World War I, he became with Jean Arp, his lifelong friend, the leader of the Dada movement in Cologne.

His witty and inventive experimentation unites subject and technique to great effect. Pioneer of the Surrealist desire to explore the subconscious and create a sense of disturbing out-of-this-world reality. His experimental techniques were a means of activating or liberating his own imagination and, by extension, ours. Don't be tempted into an overly serious, analytical, or historical approach to his work. Relax, and enter into the imaginative play he sets up.

Look for his own childhood memories, such as forests and little bird "Loplop". Enjoy his unusual techniques: witty play with collaged images (one of the first to use them); frottage (rubbed patterns); and

The Entire City Max Ernst, 1935, 60 x 81 cm (23% x 31% in), oil on canvas, Zürich: Kunsthaus. The artist created a whole series of works portraying cityscapes using different media, including oils and frottage.

décalcomania (liquid paint patterns), where accident is used to liberate images in the subconscious. Early strange, figurative images that seem to be painted dreams. Although his work is always imaginative, his later work is more abstract and lyrical, and loses bite. Better when small scale. **KEY WORKS** *Massacre of the Innocents*, 1921 (Private Collection); *The Elephant Celebes*, 1921 (London: Tate Collection); *The Fall of an Angel*, 1922 (Private Collection); *Toest and Dove*, 1927 (London: Tate Collection); *La toilette de la mariée*, 1940 (Venice: Peggy Guggenheim Gallery)

Alexei von Jawlensky

⊖ 1864-1941 P RUSSIAN

 ☑ Germany; Paris; Switzerland
 ☑ oils;

 drawings
 ☑ California: Norton Simon Museum.

 London: Christie's Images
 ☑ \$7.4m in 2003,

 Schokko – Schokko mit Tellerhut (oils)

Jawlensky was one of the minor masters of Modernism, much influenced by Kandinsky and Matisse. He created sensitive, mystical, small-scale works, with simplified forms, pure colours, and bold blue outlines. Note his birth date – earlier than you might think – he was the same age as Matisse and Kandinsky. **KEY WORKS** Landscape with a Red Roof, c.1911 (St. Petersburg: Hermitage Museum); Portrait of Alexander Sacharoff, 1913 (Wiesbaden: Städtisches Museum); Head. Red Light, 1926 (San Francisco: Museum of Modern Art)

Head of a Woman Alexei von Jawlensky, 1911, 52 x 50 cm (201/x 191/in), oil on cardboard laid on plywood, Edinburgh: National Gallery of Modern Art. The artist gave up a military career for art at age 35.

Mikhail Larionov

 Image: Russia; Switzerland; Paris
 Image: Watercolours; oils; drawings

 oils; drawings
 Image: Musée d'Art Moderne de la Ville de Paris

 la Ville de Paris
 Image: Watercolours; Musée d'Art Moderne de la Ville de Paris

 Nude (oils)
 Image: Watercolours; Musée d'Art Moderne de la Ville de Paris

He is best remembered as the founder of Rayonism (one of the briefly flourishing sub-Cubist movements before 1914), which showed objects broken up by prisms of light. Otherwise his work is not memorable. His later years were blighted by ill health and poverty. **KEY WORKS** Soldier on a Horse, c.1911 (London: Tate Collection); Rayonist Composition, c.1912–13 (New York: Museum of Modern Art)

Natalia Goncharova

 Image: Moscow; Paris
 Image: Oils; watercolours; drawings; prints

 Image: Oils; Watercolours; drawings; prints
 Image: Oils; watercolours; drawings; prints

 Image: Oils; Moscow; Paris
 Image: Oils; watercolours; drawings; prints

 Image: Oils; Moscow; Paris
 Image: Oils; drawings; prints

 Image: Oils; Moscow; Paris</t

Goncharova was the leading member of the Russian avant-garde; well born and connected (links to Pushkin family tree). Well travelled in Europe and had an openly radical lifestyle. Settled in Paris (together with Larionov, her lifelong companion and collaborator) in 1915. She was versed in early Cubism, Fauvism, and Futurism. Used a progressive, visual language with a consciously strong, Russian peasant, religious-icon accent. Bold, strong, earthy, masculine colours. KEY WORKS The Laundry, 1912 (London: Tate Collection); Rayonism, Blue-Green Forest, 1913, dated 1911 (New York: Museum of Modern Art); Lady with a Hat, 1913 (Paris: Musée National d'Art Moderne)

"Imagination is more important than knowledge, because imagination is infinite."

ALBERT EINSTEIN

Alexandra Exter

€ 1882-1949 PURUSSIAN

Russia; Paris prints; sculpture; drawings
 \$1.78m in 1989, *Composition* (works on paper)

She was a leading member of the Russian avant-garde. From Kiev, but well travelled. Effective emissary between the avantgarde movements in Russia and the West. Left Russia in 1924. Sophisticated work with strong French-Italian appearance and sensibility. Designs for book illustrations, theatre, film, ceramics, textiles.

KEY WORKS Construction, 1922–23 (New York: Museum of Modern Art); American Policeman, 1926 (Washington DC: Hirshhorn Museum)

Kasimir Malevich

⊖ 1878-1935 P RUSSIAN

 Russia; Berlin i oils; collage
 Arnsterdam: Stedelijk Museum. New York: Museum of Modern Art 2 \$15.5m in 2000, Suprematist Composition (oils)

He is regarded as the most important Russian avant-garde painter of the Modern Movement.

From 1913 to the late 1920s he developed a new type of abstract art and the aesthetic and social philosophy of Suprematism. This new art reflects the search for a new utopia in which all the old, familiar values were to be replaced by new social organizations and new beliefs. The new Soviet world was to have been designed by and for engineers, both social and mechanical. Suprematist Composition No. 56 Kasimir Malevich, 1911, 80 x 71 cm (31 x 28 in), oil on canvas, St. Petersburg: State Museum of Russia. Malevich wanted to represent the non-objective supremacy of pure feeling through the suggestion of geometric forms floating in pure white space.

Don't try and read the simple abstract forms in a literal or material way. See them as shapes floating in space, independent of gravity, ready to regroup or twist and turn, or plunge into infinity. If you can do this, you can experience the excitement and optimistic uncertainty of this revolutionary period, bravely facing an unknown future.

KEY WORKS The Knife Grinder, 1912 (New Haven: Yale University Art Gallery); Suprematist Composition, 1915 (Amsterdam: Stedelijk Museum); Dynamic Suprematism, 1916 (Cologne: Museum Ludwig); Black Square, c.1929 (St. Petersburg: State Russian Museum)

Naum Gabo

⊖ 1890-1977 P RUSSIAN

Russia; Oslo; Berlin; UK; USA Sculpture
 University of Cambridge: Kettle's Yard
 \$458,200 in 1999, Vertical Construction
 No.1 (sculpture)

Also known as Naum Neemia Pevsner. A peripatetic, self-taught pioneer of Russian Constructivism. He lived in Russia, Germany, Paris, London, and the USA. Worked closely with elder brother, Antoine Pevsner. His 3-D work emphasizes modern materials (such as Plexiglas), space, light, and kinetic movement. Expresses sophisticated aesthetic values plus social ideals – a vision of a transcendental order. **KEY WORK** *Head*. No.2, 1916 (London: Tate Collection); *Construction in Space with a Crystalline Centre*, 1938–40 (Museum of London)

Linear Construction in Space No. 1 Naum Gabo, 1944–45, height 30 cm (11¾ in), plastic and nylon thread, University of Cambridge: Kettle's Yard. Gabo created form through the description of space rather than mass.

CONSTRUCTIVISM

1917-21

Important Russian avant-garde movement. Vladimir Tatlin, later joined by Rodchenko and brothers Antoine Pevsner and Naum Gabo, developed "constructed", architectural art to reflect the modern world. They were concerned with abstraction, space, new materials, 3-D form, and social reform. Soviet disapproval meant the group fragmented across Europe, influencing the fields of architecture and decoration, and the Bauhaus and De Stijl movements.

Model of the Monument to the Third International Tatlin's unrealized visionary project was for a steel and glass monument to the Revolution, larger than the Eiffel Tower, standing in Petrograd, pointing at the Pole Star, thereby linking the world and the universe.

Birth of the Universe Antoine Pevsner, 1933, 75 x 105 cm (29% x 41% in), oil on canvas, Paris: Musée National d'Art Moderne. Pevsner's later work was characterized by spiralling three-dimensional forms.

Antoine **Pevsner**

● 1886-1962
 P RUSSIAN/FRENCH

 Image: Russia; Paris; Oslo
 Image: Oslo
 I

He was the leading exponent of Russian avant-garde, non-objective art. Creator of 2-D and 3-D pieces. Fascinated by modern technology and engineering, he made conscious use of modern materials such as Perspex, glass, and iron. Note his mastery of the dynamics of spherical surfaces, the way he loves to use projections in space and expresses the poetry of technology, especially flight. He left Russia (together with his brother Nuam Gabo) in 1921 and settled in Paris in 1923. Died a much-respected figure. KEY WORKS Construction in Space, 1929 (Basel, Switzerland: Kunstmuseum); Anchored Cross, 1933 (New York: Guggenheim Museum); Meeting of Planets, 1961 (Musee d'Art Moderne de la Ville de Paris)

El Lissitsky

■ Russia; Germany; Switzerland ■ prints; sculpture; mixed media ■ \$550,000 in 1990, *Proun No. 95* (works on paper)

A pioneering Modernist architect and artist, he was a creator of Constructivist abstractions, which develop the links between art, design, and architecture, and art as a material and spiritual experience. **KEY WORKS** Untitled, c.1919–20 (New York: Guggenheim Museum); Proun, c.1923 (New York: Guggenheim Museum)

Vladimir **Tatlin**

 Image: Paris
 Image: Paris

He was the heroic, legendary founder of Russian Constructivism. Lived in Paris in 1913 and was much influenced by Picasso

The Sailor (Self-Portrait) Vladimir Tatlin, 1911–12, 71.5 x 71.5 cm (28¼ x 28¼ in), tempera on canvas, St. Petersburg: State Russian Museum. and Futurism. Famous for his relief constructions, especially corner reliefs, and his never-built tower (*Monument to the Third International*). Made stage and industrial designs in the 1920s. Believed in art at the service of Revolution. Deadly rival of Malevich. Died in oblivion. **KEY WORKS** *The Fishmonger*, 1911 (Moscow: Tretyakov Gallery); *Mother and Child*, c.1912–13 (Private Collection)

Aleksandr Rodchenko

● 1891-1956	PU RUSSIAN
🛛 Russia 🚺	photography; oils; prints;
sculpture 💼	Moscow: Tretyakov Gallery
🏂 \$504,000 ir	1988, <i>Line</i> (oils)

An active Bolshevik with strong ideals, he believed that art must be in the service of the Revolution to create an ordered, technological society. Always demanded active participation from viewers. He was rejected by Stalin. **KEY WORKS** *Line and Compass Drawing*, 1915 (New York: Museum of Modern Art); *Composition*, 1916 (Private Collection); *Black on Black*, 1918 (New York: Metropolitan Museum of Art)

Giacomo Balla

 ● 1871–1958
 № ITALIAN
 № Rome
 № oils; sculpture; mixed media
 № Rome: Galleria
 № Nazionale d'Arte Moderna
 № \$4.4m in 1990, La scala
 degli addii – salutando (oils)

He was a leading Italian Futurist who had a brief, important, innovative, key period from 1912 to 1916. Interested in sensations: speed, flight, movement, and light, which he represented by using fragmentation and colour – progressing from

Divisionism via Cubism to clean-cut Abstraction. Declined after 1916 into decorative figuration. Also produced theatre design and poems. **KEY WORKS** *Girl Running on a Balcony*, 1912 (Milan: Civica Galleria d'Arte Moderna); *Mercury Passing in Front of the Sun*, 1914 (Private Collection)

Umberto Boccioni

 ● 1882 – 1916
 № ITALIAN

 № italy
 ● oils; sculpture

 Milan: Collection of Riccardo and Magda Jucker; Civica Galleria d'Arte Moderna

 № \$1.38m in 1988, Romanza di una cucitrice (oils)

Boccioni was a leading Futurist painter and sculptor who embraced the verve of modern life and enjoyed conflict. Joined a World War I bicycle brigade, but died falling from a horse, at the age of 34.

His work was pioneering in subject and style. He was interested in highly charged modern subjects, such as dynamic, collective experience (crowds and riots); movement and speed; memories and states of mind shown as continuous time; emotions and experiences beyond the incidental trivia of time and place. Innovative in adopting

Dynamism of a Dog on a Lead Giacomo Balla, 1912, 89 x 109 cm (38% x 43% in), oil on carvas, New York: Albright-Knox Art Gallery. Balla recreated speed in this painting by superimposing several images in layers.

French Cubist interlocking planes and fragmentation, then adding colour as a means of representing his ambitious subjects.

> His work is always on a small scale and not always successful his ambitions often outran his technical abilities and the means at his disposal. Ditto for his sculptures, of which only four remain. He is to later artists what Bleriot's flying machine is to jet aircraft. **KEY WORKS** Street Noises Invade the House, 1911 (Hanover: Niedersächsische Landesmuseum); Dynamism of a Cyclist, 1913 (Milan: Collection Gianni Mattioli); Dynamism of a Man's Head, 1914 (Milan: Civico Museo d'Arte Contemporanea); The Charge of the Lancers, 1915 (Milan: Ricardo Jucker Collection)

Unique Forms of Continuity in Space

Umberto Boccioni, 1913, height 111 cm (43 in), bronze, New York: Museum of Modern Art. The sculpture was first exhibited in plaster form in Paris in 1913, and later cast in bronze.

C.1900 - 70

Carlo Carrà

● 1881-1966 PU ITALIAN

Italy ☑ oils ☑ New York: Museum of Modern Art ☑ \$739,000 in 1990, Autunno, ritratto di Emilio Colombo (oils)

He was a prominent Futurist painter and later a leading figure in the Metaphysical movement. Early works combined Futurism's dynamism with a Cubist feel for structure. Under Chirico's influence he turned to Metaphysical painting, but later rejected the avant-garde and advocated a return to a more naturalistic type of art. Influential critic and writer on art. **KEY WORKS** Horsemen of the Apocalypse, 1908 (Art Institute of Chicago); The Funeral of the Anarchist Galli, 1911 (New York: Museum of Modern Art)

Gino Severini

€ 1883-1966 PU ITALIAN

Italy; Paris
 ☑ oils; gouache; drawings
 ☑ Rome: Galleria Nazionale d'Arte Moderna
 ☑ \$3.3m in 1990, Sea = Dancer (oils)

Severini was one of the creators of Futurism. Painter, stage designer, writer, and intellectual. Long-lived and adaptable. His early work was dull, until he

discovered Impressionism (in Paris, 1906). His most significant works are his Futurist paintings, 1911–16, which have dynamic subjects, such as trains, buses, city streets, dancers, and war machinery – all of them animated by Cubist fragmentation and strong colours. After 1916 his paintings become less dynamic and more formally pure, with precise adherence to geometric

FUTURISM

1909-15

Originating in Italy (although it had adherents in Russia), Futurism was one of the most important early avant-garde art movements, and the only one not to centre round Paris. Its main figures included Bocconi, Balla, Carrà, Severini, Wyndham Lewis, and Joseph Stella. It was widely influential, with aims set out in a series of manifestoes urging a break with the past. Futurism noisily promoted a worship of machinery, speed, modernity, and revolutionary change, using the latest avant-garde styles such as Cubism.

Interventionist Demonstration Carlo Carà, 1914, 38.5 x 30 cm (15% x 11% in), collage, Venice: Peggy Guggenheim Collection. The spiralling collage was inspired by a plane dropping leaflets onto the Piazza del Duomo.

"Art is nothing but humanized science."

GINO SEVERINI

rules. In the 1920s he made mural decorations (especially mosaics in churches); and in the 1930s grand Fascist monuments.

His work is of uneven quality - the Futurist paintings can be very good, or else very formulaic and trite. His later work is hardly known outside Italy. Like other bright sparks of the early avant-garde (such as Derain), he had only a brief period of real significance. Does a lasting reputation require longevity and large output more than talent? Fascist Italy (unlike its equivalent in Germany or Russia) produced some very fine architecture and public art. Why? And does evil political patronage irrevocably taint the art? KEY WORKS Dynamic Rhythm of a Head in a Bus, 1912 (Washington DC: Hirshhorn Museum); Red Cross Train Passing a Village, 1915 (New York: Guggenheim Museum); Suburban Train Arriving in Paris, 1915 (London: Tate Collection); Still Life with Fish, 1958 (San Francisco: Fine Arts Museums)

VORTICISM

An avant-garde British art movement, short-lived but significant as the first organized movement towards abstraction in English art. Vorticism took Cubist and Futurist ideas, aiming to shake up the stuffy British art world and society generally. Its lynchpin was Percy Wyndham Lewis, editor of Blast, the Vorticist review. Another prominent figure was Christopher Richard Wynne Nevinson, a difficult personality who had a brief flowering as a leading member of the English avant-garde, producing his best work as an official war artist in World War I. The movement foundered after its sole exhibition in 1915, but left a legacy on the development of British modernism.

Front cover of the *Blast* War Number, featuring a Wyndham Lewis woodcut. The issue included articles by Ezra Pound (who coined the movement's name) and T. S. Eliot.

(Percy) Wyndham Lewis

⊖ 1882-1957 P BRITISH

Paris; UK [] oils; drawings; mixed media
 London: Victoria & Albert Museum
 \$73,350 in 1993, *Timon of Athens – The Thebaid* (watercolours)

Lewis was a painter, writer, and journalist. An angry young man who, with his fellow Vorticists, brought Modern art to Britain. Later became a right-wing misfit and admirer of Fascism.

His work is always angular and awkward, rather like the artist himself. His powerful and original early work was among the first abstract art in Europe. He was also the author of very strong drawings and paintings of World War I battlefields (he was an official war artist). Interesting later portraits.

Note his skilled, spikey draughtsmanship and his personal and inventive use of Cubist and Futurist styles and ideas. Inventive, creative use of faceted space and figures. Interesting exploration of the concept of the man-cum-machine. Was happier with words than images. **KEY WORKS** *Praxitella*, c.1921 (Leeds: City Art Gallery); *Self-Portrait*, 1921 (Manchester: City Art Gallery); *The Mud Clinic*, 1937 (New Brunswick, Canada: Beaverbrook Art Gallery)

A Battery Shelled

(Percy) Wyndham Lewis, 1919, 182.8 x 317.8 cm (72 x 125 in), oil on carvas, London: Imperial War Museum. Lewis was one of several young professional artists employed by the government to record their experience of the battlefront.

1913 - 15

Edward Wadsworth

⊖ 1889-1949 P BRITISH

IV UK I oils I tempera ≥ \$274,500 in 1992, The Cattewater, Plymouth Sound (oils)

He was a successful member of the avantgarde who ran through the voguish styles of his time: geometric and Cubist pre-1914; representational in the 1920s; a figurative Surrealist in the 1930s; abstract in the 1940s. He produced rather good work, in a derivative way. His skill at Cubist fragmentation led him to design and paint ship camouflage in World War I. **KEY WORKS** *Abstract Composition*, 1915 (London: Tate Collection); *Satellitium*, 1932 (Nottingham: Castle Museum); *The Perspective of Idleness*, 1940 (Bolton, UK: Museums, Art Gallery; and Aquarium)

David Bomberg

⊖ 1890-1957 P BRITISH

 ☑ London; Palestine; Spain
 ☑ London: Victoria
 & Albert Museum
 ☑ \$240,700 in 1998, San Miguel, Toledo, Afternoon (oils)

Bomberg was the son of Polish Jewish immigrants. Briefly on the cutting edge of the avant-garde (c.1914) when he pioneered Cubism and Vorticism in Britain. Then changed style, producing gloomy, minor Expressionist paintings. **KEY WORKS** *In the Hold*, 1913–14 (London: Tate Collection); *The Mud Bath*, 1914 (London: Tate Collection)

William Roberts

● 1895–1980
 P BRITISH
 IFrance; Italy; UK
 I oils; drawings;
 watercolours
 I London: Bonhams
 \$124,500 in 1990, Birth of Venus (oils)

Individual Modernist who developed an interesting and curiously homely version of the working man/urban life/machine-age imagery and style pioneered by Léger. His early experience as an advertising-poster designer is (too?) evident, and his weakness is that he established a formula that became overrepetitive. Member of pioneering Vorticists, c.1914. **KEY WORKs** *The Return of Ulysses*, 1913 (London: Tate Collection); *People at Play*, c.1920 (London: Christie's Images)

Sir Jacob Epstein

● 1880-1958 P AMERICAN/BRITISH

France; UK
 sculpture; oils; drawings
 London: Tate Collection. Leeds: City Art Gallery
 \$102,920 in 1998, *Tin Hat* (sculpture)

He was an audacious and original sculptor, frequently attacked by conservative critics for indecency. Studied in Paris 1902-05, where he developed a lasting interest in ancient and primitive sculpture, which inspired much of his later work. Settled in England in 1905, and carried out a series of controversial commissions, labelled as indecent by his critics. Was influenced by Picasso, Modigliani, and Brancusi in Paris whilst working on Oscar Wilde's tomb, and associated with Wyndham Lewis and the Vorticists in London. In later years he concentrated on bronze portrait busts of luminaries, which were widely admired. KEY WORKS The Rock Drill, 1913-14 (London: Tate Collection); Rima, 1922 (London: Hyde Park); The Tomb of Oscar Wilde, 1912 (Paris: Père Lachaise Cemetery)

St. Michael Vanquishing the Devil Jacob Epstein, 1958, height 600 cm (236½ in), bronze, Coventry Cathedral (UK). Epstein created a number of large-scale biblical subjects, hoping to encourage a "new hope for the future".

MODERNISM

"A great man of action into whose hands the fairies had placed a paintbrush instead of a sword."

(PERCY) WYNDHAM LEWIS ON AUGUSTUS JOHN

Augustus John

● 1878-1961 P BRITISH

UK 🚺 oils; drawings; chalks 🖬 London: National Portrait Gallery 😰 \$180,400 in 2003, Dorelia in a Red Dress (oils)

He was truly gifted and one of the best draughtsmen of any period. His romantic bohemian temperament made him an increasing misfit – should have lived in first half of 19th century, not the 20th. His wonderful early pieces show his great originality and talent; after 1918 it went to seed and he ended up doing competent, unexceptional work – although always recognizably John.

His best works were his early drawings and the sensitive, simplified, intensely

Dorelia in a Landscape Augustus John, c.1916, 62 x 41 cm (24% x 16 in), oil on canvas, Private Collection. Gypsy life fascinated John. Dorelia (Dorothy McNeil) was his mistress, and after his wife's death, his lifelong companion. coloured landscapes – a personal interpretation of Post-Impressionism. He painted society portraits with style and panache. Unjustly underrated – deserves reinstatement.

KEY WORKS William Butler Yeats, 1907 (Manchester: City Art Gallery); The Smiling Woman, c.1908 (London: Tate Collection)

Gwen John

● 1876-1939
 № BRITISH
 Ш UK; Paris; Meudon (France)
 ☑ oils
 ☑ Cardiff (UK): National Museum of Wales.
 London: Tate Collection
 ∑ \$265,650 in
 1990, The Seated Woman (oils)

She was the sister of Augustus John and mistress of Rodin. Author of tight, overintense (neurotic?), minutely worked, rather monochromatic portraits and interiors. Had a sensitive talent, although limited in range and currently overrated compared with her brother. **KEY WORKS** *Girl Holding a Rose*, c.1910–20 (New Haven: Yale Center for British Art); *Interior (Rue Terre Neuve)*, c.1920s (Manchester: City Art Gallery)

Robert Polhill Bevan

€ 1865-1925 P BRITISH

W UK; France ↓ oils; drawings
 London: Agnew & Sons ▶ \$173,850 in
 1992, Horse Dealers at the Barbican (oils)

Bevan was an interesting, underrated painter who studied in Paris in the 1890s and met Gauguin at Pont-Aven, in Brittany. Painted traditional subjects, with successful, if limited, individual Modernist style – stiff, angular, simplified, with luminous colours. Rather better than the contemporaneous Bloomsbury set (Bell, Fry, and Grant).

KEY WORKS Hawkridge, 1900 (Private Collection); The Cab Horse, c.1910 (London: Tate Collection); Parade at Aldridge's, 1914 (Boston: Museum of Fine Arts)

THE BLOOMSBURY GROUP

A loosely-knit group of writers, artists, poets, and designers, taking their name from the London district where they were based. An intellectual élite in rebellion against Victorian restrictions, priding themselves on their sexual freedom but frequently accused of snobbery. On the artistic side, they practised and

1920s-1930s

promoted modern French art. Vanessa Bell, Duncan Grant, and Roger Fry were the artistic leading lights: their output was variable, but their confidence unshakeable.

A Group of "Bloomsberries" in Vanessa's Bell's Sussex garden. Grant is third from right; Fry kneels with arm around bust.

Sir Alfred Munnings

⊖ 1878-1959 P BRITISH

UK 🚺 oils; drawings 🖬 Dedham (England): Sir Alfred Munnings Art Museum; Castle House \$7m in 2004, *The Red Prince Mare* (oils)

The brilliant and successful Munnings was an artist who believed (like his clientele) that anything "modern" was a horrible mistake. Though blind in one eye, he had acute vision. Socially he saw only what he wanted to see. He was president of the Royal Academy.

He is remembered primarily for his hunting and racing portraits of humans and horses. He had rare flashes of inspiration, but too often his work lapses into a stock formula: half-way horizon, human upper torsos and heads plus horses' heads and ears silhouetted against a sky piled high with clouds. Though fascinating as social documents, such paintings are his least interesting artistically. He always painted a good "picture", just as some writers always write a good "story".

At his best when he was at his most informal and inventive – in his pictures of horse fairs, local races, landscapes, or gypsics. Within them (and tucked away in portraits), note his genius for capturing a specific light effect, the play of light on landscape or horses' flanks, movement, unexpected viewpoints, and spontaneous slices of life. Munnings never doubted his own talent or the values that he celebrated (and it shows).

KEY WORKS My Wife, My Horse and Myself, c.1910 (Dedham, England: Castle House); Shrimp on a White Welsh Pony, 1911 (Dedham, England: Castle House); The Friesian Bull, 1920 (Wirral, UK: Lady Lever Art Gallery)

Mark Gertler

→ 1891 – 1939
 Þ BRITISH

Ⅲ UK; Southern France
 ☑ oils
 Ⅲ Leeds: City
 Art Gallery
 ☑ \$90,750 in 1997, Boxers (oils)

He was a talented artist from a poor, Jewish immigrant family. Came to inhabit the fringes of the snobbish Bloomsbury set. Shared their interest in modern French art and painted better than they did. Figure studies (back views of nudes) and still lifes. Good design and paint handling. Committed suicide. **KEY WORKS** *Head of the Artist's Mother*, 1910 (London: Victoria & Albert Museum); *Merry-Go-Round*, 1916 (London: Tate Collection) MODERNISM

ASHCAN SCHOOL C.1891-1919

A progressive group of American painters and illustrators, comprising Sloan, Bellows, Glackens, Luks, and Henri. They believed that art should portray the everyday, sometimes harsh, realities of life – especially New York city life – and rejected officially sanctioned art (which they said was "fenced in with tasselled ropes and weighed down with bronze plates"). They generally painted gritty, poor, urban scenes in a spontaneous, unpolished style.

Robert **Henri**

Philadelphia; Paris; New York
 Oils; drawings
 Washington DC: National Gallery of Art

\$420,000 in 2003, Berna Escudero (oils)

Henri was a charismatic, hard-drinking, rebellious, and anarchic man, but a great teacher and believer in young people. He chose down-to-earth, urban subjects (note his portraits of "my people" – Irish peasants, Chinese coolics, American Indians) and had a direct, "real" style using dark tonal contrast, limited colour, and liquid brushstrokes.

Leader of the Ashcan School, in 1908 he founded The Eight, who put together

The Little Dancer Robert Henri, c. 1916–18, 102.8 x 82.5 cm (40% x 32% in), oil on canvas, Ohio: Butler Institute of American Art. Henri produced a number of paintings of dancers – some of unknowns like the model for this portrait, others of stars such as Isadora Duncan.

the first art exhibition independently curated by artists in the USA.

Henri links Eakins (he studied at Pennsylvania Academy) and Manet (he was in Paris from 1888 to 1890) – and his students: George Bellows, Stuart Davies, Edward Hopper, Rockwell Kent, Man Ray, and Trotsky (yes, Trotsky). **KEY WORKS** Antonio Banos, 1908 (Houston: Museum of Fine Arts); The Irish Girl, c.1910 (Arizona: State University Art Museum); Himself (self-portrait), 1913 (Art Institute of Chicago)

George Luks

 Europe; Philadelphia; New York
 I oils; watercolours; drawings
 Washington DC: Hirshhorn Museum
 S600,000 in 1990, *Knitters, High Bridge Park* (oils)

Luks was a vaudeville comedian. He was also pugnacious, a braggart, and hard-drinking (he is said to have died from injuries in a brawl). Painted Ashcan School scenes of New York lower-class life, but ignored the reality of poverty and overcrowding, favouring the romance of teeming humanity, male supremacy, and adventure. Note his bravura brushwork. Painted notable watercolours of his native Penn mining country. **KEY WORKS** *The Café Francis*, c. 1906 (Ohio: Butler Institute of American Art); *The Bersaglieri*, 1918 (Washington DC: National Gallery of Art)

William James Glackens

€ 1870-1938 P AMERICAN

Philadelphia; New York; France () drawings;
 oils () Fort Lauderdale: Museum of Art
 \$1.55m in 1998, Vacation Home (oils)

Philadelphia-born, he studied in Paris and was a protégé of Robert Henri. Initially a newspaper illustrator. Produced attractive and competent images of everyday New York life (interiors and exteriors), overtly derived from Manet and the Ashcan School. His work is popular imagery or illustration aspiring to the level of art. **KEY WORKS** May Day, Central Park, c.1905 (San Francisco: Museum of Modern Art); Italo-American Celebration, Washington Square, c.1912 (Boston: Museum of Fine Arts)

John **Sloan**

⊖ 1871-1951 P AMERICAN

Philadelphia; New York; Santa Fe
 drawings; oils
 Washington DC: National
 Gallery of Art
 \$2.7m in 2003, *Easter Eve* (oils)

He was a member of the Ashcan School. Started as an illustrator/cartoonist with Socialist sympathies but was opposed to the idea of art as propaganda. Produced New York scenes of the working classes, but modified harsh reality with an ideal of honest, cosy, vaguely erotic, urban happiness. Caught fleeting moments well. After 1914, worked in Santa Fe. Lost the plot after 1928. Superb etchings. **KEY WORKS** *Wake of the Ferry*, 1907 (Washington DC: Phillips College); *Recruiting in Union* **McSorley's Bar** John Sloan, 1912, 66 x 81.2 (26 x 32 in), oil on canvas, Detroit Institute of Arts. Sloan was a regular drinker at this working-class, men-only Irish tavern, and some of his sketches still decorate the walls.

Square, 1909 (Ohio: Butler Institute of American Art); Austrian-Irish Girl, c.1920 (Washington DC: Hirshhorn Museum)

C = 1900 - 70

George Wesley Bellows

● 1882-1925
 P AMERICAN
 New York
 Q oils; prints; drawings
 Washington DC: National Gallery of Art
 \$25m in 1999, Polo Crowd (oils)

Bellows was a leading member of the Ashcan School. His best period was pre-1913, when he tackled tough, gritty subjects, such as construction sites (Penn Station), slum dwellers, boxing matches – depictions of raw energy. Later work too self-conscious and affected by theories of symmetry and the Golden Section. **KEY WORKS** *Cliff Dwellers*, 1913 (Los Angeles: County Museum of Art); *Mrs. T in Cream Silk*, *No.2*, 1920 (Minneapolis Institute of Arts)

A Stag at Sharkey's George Wesley Bellows, painted 1909, $47 \times 60.4 \text{ cm}$ (18% x 23% in), lithograph by George Miller (1917), Houston: Museum of Fine Arts. Bellows's evocation of an illegal boxing match was acclaimed at the time as a landmark of realism.

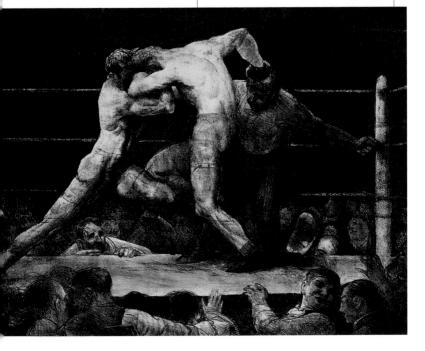

Marsden Hartley

→ 1877 – 1943 ₱♥ AMERICAN

USA; Europe i oils; prints; drawings
 San Francisco: Fine Arts Museum.
 Washington DC: National Gallery of Art
 \$2.5m in 2002, *Painting No.6* (oils)

The greatest American artist of the first half of the 20th century: original, mystical, homosexual.

His early Impressionist work was followed by paintings influenced by the German Expressionists, whom he knew (met Kandinsky and Jawlensky in Berlin and Munich c.1913). Experimented with abstraction. His "Portrait of a German Officer" series (which commemorates his male lover) is the major monument of early American Modernism. Later produced several important series of paintings in Provence (France), New Mexico, and Maine. Used vigorous

Abstraction Marsden Hartley, c.1914, 61.5 x 50.8 cm (24 ½ x 20 in), oil on paperboard mounted on panel, Houston: Museum of Fine Arts. Typical of Hartley's work of the period, this painting shows the influence of Delaunay and Kandinsky in its interest in geometric arrangements of bands and circles, and colour relationships. brushstrokes and jarring colour contrasts, such as rust and acid green. **KEY WORKS** *The Aero*, 1914 (Washington DC: National Gallery of Art); *Mount Katahdin*, *Maine*, 1942 (Washington DC: National Gallery of Art)

Max Weber

1881–1961
 IV RUSSIAN/AMERICAN
 New York; Europe
 Woodcuts; oils; chalks
 Woodcuts; Oils; chalks

 Washington DC: National Gallery of Art. Boston: Museum of Fine Arts
 S1.5m in 2002, New York (oils)

Russian-born, he was a gifted artist. Studied with Matisse (in Paris 1905–08) and produced important Cubist paintings. One of the first Americans to use modern idiom. Later, Expressionist work (à la Soutine), with Jewish subjects based on Russian memories. Moved easily between established styles – produced pleasing results but compromised originality. **KEY WORKS** Interior of the Fourth Dimension, 1913 (Washington DC: National Gallery of Art); *Rush Hour, New York*, 1915 (Washington DC: National Gallery of Art)

New York; Paris in oils; drawings
 Washington DC: Hirshhorn Museum
 \$1.1m in 2000. Still Life (oils)

Bruce was a member of an old Virginia family. Early American Modernist. Visited Paris in 1904, was influenced by Matisse, Steins, and Delaunay. Good semi-abstract still lifes with spare, geometric shapes, primary colours, hot pinks, and thick paint like cake icing. Unrecognized. Work did not sell. Gave up painting, destroyed work, and sold antiques; later committed suicide. **KEY WORKS** *Painting*, 1922–23 (New York: Whitney Museum of American Art); *Still Life: Transverse Beams*, 1928–32 (Washington DC: Hirshhorn Museum)

Stanton Macdonald-Wright

USA; Paris; London 🚺 oils 🖬 Washington DC: Smithsonian American Art Museum \$\$440,000 in 1990, *Conception Synchromy* (oils)

He was an avant-garde American painter. Studied in Los Angeles and went to live in Paris in 1913. Developed Synchronism – abstract, kaleidoscopic symphony of swirling, fragmented rainbow colours – derived from French artists such as Delaunay. Lost the plot on return to USA. **KEY WORKS** *Dragon Trail*, 1930 (Washington DC: Hirshhorn Museum); *Mural for the Santa Monica Library*, 1934–35 (Washington DC: Smithsonian American Art Museum)

Arthur Garfield Dove

→ 1880-1946 P AMERICAN

USA; Europe M drawings; oils; mixed media Washington DC: National Gallery of Art \$1.1m in 2003, *Snowstorm* (oils)

A shy, reclusive farmer *manqué*, keen sailor. First American artist to paint an abstract picture (1907–09). Produced small-scale lyrical work, derived from a love of land and seascape, full of natural shapes, rhythms, and essences of nature; also witty collages and assemblages. Unappreciated in his lifetime. **KEY WORKS** Foghorns, 1929 (Colorado Springs: Fine Arts Center); Sand Barge, 1930 (Washington DC: Phillips College); Reflections, 1935 (Indianapolis: Museum of Art)

Burgoyne **Diller**

USA 🚺 oils; sculpture 🖬 Washington DC: Hirshhorn Museum 😰 \$95,000 in 1995, *First Theme* 1959–60 (oils)

He is one of the most important American abstract artists. Produced 3-D abstract painted reliefs and geometric paintings. Simple shapes, primary colours on white or black, and understated brushwork. Much influenced by Mondrian and the Dutch De Stijl movement (see page 389), both in appearance and his aspiration for social and spiritual reformation. **KEY WORKS** Untilded (Three Men with Hats in City Street), 1932 (Ohio: Cleveland Museum of Art); Second Theme, 1949 (New York: Metropolitan Museum of Art)

Stuart Davis

№ New York; Paris
 № oils
 № Washington DC:
 Hirshhorn Museum
 № \$2.2m in 1997, Odol (oils)

Davis was a leading American Cubist. Initially trained in advertising (it shows to his advantage), and studied with Robert Henri (see page 380). From 1924, developed striking and individual abstract paintings and collages, notable for bright colours and jazzy rhythms. Borrowed motifs from popular culture; considered a progenitor of Pop Art. Fascinated by urban scenes and advertising posters. **KEY WORK** *House and Street*, 1931 (New York: Whitney Museum of American Art); *The Mellow Pad*, 1945–51 (Private Collection)

"I don't want people to copy Matisse or Picasso, although it is entirely proper to admit their influence. I don't make paintings like theirs. I make paintings like mine."

STUART DAVIS

Max Beckmann

⊖ 1884-1950 P GERMAN

☑ Frankfurt; Amsterdam; USA ☑ oils;
 Woodcuts; drawings ☑ Minnesota:
 Minneapolis Institute of Art ☑ \$20.5m
 in 2001, Self-Portrait with Horn

One of the great painters of the 20th century. Generally overlooked because never one of the Modernist "gang", and difficult, even now, for officialdom to pigeonhole. To sustain such Expressionist intensity and quality is a rare (unique?) achievement.

Produced beautiful, expressive, sombre paintings; rich colours, strong drawing. Many portraits, self-portraits, and allegories full of symbolism. Beckmann's works are very much of their time, but do not belong to any "school" or "ism". Their underlying theme is the human condition and concern for the triumph of the human spirit.

Beckmann's use of black (one of the most difficult pigments) is stunning and worthy of Manet; his understanding of the human condition is worthy of Rembrandt. His work charts a central vein of the spiritual anguish of 20th-century Europe. Born into the gifted, optimistic generation of the 1880s, he experienced the horrors of World War I and the collapse of civilized values in Germany in the 1920s and 1930s. In 1937, classed as a "degenerate"

Self-Portrait in Olive and Brown Max Beckmann, 1945, 60.3 x 49.8 cm (23% x 19% in), oil on carwas, Detroit Institute of Arts. Painted while he was writing his autobiography, A Little Yes and a Big No.

by the Nazis, he chose voluntary self-exile to Amsterdam. In 1947, he emigrated to the US, where he taught and painted. **KEY WORKS** *The Dream*, 1921 (Missouri: St. Louis Art Museum); *Departure*, 1932–33 (New York: Museum of Modern Art); *Journey on the Fish*, 1934 (Stuttgart: Staatsgalerie); *Carnival*, 1942–43 (University of Iowa Museum of Art)

THE NAZIS AND DEGENERATE ART

Nazi ideologues believed that any art that did not conform to a bourgeois ideal of well-crafted, figurative images portraying ideal heroism or comfortable day-to-day

living was the product of degenerate human beings and perverted minds. The German term, *entartete Kimst*, was coined by Hitler and the party's chief theoretical spokesperson,

1930s

Alfred Rosenberg. "Degenerate" modern artists could not exhibit or work, and many confiscated works were burnt. A Nazi-backed touring exhibition of modern and abstract art (with works by Beckmann, Dix, Grosz, Kandinsky, Mondrian, and Picasso) opened in 1937 to show how foul Degenerate art was. The plan backfired and introduced modern art to huge crowds.

Adolf Hitler and Hermann Goering, probably at the 1937 exhibition. Before he rose to power, Hitler supported himself through painting and continued to paint throughout his life.

384

🗢 1891–1969 🏴 GERMAN

Germany I prints; drawings; mixed media
 San Francisco: Fine Arts Museum. New York:
 Museum of Modern Art S \$5,445,000 in 1999,
 Portrait of the Lawyer Dr. Fritz Glaser (oils)

Dix was a mocking, bitter observer and recorder of German society during World War I and the 1920s and 1930s as its moral and social values collapsed. Anti-Nazi. Ugliness fascinated him – reflected in a powerful distortion of realistic observation with intense line, detail, and acid colour; expressed in portraits of friends and powerful engravings. He was recognized only after 1955. **KEY WORKS** Card-Playing War Cripples, 1920 (Private Collection); The Artist's Parents, 1921 (Basel, Switzerland: Kunstmuseum)

George Grosz

\varTheta 1893–1959 🏴 GERMAN

 Berlin; New York
 prints; drawings; oils

 San Francisco: Fine Arts Museum. New York:

 Museum of Modern Art
 \$2,041,000

 in 1996, Wildwest (oils)

Best remembered as the biting and original chronicler of the sad and corrosive period of Germany history between 1918 and the rise of Hitler.

His small-scale works (especially prints and drawings) are of a consciously artless, angular, modern style (in the sense of uncomfortable, provocative, and anarchic). They chronicle the uncomfortable truth behind the respectable bourgeois façade. He was fascinated by street life yet, for all his apparent criticism of it, he seems to end up loving the ugly corruptness he records.

Note the repetition of certain stock types and faces; poisonous colours and artless style to create a feeling of instability and menace. He was an early user of photomontage. His terrifying personal World War I experiences made him a pessimist, misanthrope, and political activist (Communist). His style softened c. 1924 after marriage and fatherhood. He emigrated to the USA in 1933 and reverted to being a graphic artist. KEY WORKS Suicide, 1916 (London: Tate Collection); Grey Day, 1921 (Berlin: Nationalgalerie); Pillars of Society, 1926 (Berlin: Staatliche Museum)

Christian **Schad**

● 1894 – 1982
 ™ GERMAN
 ™ Munich; Berlin; Zurich
 ™ oils; prints; collage
 ™ London: Tate Collection
 № \$492,200 in 1998,
 Bildnis einer Unbekannten (oils)

He was a painter who also made collages and prints (woodcuts), and took photos in the manner of Man Ray (see page 394). Best known for his Neue Sachlichkeit work – a cool, uncompromising, critical depiction of the German bourgeois society of the 1920s, including cold, steely portraits. The exaggerated, emphasized detail serves to highlight its emptiness. The alienating spaces show how things and people become disconnected. **KEY WORKS** Agosta, the Pigeon-Chested Man, and Rasha, the Black Dove, 1929 (London: Tate Collection); Operation, 1929 (Munich: Städtische Galerie)

Self-Portrait with Model Christian Schad, 1927, 76 x 62 cm (30 x 24½ in), oil on canvas, Private Collection. Neue Sachlichkeit ("New Objectivity") describes a tendency for German art, after 1925, to turn away from Expressionism. Schad abandoned painting in the Nazi era.

László Moholy-Nagy ● 1895–1946 [™] HUNGARIAN/GERMAN

 Europe; Chicago
 Collage; photomontage; drawings; prints

 Los Angeles: J. Paul Getty

 Museum
 \$981,500 in 2000, A XI (oils)

He was a lawyer-turned-artist and theoretical writer. Geometric Abstract artist and leading member of, and teacher at, the Bauhaus. Provided the basis for the New Photographer's movement. Sought to create order and clarity using design, abstraction, architecture, typography, constructions, and photography. He settled in Chicago in 1937. At Coffee László Moholy-Nagy, c. 1926, 28.3 x 20.6 cm (11 ½ x 8½ in), vintage gelatin silver photograph, Houston: Museum of Fine Arts. Moholy-Nagy tried to expand the scope of photography both through experimental techniques and innovative compositions. An inspirational teacher, his influence on art and design training has been profound.

KEY WORKS Photogram, 1923 (Los Angeles: J. Paul Getty Museum); A II, 1924 (New York: Guggenheim Museum); Dual Form with Chromium Rods, 1946 (New York: Guggenheim Museum)

Lyonel Feininger

€ 1871–1956 P AMERICAN/GERMAN

 Berlin; New York
 Woodcuts; drawings; watercolours

 San Francisco: Fine Arts

 Museum
 \$4.03m in 2004, Newspaper

 Readers II (oils)

Son of a concert violinist, Feininger was New York-born and -based, but spent most of his life in Germany (1887-1937). Quiet, personal style, akin to a broken glass pane in which buildings and seascape are the central subject. He blended Cubist fragmentation of form (he studied in Paris) and the misty light and dreaminess of Romanticism (his German heritage). A founder of Bauhaus, remaining there until it was closed in 1933. Talented printmaker (etchings). He influenced set designs for early films such as Max Reinhardt's Cabinet of Doctor Caligari. KEY WORKS The Bicycle Race, 1912 (Washington DC: National Gallery of Art); Sailing Boats, 1929 (Detroit Institute of Arts); Market Church at Evening, 1930 (Munich: Alte Pinakothek)

THE BAUHAUS

The most famous modern art school, on which so many others have been modelled, highly influential in the fields of architecture and design. Its teachers included Albers, Feininger, Klee, Kandinsky, Moholy-Nagy, and Schlemmer. It opened in Germany in 1919 and was closed by the Nazis in 1933 – the New Bauhaus was set up in Chicago by Moholy-Nagy in 1937. The Bauhaus tried to teach the virtues of simple, clean design; abstraction; mass production; the moral and economic benefits of a well-designed environment; democracy and worker participation.

Poster by Joost Schmidt for Bauhaus Exhibition in Weimar, July–September 1923. Bauhaus artists recognized early on the importance of graphic design as a medium to express a corporate identity and image for the school.

C = 1900 - 70

Paul Klee

⊖ 1879-1940 P GERMAN

 Germany; Bern (Switzerland)
 Mixed media; drawings
 Bern: Paul Klee Centre
 \$4,788,000 in 1989, Auftrieb und Weg, Segelflug (oils)

Klee was a prolific author of drawings, watercolours, and etchings. Dedicated teacher (Bauhaus), and a talented poet and musician. Had a fey, spiritual character and was one of the most original pioneers of the Modern Movement.

Creator of the chamber music of modern art – finely wrought, smallscale works in many media, which are reminiscent in some ways of medieval manuscript illumination (perhaps he drew on this tradition?). Note his quirky, personal imagery and the delicate, unpretentious abstracts. His work is always very sensual, visually and mentally, and delightfully and poetically odd. Had **The Golden Fish** Paul Klee, 1925–26, 50 x 69 cm (19% x 27% in), oil and watercolour on paper and board, Hamburg: Kunsthalle. In 1925 Klee joined the staff of the Bauhaus, published his *Pedagogical Sketchbook*, and displayed his work at a Surrealist exhibition in Paris.

an exquisite colour sense and produced neat, precisely worked surfaces.

Don't try to understand or intellectualize Klee – just enjoy his work and follow him wherever he chooses to take your eve and imagination (one of his wellknown writings is called "Taking a line for a walk"). Above all, let him take you back to the realm of childhood imagery, imagination, and humour. You will return to adulthood immensely refreshed, enriched, and stimulated. KEY WORKS Ancient Sound, 1925 (Basel, Switzerland: Kunstmuseum); Ad Parnassum, 1932 (Hamburg: Kunsthalle); Diana in the Autumn Wind, 1934 (Bern, Switzerland: Kunstmuseum): Death and Fire, 1940 (Bern, Switzerland: Kunstmuseum)

"The more horrifying this world becomes ... the more art becomes abstract; while a world at peace produces realistic art."

PAUL KLEE

MODERNISM

Josef Albers

Square" (oils)

● 1888-1976 P GERMAN/AMERICAN

 Weimar; USA prints; woodcuts; oils
 Essen: Albers Museum, Bottrop Collection. New Haven: Yale University Art Gallery S600,000 in 1996, Despite Mist, Study for "Homage to the

One of the great artist-educators of the Modern Movement. Pillar of the Bauhaus 1923–1933. Emigrated to USA in 1933.

His highly original work combines investigations into perception with a simple beauty. Best known for his "Homage to the Square" series (1949–70), in which he experiments with nests of squares that explore values of light and degrees of temperature in contrasting colours and hues. He uses the square because it is the most static of geometric forms, able to accentuate the colour

DE STIJL

1917-31

De Stijl (from the Dutch for "the style", was the name of a group of Dutch artists, and the journal they published – the 1920s' most influential avant-garde art magazine. Members and contributors included Piet Mondrian, Theo van Doesburg, and the architect and designer Gerrit Rietveld. The collective advocated a geometrical type of abstract art, simplification, social and spiritual form, seeking laws of harmony that would be equally applicable to life and art.

Red Blue Chair designed by Gerrit Rietveld, 1918. The hard surfaces and strong colours are a rejection of familiarity and sentimentality in favour of dynamic rationality. relationship, and is without movement. He was also an accomplished photographer and designer in stained glass.

"Homage to the Square" sounds boring, but is visually fascinating because Albers understood that you can never predict scientifically what colour is going to do, and how it constantly catches you unaware and delights you. "Homage to the Square" is the ultimate proof of this, but you need to get involved and experiment (by half closing your eyes, for instance) to really enjoy and appreciate what is going on. **KEY WORKS** *Glass, Color, and Light,* 1921 (New York: Metropolitan Museum of Art); Study for *Homage to the Square Mild Scent,* 1965 (Hamburg: Kunsthalle)

Oskar Schlemmer

⊖ 1888–1943 🕫 GERMAN

 Weimar; Breslau; Berlin
 Dils; prints;

 sculpture
 San Francisco: Fine Arts Museum.

 Basel (Switzerland): Kunstmuseum
 \$3.08m

 in 1998, Grosse Sitzendengruppe I (oils)

A leading member of the Bauhaus. Painter and sculptor. Most effective and at ease designing mural decorations for ballet and theatre. He preferred simplification, the interplay of shape and form, and reflective inner states of mind, rather than expression and dramatic impact. Liked quiet exploration and experiment. **KEY WORKS** Head in Profile, with Black Contour, 1920–21 (San Francisco: Fine Arts Museums); Group of Fourteen Figures in Imaginary Architecture, 1930 (Cologne: Wallraf-Richartz-Museum); Bauhaus Stairway, 1934 (New York: Museum of Modern Art)

Piet Mondrian

⊖ 1872-1944 P DUTCH

Netherlands; Paris; London; New York
 oils; mixed media
 New York:
 Museum of Modern Art
 \$18.75m
 a004, New York, Boogie Woogie (oils)

One of the pioneers of pure abstract art. Austere, reclusive character who hated the green untidiness of nature. Theoretically and intellectually influential in his lifetime. Had no commercial success.

The most familiar works are the abstracts of the 1920s and 1930s. They have simple

c.1900 - 70

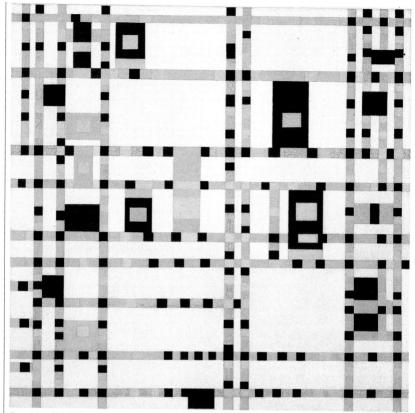

Broadway Boogie Woogie Piet Mondrian, 1942–43, 127 xr 172 rm (50 x 50 in), oil on canvas, New York: Museum of Modern Art. © 2005 Mondrian/Holtzman Trust. c/o HCR International, Warrenton, Virginia, USA

elements: black, white, and primary colours only, horizontal and vertical lines. His aim was to find and express a universal spiritual perfection, but his imagery has become a commonplace of 20th-century commercial design. Look out, also, for his late, jazzily colourful work, completed in New York. His slow and painstaking progress through Symbolism and Cubism to abstraction repays patient study.

You have to see Mondrian's work in the flesh to understand it. Reproductions make

his abstracts look bland, mechanical, and easy, with immaculate, anonymous surfaces. In fact, you can (and are supposed to see) the brush marks, the alterations, the hesitations - the struggle to achieve that harmonious balance and purity that he desperately wanted, but found so hard to attain. Note also the deliberate small scale and intimacy of most of his work. KEY WORKS The Grey Tree, 1912 (The Hague: Gemeentemuseum); Pier and Ocean, 1915 (Otterlo, Netherlands: Kröller-Müller Museum); Tableau No. IV with Red. Blue. Yellow, and Black, 1924-25 (Washington DC: National Gallery of Art); Composition in Red and Blue, 1939-41 (Private Collection)

"Abstract art ... is opposed to a natural representation of things ... it is not opposed to nature ... It is opposed to the raw, primitive animal nature of man, but it is at one with human nature."

PIET MONDRIAN

SURREALISM

Surrealism was the most influential avant-garde movement of the inter-war years. Its chief goal, asserted by its founder and leader, André Breton, was to meld the unconscious with the conscious to create a new "super reality" - a surréalisme. Cubism, Dada, and Freud were its starting points. Its enduring influence can be found notably in present-day advertising and avant-garde humour.

STYLE

Still from the 1929 Surrealist film Un Chien Andalou by Salvador Dalí and Luis Buñuel. Film was an ideal medium for Surrealism. Buñuel, working closely with Dalí, created a disconcerting and deliberately unfathomable masterpiece

Perhaps not surprisingly for a movement whose origins were largely literary and which actively championed anarchy, Surrealism in the visual arts almost immediately developed a bewildering variety of styles. It could be highly finished, aiming at a kind of heightened realism (Dalí, for example), or, at the other end of the spectrum, entirely abstract (Miró, for example). In whatever style it was executed, it generally aimed to surprise, often to shock, frequently to disturb, and always to create a dream-like atmosphere, sometimes highly specific, at other times vague and suggestive.

SUBJECTS

The personal nature of the subconscious necessarily resists categorization; Surrealist subject matter literally knew no limits. Ernst experimented with a visual equivalent of stream of consciousness writing: frottage - rubbings taken from

worn surfaces to create chance patterns. Magritte's deadpan paintings exploit enigmatic juxtapositions, often sexual. Arp, painter and sculptor, favoured simple, vaguely biomorphic shapes, seemingly randomly assembled, in bold, flat colours.

KEY EVENTS

1919	919 André Breton and Philippe Soupault write <i>Les Champs Magnétiques</i>	
1924	First <i>Surrealist Manifesto</i> issued, largely written by Breton, in Paris	4
1930	Breton formally allies Surrealism with the Proletarian Revolution	
1936	London International Surrealist Exhibition held	
1937	Leon Trotsky and Breton write Manifest for an Independent Revolutionary Art	
1939	Outbreak of World War II sees exodus of Surrealist artists to New York	

Object Meret Oppenheim, 1936, diameter 23.7 cm (91/3 in) height 7.3 cm (233/4 in), fur, china, and metal, New York: Museum of Modern Art. Oppenheim's fur-covered cup, saucer, and spoon encapsulate Surrealism's determination to subvert the everyday world.

1920s-1930s

WHAT TO LOOK FOR

Ernst was the most complete Surrealist artist in the sense that he experimented with all techniques: figuration, abstraction, and collage. In this archetypal, pioneering work he explores methods of creating imagery that were to become a commonplace of Surrealist painting. In particular, he synthesizes his study and understanding of Freud's ideas, notably about the juxtaposition of polarities such as the rational/irrational, constructive/ destructive, dead/alive, with his own experiences and desires. Oedipus means "swollen foot"; in Greek mythology he was the hero who unwittingly killed his father, married his own mother, and gouged out his eyes on realizing what he had done. Freud's "Oedipus Complex" is an inability to break infantile dependence on parents, and so become fully mature.

Oedipus Rex Max Ernst, 1922, 93 x 102 cm (36% x 40 in), oil on canvas, Private Collection. Ernst knew he had to escape the dominance of his father, who was an academic painter and devout Catholic.

In Freudian analysis, the

balloon and the birds represent a longing for escape and freedom

The hand that

cracks the nut is a metaphor for sexual intercourse. The spike and the arrow stand for pain, and the distorted scale suggests the struggle in gender relationships

Ernst was obsessed by

birds, death, and gender ever since his pet cockatoo died on the day his sister was born. The birds have human, upside-down eves

TECHNIQUES

Paint is applied in a precise but anonymous manner. Imagery has been copied from magazines and prints. Ernst was a self-taught painter and a pioneer of collage.

The psychosexual interpretation is that the nut represents the female (the crack suggesting the vulva)

The mechanical

device that pierces the finger is one that was used to punch holes in the webbed feet of chicken so as to mark their age. It suggests pain, penetration, and intercourse.

Salvador Dalí

 Image: Spain; Paris; New York
 Image: mixed media; oils; sculpture

 Image: Spain; Salvador Dalí

 Museum. St. Petersburg (Florida): Salvador Dalí

 Museum
 Image: Salvador Dalí

Dalí was a flamboyant self-publicist, and one of the most popular painters of the 20th century. Made a brief but major contribution to Surrealism.

He was an artist of astonishing technical precosity and virtuosity. He mastered almost any style (see early work), finally choosing one based on the detailed, "realistic", 17th-century Dutch masters – instantly popular and recognizable as "very skilful" (the optical illusions are breathtaking). Ultimately just a flashy showman with a big ego and a long moustache – like a singer who churns out popular arias in a spectacular way, but devoid of any real expression, meaning, or freshness. Soft Construction with Boiled Beans: Premonition of Civil War Salvador Dalí, 1936, 110 x 83 cm (43 ½ x 32½ in), oil oin canvas, Philadelphia: Museum of Art. The second half of the painting's title was added on the outbreak of the Spanish Civil War.

There is one exception to the above. Look for the works of 1928-33, which are great and profound. Briefly, as a true pioneer of the Surrealist movement, Dalí created works to explore his "paranoia-critical method". Using Freudian ideas about dreams and madness, he produced obsessional images in which detailed reality is suddenly transformed into different, intricate, and disturbing images. Technically and imaginatively brilliant. He ought to have persisted with it. KEY WORKS Seated Girl Seen from the Rear, 1925 (Madrid: Museo Nacional Centro de Arte Reina Sofia); The Persistence of Memory, 1931 (New York: Metropolitan Museum of Art); Surrealist Composition with Invisible Figures. c.1936 (Private Collection); Christ of St. John of the Cross, 1951 (Kelvingrove, Glasgow: Art Gallery and Museum)

 $c \, . \, 1 \, 9 \, 0 \, 0 - 7 \, 0$

Joan **Miró**

⊖ 1893–1983 🕫 SPANISH

 ■ Barcelona; Paris; Mallorca
 ■ mixed media; ceramics; sculpture; prints
 ■ Barcelona:

 Foundation Joan Miró. Mallorca: Pilar and Joan Miró Foundation and Museum
 ■ \$11.5m in 2001, Portrait of Mme K (works on paper)

He was a leading Surrealist painter and sculptor: experimental, unconventional, influential. Searched for a new visual language, purged of stale meanings and appealing to the senses.

Miró is best known for his abstract and semi-abstract works – highly structured, poetic, dreamy; simple forms floating on fields of colour. Let them suggest anything (cspecially something biological, sexual, primitive). Enjoy the naughty thoughts, silliness, colour, beauty, light, warmth.

Uses a limited number of forms, but repeats and makes rhymes of them. He draws on an (unconscious) memory bank of natural and landscape forms, which suggest generative power in nature. He experimented with "magic realism" before breaking into a new style c.1924. **KEY WORKS** *Le port*, 1945 (Private Collection); *The Red Sun Gnaws at the Spider*, 1948 (Private Collection); *Woman and Bird in the Moonlight*, 1949 (London: Tate Collection)

Harlequin's Carnival Joan Miró, 1924, 66 x 93 cm (26 x 36¾ in), oil on canvas, Buffalo: Albright-Knox Gallery. Miró claimed that his imagery was sometimes the result of hallucinations caused by extreme hunger.

André Masson

€ 1896 - 1987	P FRENCH
---------------	----------

 ➡ France; Spain; USA ➡ mixed media; drawings; engravings; sculpture ➡ New York:
 Museum of Modern Art ➡ \$883,945 in 1989, La femme paralytique (oils)

An artist whose reputation and influence is better known than his work. Deeply affected by World War I injuries. Leading Surrealist who explored the irrational and subconscious in intense, finely wrought paintings and drawings. Disliked order; liked experimentation and spontaneous action. Lived in the USA after 1940 – had a big impact on Abstract Expressionists. **KEY WORKS** *Pedestal Table in the Studio*, 1922 (London: Tate Collection); *Card Trick*, 1923 (New York: Museum of Modern Art)

Yves Tanguy

€ 1900-55 P FRENCH

🔟 Paris; New York; Connecticut 🛛 🚺 oils

Mew York: Museum of Modern Art

✗ \$6.77m in 2005, Derniers Jours (oils)

A self-taught Surrealist who, from c.1927, evolved (but never developed further) a style of imaginary landscapes (or sea beds?) full of weird and curiously compelling half-vegetable, half-animal forms. **KEY WORKS** *The Look of Amber*, 1929 (Washington DC: National Gallery of Art); *Promontory Palace*, 1931 (New York: Guggenheim Museum)

Man Ray

€ 1890-1976 P AMERICAN

New York; Paris; Hollywood
 photography; prints; mixed media
 Los Angeles: J. Paul Getty Museum
 \$1.5m in 2003, Impossibilité
 Dancer-Danger (oils)

The creator of memorable avant-garde Surrealist images, usually through photography. He was inventive (imaginatively and technically), witty, and anarchic. Cultivated a carefree persona with maxim that the least possible effort would give the greatest possible result. Painted documentary portraits of the Dada and Surrealist heroes. **KEY WORKS** *Silhouette*, 1916 (New York: Guggenheim Museum); *Duchamp with Mill*, 1917 (Los Angeles: J. Paul Getty Museum)

"A certain amount of contempt for the material employed to express an idea is indispensable to the purest realization of this idea."

MAY RAY

The Aged Emak Bakia Man Ray, 1970, after the original of 1924, height 46 cm (18½ in), silver, Private Collection. The sculpture is named after an earlier Man Ray Surrealist film of 1927, Emak Bakia, which means "leave me alone" in Basque.

many media and styles – individually slight but collectively expressing

her refusal to be categorized and pinned down. Had a free spirit and disliked prescribed roles, especially for women. Witches and snakes are recurring images.

KEY WORKS Object (Le déjeuner en fourrure), 1931 (Houston: Museum of Fine Arts); Sitzende Figur mit verschränkten Fingern, 1933 (Bern, Switzerland: Kunstmuseum); Red Head, Blue Body, 1936 (New York: Museum of Modern Art)

Sir Roland Penrose

1900–84 P BRITISH
 London Mixed media; collage;
 sculpture London: Tate Collection
 \$26,884 in 2003, Union Nocturne (oils)

He was a rich and eccentric painter, writer, dilettante, connoisseur, and collector – another shining example of the uniquely British "gifted amateur". A friend of Picasso and Ernst, he was a champion of Surrealism. Made and painted good (if derivative) Surrealist works. **KEY WORKS** *Night and Day*, 1937 (Private Collection); *The Last Voyage of Captain Cook*, 1936–67 (London: Tate Collection)

Paul **Delvaux**

⊖ 1897-1994 PU BELGIAN

 Belgium Oils Bruges: Palais des Beaux-Arts. St. Idesbald (Belgium): Paul Delvaux Foundation and Museum \$4,698,000 in 1999, *Le miroir* (oils)

> He was a loner who created a limited and repetitive *oeuvre* of finely detailed,

vaguely erotic, and symbolic, night-time, dreamland images based on themes of naked women, semi-deserted railway stations or landscapes, and classic buildings. Admired by, but not allied with, true Surrealists. Influenced by Magritte and De Chirico exhibition of 1926. **KEY WORKS** *A Siren in Full Moonlight*, 1940 (New Haven: Yale Center for British Art); *The Red City*, 1941 (Private Collection)

Meret Oppenheim

⊖ 1913-85 P GERMAN

 Berlin; Paris
 Sculpture; mixed media

 Boston: Museum of Fine Arts
 \$74,592 in

 2002, Tout Toujours (oils)

She will always be remembered for her Surrealist fur teacup *Object* (see page 390). Oppenheim produced engaging, delicate, whimsical work on many themes and in € 1898-1967 PU BELGIAN

 ☑ Brussels; Paris
 ☑ oils; gouache; prints
 ☑ New York: Museum of Modern Art. Minnesota: Minneapolis Institute of Art
 ☑ \$11.5m in 2003, Empire des lumières (oils)

Magritte was a leading Surrealist painter who made a virtue of his bowler-hatted, cheap-suited provincialism. Famous for use of everyday objects plus deadpan style, creating mildly disturbing images suggesting the dislocated world of dreams.

He painted small(ish) oil paintings. Used deliberately banal technique, without aesthetic virtue – imagery is everything. Transformed the familiar into the unfamiliar by weird juxtapositions, changes of scale and texture, and contradiction of expectation. The titles of his works (sometimes chosen by friends) are designed deliberately to confuse and obscure. His best work dates from the 1920s and 1930s. Change of style after 1943. Worked as a freelance advertising artist from 1924 to 1967.

Used classic Freudian symbols and references – death and decay (coffins,

night); sex (naked women, pubic parts); phallic symbols (guns, sausages, candles). Themes of claustrophobia (closed rooms, confined spaces = sexual repression?); yearning for liberty (blue sky, fresh landscapes). Witnessed his mother's suicide aged 13. Married. His work risked becoming a tired formula (his very late work is), but is saved by an active imagination and a sense of the absurd. **KEY WORKS** The Menaced Assassin, 1926 (New York: Museum of Modern Art); Reproduction Prohibited, 1937 (Rotterdam: Museum

The Human Condition René

Magritte, 1933, 100 x 81 cm (39 ½ x 32 in), oil on canvas, Washington DC: National Gallery of Art. The term "magic realism" was coined to describe the conceptual tensions between the possible and the impossible in Magritte's work. Boymans-van Beuningen); *The Song of Love*, 1948 (Private Collection); *Golconde*, 1953 (Houston: Menil Collection)

Matta

0	1911-	2002	ρø	CHILEAN
---	-------	------	----	---------

Paris; Rome; New York in a construction of a construc

Roberto Sebastián Echaurren, revolutionary spirit who was born in Santiago but settled in France in 1933 and became an early Surrealist. Like many other artists, left for the USA when World War II broke out but resettled in Paris in 1954. Author of strange, dreamlike paintings with complex spaces and totem-like figures. Had a poetic agenda: searching for links between the cosmos, the eroticism of the human body, and the human psychic space. Intended his work to exalt freedom and aid mankind's struggle against oppression.

KEY WORKS *Psychological Morphology*, 1939 (Toronto: Art Gallery of Ontario); *La Rosa*, 1943 (Ohio: Cleveland Museum of Art)

Pablo **Picasso**

Barcelona; Paris; Rome; South of France
 oils; sculpture
 Paris: Musée National
 Picasso. Barcelona: Museu Picasso
 S93m
 in 2004, *Garçon à la Pipe* (oils)

Picasso stands as the undisputed master and chief innovator of the Modern

Movement. You have to go back to Michelangelo to find anyone of equal genius or stature. He was convivial and energetic, and led a turbulent, intense, and often unhappy personal life (his many love affairs are legendary). His output of work was vast; he was equally inventive as painter, sculptor, printmaker, ceramicist, and theatre designer.

LIFE AND WORKS

Born into an artistic family in Barcelona, his prodigious talent showed itself at an

early age. He visited Paris for the first time at the age of 19, and he divided his early years between France and Spain, developing his "Blue Period", with its themes of death and deprivation. In 1904 he settled permanently in France, first evolving the "Rose Period", with images of the circus and harlequins; by 1907 he was the champion of the avant-garde and the pioneer of Cubism (see page 350).

Minotaur Caressing a Sleeping Girl 1933, 33.8 x 43.9 cm ($134 \times 17\%$ in), drypoint engraving, Private Collection. The bull is a metaphor for Picasso himself: frustratingly caught up in a marriage he wished to dissolve whilst committed to a secret, young, pregnant lover.

Although deeply committed to Spain, its art, and its people, Picasso effectively lived in voluntary exile, based in Paris, where he became the focus for the emerging School of Paris (see page 357), and latterly in the south of France. Passionately opposed to Franco's political regime, which he attacked in his art, he vowed never to set foot in his land of birth whilst Franco

lived. The dictator outlived him by 32 months.

PAINTINGS

His paintings display a bewildering range of technical and stylistic originality: he was the master of Classicism, Symbolism, and Expressionism; the inventor of Cubism, and anticipator of Surrealism. However, pure abstraction never interested him. Central to his art is a wide-ranging post-Freudian response to the human figure and the human condition – with frequent intimate references to sex and death.

sometimes blissful, sometimes anguished. All his work was highly egocentric in some way, but he had the rare ability to turn self-comment into universal truths.

"Art is a lie that makes us realize the truth."

PABLO PICASSO

Out of many themes, two invite immediate exploration: the almost daily autobiography from ambitious half-starved young hopeful to husband and womanizer to sexually frustrated old man; and the ease with which he switched styles, images, and techniques, always conscious of which was the most appropriate for his subject matter and mood.

SCULPTURE

There is a tendency to judge Picasso by his paintings whereas his true forte was for work in 3-D. These became more numerous and interesting as he grew older (the quality of his paintings declines after 1939). Here, too, he was the master of traditional techniques and a dazzling

Self-Portrait 1901, 81 x 60 cm (40 x 23³/₄ in), oil on canvas, Paris: Musée National Picasso. The starving artist aged 20, painted in Paris during his "Blue Period".

Weeping Woman 1937, 55 x 46 cm (21³/x x 18 in), oil on canvas, Melbourne: National Gallery of Victoria. Showing typical Cubist distortion, the model for this depiction of female grief is said to be Picasso's then mistress, Dora Maar. The picture was used as a study for *Guernica* (1937), painted in response to the bombing of the Spanish city by the Germans in 1937.

innovator through welding, constructions, and ceramics. In fact, many twodimensional works are simply ideas that itch to be realized in 3-D. **KEY WORKS** *Child with a Dave*, 1901 (London: National Gallery); *Family of Saltimbanques*, 1905 (Washington DC: National Gallery of Art); *Girl on a Ball*, 1905 (Moscow: Pushkin Museum); *The Lovers*, 1923 (Washington DC: National Gallery of Art); *Guernica*, 1937 (Madrid: Museo Nacional Centro Arte Reina Sofia)

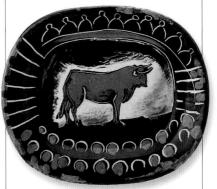

A Bull c. 1950, ceramic plate, London: Bonhams. After the War, Picasso moved to Antibes with Françoise Gillot and began his carefree, inventive work in ceramics, which have the attributes of paintings and sculpture.

Paul Nash

€ 1889-1946 PU BRITISH

Kent; Sussex; Dorset in oils; mixed media; photography in London: Tate Collection
 \$146,400 in 2004, Autumn Landscape (oils)

One of the best British artists before 1950, he successfully blended an English pastoral vision with an awareness of European modern art. The voice of "I am English first and foremost, of Europe but not in Europe."

His small-scale works in oil, pastel, or watercolour show a deeply personal first-hand response to landscape, coastline, sun, and moon, and to objects in nature. He was careful in every sense and very English, of a certain type: self-contained, serious, gentle, parochial, romantic, polite, self-assured, independent, but not too progressive. Lean, spare, well-focused imagery and style. Earthy English palette.

He worked as a war artist in both world wars. Focused on trench landscape and its destruction in World War I; flight and aircraft in World War II. His capacity for juxtaposing the unexpected and transposing one object into another by association links him with the Surrealists. Note how he abstracts from nature and organizes his perceptions, feelings, and paintings to capture the essential feel of a place - the so-called "genius loci". KEY WORKS Mineral Objects, 1935 (New Haven: Yale Center for British Art); Circle of Monoliths, 1937-38 (Leeds: City Art Gallery); Monster Field, 1939 (South Africa: Durban Art Gallery); Totes Meer (Dead Sea), 1940-41 (London: Tate Collection)

Sir Stanley Spencer

⊖ 1891-1959 P BRITISH

A difficult, argumentative but inspired personality with a unique and personal vision and great talent. Preached, practised, and illustrated sexual liberation at a time when such things were "not done".

His work shows English eccentricity at its best and most convincing. Disregarded prevailing conventions (social and moral,

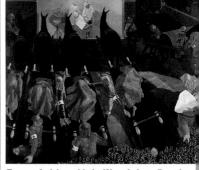

Travoys Arriving with the Wounded at a Dressing Station, Smol, Macedonia Sir Stanley Spencer, 1916, 183 x 218.5 cm (72 x 86 in), oil on canvas, London: Imperial War Museum. Spencer served in the army as a medical orderly and infantryman.

as well as artistic), and had an utterly personal agenda and unshakeable belief in his own vision and ability. Focus of his life and major work was around his home village of Cookham, which he saw as an earthly paradise. It also provided the setting for his profound belief in the return of Christ for and among ordinary people.

Observe his humanity, humour, and acerbic wit. He had a dry, careful, deliberately outdated technique inspired by early Italians, Pre-Raphaelites, and Dutch and Flemish painters. Was a masterly and inspired draughtsman. His best works are his religious and World War I subjects. Potboiler landscapes earned him money. Like all true visionary eccentrics, he managed to be separate from his own time and era yet totally of it. **KEY WORKS** *The Centurion's Servant*, 1914

(London: Tate Collection); *The Resurrection: Cookham*, 1924–26 (London: Tate Collection); *Self-Portrait with Patricia Prece*, 1936 (Cambridge: Fitzwilliam Muscum); *A Village in Heaven*, 1937 (Manchester: City Art Gallery)

Ivon Hitchens

⊖ 1893-1979 P BRITISH

He was a sensitive painter who made a slow, patient progress from figuration to abstraction. His main theme was landscape, often in long horizontal format, in which colour and form are increasingly abstracted to simple elements. Among the first in England to sustain a development of post-Cubist painting. Also painted still lifes and nudes. **KEY WORKS** Balcony at Cambridge, 1929 (London: Tate Collection); Winter Stage, 1936 (London: Tate Collection)

Henry Moore

Leeds; London; Hertfordshire Sculpture; drawings Washington DC: National Gallery of Art S \$7.5m in 2004, *Three-piece Reclining Figure: Draped* (sculpture)

Moore was a tough, gritty, ambitious Yorkshireman, one of the best-known British modern masters. His work is a popular choice for international sculptural monuments but it looks best when in a landscape setting rather than in a gallery.

His romantic response to nature and the human figure is often expressed as a synthesis of the two, so that his forms can be read simultaneously as organic nature (rocks, cliffs, trees), and as human figures. He consciously rejected Renaissance notions of ideal beauty, but was much influenced by Mexican, Egyptian, and English medieval sculpture. Direct carving

Reclining Figure (LH 175) Henry Moore, 1936, height 64 cm (25¼ in), elmwood, West Yorkshire: Wakefield Art Gallery: Moore was a founder of the English Surrealist Group in 1936. and truth to materials were an imperative of his early work; this was gradually replaced by a desire for monumentality.

Walk around his sculptures to investigate the constantly changing relationships between the different parts. Moore was fascinated by the reclining nude, and mother-and-child images. He investigated ideas in his drawings and was a superb sculptural draughtsman. Flirted with Surrealism in the 1930s; important war drawings in 1940s. Declined when he used assistants for late public monuments. **KEY WORKS** Mother and Child, 1936–37 (Leeds: City Art Gallery); UNESCO Reclining Figure, 1957 (forecourt of UNESCO headquarters, Paris); Mirror Knife Edge, 1976–77 (Washington DC: National Gallery of Art)

"... a work must first have a pent-up energy, an intense life of its own, independent of the object it may represent."

HENRY MOORE

Dame Barbara Hepworth

England; Italy; St. Ives
 Sculpture
 St Ives: Barbara Hepworth Museum and
 Sculpture Garden
 Stim in 2004, The Family
 of Man: Figure I, Ancestor I (sculpture)

Hepworth was a leading member of the first generation of British modern masters. She expressed in sculpture, for the first time, the tradition of English Romantic landscape. She was much honoured and revered both in her lifetime and subsequently.

Look for a deeply emotional response to, and identification with, nature and landscape. Her inspiration came from light, seasons, natural materials, mysteries of nature. She searched for (and found) fundamental essences and elements. These were distilled and abstracted, for instance, into simplified forms and pure colour like Matisse (she had contact with the French avant-garde in 1932), although Hepworth's starting point was nature, not the human figure. Made some geometric carvings in the 1930s; also beautiful drawings.

"In the contemplation of nature we are perpetually renewed."

DAME BARBARA HEPWORTH

Involute 1 Dame Barbara Hepworth, 1946, height 45.7cm (18 in), white stone, Private Collection. Pierced abstract form became a distinctive feature, allowing Hepworth to explore the physical essence and inherent poetry of her materials. Her first such piece dates from 1931–32.

ST. IVES GROUP 1940s-1960s

St. Ives in Cornwall became a creative colony for British artists after the arrival in 1939 of sculptor Barbara Hepworth and her then husband Ben Nicholson, who had discovered retired fisherman painter Alfred Wallis on an earlier visit to the town. Wallis's naïve paintings later inspired many of the group, which included artists Terry Frost, Patrick Heron, and sculptor Henry Moore.

Tate St. Ives, Cornwall Opened in 1993, the gallery overlooks Porthmeor Beach and exhibits modern and contemporary art.

She had a lifelong belief in truth to materials – taking stone, wood, bronze (after 1950) and making apparent the unique quality of each individual piece, adapting the final form to its own peculiarities. Initiated and developed pierced form to explore materials and evoke nature's mystery and organic growth. Used strings to express emotional response and tension. Greek titles, after visit to Greece (1953), indicate respect for Classical tradition.

KEY WORKS Doves, 1928 (Manchester: City Art Gallery); Two Forms, 1933 (London: Tate Collection); Sculpture with Colour (Oval Form) Pale Blue and Red, 1943 (Private Collection); Minoan Head, 1972 (Cambridge: Fitzwilliam Museum)

Ben Nicholson

⊖ 1894-1982 P BRITISH

England; Paris; Switzerland I oils;
 sculpture I London: Tate Collection
 \$1,936,000 in 1990, La Boutique Fantastique (oils)

Doyen of the St. Ives School, Nicholson was a pioneer of abstract art in Britain, and one of the UK's first modern artists. Son of Sir William Nicholson; he married Barbara Hepworth in 1934.

400

September 1963 Ben Nicholson, 1963, oil and collage on fibrocement, Private Collection. In the 1930s Nicholson explored abstraction through carved relief sculptures. In the 1950s he returned to the theme, making constructions out of boards that he cut, assembled, and painted.

He chose traditional subject matter (landscapes and still lifes) for his paintings, reliefs, and drawings. Moved easily between a pared-down figuration and pure abstraction, making interesting use of materials and scratched textures. The lean, athletic look and sense of calculation rather than spontaneity was central to his competitive persona, which enjoyed playing games (ball and psychological). His work shows debt to modern European art – Cubism, Mondrian, and Braque.

Notice the way in which he imposed English virtues of politeness or understatement on the unruly appearance of the European avant-garde, making it as well-tailored as a Savile Row suit and as well-mannered as a game of gentlemen's cricket (both express deep passions as well as reserve). Does the fact that his work looks equally at home in modern or traditional, country or urban, British or European settings suggest that it is bland - or does it mean it is the essence of international savoir faire? KEY WORKS St. Ives Bay: Sea with Boats, 1931 (Manchester: City Art Gallery); White Relief, 1935 (London: Tate Collection); February 1956 (menhir), 1956 (New York: Guggenheim Museum)

John Piper

€ 1903-92 P BRITISH

London
 Oils; prints
 Dils; prints
 London:
 Tate Collection
 2 \$131,200 in 2003,
 Rocky Valley, North Wales (oils)

A serious, well-regarded painter and printmaker notable for a very personal, stylized, romantic imagery of landscape and architecture. Was also a book illustrator and stage designer. Once the epitome of acceptable modernity, his work now looks dated, but will come back into fashion one day. **KEY WORKS** *Beach with Starfish*, 1933–34 (London: Tate Collection); *Autumn at Stourhead*, 1939 (Manchester: City Art Gallery)

Graham Sutherland

● 1903-80 P BRITISH

- England; France 🚺 engravings; oils
- San Francisco: Fine Arts Museums

2 \$247,050 in 2004, Toad (oils)

His work is a fascinating example of English tradition and modern idiom cohabiting. Sutherland's landscapes reveal a fascination with organic forms and metamorphosis. His portraits (his best work?) show a fascination for facial forms that contain the inner personality (like a fossil in a rock). Underrated. **KEY WORKS** Somerset Maugham, 1949 (London: Tate Collection); Christ in Glory, 1962 (Coventry Cathedral)

MODERNISM

David Alfaro Siqueiros

→ 1896-1974
 ™ MEXICAN

 Image: Mexico; Europe
 Image: Mexico
 Image: Mexico

 City (murals for public buildings)
 Image: Mexico
 Image: Mexico

 1989, Niña Madre (works on paper)
 Image: Mexico
 Image: Mexico

A prolific painter and writer who was deeply involved in progressive, political causes in Mexico in the 1920s and 1930s. He is revered as Mexico's greatest painter.

Produced solemn (gloomy?) works with strong political commitment – art in the service of the people's revolution. Look for monumental, sculptural peasants and faces; direct, earthy subjects. Was technically accomplished and quietly experimental (he made very early use of industrial paints and drip techniques), and was unshakeably consistent in his style and belief.

His crowning achievements are the vast in-situ murals in Mexico, which are revolutionary manifestos in their own right and exploit daring, cinemainspired angles and perspectives. **KEY WORKS** *Seated Nude*, 1931 (San Francisco: Fine Arts Museums); *Zapata*, 1931 (New York: Metropolitan Museum of Art)

Diego Rivera

⊖ 1886-1957
 Ø MEXICAN

 Mexico; Paris; Italy; USA
 Mexico City (fresco decorations in public buildings). Detroit Institute of Arts
 \$2.8m in 1995, Baile en Tehuantepec (oils)

Rivera was a giant – physically (6 ft, 21 stones); in terms of his charismatic personality (political revolutionary and turbulent love life); and in the quantity and scale of his work – representing

The March of Humanity in Latin America David

Alfaro Siqueiros, 1964, area 4,645 sq. metres (50,000 sq. ft), mural painting, Mexico City: Polyforum Siqueiros. Siqueiros considered this his greatest achievement and the union of all his discoveries.

social realism at its most convincing. A Marxist, loved and financed by US mega-capitalists.

The large-scale murals he created in the 1920s and 1930s were designed

for public spaces and express a utopian view of society – they are political statements of art in the service of society. His vision was a union between Mexico's Indian history and a machine-age future in which past, present, and future, nature, science, humanity, male and female, and all races and cultures coexist in harmony. He revived the art of monumental, true fresco, physically and conceptually.

The way he turns his vision into vast, crowded images is truly miraculous. He synthesized first-hand knowledge of pre-Columbian art, Modernism (Cubist space), realism, and early Renaissance frescoes (monumental, simplified forms of Giotto, Masaccio, Piero) into brilliantly organized and controlled decorative pageants, with a storyteller's instinct for memorable detail. Also produced seductive, smaller-scale easel paintings and sketches: portraits, figures, narrative scenes, and still lifes.

KEY WORKS *Still Life*, 1913 (St. Petersburg: Hermitage Museum); *Table on a Café Terrace*, 1915 (New York: Metropolitan Museum of Art); *The Aztec World*, 1929 (Mexico City: Palacio Nacional)

José Clemente Orozco

⊖ 1883-1949 P MEXICAN

Mexico; USA
 Oils; watercolours
 Guadalajara: Orozco Workshop-Museum.
Mexico City: Carrillo Gil Museum
 \$883,200 in 2004, *Cellar* (oils)

Orozco was one of the three great Mexican muralists (with Diego Rivera and David Alfaro Siqueiros). His publicbuilding murals, in a cold and austere style, are based on his experiences of the Mexican Revolution and Civil War, showing the struggles and sacrifices of the people and the pain of needless suffering. **KEY WORKS** Fresco series, 1926 (Mexico City: Casa de los Azulejos); *The Coming and the Return of Quetzalcoatl*, 1932–34 (New Hampshire: Dartmouth College)

Frida Kahlo

€ 1907-54 P MEXICAN

 Mexico
 Image: Copyoacan (Mexico):

 Museo Frida Kahlo
 Image: Sector Se

Kahlo was one of the best-known Mexican painters, who created powerful, figurative images that synthesized her sufferings, both physical (she was crippled in a car accident aged 15) and emotional (stormy marriage to Diego Rivera), with an exploration of themes of Mexican politics and identity. Is her art merely parochial, or does it touch deeper levels of emotion? **KEY WORKS** *Self-Portrait with Monkey*, 1938 (Buffalo: Albright-Knox Art Gallery); *The Two Fridas*, 1939 (Mexico City: Museo de Arte Moderno); *Self-Portrait with Cropped Hair*, 1940 (New York: Museum of Modern Art)

Suicide of Dorothy Hale Frida Kahlo, 1939, 59.7 x 49.5 cm (23 ½ x 19 ½ in), oil on masonite with painted frame, Arizona: Phoenix Art Museum. Dorothy Hale was a beautiful socialite who, after losing her husband and her financial security, threw herself to her death from the window of her New York apartment.

Giorgio de Chirico

● 1888 – 1978
 PITALIAN
 Greece; Italy; Paris; USA
 joils; sculpture
 Mew York:
 Museum of Modern Art
 \$6.4m
 in 2004, The Great Metaphysician (oils)

De Chirico was the originator of metaphysical painting. Melancholic curmudgeon with a brief period of true greatness, around 1910-20. Haunting paintings of deserted Italianate squares with exaggerated perspectives, irrational shadows, trains, clocks, oversized objects, and a sense of latent menace and ungraspable meaning. Much influenced by Nietzsche. Late work is weak. **KEY WORKS** The Uncertainty of the Poet, 1913 (London: Tate Collection); The Painter's Family, 1926 (London: Tate Collection)

Giorgio Morandi

● 1890-1964 PU ITALIAN

- Bologna
 Oils; engravings
 San Francisco: Fine Arts Museums
- \$1.35m in 1990, Natura Morta (oils)

He was reclusive, isolated, and gifted, best known for his post-1920 still lifes of simple objects (such as bottles) of great delicacy and seductive, poetic simplicity. Small scale, low key; almost monochrome, almost abstract, to be enjoyed in silence. Good pre-1920 metaphysical paintings. Beautiful etchings.

KEY WORKS Still Life, 1948 (Parma: Fondazione Magnani-Rocca); Still Life, 1957 (Hamburg: Kunsthalle)

Balthus

⊖ 1908-2001 PU FRENCH

🔟 France; Italy; Switzerland 🛛 🚺 oils

Mew York: Museum of Modern Art

№ \$3.4m in 2004, Golden Afternoon (oils)

His full name was Balthasar Klossowski de Rola Balthus. Self-taught and precocious, with Polish antecedents; well-connected intellectually (Bonnard and Rilke were family friends). Reclusive. Consciously worked against the modern grain – **The Mystery and Melancholy of a Street** Giorgio de Chirico, 1914, 88 x 72 cm (34% x 28% in), oil on canvas, *Private Collection.* De Chirico's poetic suggestions of the unpredictable were an inspiration for the Surrealists.

ideologically opposed to abstract art, determined to establish the importance of craftsmanship.

He painted landscapes and portraits. His work probes the area between innocence and perversity, reality and dream. Slow, careful workmanship. Affirmation of time-honoured virtues such as precise draughtsmanship, oil paint, observation from life, conscious creation of beauty, muted tones, delicate colour, light, and the primacy of human figure.

KEY WORKS *The Living Room*, 1941–43 (Minnesota: Minneapolis Institute of Arts); *Sleeping Girl*, 1943 (London: Tate Collection); *Japanese Girl with Red Table*, 1967–76 (Private Collection)

Hans Hofmann

1880-1966 P GERMAN/	AMERICAN
---------------------	----------

Paris; Munich; USA
 oils; drawings
 Washington DC: National Gallery of Art

\$980,000 in 2003, In Upper Regions (oils)

A pioneering, but only moderately successful, abstract painter (his style was never fully resolved – principally large squares modified by thick pigment and bright colour). Hugely gifted and influential as a teacher. Was the key figure in bringing news of the European giants (like Picasso) to the younger generation of soon-to-be American Abstract Expressionists.

KEY WORKS Autumn Gold, 1957 (Washington DC: National Gallery of Art); City Horizon, 1959 (San Francisco: Museum of Modern Art)

Elie Nadelman

● 1882–1946 POLISH/AMERICAN

 Paris; London; USA
 Sculpture

 Washington DC: Smithsonian American Art

 Museum
 \$2.6m in 1987, Tango (sculpture)

A gifted Polish sculptor of great charm, Nadelman moved to Paris in 1904. His Parisian style was eclectic in the Classical Greek tradition. He

"Imitation of objective reality is not creation... it is a purely intellectual performance, scientific and sterile..."

HANS HOFMANN

moved to London around 1914 before emigrating to New York at the onset of World War I. There he counted cosmetics queen Helena Rubinstein among his patrons; she commissioned Nadelman to create a set of marble heads for her beauty salons. In 1919 he married an heiress and became a pioneer collector of folk art. He himself created charming folk

art – inspired wood sculptures (with a hint of the Hellenistic). After a decade of living the high life he lost everything financially in the economic depression that followed the Wall Street Crash of 1929.

His sculptures often have the silhouettes of figures in Seurat's paintings. His work is an interesting and successful synthesis of ancient and modern, the common denominator being a search for purity in form and materials.

KEY WORKS Classical Head with Headdress, 1908–09 (Wisconsin: Milwaukee Art Museum); Standing Female Nude, c.1909 (Washington DC: Hirshhorn Museum); Man in the Open Air, 1915 (New York: Museum of Modern Art); The Dancer, 1920–22 (New York: Jewish Museum of Art)

> Tango Elie Nadelman, c.1918–24, height approx. 88 cm (34½ in), cherry wood and gesso, Houston: Museum of Fine Arts. Impressed by American popular culture, the artist also borrowed from folk art to make observations of high society.

Louise Nevelson

 III USA; Munich
 I sculpture; mixed

 media; oils
 III San Francisco: Fine Arts

 Museums
 III \$230,000 in 1989, Dawn's

 Wedding Chapel I (sculpture)

Born Louise Berliawsky in Kiev (family emigrated to the USA in 1905), Nevelson was brought up with wood (the family business was timber) and was always dedicated to being a sculptor (to the point of abandoning her husband and child). She only discovered her signature style in the 1950s – open-sided boxes made into reliefs, each box containing an assortment of forms created from wood scraps, painted in monochrome, usually black.

Her sculpture is most impressive when on a large scale. It is distinguished work that carries in it the sort of accumulated experience and mysterious gravitas that comes with old age. It must be absorbed slowly just like the company or wisdom of the ancients. This is a welcome reminder that no one is ever too old to be creative: Nevelson's best work was done in her 70s and 80s. **KEY WORKS** *White Vertical Water*, 1932 (New York: Guggenheim Museum); *Sky Cathedral*, 1958 (Buffalo: Albright-Knox Art Gallery)

Mirror Image 1 Louise Nevelson, 1969, height 534 cm (2101/4 in), painted wood, Houston: Museum of Fine Arts. Nevelson took the boxes that she had previously used as pedestals for her work and turned them into art, filling them with carved wooden forms. This inspiration led her to create wall-sized assemblages.

Joseph Cornell

USA Sculpture; mixed media; oils Washington DC: Smithsonian American Art Museum S \$2.3m in 2005, Untitled (Medici Princess) (mixed media)

The creator of strange, small-scale imaginative boxes. Though often pigeonholed as Surrealist, they are poetic reveries rather than Freudian dream worlds. Lived lonely, reclusive life in Flushing, New York, with his mother and crippled brother. Scoured junk shops for bits and pieces, which he filed away meticulously.

Many of the reveries are about travel that he never undertook (maps and images of Paris, for instance) or film stars he never met. Often tinkered for years with images and contents of individual boxes. The glass fronts of the boxes symbolically separate the real world from the dream. No sexual imagery – he disapproved of Surrealism's dark, "unhealthy" aspects. **KEY WORK** *Tilly Losch*, 1935 (Private Collection); *Untilled (The Hotel Eden)*, 1945 (Ottawa: National Gallery of Canada)

Grant Wood

→ 1892 – 1942 ™ AMERICAN

☑ Iowa
 ☑ oils; tempera
 ☑ Art Institute of Chicago
 ☑ \$1.25m in 1985, Arbor Day (oils)

He was a painter of fantastical, childlike landscapes. Also portraits, murals, and stained glass. His quirky work reflects

Steam Turbine Charles Sheeler, 1939, 56 x 45.7 cm (22 x 18 in), oil on canvas, Ohio: Butler Institute of American Art. The fifth in the series of six "Power" paintings commissioned by Fortune magazine.

calculated, precise, and free of human presence as any mass-produced objects. Worked for Henry Ford and shared his belief that factories are temples of worship. Replaced the sublimity of wild nature with the sublimity of the urban landscape. In 1959 he suffered a stroke and had to give up painting and photography. KEY WORKS Fugue, 1940 (Boston: Museum of Fine Arts): Aerial Gyrations, 1953 (San Francisco: Museum of Modern Art); Stacks in Celebration, 1954 (New York: Berry-Hill Galleries)

old-fashioned virtues: sobriety, strict parents, and sexual morality. He had a painstaking, stiff, old-fashioned style, often working in tempera. Iowa-raised, Wood was the (closet gay) altar boy of American regionalism.

American Gothic is as famous in American art as the Mona Lisa is in Italian art, and just as enigmatic. Does it parody the chaste and sober virtues it proclaims or is it admiring them? His work never reveals the answer, and he never confessed to anyone **KEY WORKS** American Gothic, 1930 (Art Institute of Chicago); The Midnight Kide of Paul Rever, 1931 (New York: Metropolitan Museum of Art); Daughters of the Revolution, 1932 (Ohio: Cincinnati Art Museum)

Charles Sheeler

€ 1883-1965 P AMERICAN

USA; Europe oils; photography Washington DC: National Gallery of Art \$1.7m in 1983, *Landscape* (oils)

Sheeler was a dour, romantic painter and photographer who turned the industrial landscape into works of art as carefully

Charles Demuth

€ 1883-1935 P AMERICAN

USA; Europe Ois; watercolours I New York: Memorial Art Gallery, University of Rochester \$750,000 in 1992, *Welcome to our City* (oils)

The leading Precisionist of the 1920s and 1930s, who produced small-scale views of industrial architecture (factories, water towers, and silos), carefully painted with a front-on view and emphasis on simplified geometry. Note his subtle colours and acute observation of light and shade, and the total absence of human presence. **KEY WORKS** *My Egypt*, 1927 (New York: Whitney Museum of American Art); *I Saw the Figure Five in Gold*, 1928 (New York: Wropolitan Museum of Art)

"Paintings must be looked at and looked at and looked at... No writing, no talking, no singing, no dancing will explain them." CHARLES DEMUTH

Edward Hopper

€ 1882-1967 P AMERICAN

USA; Europe I oils; engravings; watercolours
 New York: Whitney Museum of American Art
 \$12.5m in 2005, *Chair Car* (oils)

He was a taciturn, monosyllabic, New York inhabitant with a small-town puritan upbringing, who became a successful and quintessential American painter.

His imagery is the American urban landscape and its inhabitants; and also Cape Cod. Marvellous observation and recording of light (perhaps most notably harsh, electric light). Spare, lean, tough technique (like many of his subjects). Strong colour sense and ability to create tense, confined spaces. Influenced by photography and the movies (avid moviegoer), and Impressionism (visited Paris in 1906–07 and 1909–10).

How is he able to make the commonplace and banal so uneasy, significant, and memorable? Is it his magic way with light? His ability to simplify and generalize – to express a universal mood, not just an anecdotal story? His subtle space distortions that create a sense that something is wrong or about to happen? Similar talents are shown by the great black-and-white movie producers (like Hitchcock) – many of his pictures could be stills from a movie. **KEY WORKS** *Early Sunday Morning*, 1930 (New York: Whitney Museum of American Art); *Cape Cod Evening*, 1939 (Washington DC: National Gallery of Art); *Nighthawks*, 1942 (Art Institute of Chicago)

Grandma Moses

€ 1860-1961 P AMERICAN

USA (a) oils (b) Vermont: Bennington Museum
 \$180,000 in 1993, Country Fair (oils)

Née Anna Mary Robertson. A self-taught farmer's wife from Virginia in Vermont who, in the 1930s, aged 70+, became a celebrity. Her paintings are in a naïve style with nostalgic images of idyllic rural life, full of women and children. She copied details from popular prints; her work was in turn endlessly reproduced as greeting cards, wallpaper, and fabrics. **KEY WORKS** *My Hills of Home*, 1941 (New York: University of Rochester); *Black Horses*, 1942 (Private Collection); *Making Apple Butter*, 1958 (Art Institute of Chicago)

Chop Suey Edward Hopper, 1929, 81 x 96.5 cm (31½ x 38 in), oil on canvas, Collection of Mr. and Mrs. Barney A. Ebsworth. Even when successful, Hopper preferred cheap restaurants, second-hand cars, and old clothes.

Down on the Farm in Winter Grandma Moses, 1945, 49.5 x 60 cm (191/2 x 233/5 in), oil on masonite, Tokyo: Fuji Museum. Grandma Moses spent most of her life on a farm; first as hired help and then as the wife of a farmer. Many of her paintings depict her memories of that time.

Georgia O'Keefe

 → 1872 – 1986
 Þ AMERICAN
 🔟 USA 🚺 oils 💼 Washington DC: National Gallery of Art 🛛 🔊 \$3.3m in 1997, From the Plains (oils)

An influential but one-off artist, outside the mainstream of modern art. Her work will be remembered and valued far longer than many other 20th-century names that are currently in fashion or overpraised.

Her intense and exotic imagery lay in that intriguing area between figuration and abstraction. She made very powerful images of nature and architecture, which have a strong period feel of the 1920s, 1930s, and 1940s. Her ability to simplify and intensify colour, movement, and pattern has something in common with the best of the classic Disney cartoons, notably Fantasia, with which her work was contemporary (Walt Disney: 1901-66).

Many of her paintings have the shifting and fantastic qualities seen in cloud patterns in the sky. Look for plants and flowers (often in close-up), mountains, animal bones. Notice how she transformed all of them into something that has a strong unreal, even surreal, poetic life: mountains become flesh; plants become organisms like sea anemones; skulls live and see. Unusual and intense colour combinations; bold simple patterns. KEY WORKS Black Iris, 1926 (New York: Metropolitan Museum of Art); Ranchos Church, 1929 (Washington DC: Phillips College);

Jack-in-the-Pulpit No. IV, 1930 (Washington DC:

National Gallery of Art); Red Hills with White Shell, 1938 (Houston: Museum of Fine Arts); White Iris No.7, 1957 (Madrid: Museo Thyssen-Bornemisza)

Thomas Hart **Benton**

🖸 Paris: USA 🚺 oils 🖬 Missouri: Jefferson City, for murals in Capitol Building 🔊 \$1.4m in 1989. Homeward Bound (oils)

Considered the High Priest of American Regionalism, Benton came from a national, political family and was a cantankerous, homophobic, anti-Modern and energetic self-publicist. Determined painter of subjects that proclaim the authentic virtues of the Midwest, non-urban American life bulging, restless figures in heaving swirling spaces. Was a keen user of vulgar colours. Very popular, and his works influenced Jackson Pollock. KEY WORKS Martha's Vineyard, c.1925 (Washington DC: Corcoran Gallery of Art); Cattle Loading, West Texas, 1930 (Andover, Massachusetts: Addison Gallery of American Art); Roasting Ears, 1930 (New York: Metropolitan Museum of Art)

Jacob Lawrence

● 1917-2000 P AMERICAN

🔟 USA 🛛 oils 💼 Washington DC: National Gallery of Art 🛛 🔀 \$290,000 in 2003, Ten Fugitives (oils)

Lawrence's was the first voice of an authentic art by and for African-Americans. Born in Atlanta, resided in Harlem. Researched and understood the Great Migration and Ku Klux Klan persecution. He is most famous for the "Migration" series - 60 small powerful paintings in a spare, lean, modern style with intense colours, which are strengthened by their understatement and the lack of any expression of hatred. KEY WORKS John Brown Forming an Organization among the Coloured People of Adirondack Woods to Resist the Capture of Any Fugitive Slaves, 1941 (Detroit Institute of Arts); The Wedding, 1948 (Art Institute of Chicago); Street to Mbari, 1964 (Washington DC: National Gallery of Art)

Mark Tobey

● 1890 – 1976
 № AMERICAN
 № USA; England; Far East; Switzerland
 Ø oils
 ⑥ San Francisco: Fine Arts
 Museums
 № \$130,000 in 1999, Untitled (oils)

Tobey was a sensitive artist who developed a very personal abstract style, serene and luminous, out of small calligraphic marks and gestures. This did not happen until the mid-1940s when he was aged 50+ (he was a contemporary of Picasso, rather than Pollock). Was influenced by spiritual faith (a convert to Bahai), Far East calligraphy, Amerindian art, and Japanese woodcuts.

KEY WORKS Fragments in Time and Space, 1956 (Washington DC: Hirshhorn Museum); Advance of History, 1964 (New York: Guggenheim Museum); Composition, 1967 (San Francisco: Finc Arts Museums)

David Smith

USA Sculpture Washington DC: National Gallery of Art S \$3.7m in 1994, *Cubi V* (sculpture)

Smith created beautiful, inventive, poetic works made from iron, steel, and found objects, which he welded, manipulated, and coaxed into constructions of great originality. His quiet modesty, honest beliefs, and deep feeling touched his work with a profound sense of the presence of fundamental and universal forces, and of human worth. One of the most influential and original modern sculptors of his generation.

KEY WORKS Hudson River Landscape, 1951 (New York: Whitney Museum of American Art); Books and Apple, 1957 (Harvard University: Fogg Art Museum); Cubi XXVII, 1965 (New York: Guggenheim Museum)

"Painting is a state of being ... Painting is selfdiscovery. Every good painter paints what he is ... When I am in my painting I'm not aware what I'm doing." JACKSON POLLOCK

Jackson Pollock

➡ 1912-56 ₱ AMERICAN

This pioneering abstract painter of the New York School, nicknamed "Jack the Dripper", was a tortured alcoholic, who swung between sensitivity and machismo, elation and despair.

His work is at its best when on a large scale, such as $4 \ge 7 \mod 12 \ge 24$ ft), as it is only then that the passionate, heroic,

Number 6 Jackson Pollock, 1948, 57 x 78 cm (22% x 30% in), oil on paper laid down on canvas, Private Collection. Pollock first showed his drip paintings in 1948 at the Betty Parsons Gallery, New York.

monumental nature of his achievement becomes apparent. (A child of five cannot conceive or create on this scale.) He put the canvas on the floor and stood in the middle with a large can of household paint – he consciously wanted to be "in" the painting and to become physically part of it.

Look for the rhythms and flow in the threads of paint (they may be instinctive, but not arbitrary or careless). How many separate layers of paint can you see? It is just about possible to reconstruct his movements, and so be "in" the painting at second hand. But why no footprints? **KEY WORKS** *The Blue Poles: Number 11, 1952* (Canberra: National Gallery of Australia); *Lavender Mist: Number 1, 1950*, (Washington DC: National Gallery of Art); *The Deep*, 1953 (Paris: Musée National d'Art Moderne) $c \,\,.\, 1 \,\, 9 \,\, 0 \,\, 0 - 7 \,\, 0$

The Moon-Woman Cuts the Circle Jackson Pollock, 1943, 109.5 x 104 cm (43 x 41 in), oil on canvas, Paris: Musée National d'Art Moderne. Inspired by a North American Indian myth about the moon and the feminine.

ABSTRACT EXPRESSIONISM

Abstract Expressionism grew out of the human tragedies of the Great Depression and World War II, reaching maturity in the early years of the Cold War. Faced with the real possibility of the denial of freedom of expression and the extinction of the human race, artists felt compelled to act, and create art that would take up these issues.

STYLE

SUBJECTS

Sometimes energized forms (such as Jackson Pollock's) were intended to be a near documentary account of the artist's struggle to create in his or her direct encounter with the canvas. Other artists aimed to express the deepest and most universal of

KEY EVENTS

1943	Rothko, Still, and Gottlieb assert the basic goals of their art in a letter to <i>The New York Times</i>
1946	New Yorker art critic Robert Coates coins the term "Abstract Expressionism"
1947	Pollock develops new style of Surrealist-influenced "automatic" painting, dripping paint onto huge canvases laid on the ground
1956	Pollock killed in car crash
1970	Rothko, suffering from deep depression, commits suicide in his studio

It grew out of Surrealism but was never a coherent movement and it had no programme. Styles were wholly personal. It was also entirely American, and New York replaced Paris as the capital of artistic creativity. Among its leaders, Pollock dripped and flung paint onto his giant canvases, torn between the desire to allow chance to determine how it fell and to control the final result. Rothko's immense areas of subtly modulated colour had precise, meditative ends in mind.

Ballantine Franz Kline, 1948–60, Los Angeles: County Museum of Art, oil on canvas. Kline's early work was black and white; later he used colour. The spontaneity is illusory: each "gesture" was painted slowly and deliberately.

human emotions and anxieties in distorted figurative images, or fields of pure, deliberately modulated or contrasting colour. Yet as with music, ultimately all Abstract Expressionist works can only be felt intuitively rather than understood.

Man on the Dunes Willem de Kooning, 1971, oils, Private Collection. Part of the artist's passionate outpourings during the 1970s when his painting became an extreme frenzy of bold colours and paint layering, then smeared by newspapers.

late 1940s-1950s

WHAT TO LOOK FOR

Heroic imperatives dominate Abstract Expressionism. It is alternately bold and assertive, contemplative and questioning. Its impact derives in large measure from scale, large canvases - "portable murals" - that overwhelm and dazzle, seeming to draw the spectator into what can feel like a parallel universe. Texture is important,

too, whether Pollock's rivulets and rivers of paint, Still's thick, almost relief-like blocks of colour, or Rothko's layers of thinly applied colour. However, Rothko spoke for them all when he said "... if you are moved only by the colour relationships, you miss the point ... I'm interested only in exploring basic human emotions."

The Black and the

White Mark Rothko, 1956, 238 x 136 cm (93³/₄ x 53¹/₂ in), oil on canvas, Harvard: Fogg Art Museum. Abstract Expressionist works were displayed unframed so that they would be perceived as a "presence" rather than a tangible object.

Within a limited range,

Rothko's colours have an exceptional richness, a seemingly infinite series of subtle gradations

TECHNIQUES

In a typical motif, Rothko paints two hazy, softedged blocks of colour, the upper stacked weightlessly over the lower, with both appearing to hover over a delicate red base. The effect of the work is deliberately sublime, inducing a kind of quasireligious feeling.

Black in Rothko's hands achieves a gentle luminosity: the sense of an "infinite void" is palpable

Mark Rothko

● 1903-70 P AMERICAN

🔟 USA 🚺 oils 💼 London: Tate Collection. Houston: St. Thomas University. New York: Museum of Modern Art 🛛 🔁 \$14.6m in 2003, White and Black on White (oils)

A melancholic Russian émigré who settled in the USA at the age of 10, Rothko became a leading member of the New York School and pioneer of Colour Field abstract painting. Committed suicide.

His deceptively simple abstract paintings have deliberately plain, soft-edged shapes and luminous, glowing colours. His work is at its best seen on a large scale, completely filling a space such as the Rothko room at Tate Modern or the chapel at St. Thomas University. Look for his early work to see how slowly and carefully he reached this final, very personal, expression.

Treat the works with the respect and care with which they were created and give them time to reach you. Move around them so as to get to know them: stand close to the works, relax, wait, so that the colour completely fills your field of vision and seeps through your eyes into your mood and feelings. Rothko said his paintings were about "tragedy, ecstasy, and doom" - about fundamental (and romantic) emotions and passions. KEY WORKS Multiform, 1948 (Canberra: National Gallery of Australia); Untitled (Violet, Black, Orange, Yellow on White and Red), 1949 (New York: Guggenheim Museum); Green and Maroon, 1953 (Washington DC: Phillips College)

Willem de Kooning

€ 1904-97 PU DUTCH/AMERICAN

🔟 USA 🚺 oils; sculpture 🖬 Washington DC: National Gallery of Art 🛛 🔎 \$18.8m in 1989, Interchange (oils)

A Rotterdam-born painter and decorator who went to New York in 1926, and became one of the most consistent and longest-lived Abstract Expressionists.

He produced his best work between 1950 and 1963. One of the few artists to achieve a genuine synthesis between figuration and abstraction - the image (most famously, the woman) and the abstract expressive gesture coexist and interact as equal partners. After 1963 he lost control and direction, turning out

work with arbitrary gestures, flabby colours, and splodgy decoration. His last paintings were, sadly, feeble (he had Alzheimer's disease).

Wonderful colour sense, using thrilling and unusual colour juxtapositions, and complex textures and interweaving of paint, which are a pleasure to look at. He creates a truly exciting balance and tension between uncontrolled freedom and conscious control; between aggression and beauty; between abstraction and figuration (as skilled, daring, and breathtaking as a high-wire act). In the complexity of paint and imagery lurk subtle layers of meaning. Who can or will explain the tortured female? KEY WORKS Woman and Bicycle, 1952-53 (New York: Whitney Museum of American Art); Marilyn Monroe, 1954 (Private Collection); Door to the River, 1960 (New York: Whitney Museum of American Art)

Barnett Newman

🔟 USA 🛛 oils; sculptures 🛛 🖄 \$3.5m in 2002, White Fire 1 (oils)

Newman, a leading Abstract Expressionist, developed a personal style of large-scale Colour Field painting that attempted to touch emotions and aspirations beyond the power of words to express.

Look for everything or nothing. If you see the intense colour fields with the simple vertical stripes as nothing more than that,

Vir Heroicus Sublimis Barnett Newman, 1950–51, 242.2 x 513.6 cm (95% x 213% in), oil on canvas, New York: Museum of Modern Art. Originally an art critic, Newman was an articulate advocate for the Abstract Expressionists.

you will not see much. But if you see, for example, the red background drawing aside to reveal an expanding opening into an infinite blue space (the blue stripe), or the yellow stripe as a flash of cosmic light, then you will see everything. **KEY WORKS** *Moment*, 1946 (London: Tate Collection); *Dionysius*, 1949 (Washington DC: National Gallery of Art)

Franz Kline

Kline was a leading Abstract Expressionist who grew up in the industrial coal-mining region of Pennsylvania. Studied in Boston and London. Lived a lonely life in New York and died young.

At first, his big black-and-white abstract paintings from the 1950s and 1960s look like enlarged Chinese calligraphy. They are typical for their time: gestural, personal, spontaneous, moody, full of existential angst. But further acquaintance shows that this is the opposite of what they are.

Kline was not spontaneous. He worked out the compositions and placing of the brush marks very carefully. Painted wellbalanced, serene pictures with astonishing cerebral and sensual harmony. Visitors to a Kline exhibition become noticably deeply engaged with the works and each other. **KEY WORKS** *Ballantine*, 1948–60 (Los Angeles: County Museum of Art); *Chief*, 1950 (New York: Museum of Modern Art)

Robert Motherwell

USA [] oils; collage 🖬 San Francisco: Fine Arts Museums [2] \$2.6m in 2004, *Elegy* to the Spanish Republic No.71 (oils)

Motherwell was an urbane, erudite, fluent, influential painter, writer, and philosopher who was a leading Abstract Expressionist. He married Helen Frankenthaler.

His abstract paintings, drawings, and collages are always elegant. His work ranges from small-scale, intimate collages to grand, large-scale paintings. Enjoys paint, accident, the unexpected, calculated simplicity. Restrained use of colour.

His major achievement, the "Spanish Elegies" series of paintings (more than 150 canvases done over his lifetime), form a deeply emotional response to the Spanish Civil War and Motherwell's realization that civilization can regress. The collages he built around wine labels, cigarette wrappers, and music are a diary of association, not an autobiography. **KEY WORKS** *Personage (Autoportrait)*, 1943 (New York: Guggenheim Museum); *Black on White*, 1961 (Houston: Museum of Fine Arts)

Adolph Gottlieb

€ 1903-74 P AMERICAN

USA 🚺 oils 💼 Washington DC: National Gallery of Art 😰 \$850,000 in 2003, *Blast II* (oils)

Gottlieb was a well-known Abstract Expressionist, but too schematic to be one of the great artists. He had two styles: 1941–51 – pictographs, loose compartments filled with schematic and symbolic shapes (he was into Freud and Surrealism); 1950s onwards – imaginary semi-abstract landscapes, typically with a simple, round, celestial body floating above loosely painted earthly chaos. **KEY WORKs** *Romanesque Façade*, 1949 (Champaign, Illinois: Krannert Art Museum); *Ascent*, 1958 (New York: Adolph and Esther Gottlieb Foundation)

Clyfford Still

→ 1904 - 80 P
 Ø AMERICAN

One of the leading Abstract Expressionist painters, Still was intense, serious, painterly, heroic, romantic, and difficult to live with. A sensitive intellect in a rugged exterior, he was brought up in the big open spaces of Alberta, Canada, and Washington.

His early figurative work explored the relationship between humans and landscape. His later large-scale (for their time) abstract paintings are heavily worked, having rough surfaces with thick paint. Used intense colours and simple "imagery" consisting of "flames" or "flashes" of colour on a field of single colour, with a vertical format for paintings and "images". His works manifest a deliberate cragginess, intransigence, and awkwardness that reflect both the character of the artist and the agenda shared by his fellow Abstract Expressionists.

You have to spend time with the paintings and be prepared to meet the artist halfway. He saw art as a moral power in an age of conformity; life as a force pitted against nature – especially earth and sky. Thus the vertical "necessity of life" arises from the horizontal. He continued the 19thcentury tradition of Romantic landscape. **KEY WORKS** *Jamais*, 1944 (New York: Guggenheim Museum); *1953*, (London: Tate Collection)

Sam Francis

USA; France; Japan Acrylics; watercolours; prints; sculpture Washington DC: National Gallery of Art S \$3.1m in 1999, *Towards Disappearance I* (oils)

Francis took up art as therapy while recovering from spinal injuries as a World War II fighter pilot. Large-scale abstracts in which splattered and dribbled pure translucent colour floats with weightless ease over a white background, conjuring up a magical, open, light-filled space. **KEY WORKS** *Red and Pink*, 1951 (San Francisco: Museum of Modern Art); *Around the Blues*, 1956–57 (London: Tate Collection)

In Lovely Blueness Sam Francis, 1955–57, 300 x 700 cm (118 x 275¼ in), acrylic on carvas, Paris: Musée National d'Art Moderne. Francis was inspired by memories of light patterns on his hospital ceiling and the Pacific sky.

Arshile Gorky

● 1904-48 P ARMENIAN/AMERICAN

USA 0 oils 2 Washington DC: National Gallery of Art 2 \$3.6m in 1995, Scent of Apricots on the Fields (oils)

Gorky emigrated from Turkey to the USA in 1920. Original lyrical, gentle, and poetic abstract painterly style, deriving inspiration from landscape and nature. Natural colours, biomorphic forms (influence of Miró and Surrealism). Tragic, early death (like many fellow Abstract Expressionists); committed suicide after cancer, car accident, and disastrous studio fire.

KEY WORKS The Artist and his Mother, 1926–29 (New York: Whitney Museum of American Art); Hugging/Good Hope Road II, 1945 (Madrid: Museo Thyssen-Bornemisza)

Richard Diebenkorn

 ☑ USA Ø oils Mashington DC: National Gallery of Art Ø \$3.2m in 2001, Ocean Park No.67 (oils)

Considered an American West Coast Matisse (whom he was much taken with), Diebenkorn was talented, influential, very visual, but lacked the master's range and tough-minded certainty.

His early abstracts (abstraction from nature) of 1948–56 were reactions to specific places (colour, topography, light).

Untitled Arshile Gorky, 1946, 53.3 x 73.6 cm (21 x 29 in), mixed media, Private Collection. During the 1940s, Gorky spent part of each year in Virginia, where his wife's family had a farm, making drawings while in the countryside and then exploring multiple versions of the shapes and colours he had observed.

Vigorous figurative work from 1956, with bold, simple designs, glowing colour, and juicy paint. Returned to abstraction with the Ocean Park series (from 1966); these works are large scale, translucent, investigative, and statuesque. It is important to see pieces by natural light – hard, artificial light kills subtleties. Don't rush: let the eye bask and play.

His most confident work is figurative. His abstracts are always oddly tentative – justified as sensitive, responsive, and so on, but somehow he could never reach that final distillation of sensation that so distinguishes Matisse. His early abstract work can be repetitive and unstructured, and can kill colour (perhaps the reason he moved on to figuration?). Stunning response to light (as good as Hopper's). Lovely small-scale work (cigar-box lids 1976–79) and late work (still small, as a heart disease prevented him from working large scale).

KEY WORKS Seated Nude, Black Background, 1966 (Private Collection); Seated Figure with Hat, 1967 (Washington DC: National Gallery of Art); Still Life: Cigarette Butts and Glasses, 1967 (Washington DC: National Gallery of Art); Ocean Park No.64, 1973 (Pittsburgh: Carnegie Museum of Art)

Jean **Tinguely**

⊖ 1925-91 PU SWISS

 Switzerland Sculpture; mixed media
 Basel (Switzerland): Museum Jean Tinguely
 \$265,600 in 1997, Untitled, Welded Sculpture Fountain (sculpture, 1968)

The creator of bizarre, unpredictable, clanking machines, made from junk, which move and whizz, sometimes to the point of self-destruction. His work is highly original and very humorous. Thought that change is the only constant in life. Delighted in expressing an anarchic freedom (against neat, orderly Switzerland?). Married Niki de Saint-Phalle and worked with her on his most famous work, *Beaubourg Fountain.* **KEY WORKS** *The Sorcerss*, 1961 (Washington DC: Hirshhorn Museum); *Débricollage*, 1970 (London: Tate Collection); *Beaubourg Fountain*, 1980 (Paris: Centre Pompidou)

CoBrA

First founded in Paris by Belgian poet and essayist Christian Dotrement, the group were mainly inspired by their Marxist beliefs. Including Karel Appel, Asger Jorn, and Pierre Alechinksy, their art was experimental and sympathetic to Expressionism and Surrealism but showed its greatest affinity to folk art and children's art, and to works of Paul Klee and Joan Miró. CoBrA's name was adopted from the names of the three capital cities of the countries of its principal members: Co from Copenhagen, Br from Brussels, and A from Amsterdam.

Asger **Jorn**

● 1914-73
 P DANISH
 Denmark; Paris
 O oils; drawings
 San Francisco: Fine Arts Museums
 \$1.9m
 in 2002, In the Beginning was the Image (oils)

A founder member of CoBrA. Boldly and freely painted, intensely coloured, gestural works, sometimes abstract, sometimes with figurative imagery. At the forefront of European art until the mid-1960s, when Pop art became the fashion. **KEY WORKS** *My Spanish Castle*, 1953 (Boston: Museum of Fine Arts); *The Three Sages*, 1955 (Bruges: Musées Royaux des Beaux-Arts)

Karel **Appel**

● 1921 – № DUTCH
 1921 – № DUTCH
 10 Denmark; France; USA
 10 Oils; sculptures;

drawings; prints; ceramics in San Francisco: Fine Arts Museums is \$680,000 in 2002, *Women, Children, Animals* (oils)

An important postwar artist and founder member of CoBrA, he is recognizable for thickly painted, brightly coloured Expressionist paintings that attempt to capture the spontaneity of children's painting, but also benefit from adult sophistication/organization and aesthetic sensibility, together with an ability to create on a large scale. Appel has also produced scenery for a ballet. **KEY WORKS** *Burned Face*, 1961 (Private

Collection); *Hip Hip Hooray*, 1949 (London: Tate Collection)

> Turning of Friendship of America and France Jean Tinguely, 1961, 204 cm (80 ½ in), mixed media, Private Collection. The artist had shown in New York in 1960.

1948-51

Pierre Alechinsky

 Belgium; Paris; Far East
 initial oils; acrylics;

 prints
 initial san Francisco: Fine Arts Museums

 \$440,100 in 1990, Epave (oils)

A painter and printmaker who creates decorative, joyful, abstract paintings, notable for their spontaneity, lightness of touch, and glowing translucent colour. Often uses formula of a central panel surrounded by complementary border of small calligraphic images. Pleasure-giving work that is mercifully free from introspection or pretension to profound meaning.

KEY WORKS Hors de Jeu, 1962 (Rome: L'Archimede – Galleria d'Arte); To Day Red Hot, Too Hot, 1964 (San Francisco: De Young Museum)

Nicolas de Staël

€ 1914-55 P FRENCH

I Belgium; Europe; France I oils I London: Tate Collection I \$1.9m in 1990, Syracuse (oils)

An orphaned Russian aristocrat émigré who took French citizenship in 1948, de Stael started with admiration for old masters, not Modernism. Evolved a successful style that bridged the divide between figuration and abstraction, using thick, tactile paint, rich colours, and simple forms (suggestive of landscape or still life). Committed suicide (because overwrought or overworked?). His work is neglected.

KEY WORKS *Composition*, 1950 (London: Tate Collection); *Le Parc des Sceaux*, 1952 (Washington DC: Phillips College); *Mediterranean Landscape*, 1953 (Madrid: Museo Thyssen-Bornemisza)

Jean Dubuffet

→ 1901-85
 P
 FRENCH

France Doils; sculpture; prints

Périgny-sur-Yerres (Paris): Dubuffet Foundation
 \$4.3m in 2002, Paris Montparnasse (oils)

A painter, sculptor, printmaker, collector, and writer who was also the son of a wine merchant. Turned full-time artist in 1945 after an early life of the wine trade, military service, divorce, and dilettantism. Developed a challenging and consciously

Octave Pierre Alechinsky, 1983, print, Private Collection. A one-time member of the CoBrA group, Alechinsky settled in Paris in 1951 where he developed an interest in Japanese calligraphy and visited the Far East.

anti-aesthetic, anti-art establishment style – but ended up as the art establishment's favourite example of radical chic.

His art went through a succession of cycles. In each case he had a thought-out agenda and different experiments with materials, which he then promoted via exhibitions: 1942–50 portraits and graffiti; early 1950s obese nudes in smeary oil paint; late 1950s "Earth" themes and sand-gravel textures; 1960s black outlined "jigsaw" style and polystyrene sculpture. He sought intensity, not beauty. Promoted Art Brut and tapped into the unschooled creativity of children and psychotics.

Dubuffet raised naïvety to the highest level of sophistication and knew exactly what he was doing – one of the few occasions where this "game" works. The trouble with most *faux naïf* work is that you have no idea (unless told) whether the work is to be admired because it is by an untrained and innocent eye, or by an over-educated sophisticate trying to amaze us by how "simple" he or she can be. **KEY WORKS** *Spinning Round*, 1961 (London: Tate Collection); *The Triumpher*, 1973 (Périgny-sur-Yerres, Paris: Dubuffet Foundation)

Alfred Otto Wolfgang Schulze **Wols**

1913–51
 III GERMAN/FRENCH
 Germany; France
 Goils; watercolours;
 drawings
 S932,800 in 1990, Untitled (oils)

Wols was a lost soul, typical of many dispossessed, destitute, and unhappy people who were victims of political and social upheavals in central Europe during this era. Found solace in artistic activity and drink. Born in Germany, lived in France

He made small-scale works in oils and watercolours. The oils are often composed of compulsive pouring, smearing, spraying, and scratching. The watercolours frequently have an obsessive concern with detail. What distinguishes Wols from many lesser jotters and scribblers is the quantity, consistency, and integrity of his work. Unrecognized in his lifetime, he persisted with, and pioneered, a new style of expressive abstraction.

He was remarkable for his attention to detail. Every mark is there for a reason. (This is real integrity.) Try to see a group of works together: the end result, individually and collectively, is a remarkable record of someone using art to rise above hardships that killed many others – literally or spiritually. Composition Alfred Otto Wolfgang Schulze Wols, c. 1950, 24.8 x 15.9 cm (9¼ x 6¼ in), gouache on paper, Private Collection. From his Tachist phase, a method involving "taches" or stains of colour splashed on canvas.

Together they are strangely beautiful and moving to look at and be with. **KEY WORKS** *Painting*, 1944–45 (New York: Museum of Modern Art); *Bateau*, 1951 (Boston: Museum of Fine Arts)

Pierre **Soulages**

⊖ 1919- № FRENCH

France; USA; Japan 2 oils; prints
 Paris: Musee National d'Art Moderne
 \$387,200 in 1990, *Peinture 41-58* (oils)

He produced large-scale, heavily textured, gestural, painterly abstracts in which black is predominant. Intended to be more visual than emotional in impact – he considers black to be the means of making light and colour visible and alive. **KEY WORKS** 23 May 1953 (London: Tate Collection); 6 August 1956 (Canberra: National Gallery of Australia)

César (César Baldaccini)

⊕ 1921-1998
 ₱ FRENCH

France
 Sculpture; mixed media
 New York: Museum of Modern Art
 \$513,655 in 1999, L'homme de la liberté (sculpture)

César is celebrated for constructions and compressions in metal, often with unusual material, such as car parts. Very visual, human, witty, active work. Liked animal skeletons, bones, structure, surfaces like bats' wings. His work in paper and plastic lacks strength and tension (as if the material bored him?) and can be kitsch. Disturbing self-portraits.

KEY WORKS *Italian Flags*, 1960s (Private Collection); *Thumb*, 1965 (Martigny, Switzerland: Fondation Pierre Gianadda)

Yves Klein

•	1928 -	-62	ρu	FRENCH
---	--------	-----	----	--------

Untrained (except at judo), uneducated, megalomaniac dreamer, who had a brief, high-profile and influential presence.

420

His paintings, objects, and records of "happenings" (notably those saturated with his trademark YKB "Yves Klein Blue") give a unique, intense glow. The rhetoric he and his supporters used is huge: blue is the infinite immateriality of the heavens; blue fills the space between object and viewer with spiritual energy; blue leads to Zen-like transcendental experience, and so on. With a leap of imagination similar to his own, this is possible. Klein was also infamous for his scandalous behaviour throughout his short-lived career.

Is the attraction of his objects the aesthetic and spiritual experience they seek to convey? Or is it that they were and remain as instantly recognizable and as chic as the Gucci loafer or Chanel No. 5 - all of them proclaiming the possessor to be a (self-elected) member of the international club of connoisseurship and savoir-faire? Is this the first example of art as a highclass fashion accessory? And, if so, is it any the worse for that?

KEY WORKS IKB 79, 1959 (London: Tate Collection); Untitled Blue Monochrome (IKB 82), 1959 (New York: Guggenheim Museum); Requiem Blue, 1960 (Houston: Menil Collection)

Armand Fernandez Arman

Arman was a stimulating and witty manipulator of objects. His work was more visual than conceptual. Avid collector since childhood; father a furniture and knick-knack dealer; grandmother an obsessive accumulator of junk.

His work is transformed through accumulations, combustions, cut-ups. Obsessive interest in manufactured objects (such as keys, car parts, machines, dolls, or paint tubes). Their repetitive

accumulation, and luxurious and bizarre presentation out of context (for instance Perspex boxes, resin beds, and wall mounts), endow them with a kind of poetry. Cut-up musical instruments or charred furniture simultaneously shock and cause reappraisal of the true function of objects.

> KEY WORKS Accumulation of Sliced Teapots, 1964 (Minneapolis: Walker Art Center); Diana (Noli me tangere), 1986 (Toronto: Miriam Shiell Gallery); Self-Portrait-Robot, 1992 (Florence: Galleria degli Uffizi)

> > Office Fetish Armand Fernandez Arman, 1984, 76.2 x 76.2 cm (30 x 30 in), rotary telephones and metal poles, Detroit Institute of Arts. Together with Yves Klein and Jean Tinguely, Arman was a member of the Nouveaux Réalistes, who rejected painting and used real materials.

421

Henri Michaux

⊖ 1899-1984 P BELGIAN

 Belgium; France; Africa; Asia
 watercolours; prints Paris:
 Musée National d'Art Moderne
 \$65,910 in 1990, *Composition* (works on paper)

He was the author of highly original, experimental, introverted paintings. Michaux sought to use art as an escape from the material world. Worked very rapidly, without preconceptions; he used wash and diluted inks for his watercolours, as they

do not allow for revision and second thoughts. After 1956 he sometimes worked under the influence of the hallucinogenic drug mescalin. **KEY WORKS** *Meidosems*, 1948 (Boston: Museum of Fine Arts); *La bataille des éperons d'or*, 1960 (Bruges: Musées Royaux des Beaux Arts)

Marcel Broodthaers

⊕ 1924 – 1976
 ₱ BELGIAN

■ Belgium; Germany; UK ■ sculpture; photography; installations; video ■ \$687,600 in 1992, Armoire blanche et table blanche (sculpture)

Broodthaers was an unsuccessful poet turned untrained artist (in 1964) who created bizarre objects and installations or exhibitions of objects and real works of art. His aim? To investigate issues such as the meaning of art; the definition of art; art institutions and power structures; the art market and aesthetics – and in doing so to challenge received opinion. Subtle, humorous, influential, successful. **KEY WORKS** *Armoire charbonnée (Armoire à charbon)*, 1966 (Bruges: Musées Royaux des Beaux Arts); *Le drapeau noir. Tirage illimité*, 1968 (Bruges: Musées Royaux des Beaux Arts)

Henri van Herwegen Panamarenko

⊖ 1940- 🕫 BELGIAN

Belgium Sculpture; installations
 \$120,000 in 1998, Flugobiekt – Rakete (sculpture)

He is an eccentric visionary who designs weird Leonardo-like machines. They do not work in reality but they do wonders for

40 x 30 cm (15% x 11% in), gouache on paper, Private Collection. Even before he used drugs, Michaux regarded painting as an art of psychic improvisation. the imagination. The theme is liberating humanity from physical constraints by suggesting ways to jump further, to fly, to defy gravity, to reinvent time and space, and so on. Beautiful machines.

KEY WORKS Feltra, 1966 (Ghent: Stedelijk Museum voor Actuele Kunst); Aeroplane, 1967 (Wolfsburg: Kunstmuseum); The Aeromodeller, 1969–71 (New York: Dia:Chelsea)

"One must never forbid oneself anything. One must also be able to go back, one must always be able to change ..."

HANS HARTUNG

Hans Hartung

 Germany; France Paris: Musée National d'Art Moderne
 \$1,424,497 in 1990, *T 47-10* (oils)

Hartung is recognized as having been one of the first painters of gestural abstraction.

His style is spontaneous, neat, wiry, free, with pencil lines crawling over the paper and brushstrokes that have some of the characteristics of Chinese calligraphy but are never uncontrolled or arbitrary. His strong sense of (complex) composition and colour identifies him as European rather than American. His aim was to

create images expressing his innermost being. His paintings are not always as spontaneous as they look: they may be enlarged versions of small, free sketches, in which he replicates the gestures or accidental marks (but does that make the end result any less valid?). KEY WORKS T-1954-20, 1954 (Canberra: National Gallery of Australia); Lines and Curves, 1956 (San Francisco: Fine Arts Museums)

Fritz Hundertwasser

● 1928-2000 P AUSTRIAN

🖸 Austria 🛛 oils; mixed media Vienna: KunstHausWien 👂 \$441,600 in 2004, La tour de Babel perfore le soleil - un spiraloid – Tower of Babel (oils)

Born Friedrich Stowasser, Produced small, detailed, richly coloured, ornamental and jewel-like abstract works, often with a spiral motif, which is organic and labyrinthine in character (a deliberate metaphor for the self-regenerative processes of life). Used mixed media, gold and silver, wrapping paper, and jute. Refreshingly romantic and lyrical. KEY WORKS 460 Hommage au Tachisme, 1961 (Vienna: KunstHausWien); 224 The Big Way, 1955 (Vienna: Österreichische Galerie)

FLUXUS

1962-1970s

Originating in Germany, literally meaning "flow", the Fluxus movement advocated a shift from aesthetics to ethics in artistic values. It held a similar attitude to that of Dadaism, promoting artistic exploration and socio-political activism. Ignoring art theories, members often created mixed-media works from any found materials and developed the performance art movement, called "Aktions" or "Happenings". Fluxus artists shifted the importance from what an artist creates to the artist's actions, opinions, and emotions.

Literature Sausage Dieter Roth, 1967, 63 cm (25 in), mixed media, Hamburg: Kunsthalle. The work consists of Hegel's 20-volume oeuvre, ground up and stuffed into sausage skins.

1969-70, 85 x 55.5 cm (331/2 x 213/4 in), silkscreen. In 1972 the artist designed posters for the Munich Olympics. He subsequently worked on town planning projects in many parts of the world.

Günther Uecker

🖸 Germany 🚺 sculpture 🟛 Venice: Peggy Guggenheim Collection 2 \$97,415 in 2004, Large Field (works on paper)

His typical work (after 1955) consists of nails hammered into a board that are arranged in patterns that are reminiscent of electromagnetic fields. Monotony and repetition are deliberate and integral to his work. He is motivated by Zen and visions of purity and silence; it is his personal belief that he should establish harmony between people and nature.

KEY WORKS Tactile Rotating Structure, 1961 (Venice: Peggy Guggenheim Collection); TV 1963, 1963 (Venice: Peggy Guggenheim Collection)

686 Good Morning City Friedensreich Hundertwasser,

Renato Guttuso

€ 1912-87 Ø ITALIAN

D Italy oils: watercolours St. Petersburg: Hermitage Museum \$174,195 in 2004, Spaghetti Eater (oils)

Guttuso was much praised in the 1950s when considered by many (leftwing) critics to be on the cutting edge of the avant-garde; his social realist works were seen as an antidote to American gestural abstraction, thus he does capture something specific about postwar European art and politics. Founder member of the anti-Fascist association Corrente. His originality declined rapidly after the late 1950s when he became too derivative (too many borrowings from Picasso and Goya). KEY WORKS Crucifixion, 1941 (Rome: Galleria Nazionale d'Arte Moderna); Sulphur Miners, 1949 (London: Tate Collection)

Death of a Hero Renato Guttuso, 1953, 88 x 103 cm (343/ x 401/2 in), oil on canvas, London: Estorick Collection. The artist was staunchly anti-Fascist and a resistance fighter. After the war he became a Communist politician.

Alberto Burri

● 1915-95
 P
 ITALIAN

🔟 USA; Italy 🚺 collage 🖬 Rome: Galleria Nazionale d'Arte Moderna 🛛 🔊 \$2.62m in 1989, Umbria Vera, 1952 (works on paper)

He was a doctor-turned-artist who had some success in the 1950s with original work (for the time), using sacking and other non-arty materials, to produce serious looking collages. (Some connection with doctors bandaging patients - he liked to recreate blood with splashes of red paint - and using splints? Commentary on the state of postwar Europe?)

KEY WORKS Abstraction with Brown Burlap (Sack), 1953 (Turin: Galleria Civica d'Arte Moderna e Contemporanea); Composition, 1953 (New York: Guggenheim Museum)

Lucio Fontana

 ● 1899-1968
 ■ ARGENTINIAN/ITALIAN Italy oils: sculpture: ceramics: installations Rome: Galleria Nazionale d'Arte Moderna \$1.862,500 in 2002, Concetto spaziale, II Cielo di Venezia (oils)

Fontana was an unknown who in middle age became a significant figure in postwar European art, finding a successful if limited "formula" that was in tune with the mood of the times.

He is most famous for monochrome canvases with single or multiple precision cuts, and for canvases and supports that

> have been pierced or lacerated. Can be very good indeed - but can be oh, so dull! Better when several works are seen together a single work can look merely superficial or silly.

The cuttings and piercings had a meaning in the 1960s, as part of a (then new, but now worn out) exploration of the meaning of existence and the role of art. Perhaps they are now best seen as engaging period pieces with an innocent 1950s or 1960s view of the creative act and gesture as a bid for freedom (and he was over 50 when he started them). His

earlier ceramic work searched for a freedom of expression, but he needed a different medium to find full utterance. KEY WORKS Spatial Concept, 1958 (London: Tate Collection); Spatial Concept: Expectations, 1959 (New York: Guggenheim Museum); Nature, 1959-60 (London: Tate Collection)

Mario Merz

→ 1925-2003 PU ITALIAN

Italy installations; sculpture; conceptual art Berlin: Nationalgalerie \$1,323,000 in 2005, Igloo object cache-toi (sculpture)

He was a leading member of Arte Povera who in the 1960s and 1970s created works that addressed geographical and environmental issues - notably metal-

424

What's to be Done? Mario Merz, 1969, shown here in an exhibition in 1991, mixed media, Bordeaux: CAPC Musée d'Art Contemporain. One of Merz's "igloos", part of a larger installation involving painting and sculpture.

framed "igloos" covered with clay, wax branches, broken glass, etc. Produced transient, temporary work to reveal art as a process of change (like nature itself) and the artist as nomad. There are references to Fibonacci numbers (an infinite sequence of numbers in which each number equals the sum of the previous two).

KEY WORKS Crocodile in the Night, 1979 (Toronto: Art Gallery of Ontario); Igloo, 1983 (London: Courtauld Institute of Art); Unreal City, Nineteen Hundred Eighty-Nine, 1989 (New York: Guggenheim Museum)

Michelangelo Pistoletto

Italy I conceptual art; sculpture; performance; video 2 \$184,690 in 2004, Woman Walking (oils)

Pistoletto is a conceptual artist best known for work using mirrors arranged so that the spectator keeps on seeing him/herself. This is often achieved by means of polished steel sheets on which life-size photographed images of people are overlaid, thereby creating a relationship between image and spectator. Effective, puzzling, and amusing, but not as profound as claimed. **KEY WORKS** Architecture of the Mirror, 1990 (Turin: Castello di Rivoli Museum of Contemporary Art); In the First Place,

1997 (Turin: Castello di Rivoli Museum of Contemporary Art)

ARTE POVERA

1970-

An Italian term meaning "Poor Art" or "Impoverished Art". It was coined by the Italian art critic Germano Celant to describe a type of work first seen in Turin in 1970, which is now commonplace in contemporary art. The art objects are made from natural or cheap and tacky materials and carry a strong political agenda, with the proposal that the elevation of humble materials as art corresponds with the wish for the elevation of poor social classes. It also hopes to defy any possibility of being commercially exploited.

Jannis Kounellis

€ 1936-PO GREEK/ITALIAN

🔟 Italy 🚺 sculpture 🖬 Hamburg: Kunsthalle \$1.058,940 in 1990, Senza titolo (oils)

Kounellis is a leading member of Arte Povera who creates strange objects and constructions out of materials such as blankets, mattresses, sacks, and blood, and likes to show evidence or traces of flames and smoke. His intention is to draw attention to, and make one think about, the dark side of 20th-century experience, especially social deprivation and spiritual starvation.

KEY WORKS Carboniera, 1967 (London: Courtauld Institute of Art): Untitled. 1987 (New York: Guggenheim Museum)

Piero Manzoni

Italy ocnceptual art; sculpture; mixed media 🛅 Hamburg: Kunsthalle 🔀 \$840,000 in 1998, Achrome (sculpture)

He was a cherubic-looking aristocrat who was a short-lived (cirrhosis of liver), experimental artist in the forefront of releasing art from traditional ideas, processes, and forms.

He created objects and ideas that are now the commonplace of mainstream, official art, but were genuinely cuttingedge in the late 1950s and 1960s: strange white objects with no specific meaning, made by dipping material in kaolin or plaster; devices or strategies to preserve the evanescent (like the artist's breath) and challenge the idea of art as a tradable commodity; incorporating public and environment into a work of art. His work was provocative, but he was blessed with delicacy and humour. KEY WORKS Artist's Breath, 1960 (London: Tate Collection); Declaration of Authenticity No. 025, 1961 (Boston: Museum of Fine Arts)

Luciano Fabro 0 1024 ON ITALIAN

• 1750-	MALIAN	
🔟 Italy	🖸 sculpture	\$223,300
in 2002, /t	alia d'Oro (scu	ulpture)

Fabro is currently working on elegant, refined, carved sculptures using traditional materials, such as marble. He takes delight in visual and physical properties of material. Interested in craftsmanship and aesthetics - a contemporary interpretation of a tradition that goes back to Classical Greece. His work needs sunlight to bring it to life.

Enjoy his work for what it is. Let it play freely on your imagination through your own eyes. Close your ears to the wordy

jargon of those cataloguers and curators who spend more time looking at keyboards and playing with words than looking at works of art. These works have all the gloriously refined qualities of haute couture: they are an open invitation for the eye and imagination to have a truly fulfilling private feast.

KEY WORKS Italio d'Oro (Golden Italy), 1971 (Los Angeles: Museum of Contemporary Arts); Iconografia, 1975 (Private Collection); Road Map of Italy, 1979 (Turin: Castello di Rivoli Museum of Contemporary Art)

Alighiero **Boetti**

 Italy
 ↓ sculpture; conceptual art;

 mixed media
 ↓ \$431,200 in 2002, Tempo in tempo col tempo (works on paper)

Boetti was a leading member of Arte Povera. Specialized in coloured-wood creations. He created bits and pieces (such as assemblages, embroideries, drawings) that scratch away at attempting to make sense of a "fragmented but all embracing world" (so what's new?). Naïve systems, which the viewer is supposed to decode. Fashionable, not trivial, but ultimately insignificant. Untrained (it shows).

He is a useful reminder that the ideas, appearance, and agenda of the young,

"cutting-edge" art of the 1990s have been in play for a good 30 years. **KEY WORKS** *The Thousand Longest Rivers in the World*, 1977–85 (New York: Museum of Modern Art); *Aerei*, 1984 (New York: Gagosian Gallery); *Map*, 1993–94 (Private Collection)

Mimmo Paladino

⊖ 1948- № ITALIAN

Italy
 oils; prints; sculpture
 New York: Metropolitan Museum of Art
 \$225,000 in 1990, *Pozzo di eroi* (sculpture)

Creator of consciously individual, showy, expressively painted, colourful, large-scale figurative work made up of dislocated parts of animals, death masks, and bodies. Has a personal, mythical, and mystical agenda, which is probably (and deliberately?) impenetrable. A leading member of the Italian Transavanguardia movement, which included Sandro Chia and Francesco Clemente.

KEY WORKS Canto Guerriero, 1981 (Indiana: Ball State Museum of Art); Untitled, 1985 (New York: Metropolitan Museum of Art); Sette, 1991 (Buffalo: Albright-Knox Art Gallery)

Bringing the World into the World Alighiero Boetti, 1973–79, 135 x 178 cm and 132 x 201 cm (53¼ x 70 in and 53¼ x 80 in); ballpoint pen on paper mounted on linen, Private Collection. The alphabet is part of the art work.

Antoni Tàpies

 Spain Mixed media; oils; prints
 Barcelona: Fundació Antoni Tàpies
 \$753,608 in 1990, Bois et marron troué (mixed media)

He is a talented self-taught artist whose best work dates from the 1950s and early 1960s, when he used coarse materials to produce sombre heavily textured canvases expressing the uncertain, stressful mood of Cold War Europe. His later work is less convincing because it is less in tune with the times. Much highly praised, so-called avant-garde art of the 1970s and 1980s is anticipated by Tàpies. **KEY WORKS** *Great Oval or Painting*, c.1955 (Bilbao: Fine Arts Museum); *Le Chapeau Renverse*, 1967 (Paris: Musée National d'Art Moderne)

Juan **Muñoz**

 Image: Spain; UK; USA
 Image: Spain; UK; USA
 Image: Spain; Spain

Born in Madrid, he studied in London and New York. Creator of large-scale installations that fill a whole gallery – such as marquetry floors with extreme false perspective, constructions with architectural elements (such as iron balconies) that have distorted scale, and groups of figure sculptures in unexplained silent relationships. He creates feelings of disequilibrium, danger, and absurdity.

If the new museums of modern and contemporary art are no longer places

Composition LXIV

Antoni Tàpies, 1957, 97 x 162 cm (38% x 63% in), mixed media on canvas, Hamburg: Kunsthalle. Tàpies was a key member of the Spanish Dau al Set ("the seventh side of the dice" in Catalan), an artistic alliance inspired by Dada and Surrealism, reacting against the intellectual stagnation of postwar Spain. Tàpies in particular concentrated on the materiality of paint.

for individual, spiritual, and aesthetic refreshment, nor for genuinely eyeopening artistic and political challenge, but are effectively adult adventure playgrounds driven by management targets for admissions, budgets, shop sales, fund raising, and commercial sponsorship (and why not? - everyone and everything must move with the times), then these (and other similar works) are good-quality content for them. KEY WORKS Last Conversation Piece, 1984-85 (Washington DC: Hirshhorn Museum); Dwarf with a Box, 1988 (London: Tate Collection); Double Bind, 2001 (London: Tate Collection)

Eduardo Chillida

He was a Basque artist, notable for abstract constructions, mainly in forged or welded iron, that combine several Spanish influences: modern, such as Picasso, and traditional, such as old farm implements. These sculptures are

Berlin Eduardo Chillida, 2000, iron sculpture, Berlin-Tiergarten: Bundeskanzleramt. The installation of Chillida's sculpture in the Court of Honour of the Berlin Federal Chancellery coincided with the opening of his own dedicated museum, the Museo Chillida-Leku, in his home town of Hernani.

с.1900-70

"The conditions you need to be a good goalkeeper are exactly the same conditions you need to be a good sculptor! You must have a very good connection, in both professions, with time and space."

EDUARDO CHILLIDA

sometimes monumental, but always graceful – often without a base, so they touch the ground with a dancer's lightness. Many have interlocking and embracing themes.

KEY WORKS *Tximista (Lightning)*, 1957 (Washington DC: Hirshhorn Museum); *Modulation of Space*, 1963 (London: Tate Collection); *Silent Music II*, 1983 (New York: Metropolitan Museum of Art)

Jaume Plensa

Spain Conceptual art; installations; sculpture \$\$27,209 in 1990, Lau II (mixed media)

The Spaniard Jaume Plensa is a good example of the new academic modern orthodoxy that is heavily promoted by the official art establishment. He works with large-scale industrially made objects made to look significant, portentous, and profound, by being displayed in isolation or attached to big white walls in large official spaces. He "uses" steel, glass, and neon light, but the artist is only the designer: the physical creation is done anonymously, presumably in a factory.

If you remove the words that embellish the pieces ("Rembrandt", "womb", "desire", "Giotto", "a fool sees not the same tree a wise man sees"), what do they amount to? Profundity or banality? Is this art with deep meaning, or a clever exercise in marketing and packaging? Is this a good example of the way art establishments are mesmerized by big, slick machines?

KEY WORKS Knock, 1999 (Kirishima, Japan: Kirishima Open-Air Museum); Crown Fountain, 2004 (Chicago: Millennium Park)

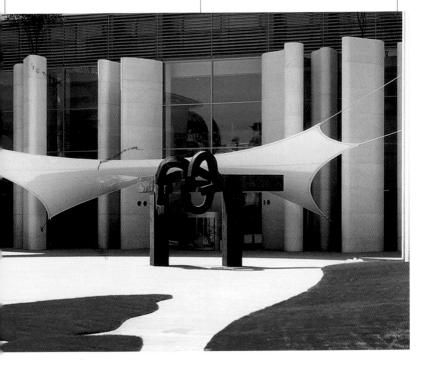

Laurence Stephen Lowry

⊖ 1887–1976 🕫 British

 NW England
 Image: Salford: Lowry Centre

 \$2.8m in 1999, Going to the Match (oils)

Lowry was a quirky painter who became critically and commercially successful with his instantly recognizable scenes of the bleak north of England – industrial landscapes inhabited by busy "stick" people. His "spontaneous naïvety" appeals to critics and intellectuals, his everyday directness to popular taste. At his best he is very good indeed, at all levels. **KEY WORKS** An Organ Grinder, 1934 (Manchester: City Art Gallery); The Feer Van, 1935 (Liverpool: Walker Art Gallery)

Victor Pasmore

■ England ■ oils; sculpture ■ Southampton: City Art Gallery ■ \$330,000 in 1997, *The Studio* of Ingres (oils)

He was an interesting pioneer of British abstraction. Started off as a spare-time painter (1927–37), then became a fulltime figurative painter who went abstract in 1948 (which was a difficult decision for him). His line and form was very sensitive (over sensitive and contrived?). His spare, cool, calculated, consciously artificial works now look dated. **KEY WORKS** *Parisian Café*, 1936–37 (Manchester: City Art Gallery); *Chiswick Reach*, 1943 (Ottawa: National Gallery of Canada)

Sir Terry Frost

● 1915-2003 P BRITISH

- Cornwall, England
 Iondon: Tate Collection
- \$70,300 in 2004, Yellow Quay (oils)

Frost was a leading St. Ives Group painter. Produced sensitive early works with gentle, fundamental shapes and colours abstracted from nature, often invoking sensations of movement, flight, or waves. His later work is more purely abstract. Took inspiration from the natural world. Wanted to convey the ecstatic and poetic experiences he found in nature. You could go round a Sir Terry Frost exhibition looking for modern art influences and colour theories (they are there to be found and that is all some people do), but what a waste of an opportunity that would be. If you go round looking for sunlight, water, leaves, and woods, and your memory or evocation of them and their interaction with you, your sight, or your emotions, you will be as uplifted as if you had spent your ideal day in the country. KEY WORKS Brown and Yellow, c.1951-52 (London: Tate Collection): Green, Black, and White Movement, 1951 (London: Tate Collection): Blue Moon, 1952 (London: Tate Collection)

Sir Sidney Nolan

⊖ 1917-92 P AUSTRALIAN

Widely travelled and acclaimed, Nolan was one of the few contemporary artists to have established a place for narrative, mythological painting, notably the "Ned Kelly" (romantic Australian outlaw) series. His distinctive style combines abstraction and figuration, and conveys a strong sense

430

of the heat and emptiness of the vast Australian landscape. Was an exponent of expressive brushwork and colour. **KEY WORKS** *The Trial*, 1947 (Canberra: National Gallery of Australia); *Kelly in Spring*, 1956 (London: Hayward Gallery)

Patrick Heron

● 1920-99 P BRITISH

 ■ England
 ■ oils; prints
 ■ London: Tate

 Gallery
 ≥ \$364,000 in 2001, Lux Eterna (oils)

Heron is greatly revered and respected as one of the pioneers of large-scale, postwar abstract art in the UK. Had a difficult, combative personality. His last years were marked by illness and personal tragedy.

He was the creator of a prolific and impressive body of work that is intensely visual, colourful, and inspired by personal emotion and things seen. One of the few artists who sought to bridge the gap between European aesthetic sensibility and American direct rawness. If possible, see his work in

Red and Blue Sir Terry Frost, 1959, 127 x 76 cm (50 x 30 in), oil on carvas, Leicester: New Walk Museum. Frost began to paint after being taken prisoner during the German invasion of Crete in 1941.

daylight – preferably sunlight – so the individual colours and colour contrasts and interactions reach their full potential of Mediterranean intensity.

His most powerful work dates from the late 1960s and early 1970s - big works with intense, simple, hard-edge colour forms that generate intense colour sensations and pulsating spaces. Stand close to them for the full power to develop in your eye. His earlier work shows the inspiration of landscape, seascape, and the light of Cornwall. His later works were looser in style. Nevertheless, everything he created was done with very great, but not always obvious, technical exactitude, KEY WORKS Boats at Night, 1947 (London: Tate Collection); Vertical: January 1956 (London: Tate Collection); Red and Yellow Image, 1958 (London: Tate Collection)

Alan **Davie**

⊖ 1920- № BR	ITISH
🔟 UK; Europe	🖉 oils; prints 🛛 🏛 London:
Tate Collection	🎾 \$85,000 in 1989, Oh to be
a Serpent that I	May Love you Longer (oils)

Davie is an unusual but well-regarded painter, working today in a totally

individual manner. Talented athlete and jazz musician. Prolific. Magic. His work is all about trying to express the inexpressible and how to reach the primal and mystical forces of humankind (the sort of experience that the hippy generation sought). If you cannot accept the possibility of magic, or are unwilling to travel with him, his work will remain meaningless and appear no more than a design for a cover to a handbook on Indian mysticism.

He needs a large scale to express fully the magnitude of his endeavours. Early work is thickly painted in an Abstract Expressionist style. Since the 1960s he has worked in a figurative style, full of signs and symbols that are highly reminiscent of Indian art and decoration. **KEY WORKS** Thoughts for a Giant Bird, 1940s (London: Bonhams); Entrance to Paradise, 1949 (London: Tate Collection); Peggy's Guessing Box, 1950 (Venice: Peggy Guggenheim Gallery)

Leon Kossoff

⊖ 1926 - 🕫 BRITISH

England I oils I \$460,800 in 2001, Children's Swimming Pool, 12 o'clock Saturday Morning, September (oils)

Kossoff is a somewhat shadowy and neglected figure, influenced by his Jewish cultural heritage. The human figure is always central to his work, which is of high quality, very thickly and crudely painted, in a strongly Expressionist style. He is inclined to gloominess, although his swimming-bath series are full of life. **KEY WORKS** *Portvait of Father*, 1978 (Edinburgh: National Gallery of Modern Art); *Two Seated Figures No.2*, 1980 (London: Tate Collection)

Frank Auerbach

⊖ 1931 - PU BRITISH

UK i oils i New York: Auerbach Collection i \$600,000 in 1990, Mornington Crescent with the Statue of Sickert's Father-in-law (oils)

Auerbach is German-born, but British by adoption. Chiefly produces small-scale paintings in which the paint can be as thick as the crust of a loaf, the result of constant revisions piled on one another. Images mostly of central, urban London, but also nudes. His work is an almost defiant declaration that although the art of painting may be considered by some to be out of fashion, it will certainly never die. **KEY WORKS** *The Sitting Room*, 1964 (London: Tate Collection); *Jym I*, 1981 (Southampton: City Art Gallery)

R. B. Kitaj

€ 1932- P AMERICAN/BRITISH

USA; England [] oils; pastels in London: Marlborough Fine Art. Edinburgh: National Gallery of Modern Art [] \$341,000 in 1994, Value, Price, and Profit (oils)

He was born in the US, but settled in the UK in the 1960s. Maintains and advances a definition of art that is central to European painting in the "grand manner" – life drawing, literary subjects, exposition of human, intellectual, and moral issues. Sees himself as a martyr crucified by ignorant British critics (with some justification).

He has a very personal style. Makes large-scale, "exhibition" pieces, with many personal and biographical references, sometimes hidden. There are crossreferences to literature and philosophy, sometimes to specific passages. He is concerned with the Jewish diaspora. Fine draughtsman and instinctive colourist. Independent of eve and mind, and (to

> his credit) difficult to pigeonhole. His refusal to compromise can seem arrogant – is this why he was recently savaged by art critics in Britain (but not in the US)? **KEY WORKS** *The Murder of Rosa Luxembourg*, 1960 (London: Tate Collection); *The Ohio Gang*, 1964 (New York: Museum of Modern Art); *The Hispanist (Nissa Torrents)*, 1977–78 (Bilbao: Fine Arts Museum)

Value, Price, and Profit, or Production of Waste

R. B. Kitaj, 1963, 152.4 x 152.4 cm (60 x 60 in), oil on canvas, Private Collection. Kitaj's self-image is that of a pilgrim existing in a cold, ugly, and exploitative world whose saving grace is the warmth generated by human creativity and intellect.

Francis **Bacon**

UK; Germany; Paris 🚺 oils; watercolours; drawings 🖻 Art Institute of Chicago 😰 \$7.8m in 2001, *Studies of the Human Body* (oils)

He was one of the most significant figurative painters of the postwar period. Largely self-taught. A loner, personally and artistically. His long-term significance has yet to be assessed and will depend on whether he is followed, or if he proves to be a dead end.

"The feeling of desperation and unhappiness are more useful to an artist than the feeling of contentment, because desperation and unhappiness stretch your whole sensibility." FRANCIS BACON

Bacon shows genuine originality in his imagery, and the way he constructs it and handles paint. His central (only?) image is of an isolated figure, usually male, often naked, under stress, in bare, brightly lit, or coloured space. Said by Bacon (and others) to indicate the condition of postwar Europe and modern human isolation. His work is beautifully crafted, with controlled drawing and line, and tense, emotional colour. There is creative interplay between what he intends and what happens accidentally.

Three Studies for Portraits (including Self-Portrait) Francis Bacon, 1969, 35.5 x 30.5 cm (14 x 12 in) each, oil on canvas, Private Collection. Bacon would only paint protraits of friends, and worked from photographs.

Pope I – Study after Pope Innocent X by Velasquez Francis Bacon, 1951, 197.8 x 137.4 cm (78 x 54 in), oil on canvas, Aberdeen: Art Gallery and Museums. An existential protest against authoritarian political power.

Like many contemporary artists, he has suffered from unhelpful excess of praise, but in truth, he has only one image and one emotion, which he repeats with variation. Late developer - nothing of sustained significance until his late 30s, then 20 years or so of very powerful work; after about 1971 (aged 61 and following the death of his lover George Dver) he declined into repetitive formula. **KEY WORKS** Three Studies for Figures at the Base of a Crucifixion, 1944 (London: Tate Collection); Study after Velasquez I, 1950 (New York: Tony Shafrazi Gallery); Three Figures in a Room, 1965 (Paris: Musée National d'Art Moderne); Study for Head of Lucien Freud, 1967 (Private Collection)

Roger Hilton

● 1911-75
 Ø BRITISH

Tate Collection 🔯 \$49,000 in 1990, Untitled (oils)

🔟 UK; France 🗕 oils; gouache 🖬 London:

A producer of gutsy paintings, sometimes abstract, sometimes with rudimentary female or abstract forms. He delighted in colour, paint, female form, causing offence, and maintaining a rough humour in the face of considerable personal problems. KEY WORKS January 1957 (London: Tate Collection); Oi Yoi Yoi, 1963

(London: Tate Collection)

Lucian Freud

● 1922 –
 P
 ■ BRITISH

🔟 UK 🚺 oils 🛍 London: Tate Collection \$6,993,000 in 2005, Red-haired Man on Chair (oils)

He is the senior living British painter. German-born grandson of Sigmund Freud, the founder of psychoanalysis. Became a British subject in 1939.

His main subject is the human figure. often naked, posed artificially as models in a studio. Sometimes paints views from windows, but anything other than the human figure he considers "frivolous". All his models are known to him personally. so there is an intimate sense of deep knowledge (love even?), not detachment. His work reveals extraordinary powers of concentration (which is not the same as intensity). Powerful portraits.

Look how carefully the eyes are painted and how much of the inner person they reveal, even when closed. How well he knows all those blemishes, bulges, lumps, private parts of the flesh that we study and examine intimately in our own bodies, but rarely see or care to look at in others. He knows every corner of his studio and the space that the models occupy. He knows exactly what he can do with his paint - and what he can't. KEY WORKS In the Silo Tower, 1940-41 (Private Collection); Girl with Roses, 1947-48 (London: British Council); Naked Man on a Bed, 1987 (London: Saatchi Collection); Naked Woman. 1988 (Missouri: St. Louis Art Museum)

The Painter's Mother Lucian Freud, 1982-84, 105.5 x 127.5 cm (411/2 x 501/4 in), oil on canvas, Private Collection. Freud once remarked, "I paint people not because of what they are like, not exactly in spite of what they are like, but how they happen to be."

Sir Anthony Caro

🔟 UK; USA 🚺 sculpture 🖬 London: Tate Collection 🔊 \$96,850 in 2002, Strand (oils)

Caro is usually proclaimed (how correctly?) as the leading contemporary British sculptor. Studied engineering at Cambridge (which shows) and worked with Henry Moore (which doesn't show).

He is a creator of sculpture constructed out of heavy metal, which is usually welded together, recycling the elements of the engineering and construction industries (plates, beams, propellers). Emphasis on structure, space, horizontals, verticals, and constructions hugging the ground or tabletop like well-organized

scrap. Displays truth to (industrial) materials? His early work (1960s) is brightly painted; later work undecorated other than with carefully controlled rust. Under the modern outer garment is a deeply traditional soul. Solid, honest,

plain speaking, down-to-earth (literally), no-frills work that emphasizes the basic values (space, construction, materials) but can be didactic and schoolmasterish, suggesting the deep-seated, sometimes stubborn, values of middle England (and none the worse for that). It isn't art full of fantasy or poetic imagination. KEY WORKS Sculpture 3, 1961 (Venice: Peggy Guggenheim Gallery); Early One Morning, 1962 (London: Tate Collection); Yellow Swing, 1965 (London: Tate Collection)

Michael Andrews

0	1928	-95	ρu	BRITISH
-	1		12	

🔟 UK; Australia 🛛 🖉 acrylics; oils 🛛 🛅 London: Tate Collection 🛛 🔊 \$75,680 in 2003, Untitled (oils)

Andrews produced sensitive work that reflected his inner personality. Large-scale paintings of places and people he knew well and felt deeply about. He possessed a delicate, unassertive technique (mainly working with spray-painted acrylic). A shy, reclusive personality. Painstakingly slow worker (hence few works), totally absorbed by his subjects and activity. English sensibility to light and nature. KEY WORKS The Colony Room, 1962 (London: Tate Collection); The Deer Park, 1962 (London: Tate Collection)

Bridget Riley

⊖ 1931- PO BRITISH

An eminent major abstract painter, Riley has a strong international reputation and a lifelong dedication to the exploration of both the visual and emotional properties of colour. Widely travelled.

She creates intensely visual, abstract paintings whose appearance and form (large scale, stripes, blocks of colour) do not result from any theory or formula but are a means of using colour and form to create sensations of light and space.

The colours interact at their edges and generate the illusion of other colours or jumps of colour. Some colours jump forwards, others back. Dark (often black) stripes create a rhythmic pulse across the surface. There is emotional as well as visual involvement.

KEY WORKS Winter Palace, 1981 (Leeds: Museums and Art Gallery); Fall, 1963 (London: Tate Collection); Orphan Elegy I, 1978 (London: British Council)

Victor Vasarely

● 1908-97 P HUNGARIAN/FRENCH

 Image: Transe
 Image: Transe
 Image: Transe
 Image: Transe
 Image: Transe
 Image: Transe
 Transe

Vasarely was one of the key figures in the creation of Op art in the 1950s. Hungarian-born, but was awarded French citizenship in 1959. He produced hardedge abstract paintings designed to give powerful optical effects and illusions that can often be explored and activated by moving around the paintings. His work was satisfying, but limited. **KEY WORKS** *Neves II*, 1949–58 (London: Tate Collection); *Quasar*, 1966 (San Francisco: Fine Arts Museums)

Morris Louis

USA 🚺 oils; acrylics 🏂 \$ in 2002, Untitled (oils)

Louis created large-scale lyrical works. The subject matter is colour, which is trickled and floated onto bare canvas

in such an inventive way that, if you suspend disbelief, the pigment can seem to be rivers, waterfalls, liquid mists of fresh pure colour (if you can enjoy a landscape, why not this?). Easy-going but satisfying. **KEY WORKS** *Tet*, 1958 (New York: Whitney Museum of American Art); *Gamma Epsilon*, 1960 (Private Collection)

Robert Rauschenberg

● 1925- P AMERICAN

 Image: USA
 Image: Mixed media; prints
 Image: Detroit

 Institute of Arts. New York: Museum of Modern

 Art. Hamburg: Kunsthalle
 Image: \$6.6m in 1991,

 Rebus (works on paper)

He is a major pioneering postwar artist. Prolific, creative, and influential. Very New York. Deeply committed to international co-operation for social change and human rights.

Produces a very consistent, personal, and visual work. Explores how to make materials (screen printing, paint, found objects, papers, fabrics, or metals) and images (from contemporary media images, words, abandoned urban detritus)

work together. The whole constitutes a chronicle of his own activities and of his culture and times. Like Canaletto, he produces works that mirror a particular society, reflecting, distorting, or glamorizing it, and are sought after by its members as souvenirs.

Has a passionate involvement, with an underlying innocence (not naïvety) – takes evident delight in collecting material and putting it together, without self-consciousness or rules. His best work is beautiful to look at, technically intriguing, layered, memorable, and puzzling. Since the 1980s his work has declined; impersonal and overblown.

Bi-Vega Victor Vasarely, 1974, 114 x 79 cm (45 x 31 in), screenprint, London: Hayward Gallery. Vasarely regarded the artist as a workman who produces prototypes for reproduction by others.

Bellini Robert Rauschenberg, 1986, 143.5 x 88.9 cm (56% x 35 in), intaglio printed in colour on woven paper, Detroit Institute of Arts. A late work by Rauschenberg, which combines high and low art imagery.

KEY WORKS Bed, 1955 (New York: Leo Castelli Gallery); Odalisk, 1955–58 (Cologne: Museum Ludwig); Soviet/American Array II, 1988 (Detroit Institute of Arts)

Larry Rivers

€ 1923-2002 P AMERICAN

USA i oils; sculpture; mixed media; collage New York: Museum of Modern Art S425,000 in 1990, *Africa I* (oils)

He was a multifaceted bohemian: painter, poet, and jazz musician from a Russian-Jewish émigré family. An influential guru. Created versatile and many-sided works, which are difficult to summarize – they can switch, within the same work, between figuration and abstraction, sharp detail and lush brushstrokes. One of the parents of Pop Art, he was also one of the first to use mass-media imagery. Also reworked famous hackneyed paintings. **KEY WORKS** Washington Crossing the Delaware, 1953 (New York: Museum of Modern Art); Camels, c.1962 (Cambridge: Fitzwilliam Museum); French Money, 1962 (Private Collection)

Alexander Calder

USA; France Sculpture; gouache Mew York: Whitney Museum (the video of him playing with his circus is its best-loved exhibit) Sculpture in 2003, *Untitled* (sculpture)

The man who gave the world the mobile, thus making it a better and happier place. Child of a sculptor father and painter mother. Trained as an engineer and industrial draughtsman, and cartoonist.

Enjoy the movement and *joie de vivre* in his mobiles (from mid-1930s) – those famous, delicately balanced constructions of wire and discs painted in primary colours or black. Tiny or large scale, they are marvels of endless variety. Stabiles are steel constructions firmly planted on the ground and immobile but their swooping shapes suggest movement. Early work includes wire figures and a circus of tiny figures, which he could animate.

Let the child in you come alive and forget worldly cares. Animate the mobiles into life (a breath of wind is usually enough); walk around and through the large stabiles to explore their life. Deceptive simplicity and soothing unpredictability are among the lifeenhancing qualities of Calder's works. If you must speak art jargon, talk about drawing in space, negative space, spatial relationships, form, and colour. Wonderful, energy-filled gouaches. KEY WORKS Lobster Trap and Fish Tail, 1939 (New York: Museum of Modern Art); The Spider, 1940 (Private Collection); Vertical Constellation with Bomb, 1943 (Washington DC: National Gallery of Art)

Ellsworth **Kelly**

⊖ 1923 - P AMERICAN

🔟 USA 🛛 🔬 oils; prints; drawings

London: Christie's Images 😰 \$2.6m

in 2004, Chatham XIII – Yellow Red (oils)

He is one of the contemporary masters, who has continued Matisse's exploration of colour. Traditional values of painting – technical perfection, visual pleasure, spiritual uplift – are still alive and well.

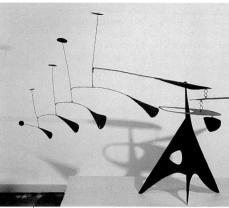

Blue Feather Alexander Calder, c. 1948, 106.6 x 139.7 x 45.7 cm (42 x 55 x 18 in), painted sheet metal and wire, Private Collection. This piece combines Calder's two inventions: "stabile" (the static base) and "mobile" parts.

His very simple, large canvases are saturated with pure colour. Let the eye and the mind relax fully and absorb the colours, shapes, and the razor-sharp edges. Enjoy them for what they are and let them play on the imagination, stretch the eye and stretch the mind's eye. Look at the meticulously painted surfaces (he always uses oil paint for richness of colour).

His works are sometimes to be enjoyed as objects seeming to float on the wall; sometimes to be seen as spaces through the wall giving onto fields of blue (sky or sea?), or red (earth or fire?). He mixes his own colours, and what he creates is a final distillation of something once seen in the world (especially architecture). It uplifts the eye and the spirit - as refreshing as chilled champagne. The canvases must be in pristine condition (damage and dirt ruin the purity and experience). KEY WORKS Rebound, 1959 (London: Anthony d'Offay Gallery); Red Curve, 1960s (Private Collection); Blue, Green, Yellow, Orange, Red, 1966 (New York: Guggenheim Museum)

Philip Pearlstein

0	1924 -	ρU	AMERICAN

USA Oils; prints; drawings 2 \$52,500 in 1990, Two Nudes on a Mexican Blanket (oils)

Pearlstein is a leading figurative painter with a raw, objective style depicting the human body as it appears, with the minimum of interpretation. Notice the artificiality within the reality: highly finished surfaces (rather than imitation of perceived textures), hidden or cut-off faces, odd viewpoints. The artificiality forces the question "why?", which in turn demands an answer or interpretation. Pearlstein lays claim to having given dignity back to the figure by rescuing it from both Expressionist and Cubist distortion, and from pornographic exploitation. His early, pre-1960s, work is Abstract Expressionist. KEY WORKS Nude Torso, 1963 (New York: National Academy of Design): Male and Female Nudes with Red and Purble Drabe, 1968 (Washington DC: Hirshhorn Museum): Model in Green Kimono. 1974 (San Francisco: Fine Arts Museums)

Andrew Wyeth

● 1917 – P AMERICAN

USA D tempera; watercolours
 New York: Museum of Modern Art
 \$1.55m in 1997, *Christina Olson* (oils)

Wyeth is the son of famous book illustrator. First achieved fame with the watercolours he painted in Maine in the late 1930s. Has a brilliant realist technique, is popular and much collected, but is unjustly derided by many contemporary critics and curators.

His subjects are carefully chosen and all have deep personal meaning. At first sight they may look ordinary, but part of Wyeth's magic is his ability to make the commonplace hauntingly memorable. He is unconcerned by fashion or being up to date. His large-scale paintings are done in tempera (not oil), which is painstakingly slow to work with and enables him to exploit his love of fine detail and focus on the quality of draughtsmanship rather than painterliness.

Observe the way he heightens realism by using strong design and unusual, artificial compositions; note also the way he contrasts fine detail with large areas of abstraction. His watercolours and drybrush paintings are painted in a frenzy (they are often tossed onto the ground, which is why they may have smudges, tears, or attached pieces of vegetation). **KEY WORKS** *Winter*, 1946 (North Carolina Museum of Art); *Christina's World*, 1948 (New York: Museum of Modern Art); *Snow Flurries*, 1953 (Washington DC: National Gallery of Art)

Claes Oldenburg

⊖ 1929 - P AMERICAN

USA Sculpture; mixed media New York: Museum of Modern Art. London: Tate Collection \$\$1.3m in 2004, Sewing Machine (sculpture)

Oldenburg was born in Europe, but brought up in the USA (his father was appointed Swedish Consul in Chicago, 1936). He is one of Pop art's most original and inventive talents.

His highly original creations work on several levels by constantly reversing normal expectations. He starts with commonplace consumer-society objects (such as a hamburger or a typewriter) and metamorphoses them into something strange and comical by altering their scale, texture, or context. Also asks questions about what constitutes a painting, sculpture, work of art, or a consumer object.

He enjoys experimenting with paradox and contradiction. He mocks the selfabsorbed seriousness of consumer society but is always teasing and humorous, never threatening. Has always been a compulsive drawer, even as a child, forever imagining transpositions that carry witty and significance resonances – such as a woman's lipstick, which becomes a rocket with a warhead and doubles as a sculptural monument in a public place. **KEY WORKS** *Two Cheeseburgers with Everything (Dual Hamburgers)*, 1962 (New York: Museum

(Dual Hamburgers), 1962 (New York: Museum of Modern Art); Lipsticks in Piccadilly Circus, London, 1966 (London: Tate Collection)

Jim Dine

⊖ 1935 - P AMERICAN

 ☑ USA; UK
 ☑ oils; acrylics; mixed media; prints; installations
 ☑ New York: Guggenheim Museum
 ☑ \$600,000 in 1996, *Hearts* (oils, acrylic on 57 canvases)

He is one of the pioneers of Pop art. His work has a strong biographical element in which tools (childhood memories of grandfather's hardware store), paint, palettes (artist's studio), and domestic objects, are prominent. Full of wit and simple poetry, released by sensitive juxtaposition of objects, colour, and stencilled labels. **KEY WORKS** *Bedspring*, 1960 (New York: Guggenheim Museum); *Pearls*, 1961 (New York: Guggenheim Museum)

POP ART

Pop Art emerged independently in New York and London in the mid-1950s, and remained the dominant avant-garde movement until the late 1960s. In America, its initial motivation was a reaction against the selfabsorption of Abstract Expressionism and a determination that art should re-engage with the real world. In the USA, Pop Art celebrated the new consumer society; in Britain, there was always an undertow of nostalgia.

SUBJECTS AND STYLE

The commonplace and the ordinary dominate: famously, Coca-Cola bottles, hamburgers, comic strips, household products, images from newspapers, advertisements – in short, almost anything produced by Western consumer society. In part, this was because Pop Art held that it was the duty of art to take the modern world as its subject. By extension, in an age of mass production, styles aimed at anonymity.

Just what is it that Makes Today's Homes so Different, so Appealing? Richard Hamilton, 1956, 26 x 24.8 cm (10½ x 9½ in), collage, Tübingen: Kunsthalle. Witty, mocking, challenging: Pop Art is born.

WHAT TO LOOK FOR

As with pop music, look for a world of youthful energy, more excited by mass advertising than the obscurities of high and abstract art. Pop Art was designed to be consciously different,

1950s-1960s

irreverent, easy to look at and remember. Fun and economic freedom, however banal and cheap, were considered more interesting than contemplating life's deepest mysteries.

Campbell's Soup Can Andy Warhol, 1962, 90.8 × 60.9 cm (35% × 24 in), screen print, New York: Leo Castelli Gallery. Bold, simple, unadorned: in short, Pop Art epitomized, the everyday made epic.

KEY EVENTS

1952	Independent Group (IG) formed in London: actively seeks to celebrate "pulp imagery"
1955	Robert Rauschenberg's <i>The Bed,</i> key proto-Pop Art work
1958	English critic Lawrence Alloway coins term "Pop Art"; Jasper Johns has first one-man show in New York
1962	Pop Art announces itself with its first major exhibition, held at the Sidney Janis Gallery in New York. Lichtenstein, Warhol, Oldenburg, and other artists are present

440

$\rm C \ . \ 1 \ 9 \ 0 \ 0 - 7 \ 0$

Wayne Thiebaud

● 1920- P AMERICAN

☑ USA Ø oils Mew York: Memorial Art Gallery, University of Rochester
 ∅ \$2.8m in 2002, Freeways (oils)

A painter of portraits, landscapes, and still lifes, which are lavishly executed in thick, buttery paint and clear, bright colours. Takes a loving but unromantic interest in the anonymous faces and products seen in the supermarket, cafeteria, or deli. His simplified style comes from his early experience as an advertising artist and cartoonist. Paints clear light, and thick blue shadows you feel you can touch.

KEY WORKS Display Cakes, 1963 (San Francisco: Museum of Modern Art); Freeway Curve, 1979 (San Francisco: Museum of Modern Art)

Roy Lichtenstein

☑ USA ☑ acrylics; oils; sculpture
 ☑ San Francisco: Fine Arts Museums
 ☑ \$6.5m in 2002, Happy Tears (oils)

He was a leading American Pop artist with an instantly recognizable style, which at first sight seems to be just largescale blow-ups of comic-book images.

Had a great ability to contradict expectations with wit and elegance – nothing is what it seems. He transformed the comic-book images (traditionally dismissed as mere trash) into elegant largescale paintings, which are in the tradition of a serious art gallery experience. He achieves this by the sophistication of his technique and the probing nature of his subject matter. (Caravaggio and Manet did something similar in their days.)

Note how he turns the mechanized impersonality of the comic-book image into something very personal. He organizes, redefines, and exaggerates his images with the skill and knowledge of an old master. Has a meticulous technique: highly controlled use of black outline; use of Ben Day dot; intense colour. Deep interest in life, love, and death (traditional high-art subjects) and in modern American society. He parodies other artists and (like Manet) plays with art history.

Anxious Girl Roy Lichtenstein, 1964, oil on canvas, Private Collection. Lichtenstein first showed in New York in 1962 with the brilliant Leo Castelli whose gallery first promoted Pop Art in the USA.

KEY WORKS Drowning Girl, 1963 (New York: Museum of Modern Art); Whaam!, 1963 (London: Tate Collection); As I Opened Fire, 1964 (Amsterdam: Stedelijk Museum); M-Maybe (A Girl's Picture), 1965 (Cologne: Museum Ludwig)

Edward Ruscha

⊖ 1937 - PI AMERICAN

USA 🚺 oils; acrylics; prints 🖬 Washington DC: National Gallery of Art 🎦 \$3.2m in 2002, *Talk About Space* (oils)

An Oklahoma boy who went LA hip in 1956, Ruscha's early work is Pop – icily perfect images of gasoline stations and billboards, plus booklets of photos of similar subjects. His recent work plays with images and words; for instance, a painting of water may have that word spelled out in a trompe-l'oeil spill of water. Uses unconventional media such as fruit juice instead of watercolour. **KEY WORKS** *Lisp*, 1968 (Washington DC: National Gallery of Art); *Accordion Fold W/Vaseline Statins*, 1973 (New York: UBS Art Collection)

Alex Katz

⊖ 1927 – P AMERICAN

Katz is a veteran, very visual, American figurative painter who reruns traditional themes and techniques in a contemporary American idiom.

He replays, with genuine inventiveness, themes and ideas beloved of the French Impressionists and Post-Impressionists (Manet, Monet, Seurat especially): airy landscapes, the middle class at play, fascination with recording the effects of light. Direct wet-in-wet oil technique; colour harmonies and dissonances; open brushwork that jumps into a focused image at a distance. Look for the selfabsorbed faces, gestures, and intriguing psychology that you find in Manet's work.

He is to French art what Californian Cabernet Sauvignon wine is to French Bordeaux – not necessarily better or worse, but noticeably different: on a bigger scale, more direct, less complex. Enjoy his works for what they are: a refreshing, eye-filling pleasure with a distinguished and recognizable pedigree. Try to view the paintings by daylight, and also notice the sketches done from life, which he works up into large scale in the studio.

KEY WORKS Ada and Alex, 1980 (Waterville, Maine: Colby College Museum of Art); Rudy, 1980 (Waterville, Maine: Colby College Museum of Art); Tracy on the Raft at 7:30, 1982 (Waterville, Maine: Colby College Museum of Art); Variek, 1988 (London: Saatchi Collection)

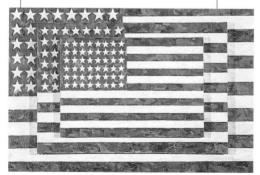

Dusk Alex Katz, 1986, 137.2 x 183 cm (54 x 72 in), oil on canvas, Private Collection. The artist's flat style and lean technique connects with his early experiences as a designer of stage sets and costume.

Jasper Johns

⊖ 1930 - P AMERICAN

USA [] oils; encaustic paints; sculpture; prints Washington DC: National Gallery of Art \$\$15.5m in 1988, False Start (oils)

Johns was a key figure in postwar American art and a founding father of Pop Art. Very influential, very much admired. Is (and will be) to American 20th-century art what Poussin is to 17th-century French art.

His art is cerebral, philosophical, closed, and self-referential. He loves polarities – works that are simultaneously cerebral and sensual, light-hearted and serious, simple and complex, beautiful and banal, realistic and illusionistic.

The classic Johns are his early American flag paintings. They caused excitement because no one could work out (and still can't?) whether they were paintings or objects, abstract works of art or literal reproductions of the flag, banal or deeply emotional – he enjoys riddles about definitions. He can work on a small scale

> (the ale cans), or a large scale (through canvases with objects attached). Used encaustic (wax) technique for his early work. **KEY WORKS** *Target with Plaster Casts*, 1955 (New York: Leo Castelli Gallery); *White Flag*, 1955 (New York: Leo Castelli Gallery); *0 through 9*, 1961 (London: Tate Collection)

> Three Flags Jasper Johns, 1958, 784 x 115.6 cm (308³/ x 45 in), encaustic on canvas, New York: Whitney Museum of American Art. A teasing play on reality and illusion.

с.1900-70

Ale Cans

Jasper Johns c.1964

Jasper Johns's *Ale Cans* – cast in bronze and painstakingly painted – is key not just in the evolution of Pop Art but of modern art as a whole. It plays a brilliantly sophisticated game with notions about the perception of, and expectations from, a work of art.

Johns was hugely influenced by the most radical (and intellectual) of the Dada artists, Marcel Duchamp. Duchamp likened art to playing a game of chess, but Johns goes further and deeper than Duchamp, and has a genuine wit. His *Ale Cans* – this is the second version he made – is a work of craftsmanship, yet it poses puzzles that are teasingly unanswerable. Is it just a worthless, throwaway object as its subject suggests? Is it a painting? Or a sculpture? Does it matter? The Ale Cans

Medium painted bronze Dimensions 14 x 20.3 x 12 cm (5 ½ x 8 x 4¼ in) Location Private Collection

result is both playful and challenging, a product of the artist's engagement with contemporary artistic debates. Many have tried to follow in Johns's footsteps, but it is a difficult game and few succeed.

"Sometimes I see it and then paint it. Other times I paint it and then see it."

JASPER JOHNS

The large oval labels are exceptionally carefully painted, raising the question, "Is it a painting rather than a sculpture?"

The use of two tins side by side (rather than a single one) is artistic and sculptural, yet the subject matter is a trivial, disposable object from everyday life

Andy Warhol

→ 1928 – 87
 P AMERICAN

 Image: Wight on the state of the state

A neurotic surrounded by drug addicts, Warhol was a key figure: his work represents one of art's turning points, changing the role of the artist and his or her way of seeing and doing things, as did Leonardo in the 16th century and Courbet in the 19th century. A great voyeur.

Look for instantly recognizable, talented work. His images were drawn from the world of Hollywood, films, TV, glamour, mass media, and advertising (Marilyn Monroe, Chairman Mao, Coca-Cola bottles, Campbell's soups). He deliberately recalled and exploited the values of the world by using its visual language: bright colours, silkscreen technique, repetition, commercial simplification, and compelling (sometimes shocking) images. Was also a (mediocre) fashion designer and film-maker.

He set up a new role model for the artist (much aspired to by today's young stars): no longer the solitary genius expressing intense personal emotion (as Picasso and Pollock did), but the artist as businessman – the equal of Hollywood film stars and directors and Madison Avenue advertising executives. Son of Czech immigrants, he acted out an American dream cycle – pursued a driving need to be famous and rich, like his subjects, and ended up

> destroying himself. **KEY WORKS** Campbell's Soup Can (see page 440); Green Disaster Ten Times, 1963 (Frankfurt: Museum für Moderne Kunst); Suicide, 1963 (New York: Leo Castelli Gallery); Jacqueline Kennedy No.3, 1965 (London: Hayward Gallery)

"I wanted to be an art businessman or a business artist. Being good in business is the most fascinating kind of art."

ANDY WARHOL

Twenty Marilyns Andy Warhol, 1962, 197 x 116 cm (771 x 45% in), silk screen, Private Collection. At about the time he produced this famous work, Warhol directed his assistant friends and hangers-on into an organization which he called The Factory.

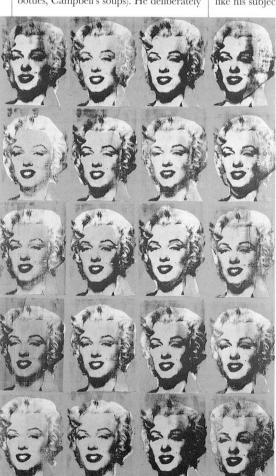

с.1900-70

Philip Guston

→ 1913-80
 P AMERICAN

Mexico; USA; Europe 🚺 oils Canberra: National Gallery of Australia \$6.5m in 2005, The Street (oils)

He was a well-regarded and influential artist whose work has had several distinct and different phases.

His early work is figurative. In about 1950 he became an Abstract Expressionist, producing shimmering, nervously painted, high-minded abstract paintings. Around 1970 he returned to figuration, with crude, but perversely poetic, cartoon-like imagery that conjures up a bizarre world of everyday junk remnants.

It is difficult to explain Guston's changes of direction other than as autobiographical. He was probably working out the consequences of a traumatic childhood (father's suicide, brother's death, memories of Ku Klux Klan). His crudity perhaps reflects an element of self-loathing? KEY WORKS The Native's Return, 1957 (London: Phillips Collection); The Painter's Table, 1973 (Washington DC: National Gallery of Art)

James Rosenquist

→ 1933 -
 P
 → AMERICAN
 →

🔟 USA 🚺 oils; prints 🛅 Ottawa: National Gallery of Canada 🛛 🔊 \$1.1m in 2005, Be Beautiful (oils)

One of the leading Pop artists, he was initially trained, and became very successful, as a New York billboard

Leaend Philip Guston, 1977, 175 x 200 cm (65¾ x 78¾ in), oil on canvas, Houston: Museum of Fine Arts. Guston said of his works around this time: "You see, I look at my paintings, speculate about them, they baffle me too. That's all I'm painting for."

painter and designer. Creates large-scale works that are chronicles of an era (1960s). Pieces together immaculately painted layers of commonplace imagery, which jump in scale and, because of their seeming disconnections, are resistant to (but demanding of) interpretation. KEY WORKS Study for Marilyn, 1962 (London: Mayor Gallery); President Elect, 1961-64 (Paris: Centre Pompidou)

Robert (John Clark) Indiana

→ 1928 -
 P
 → AMERICAN
 →

USA USA 🚺 oils: prints 🛛 🟛 San Francisco: Fine Arts Museums 🛛 \$550,000 in 2002, American Sweetheart (oils)

He is remembered for the brief period when he created imagery of simple words and numbers painted on a large scale in blazing colour. Work is flat, razor-edged, and heraldic; has effective, eve-bombarding optical impact. Often uses a single, monosyllabic command - EAT; LOVE; DIE. Influenced by billboard signs. Very Pop Art, very 1960s; now very dated. KEY WORKS The American Dream 1, 1961 (New York: Museum of Modern Art); LOVE, 1967 (New York: Museum of Modern Art); American Dream, 1971 (Boston: Museum of Fine Arts)

F-111 (detail) James Rosenquist, 1964-65, 3.48 x 26.21 metres (10 x 86 ft), oil on canvas and aluminium, New York: Museum of Modern Art. A detail from a vast composition, which was a protest against the Vietnam War and American defence spending.

Richard Hamilton

€ 1922 - PU BRITISH

 Image: UK
 Image: I

The former intellectual guru of British Pop Art who still holds court, Hamilton has an austere, rather self-conscious style, which can come across as aloof and patronizing. Seems to have a need to address his work to the high priests of the art world rather than the public at large (an odd attitude for one who claimed to be a true "pop", that is popular, artist). **KEY WORKS** Chromatic Spiral, 1950 (London: Tate Collection); Just what is it that Makes Today's Homes so Different, so Appealing? (see page 440)

Sir Eduardo Paolozzi

€ 1924-2005 P BRITISH

 UK; Europe; USA
 sculpture; prints; collage
 London: Tate Collection. San Francisco:
 Museum of Fine Arts
 \$90,200 in 2003, Portrait of the Artist (sculpture)

Born in Edinburgh, Paolozzi was the son of an Italian immigrant family who had settled in Scotland. Passionate, consistent, generous. A founder of Pop Art and one of the great (though underrated) artists of the second half of the 20th century.

His sculptures, constructions, and prints (lithographs) are kaleidoscopes of images and ideas. At their heart is a dialogue about the human condition in the modern world. The fragmentation and unexpected juxtapositions of images are never arbitrary but part of a clearly thought-out strategy, commenting on questions such as: How do we fit into our fragmentary modern world? How do we use our powers over life and death? Can technology be poetic?

This is the art of a quick-firing, endlessly demanding imagination, which got more alert with age. To connect with it, be willing to be as freely imaginative yourself, ready to see and revise all your familiar certainties. Look for the clues: the life and loves of Hollywood idols that equal those of Greek gods (we still need mythology); references to other fertile minds (for example, Burl Ives, who combined folk, band, and classical music); and to places of imagination (such as museums). KEY WORKS I was a Rich Mar's Plaything, 1947 (London: Tate Collection); Bird, 1949 (London: Tate Collection); Real Gold, 1949 (London: Tate Collection); Mosaics, 1983–85 (London Underground: Tottenham Court Road Station)

Sir Peter Blake

⊖ 1932- PU BRITISH

Ⅲ UK
 ☑ oils; prints; mixed media
 ☑ London: Tate Collection
 ☑ \$115,500
 in 2000, Little Lady Luck (oils/collage)

Blake was one of the founders of British Pop Art in the 1960s. Finely crafted work that is rather fey and increasingly has more to do with a nostalgic and often witty longing for a world that was the stuff of schoolboy dreams – comics, badges, pop and film stars, girls and wrestlers, corner shops – rather than anything modern. A Peter Pan figure. **KEY WORKS** *Self-Portrait with Badges*, 1961 (London: Tate Collection); LP cover for *Sgt. Pepper's Lonely Hearts Club Band*, 1967 (London: Victoria & Albert Museum)

Patrick Caulfield

→ 1936 -
 P
 ■ BRITISH

UK 🚺 oils; prints 🖬 London: Tate Collection 🌶 \$301,950 in 2004, *Window at Night* (oils)

A pioneering Pop artist whose work was very recognizable, with a 1960s style using mass media images and spare, simple shapes. His colours are bright and flat with a strong, black outline. Somehow he has got stuck and has never moved on. **KEY WORKS** Black and White Flower Piece, 1963 (London: Tate Collection); Still Life with Dagger, 1963 (London: Tate Collection)

Allen Jones

€ 1937 - PU BRITISH

One of the founders of Pop Art, Jones uses simple, figurative imagery, often with erotic charge (likes fetish symbolism – high heels, body-clinging garments, and so on), combined with bright, bold, "modern" abstract colour. A product of the swinging London of the 1960s and not ashamed to continue the theme. **KEY WORKS** *Wet Seal*, 1966 (London: Tate Collection); *What do you Mean, what do I Mean*², 1968 (Private Collection).

David Hockney

⊖ 1937 - PO BRITISH

UK; USA () acrylics; oils; prints; photography London: Tate Collection () \$2.6m in 2002, Portrait of Nick Wilder (oils)

A genuinely gifted artist with an acute eye and fertile imagination. Once the bad boy of British art, now a respected elder statesman. Sadly, he seems to have decided not to extend his talents (like Degas) and has settled to live the good life on undemanding potboilers (like Millais).

A truly great draughtsman – focused, precise, observant, free, who has a brilliant ability to extract only the essentials. Timely reminder of the pleasure and novelties of seeing and recording perception with feeling, still important for art even after 500 years. Has stunning technique with pencil, pen, and crayon and an immaculate sense of colour. Can make the commonplace memorable and moving. Chooses autobiographical subjects.

At his best as a draughtsman (drawing, prints, and paintings). Brilliant observer and re-creator of light, space, and character in portraits, but not as convincing (though never uninteresting) when he tries to work solely from the imagination or to be a painterly painter (from the 1980s onwards). Inspired designer of sets for theatre, opera, ballet. Is experimenting with Cubism and photography. **KEY WORKS** *Peter C*, 1961 (Manchester: City Art Gallery); *We Two Boys Together Clinging*, 1961 (London: Arts Council Collection); *California Bank*, 1964 (London: Mayor Gallery); *A Bigger Splash*, 1967 (London: Tate Collection)

Sunbather David Hockney, 1966, 183 x 183 cm (72 x 72 in), acrylic on canvas, Cologne: Ludwig Museum. 1966 was the era of the Beatles, Rolling Stones, and the Beach Boys. Homosexuality was legalized in the UK in July 1967.

CONTEMPORARY ART 1970–

1970

With the art and politics of the present and recent past it is impossible not to be subjective. It is probably wiser to identify what is in fashion than try to write instant history or make predictions. Fashion and technology have always been important factors in determining the priorities of contemporary art and politics.

very age has its obsessions. An artist of limited talent who plays up to these will receive a measure of critical acclaim and exposure that a talented artist whose interests lie elsewhere will not be granted. But fashion shifts and it might be fair to propose that a list of today's fashionable obsessions (what is "in " and "out") is a complete reverse of the list of 50 years ago. For example: today's most exhibited art often means large-scale works, shock, and gritty realism with an emphasis on headline-grabbing social issues or neurotic revelations about an artist's private life. Art works that play with concepts and words are put before the public more frequently than those concerned with looking and seeing. Celebrity status, self-aggrandisement

The Spectrum of Brick Lane David Batchelor, 2003, mixed media. Post Modernism often uses technology combined with installations and plays to an audience for whom presentation is a greater priority than content.

and satisfying the demands of rich collectors are "in"; modesty, selfdoubt, the quiet contemplation of the dignity, or absurdity of humanity, or a wish to create a better world for humankind is "out". An interest in beauty, clarity, and spiritual values is "out" (as is Picasso) whereas material values, obfuscation, and Marcel Duchamp are "in". Detachment and irony are widely praised as virtues whereas genuine passion and belief are out of fashion. Lip service is paid to personal manual skill but sloppiness can be applauded as spontaneity, and subcontracting all aspects of physical creation to anonymous hands or computers accepted without question.

ART AND TECHNOLOGY

The place of new technologies in contemporary art is ambiguous. Sometimes it seems we might be in the presence of a break out as

Germans celebrating the fall of the Berlin Wall Built in 1960 as a key element in the Iron Curtain dividing East and West, the popular uprisings of 1989 caused the wall to fall.

sloppiness can be applauded as spontaneity, and subcontracting all aspects of physical creation to anonymous hands or computers accepted without question.

ART AND TECHNOLOGY

The place of new technologies in contemporary art is ambiguous. Sometimes it seems we might be in the presence of a break out as significant as that of the early Renaissance with the PC plaving

a world-changing role akin to Gutenberg's moveable type (see page 75). But it may be that we are merely continuing a revolution that was started 100 years ago, and that what is

The Pompidou Centre (Beaubourg), Paris Completed in 1978, the gallery's popularity and visitor numbers took the authorities by surprise. sometimes lauded as profound innovation is more similar to the artistically mannered and short-lived extravagances that followed the High Renaissance (see page 108). What is more certain is that contemporary art is currently ubiquitous as a recreational and consumer activity not seen since the craze for Academic art in the later half of the 19th century. It also seems that ancient traditions of creativity such as that of Chinese art, are being lost in the rush to emulate fashionable Western modernism.

all n e in

TIMELINE: 1970 -

1974 President Nixon forced to resign after Watergate scandal

1970

1973 US withdraws from Vietnam; Yom Kippur War in Middle East 1976 Death of Chairman Mao

1975 Khmer Rouge

impose Marxist rule

(to 1979)

of terror in Cambodia

1980 Iran–Iraq War (to 1988)

1980

1979 Islamic Revolution in Iran; Soviet invasion of Afghanistan 1988 Gorbachev initiates reforms (*perestroika* and *glasnost*) in Soviet Union

> 1987 Palestinian protests (intifada) begin

ran; n of

THE RISE OF THE COMPUTER

The first true computers, using punch cards for memory, were built in Britain to crack enemy codes during World War II. The world's first electronic computer was built in the 1940s. But it was not until 1962 that computers began to reach their real potential, with the introduction of the microchip allowing the creation of much smaller machines. In 1971 the first massproduced computers became available, with Microsoft supplying software from 1975. Sales of home computers soared during the 1980s with total of 1.7 billion sold by 2004. In 1993 the arrival of the Internet, a worldwide network linked by telephone lines, gave users access to almost limitless information.

and 1980s the Western democracies had a roller coaster ride, sometimes staring into the abyss of economic turmoil, at other times adopting the mantra "greed is good". In Europe the post-war consensus of a welfare state has been opposed by those wanting a more individualistic approach. Currently in high fashion is the idea that market forces should drive everything, and that technology will somehow supply a way out of moral dilemmas. In this post-modern world beliefs in political causes or moral principles appears to have given way to a detached and ironic relativism. The shared bonds that tied the Western Alliance together since 1945, not least the idea that there were identifiable

common enemies, has begun to unravel. It is also tempting to suggest that the ideal of creating a better democratic world, which was fought for in blood, has degenerated into attitudes of self-satisfaction and selfindulgence in which everyone is encouraged to act and consume what he or she wishes, with many individual "rights" but few communal obligations. Confusingly, the USA, which was the champion of freedom and sacrificed much to defeat totalitarianism, is now the world's greatest corporate and military power. Europe similarly having fought authoritarian bureaucracies and oneparty systems seems tempted to turn her collective self into a labyrinthine bureaucracy in the name of harmonization.

THE FUTURE

Western art reflects many of today's headline issues: among them, political correctness, green issues and global

Satellite tracking station in New Mexico, USA For those who control them, satellites offer endless opportunities for communication and military targeting.

1989–91 Collapse of Soviet communism in Eastern Europe, followed by collapse of USSR (1991)

1990

1990 Iraqi invasion of Kuwait: first Gulf War

1993 Oslo Accords: limited Palestinian self-rule

1999 NATO bombing campaign 1998 India and to halt Serbian Pakistan test nuclear weapons Kosovo

persecution of Albanians in

2000

2001 US "War against Terrorism" declared after al-Qaeda terror attacks; US overthrows Taliban regime in Afghanistan 2003 Second Gulf War: US invades Iran overthrows Saddam Hussein

> 2005 French and Dutch electorates reject proposed EU constitution

451

CONTEMPORARY ART

Louise Bourgeois

⊖ 1911 - P FRENCH/AMERICAN

France; USA **b** sculpture: oils: engravings Washington DC: National Gallery of Art \$1.3m in 2002. Blind Man's Buff (sculpture)

A current heroine of feminists, Bourgeois was unknown until she was in her 60s. Daughter of an emotionally dysfunctional family, she works out the consequent trauma through her art.

Her work is eclectic and uses many materials - sculpture, constructions. installations; images of bodily experiences such as pregnancy, birth, breast-feeding; images of the house. She plays on notions of desire, attraction, repulsion, and male-female relationships. References to mother's activities of sewing and tapestry. She's not trying to illustrate anything but to recreate the way she feels: anxiety, loneliness, defencelessness, vulnerability, aggression, sex, and death.

Her womanizing father installed a young mistress in the family home who was hated by her mother: Louise was caught in the middle. Like many from Van Gogh onwards, she has turned to artistic activity to relieve her pain and find a role. Is she among those who have the ability to communicate to someone with completely different experiences? Or is she among those whose very insistence and (neurotic) predictability eventually kills the emotion or message? KEY WORKS Dagger Child. 1947-49 (New York: Guggenheim Museum); Winged Figure, 1948 (Washington DC: National Gallery of Art); Mortise, 1950 (Washington DC: National Gallery of Art); Eyes, 1982 (New York: Metropolitan Museum of Art)

Quarantania Louise Bourgeois, 1947–53, cast

1984, 200 x 68.5 x 74.2 cm (78³/₄ x 30 x 29¹/₄ in) bronze. Houston: Museum of Fine Arts. An early work suggestive of crowds and phalluses.

Agnes Martin

⊖ 1912-2004
 Ø AMERICAN/CANADIAN

USA D acrylics; oils in New York: Guggenheim Museum 🛛 🔊 \$2.3m in 2003 Leaves (oils)

Martin was a much-admired painter of gentle, lyrical abstracts, which reflect her search for spiritual purity and her rejection of material encumbrances and cares. Lived a simple life in New Mexico.

Her largish, squareshaped canvases of pure, pale colours and simple design are intended to reflect the qualities she values. They are beautiful, with a haunting luminosity, and should be experienced as much as looked at. Let your mind go free, as when contemplating the ocean.

Notice the soothing delicacy with which they are made: paint gently stroked on, precise pencil marks creating something close to those organic traces, webs, and honevcomb structures found in nature: subtle colour gradations like sunlight on early-morning mist or snow; horizontal lines suggestive of landscape spaces. KEY WORKS White Flower, 1960 (New York: Guggenheim Museum); Leaf in the Wind, 1963 (Pasadena: Norton Simon Museum)

Tony Smith

● 1912-80 P AMERICAN

USA 🖉 sculpture; oils 🖬 Washington DC: National Gallery of Art 🛛 🔊 \$150,000 in 1989, Throne (sculpture)

Smith was an architect (until 1950s), and a sculptor (from 1960s), and painter. He created simple, satisfying, engineered structures (he designed and created the models, others built the end products). They are of varying size and scale but always with human proportions - romantic rather than minimal. Sleek black surfaces add a stylish, sophisticated presence. Space is as important as form.

KEY WORKS Moondog, model 1964, fabricated 1998-99 (Washington DC: National Gallery of Art); Wandering Rocks, 1967 (Washington DC: National Gallery of Art)

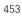

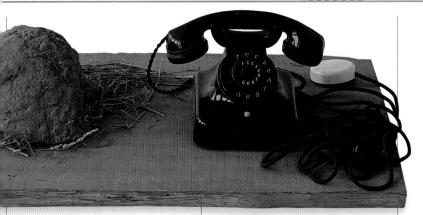

Joseph Beuys

⊖ 1921-86 PU GERMAN

Germany
 Sculpture; performance art
 Darmstadt (Germany): Hessisches
 Landesmuseum
 \$413,100 in
 1994, Stapelkopf Siegel (mixed media)

A star of the 1980s, highly regarded by intellectuals and lionized by ambitious curators and dealers, Beuys was a serious, gentle, mystic and charismatic figure who sought to comment on his own times, and was also (paradoxically) a victim of them.

To establish a connection with these works you have to establish a rapport with the whole Beuys phenomenon – the man, his appearance, his lifestyle, his biography, and his beliefs. Thus the lumps of fat, fur, or felt that you find in the museum showcases are like fragments of a total work; or, they are like the traces that a wild animal makes to establish its presence or the extent of its territory.

Only by accepting the Beuys phenomenon can you begin to "see" the energy of the world references, harmony with nature, the dilemmas of modern Germany, Beuys's early childhood experiences, and so on. If you don't want to or can't cross this threshold, don't worry – it may all be self-deception anyway. The phenomenon is an unexpected alliance of **Earth Telephone** Joseph Beuys, 1968, 220 x 47 x 76 cm (8 x 18% x 30 in), telephone, earth and grass, connecting cable on wooden board, Hamburg: Kunsthalle. Beuys saw himself as part witchdoctor, part magician.

the artist's ego with museum or commercial interests, looking for instant history. **KEY WORKS** *How to Explain Pictures to a Dead Hare*, 1965 (performance); *Felt Suit*, 1970 (London: Tate Collection); *Four Blackboards*, 1972 (London: Tate Collection); *Encounter with Beuys*, 1974–84 (New York: Guggenheim Museum)

Jules Olitski

⊖ 1922 - P AMERICAN

USA 🚺 acrylics; sculpture 🖬 Canberra: National Gallery of Australia 🚺 \$320,000 in 1990, *Strip Heresy* (oils)

Born in Russia, Olitski trained in oldmaster painting techniques. Creator of large-scale decorative abstract paintings. Uses a stain and spray-gun technique, which creates a field of atmospheric colour that seems to dissolve the picture surface. There is often a band of rich pigment along one edge or at a corner. Sensual, slightly precious, self-conscious work. **KEY WORKS** *Ino Delight*, 1962 (Saskatchewan, Canada: Mackenzie Art Gallery); *Prince Patutsky's Command*, 1966 (Canberra: National Gallery of Australia)

"In places like universities, where everyone talks too rationally, it is necessary for a kind of enchanter to appear ... I am calling for a better kind of form of thought, of feeling, of willpower."

JOSEPH BEUYS

Kenneth Noland

USA () acrylics; sculpture
 Houston: Museum of Fine Arts
 \$1.85m in 1989, *Empyrean* (oils)

Noland creates simple, direct works in which the impact is purely visual, coming solely from colour on the canvas – there is no "meaning", drawn line, or spatial depth. He plays with colour variations and simple, dynamic shapes (such as a bull's eye or a chevron) and their relationship to the shape or edge of canvas. He also plays with irregular-shaped canvases. Very American, very good. **KEY WORKS** *Song*, 1958 (New York: Whitney

Museum of American Art); *Half*, 1959 (Boston: Museum of Fine Arts); *Hade*, 1973 (Private Collection)

George Segal

€ 1924-2000 P AMERICAN

 USA
 Sculpture
 Ottawa: National Gallery of Canada

 Sculpture
 Sculpture)

A creator of environments that are like banal settings with real objects from everyday life, but in which the people are replaced by white plaster figures. Segal makes casts from real live people, wrapping them in plaster-soaked gauze bandages like a mummy. Powerful and sensitive evocation of the lonely anonymity of everyday life. His work is highly distinctive and original. **KEY WORKS** *Cinema*, 1963 (Buffalo: Albright-Knox Art Gallery); *The Gas Station*, 1963 (Ottawa: National Gallery of Canada)

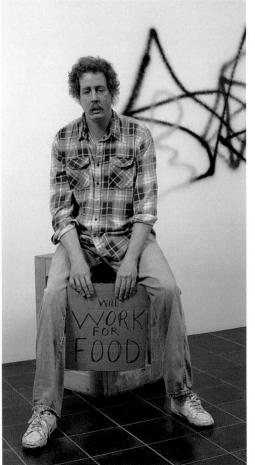

Duane Hanson

1925–96
 AMERICAN
 USA Sculpture Forida:
 Norton Museum of Art
 S280,000
 in 2001. Security Guard (sculpture)

The maker of hyperrealistic sculptures (since 1967). A modern reworking of the "everyday life" realism much loved by Victorian middle classes. His early work was strongly political.

He created unnervingly lifelike, life-size sculptures of people who are almost indistinguishable from the

"I am interested in the everyday types of things that people do, the common denominator, those things that are down to earth."

Homeless Person Duane Hanson, 1991, height 168 cm (661/2 in), mixed media, Hamburg: Kunsthalle. Hanson is often quoted: "... men lead lives of quiet desperation ..."

455

gallery-goers who look at them. His subjects are tourists, shoppers, construction workers, children – middle America at work and play. He took moulds from live models, which were then cast in polyester resin or bronze and painted; he then added real accessories, such as shoes and clothes. His stated aim was to ennoble the commonplace and ordinary by turning it and its inhabitants into art.

Slow worker – a single figure could take a year to complete. Note the realism of flesh textures, such as bruises, varicose veins, hair on forearms or legs. His figures are often in movement but always selfabsorbed and introspective (even when in a group); sometimes they are asleep. The impact comes in part from his astonishing technical skill, in part from his contemporaneity. How powerful will these works be when they eventually look like historical figures, not part of the here and now?

KEY WORKS *Tourist*, 1970 (Edinburgh: National Gallery of Modern Art); *Salesman*, 1992 (Missouri: Kemper Museum of Contemporary Art)

John Chamberlain

€ 1927 - P AMERICAN

☑ USA
 ☑ sculpture
 ☑ Texas: Chinati
 Foundation
 ☑ \$500,000 in 2003, Murmurous
 Moto, Maestro (sculpture)

Influenced by David Smith in his early work, Chamberlain was famous for sculptures (freestanding and wall reliefs) made from welded-together car parts. They are not arbitrarily made, but carefully planned and painted for aesthetic effect (look for the inclusion of chrome parts). Many of his compositions are designed to be hung on walls, rather than stood on the ground. Don't look for a social comment on car-obsessed consumer society – his later work uses non-car materials such as aluminium foil, polyurethane foam, and paper bags. Untitled John Chamberlain, c. 1960s, sheet metal, Rome: Galleria Nazionale d'Arte Moderna. Chamberlain taught at the famous Black Mountain College, near Asheville in North Carolina, which established a model for an ideal liberal education.

KEY WORKS Essex, 1960 (New York: Museum of Modern Art); Dolores Jane, 1962 (New York: Guggenheim Museum); Koko-Nor II, 1967 (London: Tate Collection)

Donald (Don) Judd

→ 1928-94 P
 AMERICAN

 Image: Wight of the state of the state

Judd created sculptures by giving instructions for the industrial production of modular (often large) box-shaped objects in polished metal and Plexiglas, which are often stacked and cantilevered. They are simple, minimal, with proportions and spaces based on mathematical progressions, and all of a piece in shape, colour, and surface. The works are detached and cool, with no human presence or reference. **KEY WORK** Untilled, 1969 (New York: Guggenheim Museum); Untilled, 1970 (New York: Guggenheim Museum); Untilled (Six Boxes), 1974 (Canberra: National Gallery of Australia)

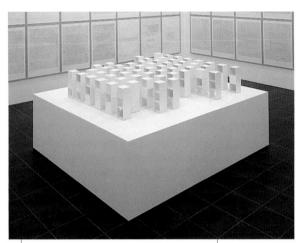

49 Three-Part Variations of the Three Different Kinds of Cubes Sol Lewitt. 1967–71, 49 units, each 60 x 20 x 20 cm (24 x 8 x 8 in), enamel on steel, Hamburg: Kunsthalle. LeWitt was a leading exponent of Minimalism, a reaction against Abstract Expressionism and Pop.

A Wall Divided Vertically into Fifteen Equal Parts, Each with a Different Line Direction and Colour, and All Combinations, 1970 (London: Tate Collection); Steel Structure (formerly Untitled), 1975–76 (San Francisco: Museum of Modern Art):

Sol Lewitt

⊖ 1928 - P AMERICAN

USA Sculpture; conceptual art; prints
 Washington DC: National Gallery of Art
 \$320,000 in 2004, Untitled (sculpture)

A pioneering Minimalist, now one of the "Grand Old Men". At first sight Lewitt's structures and wall drawings look as if they are merely mechanical applications of established mathematical systems, but they are not.

He creates a type of pure beauty that comes out of an order that is logical but not rigid or predictable. He starts with a system, ratio, or formula, which can be quite arbitrarily chosen, and employs assistants to make the modular structure or wall drawing that follows from it. His works can be on a large or small scale, but the bigger and more complex the better; they are completely self-referential and self-contained.

You can take the works intellectually and try to unravel the system, or you can take them visually for what they are and enjoy their unexpected, peaceful beauty and the way in which they generate light as well as space, thus creating a sense of emotional openness and purity. His wall drawings are created for each new location and then whitewashed out. His early work was in monochrome or white; he gradually introduced colour and his recent work is richly colourful (and less pure and less effective as a result?). **KEY WORKS** *Floor Structure Black*, 1965 (Washington DC: National Gallery of Art); Cy Twombly

National Gallery of Art)

Wavy Brushstrokes, 1996 (Washington DC:

Twombly is much admired for his highly personal abstract style consisting of apparently random scribbles and marks, sometimes incorporating bits of text and diagram. If you require order, clarity, structure, and specific meaning you will hate it; if you like improvisation, hints, whispers, and teases, you will love it. **KEY WORKS** Vengeance of Achilles, 1962 (Zurich: Kunsthaus); Quattor Stagioni (a painting in four parts), 1993–94 (London: Tate Collection)

Untitled Cy Twombly, 1970, mixed media on paper, Private Collection. Twombly settled in Rome in 1957 and some see his calligraphic style as akin to the marks found on ancient walls.

Untitled (Felt Tangle) Robert Morris, 1967, 190 x 400 x 220 cm

190 x 400 x 220 cm (74% x 157% x 86% in), felt and metal eyes, Hamburg: Kunsthalle. Morris started making his felt constructions in 1967 after moving to a studio in Colorado, which used to be an old felt factory, and where remnants were still lying to hand.

Robert Ryman

 ● 1930- P AMERICAN
 ■ USA I oils; mixed media
 ■ Schaffhausen, Switzerland: Hallen für Neue Kunst I s2.1m in 1989, Summit (oils)

A self-taught abstract painter from Nashville, Tennessee, Ryman has a limited but highly visual theme. Musical enthusiast (Charlie Parker and Thelonius Monk). His works should be seen by daylight.

His paintings are about what paintings are made from, what paint can do, and what they look like (and why not?). So don't look for subjects, concepts, and spirituality. Look instead at the way he uses oil paint (thick, thin, shiny, flat); his use of textured canvases, paper, metal surfaces, and so on; and how he fixes these works to the wall. It sounds banal, but actually they are beautiful to look at if you don't expect too much. Is it a dead end or a new beginning?

He wants his work to be shown by daylight so that the textured surfaces will look different and interesting as the light changes (white attracts light). Look at his different choices of brush marks and surface and the way they change in the same work; also at what he does with canvas (stretched or unstretched, for instance). Look also at the edges and the way he incorporates his signature. The choice of frame, or lack of one, is also his. **KEY WORKS** *Classico IV*, 1968 (New York: Guggenheim Museum); *Surface Veil*, 1970–71 (San Francisco: Museum of Modern Art); *Monitor*, 1978 (Amsterdam: Stedelijk Museum)

Robert Morris

USA 🚺 sculpture; conceptual art; land art; performance art 🛍 New York: Guggenheim Museum 🔯 \$57,500 in 1990, *Untitled* (sculpture)

Morris produces large-scale simple forms, either geometric and hard-edge, or curvilinear and soft-edge (such as mounds of hanging felt). He creates the blueprint, others make the pieces. He wants you to focus on an analysis of an activity of your perception and/or the decision-making process by which he arrives at final form – the classic agenda for Minimal art, of which he was a pioncer.

KEY WORKS Untilled (Corner Piece), 1964 (New York: Guggenheim Museum); House of Vetti I, 1983 (Hamburg: Deichtorhallen)

Fernando Botero

→ 1932 -
 P
 COLOMBIAN

□ Colombia; USA □ oils; prints ≥ \$1.4m in 1992, La Casa de las Gemelas Arias (oils)

Botero is a creator of immediately recognizable paintings and sculptures that are wholly out of the mainstream of "serious" contemporary art. Tubby, cheerful, over-inflated (literally and metaphorically) figures, meticulously painted in bright colours, through which he ridicules the pomposities of life, art, and officialdom. A breath of fresh air. **KEY WORKS** Our Lady Fatima, 1963 (Bogota: Museo de Arte Moderno); Dancing in Colombia, 1980 (New York: Metropolitan Museum of Art)

458

CONTEMPORARY ART

Richard Estes

→ 1932 -
 ⊅ AMERICAN

Gourmet Treats (oils)

🔟 USA 🚺 oils; prints 🖬 San Francisco; Fine Arts Museums 2420,000 in 2000.

The king of Photorealism, Estes uses many of the same techniques as Canaletto, but not place-specific. His views could be of any modern city.

His fine, detailed paintings of the modern urban streetscape look at first sight as though they are merely enlarged photographs - but they are not. Estes paints from photographs to create a highly complex, composite view that heightens reality in a way impossible in a single photograph, but it gives the illusion of freezing a split second, as does a photo.

Produces carefully organized compositions that divide the scene into distinct areas - for example, he might create a diptych. Uses a multipoint perspective or viewpoint and reflecting windows to show what is happening outside the picture frame, behind the back of the viewer. Note the absence of human figures and activity. Rich, intense colour harmonies. Within his self-imposed limitations he creates haunting, moody images that have beauty and detachment. KEY WORKS Parking Lot, undated (New York: National Academy of Design); Nedicts, 1970 (Madrid: Museo Thyssen-Bornemisza); Diner, 1971 (Washington DC: Hirshhorn Museum)

Nam June Paik

Japan; Germany; USA 🚺 sculpture; installations; performance art 🕅 Washington DC: Smithsonian American Art Museum \$120,004 in 2002, Vol de Nuit (sculpture)

Once a young "bad boy" with an instinct for public scandal; now he has "grand old man" status. His first interest was music (John Cage). From the 1960s he has wanted to turn TV from a medium for passive mass audiences into an individual and dynamic medium, like painting. He uses the TV screen like collage and creates large-scale installations with banks of screens. Pioneering and impressive. KEY WORKS Global Groove, 1973 (Pittsburgh: Carnegie Museum of Art); Video Flag, 1985-96 (Washington DC: Hirshhorn Museum)

Gerhard Richter

ρø	Germany	oils; prints
Î	San Francisco:	Museum of Modern Art
52	\$4.9m in 2001	Drei Kerzen (oil)

A refugee from Communist East Germany (1961), Richter trained as an orthodox Communist trompe-l'oeil social realist, then had to assimilate Western

S. with Child Gerhard Richter, c. 1995, oil on canvas. Hamburg: Kunsthalle. One of a series of eight paintings Richter made of his wife with their newborn child, showing his characteristic blurred Photorealistic technique. The compositions revisit the religious motif of the Madonna and Child.

Modernism. He is often pigeonholed with cutting-edgers now in their 30s and 40s, but is in fact old enough to be their father.

He produces three different types of work: schematic, Minimalist abstracts; splashy, messy abstracts; finely painted, soft-focus photographic imagery (most typical). What is not in doubt is his technical ability and high critical esteem. What is less clear is his meaning (he seems to deny any). Supporters says the deadpan blurriness shows his "dialectical tension" and virtuous ambivalence. Detractors ask how is it that such "important" work can be so boring? KEY WORKS Passage, 1968 (New York: Guggenheim Museum); Korn, 1982 (New York: Guggenheim Museum); St. John, 1988 (London: Tate Collection); Abstract Painting (726), 1990 (London: Tate Collection)

c.1970-

George **Deem**

⊖ 1932 - P AMERICAN

USA O oils New York: Allan Stone Gallery 2 \$3,750 in 1998, School of Winslow Homer (oils)

Deem is a New York-based painter famous for his "School of" paintings. Takes elements from well-known works by famous artists, such as Vermeer, and arranges them in a schoolroom setting – which is itself borrowed from a painting by Winslow Homer. Witty, perceptive, inventive. Uses subtle brushwork, which reproduces the techniques of the old masters. Makes you look and think twice. **Key WORKS** Visitation, 1978 (Private Collection); Vermeer's Chair, 1994 (New York: Nancy Hoffman Gallery)

Dan Flavin

€ 1933-96 P AMERICAN

USA installations New York: Guggenheim Museum S \$650,000 in 2004, Untitled (sculpture)

He was noted for constructions using fluorescent tubes and neons, usually arranged across a corner of a darkened empty room. Claimed to be playing with space of the room; illuminating dull corners (of life?) and expressing mystical notions about light. Early nostalgic references to Russian Constructivists. **KEY WORKS** *The Nominal Three (to William of Ockham)*, 1963 (New York: Guggenheim Museum); Greens Crossing Greens (to Piet Mondrian, Who Lacked Green), 1966 (New York: Guggenheim Museum)

Carl André

● 1935- PO AIVIERICAI	N
USA 🖉 sculpture	🟛 New York:
Guggenheim Museum	s800,000 in 🎾
2004, Steel-Magnesium	Plant (sculpture)

One of the first exponents of Minimal art, Andre's work reflects his boyhood in a Massachusetts shipyard town and his early job on the Pennsylvania railroad – surrounded by metal plates, girders, railway lines, industry, quarries.

Notorious for the Pile of Bricks, which hit the headlines in the 1970s (the Tate Gallery and André were ridiculed in the popular press). His most successful work is typically of industrially made components (such as bricks or metal plates), which are arranged in mathematical order; also chunky, rough-cut wood constructions made from pre-cut units. In the 1970s genuinely challenged the gallery-goer to question what is and what is supposed to be art. In 1985 he was charged with the murder of his wife (who fell from a window), but was later acquitted. KEY WORKS Equivalent VIII, 1966 (London: Tate Collection); Venus Forge, 1980 (London: Tate Collection); Bandolin, 2003 (New York: Paula Cooper Gallery); Carbon Quarry, 2004 (Düsseldorf: Konrad Fischer Galerie)

Tomb of the Golden Engenderers Carl André, c. 1976, 91.4 x 274.3 x 91.4 cm (36 x 108 x 36 in), western red cedar wood, Private Collection. André was a leading Minimalist, also writing in the tradition of concrete poetry.

Christo & Jeanne-Claude

⊖ BOTH 1935- P AMERICAN

 Europe; USA; Asia; Australia Sculpture; environmental art 2 \$320,000 in 1999, Yellow Store Front (sculpture)

Christo and Jeanne-Claude – a husband and wife partnership based in New York – travel the world to create highly original, memorable projects.

They wrap objects. They started in 1958 with small items and moved on to very large ones in 1961, e.g. wrapping the Pont Neuf in Paris and the Reichstag in Berlin, in fabric and ropes, which both suggest and conceal the thing wrapped. Also creators of landscape projects such as a 40-km (24-mile)-long curtain (literally)

running across open

Wrapped Trees Christo and Jeanne-Claude, 1997–98, Fondation Beyeler and Berower Park, Basel, Switzerland. For this installation, 178 trees were wrapped in 55,000 sq m (592,000 sq ft) of woven polyester fabric and ropes.

countryside. The big projects are deliberately temporary, so one only has a limited opportunity of seeing them.

Their underlying purpose isn't social but aesthetic – the transformation of the wellknown into the unfamiliar or disquieting while at the same time touching and involving everyone in the creative process. **KEYWORKS** Wrapped Coast, 1968–69 (New South Wales, Australia: Little Bay); Surrounded Islands, 1983 (Florida: Biscayne Bay)

Eva **Hesse**

⊖ 1936-70
 Ø GERMAN/AMERICAN

USA; Germany 🚺 sculpture; conceptual art; oils 🖬 London: Mayor Gallery 🎑 \$2m in 1997, Unfinished, Untitled, or Not Yet (sculpture)

A short-lived, deeply sensitive (and perhaps troubled) young woman of fragile health (she died of cancer), who has temporarily become a cult figure. She and her work epitomize one type of high art of the 1960s.

She had deadly serious intention and personal expression but at times was totally impenetrable. Creator of a wide range of work: abstract paintings, sculpture and Minimalist, conceptual constructions – perhaps the sign of a lost soul searching for her own reality. Her work addressed her own anxieties: Nazi persecution; being a refugee in New York; her parents' divorce; her mother's suicide; being a professional woman in a male world; her own painful divorce; her determination to be an outsider.

She was committed to the

handmade, but the concept was more important than the details. Her work makes constant allusion to female sexual anatomy.
Employed repetitive binding with strings and ropes. Hated decoration, hence the materials she used and the way they are used – works are repellent to sight and touch.

KEY WORKS Tomorrow's Apples (5 in White), 1965 (London: Tate Collection); Hang Up, 1966 (Art Institute of Chicago); Vertiginous Delour, 1966 (Washington DC: Hirshhorn Museum)

Frank **Stella**

€ 1936- PU AMERICAN

USA Dills; acrylics; mixed media
 San Francisco: Fine Arts Museums

2 \$4.6m in 1989, Tomlinson Court Park (oils)

One of today's leading abstract painters, Stella is prolific and very varied – but a constant theme is investigating what paintings are and what they can or ought to look like.

His early work reduced painting to all but its most pure, minimal, and indispensable properties: simple, flat, shaped, monochrome. He then introduced pure, bright, hard-edge colour with increasing complexity. After the early 1970s, he started to investigate how impure a painting can be and yet still remain a painting, by making constructions that are

c.1970-

rich, interlocking clusters of shape and colour. Uses varied materials.

Likes to work on a large scale. He steals ideas and techniques from sculpture and architecture, but always creates "pictures" - his creations have a back to the wall and are viewed from the front. KEY WORKS Six Mile Bottom, 1960 (London: Tate Collection); Agbatana II, 1968 (St Étienne: Musée de l'Art et de l'Industrie); Harran II, 1967 (New York: Guggenheim Museum)

Georg Baselitz

€ 1938 - ₱ GERMAN

Germany 🚺 oils; sculpture; mixed media

Canberra: National Gallery of Australia

\$1m in 2001, Der Hirte (oils)

The creator of big, lively, colourful, energetically painted, not very original paintings (neither in technique nor subject), in which bodies are often portraved upside down. Acclaimed in official art circles. Also makes large-scale, crudely hewn sculptures out of wood.

Baselitz claims (perhaps honestly?) that his works have no particular meaning, although this does not deter the art establishment from endowing them with deep significance and cheerfully paying enormous prices for them. Notice direction of the paint

Picture-Eleven Georg Baselitz, 1992, 289 x 461 cm (1133/4 x 1811/2 in), oil on canvas, Hamburg: Kunsthalle. Baselitz was one of a number of artists born and trained in Fast Germany who escaped to the West.

drips - at least they prove the figures were painted upside down and that he hasn't just up-ended his canvases. KEY WORKS Studio Corner, 1973 (Hamburg: Kunsthalle); Three-legged Nude, 1977 (Hamburg: Kunsthalle)

Brice Marden

🔟 USA 🚺 oils 🛍 San Francisco: Museum of Modern Art 22 \$2.2m in 2003, 10 Dialog 2 (oils)

Marden is a leading American Abstract painter who is not easy to pigeonhole and who has not got stuck in a rut like many of his contemporaries.

His earlier works are either single spreads of voluptuous colour or combinations of rectangular forms (panels) playing on the rectangular nature of his canvas. Uses velvety, textured paint (also beeswax and encaustic) for these. Titles of his pieces often refer to art history.

His recent works take a new direction. At first sight they look just like other examples of over-praised, messily painted abstracts. But linger and let them be what they are: the lines become like the rhythmic, moving patterns on the surface of clear deep water; the colours have the hues of autumn leaves. Reminisce about landscape. KEY WORKS Blonde, 1970 (Boston: Museum of Fine Arts); Green (Earth), 1983-84 (New York: Mary Boone Gallery); Corpus, 1991-93 (New York: Matthew Marks Gallery)

461

Robert Smithson

USA I land art; conceptual art; sculpture \$240,000 in 1998, *Double Nonsite, California* and Nevada (sculpture)

Smithson was a pioneer land artist, who was tragically killed in his 30s. He had a pessimistic view of the world: he foresaw it ending in a new ice age, not a golden age, reduced to self-destructive banality by the anonymity of urban developments and indifference to the environment. He reacted against this by offering his workings on the land (and the documentation of the process) as works of art.

KEY WORKS *Yucatan Mirror Displacements (1–9)*, 1969 (New York: Guggenheim Museum); *Spiral Jetty*, 1970 (situated at Great Salt Lake, Utah)

Judy Chicago

● 1939- P AMERICAN

 ☑ USA ☑ installations; conceptual art
 ☑ San Francisco: Museum of Modern Art
 ☑ \$2,400 in 1989, And then there was Light (works on paper)

She is best known for the collaborative venture *Dinner Party* (1973–79), a roomsize installation of a triangular table, and elaborate named place settings for 39 key historic and mythological females. Her activities are a celebration of sisterhood, but they are more popular with the public than with feminists.

KEY WORKS Dinner Party, 1973–79 (New York: Brooklyn Museum of Art); The Rejection Quartet, 1974 (San Francisco: Museum of Modern Art) Broken Circle Robert Smithson, 1971, diameter 42.7 metres (140 ft), green water, white and yellow sand flats, Emmen (Holland). Smithson was interested in historic manmade environments such as burial grounds and pyramids.

A. R. Penck

⊖ 1939 - 🕫 GERMAN

 ☑ Germany
 ☑ oils; prints; woodcuts

 ☑ Hamburg; Kunsthalle
 ☑ \$220,000 in

 1989, O A TE MI 2 (works on paper)

Born Ralf Winckler in East Germany (his earliest memory is of the fire bombing of his home town of Dresden in 1945). Creates highly individual works that have a consciously primitive and crude appearance. His hallmarks are his stylized, spindly, silhouetted figures; archaic symbols; fragmented writing. Has a personal political agenda, which is not always easy to fathom. **KEY WORKS** *View of the World, Psychotronic-Strategic-Art*, 1966–71 (Frankfurt: Städel Museum); *Standart-Bild*, 1971 (Basel, Switzerland: Kunstmuseum)

Richard Serra

⊖ 1939 - P AMERICAN

☑ USA ☑ sculpture ☑ London: Tate Collection.
 Washington DC: National Gallery of Art
 № \$390,000 in 1999, Sign Board (sculpture)

The foremost American creator of sculpture for public spaces. Produces huge works, which have a commanding presence and are held together only by gravity.

Look for giant, minimal, monumental slabs of metal, often exhibited in open urban spaces. They are unmissable and unavoidable – and often seem to be unstable, as though the pieces could fall over. Take pleasure in his interest in massive weight and the way he likes to play with the sense and appearance of it: propped, balanced, rotated, moving, about to move, added to, subtracted from, towering, ground-hugging. Loves playing with the force and direction of weight.

He is also interested in the psychology of weight, in two ways: 1) observing the impact that his massive, apparently unstable or dangerous objects have on the viewers' own space and on their bodily and mental reactions to them; 2) as a metaphor for social realities, such as the weight of government control or personal tragedy. Legal actions have been taken to have some of his works removed. **KEY WORKS** *Strike: To Roberta and Rudy*, 1969–71 (New York: Guggenheim Museum); *Five Plates*, *Two Poles*, 1971 (Washington DC: National Gallery of Art); *Balance*, 1972 (Washington DC: Hirshhorn Museum)

Chuck Close

USA joils; acrylics; prints San Francisco: Museum of Modern Art 2 \$4.3m in 2005, John (acrylics)

Close produces huge portraits of himself and his friends, always from the neck up. Works from photographs, which are squared up and the final images created tiny square by tiny square, according to a complex, time-consuming, and mechanical procedure. Uses colour after 1971. The end result is a compelling one. KEY WORKS Frank, 1969 (Minnesota: Minneapolis Institute of Arts); Big Self-Portrait, 1977-79

Self-Portrait Chuck Close, 2000, 149.5 x 120.5 cm (58³/x 47³/in), screen print, New York: Museum of Modern Art. Close was paralyzed in 1988 but continues to work with brushes strapped to his wrists. (Minnesota: Minneapolis Institute of Arts); *Georgia*, 1984 (Youngstown, Ohio: Butler Institute of American Art)

C.1970-

Jan Dibbets

Netherlands
 photography; installations
 \$60,000 in 1995, Octagon II (collage)

Photographer (black-and-white and colour) and installation maker.

His photographs are to be admired for their rigorous and meticulous qualities – formal and dry – and their limited experiments with perspective and space. Also produces installations that are strong sociological or political observations and critiques of capitalism.

His photo experiments are said to be part of a traditional Dutch interest in perspective and order that goes back to Saenredam via Mondrian. Maybe, but Dibbets does not have their feel for the poetry of space and light. **KEY WORKS** *Spoleto Floor*, 1981 (Turin: Castello di Rivioli Museum of Contemporary Art); *Four Windows*, 1991 (Tilburg, Netherlands:

De Pont Foundation for Contemporary Art)

463

Bruce Nauman

⊖ 1941 - P AMERICAN

 Image: USA
 Image: Image:

Regarded as one of the gurus of the official art world, Nauman aims to examine, document, and involve the viewer in experiences of pointless activity, humiliation, stress, and frustration.

He works in many media – video, performance, conventional sculpture, neon ... you name it. Claims to be communicating his observations of human nature and examining our perceptions of it, but focuses on activities that are pointless, repetitive, and deliberately inept. Fair enough, but does it result in anything of significance, or merely the trivial and banal? If the answer is "that's the point", then isn't it just an exercise in perversity?

To answer the above, trust your own judgment; ignore museum labels and their over-anxious insistence on significance (translation: we have committed significant money and professional credibility to this; if it isn't deemed to be significant and profound we will look like complete idiots). Better still, as this is overtly public art, to study the reactions of gallery goers. Are they engaged and interested? Dismissive and disinterested? They will tell you if his strategies amount to meaningful art. **KEY WORKS** Shelf Sinking into the Wall with Copper-Painted Plaster Casts of the Spaces Underneath, 1966 (London: Tate Collection); The True Artist Helps the World by Revealing Mystic Truths (Window or Wall Sign), 1967 (Canberra: National Gallery of Australia)

Sigmar Polke

⊖ 1941- № GERMAN

Germany D photography; oils; mixed media
 San Francisco: Museum of Modern Art
 \$1.5m in 2005, *Bavarian* (oils)

His family migrated from East to West Germany in 1953. Produces large-scale work, which often appears to be a chaotic appropriation of images from consumer society, painted onto unorthodox grounds (such as woollen blankets or furs). Claims to be attacking cliché-ridden banalitics of current society and aspires to make contact with a higher spiritual level of consciousness.

Flight – Black, Red, and Gold Sigmar Polke, 1997, 300 x 400 cm (118/x x 157½ in), mixed media, polyester fabric, Private Collection, Hamburg: Kunsthalle. Polke's most recent works reflect an interest in exploring the relationship of abstract and figurative art.

464

KEY WORKS *Paganini*, 1982 (London: Saatchi Collection); *Saturn*, 1990 (San Francisco: Fine Arts Museums)

Gilbert and George

⊖ 1943-AND 1942- P BRITISH

☑ London
 ☑ performance art; photomontage;
 video; mixed media
 ☑ London: Tate Collection
 ☑ \$420,000 in 2004, Seed (photographs)

Gilbert Proesch and George Passmore. Highly successful, narcissistic couple who regularly appear in their own work as two cheap-suited "nerds". They have a big international following. Started as real-life "living sculptures".

Their large "photopieces" (produced since 1974) are made by an unknown process and are technically very impressive. Subject matter comes out of inner-city decay and is often deliberately "inver-face" and offensive

to all sides: to liberals (racist overtones, admiration for Thatcherism, swastikas, crude little England nationalism) as much as to old-school conservatives (overt homosexuality with young boys, turds, ridicule of religion and the monarchy).

Their work unquestionably reflects something significant about British society and its art world (1970s to the 1990s), but what? Are they criticizing the physical, moral, social, and educational decay of society (the period when Britain became "a nation state equivalent of Woolworths")? Are they praising it? Exploiting it? Or pandering to chattering-class voyeurism? Their work may rapidly begin to look very dated. Are they Hogarth's successors? Do they have a true message, or is their inability to set an agenda a comment in itself on present-day British society? KEY WORKS A Portrait of the Artists as Young Men, 1970 (London: Tate Collection); Balls: the Evening Before the Morning After - Drinking Sculpture, 1972 (London: Tate Collection);

Dream, 1984 (New York: Guggenheim Museum); Here, 1987 (New York: Metropolitan Museum of Art)

Blinky Palermo

⊖ 1943-77 🕫 GERMAN

 Image: Germany
 Image: Sculpture; oils; mixed media

 Image: Frankfurt: Städel Museum. New York: Dia:Beacon
 Stödo,000 in 2002, Stoffbild (fabric painting)

Real name Peter Heisterkamp, he was a short-lived refugee from Communist East Germany to Düsseldorf (1954). Was a disciple of Beuys. Had a charismatic personality and adopted the pseudonym (Palermo) of a notorious boxer and Mafioso, Made objects, fabric works, and abstract paintings. His utopian dream was to use art as a means of modern salvation. Perhaps another case where ambition ran too far ahead of the achievement.

KEY WORKS Staircase, 1970

(London: Tate Collection); Untitled (Fabric Painting), 1970 (Frankfurt: Städel Museum); To the People of New York City (1976–77), (New York: Dia:Beacon)

James **Turrell**

•	1943-	PO AMERICAN	
ρ	USA	installations; land art	
Î	Housto	n: Museum of Fine Arts	
2	\$100,0	00 in 2000, <i>Raetho</i> (sculptu	ire)

Turrell produces gallery installations and land-art creations that are light-filled spaces. Wants to capture the physical reality (rather than the illuminating quality) of light (natural and artificial). You, the viewer, are to move about and become so involved and absorbed that you experience a different level of consciousness (spiritual or cosmic). **KEY WORKS** *Lunette*, 1974 (New York: Guggenheim Museum); *Night Passage*, 1987 (New York: Guggenheim Museum)

STREET

Street Gilbert and George, c. 1983, 121 x 100 cm (47% x 39% in), mixed media, Private Collection. Gilbert and George were among the first artists to move to the East End of London, attracted by its affordability and roughness. The area is now a fashionable art Mecca, acting as a shop window for dealers and collectors.

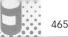

Christian **Boltanski**

⊖ 1944 - PU FRENCH

 France
 Sculpture; installations; photography

 Hamburg: Kunsthalle
 \$175,258 in 1990, Les

 saynètes comiques: le baiser caché (works on paper)

The Frenchman produces disturbing installations that are gloomy, dimly lit, labyrinthine, and claustrophobic. He collects items such as photographs, old clothes, and personal relics to address his central themes of lost childhood, death, anonymity, and the Holocaust. He attempts to create a visual requiem for all innocent victims. Familiar war subject matter, to which he brings a new twist. **KEY WORKs** *The Reserve of Dead Swiss*, 1990 (London: Tate Collection); *Gymnasium Chases*, 1991 (San Francisco: De Young Museum)

Rebecca Horn

⊖ 1944- 🕫 GERMAN

Germany; UK; USA installations;
 video London: Tate Collection
 \$49,680 in 2004, *Libelle* (sculpture)

Horn is the creator of highly original installations incorporating machines that move, click, whirr, flick paint, or flap wings, and are generally surprising or unpredictable. Her work is compulsive viewing, entertaining and unnerving, and has the ability to set off odd and possibly alarming or subversive trains of thought (which is what she is after). Machines need perfecting (too many breakdowns). **KEY WORKS** *The Hydra-Forest Performing Oscar Wilde*, 1988 (San Francisco: Museum of Modern Art); *Concert for Anarchy*, 1990 (London: Tate Collection) Monuments: The Children of Dijon Christian Boltanski, 1986, 700 x 400 cm (275% x 157% in), installation, Hamburg: Kunsthalle. Displaying photographs of anonymous French children, Boltanski has described his work as a monument to the glory of childhood.

Jorg Immendorff

● 1945- P GERMAN

 Image: Construction
 Image: Construction of the construction of th

He produces heavily painted Expressionist work that is essentially traditional and derivative (of 1920s German Expressionism and Beckmann). Addresses political issues such as the divided Germany or the environment. Typical imagery of his work is a café interior with an anonymous crowd, and symbolism of watchtowers, uniforms, barbed wire, and eagles.

KEY WORKS *The Rake's Progress*, 1992 (New Jersey: World House Gallery); *Untitled*, 1993 (New York: Philip Isles Collection)

World of Work Jorg Immendorff, 1984, 284 x 330 cm (111³/ x 130 in), oil on canvas, Hamburg: Kunsthalle. Never shy of publicity, Immendorf opened a bar in Hamburg's red light district in 1984.

с.1970-

Sean Scully

€ 1945- P IRISH/AMERICAN

UK; USA 🚺 oils; pastels 🖬 London: Tate Collection. San Francisco: Museum of Modern Art 🎗 \$310,000 in 1990, *Untitled* (oils)

He is noted for his high-minded abstract art (he believes in pure painting as high art). The favoured form is large, simple, horizontal and vertical stripes, and the technique emphasizes the qualities of paint through earthy grey colours and the subtle interplay of two and three dimensions. His works are sometimes made from separate panels. An "art for art's sake" of great refinement. **KEY WORKS** *Paul*, 1984 (London: Tate Collection); *Pale Fire*, 1988 (Texas: Modern Art Museum of Fort Worth)

Anselm Kiefer

● 1945- P GERMAN

 Image: Germany
 Image: Oil oils; acrylics; mixed media; sculpture; photography

 Image: Sculpture; photography
 Image: Condon: Tate

 Collection
 Image: \$1.05m in 2001, Athanor (oils)

Kiefer creates very large-scale, gloomy, superficially simple images, thickly painted, often with applied or collaged material. The intention is to draw your imagination in via perspectives, textures, and layers, to confront difficult conceptual issues, such as Nazi horrors and guilt for the Jewish Holocaust. A sort of modern history painting. Uses art as a means of expunging the past.

Look for the Hans Makart of our times. **KEY WORKS** *Parsifal I*, 1973 (London: Tate Collection); *Margarethe*, 1981 (New York: Marion Goodman Gallery)

Susan Rothenberg

San Francisco: Museum of Modern Art. London: Tate Collection 2 \$460,000 in 1991, *Cabin Fever* (oils)

A former dancer who came to prominence as a painter in the mid-1970s, now much displayed. Her large-scale works usually contain a human or animal form, emerging from a hazy background, on the point of mutating into something else. Weird, vaguely disturbing, and symptomatic of the American love of anxious self-analysis. **KEY WORKS** Bone Man, 1986 (New York: Museum of Modern Art); Vertical Spin, 1986–87 (London: Tate Collection)

Red Banner Susan Rothenberg, 1979, 228.6 x 314.6 cm (90 x 123¼in), acrylic on canvas, Houston: Museum of *Fine Arts*. During this decade, Rothenberg explored themes based on horses, regarding the activity and investigation as akin to painting a self-portrait.

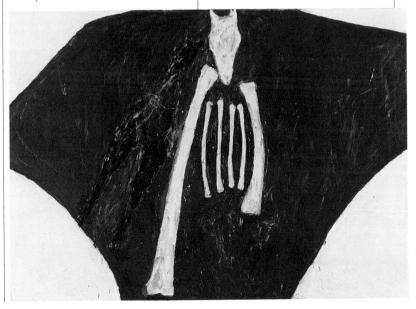

Richard Long

UK [2] land art; conceptual art; sculpture; photography [2] London: Tate Collection [2] \$190,000 in 1989, Whitechapel Slate Circle (sculpture)

Long is a leading British land artist who achieved much early success. He was a winner of awards and attained international recognition in his 30s, but from the age of 50+ has gone rather quiet.

He is an artist with very serious intentions. He works with the land, assembling bits of it (rocks, sticks, mud) in aesthetic configurations (typically, large-scale stone arrangements in a circle or line, or walls "painted" with the mud). His earlier work is in photographic form, recording marks made by him on and in the landscape he walked over.

Is he, as some claim, a development of the Constable-Wordsworth tradition (man's harmony with nature) or is he the opposite? Does he perhaps represent the modern city dweller's incomprehension of, and puzzlement at, nature – seeking to cover it in urban developments, transform it into municipal parks (however sensitively done), and bring it back to the city art gallery in chunks and buckets? **KEY WORKS** *A Square of Ground*, 1966 (London: Tate Collection); *A Line Made by Walking*, 1967

(London: Tate Collection); *Red Slate Circle*, 1980 (New York: Guggenheim Museum); *Wessex Flint Line*, 1987 (Southampton: City Art Gallery)

Jeff Wall

Canada
 D photography; conceptual art
 Hamburg: Kunsthalle
 2 \$250,000 in 2000,
 The Well (photographs)

Wall produces immaculate cibachrome photographs presented in steel frames and illuminated from behind by fluorescent tubes. The expectation created by their detailed photographic realism is that they are "from life". In fact, they are carefully selected and posed artificial tableaux, maybe using actors. A neat play on what is reality and what is art.

KEY WORKS A Sudden Gust of Wind (After Hokusai), 1993 (London: Tate Collection); Citizen, 1996 (Basel, Switzerland: Kunstmuseum)

Anthony Gormley

⊖ 1950- PU BRITISH

 Image: Wight of the second structure of the se

He is an artist of increasing stature who has never been afraid to go against the grain of fashion.

His characteristically (but not exclusively) life-size human figures have no specific features and are made of metal, visibly

Angel of the North Anthony Gormley, 1997–98, height 20 metres (65 ft), steel sculpture, Gateshead (UK). The work has a poetic significance as a memorial to the area's now defunct coal mining industry.

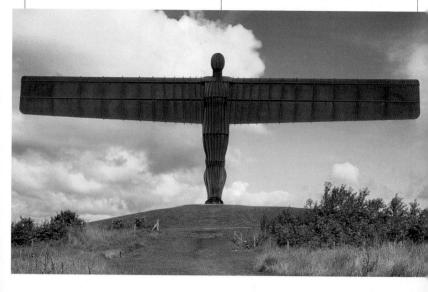

soldered together in static poses. They are casts of the artist's own body. He is wrapped in clingfilm, then cloth, then coated with wet plaster, which dries. He is then cut out of the resulting mould, which is reassembled, and lead or other metal is pressed into the void, or beaten to take his form, and the pieces are welded together.

Gormley studied Buddhism in India, and there can be little doubt that he is an artist trying to say something (in which he may or may not succeed) rather than to play to a market. His 20-metre (65-ft)high *Angel of the North* dominates the main A1 road on the approach to Tyneside. **KEY WORKS** *Bed*, 1980–81 (London: Tate Collection); *Three Ways: Mould, Hole, and Passage*, 1981 (London: Tate Collection); *Untitled (Man Falling)*, 1985 (Private Collection); *Untitled for Leeds Brick Man*, 1986 (Leeds: City Art Gallery)

Julian Schnabel

● 1951 - P AMERICAN

USA (i) oils; mixed media; prints
 Michigan: Detroit Institute of Arts
 \$325,000 in 1999, *Portrait of a Girl* (oils)

He is a much-hyped charismatic figure, considered very "bankable" in the "greed is good" boom of the 1980s. His energetic, thickly painted figurative work has striking additions, such as broken crockery and black or red velvet. Claims to deal with weighty subjects, in the tradition of great art (Van Gogh, for instance). Fashionable, but forgettable in the long term. **KEY WORKS** *Jacqueline*, 1987 (Salzburg: Rupertinum Gallery of Modern Art); *Self-Portrait in Andy's Shadow*, 1987 (Santa Monica: Broad Art Foundation)

Bill Viola

● 1951- P AMERICAN

 USA
 Uvideo; installations; photography

 Berlin: Guggenheim Museum
 \$\$59,600

 in 2002, Incrementation (sculpture)

Viola is one of a very small minority that uses video to genuinely creative effect. He tackles age-old subjects such as birth, death, and human relationships with experience and understanding, and builds up imagery in ways analogous to the processes of a painting. Also uses the technology to involve the viewer in creating the final image. Moving, perhaps even profound, work.

One of the reasons why he is so successful and convincing is that he does not use the video medium and technology as an end or phenomenon in itself. He has something he wishes to say about the human condition and uses video technology to express it. Like all the best artists, he is totally in control of his chosen medium and can take it to the edge of its limitations. **KEY WORKS** *The Sleep of Reason*, 1988 (Pittsburgh: Carnegie Museum of Art); *Nantes Triptych*, 1992 (London: Tate Collection); *The Crossing*, 1996 (New York: Guggenheim Museum)

Francesco Clemente

● 1952 № ITALIAN/AMERICAN
 № Italy; USA
 № tempera; watercolours; oils
 ➡ Bilbao: Guggenheim Museum
 № \$310,000
 in 1994, *The Celtic Bestiary* (works on paper)

He was born in Naples, lives in New York. One of the most respected members of the current art establishment. Prolific, multifaceted, multinational – multieverything. The epitome of official contemporary artistic acceptability.

Clemente creates both large-scale works and smaller ones. Explores dual themes that are the meat of political correctness, such as the relationship between the past and present, the human and animal, Europe and America, man and woman, East and West. Uses a wide variety of impeccable source material (Italian Renaissance, Indian art). Technically very sound and intellectually complex, with much symbolism to unravel.

With such correct, self-assured, firmly controlled agendas, technique, and subject matter, it is difficult to find fault. But why are the faces, eyes, and imagery in general so sad and lonely? Any art that takes itself so deadly seriously risks becoming passionless. Why the obsession with genitalia? Seems like joyless selfobsession: subjects are often sexual but not erotic. And it is the sort of art that public institutions want.

KEY WORKS *Tondo*, 1981 (New York: Museum of Modern Art); *Fire*, 1982 (Zurich: Thomas Ammann Fine Art); *Head*, 1984 (London: Victoria & Albert Museum)

Mona Hatoum

 ● 1952 –
 PU LEBANESE UK; USA; Canada; France 🚺 video; installations; performance art; sculpture 🖬 London: Tate Collection 🔯 \$130,000 in 2000, Silence (sculpture)

She is an involuntary refugee working in London. Creates installations and videos whose subjects are about exile. loneliness, and authoritarian politics, which she interweaves and interlinks with an examination of the undemocratic boundaries of traditional art practices. KEY WORKS Measures of Distance, 1988 (London: Tate Collection); Socle du Monde, 1992-93 (Toronto: Art Gallery of Ontario)

David Salle

USA 🚺 oils; acrylics; prints London: Tate Collection 🔁 \$500.000 in 1989, Tennyson (sculpture)

Salle creates large-scale figurative paintings, which are a ragbag of familiar, not very taxing, images culled from art history, adverts, design, porn, and so on. Facile and technically feeble when examined closely at first hand, they fortunately for him look quite convincing as small-scale reproductions in books or catalogues.

If you find this – or any other – artist's work awful or incomprehensible, but don't want to to say so or alienate yourself at private views, say "He (or She) has a style that is distinctly his own" (which is always true); "he neutralizes and subverts narrative and artistic conventions" (no one will dare disagree); "he appropriates art and images and simultaneously critiques them in his work" (people will be impressed, especially if they have no idea what you actually mean). KEY WORKS Sextant in Dogtown, 1987 (New York: Whitney Museum of American Art); Walking the Dog, 1992 (London: Tate Collection)

Sophie Calle

● 1953- P FRENCH

France 🚺 photography 🔊 \$20,000 in 2004, In Romance in Granada (photographs)

Calle makes gallery displays with photographs and texts. Acts as a recorder and chronicler of society - spying on

strangers, photographing them, recording what they say, involving them in her own deliberate role play. Fascinated by the interplay of public and private, fiction and reality, exhibitionism and secrecy. KEY WORKS The Birthday Ceremony, 1981 (Chicago: Donald Young Gallery); The Bronx, 1991 (Boston: Barbara Krakow Gallery)

Nan Goldin

2	1953 -	P AMERICAN	
_			

🔟 USA 🚺 photography 🛅 London: Tate Collection 🔀 \$250,000 in 2002, Thanksgiving (photographs)

She takes large-scale photographs, often in series, that create a visual diary of her social circle, travels, and emotional crises. She is especially concerned with so-called taboo (gay, lesbian, or transvestite) relationships and public awareness of their intimacies. Honest, often moving, and beautifully crafted.

KEY WORKS Nan One Month after Being Battered, 1984 (London: Tate Collection); Siobhan in my Bathtub, Berlin, 1992 (Winterthur, Switzerland: Fotomuseum)

Martin Kippenberger

● 1953-97 P GERMAN

🖸 Germany 🚺 oils; installations; performance art; prints 🖬 San Francisco: Museum of Modern Art 🔯 \$650,000 in 1999, Untitled (oils)

Created drawings, paintings, installations, and performances. Provocative, cynical, and anti-authority, he attempted to raise the trivial and "sub-cultural" to the status of high art (a mainstream activity of artists since 1900). His last work, MetroNet, is of an imaginary, underground railway world. KEY WORKS Das Ende des Alphabets (ZYX), 1990 (Ghent: Stedelijk Museum voor Actuele Kunst); The Raft of the Medusa, 1996 (San Francisco: Museum of Modern Art)

Anish Kapoor

⊖ 1954 - P BRITISH/INDIAN

🔟 UK; India 🚺 sculpture 🖬 London: Tate Collection 2368,000 in 2004, Untitled (sculpture)

Born in Bombay, he settled in the UK. Creates 3-D objects in which colour, space, and the interplay between the

с.1970-

quality toys for adults, in the best sense. His strange-looking objects are made from materials such as steel, fibreglass, or stone. They have highly polished or intensely pigmented surfaces, often on a large scale. Be prepared to suspend disbelief – stop seeing them as man-made objects and allow them to act freely on your perception and imagination. Go on, play with them.

If you let go and allow your mind and eye to follow their own course – rather as you may have been able to do as a child, looking at the sky and clouds – there is a lot there. Enjoy thrilling and strange spaces to sink into, colourful "magic kingdoms" to explore, the familiar made strange. Lots of simple, unthreatening, genuinely "out of this world" experiences. A fresh, inspiring affirmation of art's role in celebrating and creating some *joie de vivre*. **KEY WORKS** *As if to Celebrate, I Discovered a Mountain Blooming with Red Flowers,* 1981 (London: Tate Collection); *Untilled,* 1983 (London: Tate Collection); *Void Slone,* 1990 (Leeds: City Art Gallery)

Marsyas Anish Kapoor, 2002, 155 x 35 metres (508 ½ x 114½ ft), steel and PVC, London: Tate Modern. This giant sculpture was covered by a dark red fleshytextured PVC membrane – hence the reference to Marsyas, the Greek satyr who was flayed alive.

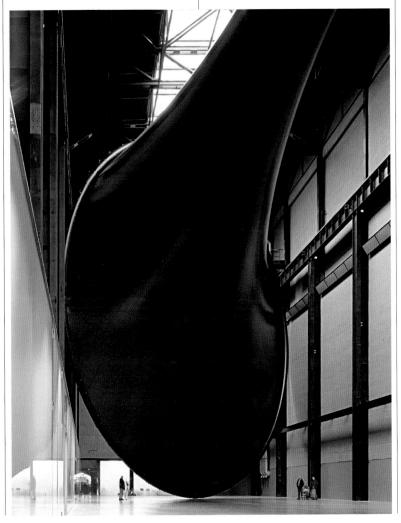

472

CONTEMPORARY ART

Cindy Sherman

⊖ 1954 - P AMERICAN

 Image: USA
 Image: Dependence of the state
 Image: Dependence of the s

Sherman is a leading New York artist beloved by art critics who swoon over the powerful manner in which she deconstructs and comments on women's role in a male-dominated consumer society.

She produces very large-scale photographs, often in high-key colour. Works in series. She acts the parts, makes the sets, and takes the photographs herself. There is no other (and no male) involvement. In the early series she depicted herself as media stereotypes and as ordinary girls and women. From 1985 she has produced series of grotesque images – teddy bears, dolls, or toys in a stew of vomit or slime; dehumanized medical dummies; also parodies of old-master portraits.

She seems to have less of a specific agenda than most commentators wish on her. She claims to have discovered this style of work almost by accident. Her grotesque images are said to be a commentary on consumerism's excessive binges and purges. Try identifying with the stereotypes that Sherman portrays – career girl, runaway teenager, Ingres portrait, and so on. **KEY WORKS** Untitled A-D, 1975 (London: Tate Collection); Untitled Film Stills (series), 1977–80 (New York: Museum of Modern Art); Nr. 261, 1992 (Hamburg; Kunsthalle)

Kiki Smith

⊖ 1954 - P AMERICAN

USA 🚺 sculpture; screenprints; body art Mew York: Museum of Modern Art \$210,000 in 1997, *Pee Body* (sculpture)

The daughter of sculptor Tony Smith, Kiki Smith trained briefly as a medical technician. She is obsessed with bodily fluids and parts, such as blood and saliva. She either displays these in jars or makes paper cutouts that suggest skin, and wax figures that seem to drip secretions. The underlying agenda for this need to play with the repellent is not clear. **KEY WORKS** *Ribs*, 1987 (New York: Guggenheim Museum); *Untitled (Train)*, 1994 (Santa

Museum); Untitled (Train), 1994 (Santa Barbara, California: Museum of Art)

Thomas Schuette

⊖ 1954 - 🕫 GERMAN

Germany
 Sculpture; mixed media; drawings
 Ghent: Stedelijk Museum voor Actuele Kunst
 \$210,000 in 1998, Grosse Geister (sculpture)

Schuette is an artist who uses techniques and ideas from several disciplines. Makes sculptures, which range from small dolllike models to large pieces, drawings, and architectural models in wood similar to doll's houses. The human figure, scale, and presence are always apparent. His work encourages an open-ended, imaginative, non-aggressive questioning of the human condition and experience. **KEY WORKS** *Weinende Frau*, 1989 (Ghent: Stedelijk Museum voor Actuele Kunst); *Belgian Blues*, 1990 (Ghent: Stedelijk Museum voor Actuele Kunst)

Robert Gober

€ 1954 -	PC AMERICAN
🛄 USA	sculpture; installations; oils; mixed
media	San Francisco: Museum of Modern Art
> \$800,0	000 in 2005, <i>Untitled Leg</i> (sculpture)

A maker of objects and installations, Gober is well regarded and much exhibited on the international circuit.

He explores various fashionable ideas, such as subversion of conventions and social norms (the happy family as oppressive rather than beneficial), gay politics, green and conservation issues. Some of his objects look like found objects but are in fact made by Gober; others are everyday objects that overtly don't work (like an unconnected sink).

Does the work at times risk becoming too humourless, oblique, obscure, and overly didactic? Does he sometimes seem to say: "Today, class, we are going to consider issues of normality and abnormality in contemporary society and strategies of how we might debate those issues by creating objects that will subvert our normal expectations"? Which interests him more: his strategies or the human issues? Aren't some of his chosen social issues very parochial? **KEY WORKS** The Subconscious Sink, 1985 (Minneapolis, Minnesota: Walker Art Center); Prison Window, 1992 (San Francisco: Museum of Modern Art); Rat Bait, 1992 (San Francisco: Museum of Modern Art)

с.1970-

Jeff Koons

⊖ 1955 - P AMERICAN

USA Sculpture; conceptual art; oils; photography New York: Guggenheim Museum St. 1m in 2001, *Michael Jackson* and Bubbles (sculpture)

He's good-looking, clever, witty, articulate, popular, good at self-publicity, successful. A former salesman and Wall Street commodity broker; now one of the darlings of the contemporary art world. Married La Cicciolina (famous Italian porn star and politician).

He glorifies and deifies the banal consumer object as a work of art. For instance, he presented pristine vacuum cleaners in the airtight, fluorescent-lit museum cases usually reserved for precious objects; he cast an inflatable toy rabbit as a polished sculpture like a Brancusi; he presented a kitsch Michael Jackson model like a Meissen figurine;

Popples Jeff Koons, 1988, 75 x 60 x 40 cm (29½ x 23½ x 15½ in), porcelain, Hamburg: Kunsthalle. This porcelain sculpture recreates in detail a sutified toy that was marketed by a cartoon show. Part of the artist's "Banality" series, it failed to sell at Sotheby's in New York in 2003.

and filmed himself and his wife making love in a sanitized, Disney-like setting. He has an obsession with newness.

His work displays layers of clever, deliberate symbolism: the pristine vacuum cleaner = phallic (male) + sucking (female) + cleaning (purity or goodness) + brand new (virginity and immortality). He comments on consumer society's relentless promotion of success and the luxury lifestyle – and also how art functions, since commodities can be turned into high art, and art into commodities. **KEY WORKS** Lifeboat, 1985 (Hamburg: Kunsthalle); Three Balls Total Equilibrium Tank, 1985 (London: Tate Collection); Pink Panther, 1988 (New York: Sonnabend Gallery); Blue Poles, 2000 (New York: Guggenheim Museum)

Andreas Gursky

 ● 1955 P
 GERMAN

 III Germany
 Iphotography

 III London: Tate Collection
 Image: \$\$255,000

 in 2005, May Day IV (photographs)

Gursky is a commercially and critically successful capturer of the high-tech, fast-paced, modern world. Produces large-scale highly coloured photographs capturing various aspects of late capitalist society. The scope of his images has expanded in size and

subject matter (looking outside his native Germany to an increasingly global stimulus) since the late 1980s. Particularly interested in the exchange

mechanisms of capitalist societies, he produces highly formalized photos of North American and East Asian stock exchanges, where the crowds are colour-coordinated in an almost Abstract Expressionist way.

Gursky can be seen as a modern descendant of history painting, cataloguing our cultural mythologies. But don't expect documentary: his interest lies in the collective and anonymous, not the individual and personal. **KEY WORKS** *Schiphol*, 1994 (New York: Metropolitan Museum of Art); *Singapore*

Stock Exchange, 1997 (New York: Guggenheim Museum); Parliament, 1998 (London: Tate Collection); 99 Cent, 1999 (New York: Metropolitan Museum of Art)

Andy Goldsworthy

⊖ 1956- P BRITISH

UK Sculpture; mixed media; photography London: Courtauld Institute of Art S \$13,300 in 2001, *Snow Cone, Grise Fjord, Ellesmere Island* (photographs)

He works mostly in the open air with, and in response to, natural materials and particular places. Creates art with leaves, ice, trees, or stones.

His deeply sensitive response to nature, places, and seasons is in the English Romantic landscape tradition (like Constable or Palmer) but he offers new forms and interpretations. He weaves together the materials he uses in ways that rival nature's own ingenuity and beauty. Most works are made for, or left, out of doors where, as he intends, they eventually melt, fall over, or disintegrate.

Makes photographic records of these outdoor works, which he presents in book form as beautiful images and objects in themselves. Also produces work for gallery spaces and urban settings, though these tend to be less successful. **KEY WORKS** Conch Shell Leafwork, 1988 (Leeds: City Art Gallery); Red Pool, Scaur River, Dunfriesshire, 1994–95 (Virginia: Sweet Briar College Art Gallery)

Felix Gonzalez-Torres

€ 1957-96 PU CUBAN/AMERICAN

USA 🚺 conceptual art; installations; mixed media 🛍 San Francisco: Museum of Modern Art \$1.5m in 2000, *Untitled, Blood* (sculpture)

He was the acme of political correctness: Cuban, gay, urban; had sad untimely death (AIDS). His work is conceptual, featuring piles of sweets or paper, photographs, light

Arch at Goodwood Andy Goldsworthy, 2002, sandstone, Goodwood: Cass Sculpture Foundation. The quarried slabs of sandstone forming the arch weigh over 100 tonnes. The old flint wall it straddles was built by French prisoners during the Napoleonic Wars.

с.1970-

bulbs, and so on. Said to explore issues of illness, death, love, loss – life's sadness and transience – with a poetic aura.

Maybe his works don't achieve their stated ends unless accompanied by curatorial handouts, catalogues, or didactic writings – in which case who is creating the art work: the artist or the curator? Well and sincerely intentioned, but in the end may amount to very little. **KEY WORKS** Unitled (Death by Gun), started 1990 (ongoing) (New York: Museum of Modern Art); Unitled (Portrait of Ross in L. A.), 1991 (Art Institute of Chicago); Unitled (Public Opinion), 1991 (New York: Guggenheim Museum)

Keith Haring

→ 1958-90
 P AMERICAN

USA 🚺 drawings; oils; mixed media; sculpture 🖬 San Francisco: Museum of Modern Art 😰 \$550,000 in 2004, *Untitled – People* (oils)

Haring was formally trained and first made his mark as a graffiti artist in the New York subway. In later life he was principally interested in marketing his easily recognizable images (simplistic pin men depicted with thick black outlines, participating in various inconsequential activities) via T-shirts, badges, and so on. The epitome of art and the artist as a brand image. Died from AIDS in 1990. **KEY WORKS** Subway Drawing, 1980–81 (New York: Hyde Collection Art Museum); Self-Portrait, 1989 (Florence: Galleria degli Uffizi)

Francis Alys

⊖ 1959-
 P BELGIAN

Mexico City (Conceptual art; oils; performance art; mixed media (2) \$160,000 in 2003, Untitled (oils)

He is a painter, and conceptual and performance artist. Active principally in Mexico City, where he sets up elaborate projects that are said to catalogue the (banal or surreal?) urban experience. Some involve other people, such as advertisement painters. On one occasion he dragged through the city a small magnetic dog that attracted metal debris. **KEY WORKS** *The Last Clown*, 1995–2000 (London: Lisson Gallery); *61 out of 60*, 1999 (London: Lisson Gallery)

Jean-Michel Basquiat

USA acrylics; mixed media; collage
 \$5m in 2002, *Profit I* (oils)

A young, black, middle-class New Yorker, who died of a drug overdose aged 28. Frenzied and prolific self-taught artist whose work powerfully reflects the obsessions and conflicts of his city and his decade.

His large-scale work has the appearance, content, and crudity of graffiti on buildings (he began his career by secretly and illegally painting on public buildings). Their sheer energy, size, number, and consistency indicate an intelligence seeking release or crying for help. Shocking, controversial, ugly, drugcrazed they may be – boring and dismissable they are not.

Words, images, and collaged materials reflect the street life in which he grew up and lived, notably: racism, money (the art market took him up and his works sold for high prices), exploitation, Third World cultures, comics, TV and films, rap music, break-dancing, junk food, black heroes, urban ghettos, and sex. **KEY WORKS** Untitled (Skull), 1981 (Santa Monica: Broad Art Foundation); Saint, 1982 (Zurich: Galerie Bruno Bischofberger)

Jake and Dinos Chapman

€ 1962-AND 1966- P BRITISH

UK 🚺 conceptual art; sculpture; mixed media London: Tate Collection 🏼 \$83,520 in 2001, *Cyber-iconic Man* (sculpture)

The brothers create life-size resin and fibreglass figures, usually of pubertal or pre-pubertal children. In part rendered with startling realism, in part distorted by grotesque, obscene, and impossible sexual organs; also mutilated anatomies, which recreate realistically the imagery of Gova's *Disasters of War*.

The brothers admit that their purpose is totally cynical – to create an aesthetic of indifference, insensitivity, with no cultural value. Shock has always been a legitimate artistic weapon, but shock for its own sake alone is worthless. **KEY WORKS** *Hell*, 1999–2000 (London: Tate Collection); *Insult to Injury*, 2003 (London: Tate Collection)

Tracey Emin

€ 1963- P BRITISH

 UK
 installations; conceptual art; sculpture;

 video
 installations; conceptual art; sculpture;

 video
 installation; Saatchi Collection; Tate Collection

 \$252,000 in 2000, My Bed (installation)

She of the now notorious unmade bed. Candidate for (but not winner of) Turner Prize, Tate Gallery 1999. All her work is a public and manic working out (exorcism) of her traumatically unhappy youth and adulthood (rape at 13; endless promiscuity; transient relationships; abortion). Is it art or should it be considered a cry for help? Where does she go from here?

Can a cry for help, alone, make art? Van Gogh cried for help, but used art as a means of attempting self-reconstruction, and he had a vision of a better world he wished to create for himself and others. Without this sort of reaching out, there is always a danger of simply lapsing into self-indulgence and self-pity – which may be necessary personally, but it isn't art. **KEY WORKS** *CV Cunt Vernacular*, 1997 (London: Tate Collection); *Just Love Me*, 1998 (Bergen, Norway: Kunstmuseum); *Hate and Power Can Be a Terrible Thing*, 2004 (London: Tate Collection)

Rachel Whiteread

● 1963 - P BRITISH

UK Sculpture; drawings; prints London: Tate Collection State \$420,000 in 2004, Untitled – 16 Spaces (sculpture)

Once one of the most fashionable of the 30-something British artists who gained international attention. She is much featured in the media.

Whiteread creates single-minded work of very serious, austere appearance. She makes physical casts in concrete, resin, rubber, and so on, of everyday objects and spaces (yes, spaces), such as the inside of a bath, spaces under chairs, and, most famously, the inside of complete rooms of a Victorian house (the house was then demolished by the local authority). The rationale behind her compositions is that she makes concrete the ordinary, banal spaces we inhabit and on which we leave the imprint of our existence.

So far has had one good and worthwhile idea, which has caught attention and which she has explored in a dedicated and conscientious manner. But do the actual objects she creates have lasting merit? Will what she creates turn out to be profound or just parochial? Where on earth does she go next? Is she a sevenday wonder, or at the beginning of a long and memorable career? Such unanswerable questions are the stuff and fun of an involvement with high-profile contemporary art. **KEY WORKS** Untitled

(Freestanding Bed), 1991 (Southampton: City Art Gallery); Untitled (Air Bed II), 1992 (London: Tate Collection); Untitled (Floor/Ceiling), 1993 (London: Tate Collection)

Damien Hirst

● 1965 –
 P BRITISH

 Image: With the second sec

Now middle-aged, once the biggest young name in the UK. Famous for cows preserved in formaldehyde, but he makes "art" with almost anything cigarette butts, paint, video... Able entrepreneur, who knows his market. As an artist and personality, he will probably auto-destruct eventually.

Hirst claims that his art is a serious discussion of death and decay. Has undoubtedly an uncanny ability to comment on current social obsessions his recent works touched that sensitive nerve of fears over the health industry. genetic engineering, getting old and infirm, etc. Equally, he and his work have the fascination of a freak show at a circus. Is he saying something long-lasting, or is his art as significant as an executive toy? The comparisons with great artists such as Picasso are silly. And when he's finished delivering the goods and wowing the media, will Hirst's work amount to more than fashion statements?

Away From the Flock (second version) Damien Hirst, 1994, 96 x 149 x 51 cm (37½ x 58½ x 20 in), steel, glass, formaldehyde solution, and lamb, London: White Cube Gallery. A replica replacing the vandalized original.

Mariko Mori

● 1967 –
 P JAPANESE/AMERICAN
 I Japan; UK; USA
 I video;
 photography
 III Chicago:
 Museum of Contemporary Art
 \$140,000 in 2002, Red
 Light (photographs)

She is the creator of strange, technically immaculate cibachrome or video images, which project a fantasy world that is a cocktail of futuristic science fiction, retro, Barbie dolls, kitsch, fashion, realism, and West and East. Her

own extravagantly dressed image is central. She claims to be projecting an image of Utopia and the necessity of believing in utopias and optimism.

Can Utopia be so anodyne? This is not the vision of Utopia that sets out to reform the key moral, social, political, and environmental issues. It is the dream world of the global mega-shopper whose ambition is the latest "must have" brand. It is effective, but deeply narcissistic. **KEY WORKS** *Birth of a Star*, 1995 (Chicago: Museum of Contemporary Art); *Empty Dream*, 1995 (Chicago: Museum of Contemporary Art)

Chris Ofili

	Η
--	---

 Image: Weight of the state of the stat

Ofili produces largish-scale technically complex works – layers of paint, resin, glitter, and collage. Famously uses elephant dung in the painted surface, or under the picture as a support (the result of a trip to his cultural homeland, Zimbabwe, in 1992). Addresses issues of black identity and experience via cultural references to the Bible, jazz, and porn. Has potential, but as yet undeveloped. **KEY WORKS** *Monkey Magic*, 1995 (Los Angeles: Museum of Contemporary Art); *No Woman No Cry*, 1998 (London: Tate Collection)

KEY WORKS Forms Without Life, 1991 (London: Tate Collection); In and Out of Love, 1991

(London: Saatchi Gallery); *Prodigal Son*, 1994 (London: White Cube Gallery)

Matthew Barney

⊖ 1967 - P AMERICAN

USA 🚺 conceptual art; installations; video; multimedia 🖻 New York: Guggenheim Museum 🛿 \$350,000 in 1999, *Cremaster 4* (sculpture)

He is a former medical student, well known for creating events of interlinked film performances, installations, videos, and art books with a common narrative or theme. Attracted by the repellent – strange, nightmarish forms made from horrible synthetic materials, slime made from Vaseline, mutants padded with cushions, bizarrely made-up models, etc.

The underlying message is unclear: is he trying to make a meaningful comment on, or critique of, Western consumer society? Or, even if he is, is he merely pandering to that society's inherent voyeurism and narcissism – its love of looking at itself even (especially?) when it is particularly distorted, repellent, or violent? **KEY WORKS** Metabolism of the Hubris Pill, 1992 (Ghent: Stedelijk Museum voor Actuele Kunst); The Cremaster Cycle, 1994–2002 (New York: Guggenheim Museum); Transextualis and Repressia, 1996 (San Francisco: Museum of Modern Art) 478

Glossary

ABSTRACT ART (See p.358) Art that does not represent objects or people from the observable world. See Delaunay (p.354); Kandinsky (p.364); Kupka (p.353); Malevich (p.371); Miró (p.393); Mondrian (p.389); Pollock (p.410); Rothko (p.414); Stella (p.462)

ABSTRACT EXPRESSIONISM (See pp.412–413) The avant-garde art of the New York School, which flourished after World War II: big, challenging, personal, emotional, painterly, and influential. See Gorky (p.417); Kline (p.415); De Kooning (p.414); Newman (p.414); Pollock (p.410); Rothko (p.414); Still (p.416)

ABSTRACTION (See pp.358–359) The word used when talking about an artist whose work distils natural forms or appearances into simpler forms, but who stops short of creating abstract art. See Hepworth (p.400); Matisse (pp.344–345); Nicholson (p.400); Wols (p.420)

ABSTRACTION LYRIQUE The type of European painting of the 1940s and 1950s in which a loose and painterly abstraction was used to express subconscious fantasy. See Burri (p.424); Michaux (p.422); Tàpies (p.428); Wols (p.420)

ACADEMIC STYLE The highly polished, finely detailed style that was promoted by the conservative 19th-century academies. Most of it was worthy but boring. A lot of it was appallingly bad. Ingres was its supreme and brilliant master. See Bouguereau (p.285); Cabanel (p.285); Ingres (p.264); Leighton (p.287); Puvis de Chavannes (p.324)

ACADEMICISM The clever but laborious reworking of established models. Exists in every age.

ACADEMIES (See p.284) The official institutions set up in many European countries to organize and promote exhibitions, art education, and aesthetic rules and standards. See also Museum of modern art; Royal Academy

ACRYLIC Modern synthetic emulsion paint that combines some of the characteristics found in traditional oil paint (such as thick impasto) with some of those found in watercolours (such as transparent washes). Hockney has been particularly successful with acrylics (See p. 447).

ACTION PAINTING Painting produced by the emphatic physical activity of the artist: for instance, throwing paint or dripping it onto a canvas. Needs to be done on a large scale for maximum impact. Messiness and accidents are among its considered virtues. See Michaux (p.422); Pollock (p.410)

AERIAL PERSPECTIVE The illusion of receding space created by the use of warm colours (such as reds and oranges) in the foreground and cool colours (such as blues) in the distance. Pinturicchio was one of the first to combine linear, or geometric, perspective with aerial perspective. Leonardo was the first to study aerial perspective scientifically. See Cuyp (p.209); Lorrain, Claude (p.182); Pinturicchio (p.97); Turrer (p.281) AESTHETICISM, AESTHETIC MOVEMENT See Art for art's sake

AESTHETICS According to the *Oxford English Dictionary*: "The philosophy or theory of taste, or of the perception of the beautiful in nature."

AFTER ... "After Rembrandt" (or whoever) means a copy by someone other than Rembrandt of an actual work by Rembrandt, made at any date.

AIRBRUSH A tool that uses compressed air to spray paint. Can produce exceedingly fine gradations of colour, or a fine line. *See* Andrews (p.435)

ALLA PRIMA Painting onto a surface directly without any underpainting or preliminary working out of the design. *See* Titian (p.143)

ALLEGORY A work of art where symbols or symbolic messages are used to convey the "meaning" of the work. Thus it alludes to more than is apparent at first sight. The hidden meanings, symbols, and cross-references may not always be easy to follow, and may be deliberately obscure in the manner of a brain-teasing puzzle. Allegory and realism were combined with notable success by the Dutch 17thcentury masters, and by 19th-century realists such as Winslow Homer (See p.294).

ALTARPIECE The picture or sculpture made to go behind or on an altar and so enhance its part in the act of Christian worship. Many are now seen removed from this context, in the setting of the secular art gallery. Altarpieces are often designed to be seen from a kneeling position, so the perspective and design is worked out accordingly (to look at them properly you need to kneel before them, even in an art gallery).

ALTO RILIEVO See Relief

AMBIGUITY Something that can be understood or seen in more than one way is ambiguous. When carefully and knowingly used by an artist, it is a quality that has great value. The word is much used currently in descriptions or explanations of contemporary art, where occasionally it has a genuine meaning or expresses a genuine virtue. However, it often seems to be a coded signal that the writer finds the message from the artist so obscure, meaningless, or confused that it is virtually incomprehensible.

ANALYTICAL CUBISM (See p.350) The works of Picasso and Braque of c.1901–11 in which they fragmented form but still used conventional painting techniques. See Braque (p.351); Picasso (pp.396–397)

ANAMORPHIC A perspective trick. An object depicted in anamorphic perspective looks distorted and unrecognizable when seen from the front. This is because the viewpoint for it is placed exaggeratedly to one side, and only by looking at it from this point will the distortions correct themselves to produce a recognizable image. The best-known example of anamorphic perspective is the skull in the foreground of Holbein's *The Ambassadors*.

ANTIQUE, ANTIQUITY Terms used to describe the art of ancient Greece and Rome.

APOTHEOSIS Elevation to divine status. Senior Christian figures and monarchs who require flattery are usually the prime candidates for images of apotheosis.

APPLIED ART Works of art that are deemed to be useful and ornamental, rather than intellectual or spiritual – such as furniture, ceramics, wallpaper, tapestries, and metalwork.

APPROPRIATION ART Objects, images, or texts removed from their normal context and placed unchanged in a new one, thereby gaining (it is said) a new, highly charged significance. Often presented as a new, "cutting-edge" idea, it could also be said to be old hat – something artists have been doing since time immemorial – the caves of Lascaux being the first examples of appropriation art. *See* Polke (p.464)

AQUATINT A method of printmaking that produces soft, often grainy, gradations in tone. *See* Goya (pp.262–263)

ARA Associate of the Royal Academy, London. There are 30 at any one time. *See also* RA; Royal Academy

ARCHAISM Imitating early, often primitive, styles.

ARMORY SHOW The exhibition held in 1913 that introduced Modern art to the United States. So called because it was held in a famous army building in New York.

ARRICCIO The smooth layer of plaster onto which the design of a fresco is made.

ARS LONGA VITA BREVIS One of those semi-learned Latin phrases, more used historically than now, which is often said to mean "Art is long-lasting, but life is short." Actually it means "Life is short and art takes a long time to create."

ART BRUT Crude pictures and graffiti on walls made by untrained amateurs and psychotics. *See* Dubuffet (p.419)

ART DECO The popular and fashionable decorative style of the 1920s and 1930s. Cinema designers loved it – Radio City Music Hall, New York, for instance.

ART FOR ART'S SAKE (See p.322) The idea that art is not concerned with storytelling, morality, religion, spiritual or intellectual enlightenment, and suchlike, but only with its own aesthetic properties of colour, form, and so on. See Chase (p.316); Dewing (p.325); Whistler (p.321)

ART HISTORY An academic discipline that originated in the 19th century to discuss and analyze works of art in a historical context, and which now includes other fields such as feminism, political and socio-economic theories, and psychology. Can be profoundly revealing and illuminating, but can also kill a work of art stone dead when it fails to acknowledge that true art – that which engages the imaginative experience of mankind – transcends mere history and academic theorizing.

ART INFORMEL A type of European abstract painting of the 1940s and 1950s, which paralleled

Abstract Expressionism in the USA. Had some general visual similarities but lacked the scale, focus, and drive of American art. *See* Dubuffet (p.419); Michaux (p.422); Wols (p.420)

ART NOUVEAU (See p.338) The highly decorative style (called *Jugendstil* in Germany, Liberty or Floreale in Italy, and Modern or style moderne in Russia) that was at the forefront of fashion in the 1890s. See Beardsley (p.325); Denis (p.325); Ensor (p.366); Klimt (p.339); Modigliani (p.357); Schiele (p.360)

ARTE POVERA (*See* p.425) Describes the work of the group of Italian avant-garde 1960s artists with a strong political agenda who made *arte povera* (poor art) objects created from cheap and tacky materials. Kounellis, who was one of the leading proponents of *arte povera*, had a particular liking for sacking, blood, and marks made by flames and smoke. *See* Boetti (p.427); Kounellis (p.426); Merz (p.424)

ARTIST'S PROOF Limited-edition prints, exclusively for the artist's own use or sale. They are marked A/P and are not numbered.

ARTS COUNCIL OF GREAT BRITAIN Founded in 1945 to promote art. Government-funded but not government-controlled. Currently going through a difficult period (being pressured by the government) but fighting back.

ASHCAN SCHOOL (See p.380) Important group of late-l9th-century American painters and illustrators who believed that art should portray the day-to-day harsh realities of life and that artists should be seen to get their hands (and clothes) dirty. See Bellows (p.381); Glackens (p.380); Henri (p.380); Luks (p.380); Sloan (p.381)

ASSEMBLAGE A 3-D picture made from different everyday materials.

ATELIER French word for "studio".

ATELIER LIBRE A studio where you pay a fee for organized group sessions to paint from a model, but where there is no tuition. Important feature of the Parisian avant-garde in the late 19th century.

ATTRIBUTE Symbol associated with a figure that enables it, for example, to be identified as a particular saint or god; thus Juno always has a peacock, St. Catherine the wheel on which she was nearly martyred, and so on.

ATTRIBUTED TO ... "Attributed to Rembrandt" (or whoever) means that a work is probably by that artist, but there is still some doubt about how much of it was done by the master.

ATTRIBUTION An informed opinion as to the authorship of a work of art when there is no definite proof. *See also:* Attributed to ...; By ...; Follower of ...; Manner of ...; Studio of ...

AUREOLE Circle of light surrounding the head or body of a holy figure.

AUTOGRAPH A work of art believed to be entirely by a particular artist.

AUTOMATISM High-class doodling directed by the unconscious mind. Much in vogue with the Surrealists. *See* Ernst (p.369); Miró (p.393)

AVANT-GARDE Art that is so innovative as to be ahead of the mainstream art of its time and rejected as unacceptable by the official system and institutions. Most work that is currently called avantgarde by the official museum and gallery system is not – simply because once officialdom adopts it and blesses it, it becomes part of the mainstream. The heroic period of the modern avant-garde was 1880–1960.

"BAD PAINTING" Name for a small group of artists with no fixed agenda who created messily painted figurative images as a reaction against Minimal art and Conceptual art in the 1970s. They were well named! See Salle (p.470); Schnabel (p.469)

BALDACCHINO Italian word for "canopy". A fringed canopy in cloth or a structure in metal or stone that is fixed like a roof over an altar, a throne, or a holy object.

BAMBOCCIATA Small old-master painting (usually 17th century) of humble, peasant subject matter and street life. Named after a minor Dutch artist called Pieter van Laer (c.1592–1642), who worked in Rome and was nicknamed Bamboccio ("rag doll") because he was small and deformed.

BARBIZON SCHOOL (See p.305) Group of progressive mid-l9th-century French landscape painters who worked in and around the village called Barbizon in the forest of Fontainebleau, near Paris. See Corot (p.304); Rousseau, Théodore (p.304)

BAROQUE (See pp. 178–179) The dominant style of the 17th century. Look for: illusion, movement in space, drama, love of rich colour and materials; heaviness, seriousness, pomposity. See Bernini (pp. 173–175); Champaigne (p. 182); Cortona (p. 177); Rembrandt (pp. 200–201); Rubens (p. 191); Snvders (p. 190); Thornhill (p. 217)

BAS RELIEF See Relief

BAUHAUS (See p.386) Famous modern art school, opened in Germany in 1919 and closed by the Nazis in 1933. Highly influential in the fields of architecture and design. See Albers (p.388); Feininger (p.386); Kandinsky (p.364); Klee (p.387); Moholy-Nagy (p.386); Schlemmer (p.388)

BEAUX ARTS The fine arts.

BELLE PEINTURE Beautiful paint handling in the sense of a rather self-indulgent love of luscious paint, elegant brushstrokes, and a lively paint surface – perhaps at the expense of any other quality such as subject matter and observation.

BEN DAY Cheap, simple printing process invented in 1879 by Benjamin Day, a New York newspaper engraver. Uses patterns of dots that differ in density to create a half-tone image. Employed extensively in newspapers and magazines, and suitable for both black-and-white and colour. With a magnifying glass, the dot patterns are clearly visible. Se Lichtenstein (p.441) **BIEDERMEIER** The predominant style in Austria and Germany in the first half of the 19th century. Plain, bourgeois, modest, conservative, well made.

BINDER Material (such as oil) that holds particles of pigment together and so makes paint.

BIOMORPHIC FORMS Softly contoured organic (rather than geometric) forms used in abstract art. *See* Arp (p.368); Gorky (p.417); Miró (p.393)

BISTRE Brown pigment made from charred wood, used as ink or chalk. *See* Rembrandt (pp.200–201)

BITUMEN Rich brown tarry pigment. Looks wonderful when fresh but it is disastrous because it never dries and soon turns into a black, bubbly mess. *See* Géricault (p.269); Reynolds (p.239); Ryder (p.295)

BLAUE REITER, DER (THE BLUE RIDER)

(See p.365) Important avant-garde group of German Expressionists, based in Munich c.1911. Wanted to put spiritual values into art and used abstraction, simplification, and the power of colour as a means of doing this. See Kandinsky (p.364); Klee (p.387); Macke (p.365); Marc (p.365); Minter (p.364)

BLEED 1) What happens when one layer or area of colour seeps into another and changes it. 2) In printing, a picture or text that runs off the edge of the paper is said to bleed.

BLOOM Blue or white "film" that develops on badly stored oil paintings.

BLOOMSBURY GROUP (See p.379) The name of a group of English writers, artists, poets, and designers, who practised and promoted modern French art in the 1920s and 1930s. See Lewis, (Percy) Wyndham (p.376)

BLOT DRAWING Using deliberate or accidental stains or blots on a piece of paper to get the imagination going. *See* Cozens, Alexander (p.244); Leonardo (pp.132–133)

BODY ART Art that takes the body as its subject or object (or both). Refers to such use in performance art, contemporary sculpture, or video.

BODY COLOUR Watercolour mixed with opaque white.

BOLOGNESE SCHOOL (See p.166) Important 17th-century Italian school of artists based in and around Bologna, who successfully combined Classicism and theatricality. See Carracci (p.167); Domenichino (p.168); Guercino (p.172); Reni (p.166)

BOOK OF HOURS A prayer book used by laymen for private devotions. The hours refer to the times of day when prayers are said.

BOTTEGA The area of an old master's studio used by his apprentices.

BRÜCKE, DIE (THE BRIDGE) (See p.362) Important avant-garde group of German Expressionists based in Dresden,1905–13, with radical political and social views expressed through modern, urban, subject matter or landscapes and figures.

See Kirchner (p.362); Heckel (p.363); Nolde (p.362); Pechstein (p.363); Schmidt-Rottluff (p.363)

BRUSH Instrument for applying paint that has been in use since the early Stone Age.

BRUSHWORK A painter's individual handling of paint texture, especially oils. Can be very distinctive – thin, thick, flat, juicy, rough, and so on – and a major element in an artist's style. Or can be virtually anonymous, even mechanical and boring. *See* Ingres – anonymous (p.264); Rembrandt – interesting (pp.200–201)

BUCRANIUM (PL. BUCRANIA) Decorative motif featuring the horned head or skull of an ox.

BUON FRESCO True fresco – the real thing, painting into wet plaster. See also Fresco; Mezzo fresco

BURIN The main tool used in engraving. You push it like a chisel and it ploughs out a line on the metal or wooden surface.

BURR When you engrave a line with a burin, like a plough it leaves a ridge of dug-out material (burr) on either side of the furrow. If this is retained, the printed line has an extra rich, soft quality, though the burr soon wears away.

BY ... One of the shortest but most important words in the commercial and academic art world. The description "by Rembrandt" (or any other master) means that there is definite proof (or, at least, substantial evidence) that the artist painted it. *See also* Attribution

BYZANTINE ART The artistic tradition that flourished in Byzantium (Constantinople), the capital of the Eastern Roman Empire from c.330 CE to the mid-15th century. Notable for stylized depictions of Christianity and Imperial Rome in mosaics, freescoes, and relief sculpture.

CADMIUM The metal cadmium was discovered in the early 19th century and from then on new cadmium pigments (yellow, orange, and red) were produced. Popular because it was cheap and durable.

CALLIGRAPHY The art of fine handwriting.

CAMDEN TOWN GROUP Small, progressive group of English painters who lived and worked in Camden Town, London, 1911–14. They were influenced by the Post-Impressionists.

CAMERA LUCIDA Latin for "light chamber". A machine for drawing and copying that uses a prism and gives the illusion of seeing a real object as if it were on a piece of paper.

CAMERA OBSCURA Latin for "dark chamber". A box-like device that projects an image through a small hole or lens onto a sheet of paper or other material so that its outline can be traced. Same principle as a simple photographic camera. *See* Canaletto (p.235); Vermeer (p.213)

CANVAS The material on which most largish pictures are painted. Inexpensive, flexible, durable, shapeable. In common use by 1500. Linen is the traditional material; cotton duck has been used widely since 1945.

CAPRICCIO A fantasy townscape combining both real and imaginary buildings. Used to good advantage by decorative 18th-century artists such as Panini. See Canaletto (p.235); Guardi (p.236); Van der Heyden (p.210); Panini (p.234)

CARAVAGGISTI Followers of Caravaggio (See pp.170–171), from all over Europe, who were influenced by his subjects, realism, and dramatic lighting. See Gentileschi (p.169); Zurbarán (p.185)

CARICATURE An exaggerated, ludicrous, or satirical portrait. *See* Carracci (p.167); Daumier (p.307); Hogarth (p.238)

CARMINE A red pigment that is ostensibly good for flesh tones, but has the fatal disadvantage of rapidly losing its colour, which is why some of Reynolds's sitters look like white-faced ghosts (*See* p.239).

CAROLINGIAN ART Produced in Europe in the 8th and 9th centuries during the reign of Charlemagne (800–14) and his successors.

CARTOON A full-size drawing that is used as the design for a painting or tapestry. *Se* Leonardo (pp.132–133); Michelangelo (p.136); Raphael (p.134)

CASEIN Strong adhesive made from curd (milk).

CASSONE Elaborately decorated Italian Renaissance marriage chest, sometimes with lid(s) and sides painted by leading artists.

CATALOGUE RAISONNÉ A complete, annotated, and scholarly catalogue of all known and attributed works by an artist.

CHALK Soft, fine, grained rock used for drawing. The white variety is processed from calcium carbonate, the black from carbonaceous shale, and the red (sanguine) from haematite (iron ore).

CHARCOAL Charred twigs or sticks used for drawing.

CHIAROSCURO Pronounced contrast between brightness and darkness. From the Italian *chiaro* (bright), *ascuro* (dark). *See* Bol (p:202); Caravaggio (pp.170–171); La Tour (p.184); Rembrandt (pp.200–201); Ribera (p.185); Zurbarán (p.185)

CHINESE WHITE White pigment with the same chemical components as zinc white but less transparent.

CHINOISERIE Works of art reflecting a fanciful idea of China. Especially in vogue in Europe from the late-17th to the mid-18th centuries.

CIBACHROME A colour print made from a slide. Usually large scale and with high definition and clarity. *See* Wall (p.468)

CINQUECENTO Italian for "16th century" (1500–99).

CIRCLE OF ... "Circle of Rembrandt" (or whoever) means a work done in the artist's time and showing his influence.

CIRE PERDUE See Lost wax

CLAIR-OBSCUR French term for *chiaroscuro*. See Chiaroscuro

CLASSIC Much used and abused word. Sometimes it means logical, symmetrical, well established, archetypal; sometimes it means the moment of highest achievement by an artist or of a general style. Not an alternative word for Classical.

CLASSICAL Belonging to, or deriving from, ancient Greece and Rome.

CLAUDE GLASS A small, portable, dark, convex mirror. Hold it up to a real landscape and you get a miniaturized, subtle, coloured version of it that looks a bit like a painting by Claude. See Lorrain, Claude (p. 182)

CLEANING See Restoration

CLICHÉ VERRE (OR GLASS PRINT) A cross between photography, printmaking, and etching. You draw the design on a glass plate and print it onto light-sensitive paper. See Corot (p.304); Millet (p.305); Rousseau, Théodore (p.304)

CLOISONISM From the French *claison*, meaning "partition". A style of painting in which areas of pure colour are surrounded by narrow bands of black or grey. Looks like *claisomé* enamel decoration of metals. Although Gauguin took the credit for inventing the style, and most fully realized its possibilities, it was Emile Bernard (p.532); Gauguin (p.329)

CoBrA (See p.418) A group of post-World War II European avant-garde artists known for colourful, expressive, abstract work. So called because of the initial letters of their native cities: Copenhagen, Brussels, Amsterdam. See Alechinsky (p.419); Appel (p.418); Jorn (p.418)

COGNOSCENTI From the Italian *conoscere*, "to know". Those who have inside knowledge.

COLL. From the collection of the person or organization named.

COLLAGE Photographs, bits of newspaper, magazines, wallpaper, and so on, pasted down, and sometimes painted around and over. An art form much used by the Cubists. *See* Braque (p.351); Picasso (pp.396–397); Rodchenko (p.373); Schwitters (p.368)

COLOUR FIELD PAINTING A type of Abstract Expressionism painting whose principal feature is a large expanse of colour with no obvious point of focus or attention. *See also* Abstract Expressionism. *See* Newman (p.414); Rothko (p.414)

COLOUR WHEEL A circular diagram showing the relationships between primary, secondary, tertiary, and complementary colours. An indispensable tool for anyone working with colour. **COMMERCIAL ART** Art commissioned exclusively for commercial purposes, such as advertising or packaging.

COMPLEMENTARY COLOURS Each primary colour – red, yellow, blue – has its own, exclusive, complementary colour – green, purple, orange. These are made by mixing the other two primaries. When the corresponding pair of primary and complementary colours are placed side by side, they cause an optical vibration in the eye and activate each other.

COMPOSITION The arrangement of the shapes and areas of a picture, considered as surface pattern only.

COMPUTER ART Works of art made with the aid of a computer. *See* Paik (p.458)

CONCEPTUAL ART Works of art where the only thing that matters is the idea or concept. No value or merit is awarded in materials or to physical or technical skill. The problem for many people is that the ideas and concepts offered often seem utterly banal, and the works appear to have no visual or aesthetic interest. Came into fashion in the late 1960s; still very much the thing for many official art establishments and museum curators. *See* Beuys (p.453); Duchamp (p.367); Gonzalez-Torres (p.474); Hesse (p.460)

CONNOISSEURSHIP Knowledge, understanding, and appreciation of works of art, with emphasis on visual and aesthetic qualities.

CONSERVATION Creating the environment in which a work of art is properly looked after, without undue interference, and without the need to restore and repair. Not to be confused with restoration.

CONSTRUCTIVISM (See p.372) Very important avant-garde movement (1917–21) concerned with abstraction, space, new materials, 3-D form, and social reform. See Gabo (p.372); Pevsner (p.372); Tatlin (p.373)

CONTÉ A French brand of chalk or crayon, named after Nicolas-Jacques Conté (1755–1805), the scientist who invented it. Seurat used black conté crayon on rough, grainy paper to create exquisite small-scale drawings, which show simplified forms and subtle gradations of tone.

CONTEMPORARY ART Usually taken to mean works of art produced since 1960.

CONTEXT ART Art that criticizes the commercial activities and institutions of the art world with a view to investigating or revealing its political machinations and manipulations.

CONTRAPPOSTO From the Italian *contrappore*, meaning "to oppose". A pose in which the body below the hips is twisted in the opposite direction from the body above the hips.

CONTRE-JOUR "Against the light" – looking at things that are strongly lit from behind, and so almost silhouetted. Bingham's *Fur Traders* is a masterpiece of *contre-jour*, reflection, and bathed light.

CONVERSATION PIECE A group portrait set in a room or a garden showing polite conversation or a related activity such as a tea party. *See* Devis (p.239); Hogarth (p.238); Zoffany (p.241)

COPY An imitation of an original. May be honest, may be a forgery. *See also* Forgery

C-PRINT Colour print made from a colour negative.

COULISSE A compositional device (*en coulisse* is French for "in the wings") in which rocks, trees, and so on are placed at the sides of a painting to lead the eye into the centre.

CRAQUELURE The network of cracks that can develop on the surface of old oil paintings.

CRAYONS Chalks mixed with oil or wax.

CROSS HATCHING Criss-crossing parallel lines, which can be varied to create tone.

CUBISM (See p.350) The most significant art and design innovation of the 20th century, Cubism overturned conventional systems of perspective and ways of perceiving form. See Braque (p.351); Gris (p.351); Léger (p.3522; Picasso (pp.396–397)

CURATOR Someone who organizes an exhibition, sets the agenda for it, and chooses the participating artists.

DADA (See p.367) The first of the modern anti-art movements. Deliberately used the absurd, banal, offensive, and tatty to shock and to challenge all existing ideas about art, life, and society. Originated in New York in 1915, and in Zurich in 1916. See Arp (p.368); Duchamp (p.367); Ernst (p.369); Man Ray (p.394); Picabia (p.367)

DANUBE SCHOOL The group of painters from middle Europe who developed landscape painting in the early 16th century. See Altdorfer (p.158); Cranach (p.125)

DEACCESSION A work of art that has been catalogued as part of a collection needs a formal act of deaccession to undo the formality of officially cataloguing it. Whether or not museums should have the power to deaccession is a subject of hot debate.

DECALCOMANIA Technique in which paint is splashed onto paper with a big brush and covered while still wet with another sheet of paper before the two are rubbed together. The result is a pattern that looks like a weird, fantastic forest or jungle. Used by the Surrealists as a means of harnessing accidents to create spontaneous, unpreconceived subjects and forms. See Ernst (p.369)

DECONSTRUCTION The currently fashionable idea that the true meaning of a work of art is found, not by examining what an artist professed to mean or tried to say, but by analyzing the way he or she expressed it.

DECORATIVE ARTS See Applied art

DEGENERATE ART ("ENTARTETE KUNST") (See p.384) The Nazi term for any art they believed to be the product of degenerate human beings and perverted minds and which did not conform to a bourgeois ideal of well-crafted, figurative images portraying heroism or comfortable day-to-day living, .

DE GUSTIBUS NON EST DISPUTANDUM

Latin maxim meaning "There is no accounting for taste."

DEL., DELIN. Found on prints after an artist's name. Means the artist drew the design, but that the print may have been made by someone else.

DEVICE An emblem or motto that an artist or printmaker uses instead of a signature. *See* Whistler – butterfly device (p.321)

DIDACTIC Consciously teaching or instructing.

DIFFICULTY All major works of art are difficult in that they require time and effort, and test the perception, intellect, and emotions of both creator and viewer. However, it does not follow, as some commentators seem to think, that because something is difficult to unravel or understand it is therefore a major work of art.

DIGITAL ART Art that uses computers and the Internet. *See* Paik (p.458)

DILETTANTE Today a disparaging word to describe someone with a superficial and unserious interest in the arts. But in the 18th century it was used as a word of praise, denoting a deep and profound interest and pleasure not just in the visual arts but in the whole richness of human possibility.

DIORAMA A peepshow with artistic pretensions. Can be the size of a small box or a large building.

DIPTYCH A picture made in two parts. An altarpiece that is a diptych usually has the two parts hinged together.

DISEGNO Italian term covering both drawing and design. Skill in *disegno* was very highly valued in the Renaissance. See Michelangelo (p.136); Raphael (p.134)

DISTEMPER Powdered colours mixed with size; impermanent. Used by scene painters in the theatre. Old paintings in distemper have a very dark and dusty appearance.

DISTRESSED Smart way of saying "in poor condition".

DIVISIONISM (*See* p.320) A way of painting in which colour effects are obtained optically rather than by mixing colours on the palette. Securat was the originator of Divisionism but died young, so Signac became its chief promulgator. *See* Pissarro (p.314); Securat (p.320); Signac (p.320)

DONOR Somebody who commissions a work of art and gives it to an institution (such as a church). In the Renaissance, the image of the donor was often included in the picture.

DRAGGING Paint pulled across a surface in an uneven way so that the underneath layer of paint shows through.

DRAPERY MAN (DRAPERY PAINTER) A studio assistant who painted the unimportant bits of drapery.

DRAUGHTSMAN Someone who draws, but you have to do it very well to deserve the name.

DRY BRUSH A technique whereby a watercolour brush is squeezed almost dry, to produce a fine, opaque line. *See* Dürer (pp.126–127); Wyeth (p.439)

DRY POINT A type of print technique. A metal plate is scratched with a sharp point, producing a burr. Often used to add extra touches to etching and engraving. *See also* Burr. *See* Rembrandt (pp.200–201)

DUCK A type of canvas, usually made of cotton.

EARTH ART See Land art

EARTH COLOURS Pigments such as ochre and umber made from earth.

EASEL PICTURE A picture of a size to fit on and be painted at an easel in a studio – so in practice not much taller than two metres (6 ft 4 in).

ECLECTIC Borrowing freely from a wide variety of sources. *See* Carracci (p.167)

ÉCORCHÉ French for "flayed". A drawing or model that shows a human or animal body without its skin.

EDITION All the impressions made from a single printing plate and issued at the same time.

EIGHT, THE Important group of eight avant-garde American artists (Arthur Davies, William Glackens, Robert Henri, Ernest Lawson, George Luks, Maurice Prendergast, Everett Shinn, and John Sloan) formed in 1907 for a New York exhibition and which gained notoriety. Some were part of the Ashcan School; some were colourfully modern. See also Ashcan School. See Glackens (p.380); Henri (p.380); Luks (p.380); Sloan (p.381)

ELEVATION View of a building from one vantage point.

EMBLEM 1) An object symbolizing or suggesting another object. 2) A picture, possibly with a motto or set of verses, that spells out a message of moral instruction. Very popular in 17th-century Holland.

EMPATHY Transferring your feelings and personality onto a person or a work of art.

EMPIRE STYLE Grand imperial decorative style that started in Paris and spread throughout Europe. The style of choice in Napoleon's era, it consisted of hyped-up Neo-Classicism with the addition of other motifs, often Egyptian. Sometimes called Regency in England.

EMULSION A medium containing materials that will not mix naturally – such as oil and water – but which are made to do so by adding an emulsifying agent. Egg yolk is such an agent; tempera is an emulsion. See also Tempera **ENCAUSTIC** Pigments mixed with molten wax and fused to a surface. Much used by the ancient Greeks. Has had a recent revival. *See* Johns (p.442); Marden (p.461)

ENGRAVING Print technique. A sharp V-shaped tool is pushed across a metal plate producing precise, clear-cut lines. Widely used since the early Renaissance. Dürer's incomparable engraving technique strongly influenced young Aubrey Beardsley, who loved the dramatic and erotic qualities of bold black-and-white illustrations. *See* Beardsley (p.325): Dürer (pp. 126–127)

ENLIGHTENMENT (THE) In the mid-18th century, upholders of The Enlightenment believed that human reason could (and would) solve most problems and create heaven on earth. Also known as the Age of Reason (pp.218–221)

ENTARTETE KUNST See Degenerate art

ENVIRONMENT ART Creating an environment (such as a room, but can be outside) so that the presence of the visitor in it becomes an integral part of the experience or event. Early works tended to bombard onlookers with light, sound, smell, and touch, so they had to react. Developed in the 1960s. See also Installation.

ESQUISSE French word for "sketch".

ETCHING Print technique widely used since the 17th century. The line is first drawn by hand, then acid is used to make the line eat into the metal plate. It produces a delicate free-flowing line with a soft outline. Picasso's *The Vollard Suite* is arguably the greatest achievement in all 20th-century etching. *See* Picasso (pp.396–397); Rembrandt (p.200); Whistler (p.321)

EUSTON ROAD SCHOOL English group founded in the 1930s who promoted realism à la Cézanne. See Pasmore (p.430)

EX-VOTO Latin: "from a vow". A work of art made as an offering to a god, usually to ask a favour or as a thank you for a prayer answered.

EXC., EXCUDIT Latin for "he executed it". Found on prints, identifying the engraver or publisher.

EXISTENTIALISM The fashionable philosophy among the Western intellectual clite in the immediate postwar period. Says, in essence, that individuals are only responsible to themselves and therefore they are free, even obliged, to express themselves as personally and individually as possible. Very influential with avant-garde artists and writers of the time. *See* Pollock (pp.410–411)

EXPRESSIONISM (See pp.358–359) Style conveying heightened sensibility through distortion of colour, drawing, space, scale, form, or intense subject matter, or a combination of these. One of the principal strands of 20th-century German art. See also Blaue Reiter, Der; Brücke, Die

EYE LEVEL Everything we see is at, above, or below eye level. When looking at a figurative picture this needs to be worked out in order to read the objects and space relationships correctly.

FACTURE See Handling

FAKE A work of art deliberately made or altered so as to appear to be better, older, or other than what it, in fact, is. See also Forgery

FANCY PICTURE English 18th-century pictures of a single figure, or a group of figures, in an open-air setting doing nothing very much other than looking sweet, appealing, and picturesque. See Gainsborough (p.240)

FAUVES, LES (See p.346) French avant-garde movement, which originated in 1905. One of the key early movements in Modern art. Decorative and expressive works full of bright colour and flat patterns, loosely painted. Fauve is the French word for "wild beast". See Braque (p.351); Derain (p.347); Dufy (p.353); Matisse (pp.344–345); Vlaminck (p.346)

FEC., FECIT., F. Latin for "he/she made it". Sometimes accompanies an artist's signature, as a sort of double declaration of authenticity.

FÊTE CHAMPÊTRE French for "outdoor feast". A group of elegant ladies and gents having a relaxed and happy time in a landscape setting and evidently absorbed with each other, love, and music. Much in vogue in 18th-century France. Also sometimes referred to as *fet galante. See* Lancret (p.224); Pater (p.224); Watteau (pp.222–223)

FIGURATIVE ART Art that represents recognizable nature and objects. The opposite of abstract art.

FIGURE The human form.

FIN DE SIÈCLE Refers to the jaded, decadent attitudes in vogue at the end of the 19th century.

FINE ARTS Painting, sculpture, and architecture.

FINISH A work of art that is executed in meticulous detail is called "highly finished". See Ingres (p.264)

FIXATIVE A transparent spray that fixes chalks, charcoal, and pastel to paper, and stops them smudging and rubbing.

FL., FLOREAT Latin for "he/she flourished". If the actual birth and death dates of an artist are not known, it is customary to give the dates when he or she was known to be working (i.e. flourished). Same as "active".

FLUXUS (See p.423) International group of artists set up in Germany in 1962. Promoted "happenings" with spectator participation. Opposed to anything that smacked of tradition or professionalism. See Beuys (p.453)

FOLLOWER OF ... Somebody working in the style of a particular artist, but not necessarily a pupil or assistant. See also Attribution; Manner of ...

FORESHORTENING A perspective trick. An extreme example is a painting that gives the illusion of an arm pointing directly at the spectator; in fact only the hand is shown, the arm being hidden behind the hand. See Caravaggio (pp.170–171); Lanfranco (p.168); Mantegna (p.107); Masaccio (p.88); Sebastiano del Piombo (p.135); Uccello (p.92)

FORGERY Something made in fraudulent imitation of another thing already existing. See also Fake

FORM The shape, size, movement, texture, colour, and tone of an object.

FOUND OBJECT See Objet trouvé

FRENCH REVOLUTION 1789 – a key date. The most important political event of the 18th century and a watershed for the arts, as for so much else in European history.

FRESCO Italian for "fresh". Painting on the wet plaster of a wall so that when it dries, the painting is the plaster. This has to be done rapidly and with absolute certainty, as there is no possibility for corrections other than hacking off the plaster and starting again. Michelangelo's ceiling in the Sistine Chapel is fresco painting at its most magnificent. *See also* Buon fresco; Mezzo fresco

FROTTAGE From the French footter, "to rub". Making an impression of a textured surface by placing a piece of thin material over it and rubbing it with something like a wax crayon. Used by the Surrealists to stimulate ideas and painting. See Ernst (p.369)

FUTURISM (See p.375) One of the most important early avant-garde art movements. Originated in Italy 1909–15 and was widely influential. Noisily promoted a worship of machinery, speed, modernity, and revolutionary change, using the latest avant-garde styles such as Cubism. See Balla (p.374); Boccioni (p.374); Lewis, (Percy) Wyndham (p.376); Severini (p.375)

GAMBOGE A rich golden-yellow pigment.

GENDER SURFING Mixing up sexual roles in order to entertain and amuse.

GENRE A particular category of subject matter – such as portrait, landscape, marine, or history painting.

GENRE PAINTING A type of picture that purports to show a reassuring glimpse of everyday life. Usually small scale and intimate. Invented in 17th-century Holland and much in vogue in other prosperous bourgeois circles, such as 18th-century France, Biedermeier Germany, and 19th-century Britain. The French artist James Tissot was deservedly successful in 1870s Victorian London. See Chardin (p.224); Greuze (p.224); Hooch (p.211); Maes (p.208); Terborch (p.210); Tissot (p.302); Vermeer (p.213); Wilkie (p.280)

GEORGIAN A vague term much loved by estate agents and antique dealers meaning anything British, of the 18th and early 19th centuries, and therefore desirable – all British monarchs between 1714 and 1830 were called George, from George I to George IV.

GESAMTKUNSTWERK Untranslateable German word meaning "total work of art". The idea is the creation of a totality in which architects, painters, sculptors, writers, musicians, poets, and so on, all make an equal contribution so that the whole is greater than the sum of the individual parts. Wagner was enthused by the idea – but with himself as the creative controlling genius.

GESSO A white absorbent ground for painting in tempera or oil. Made from chalk or gypsum mixed with glue.

GESTALT A one-word way of saying that the mind tries to turn chaos into order. It organizes what it perceives and senses, and tends to make the final result greater than the sum of the individual parts.

GESTURE PAINTING See Action painting

GILDING Covering a surface with gold leaf.

GLASS PRINT See Cliché verre

GLAZING 1) Old-master technique of covering a layer of already-dried oil paint with a transparent layer of a different colour. One of the reasons for the rich, resonant, and subtle colour effects in old masters. A very strong, durable technique. 2) Putting glass, in a frame, over a picture to protect it.

GOLDEN SECTION A mathematical proportion thought to be very beautiful. Take a line AB and divide it by C so that the ratio AC : CB = AB : AC. In practice it works out at approximately 8 : 13. Widely used. *See* Poussin (pp.180–181)

GOTHIC The principal European style in the arts (and especially architecture) before the Renaissance, from the 12th to 15th centuries. Characterized by the soaring vertical and pointed arch. The underlying message is spiritual uplift and devotion.

GOTHIC REVIVAL The reawakened interest in medieval art in the 18th and 19th centuries. Called by the French *style troubadour*.

GOUACHE Opaque watercolour: Ideal for Jacob Lawrence who wanted to work on a small scale with spare, lean, and intense colours. See Calder (p.438); Lawrence (p.409); Lewis, John Frederick (p.288); Matisse (pp.344–345); Watteau (pp.222–223)

GRAFFITO Strictly speaking, "graffito" (or "sgraffito") describes any design scratched through a layer of paint or other material, to reveal a different ground underneath. The plural "graffiti" now describes unauthorized designs or words which are painted, sprayed, scratched, or scribbled onto walls or other publicly visible surfaces, sometimes by political activists, sometimes by vandals, and sometimes by those with highly sophisticated artistic and graphic skills. *See* Basquiat (p.475); Dubuffer (p.420)

GRAND MANNER An ambitious type of painting that promotes the idea of heroic characters and events, and resonates with implications of history, authority, and greatness. History painting and portraiture are the usual subjects. Showy, eloquent, and rhetorical; at its best convinces by overwhelming, at its worst looks insincere, artificial, and ludicrous. Reynolds fervently believed in the merits of grand manner painting. He succeeded with it in his portraits, but failed spectacularly when it came to history painting. See Copley (p.256); Kitaj (p.432); Reynolds (p.239); Sargent (p.326); Stuart (p.257)

GRAND TOUR (See p.234) Once-in-a-lifetime tour around Europe to see the major sights and works of art, and to experience life – very much the done thing in the 18th and 19th centuries.

GRAPHIC ART Art primarily dependent on the use of line, not colour, such as drawing, illustration, engraving, and printmaking.

GRISAILLE A painting made with different greys and no colours.

GROTESQUE Decorative design incorporating fanciful human, animal, and plant features. The inspiration was the designs found in excavated crypts of grottoes (hence the name) in Rome in the early 16th century, notably the Golden House of Nero. In the 18th century the word came to mean something ridiculous and unnatural. See Raphael (p.134)

GROUND 1) The final, prepared surface of a support, which will be painted on. 2) Also the name of the substance used for such preparation. The purpose of the ground is to create a smooth surface with a sympathetic texture for the artist to paint on, and which also isolates the paint from the support. A ground can be of any colour. The old masters traditionally used a middle tone so that they could paint brighter than the ground for highlights, and darker for shadows. Since Impressionism, grounds are usually white to make colours as bright as possible. *See also* Primer; Sinking in; Support

GUILD Medieval organization that trained and protected its members. Painters often belonged to the Guild of St. Luke (he was the patron saint of painters). The High Renaissance masters despised them, and the academies took over their role. See also Academies

GUM ARABIC Binder used for watercolours – the gum comes from certain varieties of acacia tree.

HALF-TONE Any tone or shade that lies between the extremes of light and dark.

HALO Circle endowed with divine light surrounding the head of a holy person.

HANDLING The way a medium – such as paint, clay, or charcoal – is used and manipulated. All artists have their own individual way of handling their material, which is as personal as handwriting.

HAPPENING "Artistic" event, supposedly spontaneous, similar to a theatrical performance and presented as a work of art. Typical 1960s phenomenon. See also Fluxus. See Beuys (p.453); Dine (p.439); Klein (p.422); Oldenburg (p.439); Rauschenberg (p.437)

HARDBOARD Compressed fibreboard – a cheap alternative to canvas or panels. Called masonite in the USA.

HARD-EDGE PAINTING Abstract painting using solid areas of colour with clear, sharp outlines. See Kelly (p.438); Morris, Robert (p.457); Noland (p.454); Riley (p.436)

 \triangleright

HATCHING Parallel lines placed side by side in differing densities, used in drawing to create tone and shadow.

HELLENISTIC Greek and Greek-influenced art of the 4th century to the 1st century BCE (sometimes identified as the period from the death of Alexander the Great in 323 BCE to the defeat of Antony and Cleopatra at Actium in 31 BCE).

HERM Figure with a bearded head on a column tapering from top to bottom, sometimes with a big phallus. Named after the Greek god Hermes.

HIERATIC From the Greek for "priestly". 1) Stylized conventional portrayal of a religious figure. 2) Cursive form of hieroglyphic script used by the priests in ancient Egypt.

HIGH ART Every age proposes certain subjects or styles (or both) as its own appropriate and acceptable high art – art that is very seriously intentioned and aims to express a profound intellectual and spiritual meaning. In the 18th century this was history painting; in the 18th century, landscape painting; in the early 20th century, abstract art; in the late 20th century, Conceptual art. Whether or not the aim is achieved is another matter – sometimes the individual results never rise above banality. *See also* Conceptual art; Grand manner

HIGH RELIEF See Relief

HISTORICISM An obsessive interest in the past, often adopted by those unable to face the present, let alone the future.

HISTORY Our relationship with the past is constantly changing. It is only recently that we have characterized the past as a series of separate epochs, removed from the present, each with its own unique values. Thus we now go to great lengths to preserve the past as a relic and call it a national heritage. Nowadays we worship old art, antiques, and memorabilia, and officially approve of "modern" types and styles of art that look consciously different from the art of the past. In earlier times there was perceived to be a continuum between past and present, which made history, mythology, and antiquity part of the here and now.

HISTORY PAINTING Subjects of classical mythology, history, and biblical themes. Until the end of the 19th century, any seriously ambitious painter had to succeed as a history painter or settle as an also-ran. See also Grand manner; High art. See David (p.252); Moreau (p.324); Poussin (pp.180–181); Reynolds (p.239); West (p.256)

HOLOGRAM, HOLOGRAPH A 3-D image produced by a complex process of light from a laser striking a special photographic image. Clever, but is it any more impressive than using paint to create the illusion of space or movement on a static flat surface?

HORIZON LINE The horizontal line across a picture that is at the artist's eye level.

HUDSON RIVER SCHOOL (See p.290) Loosely organized group of American painters who established a new tradition for landscape painting in the USA. See Bierstadt (p.292); Church (p.290); Cole (p.290); Moran (p.292)

HUE Commonly described as colour. Normal vision can differentiate between approximately 10 million different hues.

ICON 1) A sacred image – especially the images of Christ, the Virgin, and the saints produced for the Greek and Russian Orthodox churches. 2) A highly influential and widely admired cultural image.

ICONOCLASM The destruction of images – either literally or metaphorically.

ICONOGRAPHY The language of images or language created by images – especially symbols, allegory, and so on.

ICONOLOGY The study or interpretation of iconography.

IDEAL That physical, intellectual, or emotional perfection which humans can never achieve. It can only be imagined or aspired to, but art can represent it. See Raphael (p.134)

ILLUMINATED MANUSCRIPT A handwritten text decorated with paintings and ornaments.

ILLUMINATION (*See* p.77) The embellishment of a written text with gold, silver, or colour.

ILLUSIONISM Deceiving the eye into believing that what is painted is real.

IMITATOR OF ... See also Manner of ...

IMP. Latin for "he has printed it". Appears on prints, together with the name of the printer or publisher.

IMPASTO Oil paint thickly applied (think of toothpaste). *See* Auerbach (p.432); Rembrandt (pp.200–201); Van Gogh (pp.330–331)

IMPRESSION A print made by pressing a plate or block onto a piece of paper.

IMPRESSIONISM (See pp.312–313) The famous progressive movement that started the dethronement of Academic art. The Impressionists went back to nature with the intention of painting only what the eye could see and created small-scale works of contemporary scenes, landscapes freely and directly painted en plein air (outdoors), portrait, and still lifes. See Caillebotte (p.311); Cezanne (pp.334–335); Degas (p.315); Manet (p.307); Monet (p.310); Morisot (p.314); Pissarro (p.314); Renoir (p.311); Sisley (p.314)

IMPRIMATURA A type of coloured primer applied over a white background.

INCUNABULA Books printed before 1500, generally illustrated with woodcuts.

INDIGO A dark blue vegetable dye or colour made from a tropical plant of the pea family.

INDIAN INK Black ink made with carbon particles. So-called because it was originally imported from India.

INSTALLATION A work of art that integrates the exhibition space into its content. Currently the most pervasive form of official or museum art – probably for administrative and economic reasons as much as for artistic ones. The new museums of contemporary art usually have vast spaces to fill. It is much more economical and labour-saving for them to fill each space with one huge installation (particularly if you can persuade artists to set it up themselves) than to employ an army of people to hang, arrange (and keep a security check on) dozens of small-scale objects. *See* Barney (p.477); Bourgeois (p.452); Chicago (p.462); Gober (p.472); Hirst (p.476); Muñoz (p.429); Whiteread (p.476)

INTAGLIO A design that is cut into a surface such as metal, jewel, or stone.

INTENSITY The strength or brightness of a colour.

INTERNATIONAL GOTHIC A style of painting in favour in the late 14th and early 15th centuries. Colourful, very decorative, and rather artificial, with lots of realistic detail in costumes, animals, and landscapes. It often depicts court life. *See* p.74; Gentile da Fabriano (p.83); Limbourg brothers (p.77); Pisanello (p.84); Sassetta (p.83)

INTIMISME Small-scale, Impressionist-style pictures showing domestic interior scenes. See Bonnard (p.336); Vuillard (p.336)

IN., INV., INVENIT Latin for "he created, designed, invented it". Found on prints, together with the name of the artist who made the original design.

IRONY To convey a meaning by expressing the opposite. It is a term much used currently when commenting on contemporary art. As with "ambiguity", it is often a way of masking the fact that the commentator may have no idea about what the artist is trying to say. See also Ambiguity

"ISM" Shorthand way of referring to a succession of artistic movements from the late 19th century onwards – Impressionism, Fauvism, Cubism, Surrealism, Expressionism, and so on.

ISOMETRIC DRAWING Technical drawing that keeps the scale of height, width, and depth constant, and does not use perspective.

ITALIANATE Strictly speaking, a work of art that recalls the Italian Renaissance, but sometimes used to describe a work with an Italian character, especially a golden light. The Dutch artist Jan Both (*See* p.212) studied in Rome and introduced the arcadian Italianate landscape to Holland.

JACOBEAN Works of art produced in England during the reign of James 1 (1603–25), and works in that style.

JAPONISM (See p.322) The influence of Japanese art on Western art. See Cassatt (p.316); Dewing (p.325); Gauguin (p.329); Tobey (p.410); Vallotton (p.332); Whistler (p.321)

JOURNEYMAN From the French *journée* (day). Someone employed to work by the day – perhaps a skilled worker who has completed his apprenticeship but is not yet a master craftsman.

JUGENDSTIL See Art Nouveau

KAOLIN Fine white clay used for making porcelain.

KEY A painting is in a high key if the colours are predominantly bright and light, and in a low key if dark and sombre. Like major and minor keys in music.

KINETIC ART Works of art with moving parts. See Calder (p.438); Gabo (p.372)

KITCHEN SINK SCHOOL Group of British artists active in the 1950s, whose subjects were slummy interiors.

KITSCH Mass-produced, decorative, popular, cheap knick-knacks, which are widely bought and condescendingly dismissed by the well educated as in bad taste, sentimental, rubbish. Art that has such characteristics or is deliberately "vulgar" or "trashy".

LACQUER Varnish made from natural resins. Tends to go yellow with age. Modern synthetic equivalents are also commonly referred to as lacquer.

LAND ART Fashioning land into a work of art. Cannot be exhibited in a museum or gallery, but photographs of Land art projects are shown. Developed in the late 1960s. See Long (p.468); Smithson (p.462); Turrell (p.465)

LANDSCAPE A painting in which natural scenery is the principal subject and the motivating idea. Began to come into its own in the 17th century, and by the end of the 19th century replaced history painting as the main aim of any ambitious young artist. See also Barbizon School

LAYERS OF MEANING See Ambiguity

LAY FIGURE A jointed wooden model of the human figure, often life-size, which could be dressed up and used in the studio in place of a live model. Like the dummies seen in shop windows.

LAYING IN See Underpainting

LAYOUT Drawing or design that shows what the final appearance of a decorative scheme, advert, book cover, or newspaper page will look like.

LEAN Oil paints with a low oil content. They look spare and lack bulk, just like a lean person.

LIBERTY Italian name for Art Nouveau, so named after Liberty's store in London. See also Art Nouveau

LIFE CLASS A group of artists drawing or painting from a live model.

LIMITED EDITION An edition of a specific number of prints, each one numbered and marked. Thus 7/50 means the 7th print out of a limited number of 50. Nowadays sometimes used as a promotional hype or catchphrase to trap the unwary – do you seriously believe an edition of several hundreds or even thousands is "limited"?

LIMNER Out-of-date word for an artist. Usually describes a portrait painter, and probably a painter of miniatures.

LINEAR Describes a work of art in which outlines predominate.

LINEAR PERSPECTIVE See Perspective

LINOCUT A relief print made from a piece of linoleum. Linoleum floor covering is nice to use because it is strong but soft, and carves well and more easily than a block of wood. *See* Picasso (pp.396–397)

LITHOGRAPHY This complicated printmaking process produces an image that looks as if it has been made with a soft or greasy crayon. Came into its own in the early 19th century. *See* Daumier (p.307); Géricault (p.269); Schmidt-Rottulff (p.363)

LOCAL COLOUR The actual colour of an object. Local colour is changed and modified by light and shade, distance, the colour of nearby objects, and so on – so what you see may be rather different from the actual local colour.

LOST WAX (CIRE PERDUE) A complicated method of casting sculpture. To oversimplify: make your model out of wax; encase it in a heat-resistant layer of plaster or clay; drill a hole in the plaster; heat it all up until you know the wax is melted; pour it out and fill the resulting space with bronze; let it cool; crack open the mould and there is your sculpture.

LOW RELIEF See Relief

LUMINISTS A group of mid-19th-century American landscape and marine painters notable for a polished realism in which all signs of brushstrokes were eliminated, and fine gradations of tone were used to produce luminous effects. The result is often one of cerie, breathless, clear stillness. Impending storms also feature. See Heade (p.291); Lane (p.291)

LUNETTE A semi-circular painting, such as a half moon. Usually a decorative element over a window or door.

MAGENTA A brilliant red-purple. Named after the textile town in northern Italy.

MAHLSTICK A thick cane with a soft padded head (a bit like a drumstick). Used by painters to support an arm or wrist. The head can rest on the painting without damaging it.

MANDORLA An almond-shaped outline round the body of a holy person endowed with divine light, usually Christ.

MANGA Popular Japanese comics and cartoons.

MANIKIN A small lay figure. See Lay figure

MANNER OF ... "Manner of Rembrandt" (or whoever) means that the work is in Rembrandt's style but done at a later date, by someone else. See also Attribution; By ...; Follower of ...; Studio of ...

MANNERISM (See p.146) The predominant style c.1520–1600: elongated figures, artificial poses,

complicated or obscure subject matter, vivid colour, unreal textures, deliberate lack of harmony and proportion Seen at its best in Italy and France. *See* Bronzino (p.148); Pontormo (p.148)

MAQUETTE A small clay or wax model to show what a finished full-size sculpture will look like.

MARBLING A decorative effect that swirls coloured paints around so that it has the same sort of quality as the patterns found in coloured marble.

MARINE PAINTING A seascape with a narrative action, such as a naval battle.

MAROUFLAGE From the French *moroufle*, "strong glue". To pin a painted canvas to a wall or panel.

MASKING To protect one area of a work of art from what is being done to another area or to the work as a whole. Masking can be done by using protective tape or a varnish that can later be removed.

MASONITE See Hardboard

MASTER OF ... A title given to an artist of unidentified personality, but one whose hand has been detected because a group of works are all in the same style. He is usually named after his best known work, his patron, or the region where he worked – e.g the Master of the St. Bartholomew Altarpiece. *See* Campin (Master of Flemalle) (p.111)

MASTERPIECE A work of art of outstanding quality. Originally it was the work that an artist had to submit to his guild to prove his ability so that he could become a master. See also Guild

MASTIC Gum or resin.

MATT, MATTE Not shiny or glossy.

MEDIUM 1) (pl. media) The material worked with and manipulated to make a work of art – such as oil paint, watercolour, charcoal, or clay. 2) (pl. mediums) A liquid that can be added to paints to make them act differently (for instance, to thin them or make them dry more quickly).

MEMENTO MORI A reminder of death.

METALFOINT A means of drawing using a fine needle of pure metal to make a mark on specially prepared paper. *See also* Silverpoint

METAMORPHOSIS The change of something into something else, often the transformation of a human being or god into an animal or vegetation. Ovid's great book Metamorphoses, in which he narrates with compelling verbal imagery stories of the Classical deities who often changed their form in order to achieve their desires, is one of the main sources of mythological imagery in art. Metamorphosis appeals to artists since the visual transformation of the known and familiar into something recognizable but beyond reality is one of art's great possibilities

METAPHOR Using a subject or object in a work of art to bring to mind one that is not actually represented.

METAPHYSICAL ART Italian avant-garde art movement of the 1920s that depicted a seemingly real world, but where all the spaces, relationships, and situations are outside everyday human experience. *See* Chirico (p.404); Morandi (p.404)

MEZZO FRESCO Fresco painting, but on to dry plaster so that the paint is only partially absorbed. *See also* Buon fresco; Fresco

MEZZOTINT A type of print. It was used mostly in the 18th century in England for portraits and is recognizable by very rich blacks and good half-tones. *See* Gainsborough (p.240); Reynolds (p.235)

MINIATURE A very small picture, usually a portrait, very finely painted, usually on ivory, vellum, or card. The term comes from the Latin "minium" – the red lead that produced the red ink used in medieval illuminated manuscripts to emphasize initial letters – it has nothing to do with the Latin *minituts*, "tiny". See Copley (p.256); Hilliard (p.161); Holbein (p.160); Oliver (p.161)

MINIMAL ART A type of art that first became fashionable in the 1960s, designed for gallery and museum exhibition. Usually three-dimensional, large scale, and geometric, with the slick, anonymous, precision qualities of manufactured or machine-made objects and little obvious visual significance or personal craftsmanship. The artistic significance lies in the ideas embodied but ... See also Conceptual art. See André (p.459); Flavin (p.459); Judd (p.257); Lewitt (p.456); Morris, Robert (p.457)

MISERICORD A hinged seat found in church choir stalls. Look underneath for carvings, often of glorious quality.

MISERICORDIA Latin word for "mercy".

MIXED MEDIA Describes a work of art made with a variety of materials and techniques.

MOBILE A hanging sculpture with shapes or solids hung from wires or strings so that they move freely. If you see them, don't be afraid to blow on them so that they move and come to life (but do not touch them). *See* Calder (p.438)

MODELLO A small version of a large picture done to impress a patron and show what the commission will be like.

MODERN ART The great flowering of Modern art occurred between 1880 and 1960, and it embraces all the avant-garde works produced at that time. It starts with Manet and the Impressionists and continues until the New York School. Three characteristics are worth mentioning: 1) A claim to break with the past – all other previous art movements emphasized their inheritance from, or rejuvenation of, the art of the past. 2) A defiance of all existing art institutions and the creation of works of art which were "homeless", in the sense that they belonged in no existing institution. 3) A plethora of styles and ideas. Modern artists were at their most active in those places where freedom of speech and thought was most at risk, or under threat. (pp.340–343)

MONOCHROME See Grisaille

MONOLITH A sculpture carved or cast as a single piece.

MONOTYPE A single print made by painting onto glass or metal and then transferring the image onto a piece of paper pressed over it.

MONTAGE Use of cut-up, ready-made photographic and printed images (such as magazine advertisements) arranged and stuck down to make a work of art. See Grosz (p.385); Heartfield (p.369)

MORBIDEZZA Italian word for "softness", used to mean soft-focus effects.

MORDANT From the French verb *mordre*, "to bite". An acid that eats away at a metal plate, for example.

MOSAIC A design or picture made of small bits of stone or coloured glass, or other materials. Widely used by the Greeks and Romans, and a favourite of Byzantine art.

MOTIF A recurring or dominant theme, pattern, or subject.

MOUNT Works on paper are usually mounted on a piece of board and have a border between them and the frame. Good mounting and framing can bring a picture alive. In general, make the bottom border about 20 per cent deeper than the others.

MULTIFACETED See Ambiguity

MULTIPLE Catch-all term for editioned works of art that do not belong to traditional categories such as prints, cast sculptures, or tapestries.

MURAL A painting on a wall or ceiling.

MUSEUM OF MODERN ART The dominant art institution of the second half of the 20th century. The first museum of modern art was MoMA, which opened in New York in 1929. They now exist all over the world and are as important and influential for contemporary art (and increasingly as dictatorial and stultifying) as the academics were in the 19th century.

NABIS Group of progressive artists working in France c.1892–99. Believed in art for art's sake, decoration, simplification, emotion, and poetry. The name means "prophets" in Hebrew. Paul Sérusier was one of the group's founders and was much indebted to Gauguin and Bernard. *See* Bonnard (p.336); Denis (p.325); Sérusier (p.332); Vallotton (p.332); Vuillard (p.336)

NAÏVE ART Art that looks as if it is done by someone who has had no professional training – with childish subject matter, bright local colours, wonky perspective, and unsophisticated enthusiasm. Can be genuine, but can be a consciously adopted pose – and it is not always easy to tell which is which. One is genuine and heartfelt, the other is artificial playacting. Douanier Rousseau, a retired customs official, was one of the genuine. See Grandma Moses (p.408); Rousseau (Le Douanier) (p.332) (both genuine)

NARCISSISM Triumphant bourgeois capitalism invariably produces an art that is obsessed with its own way of life, image, and material prosperity (true for 15th-century Netherlands, 17th-century Holland, Second Empire France, and Victorian England; at no time more true than today). Extravagant contemporary claims are also made for the quality and significance of the art (capitalist success is very dependent on convincing marketing).

NARRATIVE ART Art that tells a story. Hogarth's narrative pictures, which he called "modern moral subjects", depicting the follies of human behaviour, show how a good story never fails to appeal.

NATIONAL ACADEMY OF DESIGN Founded in New York in 1825, to be the American equivalent of the Royal Academy in London.

NATURALISM The representation of nature with the least possible formal distortion or subjective interpretation.

NATURE MORTE French for "still life".

NAVICELLA A representation of the story of Christ walking on the water.

NAZARENES (See p.273) Group of progressive young Germans who formed a group in 1809 to revive the spirit and techniques of early Christian and Renaissance art.

NEGATIVE SPACE The space between objects. In a painting or sculpture it can have as much significance or shape as the objects represented and can be manipulated and coloured. Of great importance to artists, but often unnoticed or ignored by those looking at works of art (if you have difficulty seeing negative spaces, try turning the work upside down and then looking them). See Whiteread (p.476)

NEO-CLASSICISM The predominant fashionable style from about 1770 to 1830, emphasizing the spirit and appearance of Classical Greece and Rome. Tends to be severe, didactic, well made, and architectural (prefers straight lines). Succeeds best in architecture, furniture, and sculpture; seen at its finest in England (the Adam style) and France (Louis XVI style). See p.258–261; Canova (p.254); David (p.252); Hamilton (p.241); Houdon (p.252); Mengs (p.249); Vien (p.252)

NEO-EXPRESSIONISM A type of large-scale painting, fashionable in the 1970s, made in an aggressively raw and Expressionist manner with surfaces heavily laden with paint and sometimes including objects, like smashed crockery. Lays claims to portentous or doom-laden subject matter. See Baselitz (p.461); Clemente (p.469); Kiefer (p.467); Schnabel (p.469)

NEO-IMPRESSIONISM Impressionist subject matter painted through the strict application of the scientific colour theories of Divisionism. *See also* Divisionism. *See* Seurat (p.320); Signac (p.320)

NEO-PLASTICISM The philosophy of De Stijl. See Stijl, De

NEO-ROMANTICISM British painting of the 1930s, 1940s, and 1950s that gave a modern interpretation to the romantic and visionary landscape tradition that stemmed from Blake and Palmer. See Sutherland (p.401); Piper (p.401) NEUE SACHLICHKEIT German, meaning "New Objectivity". A stern, precise, and detailed style often socially critical in content, fashionable in Germany in the 1920s. See Dix (p.385); Grosz (p.385); Schad (p.385)

NEW ENGLISH ART CLUB Founded in Britain in 1886 as a progressive anti-academic group committed to spontaneity and plein-air painting. *See* Sargent (p.326); Sickert (p.326)

NEW OBJECTIVITY See Neue Sachlichkeit

NEW REALISM Term applied to a diverse group of European artists working in the 1960s who used disposable everyday materials to create unusuallooking works with obscure but vaguely symbolic or mystical meanings. *See* Arman (p.421); Christo & Jeanne-Claude (p.460); Klein (p.421)

NEW YORK SCHOOL See Abstract Expressionism

NON-OBJECTIVE ART See Abstract art

NORWICH SCHOOL (See p.276) Important group of landscape and seascape painters based in Norfolk c.1805–25. Inspired by the flat Norfolk landscape, with big skies, and by the Dutch masters. They were brilliant water colourists. "Old Crome" was the School's principal founder.

NUDE, NUDITY The unclothed human body. As man is God's highest creation, painting and sculpting the nude has traditionally been the highest aspiration for art. Nudity implies dignity; nakedness implies shame.

OBJET D'ART Small decorative objects such as snuff boxes, scent bottles, and figurines.

OBJET TROUVÉ An object found by chance (such as a piece of wood or even a bicycle wheel), which an artist uses or displays for its aesthetic merit. *See* Duchamp (p.367); Nash (p.398); Schwitters (p.368)

OCHRE A pigment made from clay. Ranges from pale yellow to reddish brown depending on the clay. The stuff you buy in tubes is a sort of dirty yellow.

ODALISQUE From the Turkish word *odalik* (*oda* = chamber; *lik* = function). An Oriental female slave, usually half-naked and reclining. Ingres and Matisse both favoured the subject. Ingres's celebrated *Grande Odalisque* annoyed the public and the critics because they thought the anatomy was wrong. *See* Ingres (p.264); Matisse (pp.344–345)

OEUVRE An artist's entire output.

OIL The principal oil used in painting is linseed oil, which is made from flax seeds. It is slow-drying (can take days or weeks) and can go yellow with age. Poppy oil is also widely used.

OIL PAINT, OILS Oil painting, in the sense known today, developed in the 15th century and became the dominant type of painting in the 16th and 17th centuries. Among the advantages of oil paints are their flexibility, versatility, portability, strength, and rich appearance, and the fact that they are most

pleasurable to work with. Oil paints are made by mixing powdered pigments with oil.

OLD MASTER Strictly speaking describes any artist from the early Renaissance to roughly the mid-19th century. Popularly speaking describes any such artist whose reputation has stood the test of time, although reassessments and rediscoveries do occur. For example Vermeer was rediscovered at the end of the 19th century. Georges de La Tour is currently being reassesd.

OLEOGRAPH A special type of print made on a textured surface that deliberately imitates the look of an oil painting.

OMEGA WORKSHOPS An avant-garde British enterprise (c.1913–15) that produced modern furniture, pots, screens, and so on. A brave attempt, but the products were often rather shoddy. *See* Lewis, (Percy) Wyndham (p.376)

OMP 1) Old master picture. 2) Ordinary member of the public.

OP ART (ABBREV. OF OPTICAL ART) A type of abstract art that was at the forefront in the 1960s. Typified by hard-edge paintings, often in black and white, which bombard the eyes and cause them to "see" colours or shapes that are not actually there. Can be disorientating and exhausting to look at. Suited the psychedelic experiences and bright lifestyles of the 1960s. *See* Vasarely (p.436)

OPTICAL MIXTURE See Divisionism

ORGANIC What is usually meant is that everything in a work of art hangs together, with nothing extraneous or irritatingly out of place.

ORIGINAL PRINT A print where the artist originates the image to be printed – not a reproduction of an already existing painting.

ORPHISM An early Parisian-based abstract art movement in which loosely painted areas of rainbow colours were the dominant theme. *See* Delaunay (p.354); Kupka (p.353)

ORPIMENT Brilliant lemon-yellow pigment. Poisonous.

ORTHOGONAL A line that works as perspective, apparently leading the eye from the surface of the picture towards its vanishing point.

OVERPAINTING Layers of paint applied over the initial layers once they have dried, so that the layers don't mix.

PAINT Paint consists of colouring matter dispersed in a binder. There are many types of colouring matter and binders, which produce anything from watercolours to oil paints.

PAINTERLY A picture painted in a painterly manner is one in which the artist has deliberately used the physical properties of paint. Thus, for oils, it might be intensity or subtlety of colour, thick impasto, and juicy swirls; for watercolour, it might be transparency and washes. *See also* Handling **PALETTE** 1) The flat surface on which artists lay out and mix their paints. Traditionally it is oval in shape with a hole for the thumb. 2) The term also refers to the range of colours that an artist uses. Most artists establish a preferred and limited range, which they get to know well and which is very recognizable: for example, Monet used rainbow colours, Rembrandt used earth colours.

PALETTE KNIFE A knife with a blunt, flexible blade used for mixing paint and for scraping paint off, or spreading it on, a canvas.

PALLADIAN Gutsy Classical style influenced by, or imitating the architecture of, the Venetian Andrea. Palladio (1508–80). Much in fashion in Britain in the first half of the 18th century.

PANEL A firm support (such as wood, board, or metal) on which a picture is painted. Canvas, even when tightly stretched, is not firm.

PANORAMA A scene or landscape painted on a cylindrical surface. The viewer stands in the middle with a 360-degree view and hopes to have the illusion of a real open-air view.

PANTOGRAPH A simple tool for enlarging or reducing drawings in size by tracing their outline. It looks like four rulers hinged together.

PAPER First made in China 100 CE and in the West in the 13th century. Paper is made from cellulose fibres, beaten to a pulp, and spread out in a thin film and dried. The best paper is still made from linen rag. Cheap paper is made from wood pulp and soon discolours and goes brown (like newspaper).

PAPIER COLLÉ French for "pasted paper". Pieces of paper prepared by the artist – not newspaper cuttings or similar, as used in collage – stuck down and incorporated into a painting. *See also* Collage. *See* Braque (p.351); Gris (p.331); Matisse (pp.344–345)

PAPIER MÂCHÉ French, lit. "chewed paper". Shredded paper mixed with a flour-and-water paste to form a pulp that can be shaped into 3-D objects. These are lightweight but firm when the mixture dries.

PARADIGM Example or pattern.

PARCHMENT The skin of an animal prepared as a material for writing or painting. Parchment is usually sheep or goat; vellum is cow.

PARQUET Thin wooden strips attached to the back of a warped wooden panel to straighten and strengthen it. Not used now, as current wisdom is that it does more harm than good.

PASSAGE A small but distinctive part of a work of art.

PASTEBOARD A stiff support made by pasting layers of paper together.

PASTEL Powdered pigment mixed with gum or resin. It is applied directly on paper and then often smudged and softened with the fingers, producing soft, chalky tones. Fragile and easily damaged. *See* Carriera (p.229); Degas (p.315)

PASTICHE A work of art created in the manner of a specific artist, not a copy of a known work.

PASTORAL A scene portraying the life of shepherds and country people in an idealized way. The general atmosphere is usually sunny, fertile, peaceful, innocent, and carefree. The French painter Claude Lorrain originated the pastoral landscape in the mid-17th century.

PATINA The mellow tone and slightly worn look that surfaces acquire with age, especially metal and wood. Usually considered to be attractive.

PATRON Somebody who commissions works of art from living artists – and so often influences the content or appearance of the work.

PEDESTAL The base on which a statue is placed.

PENDANT A painting designed to make a pair with, or companion to, another.

PENSIERO Italian for "thought". A preliminary drawing or sketch.

PENTIMENTO Italian for "repentance". A mark or alteration made during the creation of a painting that is subsequently painted over but which can be seen or detected, maybe as a ridge in the paint, maybe because the top surface becomes transparent with age, or perhaps through infrared photography or X-rays.

PERCEPTUAL ART Any art that places importance on engaging the eye by the visual appearance and visual interest of a work. Conceptual art is more concerned with ideas than with engaging the eye.

PERFORMANCE ART The 1970s follow-on to 1960s "happenings"; same sort of thing but more structured, theatrical, and sometimes even scripted. There is still a lot of it about. *See* Beuys (p.453); Hatoum (p.470); Klein (p.422); Morris, Robert (p.457); Nauman (p.464)

PERSPECTIVE The basic rules of linear or geometric perspective were established in the Renaissance and are: a fixed, single viewpoint with lines that meet at a vanishing point, so creating the illusion of 3-D space on a flat surface. See Angelico (p.89); Bellotto (p.236); Canaletto (p.235); Christus (p.115); Estes (p.458); Piero della Francesca (p.100); Uccello (p.92)

PHALANX Influential group of Munich artists, led by Kandinsky in 1901, who were opposed to the oldfashioned Academy and all conservative views, and who organized exhibitions and ran a Modern art school. See Kirchner (p.362); Kandinsky (p.364); Münter (p.364)

PHILISTINE Somebody with a complete lack of interest in art or culture of any sort.

PHOTOGRAPHY The invention of photography had a profound impact on artists, and at once raised a host of practical and aesthetic issues: for example, hack portrait painters were put out of business. Progressive artists such as Degas openly welcomed photography's influence and uses; others used it and pretended they had not. Some tried to rival its meticulous accuracy; others sought to record sensations beyond the reach of photography (Impressionists). Whether photography was "proper art" was hotly debated (and still is by some) – Ingres said it could never be. The earliest surviving photograph was taken in France in 1827. Daguerre established it as a serious medium in 1837. See Degas (p.315); Ingres (p.264)

PHOTOGRAVURE A commercial printing process invented in the 19th century.

PHOTOMONTAGE A technique of cutting up photographs, newspaper pieces, or advertisements and combining them with drawings and lettering to produce striking, provocative, or illogical images. The German artist John Heartfield produced powerful work commenting on the turmoil and ideological struggles in Germany and Eastern Europe between the two World Wars. *See* Ernst (p.369); Grosz (p.385); Heartfield (p.369)

PHOTOREALISM Paintings that look like large, colour photographs but are in fact meticulously executed paintings. They often take shiny, reflecting surfaces as their motif. Became a popular style in the 1970s. See Estes (p.458)

PICTOGRAPH, PICTOGRAM A pictorial symbol representing an object or idea. Road signs are a good example; so are hieroglyphs.

PICTURE PLANE When a picture acts as a window onto a real or imaginary world, the picture plane is the equivalent of the sheet of glass that divides the spectator's world from the world of the picture.

PICTURESQUE Today it means little more than attractive or charming. In the 18th century it embraced serious ideas about what was beautiful in nature, usually involving irregularity, informality, and a bit of wildness. These notions had considerable influence on 18th-century English landscape design.

PIGMENT The colouring matter in paint. It does not dissolve in the liquid that carries it, such as oil or water. Colouring matter that does dissolve is called a stain or dye.

P. PINX., PINXIT Latin for "he/she has painted it". Found on prints to show who painted the original picture that has been copied in the print.

PLAQUETTE A small cast metal relief, or replica, of a small work of art, usually in bronze or lead, which is applied as decoration to another object such as a piece of furniture or stone vase. Can be made in multiple copies. The sculptural equivalent of a print.

PLASTIC ARTS Strictly speaking, only those arts that involve moulding and modelling (such as sculpture made from clay). In practice, it often refers to all the visual arts.

PLASTICITY 1) Any material that is pliable, stretchable, and durable, so that it can be modelled and moulded, has plasticity. 2) A drawing is said to have plasticity if it gives a convincing illusion of a 3-D form. **PLATE MARK** In printmaking, the indentation left on a sheet of paper by the pressure of a metal plate or wooden block carrying the print design.

PLEIN AIR (See p.305) A painting begun and completed in the open air, or one that conveys the qualities and sensations of open-air painting. Boudin's plein-air spontaneity was genuine and greatly influenced the young Monet. See Boudin (p.304); Constable (p.277); Corinth (p.337); Corot (p.304); Landseer (p.288); Monet (p.310); Rousseau, Théodore (p.304); Sargent (p.326); Zorn (p.327)

POCHADE A small oil sketch made out of doors in one sitting. *See* Bonington (p.268); Constable (p.277); Corot (p.304)

POINTILLISM Divisionism as practised by Seurat, Signac, and Camille Pissarro. *See also* Divisionism

POINTING MACHINE A machine perfected in the 19th century that enabled the dimensions of a small 3-D model (sometimes made by the sculptor) to be mechanically transferred to a larger block of stone so that an exact but bigger version could be carved, either by the sculptor or by someone else. See Rodin (p.318)

POLYCHROME Many coloured. Used especially in reference to painted sculpture.

POLYMER PAINTS Similar to acrylics.

POLYPTYCH An altarpiece made of more than three panels that are hinged together.

POP ART (See p.440) Predominant movement of the 1950s and 1960s, especially in the USA and UK. Played about with the popular fetishes of the consumer society (such as advertisements, comics, and well-known brand images like Coca-Cola). Often used quick and inexpensive commercial art techniques. The US version used exclusively contemporary imagery; the UK version carries a heavy dose of nostalgia and whimsy. See Blake, Sir Peter (p.446); Caulfield (p.446); Indiana (p.445); Johns (p.442); Jones (p.446); Lichtenstein (p.441); Rosenquist (p.445); Warhol (p.444)

POPPY OIL An oil extracted from poppy seeds. Similar to linseed oil, but thicker, and even slower to dry. *See also* Oil

PORTFOLIO A case, usually big and flat, for carrying works of art on paper.

PORTRAIT A likeness of a person or an animal. What is like, and what is not, is of course where the arguments begin.

POSTER PAINT Inexpensive, brightly coloured gouache. *See* Gouache

POST-HUMAN The buzz phrase to describe subjects that focus on media or consumer obsessions and new technology (such as computers, genetic engineering), and their influence on the human body.

POST-IMPRESSIONISM (See p.328) Catchy phrase that doesn't mean very much, except that it includes all the more or less progressive artists from about 1885

to 1905. Can be used as widely or as narrowly as you please. The four principal Post-Impressionists, who did indeed start with Impressionism and then sought to develop a more formal or symbolic style, are Cézanne (pp.334–335); Gauguin (p.329); Seurat (p.320); and Van Gogh (pp.330–331).

POST-MODERNISM The triumph of style over substance. Art and architecture (but literally anything or anyone in fashion, politics, music, literature – you name it) of the 1980s and 1990s and now, with nothing much to say of real substance or meaning (although it might be claimed otherwise), presented in a very cool, selfconscious, stylish (and overdesigned?) manner. Not art for art's sake, but style for style's sake. "Branding" and designer clothes are very post-modern, as are many dot.com companies and many Internet websites.

POST-PAINTERLY ABSTRACTION Cult term for American large-scale, colourful, simple-design abstract painting in the 1960s, either hard-edge, or loose, or lyrical. *See* Kelly (p.438); Louis (p.437); Noland (p.454); Olitski (p.453); Stella (p.460)

POTBOILER A work of art produced merely to earn the necessities of life – or in the case of the already successful, just to make money.

POUNCING Pricking small holes in the drawn outlines of a cartoon. You can then transfer the design to another surface by sprinkling the cartoon with fine soot so that it falls through the holes and leaves a mark.

PRECISIONISTS Group of American artists prominent in the 1920s and 1930s whose theme was modern industry and urban landscapes, portrayed in an idealized and romantic way with acute observation and a smooth, precise technique. *See* Demuth (p.407); Sheeler (p.407)

PREDELLA In an altarpiece, the strip of small-size paintings set in the frame at the bottom of the main painting. They are usually narrative scenes related to the subject of the main painting.

PRE-RAPHAELITES (*See* p.297) Small and influential group of young British artists who came together in 1848 and aimed to challenge conventional views by championing the artists who came before Raphael. *See* Hunt (p.298); Millais (p.298); Rossetti (p.296); Ruskin (p.296)

PRIMARY COLOURS Red, yellow, and blue. In theory all other colours can be made from them – but coloured pigments and coloured lights can and do behave differently.

PRIMER A primer is applied to a support to isolate the support from the ground and the final paint surface. Without a primer, raw canvas or raw wood would simply absorb the paint and/or react chemically with it, thereby making the artist's task impossible or even destroying the work – unless, of course, the artist wants the effect of the paint being absorbed by (therefore staining) raw canvas or wood. *See also* Ground; Sinking in; Support

PRIMITIVE ART Old-fashioned and politically incorrect way of describing the early or traditional art of societies, such as African tribes and the Inuits.

In fact, most of it is highly sophisticated, if properly understood. See also Naïve art

PRINT The image made by pressing an inked or painted surface onto a piece of paper.

PROBLEMATIC Useful word and concept currently much used by critics and commentators, especially in the USA. Can mean there is a genuine problem that is worth discussing. More often it is a polite and coded way of saying "meaningless". If you find a work of art or someone's point of view incomprehensible or futile, don't admit defeat or tell the truth. Look serious and describe it as "problematic".

PROFIL PERDU French, lit. "lost profile". A head that is turned away so that the back of the head, together with the outline of the check and chin, can be seen – the rest of the profile being lost from view.

PROOF A trial print. It allows the artist and the printmaker to see what is happening. They can then make adjustments before arriving at the final version from which the print run will be made.

PROVENANCE The pedigree of a work of art – a list of who owned it and when.

PURE COLOUR Colour used straight from the tube without mixing.

PURISM Fashionable Parisian art movement of the 1920s. Used Cubist ideas to produce figurative art (lots of still lifes) that was supposedly pure in design, form, and colour. Most of it was rather boring and forgettable.

PVA Polyvinyl acetate: man-made resin used as a paint medium and in varnishes and adhesives.

QUADRATURA A painting on a ceiling or wall that gives the illusion of extending the real space of a room. Often includes illusionistic details or extensions of the architecture, such as columns.

QUADRA RIPORTATO Italian, lit. "carried picture". A picture painted on a ceiling to look as if it were an easel painting hung overhead.

QUATTROCENTO Italian for "15th century" (1400–99).

RA Full member of the Royal Academy, London. There are 40 at any one time; they have to give the Royal Academy a work that they have produced. *See also* Royal Academy

RAYONISM Avant-garde Russian movement c.1913, which came near to abstraction, whose subject was light and rays of light. *See* Goncharova (p.370); Larionov (p.370)

READY-MADE A mass produced object taken by an artist and turned into his/her own "creation" by the addition of a signature or some other small alteration. The most famous ready-made is Duchamp's urinal, which he called *Fountain* (*See* p.367) and exhibited as a work of art in 1917. *See also* Objet trouvé

REALISM (See pp.300–301) 1) Every generation seems to define realism in its own way. For example,

Renaissance artists thought their art was real because they opened a "window on the world", showing 3-D space and human emotion with an accuracy and intensity not seen before. On the other hand, some modern abstract painters thought they were more real by showing the reality that a picture is just paint on a flat surface. At the moment, some contemporary artists regard themselves as realists because they confront current social, green, or gender issues ... and so on. 2) Realism with a capital "R" was the progressive movement in art and literature in the mid-19th century (especially in France) that was concerned with social realities and showing fact rather than ideals and aesthetics. The early novels of Zola are a good example. See Courbet (p.306)

RECESSION The illusion of depth in a picture. *See also* Aerial perspective; Perspective

RED CHALK See Sanguine

REFORMATION Sixteenth-century religious movement that sought to modify Roman Catholic doctrine and practice. It led directly to the establishment of the Protestant churches.

REGENCY See Empire style

REGIONALISM American movement of the 1930s that was the first expression of a consciously independent American art. Its vision was of a real American art, springing from American soil and seeking to interpret American life. *See* Benton (p.409); Wood (p.406)

RELIEF From the Italian *rilevare*, "to raise". Sculpture carved from a flat or curved surface so that part of the image projects. If the image projects slightly, it is known as bas relief (low relief). If it projects more boldly, it is known as alto rilievo (high relief).

RELIEF PRINT A print made from a block or plate in which the area not to be printed is cut away, leaving the part to be inked standing in relief. *See also* Wood engraving; Woodcut

RELINING The process by which a damaged canvas is stuck down on a new one.

REMARQUE PROOF A trial print on which an artist has written or drawn instructions as notes for what to do next. *See also* Proof

RENAISSANCE (See pp.86-87; pp.108-109; pp,138–139). French, lit. "rebirth". The flowering of new ideas in Italian art between 1300 and 1550, which has influenced the subsequent development of all Western art. The three key ideas that developed during the Renaissance with increasing sophistication were: 1) The work of art as a window on the world the illusion of looking at space, light, the human figure, or landscape. 2) Man as the measure of all things - human scale, proportion, emotion, ideals, or spirituality as the central theme and yardstick for art. 3) Reverence for Christianity, the Bible, and Classical antiquity - the interpretation of the Christian message by illustrating the Old and New Testaments, and the adaptation and use of Classical (Greek and Roman) ideas, literature, and images.

REPLICA In art-collecting terminology, a copy of a picture or sculpture made by the artist himself.

REPOUSSOIR From the French repousser, "to push back". A figure or object in a painting that directs the eye to the main point of interest. Same as *coulisse*. See Coulisse

REPRESENTATIONAL ART Art that depicts recognizable objects and figures, although they may not necessarily be true to life.

REPRODUCTION A copy of a picture or print made by mechanical means, such as photography.

REREDOS The decorated screen behind an altar. It is usually sculpted, sometimes painted, and can take the form of a tapestry or hanging or decorative metalwork.

RESIN The main ingredient of varnish. Natural resins come from trees and plants.

RESIST Something applied to a surface to prevent the penetration of liquids. Usually a varnish, or a similar coating, or masking tape.

RESTORATION Repairing a work of art that has become damaged through accident, decay, or neglect. The ethics of restoration are as complicated as medical ethics. How much transplanting, patchingup, and cleaning can occur before the object dies aesthetically or becomes unrecognizable? Best motto: if in doubt, leave well alone, because once it is dead or ruined there is nothing you can do. A terrifying number of paintings have been ruined by overcleaning in the last 50 years, and as yet no one has properly faced up to the fact. The *Mona Lisa* had eyebrows – until an unvise early restorer accidentally removed them.

RETABLE An altarpiece of one or more fixed (not hinged) framed panels.

RETARDANT A medium that slows down the rate at which paint dries.

RETARDATAIRE From the French *retard*, "delay". Not up to date.

RETINAL PAINTING Another name for Op art. See Op art

RETOUCHING Repainting very small areas of a picture that have become damaged.

RETRO An object made with current-day materials or technology. Its external appearance is stylized to make it appear as an authentic product of another era (especially the 1930s or 1940s); for instance, a transistor radio in a case that makes it look to be a 1930s wireless.

RETROSPECTIVE An exhibition that shows a comprehensive selection of an artist's works covering his or her whole life, or a particular period. Can make or break the artist's reputation or spirit: works that are incomprehensible or neglected when seen in isolation can blossom when seen in their full context; works that looked wonderful on their own can suddenly seem boringly repetitive when shown together. Picasso would not allow retrospectives, arguing that the only thing that mattered was what he was doing now.

ROCAILLE A decorative motif using shells and rocks, or shell-like swirls and curls.

ROCOCO (See pp.226–227) The predominant style of the first half of the 18th century. Look for curves, pretty colours, playfulness, youth, elegance, fine craftsmanship, extravagance, carefree attitudes, and references to real and fanciful nature (flowers, leaves, rocks, birds, monkeys, or dragons). See Boucher (p.224); Gainsborough (p.240); Guardi; (p.236) Tiepolo (p.230); Watteau (pp.222–223)

ROMANESQUE The main style of Christian Europe in the 11th and 12th centuries, seen mostly in architecture and recognizable by thick walls, small windows, and rounded arches. Look also for wall paintings, tapestries (such as the Bayeux tapestry), stained glass, and illuminated manuscripts.

ROMANISTS A group of Flemish painters who went to Italy in the early 16th century and were influenced by the contemporary Italian art they saw there. See Gossaert (p.116)

ROMANTICISM (See pp.266–267) The movement in art, music, and literature in the late-18th and early 19th centuries that produced some of the greatest and best-loved works of art of all time. The Romantics believed in new experiences, individuality, innovation, risk-taking, heroism, freedom of imagination, love, and living life to the full. See Constable (p.277); Delacroix (p.268); Friedrich (p.272); Géricault (p.269); Turner (p.281)

ROYAL ACADEMY Prestigious organization founded in London in 1768 to promote high standards in art, to run an art school, and to exhibit work by artists, both living and dead. Very successful in promoting British art in the 18th and 19th centuries. Privately funded, and therefore never an instrument of state control. In the 20th century, it gained (rightly) a reputation for stuffiness and for being anti-modern, but it is now becoming more up to date. See Reynolds (p.239)

SACRA CONVERSAZIONE The Madonna and Child surrounded by saints. They are all in a single space and aware of each other though not necessarily communicating with each other. Much exploited in Venetian Renaissance art. See Mantegna (p.107); Bellini (103); Angelico (p.89); Filippo Lippi (p.88)

SALON The French official annual public art exhibition, controlled by the Académie. Immensely influential, especially in the 19th century, when it was the bastion of conservative attitudes. *See also* Academies; Impressionism

SALON D'AUTOMNE Annual autumn exhibition of contemporary art in Paris. Much used by early pioneers of Modern art as a means of showing their work. See Bonnard (p.336); Marquet (p.347); Matisse (pp.344–345); Rouault (p.354)

SALON DES INDEPÉNDANTS Annual spring show of contemporary art in Paris. It is open to all comers, with no selection by a jury. Much used by early pioneers of Modern art as a means of getting

their work seen by the public. *See* Matisse (pp.344–345); Redon (p.324); Seurat (p.320); Signac (p.320)

SALON DES REFUSÉS The exhibition held in Paris in 1863 that showed work by artists who had been turned down by the official Salon. One of the key events in late-19th-century art. See Cézanne (pp.334-335); Courbet (p.306); Fantin-Latour (p.302); Manet (p.307); Pissarro (p.314); Whistler (p.321)

SANGUINE Red chalk. Used finely it can produce exquisite small drawings. Michelangelo achieved a mastery of the medium, which was not seen again until the carly 18th century, in France. *See* Michelangelo (p.136); Rubens (p.191); Watteau (pp.222–223)

SARCOPHAGUS Stone coffin (Roman, Egyptian, etc.), often decorated with relief sculpture.

SATURATION The degree of intensity of a colour.

SCHEMA A very basic diagrammatic drawing, such as an egg shape to indicate a head.

SCHOOL Group of artists whose work shows some similarities. A useful, but often very imprecise, term.

SCHOOL OF BOLOGNA (*See* p.166). Term encompassing 16th-century artists working in Bologna, fusing Venetian and Florentine influences into a distinctive Bolognese style. *See* Carracci (p.167); Domenichino (p.168); Guercino (p.172); Reni (p.166)

SCHOOL OF FONTAINEBLEAU (See p.153) Group of 16th-century Italian, French, and Flemish painters who decorated the Palace of Fontainebleau for Henri IV. See Abbate (p.154)

SCHOOL OF PARIS (*See* p.357) A useful term embracing the various artists, schools, and movements who pioneered new ideas in Paris in the first half of the 20th century.

SCOTTISH COLOURISTS Four progressive Scottish painters – Cadell, Fergusson, Hunter, and Peploe – who were active before 1914, producing high-quality work in bright colours with simplified stylisation that was much influenced by French Fauvism. Peploe spent several years in Paris, and was among the first to put modern French ideas into practice in Britain.

SCULP, SCULPSIT, SC., SCULPEBAT Latin for "he cut it" or "he carved it". Found on prints to indicate the name of the person who made the plate or block. Sometimes found on sculpture to indicate an original carving, not a cast.

SCULPTURE Three-dimensional work of art made by carving, modelling, or constructing. Like a picture, it has no useful function in itself.

SCUMBLE A thin layer of oil paint dragged over a bottom layer of paint in such a way that the scumble breaks up, allowing the bottom layer to show through.

SEASCAPE A picture that takes the sea as its subject. If the subject is ships, it is called a marine painting.

SECESSION (See p.338) Groups of progressive German and Austrian artists who challenged the

ideas and authority of the academies in the 1890s. In Vienna, Gustav Klimt, a leading member of the Secession, explored the themes of love and sexuality that obsessed both the conservatives and the radical modernizers.

SECONDARY COLOURS The colours produced by mixing primary colours: blue + yellow = green; yellow + red = orange; blue + red = purple.

SECULAR Belonging to the everyday world, not to the spiritual or religious world.

SEICENTO Italian for "17th century" (1600-99).

SEMANTICS The study of the meaning of words.

SEMIOTICS The study and interpretation of signs and the way they signal an underlying state of affairs, attitudes, observations, ideas, and actions. A simple example is the way we all understand and react to the convention that a red traffic light means stop and a green one go.

SEPIA Brown pigment used for ink and watercolour. It comes from an octopus or cuttlefish and fades easily.

SERIGRAPHY General term for the art of silkscreen printing. *See* Silkscreen printing

SETTECENTO Italian for "18th century" (1700–99).

SFUMATO Soft outlines and a smooth, smoky transition between areas of colour. *See* Leonardo (pp.132–133)

SGRAFFITO See Graffiti

SICCATIVE 1) Adjective; means that it will dry – linseed oil is siccative, olive oil is not. 2) Noun; means a drying agent – something added to oil to speed up the rate at which it dries.

SIGNIFICANT FORM The idea that beauty in a work of art lies solely in colour, composition, and line. It was influential in early 20th-century English art and helped to develop abstract art.

SILHOUETTE Black paper cutout of the profile of a face, invented by a French Minister of finance called M. de Silhouette in the 18th century.

SILKSCREEN PRINTING (OR SERIGRAPHY)

A printmaking method in which ink or paint is squeezed through a fine mesh screen, usually made of silk, on which the design has been made. Invented c.1900 and used widely by modern artists, especially those with an eye for bold designs and bright colours. *See* Warhol (p.444)

SILVERPOINT A method of drawing using an instrument with a fine silver tip, which makes a fine grey line on specially prepared paper. *See* Dürer (pp.126–127); Leonardo (pp.132–133)

SIMILE In art, more or less the same as metaphor and allegory. *See* Allegory

SIMULACRUM An illusionary image that is so effective that it supplants reality.

SIMULTANEOUS CONTRAST The effect

whereby if you project a white light onto a screen already illuminated with a light in one of the primary colours, the white light will appear in that colour's complementary colour. For instance, if you project a white light onto a screen already illuminated with a blue light, the white light will appear orange.

SINKING IN This happens when oil is absorbed from paints into the ground – the canvas, for instance. It leaves the paint looking dry and dull.

SINOPIA (**PL. SINOPIE**) The underdrawing for a fresco; it is usually made in red ochre.

SIZE Gelatine or animal skin glue – when melted and made into a solution it can be painted onto a surface to make it waterproof and suitable for painting on. *See also* Distemper

SKETCH A rapidly executed work in any medium. Used by artists to sort out general ideas for a painting (or sculpture), or to note the essential features of it. See Constable (p.277)

SOCIAL REALISM Describes works of art showing every day life often its harsher aspects. In the 19thcentury, social realist pictures showed the labouring classes, prostitutes, sickness, death, or adultery painted in photographic detail. Today, they are conceptual works addressing such issues as AIDS, gender, race, feminism, sexuality, anxiety, and loneliness. In the 1850s and 1860s, Ford Madox Brown addressed the issues of forced emigration from the UK, inspired by the departure for Australia of his sculptor friend, Thomas Woolner. *See also* YBAs

SOCIALIST REALISM The official art of the Communist dictatorship of the Soviet Union, mostly heroic portrayals of the Party faithful and ardent workers. Copied in other hard-line communist countries, such as Mao's China and Castro's Cuba.

SOFT-GROUND ETCHING A type of etching producing an effect that looks like a pencil or chalk drawing. Complex technique and rare. *See* Etching

SOFT SCULPTURE Sculpture made from soft materials such as cloth, fur, or felt.

SOPRA PORTE From the Italian, lit. "over the doors". Paintings made to go in the space above doorways – often landscapes or still lifes.

SOTTO IN SU Latin for "from below upwards" – an illusionistic effect so that when you look up at figures painted on a ceiling they appear to float in space. *See* Correggio (p.150); Mantegna (p.107); Tiepolo (p.230); Veronese (p.142)

SOVIET REALISM See Socialist Realism

SPATTER Paint flicked off the end of a brush.

SPREZZATURA From the Italian, meaning "nonchalance", "ease". The ability to do things with speed and ease.

SQUARING UP A reliable way of transferring a drawing accurately onto a larger surface. You draw a

grid of squares over the drawing and an equivalent grid with the same number of squares over the larger surface. Copy the contents of each square of the drawing into the equivalent square on the larger – and, hey presto, it works. *&e* Robinson (p.317); Sickert (p.326)

SQUEEGEE A rubber blade or roller used for pressing the ink through a silkscreen to make prints. *See also* Silkscreen

ST IVES GROUP (See p.400) Group of British artists working in St Ives, Cornwall, in the 1940s, 1950s, and 1960s. See Frost (p.430); Hepworth (p.400); Heron (p.431); Moore (p.399); Nicholson (p.400)

STAFFAGE People or animals in a landscape that are incidental to the general theme or view but add scale or a bit of human interest, act as repoussoir, or help the perspective. *See also* Repoussoir

STATE When working on a print, artists will often take an impression to see what is happening and help them decide what to do next. Each such impression is called a "state" and may carry a number. Dedicated print collectors love them because they are rare and show how the artist arrived at the final state, which is the one that is printed in quantity.

STEEL ENGRAVING An engraved or etched copper plate that has been faced with steel by electroplating to make it harder and therefore able to produce more impressions. Some of the softness and subtlety of the image is lost in the process.

STIJL, DE (See p.389) Dutch for "the style". The most influential avant-garde art magazine in the 1920s, founded and promoted by a group of Dutch artists (it is also the name of their movement). Advocated a geometrical type of abstract art, simplification, social and spiritual form. See Mondrian (p.389)

STILL LIFE A depiction of inanimate objects such as fruit, flowers, jugs, plates, bottles, or dead birds or animals. Seventeenth-century Holland liked lavish still lifes (and Jan Davidsz de Heem excelled at them). Simple ones were favoured in the Enlightenment. The pioneers of Modern art used them to break new ground in ways of seeing. The only Perceptual art subject that can be prearranged and (almost) totally controlled by the artist. See Cézanne (pp.334–335); Chardin (p.224); de Heem (p.199)

STIPPLE ENGRAVING Ingenious marriage of engraving and etching techniques, which produces a print that looks like a chalk drawing. Much used in the 18th century for portraits.

STIPPLING Small dots or strokes applied in differing densities to create areas of tone or of light and shade.

STREET ART Works of art in public places, such as murals on buildings, graffiti, pavement art, and "happenings". *See also* Happening

STRETCHER The wooden frame over which canvas is stretched to make a surface for painting. Never forget to look at the backs of paintings – sometimes they are more interesting than the front, and the labels attached to stretchers can tell a history in themselves.

499

STRUCTURALISM Buzzword for the study of the meaning of signs. Used to be called "iconology".

STUDIO OF ... Describes a work made by the assistants in a master's studio. Looks as though it has been created by the master, but it has not and usually appears a bit mechanical, tired, or overfamiliar. *See also* Attribution; By ...; Follower of ...; Manner of ...; Manner

STUDY A preliminary drawing or painting made before going on to the final version, but worked out in considerable detail.

STURM, DER German for "the storm". Name of a magazine and art gallery in Berlin, which was a major influence in promoting German and foreign modern art in Germany between 1912 and 1932.

STYLE A distinctive way of doing things, which can be analyzed and its unique combination of characteristics identified. To be one of the memorable greats, you need a style that is new, instantly recognizable, technically accomplished, easy to describe in words, and easy for the public and other professionals to mimic.

STYLE OF ... In the same style as a particular artist, but not by that person. *See also* Attribution; By ...; Follower of ...; Manner of ...; Studio of ...

SUBJECT, SUBJECT MATTER The theme(s) of a work of art. An artist may be seeking to show ideas or issues that are wider or deeper than the actual objects and figures represented.

SUBLIME A feeling of grandeur or awe induced by a work of art or nature – an aesthetic concept much discussed in the 18th century, reaching its fullest expression in the late-18th and early 19th centuries. Someone standing on a mountain top and gazing into a ravine that has a powerful waterfall, while storm clouds gather overhead, is a typical example, and one much used in art. Turner lusted after sublime experiences in both life and art. See Friedrich (p.272); Martin, John (p.280); Turner (p.281)

SUCCESSIVE CONTRAST Take a brightly coloured sheet of paper in a primary colour (red, for example). Stare at it for a minute then look at a white wall. You will "see" a ghost-like image of the sheet of paper in its complementary colour (green in this case). This automatic creation in the mind's eye of the complementary colour is called successive contrast.

SUPERREALISM See Photorealism

SUPPORT A painting needs a support, which may be canvas, a wood panel, a copper sheet, paper, etc. The artist needs to prepare the support by painting on to it a primer, and then a ground, to create a suitable smooth surface on which the picture can be painted. *See also* Ground; Primer

SUPREMATISM Russian avant-garde movement, pre-World War I, that strove to create a new spiritual awareness by developing an abstract art based on simplified geometric form, simple colour, and floating spatial relationships, unlike anything found in the material world. *See* Lissitsky (p.373); Malevich (p.371) SURREALISM (See pp.390–391) The leading avantgarde movement of the 1930s. It sought to reach a new "super reality" by defying logic and accessing the unconscious (it was strongly influenced by Freud's theories). Used almost every artistic style from abstraction to realism. Magritte turned reality on its head by confounding normal experiences, but in a way that was more poetic than shocking. See Arp (p.368); Dali (p.392); Delvaux (p.394); Ernst; (p.369) Magritte (p.395); Mar Ray (p.394); Masson (p.393); Matta (p.395); Miró (p.393); Tanguy (p.393)

SYMBOLISM (See pp.322–323) Started as a progressive movement in 19th-century French poetry (Rimbaud, Baudelaire, Mallarmé, Verlaine), which influenced a number of painters interested in the mystical and spiritual. Look for strange, enigmatic and allegorical subjects designed to play on the emotions and come close to the power of dreams. See Ensor (p.366); Moreau (p.324); Puvis de Chavannes (p.324); Redon (p.324)

SYNAESTHESIA The rare ability to experience colour sensations as a physical (as opposed to an imaginative) experience when other senses such as taste and hearing are stimulated. *See* Kandinsky (p.364)

SYNCHRONISM American version of Orphism. See Macdonald-Wright (p.383)

SYNTHESIS Bringing two or more separate things or ideas together to create another, different one.

SYNTHETISM See Cloisonism

SYNTHETIC CUBISM (See p.350) The works done by Picasso, Braque, and Gris c.1912–15, featuring fragments of newspapers, tickets, and so on, incorporated into paintings.

TABLEAU VIVANT French, lit. "living painting". A depiction of a scene by silent and motionless costumed participants. Many old-master paintings can be turned into *tableaux vivants*.

TACHISME From the French *tâche* for "patch" or "spot". Group of postwar French painters, contemporary with the Abstract Expressionists, who produced freely painted abstract pictures. Interesting, but not major. *See* Soulages (p.420)

TEMPERA Emulsion made of powder pigments bound together with egg yolk and thinned with water. Very quick-drying, tough, and permanent. Has to be applied in short strokes, so covering a large area is painstakingly slow. The favoured medium in early-Renaissance Italy until replaced by oil paint. Still used occasionally. Sc Clemente (p.169): Ghirlandaio (p.95): Michelangelo (p.136): Piero della Francesca (p.100): Wyeth (p.439)

TENEBRISM A style of painting with bright lights and dark shadows as practised by Caravaggio and his Spanish and Neopolitan followers. Same sort of thing as *chiaroscuro*. Spanish-born José Ribera, who settled in Naples, used dramatic lighting to emphasize his deliberate realism. *See also* Chiaroscuro. *See* Caravaggio (m.170–171); Ribera (p.185); Zurbarán (p.185)

TERM See Herm

TERRIBILITÀ Italian for "awe". A sense of awe and foreboding about the human condition – in particular its essentially tragic nature, its unpredictability, the inevitability of pain and suffering, and the certainty of God's final judgement. See Michelangelo (p.136)

TERTIARY COLOURS The result of mixing a primary and a secondary colour (such as red and green) or two secondary colours (such as green and orange). The latter, in particular, results in muddy colours – browns, greys, and blacks.

TESSERAE (SING. TESSERA) The small pieces of material used to make a mosaic.

THUMBNAIL SKETCH A small, rapidly executed sketch that captures all the essential features of the subject.

TINT The variation in a colour made by mixing it with another.

TITANIUM WHITE White pigment with the purest whiteness and best opacity. Perfected in the 1920s and now the largest selling pigment.

TONDO Italian, meaning "round". A circular painting or relief sculpture.

TONE The lightness or darkness of a colour. Also described by referring to the lightness, value, intensity, or brilliance of a colour.

TOOTH The degree of roughness of a painting support (such as paper or canvas).

TOPOGRAPHY The detailed depiction of an actual place. R. P. Bonington excelled at it, and produced luminous and detailed watercolours and oils of picturesque places such as Verona. See Bonington (p.268)

TRANSAVANGUARDIA Italian movement of the late 1970s that sought to re-establish socalled traditional artistic priorities, such as expressive painting, colour figuration, and individuality. More a reaction against the anonymity of Minimalism than a coherent agenda for something. See Clemente (p.469); Paladino (p.427)

TRECENTO Italian for "14th century" (1300-99).

TROMPE L'OEIL French, lit. "deceives the eye". A *trompe l'oeil* painting is designed to trick viewers into thinking that what they see is the real thing.

TURPENTINE Strong-smelling, quick-drying, thin liquid made from pine resin, used for diluting oil paints.

UKIYO-E Popular Japanese paintings and woodblock prints made in the 17th, 18th, and 19th centuries. Decorative and brightly coloured with strong designs, they portray courtesans, landscapes, animals and birds, narrative scenes, etc. Ukiyo-e means "floating world", but for some reason no Western writer seems able to explain convincingly the idea it enshrines. Hiroshige, one of the masters of Ukiyo-e, is noted for his poetic reverence for nature, and his deftness in expressing the effects of mist, rain, and snow. **UMBER** A dark brown earth pigment. Raw umber is dark yellow-brown; burnt umber is dark reddish-brown.

UMBRIAN SCHOOL Italian artists who worked in and around Perugia in the 15th and 16th centuries. *See* Piero della Francesca (p.100); Raphael (p.134); Signorelli (p.95)

UNDERPAINTING Complete detailed design for a picture made in a dull monochrome then painted over to make the finished work.

UT PICTURA POESIS Latin saying expressing the idea that paintings can fulfil the function of written texts, especially poetic and lyrical ones.

UTRECHT SCHOOL A group of 17th-century Dutch artists who visited Rome and were strongly influenced by the works of Caravaggio. The leading member of the Utrecht School was Gerrit van Honthorst, who is especially known for his striking use of artificial light. *See* Honthorst (p.204); Terbrugghen (p.199)

VALUE, COLOUR VALUE The lightness or darkness of a colour: low value is dark; high value is bright.

VANISHING POINT See Perspective

VANITAS A still life containing symbolic references (such as skulls or extinguished candles) to death and the transitory nature of life.

VARIANT A copy that is slightly different from the original.

VARNISH A hard-drying transparent protective substance, which is painted on to the surface of a painting to protect that surface and give the colours a unity of texture and appearance. Varnish is suitable for paintings on a panel or canvas, but it tends to make the pictures go darker with age.

VARNISHING DAY See Vernissage

VEDUTA Italian from *vedere*, "to view". A more-orless accurate view of a town or city. The 18th-century artists who painted them were called *vedulisti. See* Bellotto (p.236); Canaletto (p.235); Piranesi (p.249)

VEHICLE The liquid that binds pigments together to make paint; oil, for instance.

VELLUM Fine parchment made from the skin of a calf. (Same derivation as "veal".)

VERDIGRIS 1) A poisonous, green or greenish-blue pigment made from copper; it is fugitive and eventually goes dark brown. First used by the ancient Greeks (it comes from vert de Grèce, green from Greece). 2) The greenish or bluish patina that forms on copper, brass, and bronze.

VERMILION Bright-red pigment made from mercury and sulphur. First made by the ancient Greeks.

VERNISSAGE French word for "varnishing day". This was the day before an exhibition opened, when

 \searrow

artists added the finishing touches or final varnish to their work, which was already hanging on the wall. Nowadays *venissage* is simply a chic name for private viewing.

VIDEO ART A work of art made to be viewed on one or more television screens installed in a gallery. Claims to investigate and use the artistic possibilities of the medium – the unique colour, brightness, and movement that television has. It usually has no narrative or documentary content and so is utterly different from what you see on television at home. See Hatoum (p.470); Hirst (p.476); Paik (p.458); Viola (p.469)

VIGNETTE Either a small, usually figurative, design, such as a portrait or a still life, without a border and shading off at the edges, or a scene describing a brief, often domestic, narrative incident. Originally it meant a design of vine leaves and tendrils.

VINGT, LES Influential avant-garde Belgian group of the 1880s, who showed their own work alongside most of the progressive French artists from Manet onwards. See Ensor (p.366)

VIRIDIAN A bright-green chrome-based pigment, non-poisonous, introduced in the early 19th century.

VORTICISM (See p. 376) Avant-garde British art movement, 1913–15. Took up Cubist and Futurist ideas and aimed to shake up the stuffy British art world and society generally. See Bomberg (p.377); Lewis, (Percy) Wyndham (p.376); Roberts (p.377)

WASH Very watery watercolour or ink flooded on to paper from a brush to cover a large area. Ruskin used watercolour wash with great effect to capture the texture of architectural brick- and stonework as well as light and atmosphere.

WATERCOLOUR Any type of painting medium soluble in water is, technically, watercolour. What is usually meant, however, are those works on paper with thin washes of transparent watercolour paint that the English find so appealing. The technique is fiendishly difficult. Notice how the greatest masters have the ability to combine luminous atmospheric effects and minute detail in the same work; for some reason no other medium can do this so successfully. Thomas Girtin was a genuine innovator, and potentially one of the greatest watercolour masters, but he died of consumption at the age of 27. Sær Cézanne (pp.334–335); Girtin (p.244); Turner (p.281)

WET INTO WET Painting wet paint into wet paint. In oils, this produces a very luscious, juicy result. See Manet (p.307); Ribera (p.185); Sargent (p.326); Velasquez (p.187)

WHITE LEAD The most important pigment in the history of Western painting. The only white pigment available until the 19th century, made from lead strips. It absorbs X-rays and so allows X-ray photography to reveal what goes on under the visible surface of a painting. WOOD ENGRAVING A printmaking process that uses a block of very hard fine-grained wood, such as box. Look for small-scale works in black and white, which have minute and fine detail.

WOODBLOCK PRINT Usually refers to Japanese woodcuts.

WOODCUT One of the most basic printing techniques, whereby the design to be printed is cut into a block of wood. Most 15th- and 16th-century prints, especially for book illustration, use the technique. It was replaced by metal engraving and then revived at the end of the 19th century. No one has ever surpassed the mastery of Durer. See Cranach (p.125); Dürer (pp.126–127); Gauguin (p.329); Holbein (p.160); Kollwitz (p.366); Munch (p.360); Schad (p.385); Schmidt-Rottluff (p.63)

WORKSHOP OF ... See Studio of ...

W. P. A. Stands for Works Progress Administration, an American government scheme to give employment to artists during the 1930s Depression. Involved all the arts and sponsored 100,000 paintings, 2,500 murals and 2 million posters.

X-RAY A standard conservation and restoration technique. Because underpainting is often done with paints mixed with white lead, X-ray photographs will show what went on under the surface of a surface (since X-rays don't pass through lead). See also White lead

XYLOGRAPHY Rarely used word for woodcut or wood engraving.

YBAs Young British Artists. Band of so-called "cutting-edge" artists who captured an international following in the 1990s, when they were mostly aged around 30. Many trained at Goldsmiths College, London. Work is mostly Conceptual. Themes tend to be current social issues. Very efficient at "making art", but curiously passionless. See also Social realism. See Hirst (p.476); Offli (p.477); Whiteread (p.476)

YELLOWING Oil paintings can darken or yellow with age. Yellowing is caused by old linseed oil or by dirt or by smoke (nicotine leaves a yellow deposit), or a combination of these.

ZIGGURAT Ancient Mesopotamian pyramid-shaped tower with a square base.

ZINC WHITE An alternative pigment to white lead. It is not poisonous and is the least opaque of all white pigments.

WHITE SPIRIT A turpentine substitute.

Index

Page numbers in **bold** refer to main entries.

A

Abbate, Niccolò dell' 154 Abstract Expressionism 405, 412-13, 414-17, 431, 440, 445 Abstraction 353, 356, 358-9, 374, 383, 389, 393, 400, 410, 436, 457.467 Colour Field 414 Geometric 386, 388 Synchronism 383 see also Abstract Expressionism; CoBrA Academic Art 258-61 Academies 22-3, 284 Britain 238, 239, 241, 284, 298, 379 France 284, 306, 312 acrylics 35 Adam, Robert 242, 250 Kedleston Hall. Derbyshire 250 Aegean World, Early 52-3 Aertsen, Pieter 156 The Adoration of the Shepherds 156 Aestheticism 321, 322-3. 325 African sculpture 347, 349, 357 Agasse, Jacques-Laurent 247 Miss Casenove on a Grey Hunter 247 Age of Reason 219, 224, 246 Albers, Josef 386, 388 "Homage to the Square" 388 Alechinsky, Pierre 418, 419 Octave 419 Algardi, Alessandro 169 Allan, David 246 Alma-Tadema, Sir Lawrence 288 The Tepidarium 288 Altdorfer, Albrecht 158 Beheading of St. Catherine 158 Alys, Francis 475 America American School, rise of 256, 257 Contemporary 452-7, 458, 459-3, 464, 467, 469, 470, 472-3, 474-5, 477 Declaration of Independence 221 Early Modernists 380 - 3expansion 261 Impressionism 316-17 Modernists 37 404-17, 436-45 Romanticism 274, 275, 290-5

André, Carl 459 Tomb of the Golden Engenderers 459 Andrews, Michael 435 Angelico, Fra 89 The Beheading of St. Cosmas and St. Damian 89 Santa Trinità Altarpiece 22 Antonello da Messina 104 Appel, Karel 418 Arcimboldo, Giuseppe 159 Water 159 Arellano, Juan de 186 Still Life of Flowers in a Basket 186 Arman, Armand Fernandez 421 Office Fetish 421 Arp, Jean (Hans) 367, 368-9 390 Head 368 Art Brut 419 Art Nouveau 325, 338. 357 Arte Povera 425, 426, 427 artist. masterpiece, definition 26-7 role of 18-20 through history 16-17 Ashcan School 380, 381 Auerbach, Frank 432 Avercamp, Hendrick 208 Winter Scene with Skaters near a Castle 209

B

Baldung Grien, Hans 125 Balla, Giacomo 374, 375 Dynamism of a Dog on a Lead 374 Balthus 404 Bandinelli, Baccio 20 Cosimo de' Medici 20 Barbizon School 304, 305 Barney, Matthew 477 Barocci, Federico 151 The Circumcision of Christ 151 Baroque Era 39, 146, 151, 162-5, 173, 174-5, 177, **178-9**, 185-9, 190-3 architecture 164-5 Barry, James 241 Bartolommeo, Fra Baccio della Porta 135 Baselitz, Georg 461 Picture-Eleven 461 Basquiat, Jean-Michel 475 Bassano, Jacopo 151 Batchelor, David 448-9 The Spectrum of Brick Lane 448-9 Batoni, Pompeo Girolamo 237 Baudelaire, Charles 270 Bauhaus 364, 372, 386, 387, 388

Beardsley, Aubrey 325 Beckmann, Max 362, 384 Self-Portrait in Olive and Brown 384 Bell, Vanessa 379 Bellini, Gentile 102 Procession in St. Mark's Square 102-3 Bellini, Giovanni 102, 103, 143 Agony in the Garden 103 Bellini, Jacopo 102 The Madonna of Humility adored by Leonello d'Este 102 Bellotto, Bernardo 236-7 View of Warsaw from the Royal Castle 236 Bellows, George Wesley 380, 381 A Stag at Sharkey's 37, 381 Benton, Thomas Hart 409 Berenson, Bernard 24, 142 Bernard, Emile 332 Bernini, Gianlorenzo 169, 173-5, 178 Apollo and Daphne 173 Cornaro Chapel 174-5 Fontana del Moro 178 Fountain of the Four Rivers 162 Berruguete, Pedro 118 Beuys, Joseph 41, 43, 453 Earth Telephone 453 Bevan, Robert Polhill 378 Bible 130, 297, 302 Title Page, the Great Bible, 1539 130 Bierstadt, Albert 292 Bingham, George Caleb 292 Blake, Sir Peter 446 Blake, William 248, 280 The Ancient of Days 248 Blaue Reiter, Der 364, 365 Bloomsbury Group 378, 379 Boccioni, Umberto 374, 375 Unique Forms of Continuity in Space 374 Böcklin, Arnold 325 Boetti, Alighiero 427 Bringing the World into the World 426-7 Bol, Ferdinand 202 Portrait of a Husband and Wife 202 Bologna, School of 166 Boltanski, Christian 41, 466 Monuments: The Children of Dijon 466 Bomberg, David 377 Bonington Richard Parkes 268-9 The Undercliff 268-9 Bonnard, Pierre 336 The Almond Tree in Blossom 336 Bordone, Paris 151 Bosch, Hieronymus 121, 324

The Garden of Earthly Delights: Hell 120 Triptych of the Temptation of St. Anthony 120-1 Botero, Fernando 457 Both, Jan 212 Botticelli, Alessandro 26, 88, 96, 98-9, 299 The Adoration of the Magi 96 Birth of Venus 26, 44-5 La Primavera 98-9 Boucher, François 224-5, 226, 227 Bacchus and Erigone 227 Bouguereau, William-Adolphe 285 The Birth of Venus 285 Bourdichon, Jean 119 Anne of Brittany with St. Anne, St. Ursula, and St. Helen 119 Grandes Heures 119 Bourgeois, Louise 452 Quarantania 452 Bouts, Dieric 114 Hell 114 Bramante 138 Brancusi, Constantin 39, 356 Bird in Space 356 Braque, Georges 35. 346, 350, 351, 401 Studio V 351 Brett, John 298 Breton, André 390 Les Champs Magnétiques 390 Manifesto for an Independent Revolutionary Art 390 Surrealist Manifesto 390 Britain Academic Art 259, 260, 261, 286-9 contemporary 465, 468, 470-1, 474, 475-6, 477 modern masters 398-401, 430, 431-6, 446 - 7painting, 18th century 219-21, 238-48 Romanticism 259, 260, 261, 266, 276-82 see also Bloomsbury Group; English Landscape Tradition; Pre-Raphaelites; St Ives Group; Vorticism bronze sculpture 38 Bronzino, Agnolo 146, 148-9 An Allegory with Venus and Cupid 148 Broodthaers, Marcel 422 Brown, Ford Madox 296 Work 296 Browning, Robert 297 Bruce, Patrick Henry 383 Brücke, Die 362, 363 Brueghel, Jan 195 Bruegel, Pieter (the elder) 157, 195 Hunters in the Snow -February 157 Tower of Babel (detail) 157

18 86 105 139 170

The Triumph of Death 74 Brueghel, Pieter (the younger) 195 A Village Festival in Honour of St. Hubert and St. Anthony 195 Brunelleschi, Filippo 75 Dome of Florence Cathedral 75 Burgundian School 85 Burne-Jones, Sir Edward Coley 297, 298-9 St. George and the Dragon 299 Burri, Alberto 424 Byron 268 Byzantine Art 64-5, 78, 79.155 Christ Pantocrator 64-5 Emperor Justinian I and his Retinue 65 Madonna and Child 64

С

Cabanel, Alexandre 285 Cleopatra Testing Poisons on Those Condemned to Death 285 Caillebotte, Gustave 311 Calder, Alexander 40, 340-1, 438 Blue Feather 438 studio 40 Young Lady and her Scribe 340-1 Calle, Sophie 470 Callot, Jacques 164 The Hanging 164 Campin, Robert 111 Canaletto, Giovanni Antonio 235, 236, 237 The Basin of San Marco on Ascension Day 234-5 Canova, Antonio 254, 255 Cupid and Psyche 254 Paulina Bonaparte Borghese as Venus 250, 254 Caravaggio 168, 169, 170-1, 172, 177, 185 199 Judith and Holofernes 170 The Sick Bacchus 171 The Supper at Emmaus 170-1, 178 Caro, Sir Anthony 434-5 Carpaccio, Vittore 141 Dream of St. Ursula 141 Carrà, Carlo 375 Interventionist Demonstration 375 Carracci, Annibale 167. 178, 179 Farnese Palace, Rome 167, 179 Fishing 167 The Holy Women at Christ's Tomb 167 Venus and Anchises 179 Carriera, Rosalba Giovanna 229 Caterina Sagredo Barbarigo as "Bernice" 229 Cassatt, Mary 30, 316 Castiglione. Baldassare 129

The Book of the Courtier 129, 138 Catena, Vincenzo 142 Caulfield, Patrick 446 cave painting 48-9 The Great Hall, Lascaux 48-9 Cellini, Benvenuto 149 Saltcellar 149 Celtic Art 66-7 Book of Kells 67 Cennini, Cennino 30 César (César Baldaccini) 420 Cézanne, Paul 26, 180. 184, 331, 332, **334-5** 344, 346, 349, 351, 357 The Large Bathers 335, 344 Montagne Sainte-Victoire with Trees and a House 333-4 Self-Portrait 334 Still Life with Basket 334 Chagall, Marc 354-5 The Juggler 355 chalks 30 Chamberlain, John 455 Untitled 455 Champaigne, Phillippe de 183 Chapman, Jake and Dinos 475 charcoal 30 Chardin, Jean 224 Still Life 224 Charles I 165, 194, 198 Charles II 216, 217 Charles V Holv Roman Emperor, 129, 130 Chase, William Merritt 316 - 17Portrait of a Lady in Black 316 Chia, Sandro 427 chiaroscuro 184, 203 Chillida, Eduardo 428-9 Berlin 428-9 Chirico, Giorgio de 375, 394, 404 The Mystery and Melancholy of a Street 404 Christo & Jeanne-Claude 43, 460 The Gates 2-3 Surrounded Islands 43 Wrapped Trees 460 Christus, Petrus 115 Church, Frederick Edwin 290-1 Cotopaxi 291 Church, conflict, 16th century 129-31 conflict, 17th century 162 Counter Reformation Patronage 17, 20, 129 Cimabue (Cenni di Peppi) 78, 80 Madonna and Child Enthroned with Eight Angels and Four Prophets (or Maestà) 78 Classical Antiquity 17,

180, 239, 325, 400 Classical Greece 32, 33, 38, 39, 54-5 Altar of Zeus 57 The Battle of Issus 56 Boy from Antikythera 55 Centaur Triumphing over a Lapith 54 Derveni krater 57 Dying Gaul 56 Kouros 39, 53 Laocoön 58-9 Red-figure vase 54 see also Aegean World. Early; Hellenistic Art Classical Rome 32, 33, 38. 60-1 Ara Pacis (Imperial) 60 Equestrian statue of Emperor Marcus Aurelius (Imperial) 60, 61 Nile in Flood (Imperial) 60 - 1see also Late Roman and Early Christian Art Claude Lorrain 154. 182-3, 212, 243 Landscape with the Marriage of Isaac and Rebekah 182-3 Clemente, Francesco 427, 469 Clodion, Claude Michel Arc de Triomphe 250 Close Chuck 463 Self-Portrait 463 Clouet, Francois 154 Charles IX 154 Coates, Robert 412 CoBrA 418, 419 Coello, Claudio 186 Cole, Thomas 290 Scene from "The Last of the Mohicans" 290 Coleridge, Samuel 266 collage 35 collectors 20-2 Columbus, Christopher 75 computers 42, 451 Conceptual art 367, 460 connoisseurs 24 Constable, John 31, 245, 277, 278-9, 304, 314, 468 Dedham Church 266 Flatford Old Mill Cottage on the Stour 277 The Hay Wain 278-9 Stour Valley 266 Constructivism 40, 368, 372. 373 Contemporary Art 29, 448-79 The Pompidou Centre, Paris 450-1 Copernicus 131 Copley, John Singleton 256 - 7Corinth, Lovis 337 Cornell, Joseph 406 Cornelius, Peter von 273 Faust 273 Corot, Jean-Baptiste-Camille 304 Woman with a Pearl 304

Correggio, Antonio 150-1, 154, 249 Cortona, Pietro da 177 Cosimo I de' Medici 20, 91, 146, 147, 149 Cosway, Richard 242 Cotman, John Sell 276 The Marl Pit 276 Courbet, Gustave 18, 300, 301, 306, 307 Caricature of Gustave Courbet 19 The Painter's Studio 300. 301 Stonebreakers 300 Cox, David 276, 277 Cozens, Alexander 244 Cozens, Robert 244 London from Greenwich Hill 243 Cranach, Lucas (the elder) 125 The Nymph of the Fountain 125 Credi, Lorenzo di 96-7 criticism 24, 25 Crivelli, Carlo 105 The Annunciation with St. Emidius 105 Crome, John 276 View of Mousehold Heath, near Norwich 276 Cubism 35, 350, 351, 352, 357, 362, 365, 370, 374, 375, 382, 383, 386, 389, 390, 396 Cuyp, Aelbert 209 A Herdsman with Five Cows by a River 209

D

Dada 41, 43, 367, 368, 369, 390, 394, 443 Dadd, Richard 289 Daddi, Bernardo 76 Polyptych with the Crucifixion and Saints 76 Dahl, Michael 217 Dalí, Salvador 390, 392 Soft Construction with Boiled Beans: Premonition of Civil War 392 Daniels, Harvey Tree 35 Dante 78, 268 Divine Comedy 101, 319 Daumier, Honoré 307 The Third-Class Carriage 307 David, Gerrit 117 God the Father Blessing 117 David, Jacques-Louis 247, 250, 251, 252-3, 267 Napoleon Crossing the Alps on 20th May 1800 253 The Oath of the Horatii 251 Davie, Alan 431 Davis, Stuart 383 dealers 20, 21 Deem, George 459 Degas, Edgar 30, 312, 315, 316, 326 Blue Dancers 30

INDEX

Little Dancer 312 The Star, or Dancer on Stage 315 Woman Drying Herself 315 Delacroix, Eugene 223, 268, 269, 270-1, 323 Liberty Leading the People 270-1 Scenes from the Massacre of Chios 268 Delaunay, Robert 354 Delaunay, Sonia 354 Delft School 196 Delvaux, Paul 394 Demuth, Charles 407 Denis, Maurice 325 Derain, André 346, 347 Devis, Arthur 239 Dibbets, Jan 463 Dickens, Charles 331 Diebenkorn, Richard 417 "Ocean Park" series 417 Diller, Burgovne 383 Dine, Jim 439 Divisionism 314, 320. 344, 374 Dix 384, 385 Dobson, William 216 Doesburg, Theo van 389 Domenichino 168 The Last Sacrament of St. Jerome 168 Donatello 88, 90-1, 101, 318 David 90 Dongen, Kees van 354 Dossi, Dosso 141 Dotrement, Christian 418 Dou, Gerritt 202 The Village Grocer 202 Dove, Arthur Garfield 383 drawing 30-1 Dubuffet, Jean 419 Duc de Berry, Jean 77 Duccio di Buoninsegna 78-9, 82, 84 Duchamp, Marcel 41, 367, 443 Fountain (Urinal) 41, 367 Hat Rack 41 Dufy, Raoul 346, 353 The Regatta at Cowes 353 Dughet, Gaspard 183 Durand-Ruel, Paul 21 Dürer, Albrecht 36. 115, 116, 124, 126-7, 148, 273 Altarpiece of the Rose Garlands 126-7 Melancolia 127 Self-Portrait at the Age of Twenty-eight 126 A Young Hare 126 Dutch art see Netherlands

E

Eakins, Thomas 295, 380 Earl, Ralph 257 Early art 29, 47–71 see also Aegean World; Byzantine; Celtic, Saxon & Viking;

Classical Greece; Classical Rome; Gothic, Early; Egypt, Ancient ; Medieval; Romanesque; egg tempera 32 Egypt, Ancient 32, 38, 39. 50-1 Bird-scarab pectoral from Tutankamun's tomb 50 Book of the Dead 50-1 Mask from mummy-case of Tutankhamun 47 Palette of Narmer 50 Relief from tomb of Ramose 51 El Greco 146, 155, 357 The Burial of Count Orgaz, from a Legend of The Resurrection 155 Eliasson, Olanus 41 The Forked Forest Path 41 Elsheimer, Adam 158 Emin, Tracey 476 encaustic 32 beeswax 32 English Landscape Tradition 243, 304 engraving 36 copperplate 36 The Engraver 36 tools 36 Enlightenment, The 219, 221, 262, 266 Ensor, James 366 Christ's Triumphant Entry into Brussels 366 Epstein, Sir Jacob 377 St. Michael Vanquishing the Devil 377 Ernst, Max 35, 324, 367, 369, 390, 391 The Entire City 369 Oedipus Rex 391 Estes, Richard 458 Eworth, Hans 161 Queen Mary I 161 exploration 75, 130, 131 Expressionism 358-9, 360-7, 382, 396, 418, 432, 466 Exter, Alexandra 370

F

Fabritius, Carel 203 Fabro, Luciano 426-7 Falconet, Etienne 226 Education de l'Amour 226 Fantin-Latour, Henri 302 Fauves, Les 346, 351, 354, 364, 370 Feininger, Lyonel 386 fête galante 222, 223 Fildes, Sir Luke 288 Doctor 288 Fiorentino, Rosso 146, 153 Flavin, Dan 459 Flemish painting 33, 114-15, 116, 149, 156, 157, 158, 190-5 Flinck, Govaert 202 Florence 74-5, 78, 80, 83, 88-100, 105, 132, 135-7, 148 Fluxus 423

Fontainebleau 153, 154, 305 Fontana, Lucio 424 Fouquet, Jean 118-19 Fragonard, Jean-Honoré 226, 228-9 The Swing 226, 228 France Academic Art 258-61, 284, 285, 306, 312 classical landscape 180 - 2contemporary 452, 466, 470 Impressionism 277, 302 304, 310-14 industrialization, 261 Neo-Classicism 218-221, 251, 252-3 Realism 300-1, 304, 306 Renaissance 118-19 Revolution 18, 221, 223, 227, 228, 253, 266 Rococo 218-221, 999-9 Romanticism 258-61. 266, 267, 268, 269-70, 304 Thirty Years' War, effect of 164 see also Art Nouveau; Barbizon School; Cubism; Divisionism; Les Fauves; Post-Impressionism; School of Paris; Symbolism Francis I 130, 131 Château de Chambord, Loire Valley 131 Francis, Sam 416 In Lovely Blueness 416 Frederigo da Montefeltro, Urbino, Duke of 106 fresco 33 Freud, Lucian 434 The Painter's Mother 434-5 Freud, Sigmund 339, 360, 367, 390, 391, 392, 395, 396 Friedrich, Caspar, David 266, 272, 273 Monk by the Sea 266 The Stages of Life 272 Winter Landscape 272 Frith, William Powell 287 Derby Day 286 Frost, Terry 400, 430 Red and Blue 430-1 Fruosino, Bartolomeo di, illuminated "P" 77 Fry; Roger 379 Fuseli, Henry 248 The Nightmare 248 Futurism 350, 370, 373, 374, **375**

G

Gabo, Naum **372** Linear Construction in Space No. 1 372 Gaddi, Taddeo **78** Gainsborough, Thomas 186, **240** Mr. and Mrs. Andrews 240

The Painter's Daughters Chasing a Butterfly 240 Galileo Galilei 165 Gallego, Fernando 118 Pietà with Two Donors 118 galleries 22-4 Grand Gallery of the Louvre 22 Guggenheim Museum, Bilbao 24 Hermitage, St. Petersburg 11 Gauguin, Paul 324, 328, 329, 331, 332 Landscape at Pont Aven 328 The Meal 329 Nevermore 329 Gentile da Fabriano 83 The Presentation in the Temple (from the Altarpiece of the Adoration of the Magi) 83 Gentileschi, Artemisia 172 Judith and her Maidservant 172 Gentileschi, Orazio 169, 172 Rest on the Flight into Egypt 169 George I 217 George II 216 George IV (Prince Regent) 280 Géricault, Théodore 267, 269 Portrait of a Woman Addicted to Gambling 269 The Raft of the Medusa 267, 269 Germany, contemporary 453, 458, 460, 461, 462, 464, 465, 466, 467, 470, 472, 473 Expressionism 121, 358, 360, 362-3, 364-5, 382, 384, 466 printing 36, 75 Romanticism 259, 260-1, 272-3, 274, 365 Thirty Years' War 163-4 Gertler, Mark 379 Ghiberti, Lorenzo 84, 86. 88 The Sacrifice of Isaac 86 Ghirlandaio, David 95 Ghirlandaio, Domenico 95 The Visitation 95 Giambologna 149 The Rape of the Sabines 149 Gibbons, Grinling 217 Woodcarving of a Cravat 217 Gilbert and George 465 Street 465 Giordano, Luca 177 The Crucifixion of St. Peter 177 Giorgione 140, 141, 143, 151, 223 The Sleeping Venus 140 The Tempest 140

The Three Philosophers 140

I N D E X

Hitchcock, Alfred 408

Giotto di Bondone 76, 78-9, 80-1, 82, 88 Campanile of the Duomo, Florence 80 Cappella degli Scrovegni, frescoes, Padua 81 The Ecstasy of St. Francis 81 Giovanni di Paolo 84 Girardon, Francois 184 Girodet-Trioson, Anne-Louis 264 Girtin, Thomas 244 The White House, Chelsea 243 Glackens, William James 380 Gober, Robert 472 Goes, Hugo van der 108, 116 The Adoration of the Shepherds 116 Portinari Altarpiece 108, 116 Goethe, Johann Wolfgang von 221, 273 Goldin, Nan 470 Goldsworthy, Andy 43, 474 Arch at Goodwood 474 Goncharova, Natalia 370 Gonzaga family 106, 147 González, Julio 352 Gonzalez-Torres, Felix 474-5 Gorky, Arshile 417 Untitled 1946 417 Gormley, Anthony 468-9 Angel of the North 468 Gossaert, Jan 116 Gothic style 73-5, 74, 76, 79, 89, 121 carvings, Chartres (Early) 71 Early **70–1** International 74, 83, 84,86 Roettgen Pietà 74 Romantic 272, 273 Rose window, Chartres, 70 Gottlieb, Adolph 412, 416 gouache 34 Goya, Francisco 262-3, 308 Los Caprichos 36, 262 The Clothed Maja 262-3 Here Neither, Plate 36, The Disasters of War 262, 263 Of What Ill will he Die? 36 The Third of May 266 Gozzoli, Benozzo 86. 92-3 The Procession of the Magi 86, 93 The Triumph of St. Aquinas 92 Grand Tour 234. 235, 237 Grant, Duncan 379 Greece see Aegean World, Early; Classical Greece Greuze, Jean-Baptiste 225 Le Geste Napolitain 225

Gros, Antoine-Jean 264

Napoleon in the Plague

Grosz, George 384, 385 Grünewald, Mathis 121, 122-3 Crucifixion (from The Isenheim Altarpiece) 122 - 3The Isenheim Altarpiece 121 The Resurrection of Christ 121 Guardi, Francesco 236 Landscape with Ruins 236 Guercino 172 Guimard, Hector Germain 338 Gursky, Andreas 473 Guston, Philip 445 Legend 445 Gutenberg, Johannes 75 Guttuso, Renato 424 Death of a Hero 424 н Hals, Frans 196, 198, 337 The Laughing Cavalier 198

House at Jaffa 264

Portrait of Madame

Bruyère 264

Hamilton, Gavin 241 Hamilton, Richard 440, 446 Just what is it that Makes Today's Homes so Different, so Appealing? 440 Hanson, Duane 454-5 Homeless Person, 454 Haring, Keith 475 Hartley, Marsden 382 Abstraction 382 Hartung, Hans 422-3 Hassam, Childe 316 Hatoum, Mona 470 Heade, Martin Johnson 291 Heartfield, John 369 Heckel, Erich 363 Heem, Jan Davidsz de 199 Still Life of Fruit and Flowers 199 Heemskerck, Maerten van 156 Family Group 156 Hellenistic Art 56-9 Altar of Zeus 57 The Battle of Issus 56 Derveni krater 57 Dying Gaul 56 Henri, Robert 380, 383 The Little Dancer 380 Henry VIII 129 Hepworth, Dame Barbara 39, 400 Involute 1 400 Heron, Patrick 400 Hesse, Eva 40, 460 Hey, Jean 119 Hicks, Edward 275 Peaceable Kingdom 275 Hilliard, Nicholas 161 Portrait of Robert Devereux, Earl of Essex 161 Hilton, Roger 434 Hirst, Damien 476-7 Away from the Flock 477 history, art 24-5

Hitchens, Ivon 398 Hobbema, Meyndert 210 Hockney, David 447 Sunbather 447 Hodler, Ferdinand 337 Hofmann, Hans 404-5 Hogarth, William 231, 238 Marriage à la Mode: VI, The Lady's Death 238 The Rake's Progress 238 Self-Portrait 238 Hokusai, Katsushika 322, 347 Japanese Ghost 322 Holbein, Hans (the younger) 160 Lady with a Squirrel and a Starling 160 Portrait of a Youth in a Broad-brimmed Hat 160 Holland see Netherlands painting, 17th century 20, 157, 196-215, 244, 302, 392 Realism 196-7 Homer, Winslow 294 Eight Bells 294 Honthorst 172 Hooch, Pieter de 211 Hopper, Edward 408 Chop Suey 408 Horn, Rebecca 41, 466 Houdon, Jean-Antoine 252 François-Marie Arouet Voltaire 252 Hudson River School 290 Hugo, Victor 270 Humanism 86, 91 Hundertwasser, Fritz 423 686 Good Morning City 37, 423 Hunt, Holman, William 276, 297, 298 Isabella and the Pot of Basil 297

I

illumination 32, 76, 77, 82, 84 Immendorff, Jorg 466 World of Work 466 Impressionism 21 312-13, 325, 326, 327, 328, 375 Indiana, Robert (John Clark) 445 Industrialization 220, 260-1 James Watt, rotary steam engine 220 Ingres, Jean-Auguste-Dominique 31, 258-9, 264-5, 287 The Turkish Bath 258-9 The Valpinçon Bather 265 Innocent X, Pope 169 Installations 41 Italy Baroque 151, 162, 164-5, 166-79 Neo-Classicism 250, 254 Renaissance 74-5,

86–7, 106, 128–31, 138–9 Rococo 229–33 see also Classical Rome; Futurism

J

James II 165 Japanese art 36, 321, 322, 325, 329, 331 Jawlensky, Alexei 370 Head of a Woman 370 John, Augustus 378 Dorelia in a Landscape 378 John, Gwen 378 Johns, Jasper 32, 440, 442-3 Ale Cans 443 Three Flags 442 Jones, Allen 446-7 Joos van Cleve 117 Jordaens, Jacob 190 Jorn, Asger 418 Judd, Donald (Don) 455 Julius II, Pope 138, 139

K

Kahlo, Frida 403 Suicide of Dorothy Hale 403 Kandinsky, Wassily 358, 359, 364, 365, 370, 384, 386 Accent in Pink 364 Black Frame 359 Kapoor, Anish 470-1 Marsyas 471 Katz, Alex 442 Dusk 442 Kauffmann, Angelica 242 Kelly, Ellsworth 438 Kiefer, Anselm 467 Kippenberger, Martin 470 Kirchner, Ernst Ludwig 362 - 3Berlin Street Scene 363 Kitaj, R. B. 30, 432 Value, Price, and Profit, or Production of Waste 432 Klee, Paul 34, 386, 387, 418 The Golden Fish 387 Klimt, Gustav 338, 339 The Kiss 339 Klein, Yves 43, 420-1 Kline, Franz 412, 415 Ballantine 412 Kneller, Sir Godfrey 216, 217 Købke, Christen, 289 River Bank at Emilliekilde 289 Kokoschka, Oskar 358, 367 Storm Tide in Hamburg 358 Kollwitz, Käthe 366 The Survivors; War against War 366 Koninck, Philips 207 Panoramic Landscape 207 Kooning, Willem de 412, 414

Man on the Dunes 412 Koons, Jeff Popples 473 Kossoff, Leon Kounellis, Jannis Kupka, Frank

L

La Tour, Georges de 170, 184, 229 St. Joseph the Carpenter 184 Lancret, Nicolas 224, 231 land art 43 Landseer, Sir Edwin 288 Lane, Fitz Hugh 291 Lanfranco, Giovanni 151, 168 Christ and the Woman of Samaria 168-9 Larsson, Carl 303 Lastman, Pieter 198, 200 The Expulsion of Hagar 199 Late Roman and Early Christian Art Holy Women at the Tomb of Christ 62 Mummy-case portrait from Fayum 62 Lawrence, Jacob 409 "Migration" series 409 Lawrence, Sir Thomas 286-7 Portrait of Arthur Wellesley, Ist Duke of Wellington 287 Le Nain Brothers 184 LeBrun 284 Léger, Fernand 352 Two Women holding a Pot of Flowers 352 Leighton, Lord Frederic 287 Garden of the Hesperides 287 Lely, Sir Peter 216 Anne Hyde, Duchess of York 216 Leonardo da Vinci 30, 96, 115, 132-3, 135, 138 The Last Supper 132-3, 138 Mona Lisa 13, 17, 133, 138 Two Horsemen 132 The Virgin on the Rocks 133 Leutze, Emmanuel Gottlieb 274-5 Washington Crossing the Delaware River, 25th December 1776 274-5 Lewis, John Frederick 289 Indoor Gossip, Cairo 289 Lewis, (Percy) Wyndham 375, 376, 377 A Battery Shelled 376 Blast Front cover of War Number 376 Lewitt, Sol 456 49 Three-Part Variations of the Three Different Kinds of Cubes 456 Lichtenstein, Rov 440, 441

Anxious Girl 441

Liebermann, Max

302, 338

A Country Brasserie, Brannenburg, Bavaria 302 Limbourg brothers 77 Les Belles Heures 77 Death, One of the Four Riders of the Apocalypse 77 Les Très Riches Heures 77 Linnell, John 276, 280 Lipchitz, Jacques 352-3 Lippi, Filippino 95 Lippi, Fra Filippo 88-9.95 Lissitsky, El 373 Lithography 37 Lochner, Stephan 85 The Last Judgement 84-5 Lombardo family 105, 106 Monument to Doge Pietro Mocenigo 105 Long, Richard 468 Longhi, Pietro 231 Exhibition of a Rhinoceros at Venice 231 Lorenzetti brothers 79 Allegory of Good Government: Effects of Good Government in the City 78-9 Lorenzo il Magnifico 90 Lorenzo Monaco 82 Madonna Enthroned between Adoring Angels 82 Lorrain, Claude see Claude Lorrain Lotto, Lorenzo 142 Louis XIII 180, 183 Louis XIV 163, 164, 165, 178, 184, 220, 226, 284 Louis XV 224, 255 Louis XVI 266 Louis, Morris 436-7 Loutherbourg, Jacques Philippe de 245 Battle Between Richard I Lionheart and Saladin in Palestine 945 Lowry, Laurence Stephen 430 Luks, George 380 Luther, Martin 126, 130 95 Theses 130

Μ

Macdonald-Wright, Stanton 383 Macke, August 358, 365 Maes, Nicolaes 203 An Eavesdropper with a Woman Scolding 203 Magritte, René 390, 394, 395 The Human Condition 395 Mahler 339 Makart, Hans 286 Malevich, Kasimir 371 Suprematist Composition No. 56 371 Malory, Morte d'Arthur 297 Man Ray 42, 367, 385, **394** The Aged Emak Bakia 394 Rayograph 42 Manet, Edouard 198,

300, 307, 308-9, 314, 317, 321, 329, 380, 442 The Bar at the Folies-Bergère 306-7 Le Déjeuner sur l'Herbe 300, 308 Olympia 308-9 Manfredi, Bartolommeo 172 Mannerism 131, 146, 148, 150, 153, 154 158 Mantegna, Andrea 73,106, 114, 151 Camera degli Sposi 73 Manzoni, Piero 426 Marc, Franz 358, 365 Faultier 358 Little Blue Horse 364-5 Marden, Brice 461 Marlow, William 245 The Pont de Gard. Nimes 245 Marquet, Albert 347 The Seine at Paris 347 Martin, Agnes 452 Martin, John 280 Masaccio (Tommaso Giovanni di Mone) 84, 88 The Trinity 88 Masolino da Panicale 84 masterpiece, definition 26-7 Masson, André 393 Massys, Quentin 115 The Money Lender and his Wife 115 materials 29-43 Matisse, Henri 324, 329, 336, **344-5**, 346, 347. 354, 362, 365, 370, 400, 438 La Cirque 345 Jazz 345 Luxe, calme, et volupté (Luxury, Serenity, and Pleasure) 345 Large Reclining Nude 344 Notes of a Painter 345 Odalisque 345 Self-Portrait 344 Matta 395 Matteo di Giovanni 101 Madonna and Child with Sts. Catherine and Christopher 101 media and materials 28-43 Medici 75, 90, 91, 116, 132, 146, 147, 149 Medieval Art 17, 19, 39, 68 - 9Book cover 69 Cross of Gero 68–9 Otto II, Holy Roman Emperor 69 St. Mark from Carolingian Gospel Book 68 Memling, Hans 114 Portrait of a Man 114 Mengs, Anton Raphael 249 Merz, Mario 424-5 What's to be Done? 425 Messerschmidt, Franz Xaver 249

Metaphysical movement 375 Metsu, Gabriel 212 Mexico, modern painting 35.402 - 3Michaux, Henri 422 The Andes Cordillera 422 Michel, Louis 229 Michelangelo 20, 26, 30, 33, 39, 88, 91, 94, 95, 126, 129, 135, 136-7 138, 139, 146, 147, 148, 149, 155, 167, 248, 269, 287, 299, 318 The Creation of Adam 33 David 26, 138 The Delphic Sibyl 128-9 Holy Family with St. John (Doni Tondo) 136 The Last Judgement 136 Pietà 137 Study of a Man Shouting 31 Millais, Jean-François 300, **305** The Angelus 305 The Gleaners 300 Millais, Sir John Everett 297. 298 The Rescue 297 Miller, George 37 lithograph of A Stag at Sharkey's 37 Milles, Carl 337 Milton, John 248 Minimalist art 456, 460 Minoan art 52-3 Bull-leaping fresco 52-3 Miró, Joan 390, 393. 417, 418 exhibition poster 11 Harlequin's Carnival 393 Modernism 21, 40-3, 80, 134, 337, **340-3**, 344, 352, 261, 364, 370, 371, 376, 377, 387, 388 see also Abstraction; Constructivism; Cubism; Dada; Expressionism; Futurism; Op art; Pop Art, Surrealism Modigliani, Amedeo 357. 377 Jeanne Hébuterne in a Yellow Jumper 357 Moholy-Nagy, László 386 At Coffee 386 Mondrian, Piet 384, 389, 401 Broadway Boogie Woogie 389 Monet, Claude 304, 310, 312, 317, 327 Impression Sunrise 312 The Japanese Bridge at Giverny 310 Waterlily Pond 310 Moore, Henry 39, 399, 400 Reclining Figure 399 Moran, Thomas 292 The Grand Canyon of the Yellowstone 292 Morandi, Giorgio 404 Moreau, Gustave 322, 324 Mori, Mariko 477

Morisot, Berthe 314 Morland, George 277 Moroni, Giovanni Battista 149 Morris, Robert 457 Untitled (Felt Tangle) 457 Morris, William 297, 298 Moses, Grandma 408 Down on the Farm in Winter 409 Motherwell, Robert 415 "Spanish Elegies" 415 Mount, William Sidney 295 Mozart 240, 246 Mucha, Alphonse 338 Sarah Bernhardt 338 Müller, Otto 362 Munch, Edvard 324, 328, 338, 360-1 The Scream 328, 361 Muñoz, Juan 428 Munnings, Sir Alfred 379 Münter, Gabriele 364 Murillo, Bartolomé 185, 186 Muybridge 260 photograph of a jumping horse 260 Mycenaean culture 52, 53 Mytens, Daniel 198

N

Nabis 325, 332 Nadelman, Elie 405 Tango 405 Napoleon 221, 250, 253, 259, 260, 266 Napoleonic Era 259-60 Nash, Paul 398 Nauman, Bruce 464 Nazarenes 273 Nazis 384 Neo-Classicism 218-21, 223, 241, 249, 250-1, Netherlands 77, 110-14, 116, 117, 119, 120, 163 Neumann, Balthasar 232 Nevelson, Louise 406 Mirror Image 1 406 Nevinson, Christopher Richard Wynne 376 New Photographer's movement 386 Newman, Barnett 412. 414-15 Vir Heroicus Sublimis 414-15 Newton, Isaac 165 Nicholson, Ben 337, 400-1 September 1963 401 Nicholson, Sir William 337 Nolan, Sir Sidney 430-1 Noland, Kenneth 454 Nolde, Emil 34, 362 The Dancers 362 Norwich School 276

0

Ofili, Chris **477** oil painting 28–9, **33** O'Keefe, Georgia **409** Oldenburg, Claes 40, 439, 440 *Giant Hamburger* 40 Olitski, Jules 453 Oliver, Isaac 161 Op art 436 Oppenheim, Meret 390, 394 *Object* 390, 394 *Orozeo*, José Clemente 35, 402–3 Overbeck, Friedrich 273

P

Pacher, Michael 124 The St. Wolfgang Altarpiece 124 Paik, Nam June 458 painting, materials, and techniques 32-5 Paladino, Mimmo 427 Palma Giovane 141 Palma Vecchio, Jacopo 140 - 1Lady with a Lute 141 Palermo, Blinky 465 Palmer, Samuel 280 Panamarenko, Henri van Herwegen 422 Panini, Giovanni Paolo 234 Ruins with Figures 234 Paolozzi, Sir Eduardo 446 Parker, Cornelia 16 Cold Dark Matter: An Exploded View 16 Parmigianino, Girolamo 146, 150, 154, 155 The Madonna of the Long Neck 150 Self-Portrait in a Convex Mirror 146 Pasmore, Victor 430 Pastels 30 Patenier, Joachim 116-17 St. Jerome in a Rocky Landscape 108 Pater, Jean-Baptiste 224 Pearlstein, Philip 438-9 Pechstein, Max 363 Pellegrini, Giovanni Antonio 230 pen and ink 31 pencil 31 Penck, A. R. 462 Penrose, Sir Roland 394 Performance art 43 Permoserin, Balthasar 252 Perugino, Pietro 97, 273 St. Sebastian 97 Pevsner, Antoine 372 Birth of the Universe 372 Photography 42, 260, 386, 458 Photorealism 458 Picabia, Francis 367 Picasso, Pablo 30, 35, 136, 329, 332, 345, **348-9**, 351, 352, 357, 373, 377, 384, 396-7, 405 A Bull 397 Les Demoiselles d'Avignon 348-9. 351 The Guitar 351 Minotaur 35

Minotaur Caressing a Sleeping Girl 396 Self-Portrait 396 Weeping Woman 397 Woman with a Guitar 351 Piero della Francesca 87. 100. 106 The Flagellation of Christ 87 Palace at Urbino 106 Resurrection of Christ 100 Piero di Cosimo 93 Pinturicchio, Bernardino di Betto 97 Pope Pius II Canonizes St. Catherine of Siena 97 Piper, John 401 Piranesi, Giovanni 249 Carceri d'Invenzione (Prisons) Plate IV 249 Pisanello (Antonio Pisano) 84 Portrait of Ginevra d'Este 84 Pisano, Nicola and Giovanni 76 Fontana Maggiore, Perugia 76 Pissarro, Camille 312, 314 Pistoletto, Michelangelo 425 Pittoni, Giovanni Battista 230 The Delivery of the Keys to St. Peter 230 Plein air painting 304, 305, 312 Plensa, Jaume 429 Pointillism 320, 346 see also Divisionism Polke, Sigmar 464-5 Flight - Black, Red, and Gold 464 Pollaiuolo brothers 94 Battle of the Ten Naked Men 94 Pollock, Jackson 409, 410-11, 412, 413 The Moon-Woman Cuts the Circle 411 Number 6 410 Pontormo, Jacopo 146, 148 Cosimo de' Medici (Il Vecchio) 146 Deposition 146 Pop Art 383, 418, **440**, 441-6 Post-Impressionism 223, 326, 328, 331, 378 Potter, Paulus 208 The Young Bull 208 Poussin, Nicolas 154, 167, 169, 180-1, 182 183, 334 Arcadian Shepherds 180-1 Portrait of the Artist 180 The Rape of the Sabines 181 Pre-Raphaelites 273, 296, **297**, 298-9, 325, 398 Preti, Mattia 177 Primaticcio, Francesco 153 Primitive art see Early art

Printmaking 36-7

Provost, Jan Pucelle, Jehan Puvis de Chavannes, Pierre 322,

R

Raeburn, Sir Henry 242 Portrait of Sir Walter Scott 242 Ramsay, Allan 239 Raphael 26, 94, 134, 135, 138, 139, 146, 147, 150, 166, 167 168, 180, 186, 241, 249, 264, 273, 297, 325 Madonna of the Pinks 27 Pope Leo X with Cardinals Giulio de' Medici and Luigi de' Rossi 134 The School of Athens 138 - 9The Sistine Madonna 134 Rauschenberg, Robert 437 The Bed 440 Bellini 437 Sleep for Yvonne Rainer 34 Rayonism 42, 370 Realism 300-1, 304, 306 Redon, Odilon 30, 322, 324-5 The Cyclops 322 Rembrandt 31, 170, 196, 198, 200-1, 202, 203, 207, 239, 307, 337 Jacob Blessing the Children of Joseph 200-1 Lion Resting 31 Self-Portrait at the Age of 63 201 Studies of Old Men's Heads and Three Women with Children (detail) 200 The Three Crosses 201 Remington, Frederic 293 The Blanket Signal 293 Renaissance 33, 79, 89, 90, 264, 312, 328 Early Renaissance 20 26, 73-5, 83, 84, 86-7, 88, 91, 92, 95, 100, 103, 135, 299 High Renaissance 17, 19, 39, 128-31, 132. 135, 138-9, 143, 146 France 118-19 see also Italy; Florence; Rome; Siena; Venice Northern Renaissance 108-9 Reni, Guido 166 Atalanta and Hippomenes 166 Renoir, Pierre-Auguste 228, 311, 312, 313 Bather Arranging her Hair 311 Boating Party 313 reproductions 29 Reynolds, Sir Joshua 186, 238, 239, 240, 242 Master Thomas Lister (The Brown Boy) 239 Ribera, José 185 The Club Foot 185 Ricci, Marco 229 Ships in a Gale 229

Ricci, Sebastiano 229 Richter, Gerhard 458 S. with Child 458 Riemenschneider. Tilman 121, 124 Rietveld, Gerrit 389 Red Blue Chair 389 Riley, Bridget 436 Rivera, Diego 402 Rivers, Larry 437 Robbia, Andrea della 91 Robbia, Luca della 91 Cantoria 91 Robert, Hubert 22 Grand Gallery of the Louvre 22 Roberts, William 377 Robinson, Theodore 317 At the Piano 317 Rococo 186, 218-21 226-7, 222-33, 250, 252 Rodchenko, Aleksandr 373 Rodin, Auguste 38, 318-19, 337, 356, 378 The Burghers of Calais 318 The Gates of Hell 318, 319 The Kiss 38, 319 The Thinker 38 Romanesque Art 39. 70-1 Nave of Pisa Cathedral 70 Romano, Giulio 147 Madonna and Child 147 Romanticism 18, 248. 249, 258-61, 266-7 297. 304. 386. 416 see also America; Britain; France; Germany Rome 138, 139,146, 162, 164 see also Renaissance; Baroque Rome, Classical see Classical Rome Rosa, Salvator 176 Self-Portrait 176 Rose, Joseph 250 Rosselli, Cosimo 94 Rossetti, Dante Gabriel 296, 297 Rosenquist, James 445 F-111 445 Roth, Dieter 423 Literature Sausage 423 Rothenberg, Susan 467 Red Banner 467 Rothko, Mark 412, 413.414 The Black and the White 413 Roualt, Georges 354 Roubiliac, Louis-François 252 Rousseau, Henri 332-3 The Rugby Players 333 Rousseau, Théodore 304, 305 Rowlandson, Thomas 247 A French Coffee House 247 Rubens, Sir Peter Paul

A French Coffee House ubens, Sir Peter Paul 20, 156, 167, 178, 186, 190, **191–3**, 195, 239, 269

I N D E X

Battle of the Amazons and Greeks 191 Hélène Fourment in a Fur Wrap 191 Marie de' Medici series 222 Samson and Delilah 192-3 Runge, Philipp Otto 273 Die Farbenkugel 273 Self-Portrait 273 Ruscha, Edward 441 Ruskin, John 296, 298. 299 Russell, Charles M. 293 Russia 32, 41, 359, 364, 368.370-3 Entombment of Christ 32 Frieze showing heroic Soviet workers, Moscow 342 Soviet Postcard from World War II 343 Ryder, Albert Pinkham 295 Jonah and the Whale 285 Roadside Meeting 295 Siegfried and the Rhinemaidens 295 Ryman, Robert 457

S

Saenredam, Pieter Jansz 205 Salle, David 470 Sargent, John Singer 326-7 The Daughters of Edward Darley Boit 326 Sarto, Andrea del 135, 153 Lamentation over the Dead Christ 135 Sassetta, Stefano di Giovanni 83 Savery, Roelandt 190 Saxon Art 66 Schad, Christian 385 Self-Portrait with Model 385 Schiele, Egon 360 Self-Portrait Nude 360 science, 17th century 165 Isaac Newton's telescope 165 Visit of Louis XIV to the Académie Royale des Sciences in 1667 Schlemmer, Oskar 386, 388 Unterhaltung I 388 Schmidt, Joos 386 Poster for Bauhaus Exhibition 386 Schmidt-Rotluff, Karl 363 Schnabel, Julian 469 Schongauer, Martin 125 School of Paris 357 Schuette, Thomas 472 Schwitters, Kurt 35, 368 YMCA Flag, Thank You, Ambleside 368 screen prints 37 silkscreen printing 37 Scully, Sean 467 sculpture materials, and techniques 38-40, 41

Sebastiano del Piombo 135 Secession 338 Segal, George 454 Senefelder, Aloys 37 Serra, Richard 462-3 Sérusier, Paul 332 The Talisman 332 Seurat, Georges 320, 324, 328 A Sunday Afternoon on the Island of La Grande Jatte 320 Severini, Gino 375 Shakespeare, William 170, 248, 297 Sheeler, Charles 407 Steam Turbine 407 Sherman, Cindy 472 Sickert, Walter Richard 326 Siena 76, 78, 82, 101 Signac, Paul 320 Signorelli, Luca 94-5 Simone Martini 82 Siqueiros, David Alfaro 35, 402 The March of Humanity in Latin America 402 Sisley, Alfred 312, 314 The Bridge at Moret 314 Sistine Chapel 128, 138, 139, 167 Sloan, John 381 McSorley's Bar 381 Sluter, Claus 85 The Moses Well 85

Smith, David 40, 410 Four Units Unequal 40 Smith, Kiki 472 Smith, Tony 452 Smithson, Robert 43, 462 Broken Circle 462 Snyders, Frans 190 Pantry Scene with a Page 190 Sorolla y Bastida, Joaquin 327 Soulages, Pierre 420 Soutine, Chaïm 357 Spain Baroque 129, 131, 178, 185-9 Spencer, Sir Stanley 398 Travoys Arriving with the Wounded at a Dressing Station, Smol, Macedonia 398 Spranger, Bartholomeus 158 St Ives Group 400, 430 Tate St Ives. Cornwall 400 St. Peter's, Rome 138, 139, 178 Staël, Nicolas de 419 Steen, Jan 211 The Christening Feast 211 Steenwyck, Harmen 197 The Vanities of Human Life 197 Stella, Frank 461-2 Stella, Joseph 375 De Stijl 368, 372, 389 Still, Clyfford 412, 413, 416

stone sculpture 39

stone-age sculpture 47 Venus of Willendorf 39, 47, 48 Stoss, Veit 124 Strauss, Richard 339 Stuart, Gilbert 257 Stubbs, George 246 Anatomy of the Horse 246 A Horse Frightened by a Lion 246 Sueur Brothers, Le 220 Cry of Liberty and the Departure for the Frontier 220 Suh, Do-Ho 41 Some/One 41 Surrealism 43, 324-5, 353, 369, 377, **390-1**, 392-5, 398, 404, 406, 412, 417, 418 Sutherland, Graham 401 Symbolism 322-3, 324-5, 325, 332, 353, 389, 396 Synchronism 383

Т

Tanguy, Yves 393 Tàpies, Antoni 428 Composition, LXIV 428 Tatlin, Vladimir 372, 373 Monument to the Third International 373 The Sailor (Self-Portrait) 373 Teniers, David 195 Boors Carousing 195 Tennyson 297 Terborch, Gerard 210 The Flea-Catcher (Boy with His Dog) 196 Terbrugghen, Hendrick 172, 199 Thiebaud, Wayne 441 Thornhill, Sir James 217 Thorvaldsen, Bertel 255 Fason with the Golden Fleece 255 Tiepolo, Giambattista 226, 230-1, 232-3 Abraham and the Three Angels 231 Apollo Bringing the Bride 232-3 Tiepolo, Giandomenico 231 Tinguely, Jean 418 Beaubourg Fountain 418 Turning of Friendship of America and France 418 Tintoretto 146, 152 St. George and the Dragon 152 Susanna Bathing 152 Tischbein, Johann Heinrich Wilhelm 221 Goethe in the Campagna 221 Tissot, James 302-3 Portrait of Mlle. L. L. 303 Titian 135, 138, 141, 143-5, 151, 155, 167, 186, 249, 287, 299, 308 Bacchus and Ariadne

144-5

I N D E X

The Emperor Charles V on Horseback in Mühlberg 138 Venus and Adonis 143 Tobey, Mark 410 Toulouse-Lautrec, Henri de 333 Le Divan, Japonais 333 Trumbull, John 274 Portrait of Alexander Hamilton 274 Tuby, Jean-Baptiste 21 Fountain of Apollo 21 Tunick, Spencer 43 Nude Installation 43 Turner, J. M. W. 31, 34, 244, 245, 266, 276, 281-3, 292 Couvent du Bonhomme. Chamonix 266 Crichton Castle (Mountainous Landscape with a Rainbow) 281 The Fighting Téméraire 282 - 3Rain, Steam, and Speed - The Great Western Railway 281 Sunset over a Ruined Castle 34 Turrell, James 465 Twombly, Cy 456

U

Uccello, Paolo *The Hunt in the Forest*Uccker, Günther Ugolino di Nerio Utrecht School 196, 199, 200, 204 Utrillo, Maurice

V

Valdés Leal, Juan de 186 Valetin, Moïse 172, 182 Vallotton, Félix 332 van de Velde, Esaias 204 van de Velde, Willem (the elder) 204 van de Velde, Willem (the younger) 205 Sea Battle of the Anglo-Dutch Wars 205 van der Heyden, Jan 210 van der Neer, Aert 207 van Dyck, Sir Anthony 186, 194-5 King Charles I of England 194 van Evck 33, 108, 109-11, 115, 117, 126 Ghent Altarpiece 108 A Man in a Turban 110 The Marriage of Arnolfini 33.109 van Gogh, Vincent 32, 328, 329, 330-1, 332, 346, 476 Portrait of Doctor Paul Gachet, the Man with the Pipe 331 Self-Portrait 330 Starry Night 330

Sunflowers 331

Van Gogh's Bedroom at Arles 328 van Goyen, Jan 205 River Landscape with Ferries Docked Before a Tower 205 van Honthorst. Gerrit 204 Supper with the Minstrel and his Lute 204 van Huysum, Jan 212 van Loo, Carle 229 van Ostade, Adriaen 206 The Piper 206-7 van Ruisdael, Jacob 208-9 van Ruysdael, Salomon 196, 206-7, 209 River Landscape with Peasants Ferrying 196 Varley, John 276 Vasarely, Victor 436 Bi-Vega 437 Vasari, Giorgio 147 The Annunciation 147 Lives of the Artists 147 Vauxcelles, Louis 346 Gil Blas 346 Vecchietta 101 Pope Pius II, Crowned by Two Cardinals 101 Velasquez 170, 185, 186, 187-9, 321, 327 Christ on the Cross 187 Les Meniñas 188-9 Waterseller of Seville 187 Veneziano, Domenico 91 Venice 33, 103-6, 135, 138, 140-4, 151-2, 230, 286 Vermeer 211, 213-15 The Artist's Studio 214-5 Christ in the House of Martha and Mary 25 Girl with a Pearl Earing 213 View of Delft 213 Vernet, Antoine-Charles Horace 260 Napoleon Giving Orders before Austerlitz 260 Vernet, Claude-Joseph 255 The Storm 255 Veronese, Paolo 142 Marriage at Cana 142 Verrocchio, Andrea del 93, 96, 132 Equestrian Monument to Bartolomeo Colleoni 93 Versailles 163, 164, 232 Chapelle Royale 164 Victoria, Queen 25 video art 42 Vien, Comte Joseph-Marie 252 Vienna Secession 338, 339 Facade of Secession Building, Vienna 338 Vigée-Lebrun, Elisabeth 255 Portrait of a Young Woman 255 Viking Art 66 Viola, Bill 42 469 The Crossing 42 Vivarini family 104-5

Madonna and Child with Sts. Peter, Jerome, and Mary Magdalene with a Bishop 104 Vlarninck, Maurice de **346** Tigboat at Chatou 346 Vollard, Ambroise 21 344 portrait of Vollard 21 Vorticism **376**, 377 Vos, Marten de **156** Vuillard, Edouard **336** Mother and Child 336

W

Wadsworth, Edward 377 Wall, Jeff 468 Wallis, Alfred 400 Ward, James 277 Gordale Scar 277 Warhol, Andy 12, 18, 37, 440, 444 Campbell's Soup Can 440 Twenty Marilyns 12, 444 watercolour 34 Watteau, Jean-Antoine 222-3, 224 L'Enseigne de Gersaint 222 Head of a Negro 223 A Journey to Cythera 222-3, 226 Pierrot: Gilles 222 Watts, George Frederick 299 Weber, Max 382 Weenix, Jan 212 Still Life 212 Weir, Julian Alden 317 West, Benjamin 256 The Death of General Wolfe 256-7 Weston, Edward 42 Weyden, Rogier van der 108, 111-13, 114, 115, 117, 124, 126 The Deposition 112-13 Portrait of a Young Woman in a Pinned Hat 108 Whistler, James Abbott McNeill 321, 322, 323. 325 Mother and Child on a Couch 321 Nocturne in Black and Gold: The Falling Rocket 323 Whiteread, Rachel 476 Wilde, Oscar 321, Wilkie, Sir David 280 The Chelsea Pensioners Reading the Waterloo Disbatch 280 William III 217 Wilson, Richard 244 Snowdon 244 Winckelmann, Johann 250 Thoughts on the Imitation of Greek Works of Art 250 Winterhalter, Franz Xavier 286 Wols, Alfred Otto 420 Composition 420 Wood, Grant 406-7 American Gothic 407 woodcarving 39

woodcuts **36** Woodington, W. F. 282 Wordsworth, William 266, 468 Wouvermans, Philips **208** Wren, Sir Christopher 217 Wright, John Michael **216** Wright, Joseph **246** Wyeth, Andrew **439**

Ζ

Zimmermann, Johann Baptiste The Last Judgement 226 Zoffany, Johann 241 The Drummond Family 241 Zola, Emile 300 Zorn, Anders 327 Girls from Dalarna Having a Bath 327 Zuccarelli, Francesco 237 An Italianate River Landscape 237 Zuccaro, Taddeo 158 Zurbarán, Francisco de 185

PICTURE CREDITS

The publisher would like to thank the following for their kind permission to reproduce their photographs.

a = above; bg = backround; b = below; c = centre; l = left; r = right; rh = running header; t = top

AKG = akg-images; AL = Alamy Images; ART = The Art Archive; BAL = www.bridgeman.co.uk; Co = Corbis

1 Corbis/Alinari Archives; 2-3 Photo: Wolfgang Volz © Christo 2005; 4 Getty Images/Photo: Gjon Mili/Time Life Pictures/@ Succession Picasso/DACS 2005; 5 Alamy Images/Robert Harding Picture Library Ltd; 6-7 Corbis/William Manning; 9 BAL/Bargello (br); Stapleton collection (cl); 9 Rex Features/Roger-Viollet (t); 10-11 Corbis/D. Hudson (b); 11 Christie's Images Ltd/C Succession Miro. DACS, 2005 (t); 12 BAL Private Collection/© The Andy Warhol Foundation for the Visual Arts, Inc/ARS, NY and DACS, London 2005; 13 Empics Ltd/Gorassini Giancarlo/ABACA; 14-15 Alamy Images/Angus Oborn; 16 © Tate, London 2005/Courtesy Frith Street Gallery: 18 BAL/Musee de la Ville de Paris, Musee du Petit-Palais, France (t); 18-19 Rex Features/Richard Young (b); 19 BAL/Private Collection (t); 20 BAL/Bargello (t); 20-21 Corbis/Dave G. Houser (b); 21 Rex Features/Roger-Viollet (tr); 22 BAL/Museo di San Marco dell'Angelico, Florence (t); 22-23 BAL/Giraudon/Louvre, Paris (b); 23 Alamy Images © David R. Frazier Photolibrary, Inc. (br); 24 Alamy Images/Donald Nausbaum (t); 24 Getty Images/Photo: David Lees/Time Life Pictures (b); 25 BAL/National Galleries of Scotland (tr); 25 Reuters/De Kunsthal Gallery, Rotterdam (tl); 26 BAL/Accademia, Florence; 27 National Gallery, London; 28 Corbis/Royalty Free; 30 BAL/Gabinetto dei Disegni e Stampe, Uffizi, Florence (tra), (trb); Pushkin Museum, Moscow, Russia (bcl), (bcr); 31 BAL/Peter Willi/Louvre, Paris (cl); Private Collection (br); 31 DK Images/Musee Marmottan (tl); Stephen Oliver (bc). 32 Alamy Images/Visual Arts Library (London) (bc); 32 BAL/Louvre, Paris (cr), (tr); 33 BAL/National Galler London (bcr), (bl). 33 DK Images/Steve Gorton (bc), (br); 33 Photo Scala, Florence/Vatican Museums and Galleries, Vatican City (to 34 Photonica/John Wilkes (bcr); 34 © Tate, London 2005 (tr); 35 BAL/Daniels, Harvey/Private Collection, (tl); Private Collection/© Robert Rauschenberg/VAGA, New York/DACS, London 2005 (bl); 35 Art Archive/Museum of Modern Art, New York/© Succession Picasso/DACS 2005 (br); 36 BAL/Private Collection (tl); On Loan to Hamburg Kunsthalle, Hamburg (bl); 36 Christie's Images Ltd (cr); 36 Corbis/Austrian Archives (tr). 36 DK Images/Artichoke prints (br); 37 BAL/ Private collection/© Hundertwasser Archives, Vienna (br); 37 Corbis/John Garrett (bl); Wolfgang Kachler (tr); 37 Mary Evans Picture Library (cl); 37 Rex Features/Peter Brooker (cr); 38 Corbis (b); C Ted Soqui (c), (tl); 39 Corbis/Elio Ciol (tl); 39 Getty Images/John Millar (cr); 40 BAL/Private collection/© ARS, NY and DACS, London 2005 (bl); Private Collection/© Estate of David Smith/VAGA, New York/DACS, London 2005 (cr); 40 Getty Images/Greg Pease (cr); 41 Alamy Images/Roger Bamber © Olafur Eliasson (t); 41 BAL/Private collection/© Succession Marcel Duchamp/ ADAGP, Paris and DACS, London 2005 (b); 42 BAL/© Man Ray Trust/ADAGP, Paris and DACS, London 2005 (tr); 42 Photo: Kira Perov/© Bill Viola: 42 Zefa Visual Media UK Ltd/A. Green (tl); 43 Photo: Wolfgang Volz, © Christo 1983 (b); 43 Magnum Photos/Alec Soth (cl); 43 Rex Features/Erik Pendzich (t); 44-45 BAL/Giraudon/Galleria degli Uffizi, Florence; 45-46 Corbis/Gian Berto Vanni (t); 46 Corbis/Sandro Vannini; 48 BAL/Naturhistorisches Museum, Vienna, Austria (b); 48 Getty Images/National Geographic/Sissie Brimberg (t); 49 BAL/Iraq Museum, Baghdad, Iraq, Giraudon; 50 BAL/Egyptian National Museum, Cairo, Egypt (bl), (tr); 51 BAL (t); 52 BAL (b); Giraudon (t); 53 BAL/Giraudon (bl); Peter Willi (br); 54 BAL/British Museum, London (b); Giraudon/Louvre, Paris (tr); 54 Corbis/Charles O'Rear (cl); 55 akg-images/Nimatallah; 56 Alamy Images/Adam Eastland (b); 56 BAL/ Alinari / Museo Archeologico Nazionale, Naples (t); 57 Corbis/Gianni Dagli Orti (br); 57 Corbis/Royalty Free (tr); 58-59 akg-images/Nimatallah; 60 BAL/Lauros/Giraudon (tr); 61 Corbis/Sandro Vannini (b); 61 Art Archive: Museo Capitoline Rome/Dagli Orti (t); 62 BAL/Giraudon/Louvre, Paris (t); 63 BAL/Castello Sforzesco, Milan; 64 Art Archive/Dagli Ort (A)/Cathedral of St Just Trieste (t); Art Archive/Dagli Orti (A) (b); 65 BAL/San Vitale, Ravenna (b); 66 BAL/British Museum, London/Boltin Picture Library (t); 66 Corbis/Werner Forman (bl); 67 BAL/MS 58 fol.34r Chi-rho (initials of Christ's name) Gospel of St. Matthew, chap. 1 v. 18, Irish (vellum)/Board of Trinity College, Dublin, Ireland; 69 akg-images/Erich Lessing (tl); 69 Art Archive/Dagli Orti (A)/Archaeological Museum Cividale Friuli(bl); Dagli Orti/Bibliothèque Municipale Abbeville; Dagli Orti/Musée Condé Chantilly (br); 70 Alamy Images/Hideo Kurihara (b); 70 BAL/Chartres Cathedral, Chartres, France (t); 71 BAL/Chartres Cathedral, Chartres, France, Peter Willi(b); 72 Corbis/Massimo Listri; 74 akg-images/Erich Lessing (b); 74 BAL/Prado, Madrid (t);

75 Alamy Images/AA World Travel Library; 76 BAL/Samuel Courtauld Trust, Courtauld Institue of Art Gallery; 77 BAL/Musee Conde, Chantilly, France (cr); Museo di San Marco dell'Angelico, Florence (bl); 78 BAL/Galleria degli Uffizi, Florence (bl); 78-79 BAL/Palazzo Pubblico, Siena; 80 Alamy Images/One World Images; 81 BAL/San Francesco, Upper Church, Assisi (br); Scrovegni (Arena) Chapel, Padua (t); 82 BAL/Fitzwilliam Museum, University of Cambridge (bc); 82-83 BAL/Louvre, Paris; 84 BAL/Louvre, Paris (bl); 85 BAL/Chartreuse de Champmol, Dijon (bc); Wallrat Richarts Museum, Cologne, Germany (t). 86 BAL/Alinari/Bargello, Florence (t); Palazzo Medici-Riccardi, Florence (b); 87 BAL/Galleria Nazionale delle Marche, Urbino; 88 BAL/Santa Maria Novella, Florence; 89 BAL/Louvre, Paris; 90 BAL/Bargello, Florence; 91 BAL/Museo dell'Opera del Duomo, Florence; 92-93 BAL/Ashmolean Museum, Oxford (t); Louvre, Paris (bc). 93 BAL/Campo Santi Giovanni e' Paolo, Venice (bc); 94 Photo Scala, Florence/Gabinetto dei Disegni e delle Stampe degli Uffizi, Florence; 95 BAL/Louvre, Paris; 96 BAL/National Gallery of Art, Washington DC, USA; 97 BAL/Hermitage, St. Petersburg, Russia (bc); Piccolomini Library, Duomo, Siena (tr); 98-99 BAL/Galleria degli Uffizi, Florence; 100 BAL/Pinacoteca. Sansepolero; Pushkin Museum, Moscow (tc); 101 BAL/Palazzo Piccolomini, Siena (br); 102-103 BAL/Galleria dell'Accademia, Venice; Louvre, Paris (tc); 103 BAL/National Gallery, London (tr); 104 BAL/Musee de Picardie, Amiens, France; 105 BAL/National Gallery, London (br); Santi Giovanni e Paolo, Venice (tc); 106 Alamy Images/Norma Joseph (cr); 106 BAL/Walker Art Gallery, Liverpool (bc); 107 BAL/Pinacoteca di Brera, Milan; 108 BAL/Gemaldegalerie, Berlin (tr); National Gallery, London (t): 109 BAL/National Gallery, London; 110 BAL/National Gallery, London; 112-113 BAL/Prado, Madrid; 114 BAL/Galleria degli Uffizi, Florence (tr); Musee des Beaux-Arts, Lille, France (bl). 115 BAL/Louvre, Paris; 116 BAL/Galleria degli Uffizi, Florence; 117 BAL/Louvre, Paris; 118 BAL/Prado, Madrid; 119 BAL/Bibliotheque Nationale, Paris, France; 120 BAL/Musee Royaux des Beaux-Arts de Belgique, Brussels (b); Prado, Madrid (tc); 121 BAL/Musee d'Unterlinden, Calmar, France (tr); 122 BAL/Musee d'Unterlinden, Colmar, France (cl), 122-123 BAL/Musee d'Unterlinden, Colmar, France; 124 BAL/St Wolfgang, Austria; 125 BAL/Walker Art Gallery, Liverpool; 126 BAL/Alte Pinakothek, Munich, Germany (tc); Graphische Sammlung Albertina, Vienna (bc); 126-127 BAL/Kunsthistoriches Museum Vienna, Austria; 127 BAL/British Museum, London (br); 128 akgimages/Erich Lessing; 130-131 Alamy Images/nagelestock.com; 130 BAL/Lambeth Palace Library, London (b); 130 Corbis/Archivo Iconografico, S.A. (t); 132 BAL/Fitzwilliam Museum, University of Cambridge (tc); 132-133 BAL/Santa Maria della Grazie, Milan; 133 BAL/National Gallery, London (tr); 134 BAL/Galleria degl Uffizi, Florence (tr); Gemaldegalerie, Dresden, Germany (br); 135 BAL/Palazzo Pitri, Florence; 136 BAL/Galleria degli Uffizi, Florence (bc); Museums and Galleries, Vatican City (t); 137 BAL/St Peter's Vatican, Rome; 138 BAL/Louvre, Paris (br); Prado, Madrid (cra); 139 BAL/Giraudon/Vatican Museums and Galleries, Vatican City; 140 BAL/Kunsthistoriches Museum, Vienna; 141 BAL/Collection of the Duke of Northumberland (tc); Galleria dell' Accademia, Venice (br); 142 BAL/Louvre, Paris; 143 BAL/Prado, Madrid; 144-145, Corbis/Trustees of the National Gallery, London; 146 BAL/Galleria degli Uffizi, Florence (bl); Kunsthistoriches Museum, Vienna, Austria (cra); 147 BAL/Galleria degli Uffizi, Florence (tr); Louvre, Pais, France (bc); 148 BAL/National Gallery, London; 149 BAL/Bargello, Florence; 150 BAL/Galleria degli Uffizi, Florence; 151 BAL/Louvre, Paris; 152 BAL/ Kunsthistorisches Museum, Vienna, Austria (tc); National Gallery, London (bc); 153 BAL/ Giraudon/Chateau de Fontainebleau, Seine-et-Marne, France, Lauros (b); 154 BAL/Kunsthistorisches Museum, Vienna, Austria; 155 BAL/Prado, Madrid (tc); Toledo, S. Tome (br); 156 BAL/Gemaldegalerie, Kassel (tr); Private Collection (bl); 157 BAL/Kunsthistorisches Museum, Vienna, Austria (br), (tc); 158 BAL/Kunsthistorisches Museum, Vienna, Austria; 159 BAL/Kunsthistorisches Museum, Vienna, Austria; 160 BAL/Chatsworth House, Derbyshire (br); National Gallery, London (t); 161 BAL/Beauchamp Collection (bc); Society of Antiquaries, London (cl); 162 Alamy Images/BL Images Ltd; 164 BAL/ Giraudon/Musee Bargoin, Clermont-Ferrand, France, Lauros (t); 164 Corbis/Massimo Listri (b); 165 Corbis/Bettmann (b); 165 Art Archive/Royal Society/Eileen Tweedy (t); 166 BAL/Prado, Madrid; 167 BAL/Hermitage, St Petersburg, Russia (bc); Louvre, Paris (tr); 168-169 BAL/Ashmolean Museum, University of Oxford (b); Vatican Museums and Galleries, Vatican City (tl); 169 BAL/Birmingham Museums and Art Gallery (tr); 170-171 BAL/National Gallery, London (t); Palazzo Barberini, Rome (bl); 171 BAL/Galleria Borghese, Rome (bc); 172 BAL/Palazzo Pitti Florence; 173 BAL/ Giraudon/Galleria Borghese, Rome, Lauros; 174-175 BAL/Santa Maria della Vittoria, Rome; 176 BAL/ National Gallery, London; 177 BAL/Galleria dell' Accademia, Venice; 178 BAL/Piazza Navona, Rome; 179 BAL/Palazzo Farnese, Rome (bl), (br), (c); 180-181 BAL/Louvre, Paris (b); Louvre,

Paris, Giraudon (bl); 181 BAL/Louvre, Paris (tr); 182-183 BAL/National Gallery, London; 184 BAL/Louvre, Paris; 185 BAL/Louvre, Paris: 186 BAL/Bonhams, London; 187 BAL/Apsley House, Wellington Museum, London (t); Prado, Madrid (b); 188-189 BAL /Prado, Madrid: 190 BAL /Wallace Collection London; 191 BAL/Alte Pinakothek, Munich (b); Kunsthistorisches Museum, Vienna, Austria (t); 192-193 BAL/National Gallerv. London; 194 BAL/Giraudon/Louvre, Paris, Lauros; 195 BAL/Fitzwilliam Museum, University of Cambridge; 196 BAL/Alte Pinakothek, Munich (bl); Private Collection (t); 197 National Gallery, London (bl), (br), (t) 198 BAL/Wallace Collection, London; 199 BAL/Hamburg Kunsthalle, Hamburg (t); Townley Hall Art Galler & Museum, Burnley, Lancashire (b); 200-201 BAL/Gemaldegalerie, Kassel (b); 200 BAL/ Barber Institute of fine Arts, University of Birmingham (t); 201 BAL/Fitzwilliam Museum, University of Cambridge (b); National Gallery, London (t); 202 BAL/Louvre, Paris (t); Giraudon/Louvre, Paris (b); 203 BAL/Harold Samuel Collection, Corporation of London (t); 204 BAL/Galleria degli Uffizi, Florence; 205 BAL/Private Collection (b); Yale Centre for British Art, Paul Mellon Collection, USA (t); 206-207 BAL/British Museum, London (t); 207 BAL/ National Gallery of Scotland, Edinburgh, Scotland (b); 208 BAL/Mauritshuis, The Hague, The Netherlands; 209 BAL/National Gallery, London (b), (t); 210-211 BAL/Wallace Collection, London; 212 BAL/Leeds Museums and Galleries (City Art Gallery); 213 BAL/Mauritshuis, The Hague (b), (t); 214-215 BAL/Kunsthistorisches Museum, Vienna; 216 BAL/ Scottish National Portrait Gallery, Edinburgh; 217 BAL/V&A Museum, London; 218 Alamy Images/Bildarchiv Monheim GmbH; 220 BAL/Musee de la Ville de Paris, Musee Carnavalet, Paris France/Giraudon (t); 221 akg-images (tr); 222 BAL/Louvre, Paris (b); 222-223 BAL/Louvre, Paris (t); 223 BAL/British Museum, London (b); 224 BAL/ Giraudon/Louvre, Paris/Lauros 225 BAL/Worcester Art Museum, Massachusetts, USA; 226 BAL (b); Wieskirche, Wies, Germany (t); 227 BAL/Wallace Collection, London (c), (bl), (br); 228 BAL/Wallace Collection, London; 229 BAL/Indianapolis Museum of Art, USA (t); Detroit Institute of Arts (b); 230 BAL/Louvre, Paris; 231 BAL/Ca' Rezzonico, Museo de Settecento (b); Scuola Grande di San Rocco, Venice (t); 232-233 BAL/Residenz, Wurzburg; 234 BAL/Collection of the Earl of Pembroke, Wilton House, Wiltshire (tl): 234-235 BAL/National Gallery, London (b); 236 BAL/Museum Narodowe, Warsaw, Poland (b); V&A Museum, London (tr); 237 BAL/Christies Images, London (t); 238 BAL/National Gallery, London (b); Private Collection, Ken Welsh (t); 239 BAL/Hermitage, St. Petersburg, Russia (br); 240 BAL/National Gallery London (t), (b); 241 BAL/Yale Center for British Art, Paul Mellon Collection, USA (b); 242 BAL/Scottish National Portrait Gallery, Edinburgh; 243 BAL/Yale Center for British Art. Paul Mellon Collection, USA (b): Private Collection (t): 244 BAL/Private Collection; 245 BAL/Charles Young Fine Paintings, London (t); New Walk Museum, Leicester City Museum Service (b); 246 BAL/Walker Art Gallery, Liverpool, Merseyside; 247 BAL/Christie's Images (b); Fitzwilliam Museum, University of Cambridge (t): 248 BAL/Detroit Institute of Arts (t): Whitworth Art Gallery, University of Manchester (b); 249 BAL/On Loan to Hamburg Kunsthalle, Hamburg (tr); 250 BAL/Galleria Borghese Rome (c); John Bethell (b); 251 BAL/Louvre, Paris (bc), (br), (c); 252 BAL/Bibliotheque de la Comedie Francaise, Paris; 253 BAL/ Chateau de Versailles, France; 254 BAL/Louvre, Paris; 255 BAL/Musee Calvet, Avignon, France (t); Museum of Fine Arts, Boston, Massachusetts, USA (b); 256-257 BAL/Private Collection, Phillips, Fine Art Auctioneers, New York, USA; 258 BAL/ Giraudon/Louvre, Paris/Lauros; 260 BAL/ Giraudon/Chateau de Versailles, France/Lauros (t); 260 Science & Society Picture Library/NMPFT (bl); 260 Science Photo Library/Eadweard Muybridge Collection/Kingston Museum (cr); 261 BAL/Guildhall Library, Corporation of London; 262-263 BAL/ Giraudon/Prado, Madrid (b); 263 BAL/Index/Private Collection (tr); 264 BAL/ Bristol City Museum and Art Gallery; 265 BAL/Louvre, Paris; 266 BAL/Fitzwilliam Museum, University of Cambridge (t); Staatliche Museen, Berlin (b); 267 BAL/Louvre, Paris (bc), (br), (c); 268-269 BAL/Castle Museum and Art Gallery, Nottingham, (t); 268 BAL/Louvre, Paris (b); 269 BAL/Louvre, Paris (br); 270-271 BAL/Louvre, Paris; 272 BAL/Museum der Bildenden Kunste, Leipzig (b); National Gallery, London (t); 273 BAL/Hamburg Kunsthalle, Hamburg; 274-275 BAL/Metropolitan Museum of Art, New York (c); 274 BAL/White House, Washington D.C. (b); 276 BAL/Norwich Castle Museum (tr); V&A Museum, London (b); 277 BAL/John Constable; 278-279 BAL/National Gallery, London; 280 BAL/Apsley House, Wellington Museum London; 281 BAL/National Gallery, London (b); Yale Centre for British Art, Paul Mellon Collection, USA (t); 282-283 BAL/National Gallery, London; 284 BAL/Giraudon/Chateau de Compiegne, Oise, France (b); Musee de la Ville de Paris, Musee du Petit-Palais, France Lauros / Giraudon (t); 285 BAL/Musee d'Orsay, Paris (b); Private Collection (t); 286 BAL/Bonhams, London; 287 BAL/Apsley House, Wellington Museum, London (t); Lady Lever Art gallery, Port Sunlight, Merseyside (b); 288 BAL/Lady Lever Art Gallery, Port

Sunlight, Mersevside; 289 BAL/Louvre, Paris (t); Whitworth Art Gallery, University of Manchester (b): 290 BAL/New York Historical Society: 291 BAL/Detroit Institute of Arts. USA: 292 BAL/National Museum of American Art, Smithsonian Institute, USA; 293 BAL/Museum of fine Arts, Houston, Texas; 294 BAL/Private Collection: 295 BAL/Butler Institute of American Art; 296 BAL/Manchester Art Gallery; 297 BAL/Delaware Art Museum, Wilmington, (b); National Gallery of Victoria, Melbourne, Australia (t): 299 BAL/William Morris Gallery, Walthamstow; 300-301 BAL/Giraudon/Musee d'Orsay, Paris; 302 BAL/Musee d'Orsay, Paris/© DACS 2005; 303 BAL/Musee d'Orsay, Paris; 304 BAL/Louvre, Paris; 305 BAL/Musee d'Orsay, Paris; 306-307 BAL/Courtauld Institute Gallery, Somerset House, London (t); 307 BAL/Walters Art Museum, Baltimore (br); 308-309 BAL/Musee d'Orsay, Paris; 310 BAL/Musee Marmottan, Paris (b); National Gallery, London (t); 311 BAL/National Gallery of Art, Washington DC; 312 BAL/Musee Marmottan, Paris (tl); Private Collection, Christie's Images (b); 313 BAL/Phillips Collection, Washington DC (bl), (br), (c); 314 BAL; Musee d'Orsay, Paris; 315 BAL/Musee d'Orsay, Paris (b); National Gallery, London (t); 316 BAL/Detroit Institute of Arts; 317 BAL/National Gallery of Art, Washington DC; 318 BAL/Hirshorn Museum, Washington DC; 319 BAL/Musee Rodin, Paris; 320 BAL/Art Institute of Chicago,; 321 BAL/V&A Museum, London; 322 BAL/Rijksmuseum Kroller-Muller, Otterloo, Netherlands (t); V&A, London (b); 323 BAL/Detroit Institute of Arts (bl), (br), (c); 326 BAL/Museum of Fine Arts, Boston, Massachusettes; 327 BAL/Nationalmuseum Stockholm, Sweden; 328 BAL/Art Institute of Chicago (b); Private Collection (t); 329 BAL/Courtauld Gallery, London (t); Musee d'Orsay, Paris, France (b); 330 BAL/Musee d'Orsay, Paris, France (t); Museum of Modern Art, New York (b); 331 BAL/Giraudon/ Bibliotheque Nationale, Paris (b); National Gallery, London (t); 332 BAL/Musee d'Orsay, Paris; 333 BAL/Bibliotheque Nationale, Paris, France (b); Solomon R. Guggenheim Museum, New York (t); 334 BAL/Musee d'Orsay, Paris (b); Musee d'Orsay, Paris (t); 335 BAL/Museum of Modern Art of the West, Moscow, Russia (t); Philadelphia Museum of Art, Pennsylvania (b); 336 BAL/Musee National d'Art Moderne, Paris, France/C ADAGP, Paris and DACS, London 2005 (t); Private Collection/© ADAGP, Paris and DACS, London 2005 (b); 338 BAL/© Mucha Trust (b); 339 BAL/ Osterreichische Galerie, Vienna, Austria; 340 Powerstock/ Superstock/Richard Cummins © ARS, NY and DACS, London 2005; 342 Alamy Images/Petr Svarc; 343 Alamy Images/Ambient Images Inc (t); 343 Corbis/Rykoff Collection (br); 344 Baltimore Museum Of Art/Cone Collection formed by Dr Claribel Cone and Miss Etta Cone of Baltimore, Maryland. BMA 1950.258/© Succession H. Matisse/DACS 2005 (b); 344 BAL/Musee Matisse Le Cateau-Cambresis, France/© Succession H.Matisse/DACS 2005 (t): 345 BAL/Musee d'Orsay, Paris/© Succession H. Matisse/DACS 2005; 346 BAL/National Gallery of Art, Washington DC/© ADAGP, Paris and DACS, London 2005 (t); Private Collection/© ADAGP, Paris and DACS, London 2005 (br); 347 BAL/Private Collection/© ADAGP Paris and DACS. London 2005: 348-349 BAL/Museum of Modern Art, New York/© Succession Picasso/DACS 2005: 350 BAL/Art Institute of Chicago (bl): Museum of Modern Art, New York/© Succession Picasso/DACS 2005 (t); 351 BAL/Giraudon/Lauros/Private Collection/© ADAGP, Paris and DACS. London 2005: 352 BAL/Christie's Image London/© ADAGP Paris and DACS. London 2005: 353 BAL/Private Collection/© ADAGP, Paris and DACS, London 2005; 355 BAL/Private Collection/© ADAGP, Paris and DACS, London 2005; 356 BAL/© ADAGP, Paris and DACS, London 2005; 357 BAL/Solomon R. Guggenheim Museum, New York; 358 BAL/Hamburg Kunsthalle, Hamburg (br); Hamburg Kunsthalle, Hamburg /C DACS 2005 (tl); 359 BAL/Musee National d'Art Moderne, Paris, France/© ADAGP, Paris and DACS, London 2005 (c); Musee National d'Art Moderne, Paris, France/© ADAGP, Paris and DACS, London 2005 (bl), (br); 360 BAL/ Graphische Sammlung Albertina, Vienna, Austria; 361 BAL/ Nasjonalgalleriet, Oslo, Norway/© Munch Museum/Munch-Ellingsen Group, BONO, Oslo, DACS, London 2005; 362 BAL/ Staatsgalerie, Stuttgart/© Nolde-Stiftung Seebull; 363 BAL/Brucke Museum Berlin/© Ingeborg & Dr Wolfgang Henze-Ketter, Wichtrach, Bern; 364 BAL/Musee National d'Art Moderne, Centre Pompidou Paris/© ADAGP, Paris and DACS, London 2005 (tl); 364-465 BAL/Saarland Museum, Saarbrucken (b); 365 BAL/ Stadtische Galerie im Lenbachhaus, Munich/© ADAGP, Paris and DACS, London 2005 (tr); 366 BAL/J. Paul Getty Museum, Los Angeles/© DACS 2005 (t); 366 Art Archive/Dagli Orti/© DACS 2005 (b); 367 Réunion Des Musées Nationaux Agence Photographique/Christian Bahier/Philippe Migeat/© Succession Marcel Duchamp/ADAGP, Paris and DACS, London 2005; 368 BAL/Abbot Hall Art Gallery, Kendal, Cumbria/© DACS 2005 (tl); Private Collection/© DACS 2005 (br); 369 BAL/Kunsthaus, Zurich, Switzerland/© ADAGP, Paris and DACS, London 2005; 370 BAL/Scottish National Gallery of Modern Art, Edinburgh/© DACS 2005; 371 BAL/State Russian Museum, St Petersburg; 372 BAL/Kettle's Yard, University of

Cambridge/The Works of Naum Gabo © Nina Williams (cl); Musee Nationale d'Art Moderne, Centre Pompidou, Paris/© ADAGP, Paris and DACS, London 2005 (tr); Private Collection (br); 373 BAL/State Russian Museum, St Peterburg, Russia/© DACS 2005; 374 BAL/Albright Knox Art Gallery, Buffalo, New York/C DACS 2005 (t); Private Collection (b); 375 BAL/Mattioli collection, Milan © DACS 2005; 376 BAL/ Imperial War Museum, London/© Wyndham Lewis and the estate of the late Mrs G.A. Wyndham Lewis by kind permission of the Wyndham Lewis Memorial Trust (a registered charity) (b); Stapleton Collection/© Wyndham Lewis and the estate of the late Mrs G.A. Wyndham Lewis by kind permission of the Wyndham Lewis Memorial Trust (a registered charity) (tr); 377 BAL/Coventry Cathedral, Warwickshire © Estate of Jacob Epstein/Tate, London 2005; 378 BAL/Private Collection, Lefevre Fine Art Ltd, London; 379 © Tate, London: 2005; 380 BAL/Butler Institute for American Art; 381 BAL/Museum of Fine Arts, Houston Texas (b); Detroit Institute of Arts (t); 382 BAL/Museum of Fine Arts, Houston Texas; 384 BAL/Detroit Institute of Arts/© DACS 2005 (t); 384 Corbis (b); 385 BAL/© Christian Schad Stiftung Aschaffenburg/VG Bild-Kunst, Bonn and DACS, London 2005; 386 BAL/Museum of Fine Arts, Houston Texas/© DACS 2005 (t); 386 Art Archive/Dagli Orti (b); 387 BAL/Hamburg Kunsthalle, Hamburg/© DACS 2005; 389 akg-images/Erich Lessing/© DACS 2005 (b); 389 Photo Scala, Florence/© Digital image, Museum of Modern Art, New York/© 2005 Mondrian/Holtzman Trust c/o HCR International Warrenton Virginia USA (tr); 390 Kobal Collection/Bunuel-Dali (t); 390 Photo Scala, Florence/© 2005, Digital image, Museum of Modern Art, New York/© DACS 2005 (b): 391 BAL/Collection of Claude Herraint, Paris/@ ADAGP, Paris and DACS, London 2005 (c), (bl), (br); 392 BAL/Philadelphia Museum of Art, Pennsylvania PA/© Salvador Dali, Gala-Salvador Dali Foundation, DACS, London 2005; 393 BAL/Albright Knox Art Gallery, Buffalo, New York/© Succession Miro, DACS 2005, 394 BAL/Private Collection/@ Man Ray Trust/ADAGP Paris and DACS London 2005 395 BAL/Private Collection/© ADAGP, Paris and DACS, London 2005; 396 BAL/Musee Picasso, Paris France/© Succession Picasso/DACS 2005 (t): Private Collection/© Succession Picasso/DACS 2005 (b): 397 BAL/Bonhams, London/© Succession Picasso/DACS 2005 (b); National Gallery of Victoria, Melbourne Australia/© Succession Picasso/DACS 2005 (t); 398 BAL/Imperial War Museum, London (t); 398-399 BAL/Wakefield Museums & Galleries, West Yorkshire/Reproduced by permission of the Henry Moore Foundation (b); 400 BAL/Private collection/Bowness, Hepworth Estate (b); 400 Corbis/Andy Keate; Edifice (t); 401 BAL/Private collection/© Angela Verren-Taunt 2005. All rights reserved, DACS; 402 BAL/Mexico City, Mexico/Ian Mursell/Mexicolore/© DACS 2005; 403 BAL/Phoenix Art Museum, Arizona/© 2005 Banco de Mexico Diego Rivera & Frida Kahlo Museums Trust. Av. Cinco de Mayo No.2, Col. Centro, Del. Cuauhtemoc 06059, Mexico, D.F./INBA; 404 BAL/Private Collection/© DACS 2005; 405 BAL/© Museum of Fine Arts, Houston, Texas, USA, Gift of Meredith J. and Cornelia Long; 406 BAL/© Museum of Fine Arts, Houston, Texas, USA/© ARS, NY and DACS, London 2005; 407 BAL/© Butler Institute of American Art, Youngstown, OH, USA, Museum Purchase 1950 (t); 408 BAL/Whitney Nuseum of American Art, New York; 409 BAL/Tokyo Fuji Art Museum Tokyo, Japan/© Grandma Moses Properties Co, 1945; 410-411 BAL/Private Collection/© ARS, NY and DACS, London 2005 (b); 411 BAL/Musee Nationale d'Art Moderne, Paris/© ARS, NY and DACS, London 2005 (tr); 412 BAL/Los Angeles County Museum of Art/© ARS, NY and DACS, London 2005 (tl); Private Collection/© Willem de Kooning Revocable Trust/ARS, NY and DACS, London 2005 (br); 413 BAL/Fogg Art Museum, Harvard University Art Museums, USA/© 1998 Kate Rothko Prizel & Christopher Rothko/DACS 2005 (br), (c); 415 Photo Scala, Florence/C 2005, Digital image, Museum of Modern Art, New York/© ARS, NY and DACS, London 2005. 416 BAL/Musee National d'Art Modern, Centre Pompidou, Paris/© Estate of Sam Francis/DACS, London 2005; 417 BAL/Private Collection/© ADAGP, Paris and DACS. London 2005; 418 BAL/Private Collection/© ADAGP. Paris and DACS, London 2005; 419 BAL/Private Collection/© ADAGP, Paris and DACS, London 2005; 420 BAL/Private Collection/©

ADAGP, Paris and DACS, London 2005. 421 BAL/Detroit Institute of Arts, USA/© ADAGP, Paris and DACS, London 2005, 422 BAL/Private Collection/© ADAGP, Paris and DACS, London 2005; 423 BAL/Hamburg Kunsthalle, Hamburg/© Estate of Dieter Roth (b); Private collection/© Hundertwasser Archives, Vienna 424 BAL/Estorick Foundation, London/© DACS 2005; 425 BAL/ CAPC Musee d'Art Contemporain, France/© Estate of Mario Merz; 426-427 BAL/Private Collection/© DACS 2005; 428 BAL/Hamburg Kunsthalle, Hamburg/C Fundacio Antoni Tapies/DACS, London, 2005 (tl); 429 akg-images/L. M. Peter/© DACS 2005; 430-431 BAL/New Walk Museum, Leicester City Museum Service/© Estate of Terry Frost; 432 BAL/Private collection/© R.B.Kitaj; 433 BAL/Aberdeen Art Gallery & Museum/© Estate of Francis Bacon 2005. All rights reserved. DACS 2005 (tr); Private collection/© Estate of Francis Bacon 2005. All rights reserved, DACS (b). 434-435 BAL/Private Collection/© Lucian Freud; 436-437 BAL/Arts Council Collection, Hayward Gallery, London/© ADAGP, Paris and DACS, London 2005; 437 BAL/Detroit Institute of Arts/© Robert Rauschenberg/VAGA. New York/DACS, London 2005 (tr): 438 BAL/Private Collection/© ARS, NY and DACS, London 2005; 440 BAL/Kunsthalle, Tubingen, Germany/© Richard Hamilton 2005. All rights reserved, DACS 2005 (tr); Saatchi Collection, London/C The Andy Warhol foundation for the Visual Arts, Inc./DACS, London, 2005. Trademarks Licensed by Campbell Soup Company. All Rights Reserved (b); 441 BAL/Private collection/© Estate of Roy Lichtenstein/DACS 2005; 442 BAL/Private collection/C Alex Katz/VAGA New York/DACS London 2005 (t): Private collection/© Jasper Johns/VAGA, New York/DACS, London 2005 (b); **443** BAL/Private Collection/© Jasper Johns/VAGA, New York/DACS, London 2005; 444 BAL/Private collection/© The Andy Warhol Foundation for the Visual Arts, Inc./ARS, NY and DACS, London 2005; 445 BAL/Museum of Fine Arts, Houston, Texas, USA/© The Estate of Philip Guston (t); Wolverhampton Art Gallery, West Midlands/© James Rosenquist/VAGA, New York/DACS, London 2005 (b); 447 BAL/Ludwig Museum, Cologne/C David Hockney; 448 Rex Features/Ray Tang (RTR)/C David Batchelor; 450-451 Alamy Images/Ian Dagnall 450 Corbis/Peter Turnley (tl); 451 Rex Features/Sipa Press (SIPA) (br); 452 BAL/Museum of Fine Arts, Houston, Texas, USA/© Louise Bourgeois/VAGA, New York/DACS, London 2005; 452-453 BAL/On loan to Hamburg Kunsthalle, Hamburg/© DACS 2005; 454 BAL/On loan to Hamburg Kunsthalle Hamburg/© Estate of Duane Hanson/VAGA, New York/DACS, London 2005; 455 BAL/Galleria Nazionale d'Arte Moderna, Rome/© ARS, NY and DACS, London 2005; 456 BAL/On loan to Hamburg Kunsthalle, Hamburg/C ARS, NY and DACS, London 2005 (t); Private Collection/©Cy Twombly, Courtesy of the Gagosian Gallery (b); 457 BAL/Hamburg Kunsthalle, Hamburg/© ARS, NY and DACS, London 2005. 458 BAL/Hamburg Kunsthalle, Hamburg/Cat 827-4 © Gerhard Richter; 459 BAL/ Detroit Institute of Arts, USA/© Carl Andre/VAGA, New York/DACS London 2005; 460 Photo: Wolfgang Volz, © Christo 1998; 461 BAL/On loan to Hamburg Kunsthalle, Hamburg/© Georg Baselitz; 462 Courtesy James Cohen Gallery, New York. Collection: DIA Center for the Arts, New York, Photo Gianfranco Gorgoni/© Estate of Robert Smithson/VAGA, New York/DACS, London 2005; 463 Photo Scala, Florence/© 2005, Digital image, Museum of Modern Art, New York/© Chuck Close, courtesy PaceWildenstein, New York; 464 BAL/Private Collection Hamburg/© Sigmar Polke; 465 © Gilbert & George; 466 BAL/ Hamburg Kunsthalle, Hamburg/© ADAGP, Paris and DACS London 2005 (t); Hamburg Kunsthalle, Hamburg, Germany/© Jorg Immendorff (b); 467 BAL/© Museum of Fine Arts, Houston, Texas, USA, Funds from National Endowment Fund for Arts & Mrs. T.N.Law/C ARS.NY and DACS, London 2005; 468 akgimages/Richard Booth/© Antony Gormley; 471 View Pictures/ Photo: Dennis Gilbert/C Anish Kapoor; 473 BAL/Hamburg Kunsthalle, Hamburg, Germany/C Jeff Koons; 474 C Andy Goldsworthy, Cass Sculpture Foundation and Michael Hue-Williams; 477-478 White Cube Gallery/Courtesy Jay Jopling/Photo: Stephen White/C Damien Hirst

AUTHOR ACKNOWLEDGEMENTS

Catalogue descriptions for old master paintings sometimes contain a caveat to the effect that although the work of art is principally by the hand of the artist in question, it is possible to detect other hands at work. So it is with this book. It came together in slightly unusual and hurried circumstances and I am very grateful to those who contributed, and whose hands can at times be detected. Nonetheless I take responsibility for what is written, and I hope that the fresh ideas outnumber the errors. In particular I would like to thank Ferdie MacDonald who was a patient and wise editor, Thomas Cussans who contributed the pages on early art and had a valuable input into many others, and Reagan Upshaw. Paintings also reveal influences and here I would like to acknowledge a few of many: Norbert Lynton, Erica Langmuir, Robert Hughes, and Umberto Morra.